Anne Forschler-Tarrasch
European Cast Iron / Europäischer Eisenkunstguß

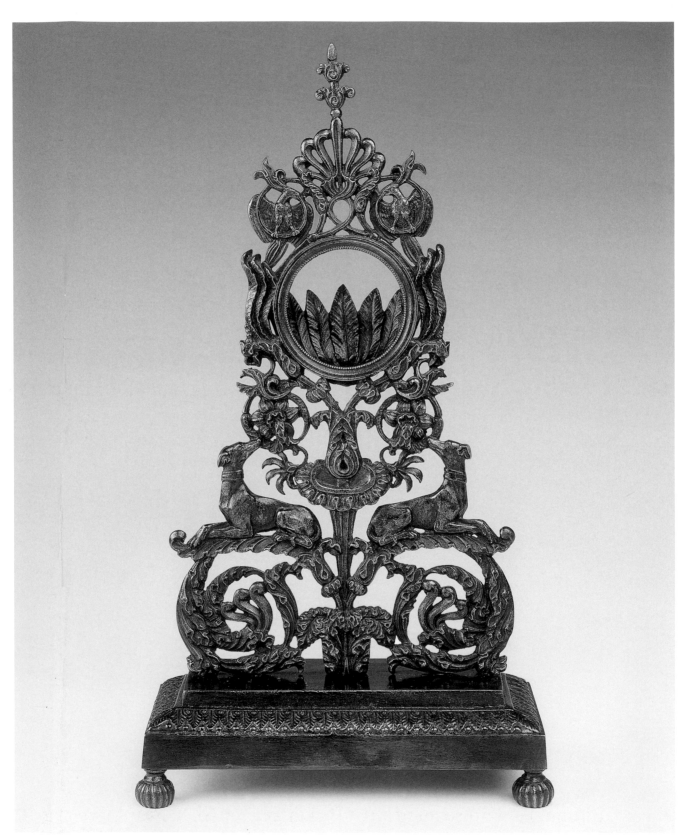

Pocket Watch Holder / Taschenuhrhalter (Cat. 756).

EUROPEAN CAST IRON IN THE BIRMINGHAM MUSEUM OF ART

THE GUSTAV LAMPRECHT AND MAURICE GARBÁTY COLLECTIONS

Anne Forschler-Tarrasch

EUROPÄISCHER EISENKUNSTGUSS IM BIRMINGHAM MUSEUM OF ART

DIE SAMMLUNGEN VON GUSTAV LAMPRECHT UND VON MAURICE GARBÁTY

Birmingham Museum of Art • Birmingham • Alabama • USA
Verlag Willmuth Arenhövel • Berlin • Deutschland (Germany) • 2009

A Publication of the / Eine Veröffentlichung des
Birmingham Museum of Art
2000 Reverend Abraham Woods, Jr. Blvd., Birmingham,
Alabama, 35203-2278 USA
Tel. (205) 254-2565 • Fax (205) 254-2714

Author / Autor:
Anne Forschler-Tarrasch, Ph. D. /Dr.
The Marguerite Jones Harbert and John M. Harbert III
Curator of Decorative Arts
Birmingham Museum of Art

This publication was generously supported by: / Diese
Publikation wurde dankenswerterweise finanziell geför-
dert durch:

- The Peter Krueger-Christie's Foundation;
- The National Endowment for the Arts;
- The Members Board of the Birmingham
 Museum of Art; and/und
- The Adele Pharo Azar Charitable Trust.

Photography Credits / Abbildungsnachweis:

Ann Arbor, Michigan, USA, Dr. Thomas Garbáty
Fig./ Abb. 36.
Bendorf, Rheinisches Eisenkunstgussmuseum
Fig./Abb. 51.
Berlin, Kunstgewerbemuseum, SMB Fig./Abb. 43 (Hans-
Joachim Bartsch).
Berlin, Kupferstichkabinett, SMB Fig./Abb. 10 (Jörg P.
Anders), 41, 48.
Berlin, Verlag Willmuth Arenhövel Fig./Abb. 11, 13, 15-17,
40, 54, A-K, M-P, 58.
Birmingham, Alabama, USA, ACIPCO Archive Fig./Abb.
32-35.
Birmingham, Alabama, USA, BMA.
-, Anne Forschler-Tarrasch Fig./Abb. 37.
-, Lamprecht Collection Records Fig./Abb. 25 f., 28-31,
 47; Cat. 928, 931, 939, 941 f., 944-46, 949, 952 f., 972 f.,
 977-83.
-, Sean Pathasema Fig./Abb. 1-4, 49, 59; Cat. 1-926.
Birmingham, Alabama, USA, Jürgen Tarrasch Fig./Abb.
38.
Büdelsdorf, Eisenkunstgussmuseum Fig./Abb. 18, 53.
Leipzig, SächsStAL Fig./Abb. 19-22.
Leipzig, Stadtarchiv Fig./Abb. 23 f.
St. Louis, Missouri, USA, St. Louis Post-Dispatch
Fig./ Abb. 27.
Wroclaw (Breslau; Poland/Polen), Muzeum Narodowe
Fig./ Abb. 6-8.

Cover illustrations / Abbildungen auf dem Umschlag:
Front / Vorderseite: Cat. 756
Back/Rückseite: Cat. 190

Editorial staff / Redaktion des deutschen Textes im Verlag:
Hannah Arenhövel, Norbert Schulz

Printed by / Herstellung:
BUD Brandenburgische Universitätsdruckerei und Verlags-
gesellschaft Potsdam mbH, Potsdam (Ortsteil Golm)

Bound by / Buchbinderische Verarbeitung:
Bruno Helm, Berlin

© 2009 by Birmingham Museum of Art, Birmingham,
Alabama, USA, Verlag Willmuth Arenhövel, Berlin,
Deutschland / Germany, and Author / und Autorin

ISBN 978-3-922912-65-1

Publications / Publikationen:
Bartel 2004 (32, Cat. 432) Fig./Abb. 52.
Bartel and Bossmann (37, 101, Fig./Abb. 34, 126)
Fig./ Abb. 5, 9.
Berliner Lokal-Anzeiger (August 15, 1916) Fig./Abb. 40.
Geschichte und Feyer (...) Fig./Abb. 55.
Hintze 1928 a (12, 123, 7) Fig./Abb. 12, 14, 42.
Neuwirth (s. Fig./Abb. 54; no. 418, 146, 420) Fig./Abb.
54, L, U-V.
Osterwald (pl./Taf. IV; 60) Fig./Abb. 45 f.
Reindel (s. Cat. 618; no pag./o. S.) Fig./Abb. 44.
Tiemann (title page/Titelseite) Fig./Abb. 57.
275 Jahre Eisenguss (...) Fig./Abb. 54, P-T.

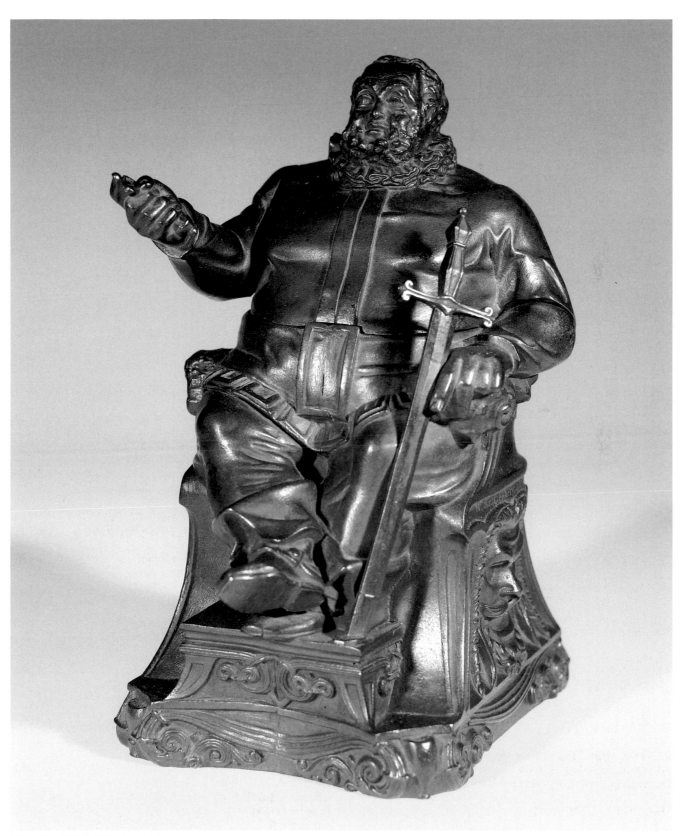

Tobacco Box / Tabakbehälter (Cat. 716)

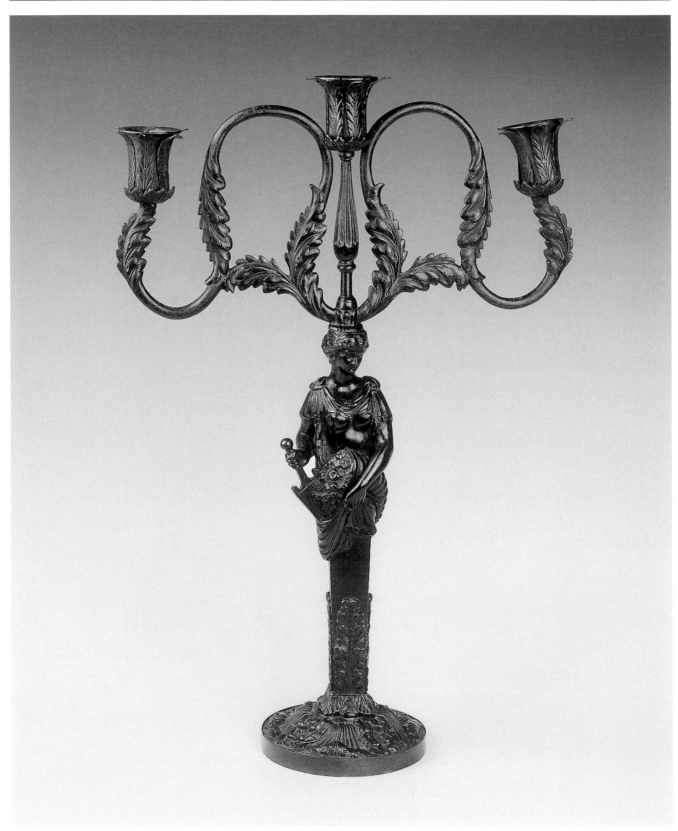

Candelabrum / Kandelaber (Cat. 801)

CONTENTS / INHALT

Catalogue / Katalog

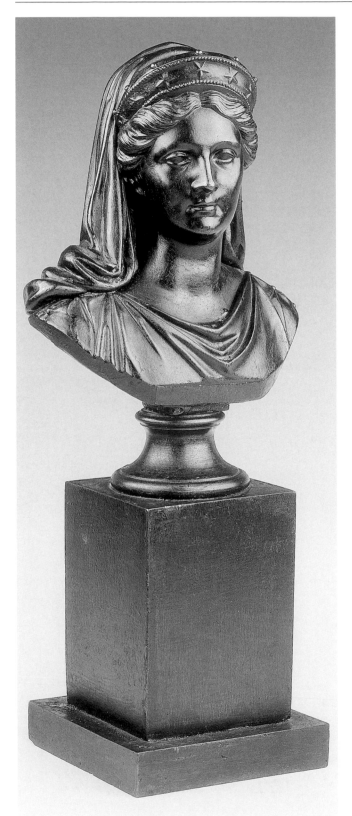

Luise, Queen of Prussia / Luise, Königin von Preußen (Cat. 602).

Foreword

Museums take justifiable pride in many aspects of their work, but perhaps none as much as in the publication of their collections. The collection is, after all, available to the public day-in and day-out. It remains at the heart of our mission; to provide a deeper understanding and appreciation of its history and significance is essential to our educational and institutional purpose. Therefore, it is with tremendous pride and pleasure that the Birmingham Museum of Art presents this most recent book, a catalogue of our distinguished collection of European cast-iron art.

The collection of cast-iron art was the first large group of objects to enter the Museum when it was founded in 1951. It played a significant role in early exhibitions and has provided an excellent foundation for the Museum's outstanding decorative arts collection, which is today a major strength of the Museum. Birmingham's decorative cast iron collection is recognized internationally for its size as well as its quality, and is the only such collection known in the United States. It has a particular resonance for the people of Birmingham, as it provides a link to the city's industrial origins.

When the American Cast Iron Pipe Company purchased the collection in 1939, its directors hoped that the technical innovation, mastery of technique, and artistic quality of the objects would inspire and excite workers at the company. They eventually decided against the creation of a private museum and instead generously donated the collection to the city's fledging museum. As a result, a broader audience is able to benefit from seeing these objects, many stunningly beautiful, and all with a rich and interesting story to tell. This publication presents a greater understanding of the individual objects and places them in the historical moment of their creation. It also compels us to look at these pieces with new insight and to appreciate more deeply their elegance and underlying craftsmanship.

Dr. Anne Forschler-Tarrasch, The Marguerite Jones Harbert and John M. Harbert III Curator of Decorative Arts at the Museum, has written an exceptional essay summarizing the history of European decorative cast-iron production, and has thoroughly documented each of the nine-hundred-plus objects in this extensive collection. We are most grateful to her for the scholarship and unswerving dedication she brought to this research and publication.

Gail C. Andrews
The R. Hugh Daniel Director

Zum Geleit

Museen sind auf viele Aspekte ihrer Arbeit stolz, am meisten aber vielleicht auf die Publikation ihrer Sammlungen. Die Sammlung ist Mittelpunkt unserer Arbeit; ein tiefes Verständnis und eine Würdigung ihrer Geschichte und Bedeutung ist für unseren pädagogischen Auftrag und Institutionszweck entscheidend. Daher präsentiert das Birmingham Museum of Art mit großem Stolz und großer Freude diesen Katalog: die Veröffentlichung unserer bedeutenden Sammlung von europäischem Eisenkunstguß.

Sie war die erste große Sammlung, die nach der Gründung 1951 ins Museum kam. Sie spielte in den ersten Ausstellungen eine wichtige Rolle und diente als solide Basis für die damals im Entstehen begriffene hervorragende Kunstgewerbe-Sammlung des Museums. Birminghams Eisenkunstguß-Sammlung ist heute für ihre Größe und Qualität international anerkannt und die einzige Sammlung dieser Art in den Vereinigten Staaten. Sie bekommt eine besondere Anerkennung durch die Bürger Birminghams, da sie eine Brücke zu dem industriellen Ursprung der Stadt bildet.

Als die American Cast Iron Pipe Company die Sammlung 1939 kaufte, erhoffte ihr Vorstand, daß die technische Innovation, die Meisterschaft der Technik und die künstlerische Qualität der Objekte die Mitarbeiter der Firma inspirieren und anregen würden. Er hat sich letztendlich gegen die Gründung eines privaten Museums entschieden und statt dessen die Sammlung an das neue Stadtmuseum übergeben. Auf diese Weise kann ein breiteres Publikum an den Objekten – viele wunderschön, alle mit einer reichen und interessanten Geschichte – teilhaben.

Diese Publikation bietet einen Einblick und Detailinformationen zur Herstellung der einzelnen Objekte und setzt diese in ihren historischen Kontext. Sie weckt außerdem das Verständnis für die Objekte und läßt uns deren Erlesenheit und eigentliche Kunstfertigkeit würdigen.

Dr. Anne Forschler-Tarrasch, The Marguerite Jones Harbert and John M. Harbert III Curator of Decorative Arts im Birmingham Museum of Art hat in einer hervorragenden Abhandlung die Geschichte der europäischen Eisenkunstguß-Produktion zusammengefaßt und jedes der mehr als neunhundert Objekte dieser umfangreichen Sammlung dokumentiert. Wir sind ihr für ihre Forschung und ihre unentwegte Hingabe an diese Arbeit sehr dankbar.

Gail C. Andrews
The R. Hugh Daniel Director

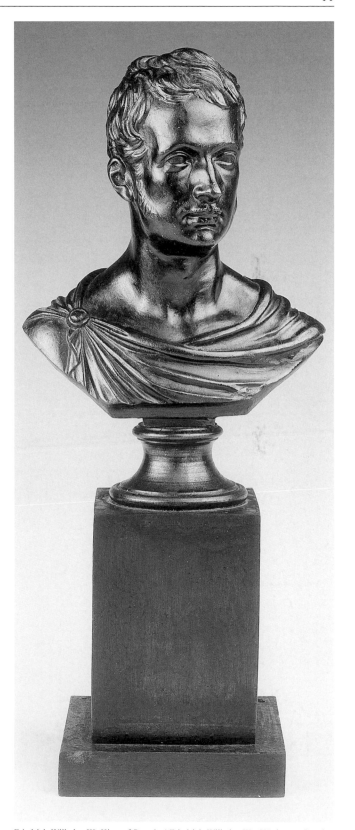

Friedrich Wilhelm III, King of Prussia / Friedrich Wilhelm III., König von Preußen (Cat. 599).

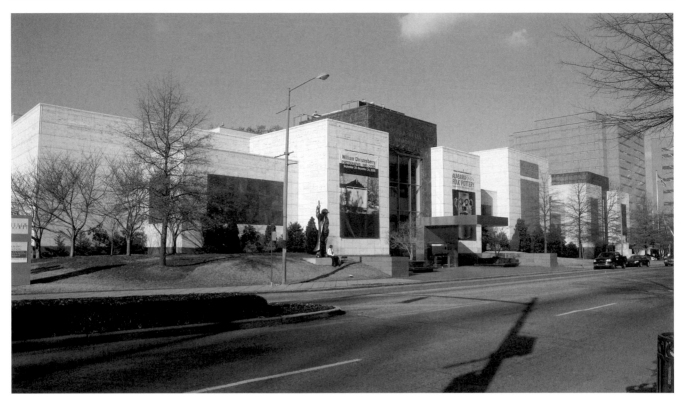

Fig./Abb. 1 Birmingham Museum of Art, main entrance / Eingangsfront; photo/Aufnahme 2006.

Fig./Abb. 2-4 Birmingham Museum of Art, gallery views / Blicke in die Ausstellung; photos/Aufnahmen 2008.

Fig./Abb. 2

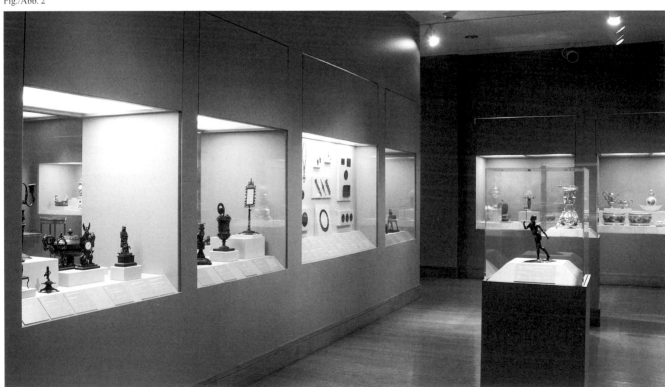

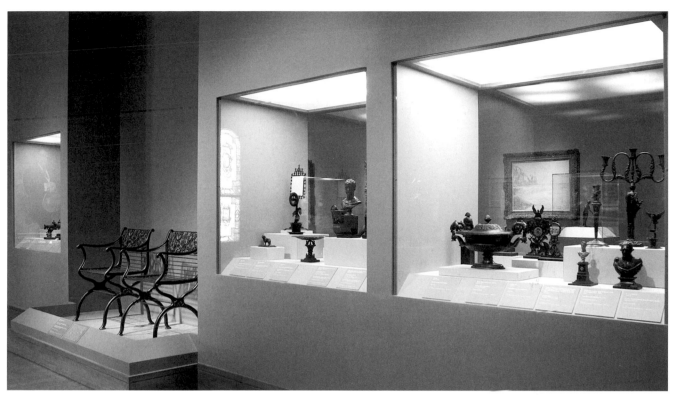

Fig./Abb. 3

Fig./Abb. 4

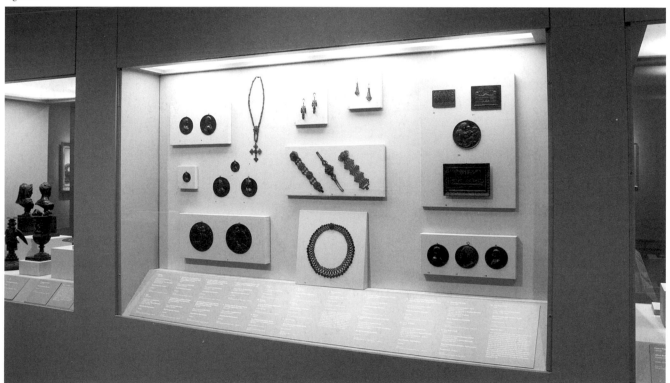

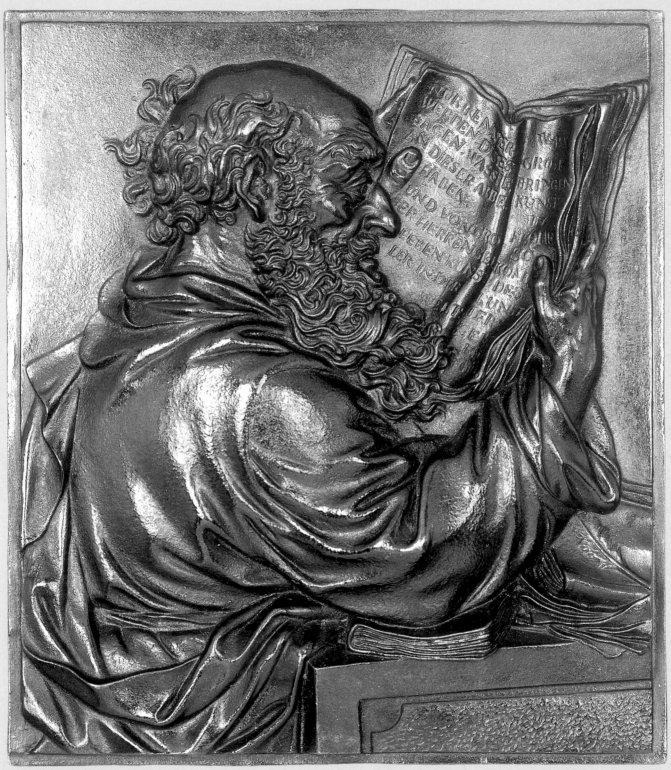

The Scholar / Der Gelehrte (Cat. 147).

INTRODUCTION / EINFÜHRUNG

The Development of Nineteenth-Century Central European Decorative Cast Iron

The rise and fall of decorative cast-iron production in Central Europe reflects the influence of the social, political, and economic currents of the period from the late eighteenth through the mid-nineteenth century. The historical events of this time: the conquest of much of Europe by Napoleon after the French Revolution, the Wars of Liberation between 1813 and 1815, a politically redefined Europe following the Congress of Vienna in 1815, and the Revolutions of 1848, all played a role in the development and production of contemporary iron objects, both useful and decorative, made for the luxury market. Due to its relatively low price and through new techniques – the refinement of foundry sand, the composition of iron (a higher phosphorus content), and new casting methods – iron as a raw material lent itself to the serial production of individual models. Vast quantities of cast-iron objects were made at foundries throughout Europe and were sold far beyond its borders.

Like monumental engineering and architectural works of the period, such as bridges and factories, the plaques, sculptures, pieces of jewelry, and household utensils cast in iron during this time are equally representative of the period leading up to and including the Industrial Revolution. The Gräflich Einsiedelsche Eisenwerk Lauchhammer in the northern part of the Kingdom of Saxony, which once cast life-sized sculptures in iron, is considered the birthplace of modern iron casting. The three royal Prussian iron foundries in Gleiwitz, Berlin, and Sayn were especially important for the development of fine, precision casting. *Berliner Eisen* is the name commonly used today to describe the products of these three foundries, although the term is often erroneously applied to cast-iron objects in general. *Fer de Berlin, fonte de Berlin*, and *Berlin iron* were also popular contemporary terms used primarily to describe the delicate jewelry made in Prussia at both public and private foundries. Exported under these names, cast-iron objects were sent to Paris, London, Italy, Scandinavia, and as far as North and South America.

Almost one-hundred years after the first royal Prussian iron foundry was established in the small town of Gleiwitz in the province of Silesia, in modern-day Poland, Johannes Franz Gustav Lamprecht (1862-1946), an architect and professor at the *Akademie für graphische Künste und Buchgewerbe* (Academy for Graphic and Book Arts) in Leipzig, began collecting nineteenth-century artistic objects made at this and the two other royal foundries, as well as products manufactured at a variety of public and private ironworks in Germany, Austria, and Bohemia. His collection, which was formed over a period of about thirty years, numbered almost one thousand objects, and was, at one time, the largest collection of its kind. In 1922, economic conditions forced Gustav Lamprecht to sell his collection to German-American businessman and entrepreneur Max Koehler of Saint Louis, Missouri. Almost twenty years later, the Koehler family sold the collection to the Birmingham-based American Cast Iron Pipe Company (ACIPCO), which in 1951 placed it on long-

Die Entwicklung des europäischen Eisenkunstgusses im 19. Jahrhundert

Aufstieg und Niedergang des Eisenkunstgusses in Zentraleuropa spiegeln die politische Entwicklung des späten 18. bis zur Mitte des 19. Jahrhunderts: die Eroberung weiter Gebiete Europas durch Napoleon nach der Französischen Revolution, die Befreiungskriege von 1813 bis 1815 und ein neugeordnetes Europa auf dem Wiener Kongreß von 1815 sowie die Revolution von 1848. Alle diese Ereignisse fanden ihren Niederschlag in der Entwicklung des neuzeitlichen Eisen- beziehungsweise Eisenkunstgusses, bei letzterem in künstlerisch gestalteten Gebrauchsgüssen oder solchen, die als Luxusware galten.

Wegen seines relativ geringen Preises bot sich das Material „Eisen", auch bedingt durch neue Techniken – Verfeinerung des Formsands, Zusammensetzung des Eisens (hoher Phosphorgehalt) und Art der Abformung – dazu an, größere Mengen nach einzelnen Modellen zu gießen. Eine Vielzahl von Eisenfeingußobjekten wurde von Eisengießereien in ganz Europa hergestellt und weit über dessen Grenzen hinweg verkauft.

Wie monumentale technische und architektonische Werke der Zeit – zum Beispiel Brücken und Fabriken – sind die während dieser Periode in Eisen gegossenen Plaketten, Skulpturen, Schmuckstücke oder Geräte charakteristisch für die Zeit der industriellen Revolution. Als Geburtsstätte des neuzeitlichen Eisenkunstgusses ist das „Gräflich Einsiedelsche Eisenwerk Lauchhammer" im Norden des Königreichs Sachsen anzusehen, wo erstmalig lebensgroße Skulpturen in Eisen gegossen wurden. Von besonderer Bedeutung für den Eisenfeinguß waren jedoch die drei „Königlichen Preußischen Eisen-Gießereien" in Gleiwitz, Berlin und Sayn. „Berliner Eisen" ist der geläufige Name, der heute benutzt wird, um die Produkte dieser drei Eisengießereien zu beschreiben, wird aber heute irrtümlicherweise oft ganz allgemein für Eisenkunstguß angewendet. „Fer de Berlin", „fonte de Berlin" und „Berlin iron" waren ebenfalls zeitgenössische Bezeichnungen, hauptsächlich benutzt, um den feingliedrigen Schmuck, der in staatlichen sowie in privaten Gießereien hergestellt wurde, zu bezeichnen. Unter diesen Namen wurden Eisenkunstgußobjekte nach Paris, London, Italien und Skandinavien oder nach Nord- und Südamerika exportiert.

Fast einhundert Jahre nachdem die erste Königliche Preußische Eisengießerei in Gleiwitz in Schlesien (Gliwice, heute Polen), gegründet worden war, begann Johannes Franz Gustav Lamprecht (1862-1946), Architekt und Professor an der Akademie für graphische Künste und Buchgewerbe in Leipzig, Objekte aus dem 19. Jahrhundert, die in den drei Königlichen Eisengießereien und anderen staatlichen sowie privaten Eisengießereien in Deutschland, Österreich und Böhmen gegossen wurden, zu sammeln. Seine Sammlung, die in über dreißig Jahren zusammengetragen wurde, zählt fast 1.000 Objekte und war zu der Zeit die größte Sammlung ihrer Art. 1922 wurde Lamprecht durch wirtschaftliche Umstände dazu gezwungen, seine Sammlung an den deutsch-amerikani-

term loan at the Birmingham Museum of Art. In 1986, the company officially donated the collection to the Museum. In 1962, inspired by the Lamprecht Collection, Maurice Garbáty, a German industrialist and patron of the arts, who emigrated with his family from Berlin to the United States in 1939, donated an additional fifty-one cast-iron objects to the Museum. Together, the Lamprecht and Garbáty collections comprise one of the largest holdings of nineteenth-century European decorative cast iron in the world and form the only such group of objects known in the United States. It is most appropriate that these objects have made their home in Birmingham since it is primarily the iron industry that was responsible for the establishment of the city and its rise as a major industrial center. As William McCulloch, who conducted much of the research on the Lamprecht Collection for the American Cast Iron Pipe Company, wrote in 1972 upon the one hundredth anniversary of the founding of the City of Birmingham, *"cast iron and its production have played a vital role in the development of the economy of this city [...] in no city could the aesthetic qualities of cast-iron art be more appreciated than in Birmingham, Alabama."*[1]

The objects in the Birmingham collection fall into several distinct groups, all marked by great beauty and unsurpassed technical achievement. They range from the most practical to the most highly decorative and include household utensils, such as plates, bowls, knife rests, napkin rings, watch stands, lamps, paperweights, and candlesticks. Purely decorative pieces, such as jewelry, busts, statuettes, relief plaques, and fine portrait medallions modeled by the Austrian artist Leonhard Posch (1750-1831),[2] were produced in large numbers at all three royal foundries and were copied at several smaller, private ones. The Birmingham collection includes models that were made in great quantity, as evidenced by the number of extant examples present in contemporary museums and private collections, as well as those so rare that probably only a handful, if that, were ever produced. In all, the collection provides a comprehensive survey of early nineteenth-century Central European cast-iron production from its inception to its demise less than fifty years later.

The history of cast-iron production in Central Europe has been dealt with in great detail in a number of publications.[3] Most European states had their own iron-casting traditions that included the early production of stove plates and military equipment like cannons and cannon balls, and even water pipes, the first of which were installed at Dillenburg Castle.[4] England and Saxony, and later Prussia, however, provided the decisive impulses that led to a new era of decorative cast-iron production.

Despite improvements in technology and a greater understanding of metallurgy in the seventeenth and eighteenth centuries, German foundries nonetheless remained far behind their British counterparts in terms of innovation and production prior to the turn of the nineteenth century. The push to develop and promote the production of decorative cast iron came only toward the end of the eighteenth century after the introduction of the cupola furnace, developed and improved upon by the English industrialist John Wilkinson (1728-1808). The cupola furnace allowed for the production

schen Geschäftsmann und Unternehmer Max Koehler aus St. Louis, Missouri, zu verkaufen. Fast zwanzig Jahre später verkaufte die Koehler-Familie die Sammlung an die American Cast Iron Pipe Company (ACIPCO) mit Firmensitz in Birmingham, Alabama, die sie 1951 als Dauerleihgabe dem Birmingham Museum of Art übergab und 1986 schließlich offiziell schenkte.

Im Jahr 1962, inspiriert von der Lamprecht-Sammlung, stiftete Maurice Garbáty, deutscher Industrieller und Kunstmäzen, der 1939 mit seiner Familie von Berlin in die USA emigriert war, dem Museum weitere 51 Objekte aus Eisenkunstguß. Zusammen bilden die Lamprecht- und die Garbáty-Sammlung eine der größten Sammlungen von Eisenkunstgüssen und die einzige Sammlung solcher Objekte in den USA. Erfreulicherweise haben diese Sammlungen ihr Heim gerade in Birmingham gefunden, beruht doch die Gründung der Stadt und ihr Aufstieg zum bedeutenden Industriezentrum auf der Eisenindustrie. William McCulloch, der die meisten Forschungsarbeiten an der Lamprecht-Sammlung für die American Cast Iron Pipe Company betrieben hat, schrieb 1972 zum hundertjährigen Jubiläum der Gründung der Stadt Birmingham: *„Eisenguß und seine Produktion haben eine entscheidende Rolle in der Entwicklung der Wirtschaft dieser Stadt gespielt [...] in keiner Stadt sonst könnten die ästhetischen Qualitäten des Eisengusses mehr geschätzt werden als in Birmingham, Alabama."*[1]

Die Objekte der Birmingham-Sammlung gliedern sich in mehrere Gruppen; jede von großer Schönheit und unübertroffener technischer Leistung. So gibt es Reliefs verschiedener Art, Schmuck, Skulpturen, Möbel oder Geräte vielerlei Funktion wie Teller, Schüsseln, Messerbänkchen, Serviettenringe oder Taschenuhrenständer, Lampen, Briefbeschwerer und Kerzenhalter. Unter den bildhauerischen Objekten wie Büsten, Statuetten und Reliefplaketten ragen besonders die feinen Porträtmedaillons des österreichischen Künstlers Leonhard Posch (1750-1831)[2] heraus. Sie wurden in großer Zahl in allen drei Königlichen Preußischen Eisengießereien produziert und zum Teil von vielen kleinen privaten Gießereien kopiert. Die Birmingham-Sammlung enthält Güsse, die in großen Mengen hergestellt wurden, erkennbar an der Anzahl vorhandener Exemplare in heutigen Museen und privaten Sammlungen, sowie Güsse, die so rar sind, daß angenommen werden kann, daß nur wenige produziert wurden. Im ganzen bietet die Sammlung einen umfassenden Überblick des Eisenkunstgusses aus dem frühen 19. Jahrhundert in Zentraleuropa von seinem Anfang bis zu seinem Niedergang weniger als fünfzig Jahre später.

Die Geschichte des Eisenkunstgusses in Europa wurde schon in vielen Publikationen ausführlich behandelt.[3] Die meisten europäischen Staaten hatten ihre eigene Tradition im Eisenguß, in deren Frühzeit vor allem Ofenplatten und Kriegsgerät wie Kanonenkugeln und Geschützrohre, aber auch Wasserleitungsrohre wie in Dillenburg[4] entstanden. Für den neuzeitlichen Eisenkunstguß jedoch kamen die entscheidenden Impulse aus England und Sachsen, nur wenig später allerdings auch aus Preußen.

of a more homogeneous iron, which enabled the metal to run into smaller channels in the molds, so that castings of a lighter and more delicate design could be produced. The cupola furnace revolutionized the iron industry, allowing small ironworks to become increasingly independent of larger foundries and enabling them to be located in or near populous urban centers. The efficiency of the cupola furnace resulted furthermore in lower operating costs, which gave foundries the freedom and economic incentive to produce decorative castings for the general consumer market. As a result, iron became for the first time a valid alternative to bronze.

The acquisition of the Silesian province in 1741 as an outcome of the War of the Austrian Succession (1740-48) was a major gain for the Prussian state. The abundance of mineral resources in the region was well known to King Friedrich II of Prussia (1712-86; 1740 king), and he forbade the import of iron from non-Prussian lands in an attempt to develop the well-populated, iron-rich region. His motives were military as well as economic; the king realized that conflict with neighboring states could indeed recur and he sought a way to ensure that his need for military equipment would be met. For this reason he did not leave the development of the Silesian iron industry to chance. Instead, he placed the establishment and development of new foundries under the auspices of the Prussian state. During the 1750s the first generation of iron foundries was established, beginning in 1754 with Malapane in Lower Silesia. The original purpose of this new foundry was to provide munitions for the king's army, but the installation of a cupola furnace at the foundry during the late 1780s gave it the technology it needed to cast decorative or artistic objects as well. Under the guidance of the Scottish engineer John Baildon (1772-1846), the first iron bridge in Germany was cast at Malapane between 1794 and 1796 and was installed over the Striegau River on the property of Graf Burghaus near Laasan in Lower Silesia. The production of other cast-iron bridges followed, including those over the Kupfergraben in Berlin in 1798, the bridge in the park at

Trotz Verbesserungen der Technik im Eisenhüttenwesen im 17. und 18. Jahrhundert blieben deutsche Gießereien bis zur Wende zum 19. Jahrhundert weit hinter den englischen zurück. Der Anstoß für den Ausbau und zur Förderung der Herstellung von Eisenkunstguß kam erst am Ende des 18. Jahrhunderts durch die Einführung des Kupolofens (einen Umschmelzofen), entwickelt durch den englischen Industriellen John Wilkinson (1728-1808). Durch den Kupolofen konnte ein homogeneres und reineres, vor allem aber dünnflüssigeres Eisen erreicht werden, das selbst in kleinere Kanäle fließen konnte, so daß der Guß von extrem zierlichen Schmuckteilen ermöglicht wurde. Der Kupolofen gestaltete die Eisenindustrie von Grund auf um und erlaubte kleinen Eisengießereien, sich von den größeren unabhängig zu machen und sich in oder auch neben bevölkerten Ballungsgebieten anzusiedeln. Die Leistungsfähigkeit des Kupolofens und der niedrige Preis von Koks resultierten in geringeren Produktionskosten, was den Gießereien die Freiheit und den wirtschaftlichen Anreiz gab, dekorative Güsse für den Konsumgütermarkt zu produzieren. Zum ersten Mal wurde Eisen eine anerkannte Alternative zu Bronze.

Die Einverleibung der schlesischen Provinz 1741 als Resultat des Österreichischen Erbfolgekriegs (1740-48) war für Preußen ein wesentlicher Gewinn. Die Fülle an Bodenschätzen in der Region war dem preußischen König Friedrich II. (1712-86; 1740 König) bekannt, und er verbot die Einfuhr von Eisen aus nichtpreußischen Ländern, um diese bevölkerte und eisenreiche Region zu entwickeln. Seine Motive waren militärisch sowie auch wirtschaftlich, da der König erkannte, daß Konflikte mit den Nachbarländern wieder auftreten konnten, und er einen Weg suchte, um seinen Bedarf an Kriegsgerät zu decken. Aus diesem Grund überließ er die Entwicklung der schlesischen Eisenindustrie nicht dem Zufall und unterstellte die Gründung und die Entwicklung neuer Eisenwerke der Schirmherrschaft des preußischen Staats. Während der 1750er Jahre wurde die erste Generation neuer Eisenhütten etabliert; die erste war Malapane in Niederschlesien 1754. Der eigentliche Zweck der Hütte war es, Munition für die königliche Armee zu schaffen, aber der Einbau eines Kupolofens Ende der 1780er Jahre gab ihr auch die nötige Technik für den Guß von dekorativen Objekten. Mit der Hilfe des schottischen Ingenieurs John Baildon (1772-1846) wurde zwischen 1794 und 1796 die erste gußeiserne Brücke in Preußen in Malapane gegossen und über dem „Striegauer Wasser" auf dem Sitz des Grafen Burghaus bei Laasan in Niederschlesien errichtet. Die Produktion weiterer gußeiserner Brücken folgte: eine über den Kupfergraben in Berlin 1798, eine im Park vom Schloß Charlottenburg (um 1800) und die Brücken für die Schloßgärten in Wörlitz und in Paretz.[5]

Vielleicht der wichtigste Schritt, den Friedrich II. bezüglich der Entwicklung der preußischen Eisenindustrie gemacht hat, war 1777 die Ernennung von Friedrich Anton Freiherr von Heinitz (1725-1802) zum Oberberghauptmann. Zusammen mit seinem Neffen und Kollegen Friedrich Wilhelm Freiherr, später Graf von Reden (1752-1815), der 1779 Direktor des schlesischen Oberbergamts in Breslau wurde, legte Heinitz das Fundament für die schnelle und höchst erfolgreiche Entwicklung der preußischen Eisenindustrie. In die-

Fig./Abb. 5 Louis Serrurier, The Iron Bridge over the Kupfergraben in Berlin / Die Eiserne Brücke über den Kupfergraben in Berlin, ca. 1800, 29 x 44,5 cm (11 7/16 x 17 1/2 in.); SSB, Inv. 73/33; in Bartel and Bossmann, 37, fig./Abb. 34.

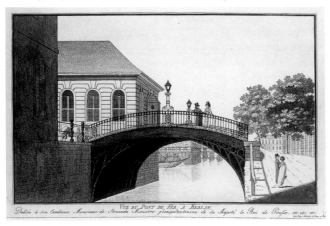

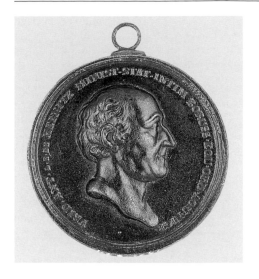

Friedrich Anton Freiherr von Heinitz (Cat. 228;
original size/Originalgröße).
◄ Obv./Vs. Rev./Rs. ►

Charlottenburg Palace, cast about 1800, and bridges for the palace gardens at Wörlitz and Paretz.[5]

Perhaps the most important step Friedrich II took toward developing the Prussian iron industry was the appointment in 1777 of Friedrich Anton Freiherr von Heinitz (1725-1802) to the directorship of the *Preußisches Bergwerks- und Hütten-Department* (Prussian Department for Mining and Metallurgy). Together with his nephew and close colleague, Friedrich Wilhelm Freiherr (later Graf) von Reden (1752-1815), who in 1779 became director of the *Schlesisches Oberbergamt* (Silesian Supervisory Mining Office) in Breslau, Heinitz laid the foundation for the rapid and highly successful development of the Prussian iron industry. During this period, Prussia – although a strong military power – was an economic backwater compared to its neighbors to the west: France, Great Britain, and the Netherlands. Both Heinitz and Reden were well aware of this fact and as a result, they initiated a series of excursions to Great Britain to study the English and Scottish mining industry. Furthermore, Prussian leaders enlisted British experts, placed workers in British plants, purchased rights to all-important technological innovations, and even acquired products that they could copy.

In addition to Malapane, the Lauchhammer foundry, located in what was then part of the Electorate of Saxony,[6] played a key role in the development of the Prussian iron industry. The foundry was established in 1725 by Benedikta Margarete Freifrau von Löwendahl and built on an iron-rich site on her family's Mückenberg estate. Detlev Carl Graf von Einsiedel (1737-1810), Benedikta Margarete's only heir, inherited the foundry in 1776. In Germany, Einsiedel was a leader in eighteenth-century metallurgy and wise enough to rely on the advice of other experts to expand and improve his foundry. Shortly after taking charge of Lauchhammer, he transferred to his foundry methods used in the most advanced areas of the iron industry. The fine quality and extreme fluidity of Lauchhammer iron led Einsiedel to attempt the casting of larger, decorative objects. To this end he established

ser Zeit war Preußen – obwohl eine starke Militärmacht – wirtschaftlich rückständig im Vergleich zu seinen Nachbarn im Westen: Frankreich, Großbritannien und den Niederlanden. Sowohl Heinitz als auch Reden war diese Tatsache bewußt, und sie initiierten eine Reihe von Reisen nach Großbritannien, um die englische und die schottische Eisenindustrie zu studieren. Außerdem wurden von Preußen englische Experten angestellt, preußische Eisenarbeiter vorübergehend in britischen Hütten untergebracht, die Rechte zu wichtigen technischen Neuheiten gekauft und auch Produkte zum Kopieren erworben.

Außer Malapane spielte das Eisenwerk Lauchhammer, damals in Kursachsen gelegen,[6] eine entscheidende Rolle bei der Entwicklung der preußischen Eisenindustrie. Das Werk war 1725 von Benedicta Margaretha Freifrau von Löwendahl gegründet und auf dem Gebiet des Ritterguts Mückenberg errichtet worden, das reich an Raseneisenstein war. Detlev Carl Graf von Einsiedel (1737-1810), der einzige Erbe Benedicta Margarethas, übernahm die Gießerei 1776. Einsiedel war führend in der Metallurgie des 18. Jahrhunderts tätig und hatte seine Gießerei mit Hilfe verschiedener Experten ausgebaut und verbessert. Kurz nachdem er die Leitung von Lauchhammer erhalten hatte, übertrug er dorthin die Produktion von anspruchsvollen Gebieten der Eisenindustrie. Die gute Qualität und extreme Fließbarkeit des Lauchhammer-Eisens führte dazu, daß Einsiedel Versuche mit dem Guß größerer Skulpturen unternahm. Er legte eine Sammlung von Gipsabgüssen nach antiken Statuen und Büsten an, erweiterte diese 1785 durch den Kauf einer großen Gruppe von Abgüssen aus Rom[7] und sammelte später Arbeiten von zeitgenössischen Künstlern als Vorlagen für die Lauchhammerproduktion. Mit dem Guß einer lebensgroßen Bacchantin 1784[8] war die Gießerei die erste, der der Guß einer größeren vollrunden Skulptur in einem Stück gelang. In der Folgezeit wurden unter anderem zahlreiche Büsten und Statuen nach antiken und zeitgenössischen Skulpturen angefertigt, aber auch Grabmäler, Möbel, Öfen und

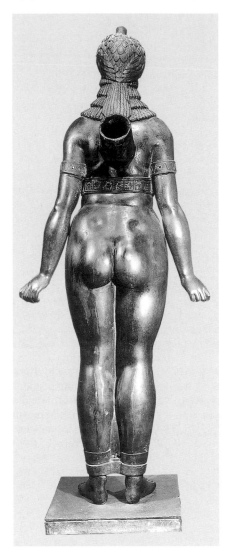

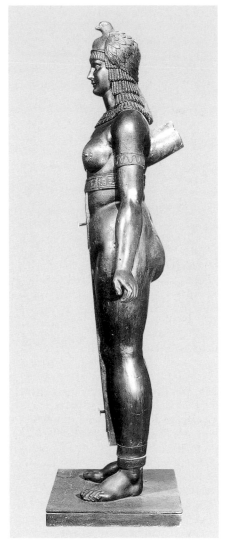

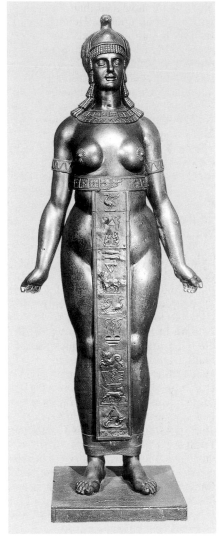

Fig./Abb. 6 Fig./Abb. 7 Fig./Abb. 8

Fig./Abb. 6-8 Part of a stove in the form of an Egyptian priestess / Ägyptische Priesterin als Ofenaufsatz, Lauchhammer, ca. 1800, H. with base / mit Sockel 174 cm (68 1/2 in.); Wrocław (Breslau; Poland/Polen), Muzeum Narodowe, Inv. V-1751.

a collection of plaster casts of ancient sculptures and busts – augmented in 1785 through the purchase of a large group of casts in Rome[7] – and later of works by contemporary artists to serve as models for Lauchhammer production. With the casting of a life-size bacchante statuette in 1784,[8] the foundry became the first to move from the production of simple, ornamental, two-dimensional relief plaques to the casting of larger, three-dimensional objects. In the following years the foundry produced other busts and statues after both antique and contemporary models, but also grave slabs, furniture, stoves, and small objects like portrait medallions and household utensils. A specialty was large figural stoves, which utilized statues mounted on top as flues.[9]

Minister Heinitz had served as advisor to Graf von Einsiedel and was cognizant of Lauchhammer's success in casting decorative objects. He and Reden visited Lauchhammer in 1782 and quickly realized that Einsiedel's foundry was

Objekte des Feingusses wie Porträtreliefs oder Kleingeräte. Eine Spezialität waren die Figurenöfen, bei denen große Statuen – auf Öfen aufgesetzt – als Abzug dienten.[9]

Minister Heinitz hatte Einsiedel beraten und wußte von Lauchhammers Erfolg. Er und Reden besuchten Lauchhammer 1782 und erkannten, daß Einsiedels Gießerei im Bereich des Eisenkunstgusses weiter fortgeschritten war als Malapane. Daraufhin strebte Heinitz nach einer Kooperation zwischen den zwei Gießereien; Modelle und Informationen wurden ausgetauscht, und 1791 schickte die preußische Verwaltungsbehörde Gießereimitarbeiter von Malapane nach Lauchhammer, um deren Form- und Gießtechniken kennenzulernen. Die Erfahrungen, die diese dort gewannen, zusammen mit den Kenntnissen, die Heinitz und Reden während der Reisen mit John Wilkinson in die englischen und schottischen Gießereien erhielten, führten zu der Gründung der Königlichen Eisengießereien in Preußen.

much more advanced than Malapane in the field of artistic casting. Consequently, Heinitz sought cooperation between the two foundries; models and information were exchanged and in 1791, Prussian mining authorities sent foundry workers from Malapane to Lauchhammer to study the techniques of modeling and casting. The experience they acquired combined with the knowledge Heinitz and Reden gained while inspecting foundries in England and Scotland with John Wilkinson led to the establishment of three royal iron foundries in Prussia.

The Royal Prussian Iron Foundries

Prior to his death in 1786, Friedrich II had envisioned the development of a number of state-sponsored iron foundries designed to produce delicate, decorative consumer objects in addition to the usual architectural elements, machines and tools, and armaments. In 1789, with the support of the new king, Friedrich Wilhelm II (1744-97; 1786 king), and with the help of Wilkinson and John Baildon, Heinitz and Reden drew up plans for the first royal foundry, to be located at Gleiwitz in Silesia, as well as for the second, which was to be built in Berlin. The idea was to outfit the foundries with cupola furnaces and introduce the use of dry sand instead of loam – a clay-like soil – in the mold-making process in an attempt to refine the foundry's decorative castings. Construction of the Gleiwitz foundry began in 1794. The first furnace was installed in 1796 and by 1798 the foundry had begun producing small cameos based on ancient Greco-Roman gems and medallions using models acquired from the English pottery factory of Josiah Wedgwood.[10] Under Reden's guidance, the foundry quickly increased its production and in the first year alone cast 1,254 medals and twenty-four crucifixes.[11] Shortly thereafter, it began producing busts, candlesticks, watch stands, and writing utensils, and in 1802 produced more than 12,000 medals as well as hundreds of decorative and practical objects.[12] In 1814 the Gleiwitz foundry opened a salesroom on its premises, in which a great variety of castings were displayed. Visitors to Gleiwitz, individual patrons of the foundry, art dealers, as well as the general public had the opportunity to visit the showroom to examine the variety of objects cast there, or to purchase castings from the list published in the foundry's printed catalogue, or *Preis Courant*.

In 1804, the royal Berlin foundry was established as a dependent of the Gleiwitz ironworks. The talent and expertise available in the Prussian capital, however, led it to quickly surpass its mother foundry in both the quality and variety of ornamental objects produced. Building on the success of the Gleiwitz foundry, decorative items, such as gems, portrait medallions, and household utensils became a standard part of the Berlin foundry's program from the first year of production. Shortly thereafter the foundry began to create its own models, which were also used later at Gleiwitz.

Around 1806 both the Berlin and Gleiwitz foundries began to produce delicate cast-iron jewelry – occasionally in conjunction with the goldsmith, jeweler, and iron caster Johann Conrad Philipp Geiss in Berlin – which became enormously

Die Königlichen Preußischen Eisen-Gießereien (KPEG)

Bereits König Friedrich II. hatte die Entwicklung von staatlichen Eisengießereien vorangetrieben, die sich auf die Produktion von feinen Konsumgütern, der üblichen architektonischen Teile, von Maschinen und Werkzeugen sowie Kriegsgerät ausrichteten. Mit der Unterstützung des neuen Königs Friedrich Wilhelm II. (1744-97; 1786 König) und mit Hilfe von Wilkinson und John Baildon entwarfen Heinitz und Reden 1789 Pläne für die erste Königliche Eisengießerei, die in Gleiwitz in Schlesien erbaut werden sollte, und für eine zweite in Berlin. Die Gießereien sollten mit Kupolöfen ausgestattet werden, und um die Kunstgüsse zu verbessern, sollte Sand anstelle von Lehm für die Formung benutzt werden. Im Jahr 1794 begann der Bau der Gleiwitzer Hütte. Der erste Kokshochofen wurde 1796 installiert. 1798 begann die Gießerei mit der Produktion von Kameen nach alten griechischen und römischen Gemmen und von Medaillons nach Modellen, die von der englischen Keramikmanufaktur Josiah Wedgwoods erworben worden waren.[10] Unter der Leitung Redens nahm die Produktion der Gießerei schnell zu, und im ersten Jahr wurden allein 1.254 Medaillen und 24 Kruzifixe gegossen.[11] Kurze Zeit später begann sie mit dem Guß von Büsten, Kerzenleuchtern, Uhrenständern und Schreibgeräten. 1802 produzierte sie unter anderem mehr als 12.000 Medaillen.[12] Im Jahr 1814 eröffnete die Gleiwitzer Hütte einen Verkaufsraum auf dem Gelände, in dem ihre Güsse ausgestellt wurden. Hier konnten Besucher die Vielfalt der Erzeugnisse besichtigen und Objekte nach dem „Preis-Courant" kaufen.

Die Königliche Preußische Eisengießerei in Berlin wurde 1804 als Tochteranstalt der Gleiwitzer Hütte gegründet. Die in der Hauptstadt vorhandenen Fähigkeiten und die Sachkenntnis der Mitarbeiter führten schnell dazu, daß die neue Gießerei in der Qualität und der Vielfalt der Kunstgüsse Gleiwitz übertraf. Auf den Erfolgen der Gleiwitzer Hütte aufbauend, gehörten Objekte wie Gemmen, Porträtreliefs oder Geräte zum Kern des Gießprogramms ab dem ersten Jahr. Bald kamen eigene Modellentwicklungen hinzu (die allerdings auch mit Gleiwitz ausgetauscht wurden).

Gleiwitz und Berlin begannen ab 1806 feinen Schmuck aus Eisen zu produzieren – zum Teil in Zusammenarbeit mit dem „*Goldarbeiter, Juwelier und Eisengießer*" Johann Conrad Geiss in Berlin –, der sehr beliebt wurde und aufgrund eines Aufrufs der Prinzessin Marianne von Preußen im Jahr 1813 – unter der Devise „*Gold gab ich für Eisen*" – die Frauen dazu bewegen sollte (und auch bewegt hat), zur Finanzierung der Befreiungskriege ihren Goldschmuck gegen Eisenschmuck einzutauschen.

Während der französischen Besetzung von Berlin (1806-12) nahm die Produktion der Berliner Gießerei ab. Dennoch fiel der Guß der ersten eisernen Denkmäler in diese Zeit. Später wurde die Gießerei für die Herstellung von Großgußwerken wie Brücken, Grabmälern oder anderen Erinnerungsmonumenten bekannt. Viele Entwürfe dafür stammen von Karl Friedrich Schinkel (1781-1841), darunter das Luisendenkmal von 1811 in Gransee, zum Gedenken an die dortige Aufbah-

Fig./Abb. 9 *„Die Königl. Eisengiesserei zu Berlin"* from the West after a design by /
von Westen nach einem Entwurf von Ludwig Eduard Lütke, Veduta from the letter-
head of the KPEG Berlin / Vedute eines Briefkopfes der KPEG Berlin, ca. 1830-40;
SSB, Inv. VII 61/809; in Bartel and Bossmann, 101, fig./Abb. 126.

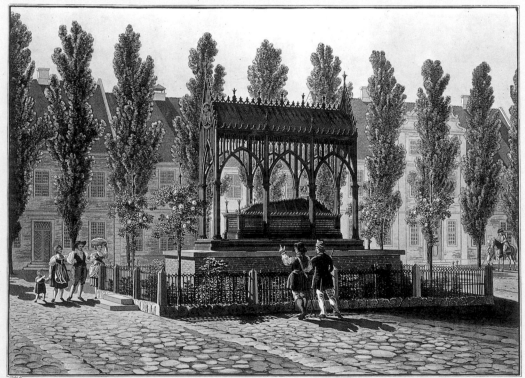

Fig./Abb. 10 Queen Luise
Memorial (1810-11) / Erinne-
rungsmal an die Königin Lui-
se in Gransee (Land Branden-
burg, Landkreis Oberhavel);
after a design by / nach einem
Entwurf von Karl Friedrich
Schinkel; Ins. below/unten
"This monument cast in iron
was erected on the Luisen-
platz in Gransee by the resi-
dents of this town, of the Rup-
pin district and Priegnitz in
memory of the night of July 25,
1810, where at this place the
body of the revered Queen
Luise of Prussia lay, as she
was transported from Hohen
Zieritz to Berlin." / *„Dies Mo-
nument in Eisen gegossen ist
auf dem Luisenplatz in Gran-
see von den Einwohnern die-
ser Stadt, des Ruppinischen
Kreises und der Priegnitz zum
Andenken der Nacht des 25ten
Julius 1810 errichtet worden,
wo an diesem Orte die Leiche
der verehrten Königin Luise
von Preussen stand, als sie
von Hohen Zieritz nach Berlin
geführt wurde"*, and/und
„Schinkel del" and/und *„Ber-
lin bei Wittich"*; KPEG Ber-
lin; Berlin, Kupferstichkabi-
nett, SMB, Inv. 125-1997

popular during the Wars of Liberation as the familiar cry, *"Gold gab ich für Eisen"* (I gave gold for iron), was heard. By donating their gold jewelry in exchange for similar pieces cast in iron, Prussian women – under the guidance of Princess Marianne of Prussia – could actively participate in the war effort.

During the French occupation of Berlin (1806-12) production at the royal iron foundry declined. Yet it was during this period that the first monuments were cast by the foundry. Later, the Berlin foundry became well known for the production of large architectural structures, bridges, tombs, as well as historical and military monuments. Many of the designs for these came from the architect Karl Friedrich Schinkel (1781-1841), including the dais erected in Gransee in 1810 in honor of Queen Luise of Prussia, who died on July 19 of that year while visiting her father in Strelitz. One of the most important monuments cast at the foundry is the 65-foot-tall Kreuzberg Monument in Berlin's Victoria Park, dedicated in 1821 to the Wars of Liberation. Schinkel conceived the overall plan. The twelve individual figures, which are positioned in niches around the monument, represent the twelve major battles fought against Napoleon and his French forces. These were designed by the well-known Berlin sculptors Christian Daniel Rauch (1777-1857), Friedrich Tieck (1776-1851), and Ludwig Wilhelm Wichmann (1788-1859).

The end of the Wars of Liberation brought an increase in the production of decorative objects at both Gleiwitz and Berlin along with the establishment of a third royal foundry in the Rhenish town of Sayn not far from Coblenz.[13] The Rhineland had become a province of the Prussian state as a result of negotiations completed at the Congress of Vienna in 1814-1815. At first, the Sayn foundry was used to produce munitions needed to fortify the strongholds at Coblenz and Ehrenbreitstein along the Rhine, which could be used to defend the new Prussian province against another French invasion. However, beginning in 1817, under the leadership of foundry inspector Carl Ludwig Althans (1788-1864), the Sayn foundry began casting decorative objects using models created at the royal foundries in Gleiwitz and Berlin.

Decorative cast-iron objects remained highly popular in Prussia throughout the years of economic scarcity that followed Napoleon's defeat. King Friedrich Wilhelm III (1770-1840; 1797 king) furnished his private rooms at his palace in Berlin with cast-iron objects supplied by the royal foundries, thereby contributing to a widespread interest in ornamental cast-iron objects, and helping to keep them in vogue for several decades. Yet, by the 1840s, decorative cast iron had begun to lose its popular appeal. The simple lines and black color, thought to be so attractive during the early decades of the nineteenth century, no longer reflected contemporary taste, which could afford to seek a more colorful, decorative form. As a result, other metals, such as zinc, copper, and bronze, which were more versatile and easily cast, once again became the preferred metals for decorative objects. Additionally, the practice by foreign and private ironworks of copying the models used at the three royal foundries led to a general decline in the quality of production.

During the Revolution of 1848, the Berlin foundry was set afire and a large quantity of models as well as archival mate-

rung der Königin Luise von Preußen (gestorben 19. Juli 1810) am 25. Juli 1810. Das größte der in der Gießerei gegossenen Monumente ist das fast 20 Meter hohe „National-denkmal für die Befreiungskriege" (1813-15) auf dem Kreuzberg in Berlin, errichtet 1817-21/26 nach einem Entwurf von Schinkel. Die zwölf überlebensgroßen Figuren stellen die Genien der zwölf Hauptschlachten gegen die napoleonische Armee dar und stammen von den Berliner Bildhauern Christian Daniel Rauch (1777-1857), Friedrich Tieck (1776-1851) und Ludwig Wilhelm Wichmann (1788-1859).

Das Ende der Befreiungskriege brachte eine Zunahme der Produktion von Eisenkunstgüssen in Gleiwitz und Berlin und die Eingliederung der „Sayner Hütte"[13] (unweit von Koblenz) als dritte „Königliche Preußische Eisen-Gießerei", nachdem dieses Gebiet als „Rheinprovinz" infolge des Wiener Kongresses 1814/15 an Preußen gekommen war. Sie diente zunächst der Produktion von Kriegsgerät und anderen Gußwaren für den Ausbau von Festungen am Rhein wie Koblenz oder Ehrenbreitstein, um die neue preußische Provinz gegen eine erneute französische Invasion schützen zu können, begann jedoch Anfang 1817 unter der Leitung des Hütteninspektors Carl Ludwig Althans (1788-1864) ebenfalls mit dem Gießen von Eisenkunstgüssen wie die Gießereien in Gleiwitz und Berlin, zum Teil nach deren Modellen.

Eisenkunstguß blieb während der Jahre nach Napoleons Niederlage höchst populär in Preußen. König Friedrich Wilhelm III. (1770-1840) stattete seine privaten Räume in seinem Palais in Berlin mit eisernen Erzeugnissen aus den Königlichen Gießereien aus und förderte dadurch das schon verbreitete Interesse an Eisenkunstguß-Erzeugnissen, welche auch für einige Jahrzehnte in Mode blieben. In den vierziger Jahren verloren dekorative Objekte aus Eisen jedoch ihre Beliebtheit. Die einfachen Linien und die schwarze Farbe, die während der ersten Jahrzehnte des 19. Jahrhunderts so attraktiv waren, entsprachen nicht mehr dem zeitgenössischen Geschmack, der zunehmend eine farbigere, üppigere Form verlangte. Jetzt wurden andere Metalle wie Zink, Kupfer und Bronze, die einfacher zu gießen waren, die bevorzugten Metalle für dekorative Objekte. Hinzu kam, daß zunehmend fremde Gießereien Eisenkunstgüsse der drei Königlichen Gießereien kopierten, meist in schlechterer Qualität und zu geringeren Preisen, was dem allgemeinen Ansehen des Eisenkunstgusses schadete.

Während der Revolution von 1848 wurde die Berliner Gießerei in Brand gesetzt und eine große Anzahl von Modellen und Geschäftsunterlagen zerstört. Obwohl die Gießerei wieder aufgebaut und die Kunstgußproduktion wieder aufgenommen wurde, erreichte diese nicht wieder den Umfang der früheren Zeiten. Die Gießerei wurde 1874 geschlossen. Fast zur selben Zeit, 1872, stellten die Gleiwitzer ihren Kunstguß ein, nahmen ihn jedoch gegen Ende des Jahrhunderts – wenn auch etwas zaghaft – wieder auf und führten ihn mit einer gewissen Regelmäßigkeit bis in die Gegenwart fort.

Der Kunstguß der Sayner Hütte war schon weitgehend reduziert, als das Werk 1865 an die Gußstahlfabrik Friedrich Krupp in Essen verkauft wurde[14] und damit endgültig das Ende des Sayner Kunstgusses gekommen war.

Die drei „Königlichen Preußischen Eisen-Gießereien" hat-

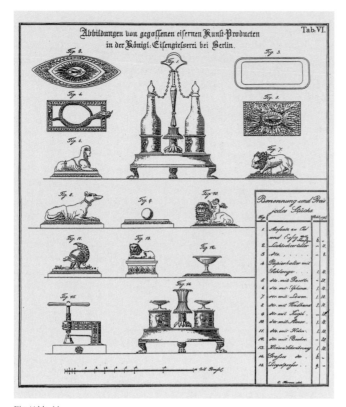

Fig./Abb. 11

Fig./Abb. 12

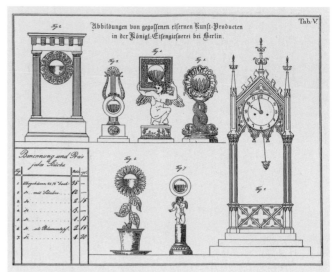

Fig./Abb. 13

Fig./Abb. 11-18 Illustrated pages from catalogues of various cast-iron foundries / Illustrierte Seiten von Katalogen von Eisengießereien.

Fig./Abb. 11, 13 From „Abbildungen von gegossenen eisernen Kunst-Producten in der Königl. Eisengiesserei bei Berlin" (1824-30), pl./Tab. VI and/und V.

Fig./Abb. 12 From „Abbildungen von gegossenen eisernen Kunst Erzeugnissen in der Königl. Eisengiesserei bei Gleiwitz" (1847), pl./Taf. XI; in Hintze 1928 a, 81.

Fig./Abb. 14 From „Saynerhütten Kunstgusswaaren-Abbildungen" (ca. 1846), pl./Taf. 3; in Hintze 1928 a, 123.

Fig./Abb. 14

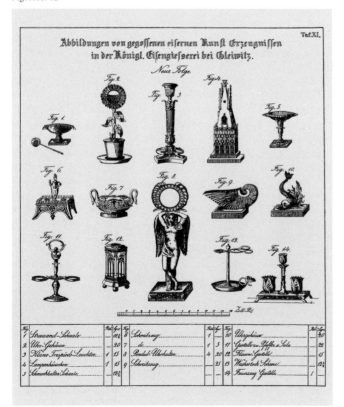

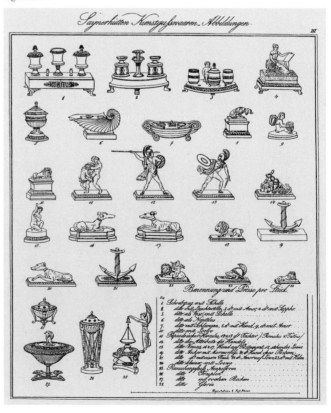

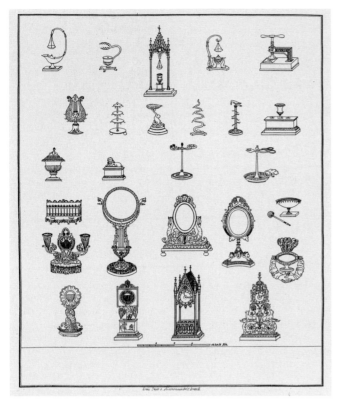

Fig./Abb. 15

Fig./Abb. 17

Fig./Abb. 18

Fig./Abb. 15 From „*PREIS-COURANT der Kunstguss-Waaren auf dem Gräflich Einsiedelschen Eisenwerk zu Lauchhammer*" (about/um 1840?), n. pag.

Fig./Abb. 16 From Cat. der „*Fürstlich Salm'schen Blansker Eisenfabrik*" (after/nach 1852), pl./Taf. 13.

Fig./Abb. 17 From „*Preis-Liste der gezeichneten Gegenstände der Kunst-Eisen-und Zink-Giesserei von Albert Meves in Berlin*" (ca. 1850-60), pl./Taf. 19.

Fig./Abb. 18 From Collection of Plates / Tafelwerk der „*Carlshütte bei Rendsburg*" (ca. 1850), pl./Taf. II; Büdelsdorf, Eisenkunstgußmuseum.

Fig./Abb. 16

rials and documents was destroyed. Although the foundry was rebuilt, it never again produced decorative objects in any great quantity and was finally closed in 1874. The Gleiwitz foundry ceased production of decorative castings in 1872, did, however, reintroduce the casting of decorative objects around the end of the nineteenth century, a practice that continues at the foundry today. The casting of decorative objects at the royal foundry in Sayn had already declined considerably by the time it was sold to the large steel manufacturer Krupp in 1865.[14] Yet, the successes of the three royal foundries during the first four decades of the nineteenth century led to the establishment of numerous private foundries in Germany and the expansion of those in Austria and Bohemia.

Private Foundries in Berlin

The number and variety of private German iron foundries has been well documented and requires only brief mention here.[15] In Berlin, there were two leading private foundries during the height of cast-iron production. Both occupied, together with the local royal Prussian iron foundry, a large share of the market for delicate cast-iron objects. The first of these was established by Johann Conrad Philipp Geiss (Geiß; 1772-1846), a goldsmith and jeweler from Offenbach am Main, who had moved to Berlin sometime prior to 1806. At this time, he appears in the records as an independent modeler for the royal iron foundry.[16] Geiss was both a designer – he is best known for his wine-leaf motif – and promoter of cast-iron jewelry, yet it is unclear when exactly he first established his own foundry. In the 1814 Berlin academy exhibition catalogue, a display of small items of cast-iron jewelry is listed under the *"foundry of the jeweler Geiss,"*[17] suggesting that by this time he had started his own business. However, it is known that during this period he had much of his jewelry cast at the Gleiwitz foundry, for in 1820 Geiss lodged a complaint against the royal foundry after it began to incorporate his designs cast there into its own work.[18] Around this time Geiss began to mark his pieces clearly with the name of his company: *"GEISS À BERLIN."* In addition to jewelry, Geiss commissioned well-known Berlin artists to create designs for his foundry, including the modeler and portraitist Leonhard Posch, who created for him two round medallions with the images of Christ and the Virgin Mary as well as a portrait of Geiss himself. Geiss's son Philipp Conrad Moritz Geiss (1805-75) joined his father in the business after his training in Gleiwitz and Malapane.

Siméon Pierre Devaranne (1789-1859) was, like Geiss, a goldsmith and jeweler in Berlin. The son of Huguenot immigrants, he established his own shop in 1814 for gold and silver bijouterie and also sold ornamental cast-iron objects. In 1828, Devaranne appears as the manufacturer of cast iron, gold, and silver objects of his own creation,[19] and is best known for his design of a butterfly, which was widely used in the production of necklaces and bracelets. Devaranne also cast a number of household utensils and small sculptures, many of which were modeled by Johann Carl Wilhelm Kratzenberg (active in Berlin 1824-39). Devaranne marked many

ten natürlich auch das Gießen von Maschinen- und Bauteilen sowie von *„Poterie-Waaren"* (Kochtöpfe et cetera) betrieben; ihre größte Bedeutung erlangten sie jedoch – in den ersten vier Jahrzehnten des 19. Jahrhunderts – durch den Eisenkunstguß, von dem viele Impulse auf zahlreiche andere staatliche und private Gießereien ausstrahlten.

Private Gießereien in Berlin

Die Anzahl und die Vielfalt von privaten deutschen Eisengießereien wurden schon mehrmals in der Literatur behandelt und benötigen hier nur eine kurze Zusammenfassung.[15] In Berlin gab es zwei führende Privatgießereien während des Höhepunkts der Eisenkunstgußproduktion, die zusammen mit der hiesigen Königlichen Eisengießerei einen großen Anteil des Markts für feine Objekte aus Eisen besaßen. Die erste wurde von Johann Conrad Philipp Geiss (Geiß; 1772-1846), Goldschmied und Juwelier aus Offenbach am Main, gegründet, der kurz vor 1806 nach Berlin gezogen war. Zunächst erscheint er als unabhängiger Modelleur für die königliche Gießerei.[16] Geiss war Entwerfer – er ist am meisten für sein Weinblatt-Motiv bekannt – und Hersteller von eisernem Schmuck. Es ist aber unklar, wann genau er seine eigene Gießerei gegründet hat. In dem Ausstellungskatalog der Berliner Akademie von 1814 ist er zum erstenmal aufgeführt: *„Aus der Gießerei des Juwelierers Herrn Geiss. 328. Proben von kleineren Eisengußwaaren."* Danach hatte er zu dem Zeitpunkt schon eine eigene Firma.[17] Es ist bekannt, daß er während dieser Zeit viel von seinem Schmuck in der Gleiwitzer Hütte gießen ließ, da er 1820 mit anderen Anzeige gegen die Königliche Gießerei erstattete, weil diese auch seine Entwürfe in ihre Schmuckproduktion einbezogen hatte.[18] Um diese Zeit begann Geiss seine Erzeugnisse mit dem Firmennamen *„GEISS À BERLIN"* zu versehen. Geiss beauftragte auch bekannte Berliner Künstler damit, Entwürfe für seine Firma zu liefern, darunter den Modelleur Leonhard Posch (1750-1831), der unter anderem für Geiss zwei runde Medaillons mit den Darstellungen von Christus und der Jungfrau Maria sowie ein Porträt von Geiss selbst schuf. Der Sohn von Geiss, Philipp Conrad Moritz Geiss (1805-75), trat nach seiner Ausbildung in Gleiwitz und Malapane in die Firma seines Vaters ein und widmete sich später vor allem dem Zinkguß.

Siméon Pierre Devaranne (1789-1859) war ebenfalls Goldschmied und Juwelier in Berlin. Der Sohn hugenottischer Immigranten gründete 1814 ein eigenes Geschäft für *„Gold- und Silber-Bijouterie"* und verkaufte außerdem dekorative Objekte aus Eisen. 1828 erscheint Devaranne als *„Fabrikant von Gold-, Silber- und feinen Eisengußwaren"* nach eigenen Entwürfen.[19] Am bekanntesten ist sein Entwurf eines Schmetterlings, den er oft bei der Gestaltung von Halsketten und Armbänder benutzte. Zu Devarannes Repertoire gehörten auch Geräte und Kleinskulpturen, von denen eine Reihe von Johann Carl Wilhelm Kratzenberg (aktiv in Berlin 1824-39) modelliert worden sind. Devaranne verkaufte viele seiner Güsse mit seiner Firmenmarke, darunter auch Objekte, die er zwar selber gegossen, aber nach Modellen der drei könig-

of his pieces with the company's name, including objects he cast himself, but which were adapted or copied from models made for the three royal iron foundries. Both of Devaranne's sons, Carl Friedrich August (1819-54), a sculptor, who designed objects for his father's foundry, and Joseph Friedrich Albert (1823-52), an engraver and medallist, joined the family business, which closed after the elder Devaranne's death in 1859.

The number of private foundries in Germany increased during the nineteenth century and those in Berlin are well described in Erwin Hintze's monograph on the subject.[20] They include the foundry of August Ferdinand Lehmann (born 1806), established in 1830. Lehmann was a businessman rather than an artist or craftsman, who sought to establish a factory for the production of a variety of cast-iron objects, both useful and decorative, including machine parts, architectural elements, and art castings.

The modeler Alfred Richard Seebass (Seebas; 1805-84) owned his own foundry in Berlin from 1829 to 1841. In that year he relocated to the city of Hanau in the state of Hessen, and entered into a partnership with E. G. Zimmermann in the production of cast iron, which lasted until 1846. Seebass later opened a foundry in Offenbach am Main. The engraver Joseph Glanz (born 1795) settled in Berlin in 1816 and worked as a freelance chaser and engraver for the royal iron foundry and many local private foundries before he established his own firm in Berlin in 1826. In 1831 Glanz relocated to Vienna, where he continued his very successful career in bronze and iron casting.

In 1837, Albert Anton Meves (Mewes; born 1812) first became a partner in the G. A. Schwan foundry in Berlin, and by 1844 had established his own bronze and iron foundry. Meves produced a variety of decorative objects in the eclectic style typical of the mid-nineteenth century, and later employed the modeler Kratzenberg, who had originally worked for Devaranne. After 1850 Meves shifted production from iron to zinc.

Foundries in Austria (including Bohemia and Moravia)

Other states followed Germany's lead in an effort to improve existing iron foundries.[21] Rudolf Graf Wrbna (1761-1823), the owner of the Horowitz ironworks, was instrumental in developing the iron industry in Bohemia during the late eighteenth and early nineteenth centuries. As a personal friend and colleague of Graf von Reden, Wrbna was able to acquire models from the royal Prussian foundries, which he used to create the first decorative castings made at Horowitz. By 1823, Wrbna and his son Graf Eugen employed local modelers and sculptors to produce new designs for the foundry including those for jewelry. Although technically not on a par with the royal Prussian foundries, the Horowitz foundry was able to cast objects of a reasonably high quality with a fine attention to detail.

In Moravia, a region in what is today the eastern part of the Czech Republic, the leading foundry was Blansko, owned

by Hugo Franz Altgraf zu Salm-Reifferscheidt (1776-1836). During the 1820s the foundry was modernized and a department for the casting of decorative objects – outfitted with a cupola furnace – was established, as was a well-equipped workshop for modelers and sculptors. Graf Salm succeeded in increasing the quality of Blansko castings and the foundry became the model in the region for art casting. Furthermore, Blansko became known for the casting of large-scale works such as sculptures, ovens, bridges, and architectural structures. Like Horowitz and the neighboring foundry of Neu-Joachimsthal, the Blansko foundry produced many castings after models created in Gleiwitz and Berlin.

In Austria proper, the Mariazell foundry, in the province of Styria, and the Joseph Glanz ironworks in Vienna were the two leading producers of cast iron during the first half of the nineteenth century. The Mariazell foundry was established in 1742 by a Benedictine monk named Eugen von Inzaghy. Later it was managed by Johann Hippmann from the town of Neu-Joachimsthal, who trained not only at the Neu-Joachimsthal foundry, but also traveled to Prussia and became familiar with cast-iron production in Gleiwitz and Berlin.

Joseph Glanz was, as previously discussed, a master ironworker, who worked originally in Berlin. After relocating to Vienna in 1831, Glanz at first manufactured small objects and jewelry in cast iron at his own foundry, but later added bronze, zinc, silver, and gold to his repertoire. He won several awards for his work, which was shown at a number of art and industrial exhibitions, and through his business connections he was able to create a prosperous trade in cast-iron jewelry. After 1838 Glanz began to focus increasingly on bronze casting, which he continued until about 1850.

Cast-Iron Technology and the Problems with Foundry Marks

Much has been written about the technology of iron casting. With regard to decorative cast iron, the art historian Jan Mende recently provided a concise summary: *"The producers of cast-iron objects profited by their experience with bronze casting. The areas of mold making, casting, and finishing are crucial to both fields. During the first two decades of its existence, the royal iron foundry in Berlin was extremely innovative in the first, the most important area, that of mold making."*[22]

During the early nineteenth century most three-dimensional objects cast in iron were produced using the lost-wax technique, adapted from the practice of bronze casting. This technique involves the creation of an original wax model, which was entirely encased in clay. Once the clay was dry, the model was heated until the wax melted completely. After the molten wax was poured out, the hollow mold was filled with hot, liquid iron. When the iron was hard and cool, the clay shell was broken apart, freeing the metal object. In this way, a solid object was cast. It was also possible to cast a hollow object using this technique. In this instance, a core model made of clay was coated with a layer of wax, which was then covered with a layer of clay. Afterward, the model was

In Mähren (heute Ostteil der Tschechischen Republik) war Blansko die führende Gießerei und im Besitz von Hugo Franz Altgraf zu Salm-Reifferscheidt (1776-1836). Während der zwanziger Jahre des 19. Jahrhunderts wurde die Gießerei modernisiert und eine Abteilung für den Eisenkunstguß mit einer gut ausgerüsteten Werkstatt für die Modelleure und Bildhauer eingerichtet. Salm gelang es, die Qualität der Güsse zu steigern. Die Gießerei wurde Vorbild in der Region für Feinguß, aber auch für größere Objekte wie lebensgroße Skulpturen, Öfen, Möbel oder Bauteile. Wie Horowitz und die Nachbargießerei Neu-Joachimsthal produzierte Blansko viele Güsse nach Modellen von Gleiwitz und Berlin.

In Österreich waren die Mariazeller Gießerei in der Steiermark und die Gießerei von Joseph Glanz in Wien führend in der Produktion von Eisenkunstguß während der ersten Hälfte des 19. Jahrhunderts.

Die Mariazeller Gießerei war 1742 durch den Benediktiner-Mönch Eugen von Inzaghy gegründet worden. Später wurde sie von Johann Hippmann aus Neu-Joachimsthal geleitet, der nicht nur an der Neu-Joachimsthaler Hütte tätig gewesen war, sondern auch Preußen bereist und in Gleiwitz und Berlin gelernt hatte.

Joseph Glanz war, wie erwähnt, in Berlin tätig gewesen, bevor er 1831 nach Wien übersiedelte, und produzierte zunächst Kleinobjekte und Schmuck aus Eisen in seiner Fabrik, später aber auch Objekte in Bronze, Zink, Silber oder Gold. Er gewann viele Preise für seine Arbeiten, die bei verschiedenen Kunst- und Industrieausstellungen gezeigt wurden. Durch seine vielen Geschäftskontakte konnte er einen regen Handel mit Eisenschmuck aufbauen. Nach 1838 stellte sich Glanz mehr und mehr auf das Gießen von Bronze um, das er bis um 1850 fortsetzte.

Zur Technik des Eisenkunstgusses und zum Problem der Gießereimarken

Über die Technik des Gießens gibt es zahlreiche Abhandlungen. Für die des Eisenkunstgusses hat Jan Mende zuletzt eine fundierte Zusammenfassung gegeben, auf die hier kurz eingegangen wird.

„Die Hersteller von Eisengußwaren profitierten damals von den Erfahrungen des Bronzegusses. Hier wie dort sind die drei Bereiche Formerei, Guß und Nachbearbeitung ausschlaggebend. Vor allem im ersten, dem wichtigsten, zeigte sich die königliche Eisengießerei in den ersten zwei Jahrzehnten ihres Bestehens außerordentlich innovativ."[22]

Bis in den Anfang des 19. Jahrhunderts wurden dreidimensionale in Eisen gegossene Objekte meistens nach dem alten Verfahren des Bronzegusses, dem Wachsausschmelzverfahren, hergestellt. Dazu wurde ein originales Wachsmodell mit Lehm umhüllt. Sobald der Lehm trocken war, wurde das Ganze erhitzt, bis das Wachs ausgeschmolzen war, dann die hohle Form mit flüssigem Eisen gefüllt und nach dem Abkühlen die Lehmform entfernt. Bei größeren Objekten, die innen hohl sein sollten, wurde das Wachsmodell auf einen Lehmkern aufgetragen, der nach dem Guß mühsam entfernt werden mußte. Mit Eisen wurde dieses Verfahren erst 1784

placed in a box filled with foundry sand, called a flask, and was heated until the wax melted. The molten wax was again drained and hot, liquid iron was poured in its place. The lost-wax technique was first successfully applied to iron casting in 1784 at Lauchhammer. However, the disadvantage to using the lost wax method was that both model and mold could be used only once, which made this technique expensive and labor-intensive. With the beginning of serial production at the end of the eighteenth century, more practical casting methods were sought by the royal Prussian foundries. In 1813, the modeler Wilhelm August Stilarsky (1780-1838) invented a new process at the Berlin foundry in which large, three-dimensional objects could be cast in multiples in so-called "piece molds." comprised of several different sections. This process was also used at the Gleiwitz foundry.[23]

During the nineteenth century, most models continued to be made first in wax or clay, but these were then copied in plaster and finally in brass or tin, from which the actual sand mold was created. For smaller objects, the traditional closed-box casting technique was used, which involved at least two upright iron frames – open at top and bottom – placed exactly one on top of the other. To cast, the lower frame was put on a flat plate and filled with foundry sand, into which the mold was pressed. The remaining sandy surfaces were dusted with a special powder that prevented the iron from adhering. After the upper frame was attached, it was also filled with compacted foundry sand, and then lifted off so that the model could be removed. Ingates – openings through which the metal was poured – and vent ducts were then added, the frame was reattached, and the flask was ready for casting. *"The creation of the mold was characterized by a great deal of manual labor. Multi-part, pierced, and minute details required expert knowledge and experience. Mold makers were therefore in great demand."*[24]
The casting of smaller objects with low relief, like medals and gems, was relatively easy and for this the closed-box casting technique mentioned above was used. This technique was often the first used by foundries as they began to cast decorative objects. In 1803 Wilhelm Albrecht Tiemann wrote an extensive description of it in the chapter "Ueber die Medaillengießerei" in his book, *Abhandlung über die Förmerei und Gießerei auf Eisenhütten*, in which he mentions the quality of the Silesian medals.[25]
After the cast was removed from the flask, the ingates and vent ducts were taken off and all surface irregularities were erased through the use of tools designed for this purpose. The process of chasing *"in addition to trimming or polishing* [was] *occasionally mentioned in contemporary sources, but could only refer to the treatment of larger objects like busts or statues because the hardness and rigidity of cast iron makes it much more difficult to chase than bronze or brass. For this reason, the royal iron foundries developed a technique [...] that allowed a cast to be removed from the flask in such a condition that made any further working of the surface [...] unnecessary and required only the application of a light, black protective coating comprised of linseed oil to refine it."*[26]

in Lauchhammer erfolgreich angewandt. Der Nachteil des Wachsausschmelzverfahrens ist jedoch, daß das Modell nur einmal benutzt werden kann, wodurch solche Güsse arbeitsaufwendig und damit teuer sind. Mit der beginnenden Massenanfertigung gegen Ende des 18. Jahrhunderts suchten die Gießereien nach neuen Wegen der rationellen Vervielfältigung (die es beim Medaillenguß bereits gab). Schließlich wurde ab 1813 in der Berliner Gießerei durch den Modelleur Wilhelm August Stilarsky (1780-1838) ein neues Einformverfahren entwickelt, das es erlaubte, aufgrund zerlegbarer Gußmodelle (aus Zinn oder Bronze) beliebig viele Eisengüsse herzustellen, das auch in Gleiwitz eingeführt wurde.[23]
Die meisten Ur-Modelle wurden zwar noch immer in Wachs oder Lehm geformt, diese jedoch danach in Gips, Messing oder Zinn kopiert, nach denen dann die eigentliche Formung im Formsand erfolgte. Für kleinere Objekte benutzte man den traditionellen „geschlossenen Kastenguß", bei dem mindestens zwei oben und unten offene, hochkantige rechteckige eiserne Rahmen benötigt werden, die durch Stecker und Ösen genau aufeinander gelegt werden können. Zum Einformen wird der untere Rahmen auf eine ebene Platte gelegt, mit Formsand gefüllt und das Modell eingepreßt, die übrige Sandfläche wird mit einer Art Puder bestäubt (als Haftschutz). Nach Aufsetzen des oberen Rahmens wird dieser auch mit Formsand gefüllt und festgestampft. Nach Abheben des oberen Rahmens wird das Modell herausgenommen, Einguß- und Entlüftungskanäle werden angebracht, der Rahmen wird wieder aufgesetzt, und der Kasten ist bereit für den Guß.
„Die Formenherstellung ist gekennzeichnet durch einen hohen Anteil an Handarbeit. Vielgliedrige, durchbrochene und untergriffige Details erforderten Fachkenntnisse und Erfahrungen. Former waren daher gesuchte Fachleute".[24]
Um bei größeren vollrunden Objekten wie Vasen die Feinheit bei Applikationen zu erzielen, wurden diese oft einzeln gegossen und auf dem gesondert gegossenen Grundkörper durch Stifte befestigt (was heute selten zu bemerken ist).
Der Guß von kleineren Reliefs (Medaillen, Gemmen und anderem) war aufgrund der geringen Reliefhöhe relativ einfach und beruht auf einer alten Tradition; er erfolgte auch im „geschlossenen Kastenguß". Für viele Gießereien bedeutete er den Einstieg in die Eisenkunstgußproduktion. Ausführlich hat ihn 1803 Wilhelm Albrecht Tiemann in seinem Buch *Abhandlung über die Förmerei und Gießerei auf Eisenhütten* in dem Kapitel „Ueber die Medaillengießerei" beschrieben, mit dem Hinweis auf die Qualität schlesischer Medaillen.[25]
Eine mechanische Nachbehandlung der Güsse reduzierte sich üblicherweise auf das Entfernen der Eingüsse und der Entlüftungsstege sowie die Glättung eventueller Gußnähte. Eine Ziselierung *„neben Schaben oder Schleifen"* wird *„in zeitgenössischen Quellen gelegentlich genannt, doch kann sich das nur auf größere Objekte wie Büsten oder Statuen bezogen haben, da die Härte und Starrheit des Gußeisens eine Ziselierung wie bei Bronze oder Messing nur schwer durchführen läßt. Deswegen hatten die Königlichen Gießereien ein Verfahren entwickelt (Beschaffenheit des Formsands und Zusammensetzung des Eisens), bei dem – zumin-*

After application, the objects were heated to volatilize the oil, leaving the object with a very hard, noncorrosive film. The application was repeated a number of times, which gave the objects a deep, matte black or dark brown finish, without obscuring any decorative details. This varnish is generally referred to as *Berliner Lack* and variants are still in use today.

During the first half of the nineteenth century, ironworks only rarely marked their products. This applies to the three royal Prussian iron foundries as well, although the Sayn foundry did identify its objects somewhat regularly with the initials *S. H.* Because all three royal foundries exchanged and borrowed models from one another, it is often difficult to discern which foundry produced which object – despite the existence of illustrated *Preis Courants* – and without effective patent laws in place during the period, smaller, private foundries copied many of the models created for the royal foundries. The Berlin foundry occasionally, albeit inconsistently, marked larger objects with the initials *K:P:E:G (Königliche Preußische Eisen-Gießerei)*. Whether or not the rare mark with an eagle and the name *BERLIN* below it is associated with the Berlin foundry is not clear.

In contrast, private Berlin foundries like Geiss or Devaranne, which produced primarily jewelry, began to mark their objects early in the history of production. However, often only one piece of a matched suite of jewelry was marked. Over the years the pieces have been separated, which makes it difficult to attribute the unmarked pieces to one particular foundry today. Medallions, medals, and plaques produced by the royal foundries usually have the name of the modeler (occasionally also the designer) impressed in the model. Unfortunately, this is often difficult to decipher on later casts.

The Collectors and their Collections

Gustav Lamprecht (1862-1946)

Johannes Franz Gustav Lamprecht was born in Leipzig on September 30, 1862,[27] the third child and second son[28] of Johann Carl Friedrich Lamprecht[29] and his wife, Johanna Mathilde Clara, née Pichel.[30] Little is known of Lamprecht's early years. Christened on November 12, 1862, in the Protestant St. Nikolai church, Lamprecht's family later attended the St. Petri church in Leipzig, where fourteen-year-old Gustav was confirmed on Palm Sunday, March 25, 1877.[31] Lamprecht probably attended the local Gymnasium with his elder brother, Reinhold, receiving a classical education with an emphasis on ancient languages, history, literature, and the arts. In 1882 he began his architectural studies at the *Königliche Kunstakademie und Kunstgewerbeschule* (Royal Art Academy and School of Applied Arts) in Leipzig, which – after a short tour in the Navy in 1883[32] – he attended until 1890 under the directorship of the artist Ludwig Nieper (1826-1906).[33] Nieper had been head of the academy since 1872 and it was under his direction that it began to move toward a new academic program focused on glass and wall

dest beim Feinguß – die Güsse so aus der Form kamen, daß eine Bearbeitung der Oberfläche [...] überflüssig wurde und diese nur noch durch einen schwarzen Leinölfirnis veredelt und geschützt zu werden brauchten."[26]

Dieser Leinölfirnis mit – je nach Gießerei – verschiedenen Zutaten wurde auf den Guß „aufgebrannt" und ergab eine leicht matte schwarze, manchmal etwas bräunliche oder bläuliche Oberfläche, ohne die Feinheiten zu verunklären. Seine Zusammensetzung wurde von den Firmen als Geheimnis streng gehütet. Er wird heute allgemein als „Berliner Lack" bezeichnet. In vereinfachter Art ist diese Technik noch heute in mechanischen Werkstätten als „Schwarzbrennen" bekannt.

Etwa ab der Mitte des 19. Jahrhunderts wurden die Oberflächen jedoch zunehmend andersfarbig gestaltet, zum Beispiel durch Verkupfern, Vernickeln oder durch Beimischungen von Farbpigmenten.

In der ersten Hälfte des 19. Jahrhunderts kennzeichneten die Eisengießereien nur selten ihre Fabrikate durch Marken oder Schriftzüge. Das gilt auch für die drei Königlichen Preußischen Eisengießereien, von denen nur die Sayner Hütte mit einer gewissen Regelmäßigkeit ihre Güsse markte („S. H."). Da diese drei Gießereien ihre Modelle – vor allem beim Feinguß – vielfach austauschten, ist eine eindeutige Zuweisung oft unmöglich, trotz der illustrierten „Preis-Courants". Bei größeren Güssen der Berliner Gießerei findet sich gelegentlich der eingestochene Name oder die Abkürzung „K:P:E:G" („Königliche Preußische Eisen-Gießerei"); ob sich auch die sehr selten vorkommende Marke mit dem Adler und der Unterschrift „BERLIN" auf diese Gießerei bezieht, ist derzeit noch ungeklärt.

Berliner Privatgießereien wie Geiss oder Devaranne, die sich vor allem der Schmuckherstellung widmeten, verwendeten dagegen frühzeitig ihren eingestochenen Namen als Zeichen der Herkunft. Allerdings wurde bei Parüren meistens nur ein einziges Teil bezeichnet, was dazu führt, daß nach Auflösen der Parüre die übrigen Schmuckteile nicht mehr eindeutig zu bestimmen sind.

Bei den kleinen und größeren Reliefs (Medaillons, Medaillen, Plaketten) der KPEG sind überwiegend die Namen der Modelleure (eventuell auch der Entwerfer) in das Modell eingestochen, die allerdings bei Nachgüssen kaum noch zu lesen sind.

Die Sammler und ihre Sammlungen

Gustav Lamprecht (1862-1946)

Johannes Franz Gustav Lamprecht wurde am 30. September 1862[27] in Leipzig geboren, als drittes Kind und zweiter Sohn[28] des Johann Carl Friedrich Lamprecht[29] und dessen Ehefrau Johanna Mathilde Clara, geb. Pichel.[30] Wenig ist über Lamprechts Kindheit und Jugend bekannt. Am 12. November 1862 wurde er in der evangelischen Kirche St. Nikolai getauft und vierzehnjährig am Palmsonntag, dem 15. März 1877, in der St. Petri-Kirche in Leipzig konfirmiert.[31] Wahrscheinlich be-

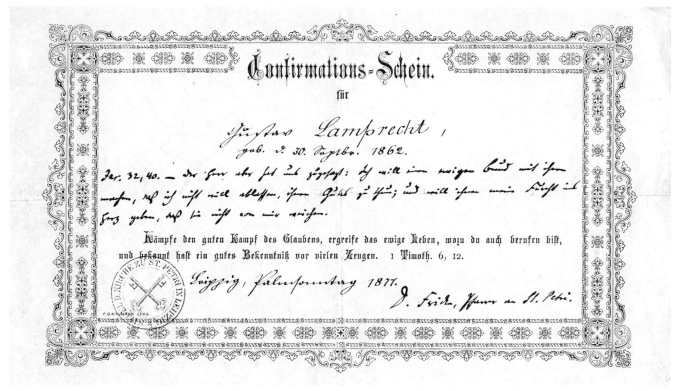

Fig./Abb. 19 Certificate of Confirmation for Gustav Lamprecht, born on Sept. 30, 1862, from Palm Sunday 1877 / „Confirmations-Schein für Gustav Lamprecht, geb. d. 30. Septb. 1862 vom Palmsonntag 1877"; SächsStAL (s. note/Anm. 31).

painting, graphic design, ornamental drawing, and the book arts. By the time Lamprecht finished his studies, the academy had moved to a new building in the *Wächterstraße*, which included modern studios used for the design and production of books.

Lamprecht must have been a successful student for on February 1, 1893, he began teaching at the school he once attended, instructing new students in architectural drawing, perspective, and design for the applied arts.[34] His course load was not heavy, and to supplement his income he took on the teaching of additional classes at the *Fachschule für Tischlerlehrlinge* (Vocational School for Carpentry Apprentices), part of the *Städtische Gewerbeschule* (Municipal Trade School), founded by Ludwig Nieper in 1875 as an institution for instruction in electrical and mechanical engineering. Two years after he began his teaching career, on August 4, 1895, thirty-two-year-old Lamprecht married Ida Lina Fischer, daughter of Friedrich Gotthelf Fischer of Krippen.[35] The couple had no children.

In 1900, Lamprecht was granted the rights and privileges of a burgher by the City of Leipzig,[36] which gave him the freedom to establish his own architectural practice. In the same year the *Königliche Kunstakademie* was renamed the *Königliche Akademie für graphische Künste und Buchgewerbe* (Royal Academy for Graphic and Book Arts), which, with an expanded academic program focused on the book arts, resulted in an increase in Lamprecht's teaching workload.

suchte Gustav das örtliche Gymnasium zusammen mit seinem älteren Bruder Reinhold, wo er eine klassische Ausbildung mit Schwerpunkt auf alten Sprachen, Geschichte, Literatur und Kunst erhielt. Er begann 1882 ein Architekturstudium an der „Königlichen Kunstakademie und Kunstgewerbeschule" in Leipzig, die er – nach einer kurzen Zeit bei der Marine 1883[32] – bis 1890 unter dem Direktorat des Künstlers Ludwig Nieper (1826-1906) besuchte.[33] Nieper war seit 1872 Direktor der Akademie, und unter seiner Leitung bekam sie ein neues akademisches Programm, welches sich auf Glas, Wandmalerei, graphische Kunst, dekoratives Zeichnen und Buchgewerbe konzentrierte. Bevor Lamprecht sein Studium abgeschlossen hatte, zog die Akademie in ein neues Gebäude in der Wächterstraße um, wo auch moderne Ateliers für den Entwurf und die Herstellung von Büchern eingerichtet waren.

Lamprecht muß ein guter Student gewesen sein, denn er begann am 1. Februar 1893 an der selben Akademie zu unterrichten. Er unterrichtete „Architektonische u. Gefäss-Formenlehre, darstellende Geometrie, Stillehre".[34] Lamprecht hatte nicht viele Kurse, und um mehr Geld zu verdienen, hielt er weitere Kurse an der Fachschule für Tischlerlehrlinge, die als Teil der 1875 gegründeten Städtischen Gewerbeschule eingerichtet worden war. Zwei Jahre nach Beginn seiner Karriere heiratete der zweiunddreißigjährige Lamprecht am 4. August 1895 Ida Lina Fischer, Tochter des Friedrich Gotthelf Fischer aus Krippen.[35] Das Paar hatte keine Kinder.

Ten years later, in 1910, Lamprecht's course load was lightened somewhat by the academy's new director, Max Seliger (1865-1920), and he was given permission by the academy to open his own architectural office, which he managed alongside his teaching duties.[37] On June 9, 1915, the academy bestowed on Gustav Lamprecht the official title of "professor."[38]

The hyperinflation that occurred in Germany in the years following World War I had the effect of depreciating the German mark and wiping out the savings of thousands of middle-class professionals. Lamprecht, then in his late fifties, was greatly affected by the postwar economic situation and, like many professors and civil servants, began to feel the squeeze. Beginning in the early 1920s, he found it necessary to repeatedly request – with little success – a salary increase commensurate with his heavy workload, but also to compensate for the devaluation of the German mark and the rise in consumer prices, which had risen more than 700% by 1922. In December 1923, Lamprecht wrote his final appeal to the *Wirtschaftsministerium* (Department of Trade and In-

Im Jahr 1900 wurde Lamprecht Bürger der Stadt Leipzig,[36] was ihm die Möglichkeit gab, ein eigenes Architekturbüro zu gründen. Im selben Jahr wurde die Königliche Kunstakademie in „Königliche Akademie für graphische Künste und Buchgewerbe" umgenannt, was (mit einem erweiterten Programm für Buchgewerbe) dazu führte, daß Lamprecht mehr Kurse unterrichten konnte. Zehn Jahre später wurden seine Lehrkurse durch den neuen Direktor Max Seliger (1865-1920) reduziert, und er bekam die Erlaubnis, ein eigenes Architekturbüro zu eröffnen, das er neben seinem Unterricht leitete.[37] Am 9. Juni 1915 verlieh die Akademie an Gustav Lamprecht den Titel „Professor".[38]

Die Inflation, die in Deutschland nach dem Ersten Weltkrieg einsetzte, wertete die deutsche Mark dermaßen ab, daß dabei weite Kreise der Bevölkerung ihre Ersparnisse verloren. Lamprecht, damals Ende fünfzig, war wie viele Professoren und Beamte sehr von der Nachkriegssituation betroffen und spürte den wirtschaftlichen Druck. Anfang der zwanziger Jahre ersuchte Lamprecht mehrmals, aber mit wenig Erfolg, um eine Gehaltserhöhung, da er viele Kurse unterrichtete,

◄ Fig./Abb. 20 Marriage Certificate. "Johannes Franz Gustav Lamprecht, architect and teacher at the Royal Art Academy in Leipzig, son of district inspector K. F. Lamprecht, also of Leipzig, single, Evangelical Lutheran religious denomination, and Ida Lina Fischer, daughter of Friedrich Gotthelf Fischer, machinist in Krippen, single, Evangelical Lutheran religious denomination, were married in the church in Krippen on August 4, 1895, in a Christian church ceremony […]" / „Trauschein. Johannes Franz Gustav Lamprecht, Architekt u. Lehrer a. d. Königl. Kunstakademie zu Leipzig, Sohn des Quartieramts=Inspektors K. F. Lamprecht das., ledig, evang.=luth. Confession, und Ida Lina Fischer, Tochter des Friedrich Gotthelf Fischer, Maschinisten in Krippen, ledig, evang.=luth. Confession, sind in der Kirche zu Krippen am 4. August 1895 christlich-kirchlich getraut worden […]"; SächsStAL (s. note/Anm. 31).

Fig./Abb. 21 Conferment of Citizenship of the City of Leipzig on June 22, 1900. "On this day the architect, teacher at the Royal Art Academy and School of Applied Arts Mr. Johannes Franz Gustav Lamprecht, born in Leipzig on September 30, 1862, with reference to the Saxon oath of citizenship he has already taken and after taking the following pledge, has been granted citizenship of this city and has been issued this certificate […] The Council of the City of Leipzig" / Verleihung des Bürgerrechts der Stadt Leipzig vom 22. Juni 1900. „Am heutigen Tage ist dem Architekten, Lehrer an der Kgl. Kunstacademie und Kunstgewerbeschule Herrn Johannes Franz Gustav Lamprecht, geboren am 30. September 1862 zu Leipzig, nach Verweisung auf den von ihm bereits früher geleisteten Sächsischen Unterthanen=Eid und nach Leistung des nachstehenden Handgelöbnisses das Bürgerrecht hiesiger Stadt verliehen und darüber gegenwärtiger Schein erteilt worden […] Der Rath der Stadt Leipzig"; SächsStAL (s. note/Anm. 31). ►

Fig./Abb. 22 Memorandum from Max Seliger to Lamprecht regarding the bestowal of the title "Professor" on June 9, 1915 / Mitteilung Max Seligers an Lamprecht über die Verleihung des Titels „Professor" vom 9.6.1915; SächsStAL (s. note/Anm. 31). ►

dustry) in Dresden. Perhaps as a result of his repeated requests for remuneration or his dissatisfaction with his employer, who had promised him just compensation, Lamprecht was asked to resign effective April 1, 1924.[39] At the time, he was sixty-one years old. Nothing is known about his life after retirement. He remained with his wife at his home on *Inselstraße* and died on April 6, 1946, at the age of eighty-three. Lamprecht was cremated and buried on May 8, 1946, at the *Neue Johannisfriedhof* in Leipzig.[40]

Gustav Lamprecht as Collector

Gustav Lamprecht began collecting cast iron twenty years after the unification of Germany (January 1871), an event that occurred when Gustav was eight years old. It is not surprising, given the historical period in which he lived coupled with his interest in architecture and the applied arts, that Lamprecht chose to focus his collecting efforts on decorative objects produced at the early royal Prussian foundries as

aber auch als Ausgleich für die Abwertung der Mark und die Erhöhung der Preise, die bis 1922 um mehr als 700 % gestiegen waren. Im Dezember 1923 schrieb Lamprecht seinen letzten Appell an das Wirtschaftsministerium in Dresden. Vielleicht als Folge seiner wiederholten – nicht stattgegebenen – Anfragen nach mehr Geld wurde Lamprecht gebeten, ab dem 1. April 1924 in den Ruhestand zu treten.[39] Zu dieser Zeit war Lamprecht einundsechzig Jahre alt. Über sein Leben als Rentner ist nichts bekannt. Er blieb mit seiner Frau in seiner Wohnung in der Inselstraße und starb am 6. April 1946 im Alter von dreiundachtzig Jahren. Lamprecht wurde eingeäschert und seine Urne am 8. Mai 1946 auf dem Neuen Johannisfriedhof in Leipzig beigesetzt.[40]

Gustav Lamprecht als Sammler

Gustav Lamprecht begann 1891 zu sammeln. Er konzentrierte seine Sammeltätigkeit auf Kunstgewerbe-Objekte, die in den Königlichen Preußischen Eisengießereien sowie in

Fig./Abb. 21

Fig./Abb. 22

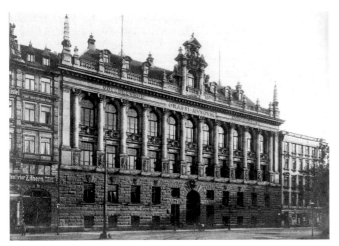

Fig./Abb. 23 Grassi-Museum, Leipzig, Königsplatz 10-11; photo/Aufnahme ca. 1914; Leipzig, Stadtarchiv, BA 1978/5039.

Fig./Abb. 24 Academy for Graphic and Book Arts / Akademie für graphische Künste und Buchgewerbe, Leipzig, Wächterstraße 11; photo/Aufnahme ca. 1920-30; Lepzig, Stadtarchiv, BA 1977/2522.

well as at other German, Austrian, and Bohemian ironworks. Decorative cast-iron objects – which had fallen out of favor during the mid-nineteenth century as zinc and bronze began to be reintroduced and used by the foundries – became highly collectible during the later part of the nineteenth century. In this period there was a great popular interest in history and historical objects that served as a link to the past and to a shared cultural identity that united – if not in practice then at least in theory – a disparate community of German principalities and kingdoms. Cast iron, which, one hundred years earlier, was seen as an intrinsically "German" material and even took on patriotic meaning during the Napoleonic Wars, found a parallel during the late nineteenth and early twentieth centuries when a similar search for a common foundation existed. Lamprecht was not alone in his collecting pursuits. In other parts of Germany equally impressive collections of decorative cast iron were being formed during this period, including those by Alfred Wolters in Bonn, Major Viktor Kurs in Berlin, Ewald Barth in Dessau, and Simon Macha in Beuthen. Most of these collections have found permanent homes in German museums, and have enjoyed the attention of the public ever since.[41]

Very few details are known of the way in which Gustav Lamprecht acquired objects for his collection. In general, the records provide no information and any documentation Lamprecht himself may have had, has not survived. We do know that Lamprecht was an educated man and was interested in all aspects of cast-iron production. This is evident in the substantial library he amassed on the subject, part of which came to the Birmingham Museum of Art with the collection of cast-iron objects. The Lamprecht library contains more than forty individual works or files about cast-iron production, including contemporary exhibition catalogues and articles from national magazines and journals, all of which deal with both useful and decorative cast-iron production. Lamprecht also collected short items about various aspects of cast iron, such as bits of information from newspapers, fliers, and advertisements, and illustrations of cast-iron ob-

anderen deutschen, österreichischen und böhmischen Hütten produziert worden waren. Dekorative Eisenkunstgußobjekte – die seit der Mitte des 19. Jahrhunderts in Ungnade gefallen waren, als Bronze wieder vermehrt von den Gießereien benutzt wurde und Zink als Gußmaterial zur Anwendung kam – waren während des späten 19. Jahrhunderts als Sammlerstücke wieder sehr gefragt. Während dieser Zeit bestand ein weit verbreitetes Interesse an Geschichte und an historischen Objekten, das der Stiftung einer gemeinsamen Kulturidentität der ehemals eigenständigen Fürstentümer und Königreiche diente. Eisenguß, der einhundert Jahre früher als „deutsches" Material angesehen wurde und während der Befreiungskriege 1813-15 eine patriotische Bedeutung angenommen hatte, fand eine entsprechende Wertung während des späten 19. und frühen 20. Jahrhunderts, als eine gleichartige Suche nach einem gemeinsamen Fundament existierte. Lamprecht war nicht allein in seiner Sammlertätigkeit. In anderen Regionen Deutschlands wurden während dieser Zeit ebenso beeindruckende Eisenkunstguß-Sammlungen zusammengetragen, darunter die von Alfred Wolters in Bonn, Major Viktor Kurs in Berlin, Ewald Barth in Dessau und Simon Macha in Beuthen. Die meisten von diesen Sammlungen haben einen festen Platz in deutschen Museen gefunden.[41]

Wenige Details sind über die Art und Weise bekannt, in der Lamprecht Objekte für seine Sammlung erwarb. Im allgemeinen bieten die Akten keine Informationen darüber und Dokumentationen von Lamprecht selbst sind nicht überliefert. Es ist aber doch bekannt, daß Lamprecht an allen Bereichen der Eisengußproduktion interessiert war, was sich auch darin zeigt, daß er eine beachtliche Bibliothek zusammengetragen hat, von der ein Teil mit seiner Sammlung in das Birmingham Museum of Art kam. Die Lamprecht-Bibliothek enthält mehr als 40 einzelne Werke und Akten über die Eisengußproduktion, einschließlich zeitgenössischer Ausstellungskataloge, Artikel aus Zeitschriften, Werbeschriften oder Anzeigen sowie Abbildungen von eisernen Objekten oder Bauwerken. Alle befassen sich mit Eisengußproduktio-

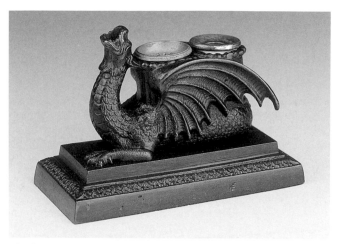

Inkwell / Schreibzeug (Cat. 704).

Inkwell / Schreibzeug (Cat. 704).

jects or structures. He catalogued his library, giving almost every individual piece a "B" number (for *Bibliothek*, or library), and putting a stamp that included his name, profession, and address on each cover.

Lamprecht also catalogued his collection; each object carries an inventory number written discreetly in white paint. A study of these numbers indicates that they were probably assigned to the objects as he acquired them because they, for the most part, do not follow any ordered system of classification. The inventory, or "Lamprecht," numbers begin with one and were assigned consecutively through number 499. The medals and gems in the collection were catalogued separately from the rest of the objects. They were given individual numbers preceded or followed by an "M," (for *Medaille*, or medal) beginning with 200M and ending with 469M. Another series of numbers identified with an "S" includes all jewelry *(Schmuck)* in the collection. The "S" series begins with the number 470S and ends with 573S. The inventory continues thereafter with number 901 and ends with number 951. The objects with inventory numbers 945 through 951 were added to the original Lamprecht Collection during the early 1940s by the American Cast Iron Pipe Company. It is not clear why Gustav Lamprecht chose to number his collection in such a way, or why the "M" series begins with number 200, which in effect, duplicates a number already found on another object. The Lamprecht system of ordering the collection was adapted by ACIPCO and has remained unchanged over the years, although the Birmingham Museum of Art has also assigned each object its own standard museum accession number. The size of the collection and the variety and types of objects it contains suggests that Lamprecht was an active collector, who sought to create a well-rounded, comprehensive collection.

Lamprecht worked closely with cultural organizations in Leipzig in an effort to promote his collection. He also shared his knowledge of and enthusiasm for cast iron with his fellow citizens by allowing his collection to be shown at local exhibitions and by participating in educational programs at the

nen verschiedenster Art. Lamprecht katalogisierte seine Bibliothek und gab fast jedem Stück eine B-Nummer (für Bibliothek) und versah es mit seinem Namensstempel.

Katalogisiert hat Lamprecht auch seine Sammlung: jedes Objekt trägt eine Inventarnummer, diskret mit weißer Farbe auf die Rückseite des Objekts geschrieben. Eine Betrachtung dieser Nummern läßt den Schluß zu, daß sie den Objekten wohl direkt nach dem Erwerb zugeteilt wurden, da sie größtenteils keiner geordneten Gruppeneinteilung folgen. Die „Lamprecht-Nummern" fangen mit 1 an und wurden bis 499 fortlaufend zugeteilt. Die Medaillen und Gemmen in der Sammlung wurden separat katalogisiert. Sie erhielten jeweils ein „M" (Medaille) voran- oder nachgestellt, angefangen mit 200M und beendet mit 469M. Eine weitere Serie von Nummern gekennzeichnet durch ein „S" (Schmuck) schließt alle Schmuckteile in der Sammlung ein. Die „S"-Serie fängt mit der Nummer 470S an und endet mit 573S. Danach geht es weiter mit der Nummer 901 und endet mit Nummer 951. Die Nummer 945 bis 951 geben die Objekte an, die während der frühen vierziger Jahre zusätzlich durch die American Cast Iron Pipe Company (ACIPCO) in die Lamprecht-Sammlung gekommen sind. Es ist unbekannt, warum Lamprecht seine Sammlung auf diese Weise numerierte, oder weshalb die „M"-Serie mit der Nummer 200 anfängt, was eigentlich eine Nummer, die auf einem Objekt ohne Buchstaben zu finden ist, verdoppelt. Lamprechts Ordnungs-System für die Sammlung wurde von der ACIPCO übernommen und ist, obwohl das Birmingham Museum of Art jedem der Objekte eine neue museumsgemäße Inventarnummer gegeben hat, über die Jahre unverändert geblieben. Die Größe der Sammlung und ihre verschiedenartigen Objekte beweisen, daß Lamprecht ein Sammler war, der anstrebte, eine umfangreiche und vielfältige Sammlung zu schaffen.

Lamprecht hat, in dem Bestreben seine Sammlung voran zu bringen, mit Kulturorganisationen in Leipzig eng zusammengearbeitet. Dazu gehört, daß er versuchte, sein Wissen über und seine Begeisterung für den Eisenkunstguß seinen Mitbürgern mitzuteilen, indem er seine Sammlung auf Aus-

Städtisches Kunstgewerbe-Museum (City Museum of Applied Arts), now part of the *Grassimuseum*, in Leipzig.

In 1915, Lamprecht's collection was shown for the first time publicly in an exhibition of nineteenth-century German art from private collections organized by the *Leipziger Kunstverein* (Art Association) and held at the *Museum der Bildenden Künste* (Museum of Fine Art), located in the center of the city. The exhibition, which included paintings, sculpture, and works on paper by well known German artists, featured highlights from Lamprecht's cast-iron collection, including portrait medallions, small sculpture, candlesticks, mirrors, household and sewing utensils, plaques and medals, and small gems after the antique. A small catalogue of the exhibition was published, which includes a list of artists associated with the collection as well as a description of each object that was included in the exhibition.[42]

In 1916, Lamprecht participated in another local exhibition, this time sponsored by the *Städtisches Kunstgewerbe-Museum* and held in the *Städtischen Kaufhaus* (City Department Store). The exhibition, entitled *Kriegergrabmal, Kriegerdenkmal*, was designed to show the way in which the German military apparatus preserved and maintained the individual graves and cemeteries of its soldiers. It also sought to show through a selection of art objects the way in which German and Austrian artists had, from the start of World War I, honored those on the front lines through their creative work.[43] Lamprecht's collection was included in a special section of the exhibition, no doubt to serve as a reminder of the patriotic role iron played during the Napoleonic Wars and to draw a connection between that early nineteenth-century struggle against France and the events of World War I.[44] The *Königliches Kunstgewerbemuseum* (Royal Museum of Ap-

stellungen zeigte und an pädagogischen Programmen des Städtischen Kunstgewerbe-Museums, heute Teil des Grassimuseums in Leipzig, teilnahm.

1915 wurde die Lamprecht-Sammlung zum ersten Mal öffentlich in der „*Ausstellung Deutscher Kunst des XIX. Jahrhunderts aus Privatbesitz*" (vom Leipziger Kunstverein organisiert) im Museum der bildenden Künste im Zentrum gezeigt. Die Ausstellung, die Gemälde, Skulpturen und graphische Arbeiten von bekannten deutschen Künstlern einschloß, umfaßte „Highlights" aus Lamprechts Eisenkunstguß-Sammlung, darunter Porträtmedaillons, Kleinskulpturen, Kerzenleuchter, Spiegel, Haushalts- und Nähgeräte, Plaketten und Medaillen sowie Gemmen nach der Antike. Es wurde ein kleiner Katalog dazu publiziert, der eine Liste von jedem Künstler, der mit der Lamprecht-Sammlung in Verbindung gebracht werden konnte, aufweist, wie auch eine Beschreibung jedes in der Austellung gezeigten Objekts.[42]

1916 war die Sammlung ein weiteres Mal in Leipzig zu sehen, diesmal im Städtischen Kaufhaus, veranstaltet vom Städtischen Kunstgewerbe-Museum, als Teil der Ausstellung „*Kriegergrabmal, Kriegerdenkmal*", die auch dazu dienen sollte, die deutsche Militärverwaltung darzustellen, wie sie Soldatengräber und -friedhöfe unterhielt und pflegte. Außerdem wollte sie durch eine Auswahl an Kunstobjekten zeigen, wie zeitgenössische deutsche und österreichische Künstler seit Anfang des Ersten Weltkriegs durch ihre Arbeiten Soldaten ehrten.[43] Die Lamprecht-Sammlung wurde in einem Sonderteil der Ausstellung gezeigt, bestimmt als Erinnerung an die patriotische Rolle, die Eisen während der Befreiungskriege 1813-15 gespielt hatte, und um eine Verbindung zwischen dem Kampf gegen Frankreich im frühen

Fig./Abb. 25 Lamprecht 1915, cover page/Titelseite. Fig./Abb. 26 Lamprecht 1915, 112-13.

LEIPZIGER KUNSTVEREIN
IM MUSEUM DER BILDENDEN KÜNSTE

AUSSTELLUNG
DEUTSCHER KUNST
DES XIX. JAHRHUNDERTS

AUS PRIVATBESITZ

NEUE FOLGE

ZWEITE VERBESSERTE UND ERWEITERTE AUSGABE

NOVEMBER – DEZEMBER 1915

III. ÄLTERE
KÜNSTLERISCHE EISENGÜSSE
AUS DER
SAMMLUNG GUSTAV LAMPRECHT,
LEIPZIG.
Die Maße sind in cm und mm angegeben.

VERZEICHNIS
DER BISHER ERMITTELTEN KÜNSTLER,
welche Aufträge an die nachstehend genannten Eisengießereien erteilten, ihre Modelle zur Benutzung überließen, auch Aufträge der Hütten ausführten, bez. als Angestellte tätig waren:

Für: Kgl. preuß. Eisengießerei zu Berlin, Kgl. preuß. Hüttenwerk zu Sayn bei Koblenz, Kgl. preuß. Hüttenwerk zu Gleiwitz

die Architekten:
Schinkel, Stüler, Strack und Fischer,

die Bildhauer:
Schadow, Rauch, Drake, Tilck, Wichmann, Straube, Wolf, Kiß, Kalide, Wiese, Thorwaldsen, Droz, David usw.,

die Medailleure:
Posch, Heuberger, Küchler, Daniel Friedrich, Friedrich Loos, Götze, Kullrich, König, Bovy, Held, Lesser, Pichler,

die Juweliere:
Moritz Geiß, Hossauer, Hofjuwelier in Berlin,

die Modelleure, Ziseleure und Kunstformer der Berliner Kgl. Gießerei:
C. Krigar, Stein, C. Jacob, Stilarsky, Röhl, Müller, Grüttner, Vollgold,

die Modelleure, Ziseleure und Kunstformer der Gleiwitzer Gießerei:
Stilarsky, Christoph Maendel, Friedrich Ludwig Beyerhaus, Theodor Kalide, August Kiß.

Für: Kgl. bayer. Erzgießerei zu München, Kgl. bayer. Hüttenwerke zu Bodenwöhr, Obereichstätt und Sonthofen

die Bildhauer und Modelleure:
Schwanthaler, Moritz Geiß, F. Woltreck, Posch usw.

Für: Königl. württembergische Erzgießerei zu Stuttgart, Königl. württembergisches Hüttenwerk zu Wasseralfingen

die Bildhauer und Modelleure:
Dannecker, Weitbrecht, Plock, (Thorwaldsen), Frank, Hofbildhauer, Stuttgart.

Für: Fürstl. anhalt. Hüttenwerk zu Mägdesprung i. H.

der Modelleur und Tierplastiker:
Kureck.

Für: Ehemal. Gräfl. Einsiedelsches Hüttenwerk zu Lauchhammer (Prov. Sachsen)

die Bildhauer:
Rietschel, Dondorf usw.

Namen der Künstler, welche für die unzähligen privaten Eisengießereien Deutschlands und Österreichs, bezw. in denselben arbeiteten, haben sich zurzeit noch so gut wie gar nicht feststellen lassen, wie denn überhaupt die Forschung auf dem Gebiete des Eisen-Kunstgusses kaum über den Anfang hinaus gediehen ist.

112

113

8

plied Arts) in Berlin held another patriotic exhibition in 1916 entitled *Gußeisen*, which also included objects from the Lamprecht Collection. The exhibition was organized by the museum in order to draw attention to the necessity of using cast iron for small decorative objects during the War and to provide historical examples of cast-iron art drawn from the period of the Napoleonic Wars.[45] More than fifty lenders participated in the exhibition, including, in addition to Gustav Lamprecht, several German museums and foundries, prominent collectors, members of the aristocracy, and Emperor Wilhelm II himself. Through these exhibitions the production of decorative cast-iron objects was encouraged during the war years and was cultivated further by one particular attempt to promote patriotism and the revitalization of the iron industry. A medal produced in 1916 with the image of a kneeling female figure holding a chain in her outstretched hands and the motto *"IN EISERNER ZEIT"* (Cat. 286) was given by the Reichsbank to citizens in exchange for their gold. Nonetheless, the attempt to revive the production of decorative cast iron at the beginning of the twentieth century was unsuccessful.

Through his participation in the exhibition *Kriegergrabmal, Kriegerdenkmal* in 1916, Lamprecht strengthened his relationship with the staff of the *Städtisches Kunstgewerbe-Museum* and in 1917 he placed his collection on long-term loan there. It can be surmised that Lamprecht was looking for a permanent home for his objects in Leipzig and intended eventually to either give or sell the collection to the museum.[46] At that time – and probably with the help of museum staff – Lamprecht was in the process of preparing a catalogue of his collection, which he expected to publish at the end of World War I.[47] As part of the catalogue, a series of 100 black and white photographs of the collection, measuring roughly 6 1/4 x 8 5/8 inches each, were taken. These include group shots of the objects arranged for primarily aesthetic purposes, rather than by type or function of object, and identified with a numbering system that does not correspond to Lamprecht's own inventory. The photographs also contain handwritten notes to the printer indicating the way in which the images were to be integrated into the catalogue. A small number of the objects photographed are identified as not part of the Lamprecht Collection. It can be presumed that these were included to provide comparable material from which to establish the importance or relevance of the Lamprecht objects. Another small group of objects included in the photographs, which were in fact originally part of the Lamprecht collection, is no longer extant. In 2002, the Birmingham Museum of Art was able to acquire this set of photographs from a private German collection. Today they serve as an important document of the collection as it existed during Gustav Lamprecht's lifetime; the photographs also provide information about objects that were once, but are no longer, part of the original collection.

Most of Lamprecht's large collection was installed as a permanent display at the *Städtisches Kunstgewerbe-Museum* in 1917. To celebrate the opening of the exhibition, Gustav Lamprecht gave a public lecture on the subject of decorative cast iron, which included a hands-on study session using objects from his collection.[48] When the collection was placed

19. Jahrhundert und den Ereignissen des Ersten Weltkriegs herzustellen.[44]

Das Königliche Kunstgewerbe-Museum in Berlin veranstaltete 1916 eine weitere patriotische Ausstellung mit dem Titel „*Gußeisen*", die auch Objekte aus der Lamprecht-Sammlung enthielt. Die Ausstellung wurde vom Museum organisiert, um auf die Notwendigkeit der Nutzung von Eisen für kleine dekorative Objekte während des Kriegs hinzuweisen und den Umtausch von Gold gegen Eisen zu fördern.[45] Mehr als fünfzig Leihgeber nahmen an der Ausstellung teil: neben Lamprecht viele deutsche Museen und Gießereien, bedeutende Sammler, Mitglieder des Adels und Kaiser Wilhelm II. selbst.

Durch diese Ausstellungen wurde die Produktion des Eisenkunstgusses während der Kriegsjahre angeregt und von verschiedenen Gießereien wieder betrieben, ohne jedoch auf Dauer erfolgreich zu sein. Markantes Beispiel dieser Zeit ist die Medaille mit der knienden weiblichen Figur, die eine Halskette darreicht und mit „*IN EISERNER ZEIT*" überschrieben ist und als Gegengabe der Reichsbank für die Ablieferung von Gold diente (Cat. 286).

Durch seine Beteiligung an der Ausstellung „*Kriegergrabmal, Kriegerdenkmal*" 1916 festigte Lamprecht seine Beziehungen zu Mitarbeitern des Städtischen Kunstgewerbe-Museums in Leipzig und deponierte 1917 dort seine Sammlung als Dauerleihgabe. Wahrscheinlich suchte Lamprecht eine dauerhafte Unterkunft für seine Sammlung in Leipzig. Er wollte dem Museum die Sammlung wohl verkaufen, vielleicht auch schenken.[46] Zu dieser Zeit – und wahrscheinlich mit Hilfe von Mitarbeitern des Museums – hatte Lamprecht einen Katalog seiner Sammlung angefangen, den er am Ende des Ersten Weltkriegs zu publizieren hoffte.[47] Für den Katalog wurde eine Serie von 100 Schwarzweißphotographien von jeweils etwa 16 x 22 cm (aufgeklebt auf Pappen von rund 27,5 x 36 cm) aufgenommen. Auf diesen sind Gruppen von Objekten wohl nach ästhetischen Gesichtspunkten zusammengestellt, anstatt nach Objekttyp oder Funktion. Sie sind mit einem Numerierungssystem versehen, das nicht mit Lamprechts Inventar korrespondiert. Auf den Pappen finden sich zum Teil handgeschriebene Notizen an den Drucker mit Erklärungen, wie die Photographien in den Katalog aufgenommen werden sollten. Eine kleine Anzahl der abgebildeten Objekte gehört nicht in die Lamprecht-Sammlung; vermutlich wurden diese als Vergleichsmaterial herangezogen. Eine andere kleine Gruppe von photographierten Objekten war ursprünglich Teil der Lamprecht-Sammlung, ist aber heute verschollen. Im Jahr 2002 hatte das Birmingham Museum of Art die Gelegenheit, diese Photographien aus einer deutschen Privatsammlung zu erwerben. Heute sind sie wichtige Dokumente der Sammlung zu Lamprechts Lebzeiten: Sie liefern Informationen über Objekte, die einmal Teil der originalen Sammlung gewesen sind.

Der Großteil der Lamprecht-Sammlung wurde als Dauerausstellung im Städtischen Kunstgewerbe-Museum in Leipzig 1917 installiert. Zur Feier der Eröffnung der Ausstellung hielt Lamprecht einen Vortrag über Eisenkunstguß anhand von Objekten seiner Sammlung.[48] Als die Sammlung ins Museum kam, wurde eine Liste aller Objekte erstellt, basierend auf Lamprechts Inventar. Die maschinengeschriebene

in the museum, a list of all objects was made, using Lamprecht's original inventory numbers as a guide. The typed list includes detailed information about each object, such as a brief description, measurements, the name of the designer or foundry if known, and also, on one occasion, purchase information. It also includes an occasional handwritten notation, indicating, for example, that certain objects were returned to Lamprecht during the course of the loan. Today, this document is housed in the *Museum für Kunsthandwerk* in Leipzig. It is entitled *Sammlung Lamprecht Handexemplar*,[49] and was most likely prepared by a member of the museum staff. The *Handexemplar* includes in its table of contents a list of the objects divided into four sections. In section I the utilitarian objects are organized into nine separate categories based on object function or type; section II provides a list of jewelry; section III includes a list of figurative sculpture; and section IV includes plaques, medallions, medals, and gems. The numbers in the *Handexemplar* correspond to Lamprecht's own inventory numbers. It is interesting to note that the surviving document does not include the "M" or "S" series of inventory numbers in its text, although they appear in the table of contents and were included in the loan to the museum. It can be assumed that this list of objects was intended to serve as a guide to the collection at the time it was placed on long-term loan at the museum.

A second document housed at the museum is entitled *Kunstwerke aus Eisenguss aus der Sammlung Professor G. Lamprecht Leipzig*. Although this document follows the format of the *Handexemplar*, *Kunstwerke* was probably created in preparation for the collection catalogue that Lamprecht had hoped to publish. Its table of contents is identical to that of the *Handexemplar*, and the information it provides is more or less the same, yet the document was clearly typed at a different time. This second document also includes only those objects with inventory numbers from one through 499. As with the *Handexemplar*, both the "M" and "S" series of numbers are missing. A copy of each document is now in the Birmingham Museum of Art.

The hardships of the First World War and the events of the German November Revolution between the fall of 1918 and the spring of 1919, coupled with the dire economic situation in Germany at war's end, prevented Gustav Lamprecht from publishing a catalogue of his cast-iron collection. The *Städtisches Kunstgewerbe-Museum* was no doubt unable to acquire the collection at this time, and Lamprecht, with a heavy heart, made the decision to sell.[50] During the early 1920s, the collection was removed from the museum, and in 1922 Gustav Lamprecht sold his collection and library to German-American businessman Max Koehler for the sum of $50,000 U.S. dollars.[51] Shortly thereafter, the objects were packed and shipped to the United States.

Max Koehler (1875-1929)

Max Koehler was born on June 27, 1875 in Davenport, Iowa, the youngest son of Henry (Heinrich) Koehler and his wife Ottilie, née Schlapp.[52] He graduated from Davenport High School and attended the University of Iowa. From 1894 to

Liste beinhaltet detaillierte Informationen über jedes Objekt, mit jeweils einer kurzen Beschreibung, den Maßen, den Namen der Entwerfer oder der Gießerei – soweit bekannt –, aber nur bei einem Objekt die Kaufinformation. Sie enthält ferner gelegentlich einen handgeschriebenen Vermerk, der zum Beispiel angibt, daß bestimmte Objekte während der Leihzeit an Lamprecht zurückgegeben wurden. Heute ist dieses Dokument im Museum für Kunsthandwerk in Leipzig. Es heißt „*Sammlung Lamprecht Handexemplar*"[49] und wurde wahrscheinlich von einem Mitarbeiter des Museums angefertigt. Das „*Handexemplar*" enthält im Inhaltsverzeichnis eine Liste der Objekte in vier Abschnitten. Im Abschnitt I sind die Gebrauchsgegenstände aufgeführt, aufgeteilt in neun weitere Gruppen nach Typ oder Funktion; Abschnitt II gibt eine Liste des Schmucks an, Abschnitt III eine Liste von Skulpturen und Abschnitt IV Plaketten, Medaillons und Gemmen. Die Nummern im „*Handexemplar*" entsprechen den Nummern im Lamprecht-Inventar, allerdings ohne „M"- oder „S"-Nummer, obwohl sie im Inhaltsverzeichnis erscheinen und bei der Übergabe an das Museum dabei waren. Vermutlich diente diese Liste als Führer für die Sammlung, während sie sich als Dauerleihgabe im Museum befand.

Ein zweites Dokument im Leipziger Museum hat den Titel „*Kunstwerke aus Eisenguss aus der Sammlung Professor G. Lamprecht Leipzig*". Dieses Verzeichnis diente wahrscheinlich zur Vorbereitung des Katalogs, den Lamprecht publizieren wollte. Dessen Inhaltsverzeichnis ist identisch mit dem im „*Handexemplar*", und die Informationen darin sind mehr oder weniger gleich. Dennoch wurde das Dokument neu geschrieben. Dieses zweite Dokument beinhaltet ebenfalls nur die Objekte mit den Inventarnummern von 1 bis 499; wie bei dem Handexemplar fehlen die „M"- und „S"-Seriennummern. Kopien der beiden Dokumente befinden sich im Birmingham Museum of Art.

Der Erste Weltkrieg und die wirtschaftlich schwierige Lage der Nachkriegszeit (Inflation) haben Lamprecht an der Publikation des Katalogs seiner Sammlung gehindert. Das Städtische Kunstgewerbe-Museum war zweifellos nicht in der Lage, die Sammlung zu erwerben, und Lamprecht entschied sich schweren Herzens, sie anderweitig zu verkaufen.[50] Anfang der zwanziger Jahre wurde die Sammlung aus dem Museum entfernt, und 1922 verkaufte Lamprecht sie mit der zugehörigen Bibliothek an den deutsch-amerikanischen Geschäftsmann Max Koehler für eine Summe von 50.000 US-Dollar, ließ sie kurz danach verpacken und in die USA verschicken.[51]

Max Koehler (1875-1929)

Max Koehler wurde am 27. Juni 1875 in Davenport, im Bundesstaat Iowa der USA, als jüngster Sohn Henry (Heinrich) Koehlers und dessen Ehefrau Ottilie, geb. Schlapp geboren.[52] Er absolvierte die Davenport High School und besuchte die University of Iowa. Von 1894 bis 1896 besuchte er Kurse im Fachbereich Jura an der University of Michigan[53] und machte schließlich seinen Abschluß 1896 an der St. Louis Law School, heute die Washington University

1896 he took courses in law at the University of Michigan[53] and eventually completed his law studies in 1896 at the St. Louis Law School, now the Washington University School of Law in St. Louis, Missouri. In 1897 Koehler married Cornelia Clopton Smith of St. Louis. The couple had two children: a daughter, Virginia Josephine,[54] and a son, Max Koehler, Jr.[55]

Koehler's father, a German immigrant from a modest background,[56] had made a fortune in the brewery business and Max and his brothers embarked on a number of highly successful business ventures. Koehler practiced law in St. Louis independently,[57] and as a member of the legal departments of the Independent Brewing Company in St. Louis and the St. Louis, Rocky Mountain and Pacific Railway Company in New Mexico that he and his brothers founded and which his older brother Hugo oversaw.[58] Due to poor health and a history of heart disease, Koehler was forced to retire from active employment around 1923. He died of heart disease on March 23, 1929, at his home in Pass Christian, Mississippi, at the age of fifty-three.[59]

Although he maintained homes in St. Louis and Pass Christian, from about 1910 Max Koehler lived in Los Angeles with his son, Max, Jr., who was an aspiring actor.[60] In California, Koehler was known as a shrewd businessman and as an art connoisseur and collector of rare books.[61] He purchased the Lamprecht Collection directly from its owner after seeing it in Leipzig in late 1922 while on one of his annual trips to Germany with his family. The Koehler family returned to New York from the German port at Bremen aboard the *America*, part of the Navigazione Generale Italiana line, arriving at their destination on January 14, 1923.[62] Cargo records from passenger ships traveling during the early part of the twentieth century have not been preserved. However, it is likely that Koehler brought the collection and library with him on the *America* on his return trip from Germany. After its arrival in the United States, the collection remained for a short period in New York, at which time the Metropolitan Museum of Art expressed an interest in acquiring certain groups of the objects, although not the entire collection.[63] When the sale fell through, the Lamprecht Collection was transferred to Koehler's home in Los Angeles.

Based on the documentary evidence, it appears that Koehler purchased the Lamprecht Collection as an investment, rather than as a group of objects to be privately displayed and enjoyed. Until late 1925, the collection remained in Los Angeles, unpacked and stored out of the public eye. Earlier that year, Max Koehler had contacted the Southwest Museum, now the Southwest Museum of the American Indian, and proposed to Charles Haskell, the museum's secretary and treasurer, the idea of a loan exhibition of decorative cast iron based on objects from the Lamprecht Collection. At some point during this period, Koehler made it clear to the museum that he wished to sell the collection for the sum of $75,000. In a letter to one of the museum's trustees, museum director Dr. James Sherer considered this option, but was put off by the high purchase price suggested by Koehler.[64] Nonetheless, a loan exhibition of the collection was arranged and was opened in December of 1925. The exhibition, which was installed in the left wing of the museum, ran for a period

School of Law in St. Louis, im Bundesstaat Missouri. 1897 heiratete er Cornelia Clopton Smith aus St. Louis. Das Ehepaar bekam zwei Kinder: eine Tochter, Virginia Josephine,[54] und einen Sohn, Max Koehler junior.[55]

Koehlers Vater, deutscher Einwanderer aus einer mittellosen Familie,[56] hatte sein Vermögen im Brauerei-Geschäft gemacht, und Max und seine Brüder fingen viele höchst erfolgreiche unternehmerische Vorhaben an. Max Koehler praktizierte in St. Louis selbständig als Anwalt[57] und war als Mitglied der Rechtsabteilungen der Independent Brewing Company in St. Louis und der St. Louis, Rocky Mountain and Pacific Railway Company in New Mexico tätig, die er und seine Brüder gegründet hatten und die sein älterer Bruder Hugo beaufsichtigte.[58] Wegen seines schlechten Gesundheitszustands und einer angeborenen Herzkrankheit mußte Koehler sich um 1923 aus dem aktiven Berufsleben zurückziehen. Am 23. März 1929 starb er in seinem Haus in Pass Christian, Mississippi, im Alter von dreiundfünfzig Jahren.[59]

Obwohl er Häuser in St. Louis, Missouri, und Pass Christian, Mississippi, besaß, lebte Max Koehler nach etwa 1910 bei seinem Sohn Max junior, einem aufstrebenden Filmschauspieler, in Los Angeles.[60] In Kalifornien war Koehler als kluger Geschäftsmann, aber auch als Kunstkenner und Sammler bekannt.[61] Er kaufte die Lamprecht-Sammlung direkt von ihrem Besitzer, nachdem er sie in Leipzig Ende 1922 bei einem seiner jährlichen Familienbesuche in Deutschland gesehen hatte. Die Koehler-Familie reiste vom deutschen Hafen in Bremen aus an Bord des Schiffes „America", das der Navigazione Genereale Italiana-Linie gehörte, nach New York zurück, wo sie am 14. Januar 1923 ankam.[62] Angaben über Schiffsladungen von Passagierschiffen Anfang des 20. Jahrhunderts sind nicht überliefert, jedoch ist es wahrscheinlich, daß Koehler bei dieser Rückreise die Sammlung und die Bibliothek bei sich hatte. Nachdem die Sammlung in den USA angekommen war, blieb sie kurze Zeit in New York. Zu der Zeit war das Metropolitan Museum of Art an der Erwerbung einiger Teile aus der Sammlung, nicht aber an der ganzen Sammlung interessiert.[63] Als es mit dem Verkauf nicht klappte, wurde die Sammlung in Koehlers Haus in Los Angeles gebracht.

Nach dem Urkundenmaterial scheint es, daß Koehler die Sammlung als Investition gekauft hatte, nicht aber als Gruppe von Objekten, die er privat ausstellen wollte oder um sie zu genießen. Bis Ende 1925 blieb die Sammlung verpackt in Los Angeles. Schon Anfang 1925 hatte Koehler das Southwest Museum, heute Southwest Museum of the American Indian, kontaktiert und dem Museums-Sekretär und -Finanzdirektor Charles Haskell vorgeschlagen, eine Ausstellung der Lamprecht-Sammlung zu veranstalten. In dieser Zeit bot Koehler dem Museum die Sammlung für 75.000 US-Dollar an. In einem Brief an einen der Museumsverwalter zog Museumsdirektor Dr. James Sherer diese Idee in Betracht, wurde jedoch von dem hohen Preis abgeschreckt.[64] Trotzdem wurde eine Ausstellung der Sammlung organisiert und im Dezember 1925 eröffnet. Die Ausstellung, im linken Flügel des Museums gezeigt, dauerte etwa zwei Monate. Es wurde über sie von den lokalen Zeitungen berichtet, und sie

of about two months. It was covered extensively in the local newspapers, and reportedly attracted *"a great deal of attention among [...] local art connoisseurs."*[65]
During the fall of 1925 and the spring of 1926, Koehler continued his efforts to sell the Lamprecht Collection to the museum. As an advocate and leader of his cause, he engaged Barbara Dacier, former field secretary of the Southwest Museum, to initiate a citywide campaign to raise enough money to purchase the collection for the museum. At the time, the museum appeared eager to acquire the collection and Koehler had agreed to sell it and the Lamprecht library in its entirety.[66] As an added incentive, Koehler pledged to the museum the sum of $15,000 to be used for renovations and restorations to the museum's historic architectural structures.

After the exhibition officially closed on February 1, 1926, the collection remained housed at the Southwest Museum while efforts to raise funds for its purchase continued. The collection continued to be a popular sight in the city and was praised for both its artistic and utilitarian value. In the spirit of late nineteenth-century efforts to improve the taste of the general public, the Lamprecht Collection was thought by local experts to be an ideal group of objects for ironworkers and artisans to study in order to *"stimulate originality of treatment and design."*[67] At one time Koehler, himself, expressed an interest in establishing a foundry in the Los Angeles area for the revival of cast-iron art, using objects from the Lamprecht collection as both source and inspiration.[68]
The campaign to raise funds for the Lamprecht Collection extended over a period of several months. However, by May of 1926 it became clear that the Southwest Museum had lost interest in purchasing the collection. In a letter from Barbara Dacier to James Sherer dated May 23, 1926, Mrs. Dacier expressed her surprise and concern that the Southwest Museum no longer wished to acquire the collection and had, in fact, asked Max Koehler to remove it from the museum. According to Sherer, the museum had made plans to shift its collecting focus to regional objects of archaeological interest rather than artworks of various periods and media.[69]

Despite this setback, Koehler continued to contact other museums about the collection for by July of 1926 the Lamprecht Collection was part of a new display at the Los Angeles Museum of History, Science, and Art in Exposition Park, now the Natural History Museum of Los Angeles County. The exhibition remained open for more than one year and in May of 1927 it was featured in the museum's newsletter, *Museum Graphic*, in a fully illustrated article.[70] The exhibition at the Los Angeles Museum of History, Science, and Art was extremely popular and drew the attention of Oscar Bruno Bach (1884-1957), the renowned New York metal designer, who visited the exhibition and praised the collection publicly as *"a basis for all metal design."*[71] Again, Koehler hoped that the collection would be purchased by the museum and retained for the citizens of Los Angeles. However, the necessary funds were not raised and the collection remained with him.
There is no indication that the collection was shown again in Los Angeles after the exhibition at the Museum of History,

zog angeblich die Aufmerksamkeit der dortigen Kunstkenner auf sich.[65]
Von Herbst 1925 bis Frühling 1926 setzte Koehler seine Versuche fort, die Lamprecht-Sammlung dem Museum zu verkaufen. Er beauftragte Barbara Dacier, ehemalige Sekretärin des Southwest Museums, eine stadtweite Spendenaktion zu initiieren. Zu dieser Zeit erschien das Museum interessiert, die Sammlung zu erwerben, und Koehler versprach, die Sammlung mit der Bibliothek als Ganzes zu verkaufen.[66] Außerdem sicherte Koehler dem Museum 15.000 US-Dollar für die Renovierung und Restaurierung der historischen Gebäude des Museums zu.

Nachdem die Ausstellung am 1. Februar 1926 offiziell geschlossen worden war, blieb die Sammlung im Southwest Museum, während die Bemühungen, genügend Geld für den Ankauf der Sammlung zu bekommen, weitergingen. Die Sammlung blieb eine Sehenswürdigkeit in der Stadt und wurde für ihren künstlerischen sowie lehrhaften Wert hoch gepriesen. Im Sinn der Bestrebungen des späten 19. Jahrhunderts, den Geschmack des allgemeinen Publikums zu verbessern, wurde die Lamprecht-Sammlung als vorbildliche Studiensammlung für Eisenarbeiter und Handwerker angesehen, um Originalität der Bearbeitung und des Entwurfs anzuregen.[67] Max Koehler selbst hatte einmal beabsichtigt, eine Gießerei in Los Angeles zu gründen, um die Kunst des Eisengusses neu zu beleben, wobei Objekte aus der Lamprecht-Sammlung als Vorbild und Inspiration dienen sollten.[68]
Die Spendenaktion für die Lamprecht-Sammlung dehnte sich über viele Monate aus. Bis Mai 1926 wurde jedoch klar, daß das Southwest Museum an der Erwerbung der Sammlung kein Interesse mehr hatte. In einem Brief von Barbara Dacier an James Sherer vom 23. Mai 1926 drückte sie ihre Verwunderung und ihre Bedenken aus, daß das Southwest Museum die Sammlung nicht mehr erwerben wolle und bat Koehler, sie aus dem Museum zu entfernen. Laut Sherer machte das Museum Pläne, den Schwerpunkt seiner Sammlung von Kunstwerken aller Perioden auf regionale Objekte von archäologischem Interesse umzustellen.[69]

Trotz dieses Rückschlags kontaktierte Koehler wegen der Sammlung andere Museen, und bis Juli 1926 wurde die Lamprecht-Sammlung Teil einer neuen Ausstellung im Los Angeles Museum of History, Science, and Art im Exposition Park, heute das Natural History Museum of Los Angeles County. Die Ausstellung dauerte mehr als ein Jahr und im Mai 1927 wurde die Sammlung im Museums-Mitteilungsblatt *Museum Graphic* mit farbigen Abbildungen veröffentlicht.[70] Sie war sehr populär und zog auch die Aufmerksamkeit des New Yorker Metallgestalters Oscar Bruno Bach (1884-1957) auf sich, der die Ausstellung besucht hatte und die Sammlung als Fundament für Metalldesign öffentlich hoch pries.[71] Wiederum hoffte Koehler, daß die Sammlung von dem Museum gekauft werden würde und damit für die Bürger von Los Angeles erhalten bliebe. Das nötige Geld kam jedoch nicht zusammen und die Sammlung blieb bei Koehler.
Vermutlich wurde die Sammlung nach dem Schließen der Ausstellung im Museum of History, Science, and Art nicht

Fig./Abb. 27 Max Koehler, Sr., in *St. Louis Post-Dispatch*, March 3, 1907.

wieder in Los Angeles ausgestellt. Gegen Ende der zwanziger Jahre verließ Koehler Los Angeles und zog sich in sein Haus in Mississippi zurück, wo er 1929 starb. Es ist unklar, was mit der Lamprecht-Sammlung unmittelbar nach dem Tod Koehlers 1929 geschah. Es gibt Vermutungen, daß die Sammlung an Koehlers Sohn Max Jr. gelangt ist. Jedoch gibt der ungewöhnliche und nomadische Lebensstil des jüngeren Koehlers mehr Hinweise darauf, daß die Sammlung durch Koehlers Witwe Cornelia in den Besitz seines älteren und einzigen lebenden Bruders Hugo überging.[72] Hugo hatte über die Jahre ein Vermögen durch seine verschiedenen Geschäftsunternehmungen angesammelt, und wie sein jüngerer Bruder Max war auch er als großzügiger Philanthrop und Sammler bekannt. Am 12. Mai 1930, ein Jahr nach Max Koehlers Tod, heiratete Hugo, der bis dahin Junggeselle war, Cornelia Koehler in Washington, D. C. Um diese Zeit adoptierte er auch Max Koehlers zwei erwachsene Kinder.[73] Es gibt kein Anzeichen, daß die Sammlung in der Öffentlichkeit gezeigt wurde, so lange sie sich noch im Besitz der Koehler-Familie befand. Hugo Koehler starb am 2. August 1939 im Alter von siebzig Jahren. Kurz danach wurde die Sammlung an die American Cast Iron Pipe Company mit Hauptsitz in Birmingham, Alabama, verkauft.

Science, and Art closed. At some point during the late 1920s, Max Koehler left Los Angeles and returned to his home in Mississippi, where he later died. It is unclear what happened to the Lamprecht Collection immediately after

Fig./Abb. 28 Exhibition of the Lamprecht Collection at the / Blick in die Ausstellung der Lamprecht-Sammlung im Los Angeles Museum of History, Science and Art; photo/Aufnahme 1926.

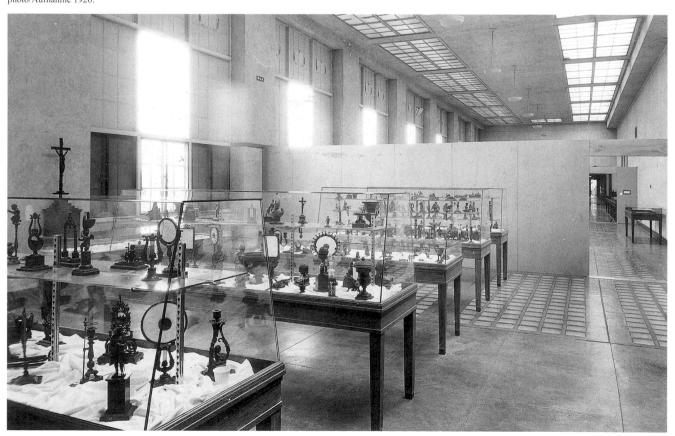

Koehler's death in 1929. It has been thought that it passed to his son, Max Koehler, Jr. However, the younger Koehler's unusual and nomadic lifestyle makes it more likely that the collection passed through Koehler's widow Cornelia into the possession of his older, and only remaining, brother Hugo.[72] Hugo had over the years amassed a great fortune through his various business ventures and, like his younger brother Max, was also known as a generous philanthropist and collector. On May 12, 1930, a year after Max Koehler's death, Hugo, who had remained a bachelor, married Cornelia Koehler in Washington, D.C. Around that time he formally adopted Max Koehler's two adult children.[73] No evidence exists that the collection was ever exhibited publicly again while it remained in the possession of the Koehler family. Hugo Koehler died on August 2, 1939, at age 70, and shortly thereafter, the collection was sold to the American Cast Iron Pipe Company, headquartered in Birmingham, Alabama.

The American Cast Iron Pipe Company (ACIPCO) and the Birmingham Museum of Art

The documentary evidence regarding the purchase of the Lamprecht Collection by the American Cast Iron Pipe Company (ACIPCO) is sketchy. Company tradition establishes that the collection was seen in Los Angeles by then-ACIPCO president William D. Moore.[74] At that time the company had offices in Los Angeles and its employees would have had a natural interest in seeing the two exhibitions of the Lamprecht Collection during the 1920s. Because Barbara Dacier's fundraising campaign was highly publicized in the *Los Angeles Times*, it is possible that ACIPCO's directors were aware of Max Koehler's interest in selling the collection. However, it was not acquired by the company until sometime in late 1939 or early 1940, after the death of Hugo Koehler.[75] Once acquired, the collection was immediately transferred to ACIPCO headquarters in Birmingham.[76] In February of 1940, the company officially announced the purchase of the collection in its employee newsletter *ACIPCO News*. At that time a selection of objects from the Lamprecht Collection was in the process of being installed in the company's service building, which housed the medical dispensary, personnel office, and other employee services. Acquired as both an educational and a commercial asset, company president Moore made his goal for the collection clear. He hoped that *"every employee* [would] *have an opportunity to see and study the various objects."* The company indicated furthermore that it had plans to *"utilize the exhibit material in several other ways."*[77] This included the development of a museum exhibition located at ACIPCO headquarters that would focus on the evolution of iron casting in art, as seen through the Lamprecht Collection, and in relationship to the contemporary commercial castings that ACIPCO produced. To that end the employees H. E. Wheeler and Mary McFarland Brown prepared a preliminary survey of the museum program in October of 1940.[78] The survey included a detailed description of a large exhibition space designed to house the entire Lamprecht Collection in one-third of the room, with the other two-thirds devoted to commercial exhi-

Die American Cast Iron Pipe Company (ACIPCO) und das Birmingham Museum of Art (BMA)

Genauere Umstände über den Kauf der Lamprecht-Sammlung durch die ACIPCO sind nicht überliefert. Die Firmentradition besagt, daß die Sammlung von ihrem damaligen Präsidenten William D. Moore in Los Angeles gesehen worden war.[74] Zu dieser Zeit hatte die Firma Büros in Los Angeles, und ihre Mitarbeiter zeigten Interesse an den zwei Ausstellungen der Lamprecht-Sammlung in den zwanziger Jahren. Da Barbara Daciers Spendenaktion in der *Los Angeles Times* veröffentlicht worden war, wußten offenbar die Direktoren der ACIPCO von Max Koehlers Wunsch, die Sammlung zu verkaufen. Allerdings wurde sie erst Ende 1939 oder Anfang 1940 von der Firma erworben[75] und zum ACIPCO-Hauptsitz in Birmingham gebracht.[76] Im Februar 1940 teilte die Firma diese Erwerbung in ihrem Rundschreiben für Mitarbeiter *ACIPCO News* offiziell mit. Zu dieser Zeit wurde eine Auswahl von Objekten aus der Lamprecht-Sammlung im Dienstgebäude der Firma, in dem die Krankenabteilung, die Personalbüros und andere Einrichtungen für Angestellte untergebracht waren, gezeigt. Aus pädagogischen sowie kommerziellen Gründen erworben, wollte Firmenpräsident Moore, daß jeder Angestellter die Möglichkeit hätte, die Sammlung zu sehen und zu studieren. ACIPCO plante außerdem, die Sammlung als Grundstock[77] für die Erarbeitung einer Museumsausstellung im ACIPCO-Hauptsitz zu nutzen, in der die Entwicklung des Eisenkunstgusses – wie in der Lamprecht-Sammlung und deren Beziehung zu zeitgenössischen Güssen, die ACIPCO produzierte – zu sehen sein sollte. Zu diesem Zweck erstellten die Angestellten H. E. Wheeler und Mary McFarland Brown im Oktober 1940 einen vorbereitenden Überblick des Museumsprogramms.[78] Dieser Überblick enthält die detaillierte Beschreibung eines großen Ausstellungsorts, in dem ein Drittel für die Lamprecht-Sammlung vorgesehen war und zwei Drittel für kommerzielle Ausstellungen bestimmt waren. Ein historischer Raum in der Art des Ausstellungsmagazins in Berlin in der ersten Hälfte des 19. Jahrhunderts war für die Lamprecht-Sammlung gedacht, in dem die Aufstellung eiserner Objekte frei im Raum und in Glasvitrinen an den Wänden einen Querschnitt des Lebens und der Interessen von Handwerkern, Modelleuren, Formern und Bauern vor mehr als einhundert Jahren in Preußen zeigen sollte.[79] Vielleicht wegen des Zweiten Weltkriegs, in den die Vereinigten Staaten im Dezember 1941 eintraten, aus finanziellen oder aus anderen praktischen Gründen, wurde der Plan für ein Museum bei ACIPCO nicht realisiert. Im Jahr 1945 wurde nur eine Handvoll Objekte ausgestellt, der Rest der Sammlung verpackt und eingelagert.[80] Zusätzlich zu den Plänen für ein zukünftiges Museum stellten die Direktoren von ACIPCO eine Forschungsgruppe zusammen, die die Lamprecht-Sammlung in Form eines kleinen Katalogs publizieren sollte. Die Arbeit wurde zum größten Teil von William McCulloch und James MacKenzie, Chefmetallurge, mit Hilfe von Mary McFarland Brown in Birmingham und Anneliese Sisco in New York durchgeführt. McCulloch und MacKenzie vertieften sich in die Lite-

bits. A period room of the type that might have been found in Berlin or Gleiwitz during the early nineteenth century was envisioned within the space for the Lamprecht Collection. The plan included the selective placement of cast-iron objects throughout the room to present a *"cross section of the life and interests of artisans, pattern makers* [modelers], *molders, and peasants of a hundred years ago in Prussia."*[79] Other objects were to be displayed in glass cases placed around the outer walls of the room. Possibly because of World War II, which the United States entered in December of 1941, or other financial or practical reasons, the plan for a museum at ACIPCO was not immediately carried out. In 1945 only a token number of objects were on view, while the remainder of the collection was crated and stored.[80]

In addition to creating plans for a future museum, the directors of ACIPCO set about forming a research group to study the Lamprecht Collection with the goal of publishing a small catalogue. The work was carried out mainly by William McCulloch and James MacKenzie, chief metallurgist, with the assistance of Mary McFarland Brown in Birmingham

ratur des frühen 19. Jahrhunderts über den Eisen- beziehungsweise Eisenkunstguß und zogen für ihre Forschungsarbeiten, die sich über viele Monate erstreckten, auch Eisenexperten zu Rate. Wegen des Kriegs war ein schriftlicher Kontakt mit deutschen Kollegen bestenfalls unregelmäßig, und Reisen nach Deutschland waren verboten. Im November 1941 gab die Firma ein kleines Heft über die Sammlung in zwei Ausführungen heraus: eine ungekürzte Ausgabe mit 37 Seiten und eine gekürzte Ausgabe mit nur 13 Seiten. Beide Versionen des Hefts *The Lamprecht Collection of Cast Iron Art* beinhalten die Geschichte der Eisenkunstgußproduktion auf der ganzen Welt mit einem Schwerpunkt auf die Produktion in Deutschland während des frühen 19. Jahrhunderts, und sie sind mit Photographien der Sammlung illustriert.[81]

Von 1940 bis 1951 war ein Teil der Sammlung im ACIPCO-Hauptsitz in Birmingham ausgestellt, da ein Museum nach dem Plan von 1940 nicht realisiert wurde. Im Mai 1951, nur einen Monat nachdem das Birmingham Museum of Art durch den Birmingham Art Club gegründet worden war,

Fig./Abb. 29 Exhibition of the Lamprecht Collection in the / Blick auf die Lamprecht-Sammlung im Birmingham Museum of Art, City Hall; photo/Aufnahme ca. 1955.

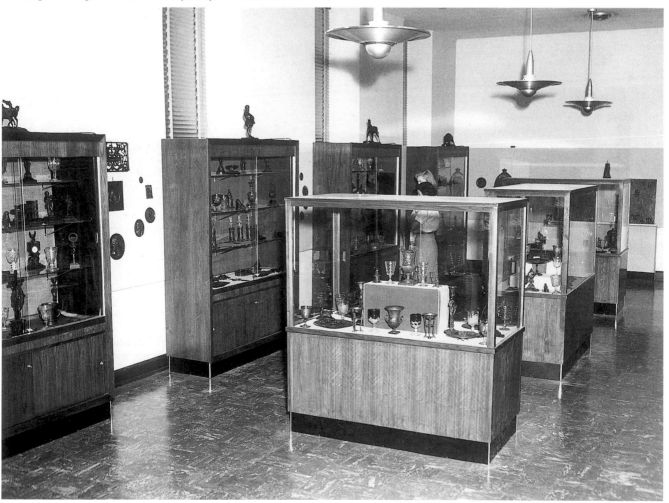

Fig./Abb. 30 Title page/Titelseite.

Fig./Abb. 31 Design for an exhibition space / Entwurf eines Ausstellungsplans.

Fig./Abb. 30-31 *"PRELIMINARY SURVEY OF MUSEUM PROGRAM"* for / Vorbereitender Überblick des Museumsprogramms für die ACIPCO, October 7-12, 1940 (s. note/Anm. 78).

and Anneliese Sisco in New York. Both McCulloch and MacKenzie spent a great deal of time reading about early nineteenth-century decorative cast iron and contacting experts in the field. Their research work was carried out gradually, over a period of several months. Due to the war, written correspondence with German colleagues was sporadic at best and any travel to Germany was prohibited. In November of 1941, the company issued a small booklet about the collection in two forms: a longer unabridged edition with thirty-seven pages; and a shorter abridged edition with only thirteen pages. Each version of *The Lamprecht Collection of Cast Iron Art* includes a history of cast-iron production throughout the world with a focus on decorative cast-iron production in Germany during the early nineteenth century, and is illustrated with photographs of objects in the collection.[81]

From 1940 until 1951, a portion of the Lamprecht Collection remained on display at ACIPCO's headquarters in Birmingham, although a company museum on the scale of that envisioned in 1940 was never realized. In May of 1951, only one month after the Birmingham Museum of Art was founded as an outgrowth of the Birmingham Art Club, the company transferred the collection to the museum's new exhibition

übertrug ACIPCO die Sammlung in die Ausstellungsräume des neuen Museums im Birminghamer Rathaus. Nach mehr als zehn Jahren Fürsorge und Ausstellung der Lamprecht-Sammlung entschieden sich die Direktoren der ACIPCO, dem Museum die Sammlung als Dauerleihgabe zu geben.[82] Richard F. Howard, damaliger Direktor des Museums, schrieb zu der Zeit: *„es ist zu hoffen, daß dieser ersten großen Sammlung, die ins neue Museum in Birmingham gegeben wurde, nach Herkunft und Art weitere folgen werden. Ferner ist zu hoffen, daß sie den Kern bildet, um den wir viel Material, das typisch ist für die Industrien, die Birminghams Existenz und wirtschaftliches Wachstum begründeten, sammeln können, ohne die hohen Standards künstlerischer Qualität, die durch das Museum gesetzt sind, zu opfern."*[83]
Während der fünfziger Jahre arbeiteten Angestellte der ACIPCO mit dem Birmingham Museum of Art zusammen, um die Lamprecht-Sammlung bekannt zu machen; sie war Höhepunkt der wachsenden Sammlung des Museums und genoß große Aufmerksamkeit beim örtlichen Publikum. Ein Artikel in der *New York Times* vom 28. Februar 1954, in dem die Sammlung als Teil des dritten Birmingham Festival of Arts vorgestellt wurde, machte die Sammlung einem größeren Publikum bekannt.[84] Während dieser Zeit zog sie die

Fig./Abb. 32-33 Reception at the Birmingham Museum of Art on May 26, 1987, in honor of ACIPCO, which in 1986 gave the Lamprecht Collection to the Museum / Empfang im Birmingham Museum of Art am 26. Mai 1987 zu Ehren der ACIPCO, die 1986 die Sammlung dem Museum gestiftet hatte.

Fig./Abb. 32 Guests examining the iron casts / Gäste beim Betrachten von Eisengüssen.

Fig./Abb. 33 ACIPCO President Paul W. Green (second from left) with officials from the Birmingham Museum of Art and the City of Birmingham during the reception / ACIPCO-Präsident Paul W. Green (zweiter von links) mit Funktionären vom Birmingham Museum of Art und der Stadt Birmingham während des Empfangs.

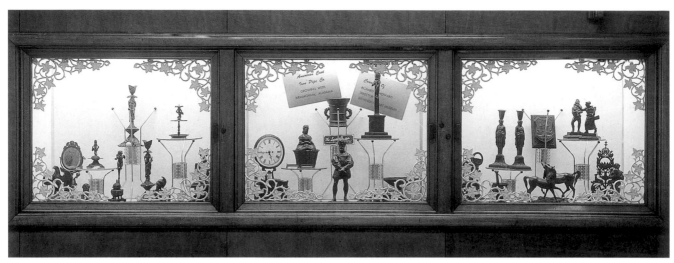

Fig./Abb. 34 Window display of the Pizitz department store / Schaufensterdekoration des Kaufhauses Pizitz in Birmingham; photo/Aufnahme March-May/März-Mai 1956.

Fig./Abb. 35 Wall case with objects from the Lamprecht Collection in the / Wandvitrine mit Objekten der Lamprecht-Sammlung im Birmingham Museum of Art; photo/Aufnahme ca. 1972.

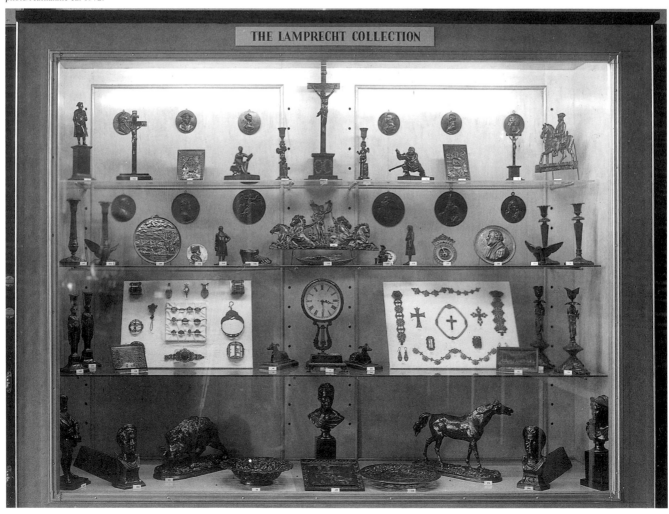

rooms in the Birmingham City Hall building. After more than ten years of caring for and displaying the Lamprecht Collection, the directors of ACIPCO had decided to put the collection on indefinite, long-term loan at the new museum, in order to *"share the collection with the citizens of Birmingham."*[82] Richard F. Howard, then director of the Museum, wrote at the time, *"it is very appropriate that this first collection of any size to come to the new museum in Birmingham should be from this source and of this type. It is hoped that it may be the nucleus around which, without in any way sacrificing the high standards of artistic quality which has been set for the museum, we may gather much material which is peculiar to the industries which are responsible for Birmingham's existence and growth."*[83] During the 1950s, ACIPCO employees worked together with the Birmingham Museum of Art to promote the Lamprecht Collection; it was a highlight of the Museum's growing collection and garnered much interest from the local community. Through an article in the *New York Times* on February 28, 1954, in which the collection was featured as part of Birmingham's third-annual Festival of Arts, the collection became known to a wider audience.[84] During this period it attracted the attention of Dr. Maurice Garbáty of Scarsdale, New York, who, as a result, donated his collection of fifty-one cast-iron objects to the Museum in 1962.

During the early years of the Museum's history, objects from the Lamprecht Collection were included in several exhibitions and advertising campaigns. In April of 1955, for example, the United Oil Manufacturing Company in Erie, Pennsylvania, used two objects from the Lamprecht Collection in an advertisement for the trade publication *Foundry*, in an issue that was dedicated to ornamental architectural ironwork in the South.

The advertisement also ran in another trade paper, *Modern Castings*, in February 1956. From March 10 through May 10, 1956, objects from the collection were placed on loan with the Pizitz department store in downtown Birmingham and were shown in an elaborate window display in celebration of the store's fifty-seventh anniversary. The theme of the window display – *"Parade of Progress"* – was the role that industry has traditionally played in developing and building the wealth of Alabama.[85] While the objects were on display at Pizitz, the department store offered public tours of the windows.[86]

On May 3, 1959, the Museum's first building opened to the public in downtown Birmingham, not far from City Hall. As the largest single collection of objects in the Museum, the Lamprecht Collection was displayed prominently.

In 1972 an addition was made to the existing east wing and in 1975, the collection was installed in the ground floor corridor of the new building.[87] At that time, the Museum's new director, John David Farmer, had plans to host a major exhibition of the collection to be accompanied by an illustrated catalogue.[88] Although these plans were never carried out, efforts were made throughout the years – the collection was reinstalled in 1982 – to display the bulk of the objects in the hope that ACIPCO would donate the collection to the Museum. This finally happened in August of 1986 when the company directors decided unanimously to give the Lam-

Aufmerksamkeit von Dr. Maurice Garbáty aus Scarsdale, New York, auf sich, was schließlich dazu führte, daß dieser 1962 seine Sammlung von 51 Eisenkunstgußobjekten dem Museum stiftete.

Während der Anfangsjahre der Museumsgeschichte wurden Objekte aus der Lamprecht-Sammlung bei verschiedenen Ausstellungen und Werbekampagnen gezeigt, so im April 1955 von der United Oil Manufacturing Company in Erie, Pennsylvania, für eine Werbung im Fachjournal *Foundry*, in einer Ausgabe, die dem künstlerischen architektonischen Eisenwerk im Süden der USA gewidmet ist. Die Werbung erschien auch in einem anderen Fachblatt, *Modern Castings*, im Februar 1956. Vom 10. März bis 10. Mai 1956 wurden Objekte der Lamprecht-Sammlung als Leihgabe an das Kaufhaus Pizitz in der Innenstadt von Birmingham gegeben und in einer aufwendigen Schaufensterausstellung als Teil des 57. Firmenjubiläums ausgestellt. Das Thema der Schaufensterausstellung – *„Parade of Progress"* (Parade des Fortschritts) – war die Rolle der Industrie, die diese bei der Entwicklung und Bildung des Wohlstands Birminghams gespielt hat.[85] Während dieser Präsentation bot das Kaufhaus öffentliche Führungen an.[86]

Am 3. Mai 1959 wurde das erste Museumsgebäude im Stadtzentrum gegenüber dem Rathaus von Birmingham eröffnet. Als größte Einzelsammlung im Museum wurde die Lamprecht-Sammlung besonders hervorgehoben. 1972 wurde der Ostflügel des Museums erweitert und die Sammlung in Räumen des neuen Gebäudeteils eingerichtet.[87] Zu dieser Zeit hatte der neue Museumsdirektor John David Farmer Pläne, eine große Ausstellung der Sammlung zu veranstalten und einen bebilderten Katalog zu publizieren.[88] Obwohl diese Pläne nie realisiert wurden, versuchte man über die Jahre – die Sammlung wurde 1982 noch einmal neu geordnet –, sie in großen Teilen auszustellen, in der Hoffnung, daß die ACIPCO sie als Geschenk dem Museum vermachen würde. Dies passierte schließlich im August 1986, als sich die Firmendirektoren einstimmig entschieden, die Lamprecht-Sammlung als Geschenk an das Birmingham Museum of Art zu geben.[89]

Damit war die – seit 1951 im Museum aufbewahrte – Sammlung für das Museum endgültig gesichert. Paul Green, zu dieser Zeit Präsident der ACIPCO, übergab die Sammlung feierlich dem Museums-Verwaltungsausschuß und den Mitarbeitern.[90] 1991 schloß das Museum seine Ausstellungsräume für den Publikumsverkehr, als es eine Renovierung seiner Gebäude und deren erneute Erweiterung durchführte. Das Museum wurde 1993 mit einer um 16.722,55 Quadratmeter größeren Ausstellungsfläche wiedereröffnet. Im selben Jahr wurden mehr als 200 Objekte der Lamprecht-Sammlung in einer eigenen Galerie im dritten Stock des Museums präsentiert.

Während der achtziger und neunziger Jahre bekam das Museum viele Anfragen, Objekte aus der Lamprecht-Sammlung für Eisenguß-Ausstellungen auszuleihen. Ein zweiter Versuch wurde unternommen, eine große Wanderausstellung mit einem Katalog der Sammlung zu organisieren.[91] Die erste große Ausstellung der Lamprecht-Sammlung fand 1994 statt, als 80 Objekte an das Bard Graduate Center for Studies in the Decorative Arts in New York für die Ausstel-

precht Collection to the Birmingham Museum of Art as a gift.[89]

Although resident at the Museum since 1951, the decision to give the Lamprecht Collection to the Birmingham Museum of Art in 1986 guaranteed the future of these important holdings. Paul Green, president of ACIPCO at the time, made the formal presentation of the collection to the Museum Board and staff, and the Museum issued a press release.[90] In 1991, the Museum closed its galleries to the public as it underwent a major expansion and renovation of its existing structure. In 1993, the Museum reopened with 180,000 square feet of new gallery space. That year more than two hundred objects from the Lamprecht Collection were installed in their own large gallery on the Museum's third floor.

During the 1980s and 1990s the Museum received a number of requests to lend objects from the collection to other institutions for inclusion in exhibitions of cast-iron material, and a second attempt was made in Birmingham to organize a large traveling exhibition accompanied by a catalogue of the collection.[91] The first major exhibition of the Lamprecht Collection was held in 1994, when eighty cast-iron objects were loaned to the Bard Graduate Center for Studies in the Decorative Arts in New York for an exhibition entitled *Cast Iron from Central Europe 1800-1850*, organized in part by the *Museum für Angewandte Kunst* (Museum of Applied Art) in Vienna. A fully illustrated catalogue was published by the Center to coincide with the exhibition, and was, until now, the only major publication dealing with European decorative cast iron to appear in the English language.

Fig./Abb. 36 Dr. Maurice Garbáty; photo/Aufnahme ca. 1947-50.

lung „Cast Iron from Central Europe 1800-1850" (veranstaltet mit dem Museum für Angewandte Kunst in Wien [MAK]), ausgeliehen wurden, zu der ein bebilderter Katalog vom Bard Graduate Center erschien – bis heute in englischer Sprache die einzige größere Publikation zum Thema europäischer Eisenkunstguß.

Maurice Garbáty (1892-1965)

In September of 1962, a second, smaller collection of decorative cast iron was given to the Birmingham Museum of Art by Dr. Maurice Garbáty of Scarsdale, New York. Dr. Garbáty, a native of Germany, was familiar with the Lamprecht Collection and was aware that it had been acquired by the Birmingham Museum of Art. Upon the donation of his collection to the Museum he wrote to then-director Richard Howard, *"I am very happy that with your help my little collection is placed with 'kindred spirits'."* [92]

Maurice Garbáty[93] was born on January 30, 1892, the son of Josef Garbáty (1851-1939), an Eastern European Jew from Lida in White Russia. In 1881, Josef Garbáty established the J. Garbáty-Rosenthal cigarette factory in Berlin, through which he amassed a fortune. In 1906, the factory was moved to a large brick building in Pankow, a wealthy borough in the eastern part of the city, and a second building was constructed in 1912. Maurice served in the German army during World War I, receiving the Iron Cross 2nd class, and then studied anthropology at the universities of Leipzig and Munich, earning a doctorate in the field during the 1920s. Out of his interest in anthropology grew an interest in the fine and decorative arts, and he, like his father and half-brother Eugen (1880-1970), became a well-known collector and patron of the arts.

When Maurice's father, Josef, retired in 1929, Maurice and Eugen assumed control of the factory, which at the time em-

Maurice Garbáty (1892-1965)

Im September 1962 kam eine zweite, kleinere Eisenkunstgußsammlung als Geschenk von Dr. Maurice Garbáty aus Scarsdale, New York, ins Museum. Dr. Garbáty, ein gebürtiger Deutscher, war mit der Lamprecht-Sammlung vertraut und wußte, daß sie sich im Besitz des Birmingham Museum of Art befand. Als er seine Sammlung dem Museum schenkte, schrieb er dem damaligen Direktor Richard Howard: „*ich bin sehr glücklich, daß mit Ihrer Hilfe meine kleine Sammlung zusammen mit 'Seelenverwandten' plaziert ist".* [92]

Maurice Garbáty[93] wurde am 20. Januar 1892 als Sohn von Josef Garbáty (1851-1939), einem osteuropäischen Juden aus Lida, Weißrußland, geboren. 1881 gründete Josef Garbáty die J. Garbáty-Rosenthal-Zigarettenfabrik in Berlin, wodurch er ein Vermögen erwarb. 1906 zog die Fabrik in ein großes Backsteingebäude in Pankow, einem wohlhabenden Bezirk im Norden der Hauptstadt, um; ein zweites Gebäude wurde 1912 erbaut. Maurice diente im deutschen Heer während des Ersten Weltkriegs und erhielt das Eiserne Kreuz 2. Klasse. Danach studierte er Anthropologie an den Universitäten Leipzig und München und promovierte in diesem Fach in den zwanziger Jahren. Aus seinem Interesse an Anthropologie entwickelte sich ein Interesse für die bildenden und angewandten Künste, und er wurde, wie sein Vater und sein Halbbruder Eugen (1880-1970), ein bekannter Sammler und Kunstmäzen.

ployed about two-thousand workers and produced more than ninety different brands of cigarettes, including the well-known *Königin von Saba* and *Kurmark* labels. The same year they changed the factory's name to *Garbáty Cigarettenfabrik GmbH* and shortly thereafter, Eugen sold his stock in the firm to Phillip Reemtsma, the leading tobacco producer in Germany. From then on, Maurice managed the company alone, despite increasing difficulties with the Nazi regime. In November of 1938, after the *Kristallnacht* pogrom against the Jews and the enactment of the *"Verordnung zur Ausschaltung der Juden aus dem deutschen Wirtschaftsleben,"* at which time any remaining Jewish businesses were transferred to non-Jewish owners, the factory was officially "aryanized" by the Nazis and the entire concern was sold by force at a fraction of its value to the Jakob Koerfer Gruppe in Cologne. Shortly thereafter, Maurice, his wife Ella, and son Thomas left Germany for Bordeaux. After a six-month stay in France, the family immigrated to the United States in June of 1939.[94] Josef Garbáty died in Berlin that same month. Maurice Garbáty died on January 5, 1965, in New York.

Maurice Garbáty began collecting in earnest during the years following World War I. He focused his collecting on the areas of Old Master paintings, Renaissance bronzes, and Egyptian antiquities, as well as on early nineteenth-century decorative objects that reflected his interest in the history of Biedermeier-era Berlin. During this period he began forming his collection of decorative cast iron, which had briefly come back into vogue during the war years. The Garbáty Collection of cast-iron art is comprised of fifty-one pieces.

Fig./Abb. 37 Dr. Thomas Garbáty, son of Maurice, viewing his father's pieces in the / Sohn von Maurice, betrachtet Sammlungsstücke seines Vaters im Birmingham Museum of Art; photo/Aufnahme 2004.

Fig./Abb. 38 Garbátyplatz, Berlin-Pankow, Florastraße; photo/Aufnahme 2006.

Als Maurices Vater Josef 1929 in den Ruhestand trat, übernahmen Maurice und Eugen die Leitung der Fabrik, die zu der Zeit etwa 2.000 Arbeiter beschäftigte und mehr als 90 verschiedene Zigarettenmarken produzierte, darunter die bekannte *„Königin von Saba"* und *„Kurmark"*. Im selben Jahr nannten die Brüder die Fabrik um in *„Garbáty Cigarettenfabrik GmbH"*. Kurz danach verkaufte Eugen seinen Anteil an der Firma an Phillip Reemtsma, den führenden Tabakproduzenten in Deutschland. Von diesem Zeitpunkt an leitete Maurice die Fabrik allein, auch wenn er ab 1933 durch das nationalsozialistische Regime in zunehmende Schwierigkeiten geriet. Im November 1938, nach dem *„Kristallnacht"*-Pogrom gegen die Juden und nach der Inkraftsetzung der *„Verordnung zur Ausschaltung der Juden aus dem deutschen Wirtschaftsleben"*, nach der alle übriggebliebenen jüdischen Unternehmen an nichtjüdische Besitzer abgegeben werden mußten, wurde die Fabrik offiziell *„arisiert"* und das ganze Anwesen zu einem Bruchteil seines Werts an die Jakob-Koerfer-Gruppe in Köln zwangsverkauft. Kurz darauf verließen Maurice Garbáty, seine Ehefrau Ella und sein Sohn Thomas Deutschland in Richtung Bordeaux. Nach einem sechsmonatigen Aufenthalt in Frankreich immigrierte die Familie im Juni 1939 in die Vereinigten Staaten.[94] Josef Garbáty starb in Berlin im selben Monat, Maurice Garbáty am 5. Januar 1965 in New York.

Maurice Garbáty hatte in den Jahren nach dem Ersten Weltkrieg ernsthaft zu sammeln begonnen. Er richtete seine Sammlertätigkeit vor allem auf Gemälde der Alten Meister, Renaissance-Bronzen, Antiquitäten aus Ägypten sowie Kunstgewerbe aus dem frühen 19. Jahrhundert, das sein Interesse an der Biedermeierperiode spiegelte. Während dieser Zeit begann er auch mit der Sammlung von Eisenkunstgüssen, ein Gebiet, das während der Kriegsjahre kurz wieder in Mode gekommen war. Die Garbáty-Eisenkunstguß-Sammlung besteht aus 51 Teilen. Wie bei Lamprecht enthält sie eine Auswahl von Arbeiten in Eisenkunstguß aus der ersten Hälf-

Like the Lamprecht objects, they encompass the range of works produced in cast iron during the early part of the nineteenth century: relief plaques, portrait medallions, watch holders, plates, paperweights, mirrors, inkwells, and small sculptures. Yet, the scope of Garbáty's collection is smaller. No doubt influenced by his interest in Berlin, Maurice Garbáty acquired objects made only at the three royal Prussian iron foundries, including one of the finest pieces in the Birmingham collection: the so-called "River Gods" plate set upon a slender foot decorated with swans and Gothic architectural elements (Cat. 835).

Maurice was able to bring his entire collection of cast-iron objects to the United States when he emigrated from Germany in 1939, but apparently never loaned his objects or exhibited the collection in any public venue.[95] In 1962 he decided to give the collection to the Birmingham Museum of Art where it joined the renowned Gustav Lamprecht Collection, thereby forming a collection of Central European decorative cast-iron objects unequalled in the United States.

te des 19. Jahrhunderts: Reliefplaketten, Porträtmedaillons, Taschenuhrenständer, Teller, Briefbeschwerer, Spiegel, Schreibzeuge oder kleine Skulpturen. Ohne Zweifel durch sein Interesse an Berlin beeinflußt, sammelte Maurice Garbáty nur Objekte, die in den drei Königlichen Preußischen Eisengießereien hergestellt worden waren, darunter eines der besten Objekte in der Birmingham-Sammlung: der sogenannte „Flußgötter-Teller" auf einem zierlichen, mit Schwänen und gotischen Architekturornamenten geschmückten Fuß (Cat. 835).

Es ist Maurice Garbáty gelungen, seine ganze Sammlung von Eisenkunstgußobjekten mit in die USA zu nehmen als er 1939 emigrierte, aber anscheinend hat er nie seine Objekte ausgeliehen oder in der Öffentlichkeit ausgestellt.[95] 1962 entschied er sich, die Sammlung an das Birmingham Museum of Art zu geben, wo sie der bekannten Lamprecht-Sammlung angegliedert werden konnte. Dadurch wurde eine Sammlung von Eisenkunstguß aus Zentraleuropa gebildet, die einmalig in den USA ist.

Conclusion

The heyday of decorative cast iron in Central Europe spans roughly thirty-five years, the same amount of time Gustav Lamprecht spent forming his collection. According to his wife Lina, it was his wish that the collection find a safe, permanent home in an institution that could truly appreciate the quality and artistic value of the objects he so carefully sought out.[96] Through the foresight of Gustav Lamprecht and his fellow collector Maurice Garbáty, this aspect of early nineteenth-century European artistic production – which, because it was so greatly influenced by events of the period, had a rather short lifespan – has been preserved for future generations.

The Birmingham Museum of Art is honored to have been entrusted with the care and safekeeping of these two important collections. Through the publication of this catalogue it is hoped that a greater understanding of and appreciation for the technological successes of the iron foundries more than two hundred years ago and the artistic objects they produced as a result can be achieved.

Zusammenfassung

Der Höhepunkt des Eisenkunstgusses in Zentraleuropa dauerte ungefähr fünfunddreißig Jahre, genauso lange, wie Lamprecht zum Zusammentragen seiner Sammlung brauchte. Übereinstimmend mit seiner Ehefrau Lina war es sein Wunsch, daß die Sammlung ein sicheres, dauerhaftes Heim in einem Museum finden sollte, welches die Qualität und den künstlerischen Wert der Objekte, die er so sorgfältig ausgesucht hatte, schätzen würde.[96] Durch die Vorausschau von Gustav Lamprecht und seinem Sammlerkollegen Maurice Garbáty wird dieser Aspekt der künstlerischen Produktion des frühen 19. Jahrhunderts – der, weil er so stark von den Ereignissen der Zeit beeinflußt wurde, ein kurzes Leben hatte – für zukünftige Generationen bewahrt.

Es ist dem Birmingham Museum of Art eine Ehre, daß ihm die Fürsorge und die Sicherheit dieser beiden wichtigen Sammlungen anvertraut wurde. Dieser Bestandskatalog an europäischen Eisenkunstgüssen des Birmingham Museum of Art präsentiert das große Spektrum unterschiedlicher Objekte verschiedener Gießereien – hier vor allem der drei Königlichen Preußischen Eisengießereien – aus der Zeit vor rund 200 Jahren und deren künstlerische Qualität und technische Vollkommenheit.

Notes

1 Unpublished speech given by William W. McCulloch in Birmingham in 1972 (BMA, Lamprecht Collection Records). McCulloch, in the steel products sales division at ACIPCO, took an active interest in the collection and conducted extensive additional research on the objects. Between September 1946 and June 1947, McCulloch was in Karlsruhe, Germany, on leave from the company. During that time he made contact with Lamprecht's widow Lina and from about 1948 was responsible for sending her "Caritas" care packages and S.A.F.E. (Save A Friend in Europe, Inc.) vouchers for food and supplies in the years following World War II until her death in 1951. In return, Lina Lamprecht wrote letters to the company, but unfortunately only rarely mentioned her late husband's cast-iron collection.
2 Forschler-Tarrasch.

Anmerkungen

1 Unveröffentlichter Vortrag von William W. McCulloch 1972 in Birmingham (BMA, Lamprecht Collection Records). McCulloch, der in der Stahlprodukte-Verkaufsabteilung bei ACIPCO gearbeitet hatte, war sehr an der Lamprecht-Sammlung interessiert und forschte ausführlich über die Sammlung. Zwischen September 1946 und Juni 1947 befand sich McCulloch in Karlsruhe, auf Urlaub von der Firma. Während dieser Zeit nahm er Kontakt mit Lamprechts Witwe Lina auf und schickte ihr von ungefähr 1948 an als Unterstützung „Caritas" Pakete und S.A.F.E. (Save A Friend in Europe, Inc.) Gutscheine für Lebensmittel und Verbrauchsmaterial bis zu ihrem Tod 1951. In ihren Dankesbriefen an die Firma erwähnte Lina Lamprecht leider kaum die Eisenkunstguß-Sammlung ihres verstorbenen Ehemannes.

3 Hintze 1928a. – Schmitz 1917. – Schmidt 1981. – Arenhövel 1982. – Ostergard 1994.

4 Dillenburg Castle, the ancestral seat of the Orange branch of the House of Nassau, is located 100 kilometers east of Bonn near the town of Herborn. It was destroyed during the Seven Year's War (1756-63) and today only the *Stockhaus* (former prison) remains. In 1664, cast-iron pipes were installed in the fountains of Versailles by order of Louis XIV, and five miles of this piping is still functioning today. See Bruce L. Simpson. *Development of the Metal Castings Industry* (Chicago: American Foundrymen's Association, 1948), 150.

5 Christa Schreiber. "Grossguss-Werke," in Arenhövel 1982, 238.

6 Today this part of Saxony is in the state of Brandenburg.

7 Redlich 1953a, 69 ff.

8 The sculpture, which is no longer extant, was cast after a figure in the Dresden royal collection (Charlotte Schreiter. "Lauchhammer und Berlin – Antikenkopien aus Eisen und Bronze," in Schreiter and Pyritz, 114).

9 Schmidt 1981, 25-33.

10 Forschler-Tarrasch 2008, 65-74.

11 Hintze 1928a, 4.

12 Schmidt 1981, 35.

13 The Sayn foundry was established in 1769/70 by the last Kurfürst of Trier, Clemens Wenzeslaus. In 1802, after the Frieden von Lunéville, the foundry became the property of the Duke of Nassau. On July 1, 1815, the Prussian state took control of the Sayn foundry.

14 By 1865 the foundry was no longer casting decorative objects. It finally closed in 1926.

15 Schmidt 1981. – Hintze 1928b. – Arenhövel 1982.

16 Schmidt 1981, 199.

17 Börsch-Supan, vol. 1, 1814, no. 328. – Hintze 1928b, 154.

18 Hintze 1928b, 154.

19 Ibid, 158. – Schmidt 1981, 204-06.

20 Hintze 1928b, 158.

21 See Leisching, Hintze 1931, and Schmidt 1981, 217-30 for a general summary.

22 Mende 2004, 39. – See also Pyritz 1994.

23 Schmidt 1981, 115 f. With this technique, the plaster mold was divided into sections and these were combined in the flask and fitted together to form a whole. After the hot iron was hardened and cooled, the individual sections were removed and the cast was taken out of the flask in one piece. This new technique was used in the casting of the twelve sculptures designed between 1819 and 1821 for the Kreuzberg Monument. Each sculpture was cast using several different molds made by Stilarsky himself.

24 Mende 2004, 40.

25 Wilhelm Albrecht Tiemann. "Ueber die Medaillengießerei," in ders., *Abhandlung über die Förmerei und Gießerei auf Eisenhütten. Ein Beitrag zur Eisenhüttenkunde.* (Nuremberg: Raspesche Buchhandlung, 1803), 101-08. – See also Hintze 1928a, 44.

26 Mende 2004, 41. – The properties of the foundry sand as well as the formula for the linseed oil varnish were protected secrets of the foundries and information about each varies. Dieter Vorsteher cites two different recipes for varnishes used in Gleiwitz and Berlin ("Die Kunst des hohlen Raumes in den Formereiwerkstätten der Saynerhütte," in Arenhövel 1982, 270 f). – Hintze 1928a, 44. – Pyritz 1994, 139.

27 In his personnel file (see note 31) Lamprecht indicates that he was born in 1862. The files of the Friedhofskanzlei of the City of Leipzig give his year of birth incorrectly as 1856.

28 Lamprecht's older siblings were Amalia Wilhelmine Clara (born on November 21, 1856), and Reinhold Carl Walther (born on January 9, 1860; died on February 23, 1945). Baptismal Register, Church of St. Nikolai, Leipzig, Jg. 1857, Bl. 7, Nr. 46 and Jg. 1860, Bl. 20, Nr. 129.

29 Born on September 15, 1835, in Zwenkau, the son of Friedrich August Lamprecht and Friederike Lamprecht, née Heyne, he is listed as a Rathsportalcassierer (cashier) at the City Hall at the time of Lamprecht's birth. Johann Carl Friedrich Lamprecht died on April 13, 1909, in Leipzig.

30 Born on August 11, 1825, daughter of Johann Heinrich Friedrich Pichel, a straw hat maker, and his wife Johanna Pichel, née Weitmann; married on November 17, 1856. Register of Weddings, Church of St. Thomas in Leipzig, Jg. 1856, Bl. 73, Nr. 327. Johanna Lamprecht died in 1899.

31 SächsStAL, Staatliche Akademie für graphische Künste und Buchgewerbe, Leipzig. Personalakte betr. Professor Lamprecht, Nr. 0038, 1913-1946, Confirmations-Schein, March 25, 1877.

32 Ibid, Ausmusterungs-Schein, June 4, 1883.

33 Ludwig Nieper. *Die Königliche Kunstakademie und Kunstgewerbeschule in Leipzig. Festschrift und amtlicher Bericht,* Leipzig, December 12, 1890, 53.

34 Ludwig Nieper. *Die Königliche Kunstakademie und Kunstgewerbeschule zu Leipzig. Bericht über die Zeitdauer von Ostern 1896 bis Ostern 1898,* Leipzig 1998, 36, 45. Lamprecht is first listed in the Leipzig address book in 1894 as architect and teacher at the Königliche Kunstakademie residing at Johannisplatz 9.

35 Lina Lamprecht was born on May 9, 1867, in Königstein, the oldest of four children. Her siblings include Hedwig Ida Körner, née Fischer, and Hermann Friedrich Fischer, born on August 15, 1869. Another sister, Martha Ida, died at age

2 Forschler-Tarrasch.

3 Hintze 1928a. – Schmitz 1917. – Schmidt 1981. – Arenhövel 1982. – Ostergard 1994.

4 Schloß Dillenburg, der Stammsitz des Oranienzweigs des Hauses Nassau, liegt circa 100 Kilometer östlich von Bonn bei der Stadt Herborn. Es wurde im Siebenjährigen Krieg (1756-63) zerstört und heute steht nur noch das „Stockhaus". – Eiserne Rohre wurden 1664 im Auftrag von Ludwig XIV. in den Wasserkünsten von Versailles installiert und rund acht Kilometer dieser Rohre funktionieren noch heute (Bruce L. Simpson. *Development of the Metal Castings Industry.* Chicago: American Foundrymen's Association, 1948, 150).

5 Christa Schreiber. "Grossguss-Werke", in Arenhövel 1982, 238-57, hier 238.

6 Heute im Bundesland Brandenburg.

7 Redlich 1953, 69 ff.

8 Das Bildwerk, das nicht mehr existiert, wurde nach einer Figur in der Dresdener königlichen Sammlung gegossen (Charlotte Schreiter. "Lauchhammer und Berlin – Antikenkopien aus Eisen und Bronze", in Schreiter und Pyritz, 109-26, hier 114).

9 Schmidt 1981, 25-33.

10 Forschler-Tarrasch 2008, 65-74.

11 Hintze 1928a, 4.

12 Schmidt 1981, 35.

13 Die Sayner Gießerei wurde 1769/70 vom letzten Kurfürsten von Trier, Clemens Wenzeslaus, gegründet. 1802, nach dem Frieden von Lunéville, ging die Gießerei in den Besitz des Herzogs von Nassau über. Am 1. Juli 1815 übernahm der preußische Staat die Sayner Hütte.

14 Ab 1865 produzierte die Sayner Hütte nur gelegentlich noch Eisenkunstguß. Sie wurde 1926 geschlossen.

15 Schmidt 1981. – Hintze 1928b. – Arenhövel 1982.

16 Schmidt 1981, 199.

17 Börsch-Supan, Bd. 1, 1814, Nr. 328. – Hintze 1928b, 154.

18 Hintze 1928b, 154.

19 Ebenda, 158. – Schmidt 1981, 204-06.

20 Hintze 1928b, 158.

21 Leisching. – Hintze 1931. – Schmidt 1981, 217-30.

22 Mende 2004, 39. – Vgl. auch Pyritz 1994, 129-53.

23 Schmidt 1981, 115 f.

24 Mende 2004, 40.

25 Wilhelm Albrecht Tiemann. "Ueber die Medaillengießerei", in ders., *Abhandlung über die Förmerei und Gießerei auf Eisenhütten. Ein Beitrag zur Eisenhüttenkunde.* Nuremberg: Raspesche Buchhandlung, 1803, 101-08. – Vgl. auch Hintze 1928a, 44.

26 Mende (wie Anm. 21), 41. – Sowohl die Zusammensetzung des Formsands als auch des Leinölfirnis waren sorgsam gehütete Geheimnisse der Gießereien. Zu beiden gibt es sehr verschiedene Angaben. Für den Gleiwitzer und den Berliner Firnis zitiert Dieter Vorsteher ("Die Kunst des hohlen Raumes in den Formereiwerkstätten der Saynerhütte", in Arenhövel 1982, 259-73, hier 270 f.) zwei unterschiedliche Rezepte aus einer handschriftlichen Quelle von 1820. – Hintze 1928a, 44. – Pyritz (wie Anm. 21), 139.

27 In seiner Personalakte (wie Anm. 29) gibt Lamprecht an, daß er 1862 geboren wurde. Die Akten in der Friedhofskanzlei der Stadt Leipzig geben das Geburtsjahr irrtümlicherweise mit 1856 an.

28 Lamprechts ältere Geschwister waren Amalia Wilhelmine Clara (geb. 21. November 1856) und Reinhold Carl Walther (geb. 9. Januar 1860; gest. 23. Februar 1946). Taufregister, St. Nikolai Kirche, Leipzig, Jg. 1857, Bl. 7, Nr. 46, und Jg. 1860, Bl. 20, Nr. 129.

29 Johann Carl Friedrich Lamprecht wurde am 15. September 1835 in Zwenkau (Sachsen, Kreis Leipziger Land) geboren als Sohn von Friedrich August Lamprecht und dessen Ehefrau Friederike (geb. Heyne). Friedrich August Lamprecht war zu der Zeit „Rathsportalcassierer" im Rathaus in Leipzig. Johann Carl Friedrich Lamprecht starb am 13. April 1909 in Leipzig.

30 Geboren am 11. August 1825 als Tochter des Johann Heinrich Friedrich Pichel, Strohhutmacher, und dessen Ehefrau Johanna Pichel, geb. Weitmann; Heirat am 17. November 1856 (Eheregister der St. Thomas Kirche in Leipzig, Jg. 1856, Bl. 73, Nr. 327). Johanna Lamprecht starb 1899.

31 SächsStAL, Staatliche Akademie für graphische Künste und Buchgewerbe, Leipzig. Personalakte betr. Professor Lamprecht, Nr. 0038, 1913-1946, Konfirmationsschein vom 25. März 1877.

32 Ebenda, Ausmusterungs-Schein vom 4. Juni 1883.

33 Ludwig Nieper. *Die Königliche Kunstakademie und Kunstgewerbeschule in Leipzig. Festschrift und Amtlicher Bericht*, Leipzig, 12. Dezember 1890, 53.

34 Ludwig Nieper. *Die Königliche Kunstakademie und Kunstgewerbeschule zu Leipzig. Bericht über die Zeitdauer von Ostern 1896 bis Ostern 1898*, Leipzig 1898, 36, 45. Lamprecht taucht zum ersten Mal im Leipziger Adreßbuch von 1894 als Architekt und Lehrer an der Königlichen Kunstakademie. Er wohnte Johannisplatz 9.

35 Lina Lamprecht wurde am 9. Mai 1867 in Königstein (Sachsen, Kreis Sächsische Schweiz) als ältestes von vier Kindern geboren. Ihre Geschwister waren Hedwig Ida (verh. Körner) und Hermann Friedrich Fischer, geboren am 15. August 1869. Eine weitere Schwester, Martha Ida, starb als Dreijährige. Lina Lamprecht starb

three. Lina Lamprecht died on February 13, 1951, in Leipzig. Upon her death, much of her estate was looted from her apartment. An investigation led to the recovery of the stolen items, which were then paid for by those individuals involved for a total of 320 DM. Her remaining estate, which, because no heirs could be found, was assumed by the German Democratic Republic, included only some jewelry and one oil painting, which were later sold by the state. There is no mention of cast iron in the correspondence. Amtsgericht Leipzig, Nachlassgericht, letters to the Staatliche Notariat Leipzig-Stadt, 1953-55.

36 SächsStAL, Personalakte (see note 31), certificate from the Rath der Stadt Leipzig, June 22, 1900.

37 Ibid, letter from Director Max Seliger to Gustav Lamprecht, September 26, 1910. Max Seliger became director of the Academy in 1901. According to the Ministry for Architecture and Historic Preservation, there are no known buildings in Leipzig designed by Gustav Lamprecht (letter to the author from Dr. Leonhardt, Stadtbezirkskonservator, Leipzig, March 29, 2007). It is not known how long Lamprecht operated his own architectural practice.

38 Ibid, notice from Seliger to Gustav Lamprecht, June 9, 1915: *"Mit allerhöchster Genehmigung ist dem Lehrer an der Königlichen Akademie für graphische Künste und Buchgewerbe in Leipzig, Johannes Franz Gustav Lamprecht der Titel Professor verliehen worden."* In his personnel questionnaire, Lamprecht indicates that he was made professor on May 16, 1911 (ibid, Personalbogen, Staatliche Akademie für graphische Künste und Buchgewerbe in Leipzig).

39 Ibid, letter from Lamprecht to the Wirtschaftsministerium zu Dresden, Leipzig, December 26, 1923; letter from the Wirtschaftsministerium to the administration of the Academy, February 22, 1924; letter from the Academy to Gustav Lamprecht, February 23, 1924.

40 Letter to the author from the Grünflächenamt, Abteilung Friedhöfe, Friedhofskanzlei, March 29, 2007: The ashes of Gustav Lamprecht were buried on May 8, 1946 in the first gravesite, third section, group row B, grave eleven of the Neue Johannisfriedhof. Also buried in the same plot were Lamprecht's brother Reinhold and his sister-in-law Emma Anna Lamprecht, née Knösing (born on May 28, 1867; died on March 29, 1942). The Neue Johannisfriedhof was secularized between 1973 and 1975 and reestablished as a public park. On February 24, 1951, the urn containing Lamprecht's ashes was reburied in the Südfriedhof, first section, group row D, grave number 11. The grave no longer exists. No obituary for Gustav Lamprecht was found.

41 The Wolters and the Kurs collections are now in the Kunstgewerbemuseum Berlin. Simon Macha's collection became part of the Landesmuseum in Beuthen (Bytom, Polen). Ewald Barth's collection spent several years at Berlin's Märkisches Museum and at the Museum für Verkehr und Technik, now Deutsches Technikmuseum Berlin. It was recently sold and is now part of the Museum für Stadtgeschichte Dessau. Of these large collections, only the Barth collection has thus far been published (see Aus einem Guß).

42 Cat. Leipzig 1915.

43 Cat. Leipzig 1916: *"Die Ausstellung 'Kriegergrabmal und Kriegerdenkmal' will zeigen, welche Sorgfalt die deutsche Heeresverwaltung auf die Erhaltung und würdige Gestaltung der Kriegergräber und Kriegerfriedhöfe auf dem Kriegsschauplatz und in den besetzten Gebieten verwendet. Sie will ferner an einer stattlichen Auswahl von Darstellung verschiedener Art dartun, mit welchem Eifer seit Kriegsbeginn deutsche und österreichische Künstler in der Heimat bemüht sind, der großen und edlen Aufgabe der Kriegerehrung sowohl in ausgeführten Arbeiten als auch in mannigfachen Entwürfen gerecht zu werden."*

44 Ibid: *"Eine besondere Abteilung bildet die umfassende Sammlung von Eisengußarbeiten (Schmuck, Medaillen und Kunstgewerbe), die Herr Professor Lamprecht in Leipzig in dankenswerter Weise zur Verfügung gestellt hat."*

45 Cat. Berlin 1916, 3: *"Infolge der Beschlagnahme der kupferhaltigen Metalle für den Kriegsbedarf ist die Kunstgießerei in Deutschland auf das Eisen, besonders für die Aufgaben der Gefallenenehrung, für Kriegergräber, Gedenktafeln, Erinnerungsmedaillen und Kleinplastik angewiesen. Um dem Bedürfnis nach lehrreichen Vorbildern des älteren deutschen Eisenkunstgusses entgegenzukommen, hat das Kgl. Kunstgewerbemuseum eine Auswahl von Eisengüssen, besonders der ehemaligen Berliner Kgl. Eisengießerei, im Lichthof zu einer Ausstellung vereinigt."*

46 Mitteilungen des Städtischen Kunstgewerbe-Museums zu Leipzig. Bericht für das Jahr 1917, Nr. 9 (February 1918), 108: *"Es ist zu wünschen, daß die wertvolle und vielfach anregende Sammlung dem Museum erhalten bleiben könnte."*

47 Mitteilungen des Städtischen Kunstgewerbe-Museums zu Leipzig. Bericht für das Jahr 1917, 106. – The catalogue was supposed to be published by Hiersemann in Leipzig.

48 Ibid, 108: *"An diese Bemerkungen schloß als Gast Herr Professor Lamprecht einen Vortrag über den künstlerischen Eisenguß und erläuterte seine Ausführungen an der Hand von Gegenständen seiner reichen Sammlung, die zur Zeit im KGM aufgestellt ist."*

49 Sammlung Lamprecht Handexemplar, unpublished manuscript, undated [before 1917] and not attributable to any one hand, but presumably prepared by a staff member of the Grassimuseum while the collection was on long-term loan there.

50 In 1948, two years after her husband's death, Lamprecht's wife Lina wrote to the

in Leipzig am 13. Februar 1951. Nach ihrem Tod wurde ihr Nachlaß in der Wohnung geplündert. Eine Untersuchung führte zur Auffindung der gestohlenen Gegenstände, die danach durch die Diebe für 320 DM gekauft wurden. Der Rest des Nachlasses wurde mangels Erben von der Deutschen Demokratischen Republik übernommen. Darunter waren einige Schmuckstücke und ein Ölgemälde, die später vom Staat verkauft wurden. Es gibt keinen Hinweis darauf, daß Frau Lamprecht noch Eisenkunstguß besessen hätte (Amtsgericht Leipzig, Nachlaßgericht, Briefe an das Staatliche Notariat Leipzig-Stadt, 1953-55).

36 SächsStAL (wie Anm. 31), Zertifikat vom Rath der Stadt Leipzig, 22. Juni 1900.

37 Ebenda, Brief vom Direktor Max Seliger an Gustav Lamprecht vom 26. September 1910. Seliger wurde 1901 Direktor. Es sind keine Gebäude von Lamprecht in Leipzig bekannt (Brief an die Autorin von Dr. Leonhardt, Stadtbezirkskonservator, Leipzig, vom 29. März 2007). Ebenso wenig ist bekannt, wie lange Lamprecht ein eigenes Büro hatte.

38 Ebenda, Brief von Seliger an Gustav Lamprecht vom 9. Juni 1915: *„Mit allerhöchster Genehmigung ist dem Lehrer an der Königlichen Akademie für graphische Künste und Buchgewerbe in Leipzig, Johannes Franz Gustav Lamprecht der Titel Professor verliehen worden".* In seinem Personalbogen gibt Lamprecht an, daß er am 16. Mai 1911 Professor wurde (ebenda, Personalbogen, Staatliche Akademie für graphische Künste und Buchgewerbe in Leipzig).

39 Ebenda, Brief an das Wirtschaftsministerium zu Dresden vom 26. Dezember 1923; Brief vom Wirtschaftsministerium an die Akademieverwaltung vom 22. Februar 1924; Brief von der Akademie an Gustav Lamprecht vom 23. Februar 1924.

40 Brief an die Autorin vom Grünflächenamt, Abteilung Friedhöfe, Friedhofskanzlei vom 29. März 2007: Gustav Lamprechts Urne wurde am 8. Mai 1946 in die Grabstätte I. Abteilung 3. Gruppe Reihe B, Grab-Nummer 11 auf dem Neuen Johannisfriedhof beigesetzt. In dieser Grabstätte fanden noch Emma Anna Lamprecht (geb. Knösing; 28. Mai 1867-29. März 1942) und Reinhold Carl Walter Lamprecht (9. Januar 1860-23. Februar 1945) ihre letzte Ruhestätte. Der Neue Johannisfriedhof wurde 1973-75 säkularisiert und in eine öffentliche Parkanlage umgewandelt (heute Friedenspark). Am 24. Februar 1951 wurde die Urne von Professor Gustav Lamprecht umgebettet in die Reihengrabstätte für Urnenbeisetzungen in der I. Abteilung 2. Gruppe Reihe D. Grab-Nummer 11 des städtischen Südfriedhofs. Das Grab existiert nicht mehr. Eine Todesanzeige für Lamprecht wurde nicht gefunden.

41 Die Wolters- und die Kurs-Sammlungen befinden sich heute im Kunstgewerbemuseum der Staatlichen Museen zu Berlin. Simon Machas Sammlung gelangte in das Landesmuseum Beuthen (Bytom, Polen). Ewald Barths Sammlung war viele Jahre als Leihgabe im Märkischen Museum, Berlin (Ost), dann als Leihgabe im Berliner Museum für Verkehr und Technik (heute Deutsches Technikmuseum Berlin), wurde vor kurzem verkauft und gehört heute dem Museum für Stadtgeschichte Dessau. Von diesen großen Sammlungen ist bis jetzt nur die Barth-Sammlung publiziert worden (siehe Aus einem Guß).

42 Cat. Leipzig 1915.

43 Cat. Leipzig 1916: *„Die Ausstellung ‚Kriegergrabmal und Kriegerdenkmal' will zeigen, welche Sorgfalt die deutsche Heeresverwaltung auf die Erhaltung und würdige Gestaltung der Kriegergräber und Kriegerfriedhöfe auf dem Kriegsschauplatz und in den besetzten Gebieten verwendet. Sie will ferner an einer stattlichen Auswahl von Darstellungen verschiedener Art dartun, mit welchem Eifer seit Kriegsbeginn deutsche und österreichische Künstler in der Heimat bemüht sind, der großen und edlen Aufgabe der Kriegerehrung sowohl in ausgeführten Arbeiten als auch in mannigfachen Entwürfen gerecht zu werden."*

44 Ebenda: *„Eine besondere Abteilung bildet die umfassende Sammlung von Eisengußarbeiten (Schmuck, Medaillen und Kunstgewerbe), die Herr Professor Lamprecht in Leipzig in dankenswerter Weise zur Verfügung gestellt hat."*

45 Cat. Berlin 1916, 3: *„Infolge der Beschlagnahme der kupferhaltigen Metalle für den Kriegsbedarf ist die Kunstgießerei in Deutschland auf das Eisen, besonders für die Aufgaben der Gefallenenehrung, für Kriegergräber, Gedenktafeln, Erinnerungsmedaillen und Kleinplastik angewiesen. Um dem Bedürfnis nach lehrreichen Vorbildern des älteren deutschen Eisenkunstgusses entgegenzukommen, hat das Kgl. Kunstgewerbemuseum eine Auswahl von Eisengüssen, besonders der ehemaligen Berliner Kgl. Eisengießerei, im Lichthof zu einer Ausstellung vereinigt."*

46 Mitteilungen des Städtischen Kunstgewerbe-Museums zu Leipzig. Bericht für das Jahr 1917, Nr. 9 (Februar 1918), 108: *„Es ist zu wünschen, daß die wertvolle und vielfach anregende Sammlung dem Museum erhalten bleiben könnte."*

47 Ebenda, 106. – Dieser Katalog sollte in dem Verlag Hiersemann in Leipzig erscheinen.

48 Ebenda, 108: *„An diese Bemerkungen schloß als Gast Herr Professor Lamprecht einen Vortrag über den künstlerischen Eisenguß und erläuterte seine Ausführungen an der Hand von Gegenständen seiner reichen Sammlung, die zur Zeit im KGM aufgestellt ist."*

49 Sammlung Lamprecht Handexemplar, unpubliziertes Manuskript, ohne Datum [vor 1917], Museum für Kunsthandwerk Leipzig.

50 1948, zwei Jahre nach dem Tod Lamprechts, schrieb seine Witwe Lina an die ACIPCO: *„der Verlust seiner Sammlung, die er seit dreißig Jahre erfaßte und für jedes Stück einen guten Preis bezahlte, war für ihn in seinen alten Tagen eine*

American Cast Iron Pipe Company, *"the lost* [sic] *of his collection, which he had been collecting during 30 years, paying a good price for each piece, was a hard grief* [sic] *to him in his old days."* (BMA, Lamprecht Collection Records, letter from Lina Lamprecht to William W. McCulloch, Leipzig, August 19, 1948).

51 "Cast-Iron Art Objects Shown," in *Los Angeles Times*, January 24, 1926, C9.

52 Ottilie Schlapp was born in Germany on September 30, 1834. The couple had a total of ten children.

53 See the *University of Michigan Catalog of Graduates, Non-Graduates, Officers, and Members of the Faculties*, 1837-1921 (Ann Arbor: University of Michigan Press, 1923).

54 Born on May 11, 1899 in St. Louis, Missouri; died on August 11, 1944, in New York.

55 Born on July 25, 1901, in St. Louis, Missouri; died on August 15, 1963, in San Diego, California.

56 Koehler's father Henry was born on May 25, 1828, in Obersalzbach, in the land of Hessen, Germany. In 1843, at age fifteen, he was apprenticed to a brewer in Mainz. By 1846 he was a *Braumeister* in Mainz and Frankfurt. Henry Koehler immigrated to New York in 1849 at age twenty-one, then worked his way west before settling in St. Louis, Missouri, where he worked as foreman at the Lemp Brewery. By 1851, Henry was in Ft. Madison, Iowa, where he leased a brewery from fellow German August Trenschel. In 1863, at the start of the Civil War, Henry returned to St. Louis, where he established the American Brewing Company with his brother Caspar. In 1872, Henry relocated to Davenport, Iowa, and became a partner in the Arsenal Brewing Company, which was absorbed by the Davenport Malting Company in 1894. In 1890, Henry, together with his sons Max, Hugo, and Oscar, reestablished the American Brewing Company in St. Louis, which in 1906 was absorbed into the Independent Brewing Company, a coalition of nine St. Louis area breweries. See Charles F. Limberg. *Life with the Koehler Family on the Mississippi from Davenport to Memphis*, unpublished manuscript dated 1979 in the Missouri Historical Society. See also John Willard. "The Colorful Quad-City Beer Barons," in *Quad-City Times* (Davenport, Iowa), October 9, 1977, D2.

57 He became a member of the Missouri Bar Association on June 15, 1899. I am grateful to Missy Stevens of the Missouri Bar Association for the information.

58 For more information: Bob Hyman. *The Other Cimarron* (members.cox.net/ sn3nut/Cimarron.htm). – Donald B. Robertson. *Encyclopedia of Western Railroad History. The Desert States* (Caldwell, Idaho: Caxton Printers, 1986), 227. – David F. Myrick. *New Mexico's Railroads. A Historical Survey* (Albuquerque: University of New Mexico Press, 1990), 160 f.

59 "Max Koehler Dies" (Obituary), in *The Daily Herald* (Pass Christian, Mississippi), March 23, 1929, 6.

60 It is difficult to tell from the records whether or not his wife and daughter also lived there.

61 "Max Koehler, Once St. Louis Attorney, Dies in Mississippi" (Obituary), in *St. Louis Post-Dispatch,* March 24, 1929, n. pag.

62 Ellis Island Passenger Records, Ellis Island Foundation, Inc. The *America* was built in Italy in 1909 for the La Veloce line. In 1912 it was sold to the Navigazione Generale Italiana line, and was finally scrapped in 1928.

63 Neeta Marquis. "City Gets Unique Display," in *Los Angeles Times*, December 20, 1925, B2.

64 Southwest Museum Archives, letter from Dr. James Sherer, director of the Southwest Museum to Dr. Henry Parker Newman of San Diego, November 10, 1925.

65 Ibid, letter from Charles Haskell to the art editor of *Art World Magazine*, January 7, 1926.

66 "Cast-Iron Art Objects Shown," in *Los Angeles Times*, January 24, 1926, C9.

67 "Iron Art Purchase Sought," in *Los Angeles Times,* March 12, 1926, A6.

68 Estelle Lawton Lindsey. "Campaign for Funds Will be Launched by Mrs. Davis, Museum Official," in *Los Angeles Times*, date unknown [April 1926].

69 Southwest Museum Archives, letter from Barbara Dacier to Dr. James Sherer, May 23, 1926.

70 Thelma Olson. "Iron Casting as an Art," in *Museum Graphic*, The Museum Patrons Association of the Los Angeles Museum, vol. 1, no. 5 (May 1927), 184-89.

71 "Cast Iron Art Display Shown at Park Museum," in *Los Angeles Times*, July 2, 1926.

72 Max Koehler, Jr. had little schooling and at age seventeen enlisted in the British army in Canada without the permission of his parents (see "Relatives of Youth Making Effort to Get Him from Army," in *St. Louis Post-Dispatch*, June 26, 1918). In 1920, he was single and attending college in Lander, Wyoming (U.S. Census, 14th Census of the United States [1920] for Fremont County, Wyoming, sheet 5A, no. 40). During the 1920s, Max, Jr. worked as an actor in Los Angeles, where he lived with his father. In 1930 he was divorced from his wife Reva Kerley, to whom he was married only a short time, and worked as a real estate salesman in Eugene, Oregon (U.S. Census, 15th Census of the United States [1930] for Lane County, Oregon, sheet 3B, no. 52). By late 1942, Max, Jr. had returned to California and was working as a longshoreman in San Francisco. On November 23 of that year he enlisted in the United States army, but served only three months (National Archives and Records Administration, U.S. World War II Army Enlistment

schwere Betrübnis." (BMA, Lamprecht Collection Records, Brief von Lina Lamprecht an William W. McCulloch vom 19. August 1948).

51 "Cast-Iron Art Objects Shown", in *Los Angeles Times*, 24. Januar 1926, C9.

52 Ottilie Schlapp wurde am 30. September 1834 in Deutschland geboren. Das Ehepaar hatte insgesamt zehn Kinder.

53 *University of Michigan Catalog of Graduates, Non-Graduates, Officers, und Members of the Faculties*, 1837-1921 (Ann Arbor 1923).

54 Geboren am 11. Mai 1899 in St. Louis, Missouri; gestorben am 11. August 1944 in New York.

55 Geboren am 25. Juli 1901 in St. Louis, Missouri; gestorben am 15. August 1963 in San Diego, Kalifornien.

56 Koehlers Vater Henry wurde am 25. Mai 1828 in Obersalzbach, Hessen, geboren. 1843, im Alter von 15 Jahren, begann er eine Lehre bei einem Bierbrauer in Mainz. 1846 arbeitete er als Braumeister in Mainz und Frankfurt. Henry Koehler wanderte 1849 nach New York aus und zog weiter nach St. Louis, Missouri. Dort arbeitete er als Braumeister bei der Lemp Brewery. Um 1851 war er in Ft. Madison, Iowa, tätig, wo er eine Brauerei von seinem Landsmann August Trenschel gepachtet hatte. 1863, am Anfang des amerikanischen Bürgerkriegs, ging er zurück nach St. Louis, wo er mit seinem Bruder Caspar die American Brewing Company gründete. 1872 übersiedelte er wieder nach Davenport, Iowa, und wurde Partner in der Arsenal Brewing Company, die 1894 von der Davenport Malting Company übernommen wurde. 1890 hat Henry zusammen mit seinen Söhnen Max, Hugo und Oscar die American Brewing Company in St. Louis neu belebt, die 1906 von den Independent Breweries Companies – einem Bund von neun St. Louis-Brauereien – übernommen wurde. – Charles F. Limberg. *Life with the Koehler Family on the Mississippi from Davenport to Memphis*, unveröffentlichtes Typoskript von 1979 in der Missouri Historical Society. – Vgl. auch John Willard. "The Colorful Quad-City Beer Barons", in *Quad-City Times* (Davenport, Iowa), 9. Oktober 1977, D2.

57 Er wurde Mitglied der Missouri Bar Association am 15. Juni 1899. Ich bedanke mich bei Missy Stevens der Missouri Bar Association für die Information.

58 Für mehr Informationen: Bob Hyman. *The Other Cimarron* (members.cox.net/ sn3nut/Cimarron.htm). – Donald B. Robertson. *Encyclopedia of Western Railroad History. The Desert States* (Caldwell, Idaho 1986), 227. – David F. Myrick. *New Mexico's Railroads. A Historical Survey* (Albuquerque, 1990), 160 f.

59 "Max Koehler Dies" (Nachruf), in *The Daily Herald* (Pass Christian, Mississippi), 23. März 1929, 6.

60 Es ist nicht klar, ob seine Frau und seine Tochter ebenfalls in Los Angeles lebten.

61 "Max Koehler, Once St. Louis Attorney, Dies in Mississippi" (Nachruf), in *St. Louis Post-Dispatch*, 24. März 1929.

62 Ellis Island Passenger Records, Ellis Island Foundation, Inc, New York. Das Schiff „America" wurde 1909 für die La Veloce-Linie in Italien gebaut. 1912 wurde es an die Navigazione Generale Italiana-Linie verkauft und 1928 verschrottet.

63 Neeta Marquis. "City Gets Unique Display", in *Los Angeles Times*, 20. Dezember 1925, B2.

64 Southwest Museum Archives, Brief von Dr. James Sherer, Direktor des Southwest Museums, an Dr. Henry Parker Newman in San Diego vom 10. November 1925.

65 Ebenda, Brief von Charles Haskell an den Kunstredakteur der *Art World Magazine*, vom 7. Januar 1926.

66 "Cast-Iron Art Objects Shown", in *Los Angeles Times*, 24. Januar 1926, C9.

67 „Iron Art Purchase Sought", in *Los Angeles Times*, 12. März 1926, S. A6.

68 Estelle Lawton Lindsey. "Campaign for Funds Will be Launched by Mrs. Davis, Museum Official", in *Los Angeles Times*, ohne Datum [April 1926].

69 Southwest Museum Archives, Brief von Barbara Dacier an Dr. James Sherer vom 23. Mai 1926.

70 Thelma Olson. "Iron Casting as an Art", in *Museum Graphic, The Museum Patrons Association of the Los Angeles Museum*, Bd. 1, Nr. 5 (Mai 1927), 184-89.

71 "Cast Iron Art Display Shown at Park Museum", in *Los Angeles Times*, 2. Juli 1926.

72 Max Koehler junior besuchte nur kurz die Schule. Mit 17 Jahren ließ er sich ohne die Erlaubnis seiner Eltern von der britischen Armee in Kanada anwerben (vgl. "Relatives of Youth Making Effort to Get Him from Army", in *St. Louis Post-Dispatch*, 26. Juni 1918). 1920 war er noch ledig und besuchte das College in Wyoming (U.S. Census, 14th Census of the United States [1920] for Fremont County, Wyoming, Blatt 5A, Nr. 40). Während der zwanziger Jahre arbeitete Max junior als Schauspieler in Los Angeles, wo er mit seinem Vater zusammen wohnte. 1930 wurde er von seiner Frau Reva Kerley geschieden, mit der er nur kurze Zeit verheiratet war, und arbeitete als Immobilienverkäufer in Eugene, Oregon (U.S. Census, 15th Census of the United States [1930] for Lane County, Oregon, Blatt 3B, Nr. 52). Ende 1942 kehrte Max junior nach Kalifornien zurück und arbeitete als Hafenarbeiter in San Francisco. Am 23. November des selben Jahrs meldete er sich freiwillig bei der US-Armee, diente aber nur drei Monate (National Archives and Records Administration, U.S. World War II Army Enlistment Records, 1938-1946). Später lebte er in Ohio, wo er vor 1951 eine Sozialversicherungsnummer bekommen hatte (Social Security Administration, Social Security Death Index, Master File). Max Koehler junior starb am 15. August 1963 in San Diego,

Records, 1938-1946). He later lived in Ohio, where he was issued a Social Security number before 1951 (Social Security Administration, Social Security Death Index, Master File). Max Koehler, Jr. died on August 15, 1963 in San Diego, California (State of California, California Death Index, 1940-1997). He was buried on August 21, of that year in Fort Rosecrans National Cemetery, a veterans' cemetery in San Diego, California (National Cemetery Administration, U.S. Veterans Gravesites, ca. 1775-2006).

73 "Hugo Koehler to Wed Widow of Brother," in *St. Louis Globe-Democrat*, May 12, 1930. – "News of the Middle West," in *Los Angeles Times*, May 14, 1930, 6.

74 Moore served as president from 1924 until 1946.

75 There are no documents pertaining to the purchase of the Lamprecht Collection in the archives of the American Cast Iron Pipe Company. For that reason, it is unknown how much ACIPCO paid for the Lamprecht Collection.

76 BMA, Lamprecht Collection Records, letter from W. R. Kennedy to Gail Trechsel, March 23, 1997: *"during the opening of the objects on their receipt, some of them were inadvertently broken. Dr. MacKenzie [...] was curious as to how such intricate designs could be made with cast iron. The irons we had at the time were not nearly so fluid, when molten, to fill such small cavities. He took the broken pieces and had an analysis made of them and discovered that the irons were of unusually high phosphorus, about 1.5% [...] We made some experimental irons approaching the art objects' composition and indeed they were more fluid."*

77 Bob Slayden. "Rare Collection of Cast Iron Objects Being Arranged for Exhibit in Service Building," in *ACIPCO News*, vol. XXV, no. 2 (February 1940), 1.

78 BMA, Lamprecht Collection Records, *Preliminary Survey of Museum Program for the American Cast Iron Pipe Company of Birmingham, Alabama, prepared by H. E. Wheeler, with assistance of Miss Brown, October 7-12, 1940*, (unpublished typed manuscript).

79 Ibid, 3.

80 ACIPCO Archives, letter from R. R. Deas, Jr. to Bruce L. Simpson, National Engineering Company, March 8, 1945.

81 ACIPCO 1941a. – ACIPCO 1941b.

82 BMA, Lamprecht Collection Records, letter from Lydia E. Rogers to John David Farmer, October 15, 1975. – See also "Acipco's Lamprecht Collection of Cast Iron Art Displayed at Museum," in *ACIPCO News*, vol. 68, no. 9 (October 1983), 10 f. – At the time, the collection was appraised by Sotheby Parke-Bernet for $43,930.00. A copy of the appraisal is in the BMA, Lamprecht Collection Records.

83 Richard F. Howard. "The Lamprecht Collection Cast Iron Objects of Art," in *Bulletin of the Birmingham Art Association* (October 1951), 3.

84 Aline B. Saarinen. "Festival of Arts. Birmingham's Third Annual is Diverse Program of Cultural Activities," in *The New York Times*, February 28, 1954, X10.

85 BMA, Lamprecht Collection Records, letter from Margaret Croswhite, Pizitz Advertising, to Cecil Carlisle, Public Relations Manager, ACIPCO, February 4, 1956.

86 ACIPCO Archives, letter from Peggy Croswhite, Pizitz Advertising, to Mr. Cecil Carlisle, Public Relations Manager, ACIPCO, May 25, 1956.

87 In 1976 the collection was appraised by Sotheby Parke-Bernet for $77,989.00. A copy of the appraisal is in the BMA, Lamprecht Collection Records.

88 BMA, Lamprecht Collection Records, letter from John David Farmer to Kenneth R. Daniel, May 30, 1975. The appraisal was prepared by Sotheby Parke-Bernet, Inc. on February 2, 1976.

89 ACIPCO had considered giving the collection to the Museum in 1969 and in preparation, an appraisal was done by Parke-Bernet Galleries, Inc., New York. The appraisal has not survived. BMA, Lamprecht Collection Records, letter from Richard F. Howard to Jack H. Schaum, October 29, 1969. In August 1986, the collection was appraised by Clive L. Howe & Associates for $54,630.00. A copy of the appraisal is in the BMA, Lamprecht Collection Records.

90 Speaking on behalf of former president William D. Moore, who was instrumental in bringing the collection to Birmingham in 1940, Kenneth Daniel, president of the company from 1963 through 1978, was quoted at the time as saying, *"The collection represents the height of the iron caster's art, and since we were in the casting business, we thought it was something we should have"* (quoted in *Lamprecht Cast Iron Collection from American Cast Iron Pipe Company*, press release from the BMA, November 1986).

91 Objects from the collection were loaned to the National Ornamental Metal Museum in Memphis, Tennessee, in 1986 for an exhibition entitled *Cast Iron: Art and Industry*. From May 1 through August 21, 1992, objects from the Lamprecht Collection were shown at Sloss Furnaces National Historic Landmark in Birmingham, Alabama, in an exhibition entitled *The Lamprecht Collection: Cast Iron in its own Right*. From April 1 through May 31, 1994, objects were loaned to Sloss Furnaces National Historic Landmark for the exhibition *The Lamprecht Collection*. In 1998, the Museum loaned objects to The Tennessee Valley Art Association in Tuscumbia, Alabama, for inclusion in the exhibition *Alabama Collects*, an exhibition of works from collections throughout the state. The exhibition ran from May 29 through June 19, 1998. In March of 1997, the BMA organized a special exhibition of the collection to coincide with the

Kalifornien (State of California, California Death Index, 1940-1997). Am 21. August wurde er auf dem Fort Rosecrans National Cemetary in San Diego, einem Friedhof für Veteranen, bestattet (National Cemetary Administration, U.S. Veterans Gravesites, ca. 1775-2006).

73 "Hugo Koehler to Wed Widow of Brother", in *St. Louis Globe-Democrat*, 12. Mai 1930. – *News of the Middle West*, in *Los Angeles Times*, 14. Mai 1930, 6.

74 Moore war von 1924 bis 1946 Präsident der ACIPCO.

75 Es existieren keine Dokumente über den Ankauf der Sammlung im Archiv der ACIPCO, daher ist unbekannt, wieviel ACIPCO für die Sammlung bezahlte.

76 BMA, Lamprecht Collection Records, Brief von W. R. Kennedy an Gail Trechsel vom 23. März 1997: *"als die Objekte nach deren Erhalt [in Birmingham] ausgepackt wurden, waren einige versehentlich gebrochen. Dr. MacKenzie [...] war neugierig, wie solche aufwendigen Modelle aus Eisenguß gemacht werden konnten. Das Gußeisen, das wir zu der Zeit hatten, war gar nicht so flüssig, wenn es geschmolzen war, um so kleine Höhlungen zu füllen. Er nahm die gebrochenen Teile, ließ sie analysieren und entdeckte, daß das Eisen einen ungewöhnlich hohen Anteil an Phosphor hatte, etwa 1,5% [...] Wir haben einige Versuche durchgeführt, bei denen die Zusammensetzung unseres Eisens dem der Kunstobjekte entsprach, und es zeigte sich, daß unser Eisen jetzt wesentlich flüssiger war als vorher."*

77 Bob Slayden. "Rare Collection of Cast Iron Objects Being Arranged for Exhibit in Service Building", in *ACIPCO News*, Bd. XXV, Nr. 2 (Februar 1940), 1.

78 BMA, Lamprecht Collection Records, *Preliminary Survey of Museum Program for The American Cast Iron Pipe Company of Birmingham, Alabama, prepared by H. E. Wheeler, with assistance of Miss Brown, 7.-12. Oktober 1940* (unveröffentliches Typoskript).

79 Ebenda, 3.

80 ACIPCO Archives, Brief von R. R. Deas, Junior an Bruce L. Simpson, National Engineering Company, vom 8. März 1945.

81 ACIPCO 1941a. – ACIPCO 1941b.

82 BMA, Lamprecht Collection Records, Brief von Lydia E. Rogers an John David Farmer, vom 15. Oktober 1975. – Vgl. auch "Acipco's Lamprecht Collection of Cast Iron Art Displayed at Museum", in *ACIPCO News*, Bd. 68, Nr. 9 (Oktober 1983), 10 f. Zu dieser Zeit wurde der Wert der Sammlung von Sotheby Parke-Bernet auf 43.930 US-Dollar geschätzt. Eine Kopie davon befindet sich im BMA, Lamprecht Collection Records.

83 Richard F. Howard. "The Lamprecht Collection Cast Iron Objects of Art", in *Bulletin of the Birmingham Art Association* (Oktober 1951), 3.

84 Aline B. Saarinen. "Festival of Arts. Birmingham's Third Annual is Diverse Program of Cultural Activities", in *New York Times*, 28. Februar 1954, X10.

85 BMA, Lamprecht Collection Records, Brief von Margaret Croswhite, Pizitz Advertising, an Cecil Carlisle, Public Relations Manager, ACIPCO, vom 4. Februar 1956.

86 ACIPCO Archives, Brief von Peggy Croswhite, Pizitz Advertising, an Cecil Carlisle, Public Relations Manager, ACIPCO, vom 25. Mai 1956.

87 Im Jahr 1976 wurde der Wert der Sammlung von Sotheby Parke-Bernet auf 77.989 US-Dollar geschätzt. Eine Kopie davon wird im BMA, Lamprecht Collection Records, aufbewahrt.

88 BMA, Lamprecht Collection Records, Brief von John David Farmer an Kenneth R. Daniel, vom 30. Mai 1975.

89 ACIPCO hatte sich schon 1969 überlegt, die Sammlung als Geschenk an das Museum zu geben. Dazu wurde eine Schätzung von Parke-Bernet Galleries, Inc., New York durchgeführt, die nicht überliefert ist. – BMA, Lamprecht Collection Records, Brief von Richard F. Howard an Jack H. Schaum vom 29. Oktober 1969. Im August 1986 wurde die Sammlung von Clive L. Howe & Associates, Atlanta, Georgia, auf 54.630 US-Dollar taxiert. Eine Kopie davon befindet sich im BMA.

90 Hier wurde der ehemalige ACIPCO-Präsident William D. Moore, der 1940 an der Erwerbung der Sammlung für Birmingham beteiligt war, von Kenneth Daniel (1963-78 Präsident der Firma) mit folgenden Worten zitiert: *"die Sammlung repräsentiert den Höhepunkt der Kunst des Eisengießens, und da wir im Eisenguß-Geschäft tätig sind, dachten wir, daß wir sie haben sollten"* (zitiert in *Lamprecht Cast Iron Collection from American Cast Iron Pipe Company*, Pressemitteilung des BMA, November 1986).

91 Objekte aus der Sammlung wurden 1986 an das National Ornamental Metal Museum in Memphis, Tennessee, für eine Ausstellung mit dem Titel „Cast Iron: Art and Industry" ausgeliehen. Vom 1. Mai bis 21. August 1992 wurden Objekte der Lamprecht-Sammlung im Sloss Furnaces National Historic Landmark in Birmingham, Alabama, in der Ausstellung „The Lamprecht Collection: Cast Iron in its own Right" gezeigt, und nochmals in der Ausstellung „The Lamprecht Collection" vom 1. April bis 31. Mai 1994. 1998 folgte eine Beteiligung an der Ausstellung „Alabama Collects" (29. Mai bis 19. Juni) der Tennessee Valley Art Association in Tuscumbia, Alabama, mit Werken aus Alabama-Sammlungen.
Im März 1997 organisierte das BMA die Sonderausstellung „Cast in Splendor: German Cast-Iron Decorative Arts", die mit dem City of Birmingham's Forty-seventh Annual Festival of Arts zusammenfiel.

City of Birmingham's forty-seventh Annual Festival of Arts. The exhibition was entitled *Cast in Splendor: German Cast-Iron Decorative Arts.*

92 BMA, Garbáty Collection Records, letter from Maurice Garbáty to Richard Howard, October 14, 1962.

93 Maurice was born Moritz, but changed his name upon becoming a United States citizen in 1944. The family also carried the name Garbáty-Rosenthal during the years they lived in Berlin. – *Jüdisches Adressbuch für Gross-Berlin, Ausgabe 1931* (Berlin: Goedega Verlags-Gesellschaft m.b.H., n. d. [1931]; Reprint Berlin: arani-Verlag, 1994), 113:
> "Garbaty, Eugen L., W 10,
> Tiergartenstraße 29 a
> Garbaty-Rosenthal, Josef, Pankow,
> Berliner Str. 126/127
> Garbaty-Rosenthal, Dr. Moritz,
> Pankow, Berliner Str. 126/127."

94 For general information on the Garbáty family and factory see *Die Cigarettenfabrik von Josef Garbáty-Rosenthal in Berlin-Pankow*, http://www.ansichtskarten-pankow.de/pankowgarbaty.htm. See also Michael Skakun, "Tobacco Road. The Garbáty Legacy," in *Aufbau*, January 23, 2003, http://www.aufbauonline.com/2003/issue02/13.html (February 2003).

95 Email correspondence between the author and Maurice's son Thomas Garbáty, September 26, 2004.

96 Lina Lamprecht wrote with regard to her husband, *"it has ever been his heart's desire, that the collection should come into good hands, to people who are able to worship these pieces of art, and to whom it might bring some happiness. Please, accept my special thanksgivings for the comforting conviction, that the collection, on which my husband bestowed so much pains, money, and time, and in which task I gratefully used to help him, has finally reached a good and safe harbour."* (BMA, Lamprecht Collection Records, letter from Lina Lamprecht to William W. McCulloch, Leipzig, December 6, 1948).

92 BMA, Garbáty Collection records, Brief von Maurice Garbáty an Richard Howard vom 14. Oktober 1962.

93 Maurice wurde als Moritz geboren, änderte aber seinen Namen, als er 1944 Staatsbürger der Vereinigten Staaten wurde. Während die Familie in Berlin lebte, trug sie den Namen Garbáty-Rosenthal. – Im *Jüdischen Adressbuch für Gross-Berlin*, Ausgabe 1931 (Berlin: Goedega Verlags-Gesellschaft m.b.H., o. J.; Reprint Berlin: arani Verlag, 1994), 113, sind verzeichnet:
> "Garbaty, Eugen L., W 10,
> Tiergartenstraße 29 a
> Garbaty-Rosenthal, Josef, Pankow,
> Berliner Str. 126/127
> Garbaty-Rosenthal, Dr. Moritz,
> Pankow, Berliner Str. 126/127".

94 Für mehr Informationen über die Garbáty-Familie und die Zigarettenfabrik siehe *Die Cigarettenfabrik von Josef Garbáty-Rosenthal in Berlin-Pankow* (http://www.ansichtskarten-pankow.de/pankowgarbaty.htm). – Siehe auch Michael Skakun, "Tobacco Road. The Garbáty Legacy", in *Aufbau* 23, Januar 2003 (http://www.aufbauonline.com/2003/issue02/13.html, Februar 2003).

95 E-Mail von Maurice Garbátys Sohn Thomas Garbáty vom 26. September 2004.

96 Lina Lamprecht schrieb dazu: *„es ist immer sein Herzenswunsch gewesen, daß die Sammlung gut aufgehoben ist, bei Leuten, die diese Kunstobjekte verehren können, und dadurch mit Glück beschert sind. Bitte nehmen Sie meine besondere Danksagung für die beruhigende Überzeugung an, daß die Sammlung, an die mein Ehemann so viel Bemühungen, Geld und Zeit schenkte, und in welcher Aufgabe ich ihm dankend geholfen habe, hat endlich einen guten und sicheren Hafen erreicht."* (BMA, Lamprecht Collection Records, Brief von Lina Lamprecht, Leipzig, an William W. McCulloch vom 6. Dezember 1948).

Covered Tureen / Deckelterrine (Cat. 852).

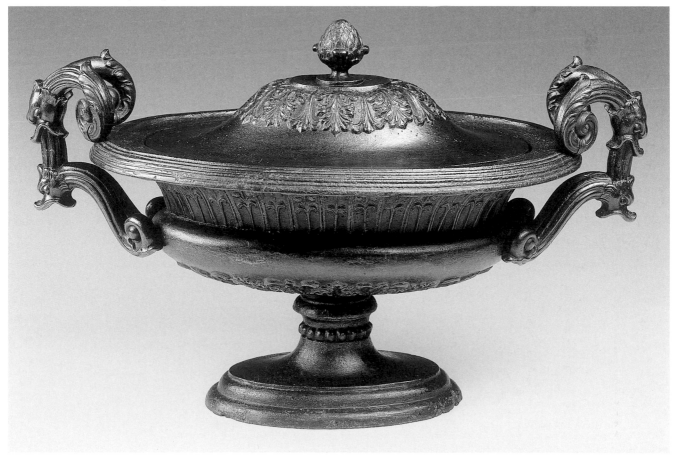

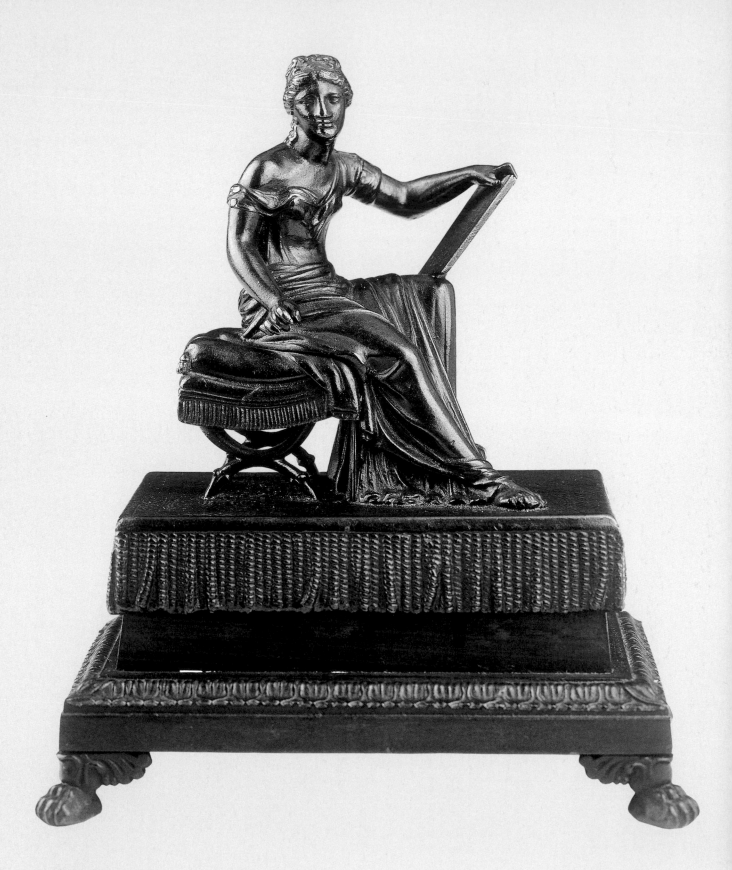

Inkwell / Schreibzeug (Cat. 689).

CATALOGUE / KATALOG

Preliminary Note

The following catalogue presents for the first time the entire European cast-iron collection at the Birmingham Museum of Art. Comprised of more than 900 objects, the collection is one of the finest and most comprehensive of its kind and is the largest collection known outside of Europe.

Most of the objects stem from the three state-sponsored „Royal Prussian Iron Foundries" (KPEG Gleiwitz, Berlin, and Sayn) and from private Berlin ironworks like Siméon Pierre Devaranne, Johann Conrad Geiss (Geiß), Albert Anton Meves (Mewes) or Alfred Richard Seebass (Seebas; later in Hanau and Offenbach). Additionally, many were made in Blansko, Glanz or Horowitz (today Czech Republic), Russia (Kasli) or non-Prussian German lands.

Due to a lack of archival material – and of price lists („Preis-Courants") – as well as an absence of foundry marks on the objects, it is often impossible to assign a cast to any particular foundry. This is further complicated by the fact that models were shared and exchanged (as with the KPEG) or simply copied without permission. The dating of many objects is also difficult. Some models were very popular and were cast and recast over a period of decades and by several different foundries. Information regarding the number of casts made of any particular model is not available.

The individual foundries are listed in the appendix (p. 350-54), however are given in the catalogue only in abbreviated form.

The objects are – unless otherwise stated – made of cast iron with a black-annealed surface. If they were cast in several different sections and then assembled (to preserve the intricacies of the relief), the number of pieces is given (pcs.).

All measurements are given in centimeters (cm) and in inches (in.). In many cases the height precedes width precedes depth, otherwise the following abbreviations apply:

Bh. = bust height
D. = diameter
H. = height
L. = length

The bust height – the height of the actual relief from the top of the head to the lower end of the neck or bust truncation – is given for each portrait medallion. This measurement is important for establishing the authenticity of a cast since any later handling can cause an incidental change to occur in the size of the base plate of the medallion. The shrinkage rate for cast iron is about 1.4 %, which means that later casts are generally 1.4 % smaller than the prototype. The farther a casting is from the original model (e.g. copies or casts after copies), the more it will be reduced in size. Later casts are usually thicker; for this reason the weight in grams (g) has been included. The sharpness of a cast can also help determine its authenticity because this, too, declines with each later cast.

Lamprecht with following number indicates the number that Gustav Lamprecht gave his objects and which is written on the back of each in white paint. **Lamprecht, Photo** with following number gives the page number of the photographic plates, used by Lamprecht to prepare a catalogue of his collection (which was never published), on which an image of the object appears.

The last section of the catalogue indicates objects in the collection that are missing today (Cat. 927-94).

Unless otherwise idicated, all objects are gifts of ACIPCO.

Vorbemerkung

Mit dem nachfolgenden Katalog von Objekten des europäischen Eisenkunstgusses im „Birmingham Museum of Art" wird dessen Bestand an Eisenkunstgüssen erstmalig vollständig vorgestellt. Mit mehr als 900 Stücken gehört diese Sammlung zu den umfangreichsten und feinsten dieser Art und ist vermutlich die größte außerhalb Europas.

Die meisten Objekte entstammen den drei staatlichen „Königlichen Preußischen Eisen-Gießereien" (KPEG; Gleiwitz, Berlin und Sayn) und privaten Berliner Gießereien wie Siméon Pierre Devaranne, Johann Conrad Geiss (Geiß), Albert Anton Meves (Mewes) oder Alfred Richard Seebass (Seebas; später in Hanau und Offenbach). Dazu kommen viele Güsse aus Österreich und Tschechien (ehemals Teil von Österreich; Blansko, Glanz, Horowitz), Rußland (Kasli) oder nichtpreußischen deutschen Ländern.

Aus Mangel an Archivalien – auch an Preislisten („Preis-Courants") – und fehlenden Firmenzeichen ist es oft unmöglich, ein Objekt einer bestimmten Gießerei zuzuordnen, zumal Modelle ausgetauscht (wie bei den KPEG) oder einfach – ohne Erlaubnis – nachgegossen wurden. Auch die Datierung ist bei vielen Objekten schwierig. Manche Modelle waren sehr beliebt und wurden über Jahrzehnte und von verschiedenen Firmen (nach)gegossen. über die Zahl von Güssen nach einem Modell ist zur Zeit keine Aussage möglich.

Die Gießereien sind im Anhang (S. 350-54) zusammengestellt, im Katalog jedoch in der Regel nur verkürzt wiedergegeben.

Die Objekte bestehen – wenn nicht anders angegeben – aus gegossenem Eisen mit schwarz gebrannter Oberfläche. Sind sie in mehreren Teilen gegossen und dann montiert (um Feinheiten des Reliefs zu erreichen), ist die Zahl der Teile genannt (T.).

Alle Maße sind in Zentimetern (cm) und in Inch (in.) angegeben. Bei mehreren Maßangaben steht Höhe vor Breite und Tiefe, bei einzelnen gelten folgende Abkürzungen:

Bh. = Büstenhöhe
D. = Durchmesser
H. = Höhe
L. = Länge

Bei Porträtreliefs ist die Büstenhöhe angegeben: die Höhe des eigentlichen Reliefs von der Kopfoberkante bis zum unteren Ende des Hals- oder Brustabschnitts. Dieses Maß ist für die Beurteilung der Authentizität eines Gusses wichtig, da durch nachträgliche Bearbeitung der Außenkante der Grundplatte eine Veränderung des Außenmaßes entstehen kann. Beim Eisenguß beträgt das Schwundmaß circa 1,4 %, das heißt, daß Nachgüsse 1,4 % kleiner ausfallen als die Vorlage. Je nach Entfernung von der Vorlage (Nachguß beziehungsweise Nachguß nach Nachguß) können die Maße entsprechend weiter abnehmen. Nachgüsse sind auch meistens dickwandiger; deswegen wurden üblicherweise Gewichtsangaben in Gramm (g) hinzugefügt. Auch die Schärfe eines Gusses ist ein Kriterium, die mit dem Nachgießen abnimmt.

Lamprecht mit einer anschließenden Zahl entspricht der Ordnungsnummer, die Gustav Lamprecht seinen Sammlungsstücken gegeben und auf deren Rückseite mit weißer Farbe geschrieben hat, und **Lamprecht, Photo** mit einer anschließenden Zahl der Nummer der Photo-Tafeln, mit denen Lamprecht eine Veröffentlichung (die nicht erfolgte) seiner Sammlung vorbereitet hatte.

Die letzten Nummern des Katalogs nennen die Objekte des Bestands, die heute verschollen sind (Cat. 927-94).

Wenn nicht anders angegeben, sind alle Objekte Geschenke der ACIPCO.

Portrait Medallions and Plaques / Porträtmedaillons und -plaketten (Cat. 1-113)

1 Albert, Prince of Saxony (1828-1902; 1873 King) / Prinz von Sachsen (1873 König)
Head in profile left in decorative cast-iron frame. / Kopf im Profil nach links in verziertem angegossenen Rahmen.
Ca. 1853. – Mod. Ernst Friedrich August Rietschel (?). – F./G. Lauchhammer (?). – Bronzed/Bronziert. – D. 13 cm (5 1/8 in.), Bh. 6.6 cm (2 5/8 in.). – 257.5 g. – Sign. on truncation indistinct, but appears to be / am Brustabschnitt undeutlich, aber sieht aus wie „Rietschel" (?).
Lamprecht 480. – Inv. 1986.474.
Museum records identify the sitter of the portrait as Albert, Prince of Saxony, the artist as Georg Conrad Weitbrecht, and the foundry as Wasseralfingen. However, the dates of the artist and the probable time the portrait was created conflict with the age of the sitter, who was only eight years old when Weitbrecht died. It is more likely that the portrait was made around 1853, the year Albert married Caroline of Sweden. Ernst Rietschel, who was active in Dresden during the period, is most likely the artist, and although the signature is indistinct, it appears to read *Rietschel*. It is interesting to note that the Lamprecht number associated with this piece does not correspond to the same number in the Handexemplar. Cp. also Cat. 105, a portrait obviously by the same hand and cast at the same foundry. /
Museumsakten identifizieren den Dargestellten als Albert, Prinz von Sachsen, den Künstler als Georg Conrad Weitbrecht und die Gießerei als Wasseralfingen. Jedoch stehen die Lebensdaten Weitbrechts und die wahrscheinliche Zeit der Entstehung des Porträts im Widerspruch zum Alter des Prinzen, der nur acht Jahre alt war, als Weitbrecht starb. Es ist wahrscheinlich, daß das Porträt um 1853 geschaffen wurde, in dem Jahr als Albert Caroline von Schweden geheiratet hat. Ernst Rietschel, der während der Zeit in Dresden tätig war, ist der mögliche Künstler, und obwohl die Signatur undeutlich ist, scheint sie wie „Rietschel" auszusehen. Es ist auffällig, daß die Lamprecht-Nummer für dieses Stück nicht mit der entsprechenden Nummer im Handexemplar übereinstimmt. Vgl. auch Cat. 105, ein Porträt von der selben Hand und in der selben Gießerei gegossen.

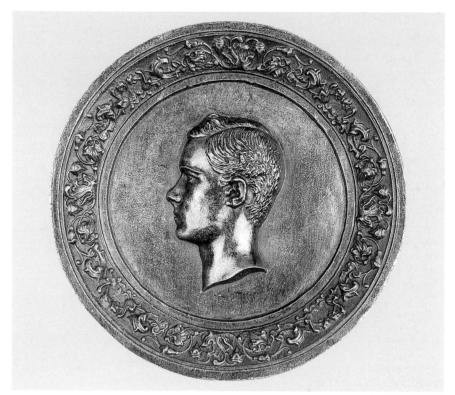

Cat. 1

Cat. 105

2 Alexander I Pavlovich, Emperor of Russia (1777-1825; 1801 Emperor) / Alexander I. Pawlowitsch, Kaiser von Rußland (1801 Kaiser)

Bust three-quarters left in the uniform of the Russian Guard with the sash and star of the Andreas Order. / Brustbild dreiviertel nach links in russischer Garde-Uniform mit Band und Stern des Andreasordens.

Plaster cast under glass in contemporary gilt wood frame / Gips unter Glas im zeitgenössischen vergoldeten Holzrahmen. – 1805. – Mod. Leonhard Posch. – D. 11.8 cm (4 5/8 in.) with frame / mit Rahmen.

Lamprecht 472. – Inv. 1986.467.

Lit.: Cp./vgl. Forschler-Tarrasch, no. 157.

Made during Alexander's and his brother Constantine's visit to Berlin where Alexander toured the royal iron foundry with the Prussian king. / Das Bildnis wurde während eines Berlinbesuchs mit seinem Bruder Konstantin gemacht, während dessen er mit dem preußischen König die Königliche Eisengießerei besuchte.

3 Alexander I Pavlovich, Emperor of Russia / Alexander I. Pawlowitsch, Kaiser von Rußland

Bust right in Russian infantry uniform with sash of the Andreas Order and military medals. / Brustbild im Profil nach rechts in russischer Garde-Uniform mit dem Band des Andreasorden und einem Ordenskreuz. Ins. around / Umschrift „ALEXANDER I: KAISER V: RUSSLAND.".

Ca. 1814-15. – Mod. Leopold Heuberger. – F./G. KPEG Gleiwitz. – D. 5.3 cm (2 1/16 in.), Bh. 4.7 (1 7/8 in.). – 34.1 g. – Sign. below truncation / unterhalb des Brustabschnitts „L: HEUBERGER".

Lamprecht 329. – Inv. 1986.361.

Lit.: Aus einem Guß, 69, no. 127. – Hintze 1928a, 20, pl./Taf. 15 (V 177).

Part of series made on the occasion of the Congress of Vienna. / Teil einer Serie, die anläßlich des Wiener Kongresses geschaffen wurde.

4 Alexander I Pavlovich, Emperor of Russia / Alexander I. Pawlowitsch, Kaiser von Rußland

Bust in profile right in Russian general's uniform with medals. / Brustbild im Profil nach rechts in russischer Generaluniform mit Orden.

1814. – Mod. Leonhard Posch. – F./G. KPEG. – D. 8.5 cm (3 3/8 in.), Bh 6.5 cm (2 9/16 in.). – 72.5 g.

Lamprecht 469. – Inv. 1986.464.

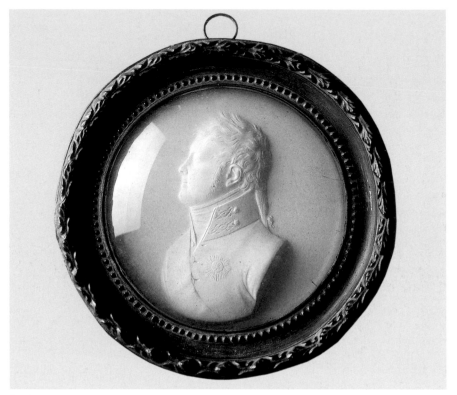

Cat. 2

Lit.: Arenhövel 1982, 72, no. 136. – Forschler-Tarrasch, no. 156. – Hintze 1928a, 21, pl./Taf. 19 (VI 7c). – Stummann-Bowert, 45, no. 7 f. (ill. pl./Abb. Taf. 12). This portrait was made in Paris during the spring of 1814, shortly before Posch returned to Berlin. / Das Porträt wurde in Paris im Frühling 1814 modelliert, kurz bevor Posch nach Berlin zurückkehrte.

Cat. 3

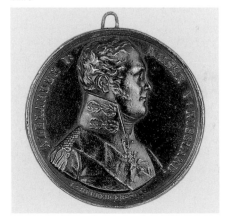

5 Anna Amalia, Duchess of Saxony-Weimar-Eisenach (1739-1807; ruled 1758-75) / Herzogin von Sachsen-Weimar-Eisenach (regierte 1758-75)

Bust in profile left. / Brustbild im Profil nach links.

1805-10. – D. 8.5 cm (3 3/8 in.), Bh. 7.8 cm (3 1/16 in.). – 93.3 g.

Lamprecht 456. – Inv. 1986.453.

Lit.: Aus einem Guß, 231, no. 1818.

Anna Amalia was the aunt of Friedrich Wilhelm, Duke of Brunswick-Oels. / Anna Amalia war die Tante von Friedrich Wilhelm, Herzog von Braunschweig-Oels. / S. Cat. 36.

6 Anton, King of Saxony (1755-1836; 1827-30 King) / König von Sachsen (1755-1836; 1827-30 König)

Head in profile right, in cast-iron frame. / Kopf im Profil nach rechts im angegossenen Rahmen.

1825-30. – Mod. Anton Friedrich König, the Younger/d. J. – F./G. probably/wahrscheinlich Lauchhammer. – D. 12.1 cm (4 3/4 in.), Bh. 8.2 cm (3 1/4 in.). – 282.2 g.

Lamprecht 346. – Inv. 1986.378.1.

Lit.: Lauchhammer Bildguß 1927, 143.

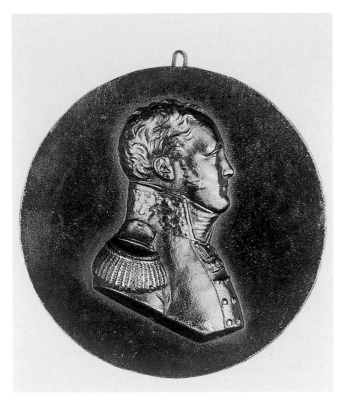

Cat. 4

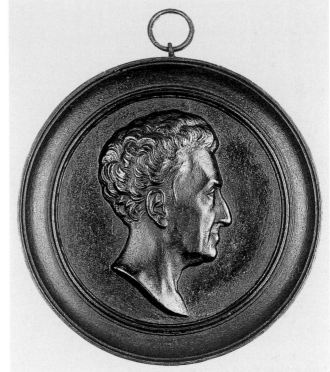

Cat. 6

Cat. 7

Cat. 5

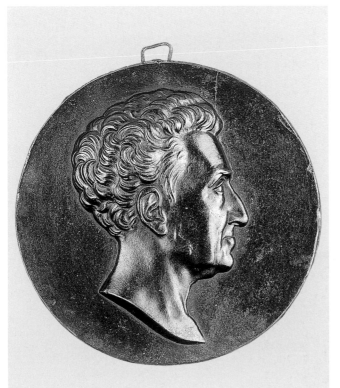

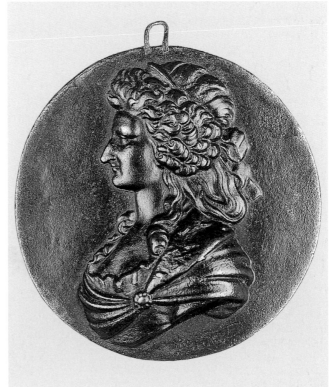

7 Anton, King of Saxony / König von Sachsen

Head in profile right. / Kopf im Profil nach rechts.

1825-30. – Mod. Anton Friedrich König, the Younger/d. J. – F./G. probably/wahrscheinlich Lauchhammer. – D. 9.7 cm (3 13/16 in.), Bh. 8.2 cm (3 1/4 in.). – 93.3 g. – Sign. on truncation illegible / am Brustabschnitt unleserlich.

Lamprecht 347. – Inv. 1986.378.2.

Lit.: Cat. Leipzig 1915, 127, no. 126. – Lauchhammer Bildguß 1927, 143.

8 Ernst Moritz Arndt (1769-1860), German Poet and Historian / deutscher Dichter und Historiker

Bust in profile left beneath bound oak leaves. / Brustbild im Profil nach links unter gebundenen Eichenblättern. / Ins. „*ERNST MORITZ ARNDT gebr. Den 26t. Decbr. 1769 gestr. Den 29t Jannar 1860*".

Ca. 1860. – 13.7 cm x 9.6 cm (5 3/8 x 3 3/4 in.), Bh. 6.9 cm (2 11/16 in.). – 369.0 g. Lamprecht 372. – Inv. 1986.399.

9 Rudolph von Auerswald (1795-1866), Prussian Statesman / preußischer Staatsmann

Bust in profile left in civilian dress with medal, in decorative, cast-iron frame. / Brustbild im Profil nach links in Zivilkleidung mit Orden, in verziertem angegossenen Rahmen.

Second quarter of the 19th century. / 2. Viertel des 19. Jh. – 21.2 x 16.2 cm (8 3/8 x 6 3/8 in.), Bh. 12.6 cm (4 15/16 in.). – 642.6 g. – Sign. on truncation / am Brustabschnitt „*FRIEDRICH F.*".

Lamprecht 358, Photo 45. – Inv. 1986.389.

Lit.: Aus einem Guß, 239, no. 2096. – Cat. Leipzig 1915, 121, no. 80.

10 Otto von Bismarck (1815-98), First Chancellor of the German Empire (governed 1871-90) / erster Kanzler des Deutschen Reiches (1871-90)

Head in profile right, in cast-iron frame with crown above. / Kopf im Profil nach rechts in mit einer Krone geschmücktem Rahmen.

Ca. 1890. – Mod. Adolf von Donndorf attributed/zugeschrieben. – F./G. probably/ wahrscheinlich Lauchhammer. – 56.2 cm x 38.2 cm (22 1/8 x 15 1/16 in.), Bh. 31.5 cm (12 3/8 in.). – Rev./Rs. cast foundry mark (illegible) / Gießereimarke (unleserlich).

Lamprecht 471. – Inv. 1986.466.

Lit.: Lauchhammer Bildguß 1927, 194.

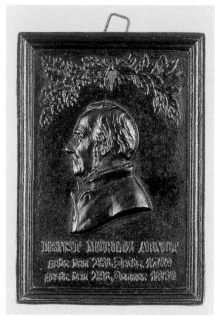

Cat. 8

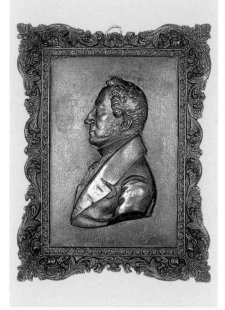

Cat. 9

Cat. 10

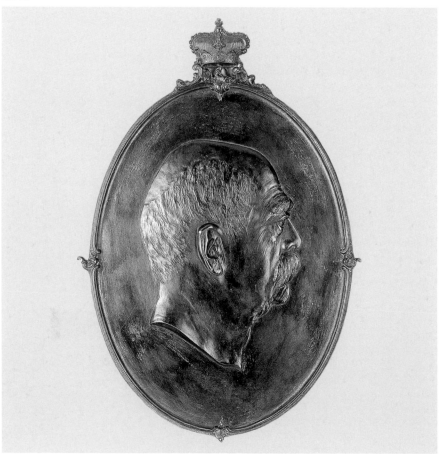

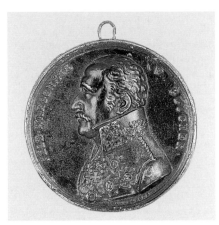

Cat. 11

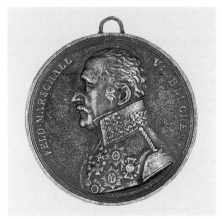

Cat. 12

around/Umschrift „FELD.MARSCHALL V: BLÜCHER".
Ca. 1814. – Mod. Leopold Heuberger. – F./G. KPEG Gleiwitz. – D. 5.4 cm (2 1/8 in.), Bh. 4.5 cm (1 3/4 in.). – 25.0 g. – Sign. below truncation / unterhalb des Brustabschnitts „L. HEUBERGER F.".
Lamprecht 336. – Inv. 1986.368 b.
Lit.: Wurzbach-Tannenberg, no. 828.
Duplicate of Cat. 11. / Dublette von Cat. 11.

13 Gebhard Leberecht Blücher, Prince of Wahlstatt / Fürst von Wahlstatt
Bust in profile left in Prussian general's uniform with military medals including the Iron Cross, the National Order of Merit, and the Order of the Black Eagle. / Brustbild im Profil nach links in preußischer Generalsuniform u. a. mit dem Eisernen Kreuz, dem Orden Pour le mérite und dem Stern des Schwarzen Adlerordens.
1815. – Mod. Leonhard Posch. – F./G. KPEG Berlin. – D. 8.3 cm (3 1/4 in.), Bh. 6.5 cm (2 9/16 in.). – 53.3 g.
Lamprecht 321. – Inv. 1986.354.
Lit.: Arenhövel 1982, 64, no. 111. – Aus einem Guß, 67, no. 112. – Cat. Leipzig 1915, 126, no. 123. – Forschler-Tarrasch, no. 200.

– Hintze 1928a, 26, pl./Taf. 36 (VI 91a). – Schmidt 1981, 86, fig./Abb. 61. – Stummann-Bowert, 48, no. 40.
This portrait was also modeled in jasper around 1815 by the Wedgwood manufactory in England. / Dieses Porträt wurde eben-

11 Gebhard Leberecht Blücher, Prince of Wahlstatt (1742-1819), Prussian Field Marshal / Fürst von Wahlstatt, preußischer Feldmarschall
Bust in profile left in Prussian general's uniform with several medals including the Order of the Black Eagle, the Iron Cross, and the National Order of Merit. / Brustbild im Profil nach links in preußischer Generalsuniform u. a. mit dem Stern des Schwarzen Adlerordens, dem Eisernen Kreuz und dem Orden Pour le mérite. / Ins. around/Umschrift „FELD.MARSCHALL V: BLÜCHER".
Ca. 1814-15. – Mod. Leopold Heuberger. – F./G. KPEG Gleiwitz. – D. 5.3 cm (2 1/16 in.), Bh. 4.5 cm (1 3/4 in.). – 35.1 g. – Sign. below truncation / unterhalb des Brustabschnitts „L. HEUBERGER F.".
Lamprecht 336. – Inv. 1986.368 a.
Lit.: Cat. Leipzig 1915, 127, no. 134. – Wurzbach-Tannenberg, no. 828.
Part of series made on the occasion of the Congress of Vienna. / Teil einer Serie, die anläßlich des Wiener Kongresses geschaffen wurde.

12 Gebhard Leberecht Blücher, Prince of Wahlstatt / Fürst von Wahlstatt
Bust in profile left in Prussian general's uniform with several medals including the Order of the Black Eagle, the Iron Cross, and the National Order of Merit. / Brustbild im Profil nach links in preußischer Generalsuniform u. a. mit dem Stern des Schwarzen Adlerordens, dem Eisernen Kreuz und dem Orden Pour le mérite. / Ins.

Cat. 13

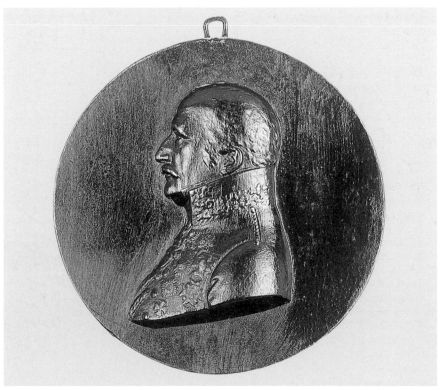

falls 1815 von der Wedgwood Manufaktur in England in Jasper nachgeformt. / S. Reilly and Savage 1973, 65 (ill./Abb.).

14 Gebhard Leberecht Blücher, Prince of Wahlstatt / Fürst von Wahlstatt
Head in profile right. / Kopf im Profil nach rechts.
1815-20. – Mod. after a bust (1816) by / nach einer Büste (1816) von Christian Daniel Rauch. – F./G. KPEG. – 4.3 x 3.3 cm (1 11/16 x 1 5/16 in.), Bh. 3.9 cm (1 9/16 in.). – 10.3 g.
Lamprecht 445M, Photo 59. – Inv. 1986.495.27.
Lit.: Cat. Leipzig 1915, 130, no. 156 (here attributed to Leonhard Posch / hier Leonhard Posch zugeschrieben).

15 Carl Ludwig, Archduke of Austria (1771-1847), Military Leader / Erzherzog von Österreich, Heerführer
Bust in profile right, set in silver mount. / Brustbild im Profil nach rechts in silberner Fassung.
Ca. 1810. – 2.5 x 2 cm (1 x 13/16 in.), Bh. 2.1 cm (13/16 in.). – 3.6 g.
Lamprecht 372M, Photo 51. – Inv. 1986.481.173.
Lit.: Schuette 1916, 283, fig./Abb. 6 (here identified as Josef II [1741-90], Holy Roman Emperor / hier als Josef II., Kaiser des Heiligen Römischen Reichs Deutscher Nation identifiziert).

16 Charlotte, Princess of Prussia (1798-1860) / Prinzessin von Preußen
Bust in profile right in chemise dress with ermine mantle. / Brustbild im Profil nach rechts im Chemisenkleid mit Hermelindraperie.
Ca. 1815. – Mod. Leonhard Posch. – F./G. KPEG. – D. 8.3 cm (3 1/4 in.), Bh. 7.8 cm (3 1/16 in.). – 57.6 g.
Lamprecht 318. – Inv. 1986.362.
Lit.: Cp./vgl. Arenhövel 1982, 71, no. 134. – Aus einem Guß, 69, no. 125. – Cat. Leipzig 1915, 126, no. 116. – Forschler-Tarrasch, no. 101. – Hintze 1928a, 28, pl./Taf. 42 (VI 123). – Schmitz 1917, 54, pl./Taf. 22. Eldest daughter of King Friedrich Wilhelm III and Queen Luise of Prussia, 1817 married Grand Duke Nicholas Pavlovich of Russia, taking the name Alexandra Feodorovna. / Älteste Tochter des Königs Friedrich Wilhelm III. und der Königin Luise von Preußen, verheiratet ab 1817 als Alexandra Feodorowna mit dem Großfürsten Nikolaus Pawlowitsch von Rußland.

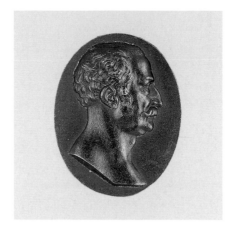

Cat. 14 (Original size / Originalgröße)

Cat. 15 (Original size / Originalgröße)

Cat. 16

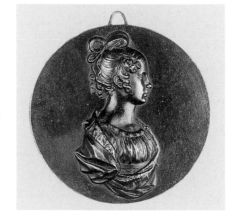

17 Gregorz Jozef Chlopicki (1772-1854), Polish General / polnischer General
Bust three-quarters right in general's uniform with fur mantle. / Brustbild dreiviertel nach rechts in Generalsuniform mit Pelzumhang. / Ins. „JOSEPH CHLOPICKI". First quarter of the 19th century / 1. Viertel des 19. Jh. – 5.7 x 9.3 cm (2 1/4 x 3 11/16 in.), Bh. 3.8 cm (1 1/2 in.). – 80.3 g.
Lamprecht 467. – Inv. 1986.462.
Lit.: Aus einem Guß, 231, no. 1820. – Schmidt 1976, 35.

18 Elisabeth Ludovica, Crown Princess of Prussia (1801-1873) / Kronprinzessin von Preußen
Bust in profile right wearing three-strand pearl necklace with cross pendant, earrings, diadem, and ermine mantle. / Brustbild im Profil nach rechts mit Diadem, Ohrgehänge, dreireihiger Halskette mit Kreuzanhänger und Hermelindraperie.
1824-25. – Mod. Leonhard Posch. – F./G. KPEG. – D. 4.5 cm (1 3/4 in.), Bh. 4.1 cm (1 5/8 in.). – 14.6 g. – Rev./Rs. „R.".
Lamprecht 326. – Inv. 1986.358.2.
Lit.: Cp./vgl. Arenhövel 1982, no. 421. – Aus einem Guß, 69, no. 123. – Forschler-Tarrasch, no. 96. – Hintze 1928a, 32, pl./Taf. 54 (VI 185c). – Salaschek, 1328.
Daughter of King Maximilian I Joseph of Bavaria, 1823 married Crown Prince Friedrich Wilhelm of Prussia. / Tochter des Königs Maximilian I. Joseph von Bayern, verheiratet 1823 mit dem Kronprinzen Friedrich Wilhelm von Preußen.

19 Martin Roche Xavier Estève (1772-1853), French Civil Servant, Treasurer of the French Crown, after 1806 General Administrator of Finances in Prussia / französischer Beamter, Generalschatzmeister der Krone Frankreichs, ab 1806 Generaladministrator der Finanzen in Preußen
Bust in profile left in French civil servant's uniform with the Cross of the Legion of Honor. / Brustbild im Profil nach links in französischer Beamtenuniform mit dem Kreuz der Ehrenlegion.
Ca. 1807. – Mod. Leonhard Posch. – F./G. KPEG. – D. 9 cm (3 9/16 in.), Bh. 6.8 cm (2 11/16 in.). – 87.0 g.
Lamprecht 323. – Inv. 1986.356.
Lit.: Cat. Leipzig 1915, 126, no. 124 (erroneously identified as Prince Schwarzenberg / irrtümlich identifiziert als Fürst Schwarzenberg). – Forschler-Tarrasch, no. 234. – Hintze 1928a, 23, pl./Taf. 25 (VI 36).

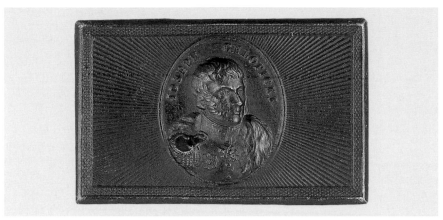
Cat. 17

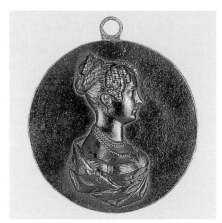
Cat. 18

20 Benjamin Franklin (1706-90), American Statesman, Writer, Scientist, and Printer / amerikanischer Staatsmann, Schriftsteller, Naturwissenschaftler und Druckereibesitzer
Bust in profile left. / Brustbild im Profil nach links.

Cat. 19

1798-1800. – Mod. after the terracotta medal (1777) by / nach der Terracotta-Medaille von Jean-Baptiste Nini based on a drawing by / nach einer Zeichnung von Thomas Walpole. – F./G. KPEG Gleiwitz. – 3.1 x 2.7 cm (1 1/4 x 1 1/16 in.), Bh. 2.2 cm (7/8 in.). – 9.9 g.

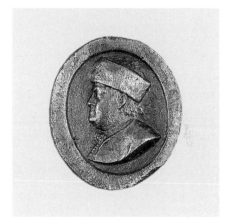
Cat. 20

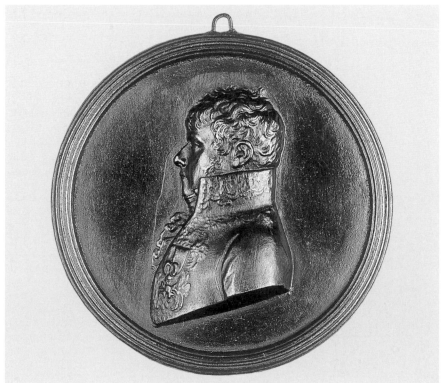

Lamprecht 462M. – Inv. 1986.495.44.
Cast after a Wedgwood jasper medallion. / Gegossen nach einem Wedgwoodmedaillon aus Jasperware.
Lit.: Tattersall, 86 (e). – Reilly and Savage, 147 (f).

21 Franz I, Emperor of Austria (1768-1835; 1804 Emperor; 1792-1806 as Franz II, Holy Roman Emperor) / Franz I., Kaiser von Österreich (1804 Kaiser; 1792-1806 als Franz II. Kaiser des Heiligen Römischen Reiches Deutscher Nation)
Bust in profile right in Austrian general's uniform with sash and ermine mantle. /

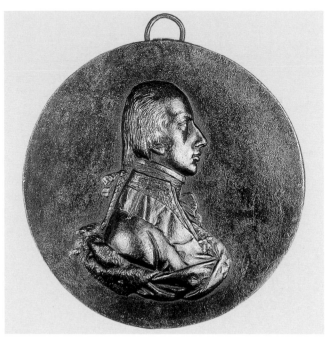

Cat. 21

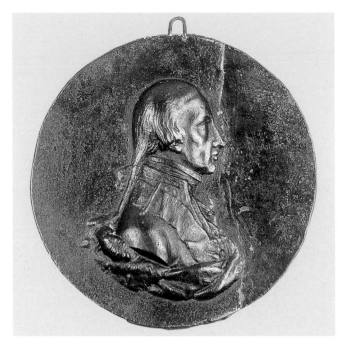

Cat. 22

Brustbild im Profil nach rechts in österrei-
chischer Generalsuniform mit Ordensband
und Hermelindraperie.
Ca. 1800. – D. 10.5 cm (4 1/8 in.), Bh. 8.1
cm (3 3/16 in.). – 168.7 g. – Rev./Rs „I".
Lamprecht 314. – Inv. 1986.350.1.
Lit.: Cat. Leipzig 1915, 124, no. 105 (erro-
neously attributed to Leonhard Posch / irr-
tümlich Leonhard Posch zugeschrieben).

**22 Franz I, Emperor of Austria / Franz I.,
Kaiser von Österreich**
Bust in profile right in Austrian general's
uniform with sash and ermine mantle. /
Brustbild im Profil nach rechts in österrei-
chischer Generalsuniform mit Ordensband
und Hermelindraperie.
Ca. 1800. – D. 10.7 cm (4 3/16 in.), Bh. 8.0
cm (3 1/8 in.). – 150.5 g (repaired/gekittet).
Lamprecht 315. – Inv. 1986.350.2.

**23 Franz I, Emperor of Austria /
Franz I., Kaiser von Österreich**
Bust in profile right in Austrian general's
uniform with the Order of the Golden
Fleece, other medals, and ermine mantle. /
Brustbild im Profil nach rechts in österrei-
chischer Generalsuniform mit u. a. dem Or-
den vom Goldenen Vlies, unten Hermelin-

draperie. / Ins. around/Umschrift „FRANZ I.
KAISER VON OESTERREICH".
Ca. 1814. – Mod. Leopold Heuberger. –
F./G. KPEG Gleiwitz. – D. 5.4 cm (2 1/8 in.),
Bh. 4.7 cm (1 7/8 in.). – 39.2 g. – Sign. be-
low truncation / unterhalb des Brustab-
schnitts „HEUBERGER".
Lamprecht 327. – Inv. 1986.359.

Cat. 23

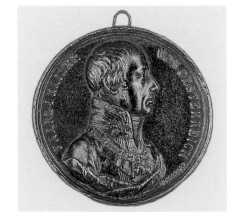

Lit.: Cat. Leipzig 1915, 127, no. 131. –
Wurzbach-Tannenberg, no. 2371.
Part of series made on the occasion of the
Congress of Vienna. / Teil einer Serie, die
anläßlich des Wiener Kongresses geschaf-
fen wurde.

**24 Friederike, Princess of Prussia (1796-
1850) / Prinzessin von Preußen**
Bust in profile right in chemise dress with
ermine mantle. / Brustbild im Profil nach
rechts im Chemisenkleid mit Hermelindra-
perie.
1815. – Mod. Leonhard Posch. – F./G.
KPEG. – D. 8.9 cm (3 1/2 in.), Bh. 7.1 cm
(2 13/16 in.). – 88.1 g.
Lamprecht 319. – Inv. 1986.352.
Lit.: Arenhövel 1982, 70, no. 128. – Cat.
Leipzig 1915, 126, no. 117. – Forschler-
Tarrasch, no. 141. – cp./vgl. Hintze 1928a,
28, pl./Taf. 43 (VI 124). – Schmidt 1976,
fig./Abb. 30.
Daughter of Prince Ludwig and Princess
Friederike of Prussia, 1818 married Duke
Leopold Friedrich of Anhalt-Dessau. / Toch-
ter des Prinzen Ludwig und der Prinzessin
Friederike von Preußen, ab 1818 mit Her-
zog Leopold Friedrich von Anhalt-Dessau
verheiratet.

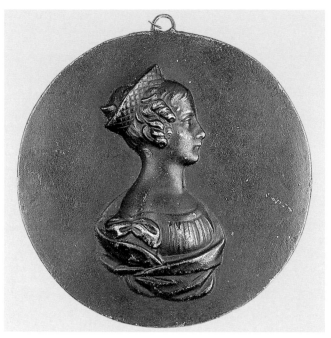

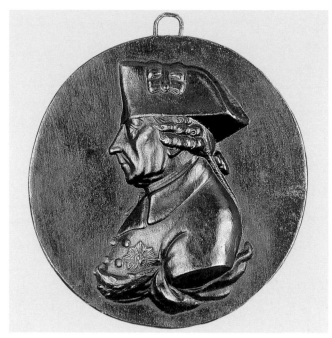

Cat. 24

Cat. 27

25 Friedrich II, King of Prussia (1712-86; 1740 King) / Friedrich II., König von Preußen (1740 König)
Bust in profile left. / Brustbild im Profil nach links.
Ca. 1800. – F./G. probably/wahrscheinlich KPEG Gleiwitz. – 2.5 x 2 cm (1 x 13/16 in.), Bh. 1.4 cm (9/16 in.). – 2.7 g.

Lamprecht 383M, Photo 51. – Inv. 1986.481.184.

26 Friedrich II, King of Prussia / Friedrich II., König von Preußen
Bust in profile right. / Brustbild im Profil nach rechts.
Ca. 1800. – F./G. KPEG Gleiwitz. – 2.2 x 1.9 cm (7/8 x 3/4 in.), Bh. 1.8 cm (11/16 in.). – 2.3 g.
Lamprecht 397M, Photo 51. – Inv. 1986.481.198.
Lit.: Schuette 1916, 283, fig./Abb. 12.

27 Friedrich II, King of Prussia / Friedrich II., König von Preußen
Bust in profile left in uniform with the Order of the Black Eagle, with ermine mantle. / Brustbild im Profil nach links in Uniform mit dem Stern des Schwarzen Adlerordens, unten Hermelindraperie.
First half of the 19th century / 1. Hälfte des 19. Jh. – D. 9.5 cm (3 3/4 in.), Bh. 8.0 cm (3 1/8 in.) 103.4 g. – Rev./Rs. „Friedrich II.".
Lamprecht 356. – Inv. 1986.387.
Lit.: Cat. Leipzig 1915, 126, no. 118 (erroneously attributed to Leonhard Posch / irrtümlich Leonhard Posch zugeschrieben).

28 Friedrich II, King of Prussia / Friedrich II., König von Preußen
Bust in profile left, head turned front, in uniform with sash and medals, and drapery. / Brustbild im Profil nach links, der Kopf leicht nach vorn gewendet, in Uniform mit Ordensband und Orden, unten Draperie.
First half of the 19th century / 1. Hälfte des 19. Jh. – Mod. Christian Daniel Rauch at-

Cat. 25

Cat. 26 (Original size / Originalgröße)

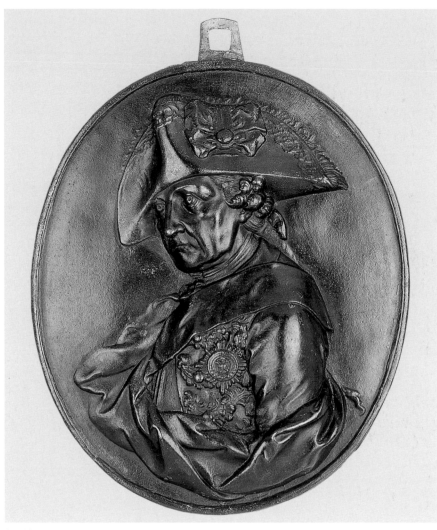

Cat. 28

tributed/zugeschrieben. – F./G. KPEG. –
15.3 x 12.9 cm (6 x 5 1/16 in.), Bh. 13.6 cm
(5 3/8 in.). – 383.8 g.
Lamprecht 357, Photo 37. – Inv. 1986.388.
Lit.: Cat. Leipzig 1915, 121, no. 82.

**29 Friedrich II, Duke of Anhalt (1856-
1918; 1904 Duke), German General and
Composer / Friedrich II., Herzog von An-
halt (1904 Herzog), deutscher General
und Komponist**
Bust three-quarters left in uniform with
medals. / Brustbild dreiviertel nach links in
Uniform mit Orden.
Ca. 1910. – F./G. probably/wahrscheinlich

Mägdesprung. – 23.3 x 19.3 cm (9 3/16 x
7 5/8 in.), Bh. 19.4 cm (7 5/8 in.). – 771.7 g.
Lamprecht 481. – Inv. 1986.475 a.
Pendant to the portrait of Friedrich II's wife,
Marie von Baden. / Gegenstück zum Porträt
der Ehefrau Friedrichs II., Marie von Ba-
den. / S. Cat. 66.

**30 Friedrich VI, King of Denmark and
Norway (1768-1839; 1808 King) / Fried-
rich VI., König von Dänemark und Nor-
wegen (1808 König)**
Bust in profile left in uniform with medals. /
Brustbild im Profil nach links in Uniform
mit Orden. / Ins. around/Umschrift „*FRE-*

DERICVS VI. KÖN: V: DAENNEMARK“.
Ca. 1814. – Mod. Leopold Heuberger. –
F./G. KPEG Gleiwitz. – D. 5.4 cm (2 1/8 in.),
Bh. 4.8 cm (1 7/8 in.). – 30.5 g. – Sign.
below truncation / unterhalb des Brustab-
schnitts „*[HE]UBERGER“*.
Lamprecht 334. – Inv. 1986.366.
Part of series made on the occasion of the
Congress of Vienna. / Teil einer Serie, die
anläßlich des Wiener Kongresses geschaf-
fen wurde.

**31 Friedrich August I, King of Saxony
(1750-1827; 1806 King) / Friedrich Au-
gust I., König von Sachsen (1806 König)**
Bust in profile right in uniform. / Brustbild
im Profil nach rechts in Uniform.
Ca. 1810. – F./G. probably/wahrscheinlich
Lauchhammer. – 2.1 x 1.6 cm (13/16 x 5/8
in.), Bh. 1.9 cm (3/4 in.). – 1.8 g.
Lamprecht 452M. – Inv. 1986.495.34.

**32 Friedrich August I, King of Saxony /
Friedrich August I., König von Sachsen**
Bust in profile right in uniform with sash,
in large cast iron frame. / Brustbild im Pro-
fil nach rechts in Uniform mit Ordensband
im angegossenen Rahmen.
Ca. 1810. – F./G. probably/wahrscheinlich
Lauchhammer. – D. 12 cm (4 3/4 in.) with
frame / mit Rahmen, Bh. 7.6 cm (3 in.). –
272.8 g. – Traces of gilding on the frame. /
Reste von Rahmenvergoldung.
Lamprecht 309. – Inv. 1986.347.1.
Lit.: Aus einem Guß, no. 1824. – Köcke,
119, fig./Abb. 13 (erroneously identified as
Prince Heinrich of Prussia after a model by
Leonhard Posch / irrtümlich als Heinrich,
Prinz von Preußen, nach einem Modell von
Leonhard Posch identifiziert). – Lauchham-
mer Bildguss 1933, 178.

**33 Friedrich August I, King of Saxony /
Friedrich August I., König von Sachsen**
Bust in profile right in uniform with sash. /
Brustbild im Profil nach rechts in Uniform
mit Ordensband.
Ca. 1810. – F./G. probably/wahrscheinlich
Lauchhammer. – D. 8.6 cm (3 3/8 in.),
Bh. 7.7 cm (3 1/16 in.). – 79.3 g.
Lamprecht 310. – Inv. 1986.347.2.
Lit.: Aus einem Guß, no. 1824. – Cat. Leip-
zig 1915, 126, no. 125. – Köcke, 119, fig./
Abb. 13 (erroneously identified as Prince
Heinrich of Prussia after a model by Leon-
hard Posch / irrtümlich als Heinrich, Prinz
von Preußen, nach einem Modell von Le-
onhard Posch identifiziert). – Lauchham-
mer Bildguss 1933, 178.

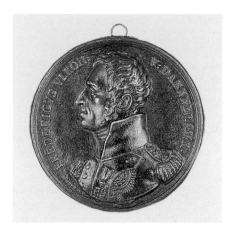

Cat. 30

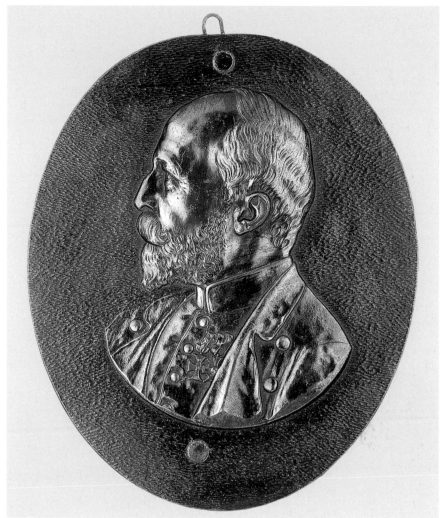

Cat. 31

Cat. 29

Cat. 32

Cat. 33

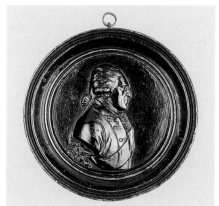

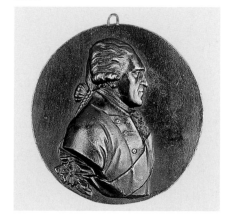

34 Friedrich August I, King of Saxony / Friedrich August I., König von Sachsen
Bust in profile right in uniform with sash, in cast iron frame. / Brustbild im Profil nach rechts in Uniform mit Ordensband im angegossenen Rahmen.
Ca. 1810. – F./G. probably/wahrscheinlich Lauchhammer. – D. 8.4 cm (3 5/16 in.), Bh. 4.0 cm (1 9/16 in.). – 170.5 g.
Lamprecht 311. – Inv. 1986.347.3.
Lit.: Aus einem Guß, no. 1824. – Köcke, 119, fig./Abb. 13 (erroneously identified as Prince Heinrich of Prussia after a model by Leonhard Posch / irrtümlich als Heinrich, Prinz von Preußen, nach einem Modell von

Leonhard Posch identifiziert). – Lauchham-
mer Bildguss 1933, 178.

35 Friedrich August II, King of Saxony (1797-1854; [1830] 1836 King) / Friedrich August II., König von Sachsen ([1830] 1836 König)

Bust in profile left in general's uniform
with epaulet, medals, and ermine mantle. /
Brustbild im Profil nach links in Generals-
uniform mit Epauletten, Orden und Herme-
lindraperie.
1830-40. – F./G. probably/wahrscheinlich
Lauchhammer. – D. 12 cm (4 3/4 in.), Bh.
8.8 cm (3 7/16 in.). – 249.0 g.
Lamprecht 348. – Inv. 1986.379.
Lit.: Aus einem Guß, no. 1941. – Bekker
2001, 90, no. 630.

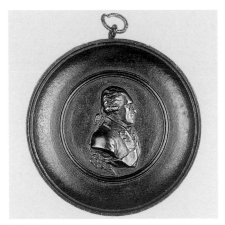

Cat. 34

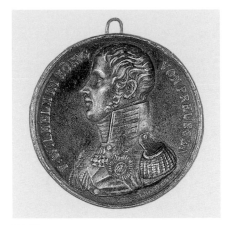

Cat. 38

36 Friedrich Wilhelm, Duke of Brunswick-Oels (1771-1815) / Herzog von Braunschweig-Oels

Bust in profile left in uniform with the Or-
der of the Black Eagle. / Brustbild im Pro-
fil nach links in Uniform mit dem Stern des
Schwarzen Adlerordens. / Ins. around/Um-
schrift „FRIEDRICH WILHELM".
Ca. 1815. – F./G. probably/wahrscheinlich
KPEG Gleiwitz. – D. 5.2 cm (2 1/16 in.),
Bh. 3.9 cm (1 9/16 in.). – 37.3 g.
Lamprecht 332. – Inv. 1986.364.
Lit.: Brockmann, 361, no. 550b.
This medal was cast to commemorate the
death of Friedrich Wilhelm, who was suc-
cessor to the principality of Brunswick-
Wolfenbüttel-Bevern. In 1806 France an-
nexed this area according to the Treaty of
Tilsit, and Friedrich Wilhelm retired to the
principality of Oels in Silesia. He later em-
barked with 2,000 soldiers to join the Bri-
tish army of Wellington in England. Fried-
rich Wilhelm died in 1815 in the Battle of
Quatre Bas near Waterloo. He was married
to Princess Marie of Baden (1782-1808). /
Diese Medaille wurde auf den Tod von
Friedrich Wilhelm gegossen, dem Thron-
folger des Fürstentums von Braunschweig-
Wolfenbüttel-Beyern, dessen Gebiet nach
dem Vertrag von Tilsit 1806 von Napoleon
dem Königreich Westfalen zugeschlagen
wurde. Friedrich Wilhelm zog sich darauf-
hin in das Fürstentum Oels in Schlesien zu-
rück. Später kämpfte er mit 2.000 Soldaten
an der Seite Wellingtons gegen Napoleon.
Er starb 1815 im Kampf bei Quatre-Bras
bei Belle-Alliance (Waterloo). Friedrich Wil-
helm war mit der Prinzessin Marie von Ba-
den (1782-1808) verheiratet.

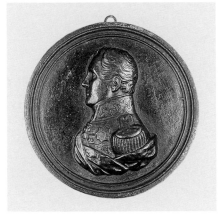

Cat. 35

Cat. 36

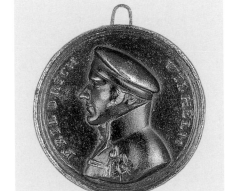

37 Friedrich Wilhelm I, Elector of Brandenburg (1620-88; 1642 Elector) / Friedrich Wilhelm I., Kurfürst von Brandenburg (1642 Kurfürst)

Bust front. / Brustbild von vorn.
First quarter of the 19th century / 1. Viertel
des 19. Jh. – D. 14.9 cm (5 7/8 in.), Bh.
11.6 cm (4 9/16 in.). – 474.1 g.
Lamprecht 458, Photo 39. – Inv. 1986.455.

38 Friedrich Wilhelm III, King of Prussia (1770-1840; 1797 King) / Friedrich Wilhelm III., König von Preußen (1797 König)

Bust in profile left in Prussian general's
uniform with the sash and Order of the
Black Eagle, the Iron Cross, and the War
Memorial Medal 1813-15. / Brustbild im
Profil nach links in preußischer Generals-
uniform mit Band und Stern des Schwarzen
Adlerordens, dem Eisernen Kreuz und der
Kriegsdenkmünze 1813-15. / Ins. around/
Umschrift „F: WILHELM III KÖNIG VON
PREUSSEN".
Ca. 1814-15. – Mod. Leopold Heuberger. –
F./G. KPEG Gleiwitz. – D. 5.3 cm (2 1/16
in.), Bh. 4.6 cm (1 13/16 in.). – 30.4 g. –
Sign. below truncation / unterhalb des Brust-
abschnitts „L. HEUBERGER F.".
Lamprecht 330. – Inv. 1986.351.3.
Lit.: Domanig 1907, 437, pl./Taf. 49. –
Wurzbach-Tannenberg, no. 2952 f.
Leopold Heuberger was an engraver at the
Viennese mint after 1801. On the occasion
of the Congress of Vienna, beginning in
September 1814, he created a series of por-
trait medallions of participants, all in simi-

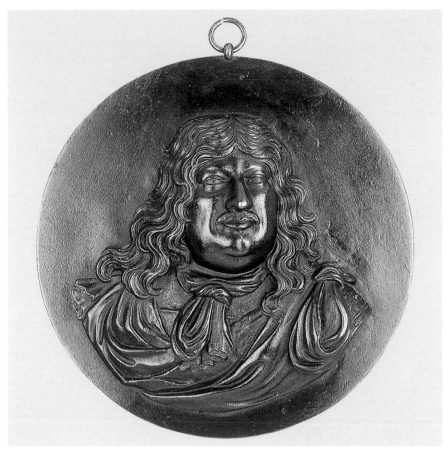

Cat. 37

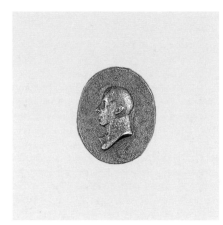

Cat. 39

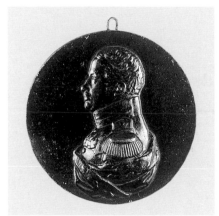

Cat. 40

Cat. 41

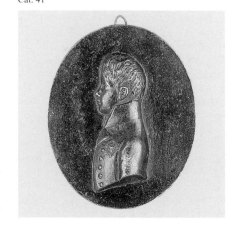

lar format. / Nach 1801 war Leopold Heuberger Graveur an der Wiener Münze. Anläßlich des Wiener Kongresses, ab September 1814, schuf er eine Reihe im gleichen Format modellierter Porträtmedaillons aller Teilnehmer. (Schmidt 1981, 136).

39 Friedrich Wilhelm III, King of Prussia / Friedrich Wilhelm III., König von Preußen
Bust in profile left in Prussian general's uniform. / Brustbild im Profil nach links in preußischer Generaluniform.
Ca. 1825. – F./G. KPEG. – 2.1 x 1.7 cm (13/16 x 11/16 in.), Bh. 1.4 cm (9/16 in.). – 4.7 g.
Lamprecht 453M, Photo 51. – Inv. 1986.495.35.
Lit.: Cat. Leipzig 1915, 131, no. 169.

40 Friedrich Wilhelm III, King of Prussia / Friedrich Wilhelm III., König von Preußen
Bust in profile left in the uniform of the Prussian First Infantry Regiment with the Order of the Black Eagle, the Iron Cross, and a third military medal, with ermine mantle. / Brustbild im Profil nach links in der Uniform des 1. Garderegiments zu Fuß mit dem Stern des Schwarzen Adlerordens, dem Eisernen Kreuz, und einem zweiten Ordenskreuz, unten Hermelindraperie.
Ca. 1825. – Mod. Leonhard Posch. – F./G. KPEG. – D. 9 cm (3 5/8 in.), Bh. 7.8 cm (3 1/16 in.). – 98.6 g. – Rev./Rs. „Friedrich Wilhelm III Koenig von Preußen" and/und „N VI 1".
Lamprecht 316. – Inv. 1986.351.1.
Lit.: Andrews 1983, 422, fig./Abb. 1. – Arenhövel 1982, 67 f., no. 122. – Cat. Leipzig 1915, 126, no. 119. – Forschler-Tarrasch, no. 73. – Hintze 1928a, 20, pl./

Taf. 17 (VI 1 f.). – Stummann-Bowert, 45, no. 13.
An older copy of the Gleiwitz model. / Ein älterer Nachguß nach Gleiwitzer Modell.

41 Friedrich Wilhelm, Crown Prince of Prussia (1795-1861; 1840 as Friedrich Wilhelm IV King) / Kronprinz von Preußen (1840 als Friedrich Wilhelm IV. König)
(Fig. p./Abb. S. 71)
Bust in profile left in uniform with the Order of the Black Eagle. / Brustbild im Profil nach links in Uniform mit dem Stern des Schwarzen Adlerordens.
Ca. 1806. – Mod. probably based on a model by / wahrscheinlich nach einem Modell von Leonhard Posch. – F./G. KPEG. – 7.3 x 5.8 cm (2 7/8 x 2 5/16 in.), Bh. 5.6 cm (2 3/16 in.). – 25.8 g.
Lamprecht 455. – Inv. 1986.452.
Lit.: Cp./vgl. Forschler-Tarrasch, no. 87.

42 Friedrich Wilhelm, Crown Prince of Prussia / Kronprinz von Preußen
Bust in profile left in the uniform of the Prussian First Infantry Regiment with the Order of the Black Eagle, the Iron Cross, the War Memorial Medal 1813-15, and the Russian St. George's Cross. / Brustbild im Profil nach links in der Uniform des 1. Garderegiments zu Fuß mit dem Stern des Schwarzen Adlerordens, dem Eisernen Kreuz, der Kriegsdenkmünze 1813-15 und dem russischen Georgskreuz.
1815. – Mod. Leonhard Posch. – F./G. KPEG. – D. 8.5 cm (3 3/8 in.), Bh. 7.1 cm (2 13/16 in.). – 51.5 g. – Rev./Rs. „N: VI. 116.".
Lamprecht 320. – Inv. 1986.353.
Lit.: Arenhövel 1982, 70 f., no. 133. – Forschler-Tarrasch, no. 88. – Hintze 1928a, 28, pl./Taf. 41 (VI 116a). – Schmitz 1917, pl./Taf. 23.

43 Friedrich Wilhelm, Crown Prince of Prussia / Kronprinz von Preußen
Bust in profile left in Prussian general's uniform with the sash and Order of the Black Eagle, the Iron Cross, the War Memorial Medal 1813-15, and the Russian St. George's Cross, with ermine mantle. / Brustbild im Profil nach links in preußischer Generaluniform mit dem Band und Stern des Schwarzen Adlerordens, dem Eisernen Kreuz, der Kriegsdenkmünze 1813-15 und dem russischen St. Georgenorden, unten Hermelindraperie.

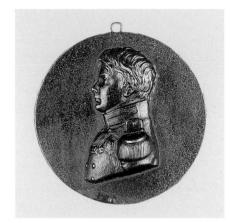

Cat. 42

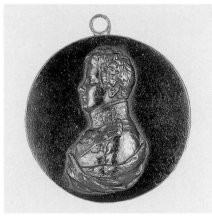

Cat. 43

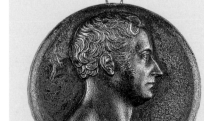

Cat. 44

Ca. 1825. – Mod. Leonhard Posch. – F./G. KPEG. – D. 4.7 cm (1 7/8 in.), Bh. 4.2 cm (1 5/8 in.). – 16.9 g.
Lamprecht 325. – Inv. 1986.351.2.
Lit.: Arenhövel 1982, 70, no. 132. – Forschler-Tarrasch, no. 89. – Cp./vgl. Hintze 1982a, 28, pl./Taf. 41 (VI 116b). – Stummann-Bowert 1984, 46, no. 15.

44 Friedrich Wilhelm, Crown Prince of Prussia / Kronprinz von Preußen
Head in profile right. / Kopf im Profil nach rechts.
Ca. 1840. – Mod. Christian Daniel Rauch attributed/zugeschrieben. – F./G. KPEG. – D. 7.6 cm (3 in.), Bh. 6.7 cm (2 5/8 in.). – 78.5 g.
Lamprecht 350, Photo 48. – Inv. 1986.381.
Lit.: Cat. Leipzig 1915, 124, no. 103.

45 Friedrich Wilhelm Carl, Prince of Prussia, called "Wilhelm the Elder" (1783-1851) / Prinz von Preußen, genannt „Wilhelm der Ältere"
Bust in profile right in uniform with the sash and Order of the Black Eagle. / Brustbild im Profil nach rechts in Uniform mit Band und Stern des Schwarzen Adlerordens.
1805-10. – F./G. KPEG. – 22.5 x 17.8 cm (8 7/8 x 7 in.), Bh. 17.0 cm (6 11/16 in.). – 1341.3 g.
Lamprecht 343, Photo 42. – Inv. 1986.375.
Lit.: Cat. Leipzig 1915, 114, no. 1. – Lauchhammer Bildguß 1933, 179 (erroneously identified as Friedrich August I of Saxony / irrtümlich als Friedrich August I. von Sachsen identifiziert).
Youngest brother of King Friedrich Wilhelm III. of Prussia. / Jüngster Bruder des Königs Friedrich Wilhelm III. von Preußen.

46 Pierre Gassend(i) (1592-1655), French Philosopher and Scientist / französischer Philosoph und Naturwissenschaftler
Bust in profile right. / Brustbild im Profil nach rechts. – Ins. „GASSENDI".
1798-1800. – Mod. after a medal (1648) by / nach einer Medaille (1648) von Jean Warin II. – F./G. KPEG Gleiwitz. – 9.5 x 7.6 cm (3 3/4 x 3 in.), Bh. 7.5 cm (2 15/16 in.). – 184.2 g.
Lamprecht 911. – Inv. 1986.493.
Cast after a Wedgwood jasper medallion, catalogued by Josiah Wedgwood in 1779 / nach einem Wedgwoodmedaillon aus Jasperware, von Josiah Wedgwood 1779 verzeichnet (S. Reilly and Savage, 160).

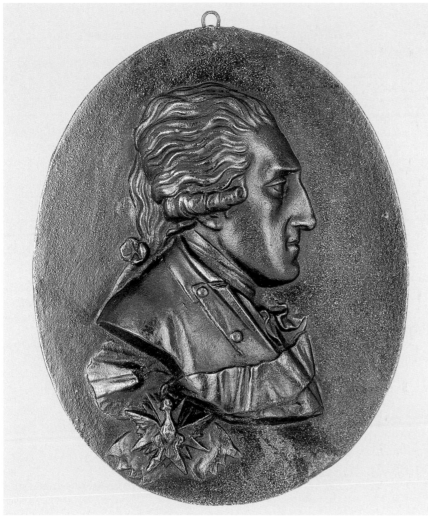

Cat. 45

47 George, Prince of Wales (1762-1830; 1820 as George IV King of Great Britain and Ireland) / Prinz von Wales (1820 als Georg IV. König von Großbritannien und Irland)

Head in profile right. / Kopf im Profil nach rechts.

Ca. 1809. – Mod. after a model by / nach einem Modell von Peter Rouw. – F./G. probably/wahrscheinlich KPEG. – 3.5 x 2.8 cm (1 3/8 x 1 1/8 in.), Bh. 3.3 cm (1 5/16 in.). – 12.3 g.

Lamprecht 448M, Photo 59. – Inv. 1986.495.30.

Lit.: Köcke, no. 11 (erroneously identified as Friedrich Phillip Rosenstiel after a model by Leonhard Posch / irrtümlich identifiziert als Friedrich Phillip Rosenstiel nach einem Model von Leonhard Posch). – Schuette 1916, 283, fig./Abb. 5 (erroneously identified as Friedrich Wilhelm IV, King of Prussia / irrtümlich identifiziert als Friedrich Wilhelm IV., König von Preußen). – cp./vgl. Schultze 1992, 502, no. 470 (silver box with the same portrait, signed by Rouw / eine silberne Dose mit dem gleichen Bildnis, signiert von Rouw).

An unsigned, plaster model of this portrait with the inscription *"GEORGIUS PRINCEPS WALLIAE MDCCCIX"* is in the Posch Werkstattnachlaß housed in the Münzkabinett Berlin. A pair of identical wax portraits are in the Fitzwilliam Museum in Cambridge, England. Peter Rouw was a sculptor and medallist. In 1807 he became sculptor and gemcutter to the Prince of Wales. / Ein unsigniertes Gips-Exemplar mit der Umschrift *„GEORGIUS PRINCEPS WALLIAE MDCCCIX"* befindet sich im Posch Werkstattnachlaß im Münzkabinett Berlin. Im Fitzwilliam Museum in Cambridge befinden sich zwei identische Wachsbildnisse. Peter Rouw war Bildhauer und Medailleur und wurde 1807 Bildhauer und Gemmenschneider des Prinzen von Wales.

48 George V, King of Hanover (1819-78; 1851-66 King) / Georg V., König von Hannover (1851-66 König)

Bust in profile left in general's uniform with epaulet, sash, medal, and ermine mantle. / Brustbild im Profil nach links in Generaluniform mit Epaulette, Ordensband und Stern, unten Hermelindraperie. / Ins. around/Umschrift *„GEORG V v. G. G. KOENIG v. HANNOVER"*.

1851-52. – Mod. Heinrich Friedrich Brehmer. – F./G. Königshütte (Harz). – 13 x 10.3 cm (5 1/8 x 4 1/6 in.), Bh. 9.4 cm

Cat. 46

Cat. 47 (Original size / Originalgröße)

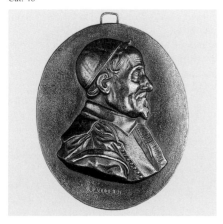

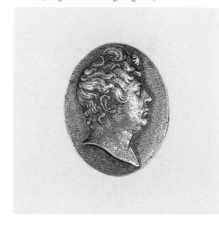

(3 11/16 in.). – 154.9 g. – Sign. below truncation / unterhalb des Brustabschnitts „BREHMER F.".
Lamprecht 353. – Inv. 1986.384.
Lit.: Hillegeist, 212 f. – Meier 1927, 13, fig./Abb. 8.
George V born Friedrich Alexander Karl, son of Ernst August, King of Hanover. / Geb. Friedrich Alexander Karl, Sohn des Königs Ernst August von Hannover.
Brehmer was a sculptor and medallist in Hanover after 1846. / Brehmer war Bildhauer und Medailleur in Hannover nach 1846.

49 Johann Wolfgang von Goethe (1749-1832), German Writer and Statesman / deutscher Dichter und Staatsmann
Head in profile left. / Kopf im Profil nach links.
1809. – Mod. Leonhard Posch, after the 1808 wax portrait by / nach dem Wachsporträt von 1808 von Gerhard von Kügelgen. – F./G. KPEG. – D. 9.1 cm (3 9/16 in.), Bh. 8.2 cm (3 1/4 in.). – 85.2 g.
Lamprecht 363. – Inv. 1986.391.2.
Lit.: Forschler-Tarrasch, no. 257. – Förschner, 76, no. 49. – Frede 1959, 87, no. 67 (pl./Taf. XIII). – H. v. Sp. 1917, 300. – Hintze 1928a, 33, pl./Taf. 57 (VII 1). – Kippenberg 7529. – Schmitz 1917, pl./Taf. 23. – Stummann-Bowert, 74, no. 38.
It is well known that Posch based his portrait on Kügelgen's wax model. / Es ist bekannt, daß Posch sein Goethe-Porträt nach Kügelgens Wachsmodell geschaffen hatte: „Der Bildhauer Posch, durch mehrere vorzügliche Arbeiten bekannt […] die Bildnisse verstorbener und lebender verdienstvoller Männer, Klopstock, Hermstaedt, sind Zeugnisse seines Talents, und die nach dem Hrn. von Kügelgen gelieferten Köpfe: Goethe und Wieland, übertreffen die schönen Originale an Zartheit der Ausführung" (Morgenblatt, 25.7.1809, 704).

50 Johann Wolfgang von Goethe
Head in profile left. / Kopf im Profil nach links.
1827. – Mod. Leonhard Posch. – F./G. KPEG. – D. 8.7 cm (3 7/16 in.), Bh. 7.9 cm (3 1/8 in.). – 94.7 g.
Lamprecht 484. – Inv. 1986.391.3.
Lit.: Bekker 2001, no. 628. – Forschler-Tarrasch, no. 258. – Förschner, 178, no. 323. – Frede 1959, 98, no. 82 (pl./Taf. XIV). – Hintze 1928a, 32 f., pl./Taf. 55 (VI 190). – Kippenberg 7533. – Schmidt 1981, 87, fig./Abb. 68. – Stummann-Bowert, 74, no. 39 (ill. pl./Abb. Taf. 14).

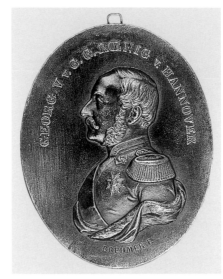

Cat. 48

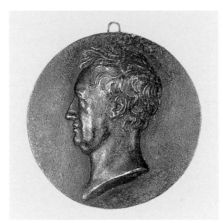

Cat. 49

Cat. 50

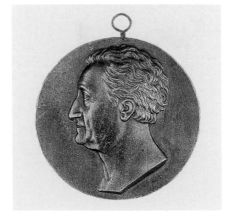

51 Johann Wolfgang von Goethe
Head in profile right. / Kopf im Profil nach rechts. / Ins. around/Umschrift „WOLFGANG VON GÖTHE".
Ca. 1890. – Mod. after a medal (1827) by / nach einer Medaille (1827) von Johann Karl Fischer based on the 1820 bust by / nach einer Büste (1820) von Christian Daniel Rauch. – D. 11.5 cm (4 1/2 in.), Bh. 7.6 cm (3 in.). – 165.7 g.
Lamprecht 362. – Inv. 1986.391.1.
Lit.: Cat. Leipzig 1915, 121, no. 76 (erroneously attributed to Jean-François-Antoine Bovy / irrtümlich Jean-François-Antoine Bovy zugeschrieben). – Förschner, 173, no. 316.

52 Samuel Christian Friedrich Hahnemann (1755-1843), German Court Doctor / deutscher Hofarzt
Bust in profile left in fur-trimmed coat. / Brustbild im Profil nach links in mit Pelz geschmücktem Mantel. / Ins. „Dr. S. HAHNEMANN".
1832. – Mod. Adolf Straube. – F./G. KPEG. – D. 9 cm (3 9/16 in.), Bh. 7.4 cm (2 15/16 in.). – 63.9 g. – Sign. on rev. / auf der Rs. „A. STRAUBE. FEC. 1832".
Lamprecht 375. – Inv. 1986.402.
Lit.: Cat. Leipzig 1915, 122 f., no. 90. – Ostergard 1994, 191, no. 28 (erroneously attributed to Leonhard Posch / irrtümlich Leonhard Posch zugeschrieben). – Scheidig, 94, fig./Abb. 38. – Schmidt 1981, 78, fig./Abb. 34 (erroneously attributed to Leonhard Posch / irrtümlich Leonhard Posch zugeschrieben).

53 Samuel Christian Friedrich Hahnemann
Bust in profile right in fur-trimmed coat. / Brustbild im Profil nach rechts in mit Pelz geschmücktem Mantel.
Brown-colored plaster / Gips, braun gefärbt. – 1834. – Mod. Adolf Straube. – D. 9.8 cm (3 7/8 in.), Bh. 7.4 cm (2 15/16 in.). – Sign. and/und dat. on truncation / auf dem Brustabschnitt „Adolf Straube 1834".
Lamprecht 483. – Inv. 1986.476.

54 Gerhart Hauptmann (1862-1946), German Writer and 1912 Nobel Prize Winner / deutscher Schriftsteller und Nobelpreisträger 1912
Head in profile right. / Kopf im Profil nach rechts.
1957. – Mod. Ludwig Gies. – F./G. Buderus. – D. 13 cm (5 1/8 in.), Bh. 9.2 cm (3 5/8 in.). – 175.8 g. – Sign. left "L.G." and below, the

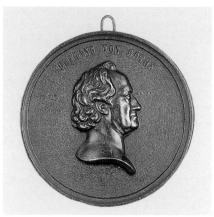

Cat. 51

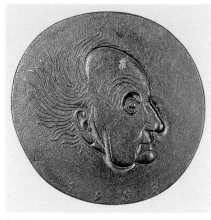

Cat. 54

date *"1957"*; on reverse Buderus foundry mark / links „*L. G.*" und unten das Datum „*1957*"; auf der Rs. Buderus Gießereimarke.
Inv. 1957.265. – Gift of / Schenkung von ACIPCO.
Lit.: Buderus Kunstguß 1997, 21. – Ernsting, 360, WVZ 394.

55 Johann I, King of Saxony (1801-73; 1854 King) / Johann I., König von Sachsen (1854 König)
Head in profile left. / Kopf im Profil nach links.

Cat. 55

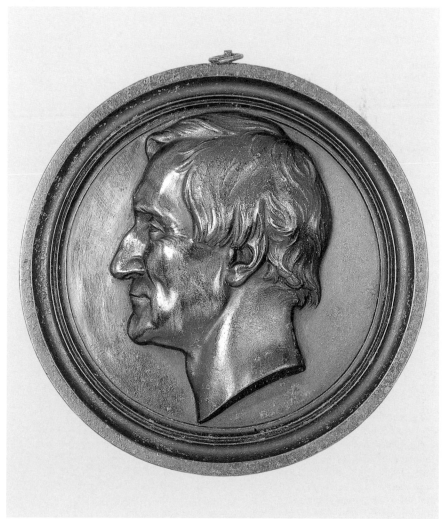

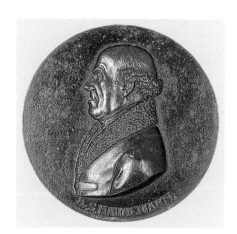
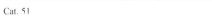

Cat. 52

Cat. 53

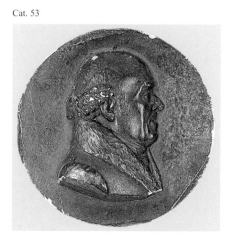

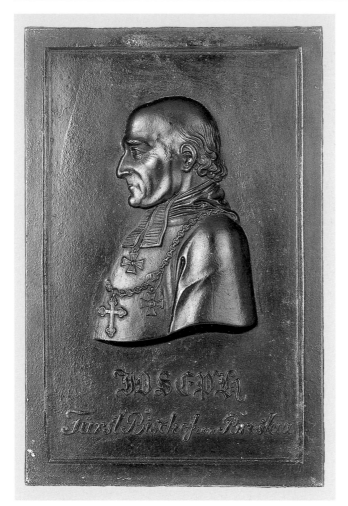

Cat. 56

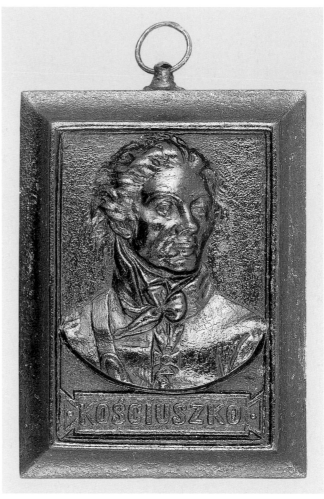

Cat. 57

1874. – Mod. Adolf von Donndorf. – F./G. Lauchhammer. – D. 20 cm (7 7/8 in.), Bh. 15.0 cm (5 7/8 in.). – 849.7 g. – Sign. on truncation / am Brustabschnitt „DON-DORF". Rev./Rs. „Eigenthum/Lauchhammer".
Lamprecht 349, Photo 41. – Inv. 1986.380.
Lit.: Cat. Leipzig 1915, 114, no. 4. – Fuchs, 132, WV 116. – Schuette 1916, 287, fig./Abb. 21.

56 Josef Knauer, Prince Bishop of Breslau (died 1844) / Fürstbischof von Breslau (gestorben 1844)
Bust in profile left. / Brustbild im Profil nach links. / Ins. „JOSEPH FürstBischof von Breslau".
1840-45. – F./G. Buchbergsthal. – 25.7 x 16.8 cm (10 1/8 x 6 5/8 in.), Bh. 14.5 cm

(5 11/16 in.). – 1098.6 g. – Marked on reverse / bez. auf der Rs. „Buchbergsthal". Inv. 2002.3. – Gift of / Schenkung von Thomas A. Cox.
Lit.: Aus einem Guß, 240, no. 2112. – Hintze 1931, 220 ff., fig./Abb. 25.

57 Tadeusz Andrezej Bonaventura Kościuszko (1746-1817), Polish General and National Hero; American General during the Revolutionary War 1775-83 / polnischer General und Nationalheld; amerikanischer General während des Unabhängigkeitskriegs 1775-83
Bust front, head slightly right, in uniform with medal. / Brustbild von vorn, der Kopf leicht nach rechts gewendet, in Uniform mit Orden. / Ins. „KOSCIUSZKO".

First quarter of the 19th century / 1. Viertel des 19. Jhs. – 9.5 x 7 cm (3 3/4 x 2 3/4 in.), Bh. 6.0 cm (2 3/8 in.). – 180.6 g.
Lamprecht 374, Photo 39. – Inv. 1986.401.

58 Gotthold Ephraim Lessing (1729-81), German Poet and Critic / deutscher Dichter und Kritiker
Bust in profile left in brass frame. / Brustbild im Profil nach links im Messingrahmen. / Ins. „LESSING".
Ca. 1796. – Mod. Abraham Abramson. – F./G. KPEG Gleiwitz. – D. 9.8 cm (3 7/8 in.) with frame / mit Rahmen; D. 7.7 cm (3 1/16 in.) without frame / ohne Rahmen, Bh. 6.4 cm (2 1/2 in.). – 61.1 g with frame / mit Rahmen. – Rev./Rs. „N VI 97.".
Lamprecht 366. – Inv. 1986.393.

Lit.: Cat. Leipzig 1915, 124, no. 98 (erroneously attributed to Leonhard Posch / irrtümlich Leonhard Posch zugeschrieben). – Hintze 1928a, 26, pl./Taf. 37 (VI 97). – Hoffmann, 133, no. 241 (ill. pl./Abb. Taf. 40).

59 Carolus Linnaeus (Carl von Linné, 1707-78), Swedish Botanist / schwedischer Botaniker

Bust in profile right in civilian dress. / Brustbild im Profil nach rechts in Zivilkleidung. / Ins. „*LINNÆUS*".

1798-1800. – Mod. after a design by / nach einem Entwurf von John Flaxman Sr. (ca. 1775). – F./G. KPEG Gleiwitz. – 8.2 x 6.6 cm (3 1/4 x 2 5/8 in.), Bh. 6.5 cm (2 9/16 in.). – 40.9 g.

Lamprecht 371. – Inv. 1986.398.

Lit.: Cat. Leipzig 1915, 127, no. 128 (erroneously attributed to Leonhard Posch / irrtümlich Leonhard Posch zugeschrieben). – Hintze 1928a, 25, pl./Taf. 32 (VI 69). – Ostergard 1994, 184, no. 19 (erroneously attributed to Leonhard Posch / irrtümlich Leonhard Posch zugeschrieben). – Cp./vgl. Reilly and Savage, 216.

This portrait is based on a model created for the English pottery manufactory Wedgwood. On January 19, 1775, John Flaxman Jr. submitted on behalf of his father, John Flaxman, Sr., a bill for *"moulding and making a cast from a medal of Lennaeus, mending a wax medal and making a mould from it,"* for which he charged two shillings. The medal he refers to is a wax made by Swedish modeler C. F. Inlander in 1773, which is now in the British Museum, London. Flaxman's original mold is now in the Wedgwood Museum at Barlaston. The founders of the royal Prussian iron foundries at Gleiwitz and Berlin toured the iron foundries of England and Scotland, returning to Prussia with modern metallurgical technology. They also visited the Wedgwood manufactory, bringing with them to Prussia a number of models for medallions, medals, and gems that were then used to produce similar objects in Gleiwitz and Berlin. / Das Porträt basiert auf einem Modell, das für die Wedgwood-Keramikmanufaktur geschaffen wurde. Am 19. Januar 1775 übergab John Flaxman Jr. seinem Vater eine Rechnung in Höhe von zwei Schillingen für „*moulding and making a cast from a medal of Lennaeus, mending a wax medal and making a mould from it*". Die genannte Medaille ist ein 1773 modelliertes Wachsporträt des schwedischen Modelleurs C. F. Inlander, das heute im British Museum in London

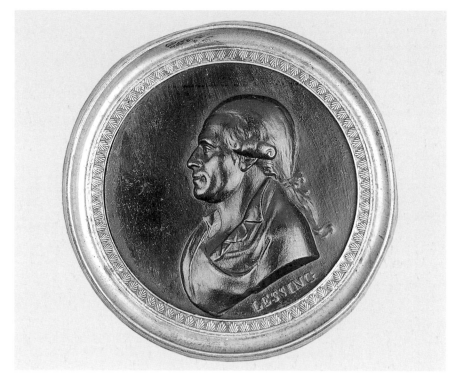

Cat. 58

Cat. 59

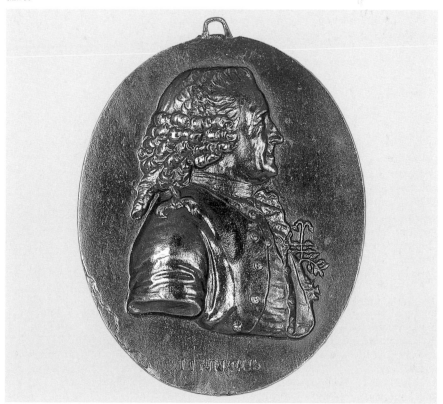

aufbewahrt wird. Flaxmans Modell befindet sich im Wedgwood Museum in Barlaston. Die Gründer der Königlichen Eisengießereien Gleiwitz und Berlin brachten von einer Reise durch England und Schottland neue Hüttentechniken nach Preußen mit. Unter anderem besuchten sie die Wedgwood-Manufaktur, von der sie eine Reihe von Modellen für Medaillons, Medaillen und Gemmen erwarben, die in Gleiwitz und Berlin in Eisen gegossen wurden.

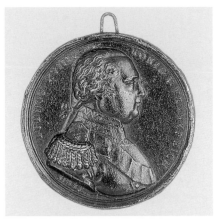
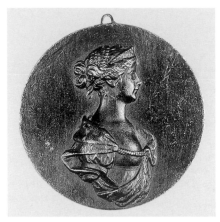

Cat. 60 Cat. 62

60 Louis XVIII, King of France (1755-1824; 1814-15 King) / Ludwig XVIII., König von Frankreich (1814/15 König)
Bust in profile right in uniform with sash and epaulet. / Brustbild im Profil nach rechts in Uniform mit Ordensband und Epauletten. / Ins. around/Umschrift „LUDWIG XVIII. KÖNIG V: FRANKREICH".
Ca. 1814-15. – Mod. Franz Detler. – F./G. probably/wahrscheinlich KPEG Gleiwitz. – D. 5.6 cm (2 3/16 in.), Bh. 4.6 cm (1 13/16 in.). – 44.0 g. – Sign. below truncation / unterhalb des Brustabschnitts „DETLER".
Lamprecht 335, Photo 60. – Inv. 1986.367.
Lit.: Forrer 1, 572. – Wurzbach-Tannenberg, no. 5627.
The model for this medal was probably created on the occasion of the Congress of Vienna. / Das Modell zu dieser Medaille wurde wahrscheinlich anläßlich des Wiener Kongresses geschaffen.

61 Louis Ferdinand, Prince of Prussia (1773-96) / Prinz von Preußen
Bust in profile left in uniform with the Order of the Black Eagle. / Brustbild im Profil nach links in Uniform mit dem Stern des Schwarzen Adlerordens.
1797-98. – Mod. Anton Friedrich König the Elder/d. Ä. attributed/zugeschrieben. – F./G. KPEG Gleiwitz. – 23.2 x 18.0 cm (9 1/8 x 7 1/16 in.) with frame, Bh. 16.1 cm (6 5/16 in.). – 575 g.
Lamprecht 301, Photo 46. – Inv. 1986.345.
Lit.: Cat. Leipzig 1915, 120, no. 72.
Brother of King Friedrich Wilhelm III of Prussia / Bruder des Königs Friedrich Wilhelm III. von Preußen.

62 Luise, Queen of Prussia (1776-1810) / Königin von Preußen
Bust right with pearls in hair, diadem, and ermine mantle, whose chain rests on the breast. / Brustbild im Profil nach rechts mit perlendurchflochtener Frisur, Diadem und Hermelindraperie, deren Kette auf der Brust ruht.

Ca. 1809. – Mod. Leonhard Posch. – F./G. KPEG. – D. 8 cm (3 1/8 in.), Bh. 6.9 cm (2 11/16 in.). – 52.3 g.
Lamprecht 317. – Inv. 1986.358.1.
Lit.: Andrews, 422, fig./Abb. 1. – Arenhövel 1982, 66 f., no. 118. – Cat. Leipzig 1915, 125, no. 115. – Forschler-Tarrasch, no. 81. – Hintze 1928a, 21, pl./Taf. 17 (VI 2c). – Schmitz 1917, 54, pl./Taf. 22.
Wife of King Friedrich Wilhelm III of Prussia / Gemahlin des Königs Friedrich Wilhelm III. von Preußen.

Cat. 61

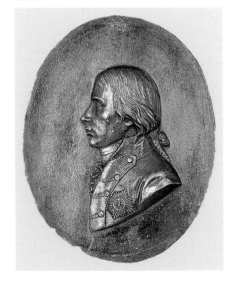

63 Luise, Queen of Prussia / Königin von Preußen
Bust im profile right with pearls in hair, diadem, and ermine mantle, whose chain rests on the breast. / Brustbild im Profil nach rechts mit perlendurchflochtener Frisur, Diadem und Hermelindraperie, deren Kette auf der Brust ruht.
Ca. 1810. – Mod. Leonhard Posch. – F./G. KPEG. – 3.5 x 3.0 cm (1 3/8 x 1 3/16 in.), Bh. 3.2 cm (1 1/4 in.). – 7.9 g.
Lamprecht 446M, Photo 59. – Inv. 1986.495.28.
Lit.: Cat. Leipzig 1915, 130, no. 158. – Forschler-Tarrasch, no. 81.
A reduction of the Posch model published in Forschler-Tarrasch. Several casts of this model were made following the Queen's death in 1810 and were worn as jewelry. / Reduzierung des Posch-Modells, das bei Forschler-Tarrasch abgebildet ist. Das Modell wurde nach dem Tod der Königin Luise 1810 in verschiedenen Größen gegossen und als Schmuck getragen.

64 Luise, Queen of Prussia / Königin von Preußen
Bust in profile right with pearls in hair and diadem, with ermine mantle, whose chain rests under the breast. / Brustbild im Profil nach rechts mit perlendurchflochtenen Haaren und Diadem, unten Hermelindraperie, deren Kette unter der Brust ruht.
Ca. 1810. – Mod. Leonhard Posch. – F./G. KPEG. – D. 8.9 cm (3 1/2 in.), Bh. 7.5 cm (2 15/16 in.). – 71.8 g.

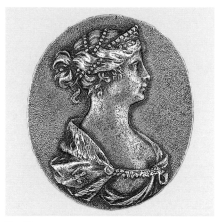

Cat. 63

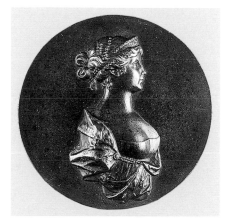

Cat. 64

Cat. 65

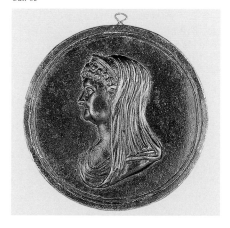

Inv. 1962.86. – Gift of / Schenkung von Dr. and Mrs. Maurice Garbáty.
Lit.: Arenhövel 1982, 67, no. 119. – Forschler-Tarrasch, no. 83. – Hintze 1928a, 21, pl./Taf. 17 (VI 2d).

65 Maria Theresia, Archduchess of Austria, Queen of Hungary and Bohemia (1717-80; reigned from 1740; from 1745 called herself Empress of the Holy Roman Empire) / Erzherzogin von Österreich, Königin von Ungarn und Böhmen (regierte ab 1740; nannte sich ab 1745 Kaiserin des Heiligen Römischen Reiches Deutscher Nation)
Bust in profile left with diadem and shawl over the head. / Brustbild im Profil nach links mit Diadem und Tuch über dem Kopf.
First quarter of the 19th century / 1. Viertel des 19. Jh. – D. 7.3 cm (2 7/8 in.), Bh. 5.4 cm (2 1/8 in.). 46.2 g.
Lamprecht 457. – Inv. 1986.454.

66 Marie, Duchess of Anhalt (1865-1939) / Herzogin von Anhalt
Bust three-quarters right. / Brustbild dreiviertel nach rechts.
Ca. 1910. – F./G. probably/wahrscheinlich Mägdesprung. – 23.3 x 19 cm (9 3/16 x 7 1/2 in.), Bh. 16.7 cm (6 9/16 in.). – 763.8 g.
Lamprecht 482. – Inv. 1986.475 b.
A pendant to the portrait of her husband, Friedrich II, Duke of Anhalt. / Gegenstück zum Bildnis ihres Mannes Friedrich II., Herzog von Anhalt. / S. Cat. 29.

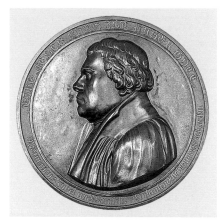

Cat. 67

Cat. 66

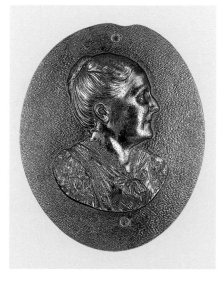

67 Martin Luther (1483-1546), German Reformer / deutscher Reformator
Bust in profile left. / Brustbild im Profil nach links. / Ins. around/Umschrift „EINE FESTE BURG IST UNSER GOTT. Reformations=Jubel und Dankfest Eintausend achthundert siebenzehn".
1817. – Mod. Wilhelm August Stilarsky after a design by / nach einem Entwurf von Johann Gottfried Schadow. – F./G. probably/ wahrscheinlich KPEG Berlin. – D. 16.5 cm (6 1/2 in.), Bh. 12.5 cm (4 15/16 in.). – 255.7 g.
Lamprecht 382, Photo 39. – Inv. 1986.405.4.
Lit.: Cat. Leipzig 1915, 121, no. 77. – Schnell, 270 f., no. 371. – Whiting, no. 847.

68 Martin Luther
Bust in profile left. / Brustbild im Profil nach links. / Ins. „D. MARTIN LVTHER".
Ca. 1817. – Mod. possibly/vielleicht Wilhelm August Stilarsky after a design by / nach einem Entwurf von Johann Gottfried Schadow for the Luther Monument in Wittenberg / für das Luther-Denkmal in Wittenberg. – F./G. KPEG. – 23 x 18.8 cm (9 1/16 x 7 3/8 in.), Bh. 12.1 cm (4 3/4 in.). – 1091.3 g.
Lamprecht 379. – Inv. 1986.405.2.
Cp. Stilarsky's portrait of Philipp Melanchthon illustrated in Blum, 84 f., no. 39. / Vgl. Stilarskys Porträt von Philipp Melanchthon abgebildet in Blum, 84 f., no. 39.

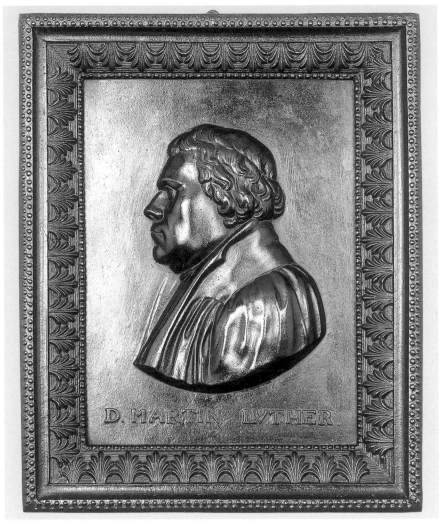

Cat. 68

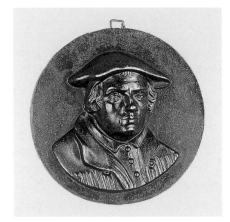

Cat. 69

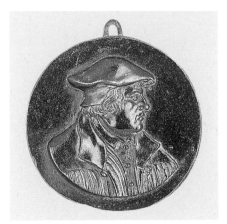

Cat. 70

Cat. 72

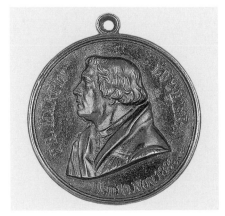

69 Martin Luther

Bust three-quarters front. / Brustbild drei-viertel von vorn.

Ca. 1817. – Mod. Wilhelm August Stilarsky. – F./G. Johann Conrad Geiss. – D. 8.9 cm (3 1/2 in.), Bh. 7.0 cm (2 3/4 in.). – 75.3 g. – Rev./Rs. sign. „GEISS".

Lamprecht 380, Photo 39. – Inv. 1986.405.3.

Lit.: Andrews, 423, fig./Abb. 4. – Arenhö-vel 1982, 62, no. 108. – Aus einem Guß, 70, no. 136. – Bekker 2001, 88, no. 625. – Hintze 1928a, 103, pl./Taf. 71, no. 4. – Hintze 1928b, 157. – Ostergard 1994, 189, no. 25.

Based on a portrait medallion created by Georg Schweigger in Nuremberg as part of his "Reformatorenserie" about 1636. This portrait was ordered by Geiss around 1817 as a pendant to a portrait of Philipp Mel-anchthon. / Basiert auf einem Porträtme-daillon, das um 1636 vom Nürnberger Ge-org Schweigger als Teil einer „Reformato-renserie" geschaffen wurde. Geiss gab die-ses Porträt um 1817 als Gegenstück zum Porträt Philipp Melanchthons in Auftrag. / S. also/auch Cat. 74. – Cp./vgl. Planiscig 1919, 204, no. 461, pl./Taf. 37.

70 Martin Luther
Bust three-quarters right. / Brustbild drei-
viertel nach rechts.
Ca. 1817. – D. 4.8 cm (1 7/8 in.), Bh. 3.9
cm (1 9/16 in.). – 23.9 g.
Lamprecht 451. – Inv. 1986.450.1.

71 Martin Luther
Silhouette bust front. / Ausgeschnittene Bü-
ste von vorn.
1860-70. – Mod. after the statue of Luther
at Worms (completed 1868) by / nach der
Luther-Statue in Worms (vollendet 1868)
von Ernst Rietschel. – F./G. Lauchhammer.
– 29.2 x 26 cm (11 1/2 x 10 1/4 in.). –
1974.6 g.
Lamprecht 378, Photo 38. – Inv.
1986.405.1.
Lit.: Cat. Leipzig 1915, 120, no. 71.

72 Martin Luther
Bust in profile left. / Brustbild im Profil
nach links. / Ins. around/Umschrift „DR.
MARTIN LUTHER. Den 10. Nov. 1883".
1883. – D. 5.6 cm (2 3/16 in.), Bh. 4.2 cm
(1 5/8 in.). – 33.0 g.
Lamprecht 907. – Inv. 1986.482.
Lit.: Whiting, no. 771.
Designed to commemorate the 400th an-
niversary of Martin Luther's birth. / Auf den
400. Geburtstag Martin Luthers.

**73 Maximilian I Joseph, King of Bava-
ria (1756-1825; 1806 King) / Maximilian I.
Joseph, König von Bayern (1806 König)**
Head in profile right. / Kopf im Profil nach
rechts. / Ins. around/Umschrift „MAXIMI-
LIANUS IOSEPHUS BAVARIAE REX".
Ca. 1806. – Mod. Joseph Losch. – F./G. Bo-
denwöhr (?). – D. 6.5 cm (2 9/16 in.), Bh.
4.1 cm (1 5/8 in.). – 31.2 g. – Sign. below
truncation / unterhalb des Brustabschnitts
„LOSCH F.".
Lamprecht 324. – Inv. 1986.357.
Lit.: Beierlein 2463 (here the inscription
around / hier mit der Umschrift „MAXIMI-
LIANUS IOSEPHUS BOIARIAE REX", a
medal by Losch that was never cast / eine
Medaille, die nie geprägt wurde). – Cat.
Leipzig 1915, 124, no. 102. – Ostergard
1994, 183, no. 14 (erroneously attributed to
Leonhard Posch / irrtümlich Leonhard Posch
zugeschrieben).
This portrait was used on the Bavarian
Kronthaler in 1809 and again for the Rhein-
gold Ducat in 1821. / Dieses Porträt wurde
für den bayrischen Kronthaler 1809 und den
Rheingold-Dukaten 1821 benutzt. / Cp./vgl.
Beierlein 2588, 2593.

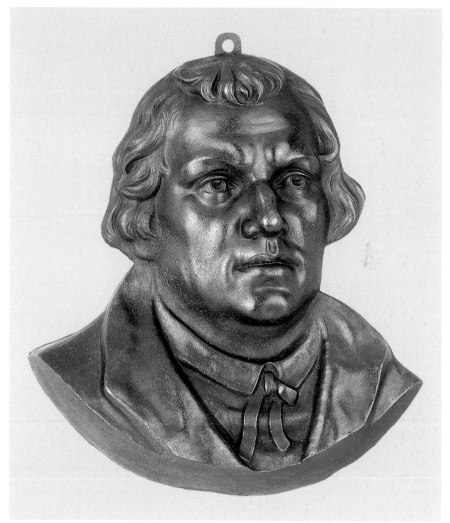

Cat. 71

Cat. 73

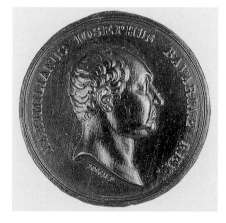

**74 Philipp Melanchthon (1497-1560),
German Humanist and Martin Luther's
Collaborator / deutscher Humanist und
Mitarbeiter Martin Luthers**
Bust front. / Brustbild von vorn.
Ca. 1817. – F./G. KPEG Gleiwitz. –
D. 9.2 cm (3 5/8 in.), Bh. 8.3 cm (3 1/4 in.).
– 76.2 g. – Rev./Rs. „N=VI. 156.".
Lamprecht 381, Photo 39. – Inv.
1986.406.1.
Lit.: Arenhövel 1982, 62, no. 109. – Aus ei-
nem Guß, 70 f., no. 137. – Bekker 2001, 88,
no. 626. – Blum, 80 f., no. 36. – Forschler-
Tarrasch, no. 915. – Hintze 1928a, 30, pl./
Taf. 49 (VI 156).

This portrait was made after a prototype in the style of Georg Schweigger as a pendant to Stilarsky's Luther portrait. / Das Porträt wurde nach einem Vorbild im Stil Georg Schweiggers als Gegenstück zu Stilarskys Luther-Bildnis gemacht. / S. Cat. 69.

75 Philipp Melchanthon
Bust in profile right. / Brustbild im Profil nach rechts. / Ins. around/Umschrift „DOCTOR PHILIPP MELCHANTHON abgeordneter der Kirche Christi bey dem Reichstage zu Augsburg. Eintausend Fünfhundert Dreissig".
Ca. 1817. – Mod. Wilhelm August Stilarsky after a design (1817) by / nach einem Entwurf (1817) von Johann Gottfried Schadow. – F./G. KPEG Berlin. – D. 16.5 cm (6 1/2 in.), Bh. 12.6 cm (4 15/16 in.). – 414.7 g. Lamprecht 383. – Inv. 1986.406.2.
Lit.: Blum, 84 f., no. 39. – Cat. Leipzig 1915, 121, no. 78. – Whiting, no. 19.

76 Klemens Wenzel Lothar, Prince of Metternich-Winneburg (1773-1859), Austrian Statesman, 1803-06 Austrian Envoy to Berlin / Fürst von Metternich-Winneburg, österreichischer Staatsmann, 1803-06 österreichischer Gesandter in Berlin
Bust front in uniform with sash and medals. / Brustbild von vorn in Uniform mit Ordensband und Orden. / Ins. around/Umschrift „FÜRST. V. METTERNICH K.K. ÖST: MINISTER".
Ca. 1814-15. – Mod. Leopold Heuberger. – F./G. KPEG Gleiwitz. – D. 5.4 cm (2 1/8 in.), Bh. 4.6 cm (1 13/16 in.). – 36.2 g. – Sign. below truncation / unterhalb des Brustabschnitts „HEUBERGER F.".
Lamprecht 340. – Inv. 1986.372.
Lit.: Bramsen, no. 2297. – Cat. Leipzig 1915, 127, no. 133. – Wurzbach-Tannenberg, no. 6256.
Part of series made on the occasion of the Congress of Vienna. / Teil einer Serie, die anläßlich des Wiener Kongresses geschaffen wurde.

77 Carl Ferdinand Friedrich von Nagler (1770-1846), Prussian Statesman, Art Collector, and Postmaster General / preußischer Staatsmann, Kunstsammler und Generalpostmeister
Bust three-quarters right in civilian dress with the Order of the Red Eagle and the Order of the Black Eagle. / Brustbild dreiviertel nach rechts in Zivilkleidung mit dem Roten Adlerorden und dem Stern des Schwarzen Adlerordens.

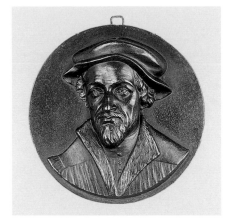

Cat. 74

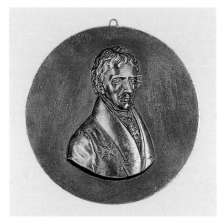

Cat. 77

Cat. 75

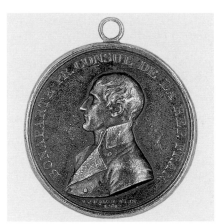

Cat. 78

Cat. 76

Cat. 80

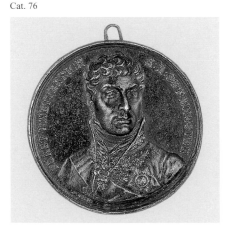

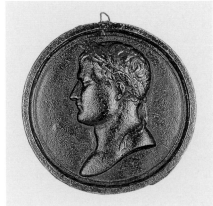

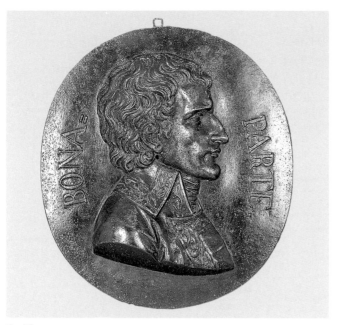

Cat. 79

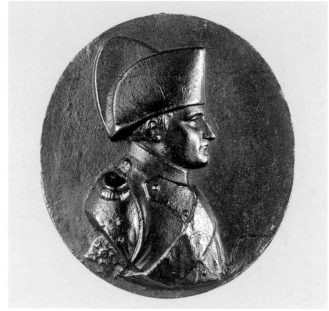

Cat. 81

Metal alloy / Gelbguß. – Ca. 1823. – Mod. Leonhard Posch attributed/zugeschrieben, after an engraving by / nach einem Stich von Ludwig Buchhorn. – D. 12.8 cm (5 1/16 in.), Bh. 9.5 cm (3 3/4 in.). – Rev./Rs. „CFF von NAGLER Königl. Preuss General Postmeister".
Lamprecht 909, Photo 40. – Inv. 1986.484.
Lit.: Arenhövel 1982, 61, no. 105. – Aus einem Guß, 67, no. 109. – Forschler-Tarrasch, no. 919. – Hintze 1928a, 102, pl./Taf. 70,1. – Schmidt 1981, 87, fig./Abb. 67. – Stummann-Bowert, 50, no. 67.

78 Napoleon I Bonaparte, Emperor of the French (1769-1821; 1804-14 Emperor) / Napoleon I. Bonaparte, Kaiser der Franzosen (1804-14 Kaiser)
Bust in profile left in civilian dress in contemporary brass frame. / Brustbild im Profil nach links in Zivilkleidung im zeitgenössischen Messingrahmen. / Ins. around/ Umschrift „BONAPARTE PR. CONSUL DE LA REP. FRAN.".
1801. – Mod. Jean-Pierre Droz. – F./G. KPEG Gleiwitz. – D. 4.8 cm (1 7/8 in.), Bh. 3.7 cm (1 7/16 in.). – 20.3 g. – Sign. below truncation / unterhalb des Brustabschnitts „I. P. DROZ F. An -IX/1801".
Lamprecht 303. – Inv. 1986.346.2.

Lit.: Cat. Leipzig 1915, 127, no. 135. – Cp./ vgl. Wurzbach-Tannenberg, no. 6515 (here a two-sided medal from 1802 with Droz portrait on obverse / hier eine zweiseitige Medaille von 1802 mit dem Droz-Porträt auf der Vorderseite).

79 Napoleon I Bonaparte, Emperor of the French / Napoleon I. Bonaparte, Kaiser der Franzosen
Bust in profile right in uniform. / Brustbild im Profil nach rechts in Uniform. / Ins. „BONA PARTE".
Ca. 1804. – 21.5 x 19.5 cm (8 1/2 x 7 3/4 in.), Bh. 18.0 cm (7 1/16 in.). – 777.6 g.
Lamprecht 302, Photo 42. – Inv. 1986.346.1.
Lit.: Cat. Leipzig 1915, 123, no. 91. – Kirmis 1912 (fig./Abb.).
According to Professor Kirmis, this portrait stems from the "early part of Napoleon's reign." / Laut Kirmis stammt dieses Porträt aus der „Frühzeit von Napoleons Regierung."

80 Napoleon I Bonaparte, Emperor of the French / Napoleon I. Bonaparte, Kaiser der Franzosen
Laureate bust in profile left. / Brustbild im Profil nach links mit Lorbeerkranz.

Ca. 1811. – Mod. Bertrand Andrieu, based on a design by / nach einem Entwurf von Louis Lafitte. – D. 13.6 cm (5 3/8 in.), Bh. 10.9 cm (4 5/16 in.). – 354.2 g. – Illegible signature on truncation. / Unleserliche Signatur am Brustabschnitt.
Lamprecht 305. – Inv. 1986.346.4.
Lit.: Bekker 2001, no. 458. – Cat. Paris 1978, 47 (example signed by / ein Exemplar signiert von Andrieu und Denon). – Cp./vgl. Hintze 1928a, 21, pl./Taf. 19 (VI 8b). – Salaschek, no. 26.

81 Napoleon I Bonaparte, Emperor of the French / Napoleon I. Bonaparte, Kaiser der Franzosen
Bust right in the imperial uniform of the Chasseurs à Cheval with trademark bicorne hat. / Brustbild im Profil nach rechts in Uniform des Chasseurs à Cheval Regiments mit dem für Napoleon typischen Zweispitz.
First quarter of the 19th century / 1. Viertel des 19. Jh. – 9.2 x 8.3 cm (3 5/8 x 3 1/4 in.), Bh. 8.6 cm (3 3/8 in.). – 91.3 g.
Lamprecht 306. – Inv. 1986.346.5.
Lit.: Cat. Leipzig 1915, 126, no. 121.

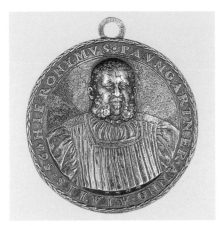

Cat. 82

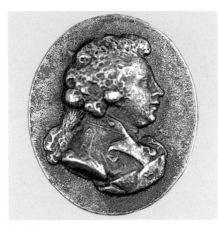

Cat. 86

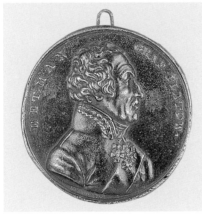

Cat. 83

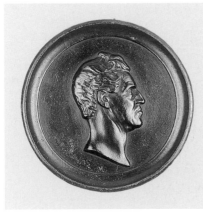

Cat. 84

82 Hieronymus Paumgartner the Elder/der Ältere (1498-1565), Nuremberg Diplomat and Patron of Albrecht Dürer / Nürnberger Diplomat und Förderer Albrecht Dürers

Bust front. / Brustbild von vorn. / Ins. around/Umschrift „HIERONYMVS. PAVMGARTNER. ANNO. ÆTATIS. 56".
First quarter of the 19th century / 1. Viertel des 19. Jh. – D. 6.7 cm (2 5/8 in.), Bh. 5.2 cm (2 1/16 in.). – 41.2 g. – Dat. on truncation / am Brustabschnitt „1553".
Lamprecht 477, Photo 37. – Inv. 1986.471.

83 Matvei Ivanovich, Count Platow (1751-1818), Cossack Hetman / Matwei Iwanowitsch Graf Platow, Kosakenhetman

Bust in profile right in uniform with sash and medals. / Brustbild im Profil nach rechts in Uniform mit Ordensband und Orden. / Ins. around/Umschrift „HETMAN GRAF PLATOW".
Ca. 1814-15. – Mod. Leopold Heuberger. – F./G. KPEG Gleiwitz. – D. 5.2 cm (2 1/16 in.), Bh. 4.4 cm (1 3/4 in.). – 35.4 g. – Sign. below truncation / unterhalb des Brustabschnitts „HEUBERGER".
Lamprecht 337. – Inv. 1986.369.
Lit.: Aus einem Guß, 69, no. 126. – Wurzbach-Tannenberg, no. 7578.
Part of series made on the occasion of the Congress of Vienna. / Teil einer Serie, die anläßlich des Wiener Kongresses geschaffen wurde.

84 Christian Daniel Rauch (1777-1857), German Sculptor / deutscher Bildhauer

Head in profile right. / Kopf im Profil nach rechts.
1840-50. – F./G. KPEG Berlin (?). – D. 13.4 cm (5 1/4 in.), Bh. 8.8 cm (3 7/16 in.). – 139.0 g.
Lamprecht 370. – Inv. 1986.397.
Lit.: Cat. Leipzig 1915, 125, no. 109. – Wruck, lot/Losnr. 611 (coll./Slg. Robert Recke).

85 Sven Rinman (1720-92), Royal Swedish Mining Councilor / Königlicher Schwedischer Bergrat

Bust in profile right. / Brustbild im Profil nach rechts. / Ins. „SVEN RINMAN".
Second quarter of the 19th century / 2. Viertel des 19. Jh. – Mod. probably after a round relief (1782) by Johann Tobias Sergel(l) or after the engraving by (Anton) Wachsmann after Sergel / vermutlich nach einem Rundrelief (1782) von Johann Tobias Sergel(l) oder nach dem Stich von (Anton) Wachsmann nach Sergel. – F./G. Finspong. – D. 8.6 cm (3 3/8 in.), Bh. 6.2 cm (2 7/16 in.). – 62.4 g. – Rev./Rs. „FINSPONG".
Lamprecht 369. – Inv. 1986.396.
Lit.: Cat. Sergel 1975, 82. – Rinman 1814, frontispiece / Frontispiz. – Thieme and Becker 30, 1936, 510).

86 Honoré Gabriel Riqueti, Comte de Mirabeau (1749-91), French Revolutionary and Political Leader / französischer Revolutionär und politischer Führer

Bust in profile right. / Brustbild im Profil nach rechts.
Ca. 1800. – F./G. probably/wahrscheinlich KPEG Gleiwitz. – 2.2 x 1.9 cm (7/8 x 3/4 in.), Bh. 1.8 cm (11/16 in.). – 2.4 g.
Lamprecht 382M, Photo 51. – Inv. 1986.481.183.
Lit.: Schuette 1916, 283, fig./Abb. 4.

87 Friedrich von Schiller (1759-1805), German Writer and Historian / deutscher Dichter und Historiker

Laureate head in profile right. / Kopf im Profil nach rechts mit Lorbeerkranz.
1793 [1796]. – Mod. Bernhard Frank after the bust by / nach der Büste von Johann Heinrich Dannecker. – F./G. Wasseralfingen. – D. 17.9 cm (7 1/16 in.), Bh. 11.6 cm (4 9/16 in.). – 955.3 g. – Sign. below truncation / unterhalb des Brustabschnitts „B. FRANK 1793".

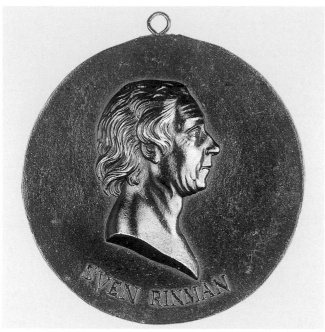

Cat. 85

Fig./Abb. 39 Rinman 1814, frontispiece / Frontispiz, sign. „gez. von Sergell" and/ und „gest. von Wachsmann" (cp./vgl. Cat. 85). Ins. „Sven Rinman / Königl. Schwed. Bergrath / Ritter des Wasa Ordens / geb. 1720 gest. 1792."

Cat. 87

Cat. 88

Lamprecht 359, Photo 41. – Inv. 1986.390.1.
Lit.: Cat. Leipzig 1915, 121, no. 79. – Eigler 2004, 42, fig./Abb. 30. – Frede 1959, 109, no. 100 (pl./Taf. XVIII). – Holst, 229 f., no. 70 (p./S. 456). – Klein, 181, fig./Abb. 2.
Bernhard Frank, a student of Johann Heinrich Dannecker, became court sculptor in Stuttgart in 1798. In the same year he sold a small plaster relief portrait of Schiller with the reverse inscription *"Friedrich Schiller im Jahre 1793 nach dem Leben gezeichnet u. modelliert von Hofbildhauer Bernhard Frank in Stuttgart."* This stands in contrast to a letter from Dannecker to Schiller dated April 6, 1796: *"Frank soll nun bald Dein Porträt zu copieren anfangen, er zittert noch zu sehr, um im kleinen es ordentlich machen zu können,"* referring apparently to Frank's copy of Dannecker's Schiller bust (Thieme and Becker 12, 339). Frede believes the date 1793 to be inaccurate, as Dannecker's bust was first modeled during the summer of 1794. He thinks it more likely that the Schiller portrait was made in 1796, as Dannecker's letter to Schiller indicates (Frede 1959, 109). More recently, Ulrich Klein asserts that the portrait was based on a small terracotta relief made in 1796 by Dannecker as a pendant to his self-portrait (Klein 2005, 181). /
Bernhard Frank, Schüler von Johann Heinrich Dannecker, war ab 1798 Hofbildhauer in Stuttgart. Im gleichen Jahr verkaufte er ein kleines Gipsporträt von Schiller mit der rückseitigen Beschriftung *„Friedrich Schiller im Jahre 1793 nach dem Leben gezeichnet u. modelliert von Hofbildhauer Bernhard Frank in Stuttgart"*. Im Gegensatz dazu steht ein Brief von Dannecker an Schiller vom 6. April 1796: *„Frank soll nun bald Dein Porträt zu copieren anfangen, er zittert noch zu sehr, um im kleinen es ordentlich machen zu können"*, anscheinend auf Franks Kopie von Danneckers Schiller-Büste hinweisend (Thieme and Becker 12, 339). Frede glaubt, daß das Datum 1793 falsch ist, weil Danneckers Büste erst im Sommer 1794 modelliert wurde. Er hält es eher für wahrscheinlich, daß das Frank-Porträt im Jahr 1796 modelliert wurde, wie Danneckers Brief an Schiller erwähnt (Frede 1959, 109). Kürzlich schrieb Ulrich Klein, daß das Schiller-Porträt von Frank als Vorbild ein Kleinrelief aus Terrakotta aus dem Jahr 1796 von Dannecker – als Pendant zu einem Selbstbildnis – habe (Klein 2005, 181).

88 Friedrich von Schiller
Laureate bust in profile right. / Brustbild im Profil rechts mit Lorbeerkranz.
Ca. 1810. – Mod. possibly/vielleicht Johann Karl Fischer after a wax portrait by / nach einem Wachsporträt von Gerhard von Kügelgen. – F./G. KPEG. – D. 8.8 cm (3 1/2 in.), Bh. 7.9 cm (3 1/8 in.). – 121.8 g.
Lamprecht 485. – Inv. 1986.477.3.
Lit.: Bekker 2001, 89, no. 629. – Frede 1959, 110, no. 105 (pl./Taf. XIX). – Klein 2005, 182, fig./Abb. 6.

89 Friedrich von Schiller
Bust in profile right. / Brustbild im Profil nach rechts.
After/nach 1810. – Mod. Leonhard Posch, probably after the bust by / wahrscheinlich nach der Büste von Gottlieb Martin Klauer. – F./G. KPEG. – D. 9.6 cm (3 3/4 in.), Bh. 8.6 cm (3 3/8 in.). – 59.5 g. – Rev./Rs. *„VII 3 Schiller"*.
Lamprecht 364. – Inv. 1986.477.1.
Lit.: Forschler-Tarrasch, no. 388. – Frede 1959, 109 f., no. 103 (pl./Taf. XVIII). – Grzimek 1982, 152, no. 1. – H. v. Sp., 300. – Hintze 1928a, 33, pl./Taf. 57 (VII 3). – Schmidt 1981, 85, fig./Abb. 55. – Stummann-Bowert, 72, no. 24 (pl./Taf. 14).
The bust referred to above, now in the Schillerhaus in Weimar, was signed by Klauer, but according to Frede, can possibly be attributed to Christian Friedrich Tieck. / Die oben genannte Büste, heute im Schillerhaus in Weimar, wurde von Klauer signiert. Laut Frede kann sie aber möglicherweise dem Bildhauer Christian Friedrich Tieck zugeschrieben werden.

90 Friedrich von Schiller
Silhouette head front. / Ausgeschnittener Kopf von vorn.
First quarter of the 19th century / 1. Viertel des 19. Jh. – 7.9 x 5.7 cm (3 1/8 x 2 1/4 in.). – 195.4 g.
Lamprecht 474. – Inv. 1986.477.2.

91 Friedrich von Schiller
Head in profile left. / Kopf im Profil nach links. / Ins. around/Umschrift *„FRIEDRICH VON SCHILLER"*.
Ca. 1890. – Mod. possibly after a medal by / vielleicht nach einer Medaille von Jean-François-Antoine Bovy. – D. 11.4 cm (4 1/2 in.), Bh. 7.5 cm (2 15/16 in.). – 160.6 g.
Lamprecht 361. – Inv. 1986.390.3.
Lit.: Cat. Leipzig 1915, 120, no. 75. – Ostergard 1994, 189, no. 26.

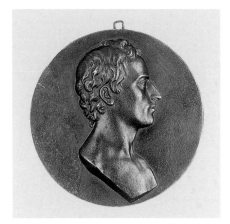

Cat. 89

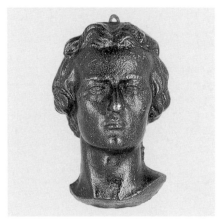

Cat. 90

Cat. 91

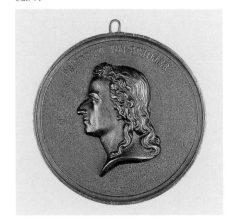

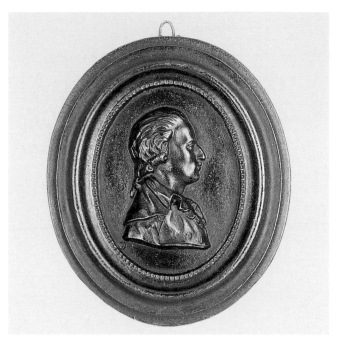

Cat. 92

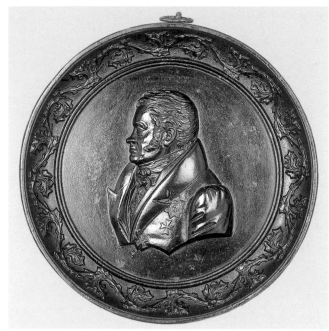

Cat. 93

92 Friedrich von Schiller
Bust in profile right in cast-iron frame. /
Brustbild im Profil nach rechts im ange-
gossenen Rahmen.
1909? – F./G. Wasseralfingen. – 17.1 x
14.6 cm (6 3/4 x 5 3/4 in.), Bh. 8.5 cm
(3 3/8 in.). – 693.6 g.
Lamprecht 360. – Inv. 1986.390.2.
Lit.: Cat. Leipzig 1915, 121, no. 81. –
Förschner, 78, no. 54.
Possibly cast to commemorate the 150th
anniversary of Schiller's birth. I thank F. W.
Eigler for the information. / Möglicherweise
auf den 150. Geburtstag Schillers entstan-
den. Meinen Dank an F. W. Eigler für den
Hinweis.

**93 Heinrich Friedrich Karl Freiherr
vom und zum Stein (1757-1831), Prus-
sian Statesman / preußischer Staatsmann**
Bust in profile left in civilian dress with the
Order of the Black Eagle and the Iron Cross,
in cast iron frame. / Brustbild im Profil nach
links in Zivilkleidung mit dem Stern des
Schwarzen Adlerordens und dem Eisernen
Kreuz im angegossenen Rahmen.
Ca. 1820. – F./G. KPEG. – D. 18 cm
(7 1/16 in.), Bh. 10.1 cm (4 in.). – 973.1 g.
Lamprecht 312, Photo 43. – Inv. 1986.348.
Lit.: Cat. Leipzig 1915, 125, no. 108. – Os-

tergard 1994, 184, no. 18 (model erroneous-
ly attributed to Leonhard Posch / Modell irr-
tümlich Leonhard Posch zugeschrieben).

**94 Anton Count Stolberg-Wernigerode
(1785-1854), Prussian Statesman / Graf
von Stolberg-Wernigerode, preußischer
Staatsmann**
Bust in profile left. / Brustbild im Profil
nach links.
1822. – Mod. Leonhard Posch. – F./G. prob-
ably/wahrscheinlich Ilsenburg. – D. 8.7 cm
(3 7/16 in.), Bh. 7.8 cm (3 1/16 in.). – 77.9 g.
Lamprecht 368. – Inv. 1986.395.
Lit.: Aus einem Guß, 232, no. 1945. – Cat.
Leipzig 1915, 124, no. 106. – Forschler-
Tarrasch, no. 397.

**95 Charles Maurice de Talleyrand-
Périgord (1754-1838), French Diplomat /
französischer Diplomat**
(Fig. p./Abb. S. 88)
Bust almost front in uniform with sash and
medals. / Brustbild fast von vorn in Uni-
form mit Ordensband und Orden. / Ins.
around/Umschrift „F: TALLEYRAND KON:
FR: MINISTER".
Ca. 1814-15. – Mod. Leopold Heuberger. –
F./G. KPEG Gleiwitz. – D. 5.4 cm (2 1/8 in.),

Bh. 4.6 cm (1 13/16 in.). – 40.1 g. – Sign.
below truncation / unterhalb des Brustab-
schnitts „L. HEUBERGER F.".
Lamprecht 339. – Inv. 1986.371.
Lit.: Wurzbach-Tannenberg, no. 8674.
Created as part of a series of participants at
the Congress of Vienna. / Teil einer Serie
von Teilnehmern des Wiener Kongresses.

Cat. 94

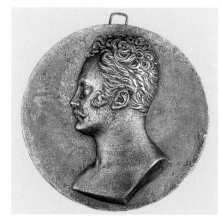

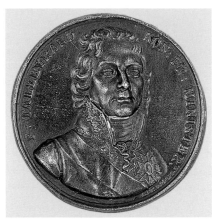

Cat. 95

96 Theresa Charlotte, Queen of Bavaria (1792-1854) / Königin von Bayern

Head in profile left in cast-iron frame. / Kopf im Profil nach links im angegossenen Rahmen. / Ins. around/Umschrift „MVEN-CHEN / MDCCCXXXVI".
1836. – Mod. Franz Woltreck. – F./G. Bodenwöhr (?) – D. 23.1 cm (9 1/8 in.), Bh. 13.3 cm (5 1/4 in.). – 2182. 5 g. – Traces of bronze patina on frame. / Reste von Bronzierung am Rahmen. – Sign. on truncation / am Brustabschnitt „F. WOLTRECK".
Lamprecht 345, Photo 41. – Inv. 1986.377. Lit.: Cat. Leipzig 1915, 114, no. 3.
Born princess of Saxony-Hildburghausen, in 1810 married King Ludwig I of Bavaria. / Geborene Prinzessin von Sachsen-Hildburghausen, ab 1810 mit König Ludwig I. von Bayern verheiratet.

97 Unknown Man / Unbekannter Mann

Bust in profile left with drapery. / Brustbild im Profil nach links mit Draperie.

Ca. 1800. – F./G. probably/wahrscheinlich KPEG Gleiwitz. – 2.2 x 1.7 cm (7/8 x 11/16 in.), Bh. 1.8 cm (11/16 in.). – 1.8 g. Lamprecht 373M, Photo 51. – Inv. 1986.481.174.

98 Unknown Man / Unbekannter Mann

Bust in profile right with drapery. / Brustbild im Profil nach rechts mit Draperie.
Ca. 1800. – F./G. probably/wahrscheinlich KPEG Gleiwitz. – 1.9 x 1.6 cm (3/4 x 5/8 in.), Bh. 1.5 cm (9/16 in.). – 1.4 g. Lamprecht 392M, Photo 55. – Inv. 1986.481.193.

99 Unknown Man / Unbekannter Mann

Bust in profile right in civilian dress. / Brustbild im Profil nach rechts in Zivilkleidung.
Ca. 1800. – F./G. probably/wahrscheinlich KPEG Gleiwitz. – 2.1 x 1.9 cm (13/16 x 3/4 in.), Bh. 1.9 cm (3/4 in.). – 1.7 g. Lamprecht 393M. – Inv. 1986.481.194.

100 Unknown Man / Unbekannter Mann

Bust in profile left. / Brustbild im Profil nach links.
Ca. 1800. – F./G. probably/wahrscheinlich KPEG Gleiwitz. – 2 x 1.9 cm (13/16 x 3/4 in.), Bh. 1.7 cm (11/16 in.). – 2.0 g. Lamprecht 375M. – Inv. 1986.481.176.

101 Unknown Man / Unbekannter Mann

Bust in profile right with drapery. / Brustbild im Profil nach rechts mit Draperie.
Ca. 1800. – F./G. probably/wahrscheinlich KPEG Gleiwitz. – 2.1 x 1.7 cm (13/16 x 11/16 in.), Bh. 1.7 cm (11/16 in.). – 2.3 g. Lamprecht 371M, Photo 55. – Inv. 1986.481.172.

102 Unknown Officer / Unbekannter Offizier

Bust in profile left in uniform in cast-iron frame. / Brustbild im Profil nach links in Uniform im angegossenen Rahmen.
First quarter of the 19th century / 1. Viertel des 19. Jh. – D. 12.2 cm (4 13/16 in.), Bh. 8.7 cm (3 7/16 in.). – 680.0 g. – Sign. on frame / am Rahmen „G. KLEMM".
Lamprecht 313. – Inv. 1986.349.

103 George Washington (1732-99), American General and First President of the United States / amerikanischer General und erster Präsident der Vereinigten Staaten von Amerika

Bust in profile right. / Brustbild im Profil nach rechts. / Ins. around/Umschrift „GEORGIO WASHINGTON SVPREMO DVCI EXERCITVVM ADSERTOR LIBERTATIS", Ins. below/unten „COMITIA AMERICANA".
1798-1800. – Mod. after a medal by / nach einer Medaille von Benjamin Duvivier, based on the bust by / nach der Büste von Jean-Antoine Houdon. – F./G. KPEG Gleiwitz. – D. 6.7 cm (2 5/8 in.), Bh. 5.1 cm (2 in.). – 56.5 g. – Sign. below truncation / unterhalb des Brustabschnitts „DUVIVIER / PARIS F."
Lamprecht 355, Photo 61. – Inv. 1986.447. Lit.: Ostergard 1994, 186, no. 20. – s. also/ auch Rulau and Fuld, 56 ff.
This medallion is the obverse of the so-called „Washington before Boston" medal, commissioned by the Continental Congress to commemorate the liberation of Boston from British occupation in March of 1776. The first medal was actually struck in Paris in 1790. A gold specimen was presented by Congress to Washington the same year. This medal now resides in the Boston Public Library. The inscription translates as: *"To George Washington supreme general*

Cat. 97–101 ca. original size/Originalgröße

Cat. 97

Cat. 98

Cat. 99

Cat. 100

Cat. 101

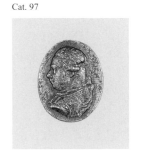
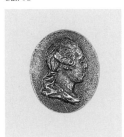
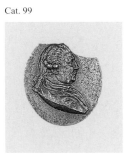
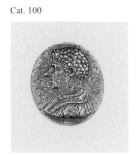
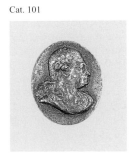

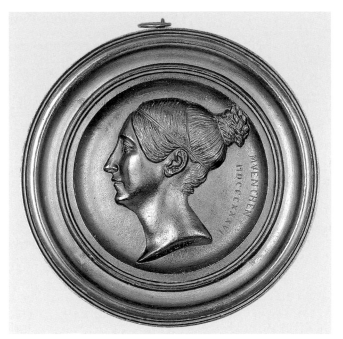

Cat. 96

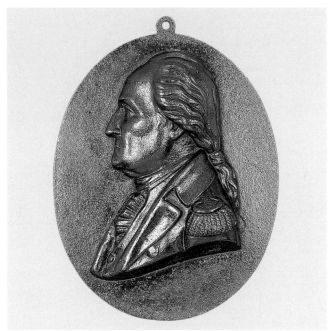

Cat. 104

of the army defender of liberty" and „*The American Congress".* /
Dieses Medaillon ist die Vorderseite der vom Continental Congress in Auftrag gegebenen sogenannten „Washington before Boston"-Medaille zum Gedenken an die Befreiung Bostons von der britischen Besetzung in März 1776. Die erste Medaille wurde 1790 in Paris geprägt. Ein goldenes Exemplar befindet sich heute in der Boston Public Library. Die Umschrift lautet übersetzt: „*An George Washington oberster General der Armee Beschützer der Freiheit"* und „*Der amerikanische Kongreß".* Cp./ vgl. George Fuld, "The Washington before Boston Medal," in *Token and Medal Society Journal* 3 (1966), 111-27.

104 George Washington
Bust in profile left in the uniform of the American Continental Army. / Brustbild im Profil nach links in der Uniform der American Continental Army.
First quarter of the 19th century / 1. Viertel des 19. Jh. – F./G. Lauchhammer (?). – 22.7 x 18.0 cm (8 15/16 x 7 1/16 in.), Bh. 18.7 cm (7 3/8 in.). – 1535.7 g. – Rev./Rs. „*L 2".*

Lamprecht 344, Photo 42. – Inv. 1986.376. Lit.: Cat. Leipzig 1915, 114, no. 2 (erroneously identified as Friedrich August I, King of Saxony / irrtümlich identifiziert als Friedrich August I., König von Sachsen). The identification of this portrait was con-

firmed by Washington experts Russell Rulau and Dr. George Fuld. / Die Identifizierung dieses Porträts wurde durch die Washington-Experten Russell Rulau und George Fuld bestätigt.

Cat. 102

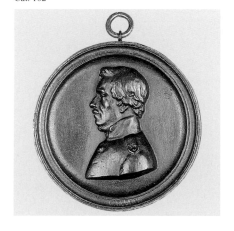

Cat. 103

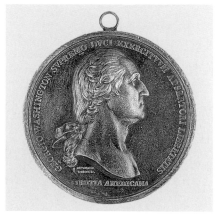

105 Heinrich Heine (?; 1797-1856), German Poet and Journalist / Deutscher Dichter und Journalist
(Fig./Abb. s. p./S. 59)
Head in profile left in cast-iron frame. / Kopf im Profil nach links im angegossenen Rahmen.
1850-55. – Mod. Ernst Friedrich August Rietschel (?). – F./G. Lauchhammer (?). – D. 13.1 cm (5 3/16 in.), Bh. 6.8 cm (2 11/16 in.). – 295.3 g.
Lamprecht 377. – Inv. 1986.404.
Museum records received from ACIPCO indicate that the sitter in this portrait is Carl Maria von Weber (1786-1826), while Lamprecht's *"Handexemplar"* clearly states that the medallion is a portrait of Heinrich Heine. The nature of the modeling suggests that the portrait was made by the same artist that created the portrait of Prince Albert of Saxony in Cat. 1, and the identical decoration on the frame indicates that the same foundry cast it. Given the date of the piece, it seems more likely that the portrait represents Heine, however this is merely conjecture. Cp. Cat. 1. /
Museenakten von ACIPCO weisen darauf hin, daß das Porträt Carl Maria von Weber (1786-1826) darstellt, während Lamprechts „Handexemplar" deutlich erklärt, daß es sich um das Bildnis Heinrich Heines handelt. Nach der Art der Modellierung zu urteilen wurde das Porträt vom selben Künstler geschaffen wie das Porträt von Prinz Albert von Sachsen in Cat. 1, und die identische Dekoration am Rahmen läßt darauf schließen, daß die selbe Gießerei es gegossen hat. Nach dem Datum des Stücks scheint es wahrscheinlicher, daß das Porträt Heine darstellt, jedoch ist dies eine reine Vermutung. Vgl. Cat. 1.

106 Johann Andreas Christoph Weise (1781-1850), Prussian Statesman / preußischer Staatsmann
Bust in profile left in civilian dress. / Brustbild im Profil nach links in Zivilkleidung.
1810. – Mod. Leonhard Posch. – F./G. KPEG. – D. 8.3 cm (3 1/4 in.), Bh. 7.1 cm (2 13/16 in.). – 59.2 g. – Sign. below truncation / unterhalb des Brustabschnitts „Posch".
Lamprecht 322. – Inv. 1986.355.
Lit.: Cat. Leipzig 1915, 126, no. 122 (erroneously identified as Karl August, Grand Duke of Weimar / irrtümlich identifiziert als Karl August, Großherzog von Weimar). – Forschler-Tarrasch, no. 407.

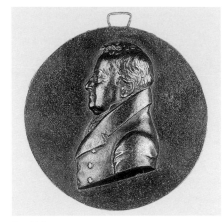
Cat. 106

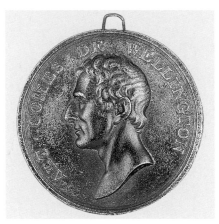
Cat. 107

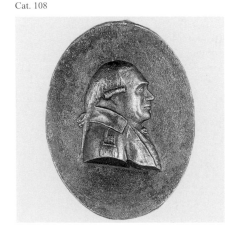
Cat. 108

107 Sir Arthur Wellesley, Earl (later Duke) of Wellington, Prince of Waterloo (1769-1852), British Field Marshal and Statesman / Graf (später Herzog) von Wellington, Fürst von Waterloo, britischer Feldmarschall und Staatsmann
Head in profile left. / Kopf im Profil nach links. / Ins. around/Umschrift *„ART. COMES DE WELLINGTON".*
Ca. 1815. – Mod. after a medal by / nach einer Medaille von Thomas Webb. – F./G. KPEG. – D. 5.1 cm (2 in.), Bh. 4.0 cm (1 9/16 in.). – 28.7 g. – Sign. on truncation / am Brustabschnitt *„Webb".*
Lamprecht 341, Photo 60. – Inv. 1986.373.
Lit.: Cat. Leipzig 1915, 130, no. 160. – Eimer, 22, no. 11. – Schmidt 1976, fig./Abb. 32. – Wurzbach-Tannenberg, no. 9268.
Webb's silver medal was created to commemorate British victories in Spain. / Webbs silberne Medaille wurde auf die britischen Siege in Spanien geprägt.

108 Abraham Gottlob Werner (1749/50-1817), Professor of Mineralogy and Mining at the Mining Academy in Freiberg / Professor für Mineralogie und Bergwesen an der Bergakademie Freiberg
Bust in profile right in civilian uniform with crossed hammer and gad on epaulet. / Brustbild im Profil nach rechts in Ziviluniform mit Schlägel und Eisen auf der Achselklappe.
1798-1800. – F./G. KPEG Gleiwitz. – 7 x 5.2 cm (2 3/4 x 2 1/16 in.), Bh. 4.2 cm (1 5/8 in.). – 40.9 g.
Lamprecht 376. – Inv. 1986.403.
Lit.: Arenhövel 1982, 62, no. 107. – Hintze 1928a, 103, pl./Taf. 73, no. 1.

109 Christoph Martin Wieland (1733-1813), German Writer / deutscher Schriftsteller
Bust in profile left. / Brustbild im Profil nach links.
1809. – Mod. Leonhard Posch after the 1808 wax portrait by / nach dem Wachsporträt (1808) von Gerhard von Kügelgen. – F./G. KPEG. – D. 9.7 cm (3 7/8 in.), Bh. 8.2 cm (3 1/4 in.). – 81.4 g.
Lamprecht 365. – Inv. 1986.392.
Lit.: Bekker 2001, no. 622. – Forschler-Tarrasch, no. 410. – Frede 1959, 119, no. 126 (no ill./keine Abb.). – Hintze 1928a, 33, pl./Taf. 57 (VII 2). – Schmidt 1981, 86, fig./Abb. 56.

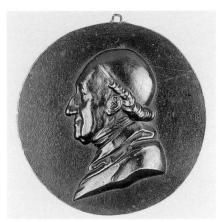

Cat. 109

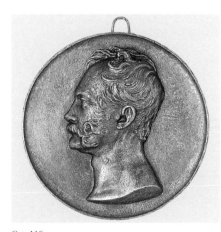

Cat. 110

Cat. 111

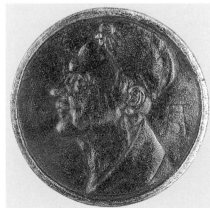

110 Wilhelm I, King of Prussia (1797-1888; 1861 King; 1871 Emperor of Germany) / Wilhelm I., König von Preußen (1861 König; 1871 Deutscher Kaiser)
Head in profile left. / Kopf im Profil nach links.
Ca. 1861. – Mod. Ferdinand August Fischer. – F./G. KPEG. – D. 7.6 cm (3 in.), Bh. 6.2 cm (2 7/16 in.). – 80.0 g. – Sign. below truncation / unterhalb des Brustabschnitts „A. FISCHER" (hardly legible / kaum lesbar).
Lamprecht 351, Photo 48. – Inv. 1986.382.
Lit.: Cat. Leipzig 1915, 124, no. 104.

111 Michael Wohlgemuth (1434-1519), Painter and Teacher of Albrecht Dürer / Maler und Lehrer Albrecht Dürers
Bust in profile left. / Brustbild im Profil nach links.
First quarter of the 19th century / 1. Viertel des 19. Jh. – Mod. after a medal by / nach einer Medaille von Albrecht Dürer (1508). – D. 5.1 cm (2 in.), Bh. 4.7 cm (1 7/8 in.). – 30.7 g. – Sign. front "D" below "A" / vorn „D" unter „A".
Lamprecht 475. – Inv. 1986.469.
Lit.: Domanig 1907, 41, pl./Taf. 5. – s. Forrer 1, 674 (for illustration of original Dürer medal / für eine Abbildung der originalen Dürer-Medaille).

112 Friedrich Heinrich Ernst, Graf von Wrangel (1784-1877), Prussian Cavalry General (1856 General Field Marshal) / preußischer General der Kavallerie (1856 Generalfeldmarschall)
Bust in profile left in uniform with mantle. / Brustbild im Profil nach links in Uniform mit Draperie. / Ins. around/Umschrift „F.v. WRANGEL GEN. D. CAVAL".
Third quarter of the 19th century / 3. Viertel des 19. Jh. – D. 13.6 cm (5 3/8 in.), Bh. 10.4 cm (4 1/8 in.). – 294.1 g.
Lamprecht 352. – Inv. 1986.383.

113 Karl Philipp Prince of Wrede (1767-1838), Field Marshal / Fürst von Wrede, Feldmarschall
Bust front in uniform with sash and medals. / Brustbild von vorn in Uniform mit Ordensband und Orden. / Ins. around/Umschrift „FELD.MARSCHALL FÜRST V: WREDE".
Ca. 1814-15. – Mod. Leopold Heuberger. – F./G. KPEG Gleiwitz. – D. 5.4 cm (2 1/8 in.),

Bh. 4.6 cm (1 13/16 in.). – 39.3 g. – Sign. below truncation / unterhalb des Brustabschnitts „HEUBERGER F.".
Lamprecht 338. – Inv. 1986.370.
Lit.: Wurzbach-Tannenberg, no. 9884.
Part of series made on the occasion of the Congress of Vienna. / Teil einer Serie, die anläßlich des Wiener Kongresses geschaffen wurde.

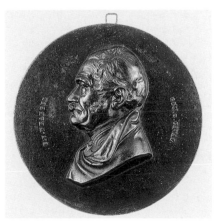

Cat. 112

Cat. 113

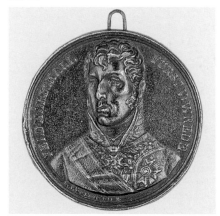

New Year's Cards / Neujahrskarten (Cat. 114-38)

KPEG Berlin (Cat. 114-23)

114 New Year's Card / Neujahrskarte 1819

In central square panel the Neue Wache in Berlin, designed 1817-18 by Karl Friedrich Schinkel and the cast-iron bridge over the Operngraben; in the upper left corner a monument in the form of an obelisk for Johann Gottlieb Fichte, erected at the Oranienburger Tor cemetery in Berlin; in the lower left corner a monument for Count Wilhelm von Schwerin in the Krekow church; at right a monument in the form of a tall obelisk with four lions on the base for the Russian Prince Kutusow, erected in Bunzlau, designed by Schinkel, the lions after models by Johann Gottfried Schadow. / Oben in dem abgegrenzten Feld die von Karl Friedrich Schinkel entworfene, 1817-18 erbaute Neue Wache und die gußeiserne Brücke über den Operngraben in Berlin. Daneben oben links ein Denkmal in Form eines kleinen Obelisken für Johann Gottlieb Fichte, aufgestellt auf dem Friedhof am Oranienburger Tor zu Berlin, unten links das Denkmal für den Reichsgrafen Wilhelm von Schwerin in der Kirche zu Krekow. Rechts das in Bunzlau errichtete, von Karl Friedrich Schinkel entworfene, Denkmal für den russischen Feldmarschall Fürst Kutusow in Form eines hohen Obelisken mit vier Löwen am Sockel, die nach Modellen von Johann Gottfried Schadow gefertigt wurden. / Ins. „1819".
Mod. Louis Beyerhaus. – F./G. KPEG Berlin. – 6.5 x 8.9 cm (2 9/16 x 3 1/2 in.). – 52.4 g.
Lamprecht 486. – Inv. 1986.478.1.
Lit.: Arenhövel 1982, 32, no. 16. – Aus einem Guß, 24, no. 7. – Bartel 2004, no. 314-17. – Cat. Köln 1979, 70, no. 375. – Schmidt 1981, 190, fig./Abb. 75. – Schmitz 1917, 50, pl./Taf. 3. – Strothotte, 278, no. 1819-2. – Stummann-Bowert, 168, no. 11.

115 New Year's Card / Neujahrskarte 1822

Six of the twelve figures from the Kreuzberg Monument in Berlin. / Sechs der zwölf Genien des Kreuzbergdenkmals in Berlin. / Ins. „GROSS GÖRSCHEN / KATZBACH / CULM / GROSS BEEREN / DEÑEWITZ / LEIPZIG" and/und „1822".
Mod. Louis Beyerhaus. – F./G. KPEG Berlin. – 6.5 x 8.9 cm (2 9/16 x 3 1/2 in.). – 61.0 g.
Lamprecht 468. – Inv. 1986.463.
Lit.: Arenhövel 1982, 33 f., no. 19. – Aus einem Guß, 25, no. 9. – Bartel 2004, no. 325-32. – Ostergard 1994, 188, no. 23. – Schmidt 1981, 131, fig./Abb. 119. – Schmitz 1917, 51, pl./Taf. 3. – Schuette 1916, 283, fig./Abb. 10. – Strothotte, 283, no. 1822-3.

116 New Year's Card / Neujahrskarte 1836

In the middle the gate to the entrance hall at Babelsberg Castle, flanked on either side by figures from the iron bridge in Sanssouci, mounted in cast-iron frame. / Im Mittelfeld das Portal zur Eingangshalle des Schlosses in Babelsberg. Auf den Seitenfeldern die Figuren der eisernen Brücke in Sanssouci, in eiserner Fassung. / Ins. „1836".
Mod. possibly/vielleicht Christoph Carl Pfeuffer. – KPEG Berlin. – 8.2 x 10.3 cm (3 1/4 x 4 1/16 in.). – 158.4 g.
Lamprecht 417, Photo 63. – Inv. 1986.431.1.
Lit.: Arenhövel 1982, 40, no. 33. – Aus einem Guß, 26, no. 21. – Bartel 2004, no. 372-77. – Cat. Leipzig 1915, 128, no. 139. – Schmidt 1981, 92, fig./Abb. 83. – Schmitz 1917, 52, pl./Taf. 6. – Strothotte, 309, no. 1836-2. – Stummann-Bowert, 170, no. 32.
Babelsberg, in Potsdam, was the home of Prince Wilhelm of Prussia (1797-1888), later Emperor Wilhelm I. The iron bridge at Sanssouci was designed by August Kiss. / Das Schloß Babelsberg in Potsdam gehörte dem Prinzen Wilhelm von Preußen, dem späteren Kaiser Wilhelm I. Die eiserne Brücke im Park von Sanssouci wurde von August Kiss entworfen.

117 New Year's Card / Neujahrskarte 1837

In the middle the Amazon Column, left a plant stand, and right a three-tiered fruit dish; in the upper left and right corners are supports for a balcony. / In der Mitte die Amazonensäule, daneben links ein Blumenständer auf einem Sockel und rechts eine mehrstufige Obstschale. Oben links und rechts Balkonkonsolen mit Gitter. / Ins. „1837".
Mod. Christoph Carl Pfeuffer. – KPEG Berlin. – 6.3 x 8.5 cm (2 1/2 x 3 3/8 in.). – 45.2 g.
Lamprecht 487. – Inv.1986.478.2.
Lit.: Andrews, 422, fig./Abb. 3. – Arenhö-vel 1982, 40, no. 34. – Aus einem Guß, 26, no. 22. – Bartel 2004, no. 378-81. – Ostergard 1994, 208, no. 56. – Schmitz 1917, 52, pl./Taf. 6. – Strothotte, 309, no. 1837-1.
The so-called "Amazon Column" was modeled by Ferdinand August Fischer after a design by Johann Heinrich Strack. / Die sogenannte „Amazonensäule" wurde von Ferdinand August Fischer nach einem Entwurf von Johann Heinrich Strack modelliert.

118 New Year's Card / Neujahrskarte 1839

Obv./Vs.: The Neues Tor and the Royal Prussian Iron Foundry, Berlin, as seen from the city. / Das Neue Tor und die Königliche Eisengießerei in Berlin von der Stadt aus gesehen. / Ins. „DAS NEUE THOR UND DIE KÖN. EISENGIESSEREI" and/und „1839".
Rev./Rs.: The Neues Tor and the Luisenstraße, as seen from the iron foundry looking toward the city. / Das Neue Tor und die Luisenstraße mit Blick in die Stadt. / Ins. „DAS NEUE THOR UND DIE LUISENSTRASSE".
F./G. KPEG Berlin. – 6.3 x 8.9 cm (2 1/2 x 3 1/2 in.). – 77.1 g. – In fine silver frame with original red leather and gilt etui. / Mit Silberrahmen im originalen, roten Lederetui.
Lamprecht 418, Photo 62 f. – Inv. 1986.431.2.
Lit.: Arenhövel 1982, 41, no. 36. – Aus einem Guß, 27, no. 24. – Bartel 2004, no. 386-92. – Cat. Leipzig 1915, 128, no. 140. – Ostergard 1994, 211, no. 61. – Schmitz 1917, 53, pl./Taf. 6. – Strothotte, 314, no. 1839-3. – Stummann-Bowert, 170, no. 33.

119 New Year's Card / Neujahrskarte 1843

View of the Berlin-Stettin train station in Berlin. / Ansicht des Berlin-Stettiner Bahnhofs in Berlin. / Ins. „BERL.STETTIN.EISENBAHN-HOF" and/und „1843".
F./G. KPEG Berlin. – 6.6 x 8.9 cm (2 5/8 x 3 1/2 in.). – 116.2 g. – On polished steel plate with fine silver frame in original red leather and gilt etui. / Auf einer polierten Stahlplatte mit feinem Silberrahmen, im originalen, roten Lederetui.
Lamprecht 419, Photo 62. – Inv. 1986.431.3.
Lit.: Arenhövel 1982, 43, no. 40. – Aus einem Guß, 27, no. 27. – Bartel 2004, no. 406-09. – Cat. Leipzig 1915, 128, no. 141. – Ostergard 1994, 213, no. 63. – Schmitz 1917, 53, pl./Taf. 7. – Strothotte, 320, no. 1843-2.

Cat. 114

Cat. 117

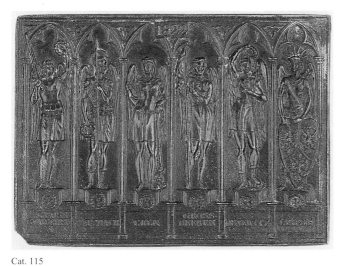

Cat. 115

Cat. 116

Cat. 118

Cat. 119

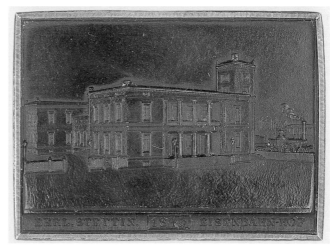

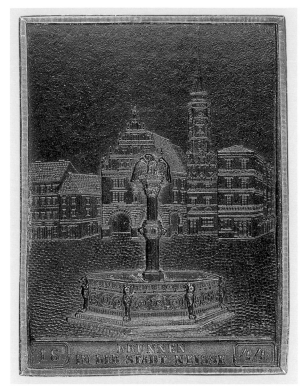

Cat. 120

Cat. 121

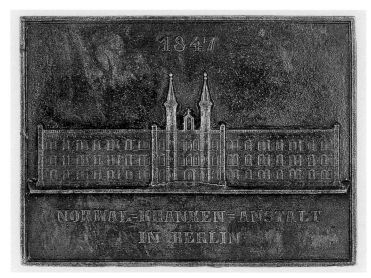

Cat. 122

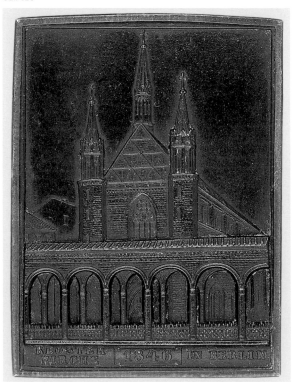

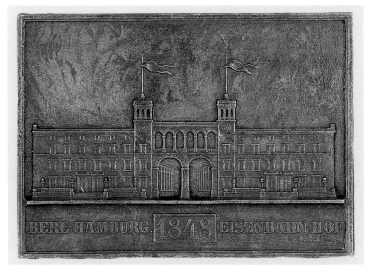

Cat. 123

120 New Year's Card / Neujahrskarte 1844

View of fountain in the city of Neisse. / Ansicht des Brunnens in Neiße. / Ins. *„BRUNNEN IN DER STADT NEISSE"* and/und *„1844"*.

F./G. KPEG Berlin. – 8.9 x 6.6 cm (3 1/2 x 2 5/8 in.). – 108.7 g. – On polished steel plate with fine silver frame in original red leather and gilt etui. / Auf polierter Stahlplatte mit Silberrahmen im originalen, roten Lederetui.

Lamprecht 420, Photo 62. – Inv. 1986.431.4. Lit.: Arenhövel 1982, 43, no. 41. – Bartel 2004, no. 410-12. – Cat. Leipzig 1915, 128, no. 142. – Ostergard 1994, 210, no. 59. –

Schmitz 1917, 53, pl./Taf. 7. – Strothotte, 321, no. 1844-2.

121 New Year's Card / Neujahrskarte 1846
View of the Klosterkirche in Berlin. / Ansicht der Klosterkirche in Berlin. / Ins. *„KLOSTER-KIRCHE IN BERLIN"* and/ und *„1846"*.
F./G. KPEG Berlin. – 8.9 x 6.6 cm (3 1/2 x 2 5/8 in.). – 64.5 g.
Lamprecht 421, Photo 63. – Inv. 1986.431.5.
Lit.: Andrews, 422, fig./Abb. 3. – Arenhövel 1982, 43, no. 43. – Aus einem Guß, 27, no. 29. – Bartel 2004, no. 416-19. – Cat. Leipzig 1915, 128, no. 143. – Schmitz 1917, 53, pl./Taf. 7. – Strothotte, 324, no. 1846-3. – Stummann-Bowert, 171, no. 42.

122 New Year's Card / Neujahrskarte 1847
View of Normal Hospital in Berlin. / Ansicht der Krankenanstalt Bethanien. / Ins. *„NORMAL=KRANKEN=ANSTALT IN BERLIN"* and/und *„1847"*.
F./G. KPEG Berlin. – 6.4 x 8.3 cm (2 1/2 x 3 1/4 in.). – 42.6 g.
Lamprecht 488. Inv. 1986.478.3.
Lit.: Arenhövel 1982, 43, no. 44. – Aus einem Guß, 27, no. 30. – Bartel 2004, no. 420-23. – Schmitz 1917, 53, pl./Taf. 7. – Strothotte, 326, no. 1847-3. – Stummann-Bowert, 171, no. 43.

123 New Year's Card / Neujahrskarte 1848
View of the Berlin-Hamburg railway station. / Ansicht des Hamburger Bahnhofes. / Ins. *„BERL-HAMBURG EISENBAHNHOF"* and/und *„1848"*.
F./G. KPEG Berlin. – 6.4 x 8.3 cm (2 1/2 x 3 1/4 in.). – 48.9 g.
Lamprecht 489. – Inv. 1986.478.4.
Lit.: Arenhövel 1982, 44, no. 45. – Aus einem Guß, 27, no. 31. – Bartel 2004, no. 424-27. – Ostergard 1994, 213, no. 64. – Schmitz 1917, 53, pl./Taf. 7. – Strothotte, 327, no. 1848-2. – Stummann-Bowert, 171, no. 44.

KPEG Sayn (Cat. 124-29)

124 New Year's Card / Neujahrskarte 1824
View of the tombstone of the Roman officer Centurio Marcus Caelius. / Darstellung der Grabplatte des Centurio Marcus Caelius. / Ins. *„SAYNERHÜTTE MDCCCXXIV"*.

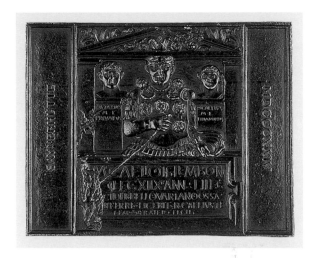
Cat. 124

Mod. Heinrich Zumpft. – F./G. KPEG Sayn. – 8.9 x 11.1 cm (3 1/2 x 4 3/8 in.). – 105.3 g.
Inv. 1962.98. – Gift of / Schenkung von Dr. and Mrs. Maurice Garbáty.
Lit.: Arenhövel 1982, 46, no. 51. – Aus einem Guß, 39, no. 34. – Beitz, 90, 92, fig./Abb. 6. – Cat. Köln 1979, 65, no. 325. – Friedhofen, 88. – Ostergard 1994, 191, no. 29. – Strothotte, 287, no. 1824-1. – Stummann-Bowert, 172, no. 6.
Roman officer Centurio Marcus Caelius was killed in the first century A. D. campaign of Varus. The original tombstone is now in the Rheinisches Landesmuseum in Bonn. / Centurio Marcus Caelius, ein römischer Offizier, fiel im Feldzug des Varus im 1. Jahrhundert n. Chr. Die Grabplatte befindet sich heute im Rheinischen Landesmuseum in Bonn.

125 New Year's Card / Neujahrskarte 1825
Plaster cast of the New Year's card with a view of the cathedral in Bonn, in cardboard frame under glass. / Gipsabdruck der Neujahrskarte mit der Ansicht der Münsterkirche zu Bonn, im Papprahmen unter Glas. / Ins. *„DIE MUENSTERKIRCHE ZU BONN"*.
Mod. Heinrich Zumpft. – F./G. KPEG Sayn. – 15.9 x 13.3 cm (6 1/4 x 5 1/4 in.).
Lamprecht 494. – Inv. 1986.478.7.
Lit.: Cp./vgl. Arenhövel 1982, 46, no. 52. – Aus einem Guß, 39, no. 35. – Cat. Köln 1979, 65, no. 326. – Friedhofen, 88. – Strothotte, 289, no. 1825-3. – Stummann-Bowert, 172, no. 7.
Zumpft's original model was not accepted by the Oberbergamt Bonn and was slightly altered by his colleague Bernhard Hundeshagen. / Zumpfts Originalmodell wurde vom

Oberbergamt Bonn nicht angenommen. Es wurde von seinem Kollegen Bernhard Hundeshagen leicht überarbeitet.

126 New Year's Card / Neujahrskarte 1826
Plaster cast of the New Year's card with a view of the Königsstuhl in Rense by Stolzenfels on the Rhine. / Gipsabdruck der Neujahrskarte mit Ansicht vom Königsstuhl von Rense bei Stolzenfels am Rhein. / Ins. *„DIESS IST DER ALTE KOENIGSSTUHL VON RENSE / BEI STOLZENFELS AM RHEIN HATT ER GESTANDEN"*.
Mod. Heinrich Zumpft after a drawing by / nach einer Zeichnung von Bernhard Hundeshagen. – F./G. KPEG Sayn. – 13.4 x 15.5 cm (5 1/4 x 6 1/8 in.).
Lamprecht 493. – Inv. 1986.478.6.

Cat. 125

Cat. 126

Cat. 127

Lit.: Cp./vgl. Arenhövel 1982, 46, no. 53. –
Aus einem Guß, 39, no. 36. – Cat. Köln
1979, 65, no. 328. – Friedhofen, 88 f. –
Strothotte, 291, no. 1826-2. – Stummann-
Bowert, 172, no. 8.
The Königsstuhl was the place where the
Holy Roman Emperor was elected in the
Middle Ages. In 1804 it was destroyed by
the French in order to build a street. The
monument was rebuilt by Johann Claudius
von Lassaulx in 1842-43. / Im Mittelalter

wurde der Heilige Römische Kaiser Deut-
scher Nation am Königsstuhl gewählt. 1804
wurde er von den Franzosen wegen eines
Straßenbaus zerstört. Das Denkmal wurde
von Johann Claudius von Lassaulx 1842-43
wiederaufgebaut.

**127 New Year's Card / Neujahrskarte
1840**
Plaster cast of the New Year's card with a
view of the Monastery St. Gereon in Co-

logne. / Gipsabdruck der Neujahrskarte mit
der Ansicht der Stiftskirche St. Gereon in
Köln. / Ins. „STIFTSKIRCHE ST. GERE-
ON IN CÖLN".
Mod. possibly/vielleicht Carl Christian Cra-
mer after a drawing by / nach einer Zeich-
nung von Georg Osterwald. – F./G. KPEG
Sayn. – 15.8 x 13.4 cm (6 1/4 x 1/4 in.).
Lamprecht 495. – Inv. 1986.478.8.
Lit.: Cp./vgl. Arenhövel 1982, 50, no. 67. –
Aus einem Guß, 40, no. 49. – Cat. Köln

Cat. 128

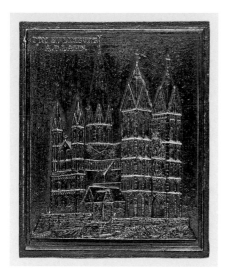

Cat. 129

1979, 66, no. 338. – Friedhofen, 90. Strothotte, 316, no. 1840-2. – Stummann-Bowert, 174, no. 23.

128 New Year's Card / Neujahrskarte 1841

Original view of the Trier Cathedral from the eleventh century. / Ursprüngliche Ansicht des Doms zu Trier aus dem 11. Jahrhundert. / Ins. „SAYNERHUETTE MDCCCXXXXI / URSPRÜNGLICHE ANSICHT DES DO- MES ZU TRIER AUS DEM XI IAHRHUN- DERTE".
Mod. Carl Christian Cramer after a draw- ing by / nach einer Zeichnung von Georg Osterwald. – F./G. KPEG Sayn. – 8.9 x 11.1 cm (3 1/2 x 4 3/8 in.). – 86.5 g. – Sign. illegible/unleserlich. / In original red leather gilt etui with descriptive card. / Im origina- len, roten Lederetui mit Beschreibungskar- te.
Inv. 1962.97. – Gift of / Schenkung von Dr. and Mrs. Maurice Garbáty.
Lit.: Arenhövel 1982, 50 f., no. 68. – Fried- hofen, 90. – Ostergard 1994, 212, no. 62.

129 New Year's Card / Neujahrskarte 1849

View of the Limburg Cathedral. / Ansicht des Doms zu Limburg. / Ins. „DOM ZU LIMBURG / A. D. LAHN".
Mod. Wilhelm Samuel Weigelt. – F./G. KPEG Sayn. – 12 x 9.6 cm (4 3/4 x 3 3/4 in.). – 122.3 g.
Lamprecht 492. – Inv. 1986.478.5.

Lit.: Arenhövel 1982, 52, no. 76. – Aus ei- nem Guß, 41, no. 56. – Cat. Köln 1979, 66, no. 345. – Friedhofen, 91. – Strothotte, 328, no. 1849-1. – Stummann-Bowert, 174, no. 32.
Undated examples of the Sayn New Year's cards were made for retail sale. / Undatierte Exemplare der Sayner Neujahrskarten wur- den für den Verkauf hergestellt.

Neusalz an der Oder (Nowa Sól, Poland/ Polen; Cat. 130-33)

130 New Year's Card / Neujahrskarte 1894

A decorative, trellised border above with crossed hammer and gad and a miner with gad in right hand and a lantern in his left; below scrolling ornament and implements of the foundry trade. / Roccaillen-Verzierung mit Schlägel und Eisen sowie Bergarbeiter mit Eisen in der Rechten und Laterne in der Linken; unten Werkzeuge und Gerät dieses Berufsstandes. / Ins. „Glück auf! / zum / Jahreswechsel / 1894" and/und „Eisenhüt- ten / & / Emaillirwerk / (W.v.K.) / Neusalz / a. O.".
F./G. Neusalz a. O. – 11.5 x 6.1 cm (4 1/2 x 2 3/8 in.). – 63.5 g.
Lamprecht 496. – Inv. 1986.478.9.
Lit.: Strothotte, 351, no. 1894-2.

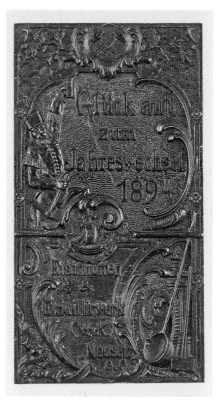

Cat. 130

131 New Year's Card / Neujahrskarte 1895

Figure of a youth holding a shield in his right hand and a torch in his left, with crossed

Cat. 131

hammer and gad and a cornucopia below. /
Jugendlicher mit Wappenschild in der Rech-
ten und Fackel in der Linken, außerdem
Schlägel und Eisen und ein Füllhorn. / Ins.
„*Glück auf! / zum Jahreswechsel / 1895 / Ei-
senhütten & Emaillirwerk / Neusalz a. O.*".
F./G. Neusalz a. O. – 6.1 x 9.5 cm (2 3/8 x
3 3/4 in.). – 41.1 g.
Lamprecht 497. – Inv. 1986.478.10.
Lit.: Strothotte, 351, no. 1895-1.

**132 New Year's Card / Neujahrskarte
1896**
Iron worker with tools and products of the
Neusalz foundry. / Eisengießer mit Werk-
zeugen und Produkten der Neusalzer Hütte. /
Ins. „*Glück auf! / 1896 / Eisenhütten &
Emaillirwerk / Neusalz a. O.*" and/und
„*WvK*" (ligated/ligiert).
F./G. Neusalz a. O. – 6.4 x 10.1 cm (2 1/2 x
4 in.). – 53.4 g.
Lamprecht 498. – Inv. 1986.478.11.
Lit.: Strothotte, 353, no. 1896-1.

**133 New Year's Card / Neujahrskarte
1897**
Upper left crossed hammer and gad, upper
right a sun with rays. / Oben links Schlägel
und Eisen, oben rechts eine Sonne mit Strah-
len. / Ins. „*Glück auf! / 1897 / Eisenhütten
& Emaillirwerk (W.v.K.) Neusalz a. O.*".
F./G. Neusalz a. O. – 5.7 x 9.8 cm (2 1/4 x
3 7/8 in.). – 39.1 g.
Lamprecht 499. – Inv. 1986.478.12.
Lit.: Strothotte, 354, no. 1897-1.

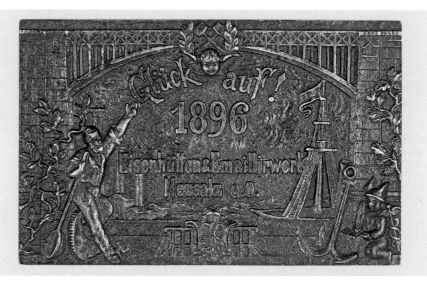

Cat. 132

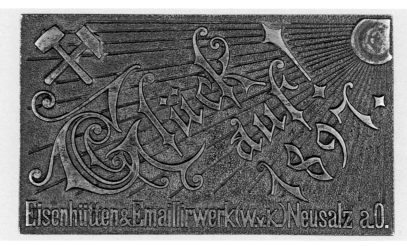

Cat. 133

Cat. 134

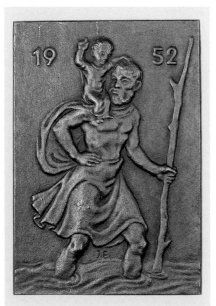

Cat. 135

Buderus (Cat. 134-38)

**134 New Year's Card / Neujahrskarte
1952**
St. Christopher with the Christ Child on his
shoulder. / Hl. Christophorus mit dem Christ-
kind auf der Schulter. / Ins. „*J.E.*" and/und
„*1952*".
Mod. Josef Enseling. – F./G. Buderus. – 14 x
9.5 cm (5 1/2 x 3 3/4 in.). – 266.1 g. – Rev./
Rs. foundry mark/Gießereimarke Buderus.
Inv. 1952.22. – Gift of / Schenkung von
ACIPCO.
Lit.: Buderus Kunstguß 1997, 20. – Stroth-
otte, 555, no. 1952-2.

Cat. 136

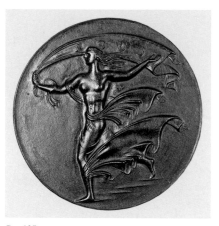

Cat. 137

Cat. 138

135 New Year's Card / Neujahrskarte 1953

St. George and the dragon. / Hl. Georg im Kampf mit dem Drachen. / Ins. „1953".
Mod. Arno Breker. – F./G. Buderus. – D. 14.3 cm (5 5/8 in.). – 534.6 g. – Rev./Rs. foundry mark/Gießereimarke Buderus.
Inv. 1953.151. – Gift of / Schenkung von ACIPCO.
Lit.: Buderus Kunstguß 1997, 20. – Strothotte, 556, no. 1953-1.

136 New Year's Card / Neujahrskarte 1954

Pierced, in the form of a phoenix. / Durchbrochen, in der Form eines Phönix. / Ins. „M" and/und „1954".
Mod. Ewald Mataré. – F./G. Buderus. – 15.8 x 14 cm (6 1/4 x 5 1/2 in.). – 452.4 g. – Rev./Rs. foundry mark/Gießereimarke Buderus.
Inv. 1954.70. – Gift of / Schenkung von ACIPCO.
Lit.: Buderus Kunstguß 1997, 20. – Strothotte, 563, no. 1954-3.

137 New Year's Card / Neujahrskarte 1955

Allegory of Hope running left with a sail. / Allegorie der Hoffnung nach links laufend mit einem Segel. / Ins. „A. Breker" and/und „1955".
Mod. Arno Breker. – F./G. Buderus. – D. 14.3 cm (5 5/8 in.). – 361.3 g. – Rev./Rs.

„A. BREKER" and/und foundry mark/Gießereimarke Buderus.
Inv. 1955.55. – Gift of / Schenkung von ACIPCO.
Lit.: Buderus Kunstguß 1997, 21. – Strothotte, 566, no. 1955-2.

138 New Year's Card / Neujahrskarte 1956

Iron extraction and processing, commemorating the 225th jubilee of the Buderus Foundry. / Eisengewinnung und -verarbeitung. Auf das 225-jährige Jubiläum der Buderus-Werke. / Ins. „ORA ET / LABORA", „1731" and/und „1956".
1956. – Mod. after an 18th century stove plate from the Eibelshäuser Hütte / nach einer Ofenplatte der Eibelshäuser Hütte aus dem 18. Jahrhundert. – F./G. Buderus. – 12.7 x 13.7 cm (5 x 5 3/8 in.). – 282.5 g. – Rev./Rs. foundry mark/Gießereimarke Buderus.
Inv. 1956.180. – Gift of / Schenkung von ACIPCO.
Lit.: Buderus Kunstguß 1997, 21. – Kippenberger, 53, fig./Abb. 35.
This motif was cast by Buderus in two additional sizes: / Dieses Motiv wurde von Buderus auch in zwei weiteren Größen gegossen: 35.5 x 41 cm (14 x 16 1/8 in.) and/und 78 x 84,5 cm (30 11/16 x 33 1/4 in.).

Plaques and Medallions of Miscellaneous Subject Matter / Plaketten und Medaillons verschiedenen Inhalts (Cat. 139-92)

139 Freiberg in Saxony / in Sachsen

In the center the coat-of-arms of the City of Freiberg with the three spires, the gates to the city, and the lion. / Wappen der Stadt

Cat. 139

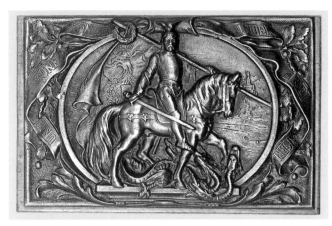

Cat. 140

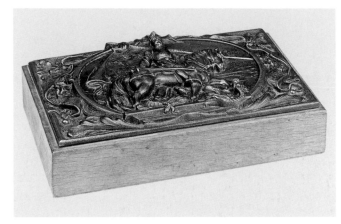

Cat. 140

Freiberg mit den drei Türmen, dem Stadttor und dem Löwen. / Ins. „FREIBERG".
Second half of the 19th century / 2. Hälfte des 19. Jh. – F./G. possibly/vielleicht Lauchhammer. – 17.2 x 12.4 cm (6 3/4 x 4 7/8 in.). – 1722.2 g. – Mounted on wood. / Auf Holz montiert.
Lamprecht 286. – Inv. 1986.339.8.

140 Otto von Bismarck as Knight in Shining Armor / als Ritter ohne Furcht und Tadel

Rectangular plaque mounted on wood, in the central cartouche Otto von Bismarck as a knight on horseback with three-headed dragon, in the background a landscape with river and castle. / Rechteckige Plakette auf einem Holzblock montiert, im Mittelfeld eine Kartusche mit Otto von Bismarck als Ritter zu Pferde mit dreiköpfigem Drachen, im Hintergrund eine Landschaft mit Fluß und Schloß. / Ins. l. and/und r. „UNTER / FÜNF / KÖNIGEN / UNTER / DREI / KAISERN".
Ca. 1897. – 8.8 x 14 cm (3 7/16 x 5 1/2 in.). – 450.2 g. – Stamped on reverse of the wood / Auf der Rs. des Holzblocks gestempelt „Dieses Holz ist im Sachsen- / wald gewachsen. / Friedrichsruh, 28. Aug. 97." and/und „Fürstlich von Bismarck'sche Forstverwaltung".
Lamprecht 943. – Inv. 1986.339.9.
Lit.: Ferner and Genée, 123, fig./Abb. 216. – Historismus 1989, 158, no. 163. – Renaissance der Renaissance 1992, 232, no. 255.

141 Napoleon Crossing the Alps / Napoleon die Alpen überquerend

Napoleon crossing the Alps over the St. Bernhard pass in 1800. / Napoleon überquert die Alpen über den Sankt-Bernhard-

Paß 1800. / Ins. „BONAPARTE" (indecipherable / mehr nicht lesbar).
Ca. 1830. – Smaller copy of the relief by Siméon Pierre Devaranne, modeled around 1830, after the painting by Jacques Louis David (1800) possibly with the use of a later engraving by Giuseppe Longhi. / Verkleinerte Nachbildung des Reliefs von Siméon Pierre Devaranne, das dieser nach dem Gemälde von Jacques Louis David (1800), vielleicht mit Hilfe eines Nachstichs von Giuseppe Longhi, um 1830 modelliert hat. – 16.2 x 13 cm (6 3/8 x 5 1/8 in.). – 457.4 g.
Lamprecht 308. – Inv. 1986.346.7.
Lit.: Cp./vgl. Bethmann Hollweg and Westphal, 26 f., no. 9 (sign. „Devaranne fec.";

Cat. 141

34 x 28.7 cm, with frame / mit Rahmen; Ins. „BONAPARTE HANNIBAL / KAROLUS MAGNUS"). – Eigler 2004, 53, fig./Abb. 48 (F./G. Wasseralfingen).

142 Friedrich II, King of Prussia (1770-1840; 1740 King), on Horseback / Friedrich II., König von Preußen, zu Pferde

First quarter of the 19th century / 1. Viertel des 19. Jh.
Mod. after an engraving "Frédéric II Roi de Prusse" by / nach einem Stich „Frédéric II Roi de Prusse" von Daniel Nikolaus Chodowiecki. – 20.9 x 19.4 cm (8 1/4 x 7 5/8 in.). – 537.3 g. – The horse's tail missing. / Der Pferdeschwanz fehlt.
Lamprecht 448, Photo 34. – Inv. 1986.386.
Lit.: Aus einem Guß, 240, no. 2110.

143 Johannes Gutenberg (= Johannes Gensfleisch zur Laden; ca. 1400-68), German Goldsmith and Printer / deutscher Goldschmied und Buchdrucker

Frame with decorative, pierced, and scrolled border, in the center against a blue fabric ground the silhouette figure of Gutenberg. / Eiserner, durchbrochener und verzierter Rahmen, in der Mitte auf blauem Stoff die ausgeschnittene Figur von Gutenberg.
1840-50. – Mod. after a design (1832-33) by / nach einem Entwurf von Bertel Thorvaldsen. – 33.7 x 29.2 cm (13 1/4 x 11 1/2 in.). – 1251.7 g.
Lamprecht 385. – Inv. 1986.408.
The Gutenberg Monument in Mainz, designed by Thorvaldsen, was erected in 1837 by his student Hermann Wilhelm Bissen. / Das Gutenberg-Denkmal in Mainz, von Thorvaldsen entworfen, wurde 1837 von seinem Schüler Hermann Wilhelm Bissen errichtet.

Cat. 142

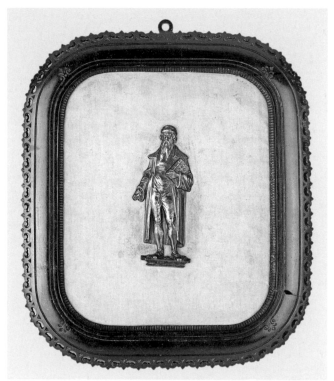

Cat. 143

Cat. 146

144 Servius Sulpicius Galba (3 B.C.-A.D. 69; 68-69 Emperor), Roman Emperor / römischer Kaiser

Laureate head in profile left, in brass frame. / Kopf im Profil nach links mit Lorbeerkranz, im Messingrahmen.

1830-40. – D. 13.3 cm (5 1/4 in.). – 314.7 g. Lamprecht 386. – Inv. 1986.409.

Cast in two parts (medallion and portrait). / In zwei Teilen gegossen (Medaillon und Bildnis).

145 Roman Coliseum / Kolosseum in Rom

Ins. „*AMPHIT FLAVIVM REPARATVM*" and/und „*ANNO • A • NATIVITATE • / CHRISTI / CIƆIƆCCCVI •*" [= 1806].

First quarter of the 19th century / 1. Viertel des 19. Jh. – D. 6.7 cm (2 5/8 in.). – 41.0 g. Lamprecht 387, Photo 62. – Inv. 1986.410. Probably a later cast of the obverse of a medal commemorating the restoration of the Coliseum after 1825. / Wohl Nachguß

Cat. 144

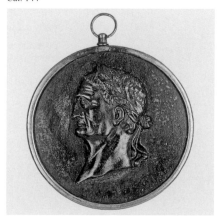

Cat. 145

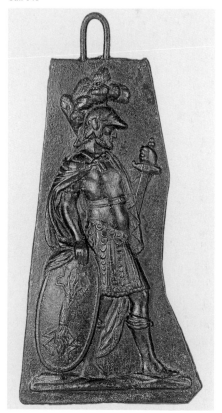

der Vorderseite einer Medaille auf die Restaurierung des Kolosseums ab 1825.

146 Mars

Irregularly shaped, the figure in profile right holding a shield in right hand and sword in left. / Unregelmäßig ausgeschnittene Figur im Profil nach rechts mit einem Schild in der Rechten und einem Schwert in der Linken.
17th century (?) / 17. Jh. (?). – 24.5 x 13 cm (9 5/8 x 5 1/8 in.). – 1186.9 g.
Lamprecht 388. – Inv. 1986.411.
Probably part of a stove plate. / Wohl Teil einer Ofenplatte.

147 The Scholar / Der Gelehrte

(Fig./Abb. s. p./S. 14)
Half figure of a bearded man reading a folio. / Halbfigur eines bärtigen Mannes in einem Folianten lesend. / Ins. „*NUR KENNER WERDEN DIES SAGEN, WAS SIE AN DIESER ARBEIT HABEN. UND VON GROSER HERREN GELD. LEBEN KÜNST / LER IN DER WELT. WANN GROSE BRINGEN KUNST IN FLOHR. SO KOMT DES KÜNSTLERS GEIST EMPOR*".
Ca. 1818. – Mod. Leonhard Posch after a most-likely Roman wax relief of the period around 1700. / nach einem wohl römischen Wachsrelief der Zeit um 1700. – F./G. KPEG. – 20.3 x 17.5 cm (8 x 6 7/8 in.). – 1138.4 g.
Lamprecht 416, Photo 45. – Inv. 1986.430.
Lit.: ACIPCO 1941a, fig./Abb. 3. – Arenhövel 1982, 94, no. 195. – Bloch and Grzimek, no. 25. – Cat. Leipzig 1915, 120, no. 74. – Forschler-Tarrasch, no. 842. –

Gleiwitzer Kunstguß 1935, 59. – Grzimek 1982, 154, no. 14. – H. v. Sp., 298. – Schmidt 1976, fig./Abb. 39.

148 Calling Card / Visitenkarte

Inscribed with the name *"Professor Plattner"* on small tablet set in landscape with view of foundry buildings, below crossed hammer and gad. / Mit dem Namen „*Professor Plattner*" auf einem rautenförmigen Feld in einer Landschaft mit der Ansicht eines Gießerei-Gebäudes, unten Schlägel und Eisen.
1842-56. – F./G. possibly/vielleicht Lauchhammer. – 4.6 x 7.2 cm (1 13/16 x 2 13/16 in.). – 29.6 g. – Break to upper left corner. / Oben links gebrochen.
Lamprecht 422. – Inv. 1986.432.1.
Lit.: Cat. Leipzig 1915, 128, no. 144.
Carl Friedrich Plattner (1800-58) was professor of metallurgy at the Freiberg Mining Akademie from 1842 to 1856. / Carl Friedrich Plattner war 1842 bis 1856 Professor der Hüttenkunde an der Freiberger Bergakademie.

149 Calling Card / Visitenkarte

In the center a small, oval cartouche against a ground of flowers and foliage. / In der Mitte ein kleines, ovales Feld, umgeben von Blumen und Laubwerk. / Ins. „*Gräfl. / Stolberg Wernigerödische / Eisengiesserei / in Ilsenburg / A/HR*".
Second quarter of the 19th century / 2. Viertel des 19. Jh. – F./G. Ilsenburg. – 7 x 10.4 cm (2 3/4 x 4 1/8 in.). – 89.1 g.
Lamprecht 423, Photo 63. – Inv. 1986.432.2.
Lit.: Cat. Leipzig 1915, 117, no. 39.

150 Plaque Commemorating the Tenth Anniversary of the Creation of the Royal Iron Foundry Sayn as a Royal Foundry Office in 1816 / Jubiläumsplakette auf die Ernennung der „*Königlichen Eisengiesserey zu Saynerhütte*" zum „*Königlichen Hüttenamt*" 1816

In arch with tracery above and below sits a female figure among products of the KPEG Sayn – urns, cannon and cannon balls, machine parts, and architectural elements – as allegory of the iron industry wearing a crown in the form of a foundry oven, in her left hand she holds a tablet upon which a crown and the initials *"FWE"* (ligated) and the year *"1826"*, her right hand holds a stylus, with which she points to the tablet. / Innerhalb einer Rundbogenarkade sitzt die Allegorie der Eisenindustrie mit einer Krone in Form eines Gießerei-Gebäudes. In ihrer Linken hält sie eine Platte mit einer Königskrone über den Initialen „*FWE*" (ligiert) und der Jahreszahl „*1826*", auf die sie mit einem Stift in der Rechten zeigt.
1826. – Mod. Heinrich Zumpft (?).– F./G. KPEG Sayn. – 16.3 x 9.6 cm (6 7/16 x 3 3/4 in.). – 225.3 g. – / Ins. lower right / unten rechts „*SAYNERH*[ÜTT]*E*", partially concealed by a slanted, crowned crest with an eagle. / zum Teil durch ein schrägstehendes bekröntes Wappen mit einem Adler verdeckt.
Lamprecht 424, Photo 63. – Inv. 1986.433.
Lit.: Andrews, 422, fig./Abb. 2. – Cat. Leipzig 1915, 122, no. 89. – Dębowska 2006, 30, 59. – Ostergard 1994, 204, no. 53.
The initials "FWE" most certainly belong to Crown Prince Friedrich Wilhelm (from 1840 ruled as Friedrich Wilhelm IV, King

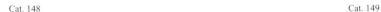

Cat. 148

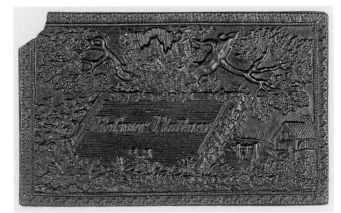

Cat. 149

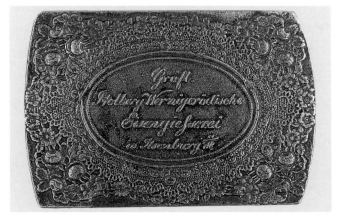

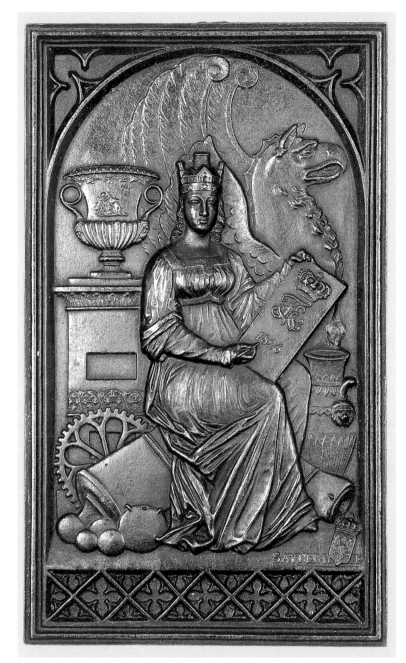

Cat. 150

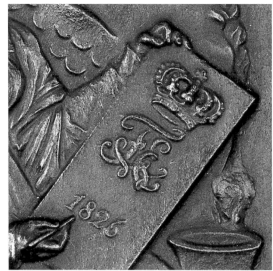

Cat. 150 (Detail)

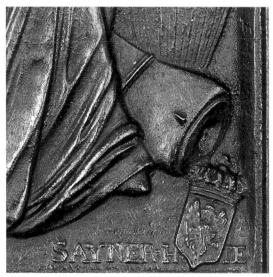

Cat. 150 (Detail)

of Prussia) and his wife Elisabeth Ludovika, who attended the foundry's celebration in 1826. The background of the plaque shows important, partly identifiable products of the foundry from previous years. Highlighted by a griffin from the "Lion's Gate" of the Alexander fort on the "Kartause" in Coblenz, the products include an oven with a vase garniture, another vase, a cogwheel, cannons, and cannon balls.
The identical initials "FWE" beneath the king's crown can be found on another plaque, dated November 18, 1833, that was apparently cast on that day to commemorate a visit of the crown prince to the foundry. /

Bei „FWE" handelt es sich sicherlich um die Initialen des Kronprinzen Friedrich Wilhelm (ab 1840 als Friedrich Wilhelm IV. König von Preußen) und seiner Frau Elisabeth Ludovika, die wohl anläßlich des Festes zu Besuch waren. Der Hintergrund zeigt bedeutende, zum Teil identifizierbare Produkte der Gießerei vergangener Jahre.

Betont durch den einen Greifen vom „Lö-wentor" der Feste Kaiser Alexander auf der Kartause in Koblenz, finden sich ein Ofen mit einem Vasenaufsatz, eine weitere Vase, ein Zahnrad, Kanonen und Kanonenkugeln. Die Initialen „FWE" unter der Königskrone finden sich dann auf einer Plakette identisch wieder, die auf den 18. November 1833 datiert ist und offensichtlich aus Anlaß des Besuchs des Kronprinzen an diesem Tag gegossen wurde (Thiele 1920, 191, fig./Abb.; Schmitz 1917, 55, pl./Taf. 25).

151 Printing Plate / Gießerei-Druck-platte
Page from an edition of the Old Testament, Judges 7:13 to 8:5, published by the Canstein Bible Institute in Halle. / Seite einer Ausgabe des Alten Testaments, das Buch der Richter, 7:13 bis 8:5, von der Canstein-schen Bibelanstalt in Halle herausgegeben. 19th century / 19. Jh. – F./G. Cansteinsche Bibelanstalt, Halle (?). – 10.3 x 7.8 cm (4 1/16 x 3 1/16 in.). – 559.5 g.
Lamprecht 425. – Inv. 1986.434.
One of the earliest noteworthy organiza-

tions formed for the specific purpose of circulating the Scriptures was the Canstein Bible Institute (Bibelanstalt), founded in 1710 in Halle in Saxony by Karl Hildebrand, Baron von Canstein (1667-1719). He invented a method of printing whereby the Institute could produce Bibles and Testaments in Luther's version at a very low cost, and sell them in small size at competitive prices. In 1722 editions of the Scriptures were also issued in Bohemian and Polish. When Canstein died, he left the Institute in the care of his friend August Hermann Francke, founder, in 1698, of the famous Waisenhaus (orphanage) at Halle. The Canstein Institute has issued some 6,000,000 copies of the Scriptures. / Eine der ältesten Einrichtungen für die Verbreitung der Bibel ist die Cansteinsche Bibelanstalt, 1710 in Halle von Karl Hildebrand, Freiherr von Canstein (1667-1719) gegründet. Canstein erfand eine Druckmethode, durch die die Anstalt die Luther-Bibel sehr günstig produzieren und, in kleinem Format, preiswert verkaufen konnte. 1722 wurde die Bibel auch in Böhmisch und Pol-

nisch herausgegeben. Als Canstein starb, ging die Anstalt in die Obhut seines Freundes August Hermann Francke, Gründer des berühmten Waisenhauses in Halle 1698. Die Cansteinsche Bibelanstalt hat etwa 6.000.000 Exemplare der Bibel herausgegeben.

152 Falkenstein Castle by Meisdorf in Saxony / Burg Falkenstein bei Meisdorf in Sachsen
1845-50. – F./G. Mägdesprung. – 9.4 x 10.4 cm (3 11/16 x 4 1/8 in.). – 135.6 g. – / Ins. „FALKENSTEIN" and at base of relief / und unten am Relief „Mägdesprung".
Lamprecht 426, Photo 63. – Inv. 1986.435.
Lit.: Reichmann, 135, fig./Abb. 94.
The castle Falkenstein was built about 1120. / Die Burg Falkenstein wurde um 1120 erbaut.

153 Alexisbad in the Harz Mountains / im Harz
Today a part of the Harzgerode (Saxony-Anhalt). / Heute Ortsteil von Harzgerode (Sachsen-Anhalt). / Ins. „ALEXISBAD".
1845-50. – Mod. Johann Heinrich Kureck attributed / zugeschrieben. – F./G. Mägde-sprung. – 10.8 x 13.5 cm (4 1/4 x 5 5/16 in.). – 261.8 g.
Lamprecht 427, Photo 63. – Inv. 1986.436.
Lit.: Aus einem Guß, 55, no. 98. – Reichmann, 133, fig./Abb. 89.

154 Viktorshöhe on the Ramberg in the Harz Mountains / auf dem Ramberg im Harz
View of the look-out tower. / Blick auf den Aussichtsturm. / Ins. „VICTORS=HÖHE".
1845-50. – Mod. Johann Heinrich Kureck. – F./G. Mägdesprung. – 11 x 13.5 cm (4 5/16 x 5 5/16 in.). – 268.9 g. – / Sign. „H Ku-reck/Mägdesprung".
Lamprecht 428, Photo 63. – Inv. 1986.437.
Lit.: Reichmann, 134, fig./Abb. 91.

155 Off to the Hunt / Der Gang zur Jagd
Two hunters with dogs on their way to the hunt, in cast-iron frame decorated with oak leaves and acorns. / Zwei Jäger mit Hunden auf dem Weg zur Jagd, in angegossenem Rahmen, verziert mit Eichenblättern und Eicheln. / Ins. „Der Gang zur Jagd.".
Second quarter of the 19th century / 2. Viertel des 19. Jh. – F./G. Lauchhammer. – 21 x 21 cm (8 1/4 x 8 1/4 in.). – 1525.9 g.
Lamprecht 429, Photo 43. – Inv. 1986.438.
Lit.: Cat. Leipzig 1915, 120, no. 73.

Cat. 151

Cat. 153

Cat. 154

Cat. 152

Cat. 155

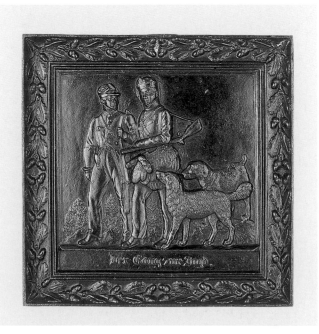

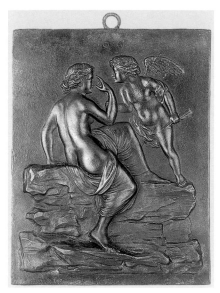

Cat. 156

156 Cupid and Psyche / Amor und Psyche

Second quarter of the 19th century / 2. Viertel des 19. Jh. – 24.5 x 19.7 cm (9 5/8 x 7 3/4). – 1391.4 g.
Lamprecht 430, Photo 47. – Inv. 1986.439.

157 Terpsichore, Muse of Dance / Muse des Tanzes

First quarter of the 19th century / 1. Viertel des 19. Jh. – Mod. after a Wedgwood medallion by John Flaxman, Jr. / nach einem Wedgwood-Medaillon von John Flaxman Jr. / Ins. „*TERPSICORI*". – F./G. KPEG. – 16.2 x 12 cm (6 3/8 x 4 3/4 in.). – 318.1 g.
Lamprecht 431. – Inv. 1986.440.
Lit.: Ostergard 1994, 204, no. 50.

158 Euterpe, Muse of Lyric Poetry / Muse der lyrischen Dichtung

First quarter 19th century / 1. Viertel des 19. Jh. – Mod. after a Wedgwood medallion by John Flaxman, Jr. / nach einem Wedgwood-Medaillon von John Flaxman Jr. / Ins. „*EUTERPE*". – F./G. KPEG. – 16.5 x 11.8 cm (6 1/2 x 4 5/8 in.). – 269.1 g.
Lamprecht 432. – Inv. 1986.441.
Lit.: Cp./vgl. Ostergard 1994, 204, no. 51. – Wedgwood 1992, 348, no. 845.

159 Morning (Aurora with the Genius of Light) / Der Morgen

Ca. 1820. – Mod. Leonhard Posch, based on a tondo (1815) by / nach einem Tondo (1815) von Bertel Thorvaldsen. – F./G. KPEG. – D. 13.2 cm (5 3/16 in.). – 162.8 g. – Rev./Rs. „*Der Morgen*" and/und „*N=VIII 11*".
Lamprecht 433. – Inv. 1986.442.

Cat. 157

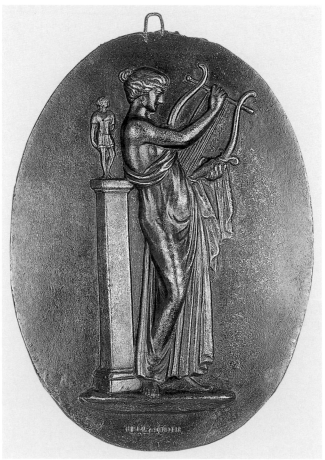

Cat. 158

Lit.: Arenhövel 1982, 92 f., no. 193. – Bott and Spielmann, 80, fig./Abb. 3. – Forschler-Tarrasch, no. 843. – Gleiwitzer Kunstguß 1935, 76. – Ostergard 1994, 203, no. 49. The tondo by Thorvaldsen is in the Thorvaldsens Museum in Copenhagen. / Das Tondo von Thorvaldsen befindet sich im Thorvaldsens Museum in Kopenhagen (Cat. Thorvaldsen 1977, 230, no. 82).

160 Night (Night with her Children Sleep and Death) / Die Nacht

Ca. 1820. – Mod. Leonhard Posch, based on a tondo (1815) by / nach einem Tondo (1815) von Bertel Thorvaldsen. – F./G. KPEG. – D. 13.2 cm (5 3/16 in.). – 138.9 g. – Rev./Rs. „Die Nacht" and/und „N VIII 10". Lamprecht 434. – Inv. 1986.443.
Lit.: Arenhövel 1982, 94, no. 194. – Bott and Spielmann, 81, fig./Abb. 4. – Forschler-Tarrasch, no. 844. – Gleiwitzer Kunstguß 1935, 76. – Ostergard 1994, 203, no. 49. The tondo by Thorvaldsen is in the Thorvaldsens Museum in Copenhagen. / Das Tondo von Thorvaldsen befindet sich im Thorvaldsens Museum in Kopenhagen (Cat. Thorvaldsen 1977, 228, no. 81).

161 Hylas Seized by the Water Nymphs / Raub des Hylas durch die Wassernymphen (Fig. p./Abb. S. 108)

Second quarter of the 19th century / 2. Viertel des 19. Jh. – Mod. after a relief (1833) by / nach einem Relief (1833) von Bertel Thorvaldsen. – F./G. Ilsenburg. – 10.5 x 14.6 cm (4 1/8 x 5 3/4 in.). – 194.5 g. – In wood frame. / Im Holzrahmen.
Lamprecht 436. – Inv. 1986.445.
Lit.: Bott and Spielmann, 64, fig./Abb. 10. – Ostergard 1994, 206, no. 54.
The original by Thorvaldsen was executed in Rome and is now in the Thorvaldsens Museum in Copenhagen. / Das Original von Thorvaldsen entstand in Rom und befindet sich im Thorvaldsens Museum in Kopenhagen.

162 Cupid and Ganymede Playing Dice / Amor und Ganymede spielen Würfel

(Fig. p./Abb. S. 108)
Second quarter of the 19th century / 2. Viertel des 19. Jh. – Mod. after a relief (1831) by / nach einem Relief von Bertel Thorvaldsen. – F./G. Ilsenburg. – 7.2 x 9.8 cm (2 13/16 x 3 7/8 in.). – 125.4 g.
Lamprecht 437, Photo 48. – Inv. 1986.446.1.
Lit.: ACIPCO 1941b, fig./Abb. 3. – Cat. Leipzig 1915, 122, no. 83.
The original by Thorvaldsen was executed in Rome and is now in the Thorvaldsens

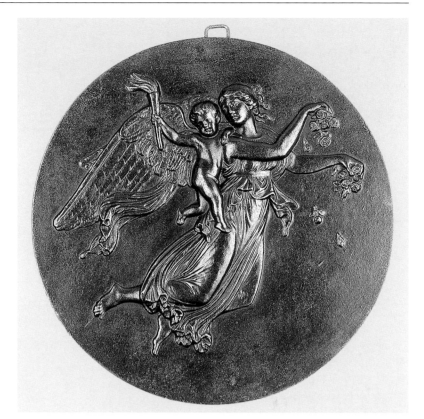

Cat. 159
Cat. 160

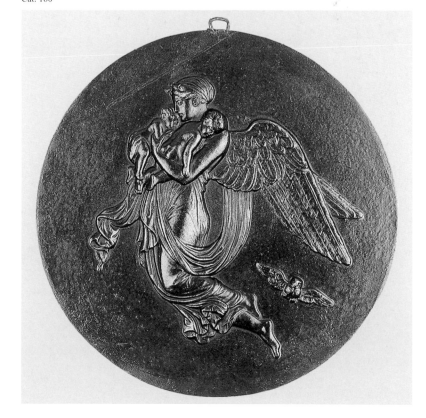

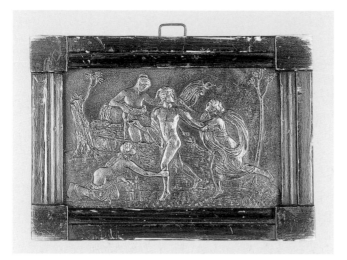

Cat. 161

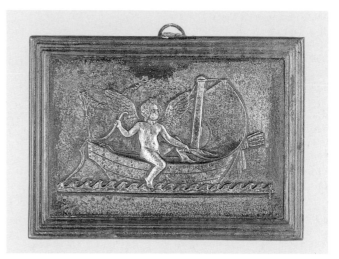

Cat. 164

Cat. 162

Cat. 163

Cat. 165

Cat. 166

Museum in Copenhagen. / Das Original von Thorvaldsen entstand in Rom und befindet sich heute im Thorvaldsens Museum in Kopenhagen.

163 Cupid and Hymen Spinning the Thread of Life / Amor und Hymen spinnen den Faden des Lebens

Second quarter of the 19th century / 2. Viertel des 19. Jh. – Mod. after a relief (1831) by / nach einem Relief von Bertel Thorvaldsen. – F./G. Ilsenburg. – 7.2 x 9.8 cm (2 13/16 x 3 7/8 in.). – 158.2 g.
Lamprecht 438, Photo 48. – Inv. 1986.446.2.
Lit.: ACIPCO 1941b, fig./Abb. 3. – Cat. Leipzig 1915, 122, no. 84.
The original by Thorvaldsen was executed in Rome and is now in the Thorvaldsens Museum in Copenhagen. / Das Original von Thorvaldsen entstand in Rom und befindet sich heute im Thorvaldsens Museum in Kopenhagen.

164 Cupid Sailing / Amor segelt

Second quarter of the 19th century / 2. Viertel des 19. Jh. – Mod. after a relief (1831) by / nach einem Relief von Bertel Thorvaldsen. – F./G. Ilsenburg. – 7.2 x 9.8 cm (2 13/16 x 3 7/8 in.). – 120.1 g.
Lamprecht 439. – Inv. 1986.446.3.
The original by Thorvaldsen was executed in Rome and is now in the Thorvaldsens Museum in Copenhagen. / Das Original von Thorvaldsen entstand in Rom und befindet sich heute im Thorvaldsens Museum in Kopenhagen.

165 Cupid Charms Flowers from a Stony Ground / Amor zaubert Blumen aus einem steinernen Boden

Second quarter of the 19th century / 2. Viertel des 19. Jh. – Mod. after a relief (1831) by / nach einem Relief von Bertel Thorvaldsen. – F./G. Ilsenburg. – 7.2 x 9.8 cm (2 13/16 x 3 7/8 in.). – 131.3 g.
Lamprecht 440. – Inv. 1986.446.4.
Lit.: ACIPCO 1941b, fig./Abb. 3.
The original by Thorvaldsen was executed in Rome and is now in the Thorvaldsens Museum in Copenhagen. / Das Original von Thorvaldsen entstand in Rom und befindet sich heute im Thorvaldsens Museum in Kopenhagen.

166 Cupid Riding a Lion / Amor reitet auf einem Löwen

Second quarter of the 19th century / 2. Viertel des 19. Jh. – Mod. after a relief (1831) by / nach einem Relief von Bertel Thor-

valdsen. – F./G. Ilsenburg. – 7.2 x 9.8 cm (2 13/16 x 3 7/8 in.). – 147.5 g.
Lamprecht 441. – Inv. 1986.446.5.
Lit.: ACIPCO 1941b, fig./Abb. 3.
The original by Thorvaldsen was executed in Rome and is now in the Thorvaldsens Museum in Copenhagen. / Das Original von Thorvaldsen entstand in Rom und befindet sich heute im Thorvaldsens Museum in Kopenhagen.

167 Cupid Sets Stone on Fire / Amor setzt Stein in Brand

Second quarter of the 19th century / 2. Viertel des 19. Jh. – Mod. after a relief (1831) by / nach einem Relief von Bertel Thorvaldsen. – F./G. Ilsenburg. – 9.8 x 7.2 cm (3 7/8 x 2 13/16 in.). – 147.1 g.
Lamprecht 443. Inv. 1986.446.7.
Lit.: ACIPCO 1941b, fig./Abb. 3.
The original by Thorvaldsen was executed in Rome and is now in the Thorvaldsens Museum in Copenhagen. / Das Original von Thorvaldsen entstand in Rom und befindet sich heute im Thorvaldsens Museum in Kopenhagen.

168 Infant Hercules / Herkules als Kind

First quarter of the 19th century / 1. Viertel des 19. Jh. – F./G. KPEG. – 5 x 4.1 cm (1 15/16 x 1 5/8 in.). – 22.3 g.
Lamprecht 444. – Inv. 1986.446.8.

169 Cupid in the Underworld, as the Tamer of Cerberus with Pluto's Pitchfork / Amor in der Unterwelt als Bändiger von Cerberus mit Plutos Heugabel

Second quarter of the 19th century / 2. Viertel des 19. Jh. – Mod. after a relief (1828) by / nach einem Relief von Bertel Thorvaldsen. – F./G. Ilsenburg. – 4 x 5.2 cm (1 9/16 x 2 1/16 in.). – 36.8 g.
Lamprecht 445. – Inv. 1986.446.9.
Lit.: Cat. Leipzig 1915, 129, no. 146.
The original by Thorvaldsen was executed in Rome and is now in the Thorvaldsens Museum in Copenhagen. / Das Original von Thorvaldsen entstand in Rom und befindet sich heute im Thorvaldsens Museum in Kopenhagen.

170 Bacchante and a Child Satyr / Bacchant und ein junger Satyr

Second quarter of the 19th century / 2. Viertel des 19. Jh. – Mod. after a relief (1833) by / nach einem Relief von Bertel Thorvaldsen. – F./G. Ilsenburg. – 3.7 x 5.3 cm (1 7/16 x 2 1/16 in.). – 31.9 g.
Lamprecht 446. – Inv. 1986.446.10.

Cat. 167

Cat. 168

Cat. 169

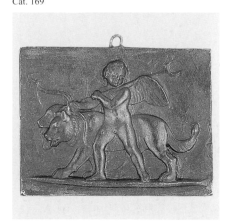

Cat. 170

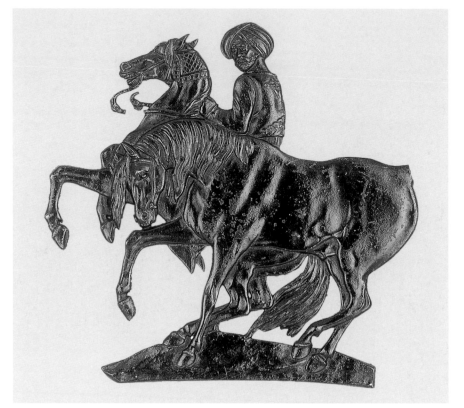

Cat. 172

Cat. 173

The original by Thorvaldsen was executed in Rome and is now in the Thorvaldsens Museum in Copenhagen. A carved wood example was sold at Sotheby's Olympia London on December 2, 2003, lot 595. / Das Original von Thorvaldsen entstand in Rom und befindet sich heute im Thorvaldsens Museum in Kopenhagen. Ein Exemplar aus geschnitztem Holz wurde bei Sotheby's Olympia am 2. Dezember 2003, Losnr. 595, verkauft.

171 Cupid in Heaven on Jupiter's Eagle with the Thunderbolt / Amor im Himmel auf Jupiters Adler mit dem Donnerkeil
First quarter of the 19th century / 1. Viertel des 19. Jh. – F./G. KPEG. – 4.5 x 5.3 cm (1 3/4 x 2 1/16 in.). – 25.6 g.
Lamprecht 447. – Inv. 1986.446.11.

172 Turkish Horseman / Türkischer Reiter
First quarter of the 19th century / 1. Viertel des 19. Jh. – F./G. Eisenberg. – 19.7 x 20.8

Cat. 171

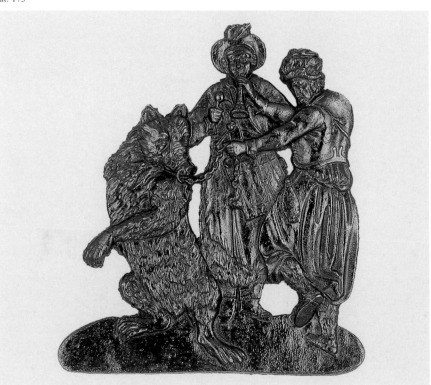

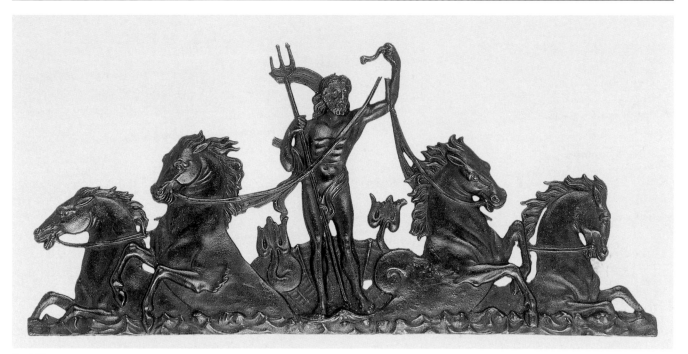

Cat. 175

Cat. 174

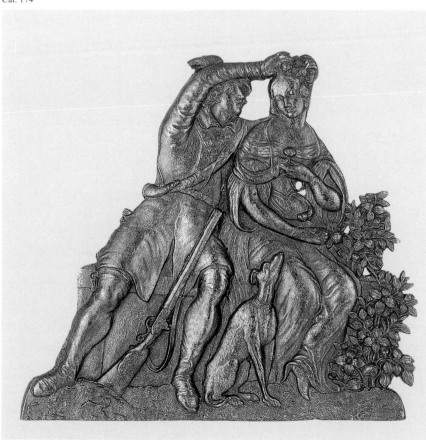

cm (7 3/4 x 8 3/16 in.). – 412.6 g. – Rev./ Rs. *„Eisenberg"* and crossed hammer and gad / und Schlägel und Eisen.
Lamprecht 449, Photo 34. – Inv. 1986.448.

173 Two Musicians and a Bear / zwei Musikanten und ein Tanzbär
Ca. 1830. – Mod. Georg Conrad Weitbrecht. – F./G. Wasseralfingen. – 18.4 x 16.3 cm (7 1/4 x 6 7/16 in.). – 546.0 g.
Lamprecht 450, Photo 33. – Inv. 1986.449.

174 Pair of Lovers / Liebespaar
Second quarter of the 19th century / 2. Viertel des 19. Jh. – Mod. Christian Plock. – F./G. Wasseralfingen. – 19.6 x 21.5 cm (7 11/16 x 8 7/16 in.). – 743.3 g.
Lamprecht 460, Photo 33. – Inv. 1986.457.
Lit.: Aus einem Guß, 240, no. 2114. – Schuette 1916, 287, fig./Abb. 20.

175 Neptune with his Carriage and Four Horses / Neptun mit seinem Viergespann
First quarter of the 19th century / 1. Viertel des 19. Jh. – F./G. possibly/vielleicht KPEG. – 20.5 x 44 cm (8 1/16 x 17 5/16 in.). – 1325.8 g. – A small piece of the reins is missing below Neptune's left hand. / Unterhalb von Neptuns linker Hand fehlt ein kleines Stück vom Zügel.
Lamprecht 461, Photo 37. – Inv. 1986.458.

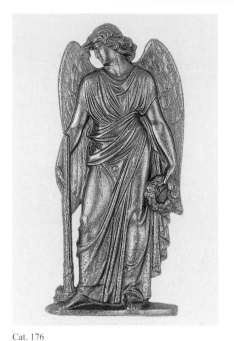

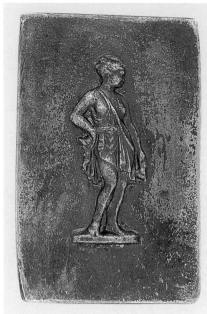

Cat. 176 Cat. 177

Cat. 178

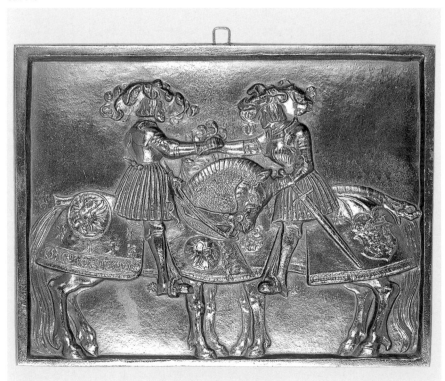

176 Genius of Death with Lowered Torch / Genius des Todes mit der gesenkten Fackel
Second quarter of the 19th century / 2. Viertel des 19. Jh. – 33.6 x 15.9 cm (13 1/4 x 6 1/4 in.). – 2010.5 g.
Lamprecht 462. – Inv. 1986.459.

177 Female Figure / Weibliche Figur
Classically dressed female figure standing right. / Antikisch gekleidete stehende Frau nach rechts.
Second quarter of the 19th century / 2. Viertel des 19. Jh. – 5.7 x 3.6 cm (2 1/4 x 1 7/16 in.). – 30.1 g.
Lamprecht 473. – Inv. 1986.468.

178 Charles V (1500-58), Holy Roman Emperor and Ferdinand I (1503-64), King of Bohemia and Hungary, on Horseback / Karl V., Kaiser des Heiligen Römischen Reichs Deutscher Nation, und Ferdinand I., König von Böhmen und Ungarn, zu Pferde
Ca. 1892. – Mod. after a prototype (1527) by / nach einem Bild von Albrecht Dürer. – F./G. Ilsenburg. – 17 x 22.1 cm (6 11/16 x 8 11/16 in.). – 715.9 g. – Rev./Rs. an illegible handwritten reference to the prototype / eine unleserliche Notiz zum Vorbild.
Lamprecht 478. – Inv. 1986.472.
Lit.: Ilsenburg c, pl./Taf. 147, no. 905.

179 Royal Iron Foundry at Gleiwitz / Königliche Eisengießerei bei Gleiwitz
View of the foundry /Ansicht der Hüttenanlage. / Ins. „KÖN: EISENGIESSEREI BEI GLEIWITZ 1855.".
1855. – Mod. Friedrich Beyerhaus. – F./G. KPEG Gleiwitz. – 12.3 x 17.8 cm (4 13/16 x 7 in.). – 346.7 g.
Lamprecht 490, Photo 62. – Inv. 1986.479.
Lit.: Bimler 1914c, 3. – Cat. Gliwice 1988, no. 5, fig./Abb. 4. – Dębowska 2006, 79. – Ostergard 1994, 209, no. 58. – cp./vgl. Stummann-Bowert, 195.

180 Royal Hanover Iron Foundry at Königshütte by Lauterberg in the Harz Mountains / Königliches Hannöversches Eisenwerk zu Königshütte bei Lauterberg im Harz
View of the new casting hall built in the neo-Gothic style at the Royal Hanover Iron Foundry at Königshütte. In cast and gilt frame with grape leaves and grapes. / Ansicht der neuen Gießhalle im neo-gotischen Stil der Königshütte. Im angegossenen, vergoldeten Rahmen mit Traubenblättern und

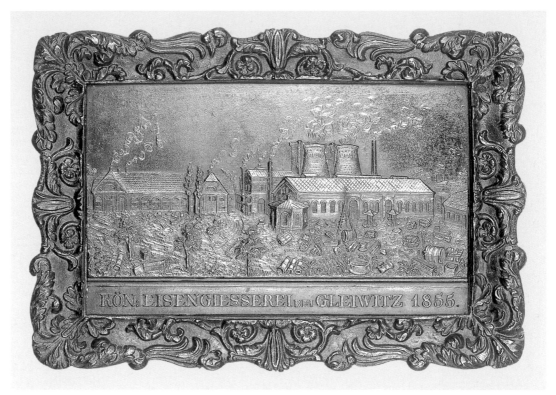

Cat. 179

Cat. 180

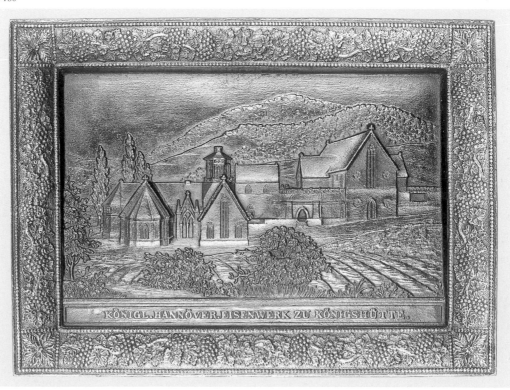

Cat. 181

Cat. 182

Cat. 183

Trauben. / Ins. „KÖNIGL. HANNÖVER. EISENWERK ZU KÖNIGSHÜTTE".
Ca. 1830. – Mod. possibly/vielleicht Friedrich Ferdinand Splittgerber. – F./G. Königshütte (Harz). – 13.4 x 18 cm (5 1/4 x 7 1/16 in.). – 387.1 g.
Lamprecht 491, Photo 62. – Inv. 1986.480.
Lit.: Aus einem Guß, 54, no. 87. – Hillegeist, 210, fig./Abb. 156 (vol./Bd. 2). – Ostergard 1994, 210, no. 60.
In the same tradition as the Prussian New Year's cards, designed to present the new building visually to clients and to serve as an advertisement. Cast shortly after the completion of the new casting hall at the foundry in 1830. / Steht in der gleichen Tradition wie die preußischen Neujahrskarten, entworfen um das neue Gebäude vorzustellen und als Werbung zu dienen. Gegossen kurz nach der Fertigstellung der neuen Gießereihalle 1830.

181 Three Winged Cherubs Working in the Garden / Drei geflügelte Putten bei der Gartenarbeit
Second quarter of the 19th century / 2. Viertel des 19. Jh. – D. 21 cm (8 1/4 in.). – 596.2 g. – Sign. below relief illegible / unterhalb des Reliefs unleserlich.
Lamprecht 908. – Inv. 1986.483.

182 Allegory of Art and the Light Bringing Genius / Allegorie der Kunst und des Licht bringenden Genius
First quarter of the 19th century / 1. Viertel des 19. Jh. – Mod. Georg Conrad Weitbrecht. – F./G. Wasseralfingen. – 19.6 x 26 cm (7 11/16 x 10 1/4 in.). – 1455.7 g.
Lamprecht 901, Photo 35. – Inv. 1986.486.

183 Hercules and the Cerynitian Hind / Herkules und die Keryneische Hirschkuh
First quarter of the 19th century / 1. Viertel des 19. Jh. – Mod. Georg Conrad Weitbrecht. – F./G. Wasseralfingen. – 17.5 x 20.3 cm (6 7/8 x 8 in.). – 406.1 g.
Lamprecht 902, Photo 35. – Inv. 1986.487.
Lit.: Aus einem Guß, 240, no. 2115.

184 Blind Jack
20th century / 20. Jh. – F./G. Buderus. – 25.1 x 6.3 cm (9 7/8 x 2 1/2 in.). – 596.8 g.
Lamprecht 903. – Inv. 1986.488.
Lit.: Ames, 89, fig./Abb. 230.
Identified by Ames as "Blind Jack," born John Metcalfe of Knaresborough (1717-1810). He became blind at age six, but learned to play the violin, ride, swim, build houses and bridges, and is famous for the

Cat. 184

Cat. 185

Cat. 186

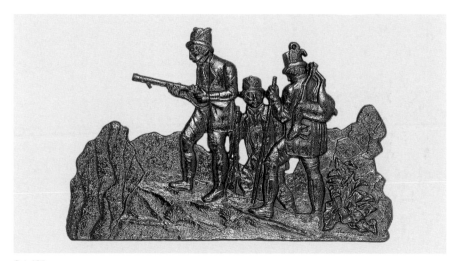

Cat. 187

Cat. 188

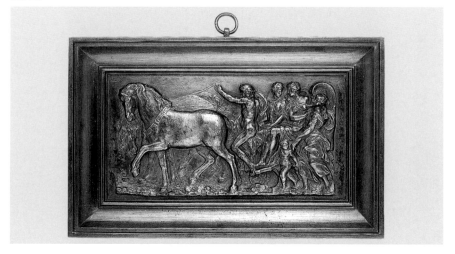

many roads constructed by him. / Von Ames als „Blind Jack" identifiziert. John Metcalfe von Knaresborough (1717-1810) erblindete im Alter von sechs Jahren und lernte trotzdem Geige spielen, schwimmen sowie Häuser und Brücken bauen. Bekannt wurde er wegen der vielen Straßen, die er gebaut hat.

185 Hunter with Dog / Jäger mit Hund
20th century / 20. Jh. – F./G. Buderus. – 28.9 x 24.3 cm (11 3/8 x 9 9/16 in.). – 879.6 g.
Lamprecht 904. – Inv. 1986.489.

186 The Siblings / Die Geschwister
1830-40. – F./G. Eisenberg (?). – 19.1 x 22.3 cm (7 1/2 x 8 3/4 in.). – 613.3 g.
Lamprecht 905. – Inv. 1986.490.
Lit.: Aus einem Guß, 184, 240, no. 2117. – Schmidt 1976, 64, fig./Abb. 57.
An example marked *"Eisenberg"* is in the Barth and Fischer collection. / Ein Exemplar bezeichnet mit „*Eisenberg"* befindet sich in der Sammlung Barth/Fischer.

187 Hunters with Dog / Jäger mit Hund
20th century / 20. Jh. – F./G. Buderus. – 17 x 26.5 cm (6 11/16 x 10 7/16 in.). – 783.6 g.
Lamprecht 906. – Inv. 1986.491.

188 Antique Mythological Scene / Antikisierende mythologische Szene
Classical figures with horses in cast-iron frame. / Klassizistische Figuren mit Pferden in angegossenem Rahmen.
Second quarter of the 19th century / 2. Viertel des 19. Jh. – F./G. Ilsenburg. – 15.7 x

Cat. 189

Cat. 190

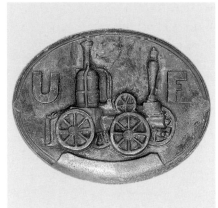

Cat. 191

24.6 cm (6 3/16 x 9 11/16 in.). – 1206.5 g.
– Rev./Rs. foundry mark / Gießereimarke
Ilsenburg.
Lamprecht 910. – Inv. 1986.492.
Lit.: Ilsenburg c, pl./Taf. 147, no. 373.

189 Garland of Corn / Ährenkranz
First half of the 19th century / 1. Hälfte des
19. Jh. – 13 x 9.7 cm (5 1/8 x 3 13/16 in.). –
139.7 g.
Lamprecht 913. – Inv. 1986.512.

**190 Fragment of a Watchholder / Frag-
ment eines Uhrenständers**
Ca. 1830. – F./G. Devaranne. – 12.7 x
14.6 cm (5 x 5 3/4 in.). – 237.3 g.
Lamprecht 914. – Inv. 1986.513.
Lit.: Hintze 1928b, 161. – Schmitz 1917, 56,
pl./Taf. 31.

**191 Steam-Powered Fire Engine /
Dampffeuerspritze**
Ca. 1940. – Mod. after a fire mark issued
by the United Fireman's Insurance Compa-
ny of Philadelphia in 1860 (reproduction). /
Nach einer Feuerversicherungsplakette der

United Fireman's Insurance Company of
Philadelphia 1860 (Nachguß). – F./G. ACIP-
CO. – Ins. „ U " and/und „ F ". – 24 x 30 cm
(9 7/16 x 11 13/16 in.). – 2689.8 g.
Lamprecht 950. – Inv. 1986.524.
Showing one of the first steam-powered
fire engines (operated 1857-67), made by
Reaney and Neafie of Philadelphia, used
by the United Fireman's Insurance Compa-
ny of Philadelphia. / Gezeigt ist eine der er-
sten mit Dampf betriebenen Feuerwehr-
spritzen (in Betrieb 1857-67), hergestellt
von Reaney und Neafie, Philadelphia, und
von der United Fireman's Insurance Com-
pany, Philadelphia, benutzt.

**192 Ruler with a Replica of the Sculp-
tures from the North Side of the
Parthenon Frieze / Lineal mit Relief nach
dem Fries der Nordseite des Parthenon**
Mid 19th century / Mitte des 19. Jh. – Mod.
John Henning. – F./G. Ilsenburg. – 5.7 x
47.7 cm (2 1/4 x 18 3/4 in.). – 556.6 g.
Inv. 1962.96. – Gift of / Schenkung von Dr.
and Mrs. Maurice Garbáty.
Lit.: Bauhoff, 366, fig./Abb. 298 (vol./Bd. 2).
– Ilsenburg c, pl./Taf. 124, no. 471d.
Detail of the Parthenon frieze (447 to 432
B. C.), the north side showing a procession
to the temple at the Panathenaic festival,
which was held every fourth year in homage
to the goddess Athena, and was celebrated
with contests, sacrifices, and with the pre-
sentation of a folded *peplos* to the goddess's
statue. / Teil des Parthenon-Frieses (447-32
v. Chr.), seiner Nordseite mit dem Umzug
zum Tempel während des panathenischen
Fests, das alle vier Jahre stattfand, als
Hommage für die Göttin Athene. Das Fest
wurde mit Wettbewerben, Opfern und mit
der Übergabe eines Peplos an eine Statue
der Göttin gefeiert.

Cat. 192

Religious Plaques and Medallions / Religiöse Plaketten und Medaillons (Cat. 193-226)

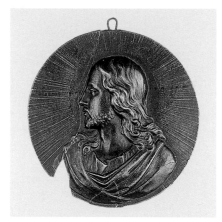

Cat. 193

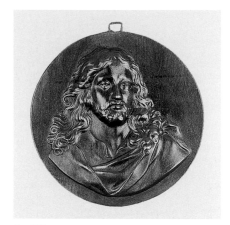

Cat. 195

193 Jesus Christ / Christus
Radiant bust almost front, slightly left, the head in profile left. / Brustbild fast von vorn, leicht nach links gewendet, der Kopf im Profil nach links mit Strahlenkranz.
1820-30. – Mod. Leonhard Posch. – F./G. KPEG. – D. 10.1 cm (4 in.). – 65.8 g. – Vertical break, small piece missing from corner / Vertikalbruch, kleine Ecke fehlt.
Lamprecht 390, Photo 48. – Inv. 1986.413.1.
Lit.: ACIPCO 1941a, b, frontispiece. – Forschler-Tarrasch, no. 852. – cp./vgl. Sommer 1981, no. B9, B14, B16.

194 Jesus Christ / Christus
Radiant bust almost front, slightly left, the head in profile left. / Brustbild fast von vorn, leicht nach links gewendet, der Kopf im Profil nach links mit Strahlenkranz.
1820-30. – Mod. Leonhard Posch. – F./G. KPEG. – D. 9.8 cm (3 7/8 in.). – 210.7 g.
Inv. 00.293. – Anonymous gift. / Unbekannte Stiftung.
Lit.: Forschler-Tarrasch, no. 852. – cp./vgl. Sommer 1981, no. B9, B14, B16.
Probably came to Museum through ACIPCO in 1951. / Wahrscheinlich ein Geschenk der ACIPCO 1951.

195 Jesus Christ / Christus
Bust front, the head slightly right. / Brustbild von vorn, der Kopf leicht nach rechts gewendet.
Ca. 1816. – Mod. Leonhard Posch. – F./G. Johann Conrad Geiss. – D. 9.2 cm (3 5/8 in.). – 77.4 g. – Rev./Rs. „G" and/und „Geiß".
Lamprecht 391, Photo 48. – Inv. 1986.413.2.
Lit.: Forschler-Tarrasch, no. 849. – Hintze 1928a, 26, pl./Taf. 35 (VI 86).

196 Jesus Christ / Christus
Radiant bust front, the head slightly right. / Brustbild von vorn, der Kopf leicht nach rechts blickend, mit Strahlenkranz.
1819-20. – Mod. Leonhard Posch. – F./G. KPEG. – D. 10.5 cm (4 1/8 in.). – 87.5 g. – Rev./Rs. „N VII.".
Lamprecht 470. – Inv. 1986.465.
Lit.: Forschler-Tarrasch, no. 850. – Hintze 1928a, 34, pl./Taf. 60 (VII 25). – Stummann-Bowert, 83, no. 33.

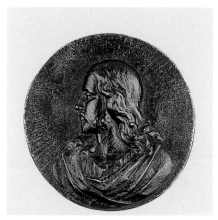

Cat. 194

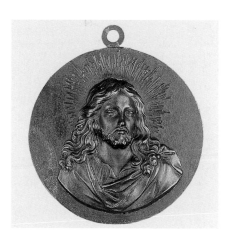

Cat. 196

Cat. 197

197 Jesus Christ / Christus
Radiant bust front. / Brustbild von vorn, mit Strahlenkranz.
Metal alloy/Gelbguß. – First quarter of the 19th century / 1. Viertel des 19. Jh. – D. 13.6 cm (5 3/8 in.).
Lamprecht 479, Photo 50. – Inv. 1986.473.

198 Jesus Christ / Christus
(Fig. p./Abb. S. 118)
Bust in profile right. / Brustbild im Profil nach rechts.
17th century (?) / 17. Jh. (?) – 15.5 x 12 cm (6 1/8 x 4 3/4 in.). – 750.1 g.
Lamprecht 392, Photo 37. – Inv. 1986.413.3.

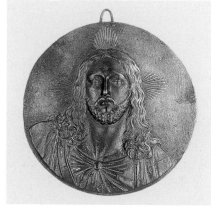

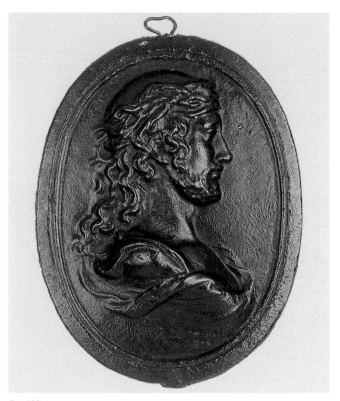

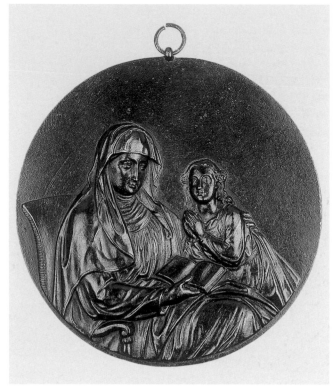

Cat. 198 Cat. 199

199 St. Anne Teaching the Virgin Mary to Read / Die Hl. Anna die Jungfrau Maria das Lesen lehrend
First quarter of the 19th century. / 1. Viertel des 19. Jh. – F./G. Mariazell. – D. 13.4 cm (5 1/4 in.). – 179.9 g.
Lamprecht 394, Photo 50. – Inv. 1986.415.
Lit.: Cat. Leipzig 1915, 122, no. 87.

Cat. 200

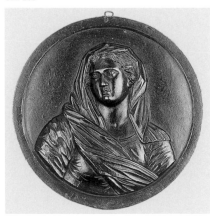

200 Madonna
Draped bust three-quarters front, the head turned to the left. / Brustbild dreiviertel nach vorn, der Kopf leicht nach links gewendet, mit Draperie.
First quarter of the 19th century / 1. Viertel des 19. Jh. – F./G. possibly/vielleicht Mariazell. – D. 12.7 cm (5 in.). – 225.5 g.
Lamprecht 393, Photo 49. – Inv. 1986.414.
Lit.: Cp./vgl. Pichler, fig./Abb. 8 (here with halo / hier mit Strahlenkranz).

201 Madonna of the Chair / Madonna della Sedia
Ca. 1820. – Mod. Leonhard Posch. – Cast iron on brass / Eisenguß auf Messing. – D. 11.5 cm (4 1/2 in.). – 276.9 g.
Lamprecht 912. – Inv. 1986.485.
Lit.: Arenhövel 1982, 91, no. 189. – Aus einem Guß, 233, no. 1950. – Cp./vgl. Cat. Gliwice 1988, no. 2. – Forschler-Tarrasch, no. 847. – Grzimek 1982, 154, no. 11. – Hintze 1928a, 104, pl./Taf. 76. – Stummann-Bowert, 80, no. 5.
After an engraving by Raphael Morghen, after the original tondo (1513/14) by Raphael, which is now in the Palazzo Pitti

in Florence. / Nach dem Stich von Raphael Morghen, gestochen nach dem kreisförmigen Gemälde (1513/14) von Raphael, das sich im Palazzo Pitti in Florenz befindet.

202 Madonna of the Chair / Madonna della Sedia
Ca. 1820. – Mod. Leonhard Posch. – F./G. KPEG. – D. 10.5 cm (4 1/8 in.). – 94.0 g.
Lamprecht 409. – Inv. 1986.425.1.
Lit.: S. Cat. 201.

203 Madonna of the Chair / Madonna della Sedia
Ca. 1820. – Mod. Leonhard Posch. – F./G. KPEG. – D. 8 cm (3 1/8 in.). – 116.1 g.
Lamprecht 410. – Inv. 1986.425.2.
Lit.: S. Cat. 201.

204 St. Leopold with the Architectural Plans for Klosterneuburg near Vienna / Hl. Leopold mit Architekturplänen für Klosterneuburg bei Wien
First quarter of the 19th century / 1. Viertel des 19. Jh. – F./G. Mariazell. – D. 13.4 cm (5 1/4 in.). – 211.5 g. – Rev./Rs. „St. Leopoldus".

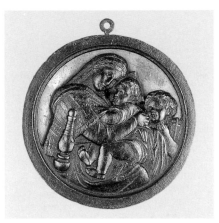

Cat. 201

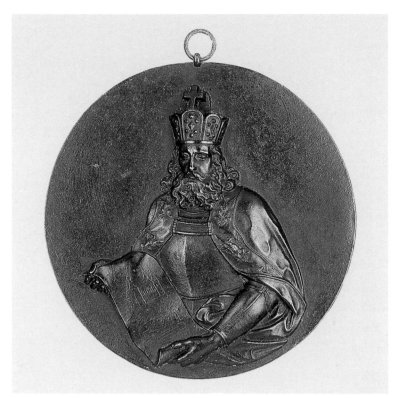

Cat. 204

Cat. 205

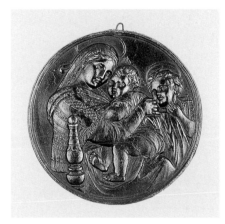

Cat. 202

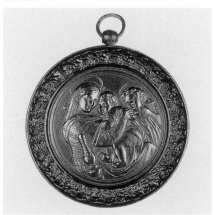

Cat. 203

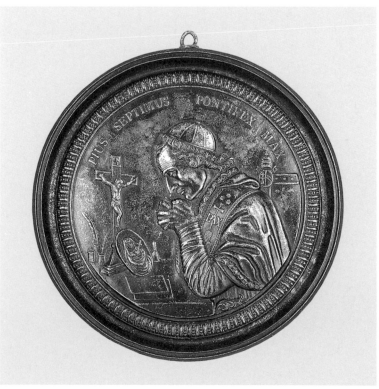

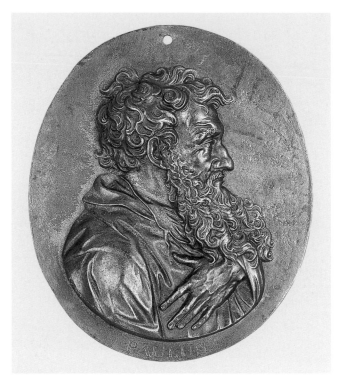

Cat. 206

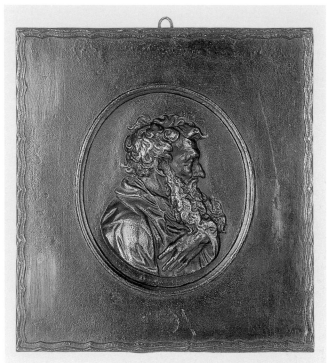

Cat. 207

Cat. 208

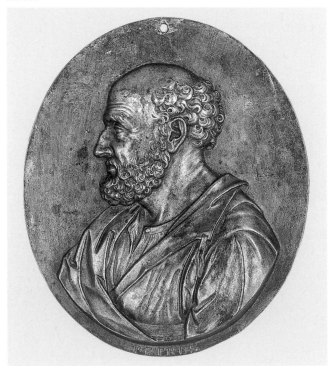

Cat. 209

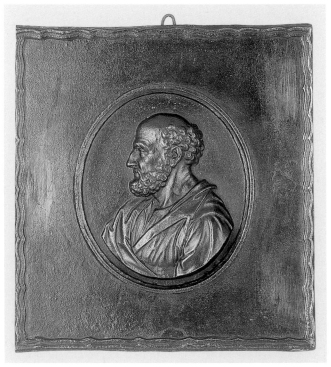

Lamprecht 395, Photo 50. – Inv. 1986.416. Leopold III of Babenberg (1075-1136), Margrave of Austria, founder of Klosterneuburg, and now patron saint of Austria, was canonized in 1485. / Leopold III. von Babenberg (1075-1136), Markgraf von Österreich, Gründer von Klosterneuburg, und heute Schutzheiliger von Österreich, wurde 1485 heiliggesprochen.

205 Pope Pius VII (Gregor Barnabas Luigi Duke Chiaramonti, 1742-1823; 1800 Pope) / Papst Pius VII. (Gregor Barnabas Luigi Herzog Chiaramonti; 1800 Papst) (Fig. p./Abb. S. 119)

The Pope in profile left praying before a crucifix. / Der Papst im Gebet nach links vor einem Kruzifix. – Ins. around/Umschrift *„PIUS SEPTIMUS PONTIFEX MAX"*.
Ca. 1800. – Mod. Anton Friedrich König the Elder/d. Ä. based on a medal by / nach einer Medaille von Tommaso Mercandetti. – F./G. KPEG Gleiwitz. – D. 16.2 cm (6 3/8 in.). – 636.2 g.
Lamprecht 459. – Inv. 1986.456.
Lit.: Aus einem Guß, 240, no. 2105. – Schmidt 1976, 34.
Mercandetti was a medallist at the Papal Mint in Rome. / Mercandetti war Medailleur an der Päpstlichen Münze in Rom.

206 Apostle Paul / Apostel Paulus
Bust in profile right. / Brustbild im Profil nach rechts. / Ins. *„PAULUS"*.
Ca. 1817. – Mod. Leonhard Posch. – F./G. KPEG. – 14.9 x 12.7 cm (5 7/8 x 5 in.). – 221.9 g.
Lamprecht 396, Photo 49. – Inv. 1986.417.
Lit.: ACIPCO 1941a, fig./Abb. 3. – Arenhövel 1982, 86 f., no. 181. – Aus einem Guß, 239, no. 2100. – Cat. Leipzig 1915, 124, no. 100. – Forschler-Tarrasch, no. 873. – Gleiwitzer Kunstguß 1935, 53. – Grzimek 1982, 153, no. 10. – Hintze 1928a, 36, pl./Taf. 69 (XII 1). – Howard, cover ill./Titelbild. – Stummann-Bowert, 83, no. 30.

207 Apostle Paul / Apostel Paulus
Bust in profile right, in large, cast-iron frame with wavy edge. / Brustbild im Profil nach rechts, in großem, angegossenem Rahmen mit welliger Kante. / Ins. *„PAULUS"* (barely legible / kaum lesbar).
1820-30. – Mod. Leonhard Posch. – 23.9 x 22.2 cm (9 7/16 x 8 3/4 in.), Bh. 12.3 cm (4 13/16 in.). – 1308.1 g. – Rev./Rs. *„S"*.
Lamprecht 398. – Inv. 1986.419 a.
Lit.: S. Cat. 206.

208 Apostle Peter / Apostel Petrus
Bust in profile left. / Brustbild im Profil nach links. / Ins. *„PETRUS"*.
Ca. 1817. – Mod. Leonhard Posch. – F./G. KPEG. – 15 x 12.7 cm (5 7/8 x 5 in.). – 163.0 g.
Lamprecht 397, Photo 49. – Inv. 1986.418.
Lit.: ACIPCO 1941, fig./Abb. 3. – Arenhövel 1982, 88, no. 182. – Aus einem Guß, 239, no. 2101. – Cat. Leipzig 1915, 124, no. 101. – Forschler-Tarrasch, no. 872. – Gleiwitzer Kunstguß 1935, 53. – Hintze 1928a, 36, pl./Taf. 69 (XII 2). – Schmidt 1981, 82, fig./Abb. 42. – Stummann-Bowert, 83, no. 31.

209 Apostle Peter / Apostel Petrus
Bust in profile left in large, cast-iron frame with wavy edge. / Brustbild im Profil nach links, in großem, angegossenem Rahmen mit welliger Kante.
1820-30. – Mod. Leonhard Posch. – 23.8 x 22 cm (9 3/8 x 8 11/16 in.), Bh. 12 cm (4 3/4 in.). – 1248.3 g. – Rev./Rs. *„XII"*.
Lamprecht 399. – Inv. 1986.419 b.
Lit.: S. Cat. 208.

210 Apostle Peter / Apostel Petrus
Bust almost front, the head in profile left. / Brustbild fast von vorn, der Kopf im Profil nach links. / Ins. *„SANCT PETRUS."*.
Ca. 1820. – Mod. Leonhard Posch. – F./G. KPEG Berlin or/oder Gleiwitz. – 11.4 x 8.9 cm (4 1/2 x 3 1/2 in.). – 143.0 g.
Lamprecht 403, Photo 49. – Inv. 1986.422.1.
Lit.: Arenhövel 1982, 86, no. 179. – Cat. Leipzig 1915, 122, no. 86. – Forschler-Tarrasch, no. 864. – Gleiwitzer Kunstguß 1935, 64 (Abb.). – Hintze 1928a, 36, pl./Taf. 68 (X14).
After an engraving by Raphael Morghen based on the fresco *The Last Supper* by Leonardo da Vinci in the Cloister Santa Maria delle Grazie in Milan. / Nach einem Stich von Raphael Morghen nach dem „Abendmahl" von Leonardo da Vinci im Kloster Santa Maria delle Grazie in Mailand.

211 Apostle Matthew / Apostel Matthäus
Bust in profile right. / Brustbild im Profil nach rechts. / Ins. *„SANCT MATHEUS"*.
Ca. 1820. – Mod. Leonhard Posch. – F./G. KPEG Berlin or/oder Gleiwitz. – 11.4 x 8.7 cm (4 1/2 x 3 7/16 in.). – 116.0 g.
Lamprecht 405, Photo 49. – Inv. 1986.422.3.
Lit.: ACIPCO 1941a, fig./Abb. 3. – Arenhövel 1982, 86, no. 173. – Aus einem Guß,

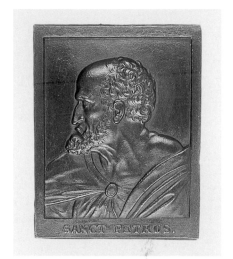

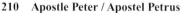

Cat. 210

Cat. 211

Cat. 212

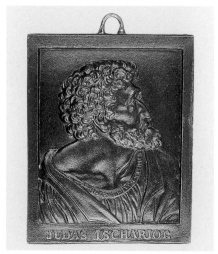

237, no. 2060. – Cat. Leipzig 1915, 122, no. 85. – Forschler-Tarrasch, no. 863. – Gleiwitzer Kunstguß 1935, 64 (ill./Abb.). – Hintze 1928a, 35, pl./Taf. 67 (X6). – Stummann-Bowert, 83, no. 28.
After *The Last Supper* by / Nach dem „Abendmahl" von Leonardo da Vinci (s. Cat. 210).

212 Apostle Judas Iscariot / Apostel Judas Ischariot (Fig. p./Abb. S. 121)

Bust almost front, the head in profile right. / Brustbild fast von vorn, der Kopf im Profil nach rechts. / Ins. „*JUDAS DER VERAETHER*" and/und „*JUDAS ISCHARIOT*".
Ca. 1820. – Mod. Leonhard Posch. – F./G. KPEG Berlin or/oder Gleiwitz. – 11.4 x 8.7 cm (4 1/2 x 3 7/16 in.). – 152.6 g.
Lamprecht 406, Photo 49. – Inv. 1986.422.4.
Lit.: Arenhövel 1982, 86, no. 180. – Aus einem Guß, 84, no. 162. – Cat. Köln 1979, no. 305. – Forschler-Tarrasch, no. 861. – Gleiwitzer Kunstguß 1935, 64. – Hintze 1928a, 36, pl./Taf. 68 (X15).
After *The Last Supper* by / Nach dem „Abendmahl" von Leonardo da Vinci (s. Cat. 210).

213 St. John the Evangelist / Apostel Johannes Evangelist

Half figure seated right, the head front. / Brustbild sitzend nach rechts gewendet, der Kopf von vorn.
Ca. 1818. – Mod. Leonhard Posch. – F./G. KPEG. – 39.7 x 30.5 cm (15 5/8 x 12 in.).
Lamprecht 414. – Inv. 1986.429.1.
Lit.: Arenhövel 1982, 88 f., no. 183. – Aus einem Guß, 84, no. 154. – Cat. Leipzig 1915, 125, no. 114. – Forschler-Tarrasch, no. 869. – Gleiwitzer Kunstguß 1935, 64. – Hintze 1928a, 35, pl./Taf. 67 (X2), 104, pl./Taf. 74,2. – Schmidt 1981, 82, fig./Abb. 44. – Stummann-Bowert, 81, no. 13 (pl./Taf. 15).
Model created for Johann Conrad Geiss after an 1808 engraving by Johann Gotthard von Müller based on a copy of the painting by Domenichino (Domenico Zampieri, 1581-1641), then in the collection of the Prince Narischkin in St. Petersburg. / Angefertigt für Johan Conrad Geiss nach dem 1808 datierten Stich von Johann Gotthard von Müller nach einer Kopie des Gemäldes von Domenichino (Domenico Zampieri, 1581-1641), die sich damals in der Samm-

lung des Prinzen Narischkin in St. Petersburg befand / (s. Anne Short ed., *Selected Masterworks from the Bob Jones University Museum and Gallery* [2001], 262 f.).

214 St. John the Evangelist / Apostel Johannes Evangelist

Half figure seated right, the head front. / Brustbild sitzend nach rechts gewendet, der Kopf von vorn. / Ins. „*ICH WAR IM GEIST*" and/und „*DA GERIETH ICH AM TAGE DES HERRN / IN EINE ENTZÜCKUNG UND / HÖRTE HINTER MIR EINE STIMME / GLEICH DEM POSAUNENSCHALLE*".
Ca. 1818. – Mod. Leonhard Posch. – F./G. KPEG. – 13 x 12.4 cm (5 1/8 x 4 7/8 in.). – 364.0 g.
Lamprecht 415, Photo 50. – Inv. 1986.429.2.
Lit.: S. Cat. 213.

215 St. John the Evangelist / Apostel Johannes Evangelist

Bust front, the head nodded to the left. / Brustbild von vorn, der Kopf nach links geneigt. / Ins. „*S. JOHAN. EVANGELIST.*".

Cat. 213

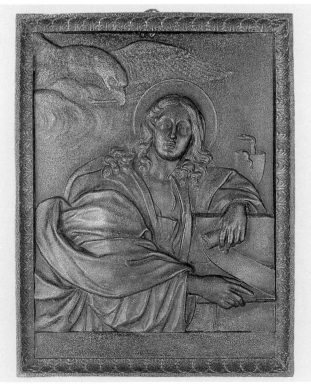

Cat. 214

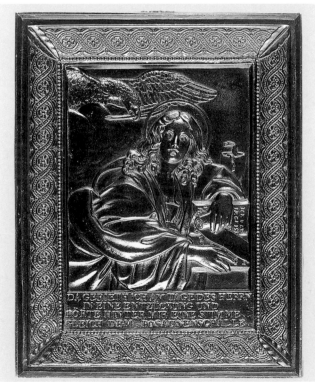

Ca. 1820. – Mod. Leonhard Posch. – F./G.
KPEG Berlin or/oder Gleiwitz. – 11.4 x
8.7 cm (4 1/2 x 3 7/16 in.). – 133.4 g.
Lamprecht 404, Photo 49. – Inv. 1986.422.2.
Lit.: ACIPCO 1941a, fig./Abb. 3. – Aren-
hövel 1982, 86, no. 172. – Aus einem Guß,
85, no. 164. – Forschler-Tarrasch, no. 860.
– Gleiwitzer Kunstguß 1935, 64. – Hintze
1928a, 35, pl./Taf. 67 (X5).
After *The Last Supper* by / Nach dem
„Abendmahl" von Leonardo da Vinci (s.
Cat. 210).

216 St. John the Evangelist / Apostel Jo-
hannes Evangelist

Bust three-quarters right with the head fac-
ing front, the left arm resting on a book
with a scroll in the left hand, behind a cup
with viper. / Brustbild dreiviertel nach rechts
mit dem Kopf nach vorn, der linke Arm
ruht auf einem Buch, in der linken Hand ei-
ne Schriftrolle, hinten ein Becher mit Gift-
schlange.
Ca. 1818. – Mod. Leonhard Posch. – F./G.
KPEG Gleiwitz. – D. 13 cm (5 1/8 in.). –
130.1 g. – Rev./Rs. „N: VIII.4".

Inv. 2007.17. – Museum purchase with par-
tial funds provided by / Ankauf mit finan-
zieller Unterstützung von Daniel Durso.
Lit.: Aus einem Guß 1988, 232, no. 1937. –
Forschler-Tarrasch, 874. – Hintze 1928a,
35, pl./Taf. 65 (VIII4).
After the painting *St. John the Evangelist*
by Domenichino (s. Cat. 213). The model
was originally created for the private found-
ry Geiss in Berlin and was adapted from a
more detailed model by Posch. / Nach dem
Gemälde „Apostel Johannes Evangelist" von
Domenichino (s. Cat. 213). Das Modell
wurde ursprünglich für die private Gießerei
Geiss in Berlin nach einem detaillierteren
Modell von Posch hergestellt.

217 Madonna and Child / Maria mit
dem Kind

First quarter of the 19th century / 1. Viertel
des 19. Jh. – F./G.Carlshütte. – 14 x 8 cm
(5 1/2 x 3 1/8 in.). – 109.8 g. – Bronzed/
bronziert. – Rev./Rs. „C H" and crossed
hammer and gad / und Schlägel und Eisen.
Lamprecht 400. – Inv. 1986.420.
Lit.: Arenhövel 1982, 90, no. 186. – Hintze
1928a, 35, pl./Taf. 64 (VIII 9).

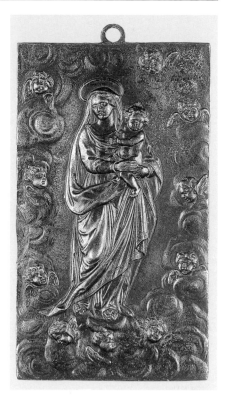

Cat. 217

Cat. 215

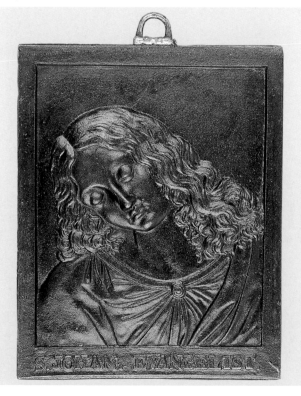

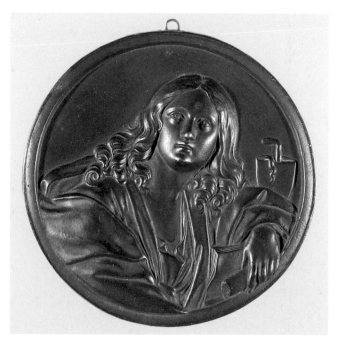

Cat. 216

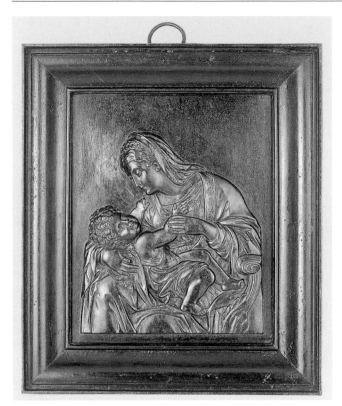

Cat. 218

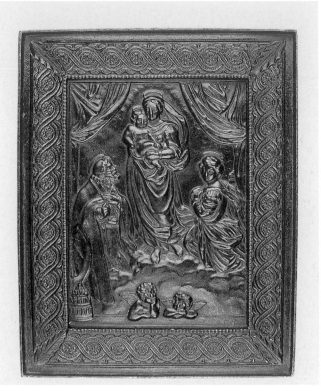

Cat. 219

218 Madonna and Child / Maria mit dem Kind
Ca. 1820. – Mod. Leonhard Posch. – F./G. KPEG Berlin or/oder Gleiwitz. – 26.9 x 23.3 cm (10 9/16 x 9 3/16 in.). – 1665.4 g. Lamprecht 407, Photo 46. – Inv. 1986.423. Lit.: Forschler-Tarrasch, no. 846. – Grzimek, 154, no. 13. – Hintze 1928a, 105, pl. 80,2. – Schmidt 1981, 82, fig./Abb. 41. – Stummann-Bowert, 80, no. 4.

219 Sistine Madonna / Sixtinische Madonna
Ca. 1825. – Mod. Johann Friedrich Gottlieb Müller. – F./G. KPEG. – 13.6 x 11 cm (5 3/8 x 4 5/16 in.). – 245.4 g. Lamprecht 411, Photo 50. – Inv. 1986.426. Lit.: Arenhövel 1982, 91, no. 188. – Aus einem Guß, 84, no. 156. – Cat. Köln 1979, no. 308. – Cat. Leipzig 1915, 125, no. 111. – Ostergard 1994, 197, no. 38.
After an engraving by Johann Friedrich Müller based on the 1512/13 painting by Raphael now in the Gemäldegalerie Dresden. / Nach einem Stich von Johann Friedrich Müller nach dem 1512/13 entstandenen Gemälde von Raphael, heute in der Gemäldegalerie Dresden.

220 The Last Supper / Abendmahl
Ins. *„MEN DICO VOBIS QUIA UNNUS VESTRUM ME TRADITURUS EST."* and/ und *„MATT. C. XXVI".*
1818. – Mod. Francesco Putinati. – F./G. KPEG Berlin (cast also in / gegossen auch in Horowitz). – 9.8 x 15.4 cm (3 7/8 x 6 1/16 in.). – 288.1 g. – Sign. lower left / links unten *„Putinati F./1818".*
Lamprecht 401, Photo 48. – Inv. 1986.421.1. Lit.: Arenhövel 1982, 84, no. 168. – Cat. Köln 1979, no. 307. – Cat. Leipzig 1915, 129, no. 147.
After *The Last Supper* by / Nach dem „Abendmahl" von Leonardo da Vinci (s. Cat. 210; cp./vgl. Cat. 221 f.).

221 The Last Supper / Abendmahl
1822-23. – Mod. Leonhard Posch. – F./G. KPEG Berlin or/oder Gleiwitz. – 11.8 x 17.4 cm (4 5/8 6 7/8 in.). – 429.7 g. Lamprecht 402. – Inv. 1986.421.2. Lit.: Arenhövel 1982, 84, no. 167. – Aus einem Guß, 83, no. 149. – Cat. Gliwice 1988, no. 1, fig./Abb. 1. – Forschler-Tarrasch, no. 854. – Gleiwitzer Kunstguß 1935, 48. – Hintze 1928a, 105, pl./Taf. 81. – Rasl 1980, 116 f., no. 177. – Schmidt 1981, 80,

fig./Abb. 39. – Spiegel, 135, fig./Abb. 24. – Stummann-Bowert, 82, no. 17.
After *The Last Supper* by / Nach dem „Abendmahl" von Leonardo da Vinci (s. Cat. 210; cp./vgl. Cat. 220, 222).

222 The Last Supper / Abendmahl
Ca. 1940. – Mod. by Windsor Furnace, Burks County, Pennsylvania. – F./G. Hamilton, Ohio (gilt/vergoldet). – 36.2 x 63.5 cm (14 1/4 x 25 in.). – Marked/bez. circle with an „H" in the middle / Kreis mit eingeschriebenem „H".
Lamprecht 951. – Inv. 1986.525.
After *The Last Supper* by / Nach dem „Abendmahl" von Leonardo da Vinci (s. Cat. 201; cp./vgl. Cat. 220 f.).
Relief plaques after this painting were cast in various sizes by different foundries and were often finished by different modelers (Francesco Putinati or Johann Carl Wilhelm Kratzenberg) after the „original" by Leonhard Posch, which is difficult to date exactly. /
Reliefs nach diesem Gemälde wurden in unterschiedlichen Größen von verschiedenen Gießereien hergestellt, zum Teil von anderen Modelleuren bearbeitet (Francesco

Cat. 220

Cat. 221

Cat. 222

Putinati oder Johann Carl Wilhelm Kratzenberg), die sich wohl alle an die „Urfassung" von Leonhard Posch anlehnten, die nicht genau zu datieren ist. / (s. Arenhövel 1982, 84, Cat. 167 f.).

223 The Entombment / Grablegung Christi
Ca. 1820. – Mod. Leonhard Posch. – F./G. KPEG Berlin or/oder Gleiwitz. – 27 x 21.9 cm (10 5/8 x 8 5/8 in.). – 1590.2 g.
Lamprecht 408, Photo 47. – Inv. 1986.424.
Lit.: Arenhövel 1982, 89, no. 185. – Aus einem Guß, 83, no. 148. – Forschler-Tarrasch, no. 871. – Gleiwitzer Kunstguß 1935, 59. – Hintze 1928a, 105, pl./Taf. 80,1. – Schmidt 1976, fig./Abb. 40. – Schmidt 1981, 81, fig./Abb. 40. – Schmuttermeier, 19, no. 10. – Spiegel, 130, fig./Abb. 17.
Traces of bronzing. According to E. W. Braun, after Guglielmo della Porta in imitation of an Italian bronze plaque from the end of the sixteenth century. / Reste von Bronzierung. Laut E. W. Braun nach Guglielmo della Porta in Anlehnung an eine italienische Bronze-Plakette vom Ende des 16. Jahrhunderts. / (s. E. W. Braun, *Die Bronzen der Sammlung Guido von Rhó in Wien* [Wien 1908], pl./Taf. XLVII.).

224 Procession to Calvary / Christus, das Kreuz tragend
Ins. *„JESUS TRÄGT SEIN KREUZ MIT GEDULD"*.
Ca. 1820. – Mod. Leonhard Posch. – F./G. KPEG. – 14.3 x 11.1 cm (5 5/8 x 4 3/8 in.). – 263.3 g.

Cat. 223

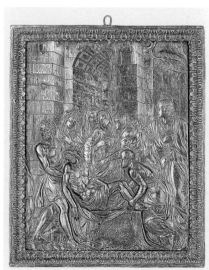

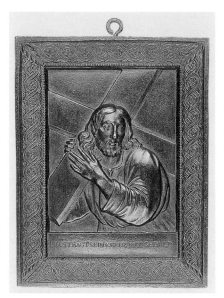

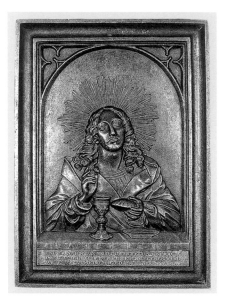

Cat. 224

Cat. 225

Lamprecht 412, Photo 50. – Inv. 1986.427. Lit.: Arenhövel 1982, 89, no. 184. – Aus einem Guß, 83, no. 148. – Ferner and Genée, 35, fig./Abb. 25. – Forschler-Tarrasch, no. 870. – Gleiwitzer Kunstguß 1935, 54. – Hintze 1928a, 104, pl./Taf. 74,3.

Posch created this model for the jeweler and foundry owner Johann Conrad Geiss. It was also used by other foundries and with another inscription (s. below). / Posch hat dieses Modell für den Juwelier und Gieße-reibesitzer Johann Conrad Geiss angefer-

tigt. Es wurde auch von anderen Gieße-reien benutzt, auch mit der Inschrift *„WER SEIN KREUZ NICHT AUF SICH / NIMT UND FOLGET MIR / DER IST MEIN NICHT WERT".* / (s. Arenhövel 1982, 89, no. 184).

225 Sacrament of Christ / Christus, das Abendmahl einsetzend

In Gothic arch, radiant Christ sitting with his right hand raised, in his left hand a piece

of bread. / In einem Rundbogen mit gotisie-renden Dreipässen in den Zwickeln sitzt Christus am Tisch, die rechte Hand erho-ben und in der Linken das Brot haltend. / Ins. *„UND ER NAHM DAS BRODT DANKTE UND SPRACH: DAS IST MEIN LEIB DER FÜR EUCH GEGEBEN WIRD DAS THUT ZU MEINEM GEDAECHT-NISS LUC XXII 19".*

Ca. 1820. – F./G. KPEG. – 16.5 x 11.7 cm (6 1/2 x 4 5/8 in.). – 283.7 g.

Lamprecht 413, Photo 48. – Inv. 1986.428. Lit.: Aus einem Guß, 222, no. 1664. – Forschler-Tarrasch, no. 875. – Hintze 1928a, 104, pl./Taf. 78,1.

After an engraving by Ludwig Buchhorn based on a painting by Carlo Dolci now in the Gemäldegalerie Dresden. / Nach einem Stich von Ludwig Buchhorn nach dem Ge-mälde von Carlo Dolci, heute in der Dresd-ner Gemäldegalerie.

226 Christ and the Adulteress / Christus und die Ehebrecherin

1827. – Mod. Francesco Putinati. – F./G. KPEG. – 8 x 14 cm (3 1/8 x 5 1/2 in.). – 152.8 g. – Sign. lower center / Mitte unten *„F. Putinati F. / A.1827".*

Inv. 1962.88. – Gift of / Schenkung von Dr. and Mrs. Maurice Garbáty.

Lit.: Arenhövel 1982, 92, no. 191.

After an Italian prototype from the mid-sixteenth century. / Nach einer italienischen Vorlage aus der Mitte des 16. Jahrhunderts.

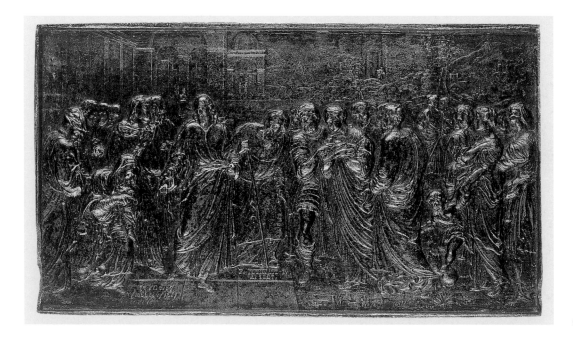

Cat. 226

Medals / Medaillen
(Cat. 227-87)

227 Napoleon Crossing the Alps at the St. Bernhard Pass / Napoleon überquert die Alpen über den Sankt-Bernhard-Paß
Obv./Vs.: General Napoleon on horseback crossing the Alps at the St. Bernhard Pass on May 14, 1800, prior to the battle of Marengo. / General Napoleon zu Pferde die Alpen über den Sankt-Bernhard-Paß am 14. Mai 1800 vor der Schlacht bei Marengo überquerend. / Ins. „*PASSAGE DU GD. St. BERNARD LE XXV FLOREAL AN VIII*".
Rev./Rs.: –.
Ca. 1800. – Mod. Bertrand Andrieu. – F./G. KPEG. – D. 5.7 cm (2 1/4 in.). – 26.5 g.
Sign. at left edge / links am Rand „*ANDRIEU F.*".
Lamprecht 304. – Inv. 1986.346.3.
Lit.: Bramsen, no. 35. – Cat. Paris 1978, 29 (f). – Wurzbach-Tannenberg, no. 6500.
According to the Napoleonic Republican calendar, Napoleon and his troops crossed the St. Bernhard Pass on the 24th Floréal in the year VIII (May 14, 1800), not the 25th Floréal in the year VIII (May 15, 1800) as found on medal. / Dem napoleonischen republikanischen Kalender entsprechend, überquerten Napoleon und seine Truppen den Sankt-Bernhard-Paß am 24. Floréal im Jahr VIII (14. Mai 1800), und nicht am 25. Flo-

Cat. 227

réal im Jahr VIII (15. Mai 1800) wie es auf der Medaille steht.

228 Friedrich Anton Freiherr von Heinitz (1725-1802), Co-Founder of the Prussian Royal Iron Foundries / Mitbegründer der Königlich Preußischen Eisengießereien
(Fig. p./Abb. S. 19)
Obv./Vs.: Head in profile right. / Kopf im Profil nach rechts. / Ins. around/Umschrift „*FRID.ANT.L. B. DE. HEINITZ MINIST. STAT. INTIM. BORUSS. EQU. ORD. AQU. NIGR.*".
Rev./Rs.: Laurel wreath / Lorbeerkranz. / Ins. „*EN REDEVNT / TEMPORA / ATHENAE*".
Ca. 1802. – Mod. Anton Friedrich König the Elder/d. Ä. – F./G. KPEG Gleiwitz. – D. 5.2 cm (2 1/16 in.). – 41.0 g. – Sign. on truncation / am Brustabschnitt „*KÖNIG*".
Lamprecht 342, Photo 60. – Inv. 1986.374.

229 Northern Germany Apothecary Association / Norddeutscher Apotheker Verein
Obv./Vs.: Bust of Rudolph Brandes (1795-1832) front. / Brustbild des Rudolph Brandes (1795-1832) von vorn. / Ins. around/ Umschrift „*RUDOLPH BRANDES STIFTER DES NORDDEUTSCHEN APOTHEKER VEREINS*".
Rev./Rs.: „*ZUM ANDENKEN AN DIE VERSAMMLUNG ZU KÖNIGSHÜTTE D. 3-5t JUNI 1846*".
1846. – F./G. Königshütte (Harz). – 7.0 x 5.2 cm (2 3/4 x 2 1/16 in.). – 33.7 g.
Lamprecht 373. – Inv. 1986.400.
Lit.: Cat. Leipzig 1915, 127, no. 127.

230 War and Peace / Krieg und Frieden
Obv./Vs.: In the background a Greek temple with the statue of Pallas Athena sur-

rounded by people, in the foreground, men engaged in peaceful work. / Im Hintergrund ein antiker Rundtempel mit einer Statue der Pallas Athene, umgeben von Menschen, davor Menschen bei der Arbeit. / Ins. „*FLEISS UND FREUDE / KEHREN WIEDER*".
Rev./Rs.: The figure of lamenting Prussia with a shield displaying the Prussian eagle in front of a Greek temple with the statue of Pallas Athena, before her a broken plough and a destroyed well in reference to commerce and agriculture. / Die klagende Borussia vor einem Rundtempel mit Standbild der Pallas Athene, neben ihr ein Schild mit dem preußischen Adler, vor ihr ein zerbrochener Pflug und ein zerstörter Brunnen als Hinweis auf Handel und Ackerbau. / Ins. „*OEDE TRAUREN / FLUR UND BERGE / MDCCCVI-MDCCCVIII*".
1809. – Mod. Leonhard Posch based on a drawing by / nach einer Zeichnung von Ludwig Wolf. – F./G. KPEG Berlin. – D. 19 cm (7 1/2 in.). – 972.8 g. – Sign. on obverse below relief left / auf der Vs. links unterhalb des Reliefs „*WOLF DEL.*" and right/und rechts „*POSCH FEC*".
Lamprecht 389. – Inv. 1986.412.
Lit.: Arenhövel 1982, 77, no. 153. – Aus einem Guß, 75, no. 145. – Cat. Leipzig 1915, 124 f., no. 107. – Forschler-Tarrasch, no. 840. – Hintze 1928a, 104, pl./Taf. 77,2. – Köcke, 116, no. 15 f. – Müseler 49.1/16.
This medal refers to the collapse of Prussia during the Napoleonic Wars, the departure of the royal family in 1806, and the return to Berlin of King Friedrich Wilhelm III on December 23, 1809. It was cast at the Royal Prussian Iron Foundry in Berlin and sold along the route between Königsberg in East Prussia, where the royal family spent their exile, and Berlin. The king and his wife, Queen Luise, received a copy in an etui of Moroccan leather. /
Diese Medaille bezieht sich auf den Zusammenbruch Preußens während der Napoleonischen Kriege, die Abreise der königlichen Familie 1806 und die Rückkehr des Königs Friedrich Wilhelm III. am 23. Dezember 1809. Sie wurde in der Berliner Eisengießerei gegossen und an der Strecke zwischen Königsberg in Ostpreußen, wo die königliche Familie ihr Exil verbracht hatte, und Berlin verkauft. Der König und seine Gattin, Königin Luise, erhielten ein Exemplar in einem Etui aus Maroquinleder. / (GStA PK, 1 HA Rep. 112 Oberbergamt, Nr. 117, „Acta wegen Anfertigung einer Medaille aus Gußeisen zur Feier der

Cat. 229

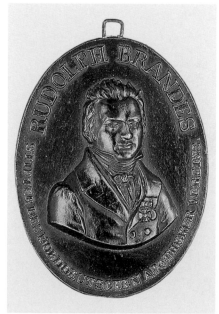

Cat. 230 (Obv./Vs.)

Cat. 230 (Rev./Rs.)

Rückkunft Sr. Majestät des Königs 1809-1810").

231 Success in the Harz Mining Industry / Erfolg im Harzer Bergbau

Obv./Vs.: The figure of Fortune standing on a wheel in the sea holding a sail with the motto „*FRONTE CAPILLATA EST*", in the background a sailboat and coastal landscape. / Die Figur der Fortuna steht auf einem Rad in der See und hält ein Segel mit dem Motto „*FRONTE CAPILLATA EST*", der Hintergrund zeigt ein Segelschiff vor einer Küste.

Rev./Rs.: –

First quarter of the 19th century / 1. Viertel des 19. Jh. – Mod. Heinrich Christian Bonhorst. – F./G. possibly/vielleicht Clausthal. – D. 6.3 cm (2 1/2 in.). – 94.7 g.

Lamprecht 435. – Inv. 1986.444.

Lit.: Auktion Künker, no. 5283.

The obverse only of a two-sided medal. The reverse of the original medal shows a mining establishment between two pine trees decorated with cornucopia, with an inscription that refers to the lack of gold mined in the Harz Mountains, which was compensated for by the surplus of silver and lead. / Es handelt sich hier nur um die Vs. einer Medaille. Die Rs. der originalen Medaille zeigt eine Bergwerksanlage zwischen zwei mit Füllhörnern behangenen Tannen, mit den Inschriften, die sich auf die fehlende Goldgewinnung im Harz beziehen, die jedoch durch die Silber- und Bleigewinnung ausgeglichen wird. / Sign. „*H.B.*". – Ins. „*AUREA HERCINIÆ STERILTAS*" and/und „*DITESCIT AB IMO*".

232 Martin Luther (1483-1546), 300 Years of the Reformation / 300 Jahre Reformation

Obv./Vs.: Bust front, holding the Bible. / Brustbild von vorn, die Bibel in den Händen. / Ins. around/Umschrift „*Dr. Martin Luther gebor. 1483. gestorb. 1546*".

Rev./Rs.: Luther with his Ninety-Five Theses at the door of the All Saints Church in Wittenberg. / Thesenanschlag an der Schloßkirche in Wittenberg. / Ins. around/Umschrift „*Mit Gott begonnen zu Wittenberg den 31 October 1517*".

1817. – Portrait possibly after a model by / Porträt möglicherweise nach einem Modell von Leonhard Posch. – F./G. KPEG. – D. 10.3 cm (4 1/16 in.). – 255.1 g.

Lamprecht 384. – Inv. 1986.407.

Lit.: Aus einem Guß, 234, no. 1970. – Forschler-Tarrasch, no. 913. – Gleiwitzer

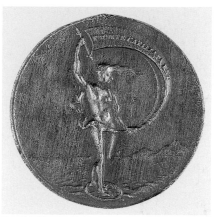

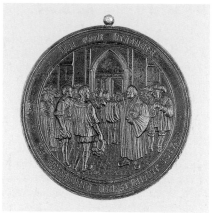

Cat. 231 (Obv./Vs.) Cat. 232 (Obv./Vs.) Cat. 232 (Rev./Rs.)

Kunstguß 1935, 55. – Hintze 1928a, 104,
pl./Taf. 75,2. – Whiting, no. 608.
Cp./vgl. Cat. 233.

**233 Martin Luther, 300 Years of the Re-
formation / 300 Jahre Reformation**
Obv./Vs.: s. Cat. 232.
Rev./Rs.: Ins. „DRITTE / SAECULAR FEI-
ER / DER / REFORMATION / 1817".
1817. – F./G. KPEG. – D. 3.8 cm (1 1/2 in.).
– 13.4 g.
Lamprecht 431M. – Inv. 1986.495.12.
Lit.: Cat. Leipzig 1915, 131, no. 164. – S.
also/auch Cat. 232.

**234 Martin Luther, 300 Years of the Re-
formation / 300 Jahre Reformation**
Obv./Vs.: Bust front holding the Ninety-
Five Theses. / Brustbild von vorn, die Thesen
haltend. / Ins. around/Umschrift „MARTI-
NVS LVTHERVS THEOLOGIAE DOC-
TOR".
Rev./Rs.: „ZUM / ANDENKEN / DER DRIT-
TEN / IUBEL FEIER / DER KIRCHEN
VERBESSERUNG / D: 31ᵀ OCTBR: 1817".
1817. – D. 5.1 cm (2 in.). – 18.1 g.
Lamprecht 452. – Inv. 1986.451.1.
Lit.: Cat. Leipzig 1915, 131, no. 165.

**235 Martin Luther, 400th Anniversary
of his Birth / 400. Jahresfeier seiner Ge-
burt**
Obv./Vs.: Bust front, head slightly left. /
Brustbild von vorn, der Kopf leicht nach
links gedreht. / Ins. around/Umschrift
„DOCTOR. MARTIN. LUTHER. REFOR-
MATOR".

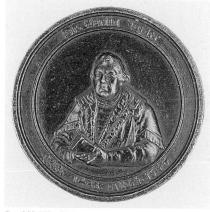

Cat. 233 (Obv./Vs.) Cat. 233 (Rev./Rs.)

Cat. 234 (Obv./Vs.) Cat. 234 (Rev./Rs.)

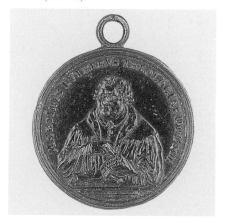

Rev./Rs.: „ZUM GEDÄCHTNIS DER 400 JÄHRIGEN GEBURTSFEIER" and Ins. around / und Umschrift „EISLEBEN. WITTENBERG. WORMS. 1483. 10. NOVEMB. 1883".
1883. – D. 6.3 cm (2 1/2 in.). – 106.4 g.
Lamprecht 453. – Inv. 1986.450.2.
Lit.: Cp./vgl. Loos 1842, 8, no. H.a.78. – Schnell, 260, no. 349. – Whiting, no. 769.

236 Heinrich Duke of Saxony (1473-1541; ruled from 1539 as Heinrich the Pius), 300 Years of the Reformation in Dresden / Heinrich Herzog von Sachsen (regierte ab 1539 als Heinrich der Fromme), 300 Jahre Reformation in Dresden
Obv./Vs.: Bust front. / Brustbild von vorn. / Ins. around/Umschrift „HEINRICH HERZOG Z. SACHSEN 1539. IUBELFEIER DER REFORMATION IN DRESDEN D. 6. JULI 1839".
Rev./Rs.: A cross with the Bible, sword, and helmet. / Kreuz mit Bibel, Schwert und Helm. / Ins. around/Umschrift „NEHMET DEN HELM DES HEILS UND DAS SCHWERT DES GEISTES WELCHES IST DAS WORT GOTTES".
1839. – F./G. Lauchhammer (?). – D. 5.4 cm (2 1/8 in.). – 55.7 g.
Lamprecht 454. – Inv. 1986.451.2.
Lit.: Schnell, 254, no. 333. – Wurzbach-Tannenberg, no. 3657.

237 Christian Albrecht, Duke of Schleswig-Holstein-Gottorf, Bishop of Lübeck (1641-95) / Herzog von Schleswig-Holstein-Gottorf, Bischof von Lübeck
Obv./Vs.: Portrait bust in profile right. / Brustbild im Profil nach rechts. / Ins. around/Umschrift „CHRIST. ALB. HER. N. DVX. S. H.S.D.C.O.D.".
Rev./Rs.: A rocky mountain in clouds with a crown above and a warrior storming the summit with shield and sword below. / Ein spitz zulaufendes Felsmassiv in Wolken unterhalb einer schwebenden Krone, unten ein Krieger mit Schild und Schwert den Gipfel erstürmend. / Ins. around/Umschrift „PER ASPERA AD ASTRA".
First quarter of the 19th century / Erstes Viertel des 19. Jh. – D. 5.7 cm (2 1/4 in.). – 38.5 g.
Lamprecht 419M, Photo 61. – Inv. 1986.494.
Christian Albrecht became duke upon his father's death in 1659. In this position he was forced to constantly fend off the military advances of the Danish King Christian V. / Christian Albrecht wurde 1659 nach dem

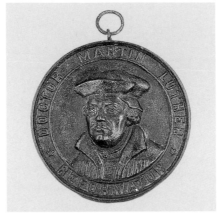

Cat. 235 (Obv./Vs.)

Cat. 235 (Rev./Rs.)

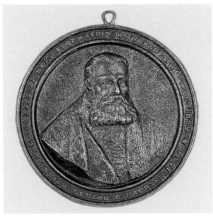

Cat. 236 (Obv./Vs.)

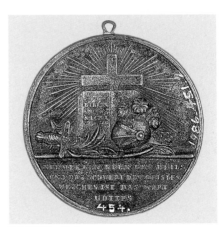

Cat. 236 (Rev./Rs.)

Cat. 237 (Obv./Vs.)

Cat. 237 (Rev./Rs.)

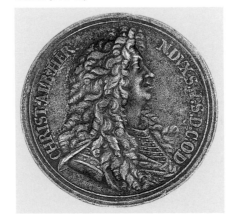

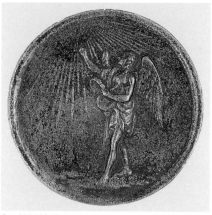

Cat. 238 (Obv./Vs.)

Cat. 238 (Rev./Rs.)

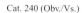

Cat. 239 (Obv./Vs.)

Cat. 239 (Rev./Rs.)

Cat. 240 (Obv./Vs.)

Cat. 240 (Rev./Rs.)

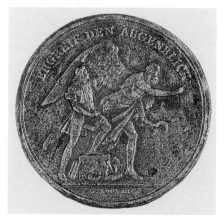

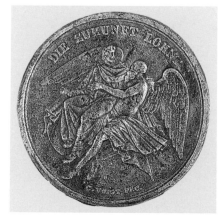

Tod seines Vaters Herzog und mußte sich der Angriffe des dänischen Königs Christian V. ständig erwehren.

238 Birth or Baptismal Medal / Geburts- oder Taufmedaille

Obv./Vs.: An angel with wreath of roses and lyre reaches for the sun. / Ein Schutzengel mit Rosenkranz und Leier streckt sich nach der Sonne.
Rev./Rs.: Star border. / Sternenkranz. / Ins. „DIESER ERSTEN SONNE DIE DICH BESCHIEN UND NICHT VERALTETE SEY DEIN ALTER GLEICH".
Ca. 1800. – Mod. Daniel Friedrich Loos. – F./G. KPEG Berlin. – D. 3.6 cm (1 7/16 in.). – 15.7 g.
Lamprecht 421M. – Inv. 1986.495.2.
Lit.: Sommer 1981, B44.

239 Free City of Krakow / Freistadt Krakau

Obv./Vs.: Arms of Krakow. / Stadtwappen von Krakau. / Ins. around/Umschrift „POPULUSQUE CRACOVIENSIS D. VI. SEPT: A. MDCCCXVIII SENATUS".
Rev./Rs.: Three areas enclosed by oak leaves, each with an inscription / Drei Eichenblattkränze umgeben die Inschriften: 1) „ERN: WILLEL: / BARONI / REIBNITZ PRAESIDI / IUDIC: SUPP: / ET APPELLATIO / NUM", 2) „IGNATIO / MIACZYNSKI. / ORDINIS. S. STANIS: / I. CLASSIS EQUITI" and/und 3) „IOSEPHO / COMITI / SWERTS-SPORK / S.G.R.A.M. / INTIMO CONSIL: / ORDIN.S.STEPH: / EQUITI", additionally the ins. around / außerdem die Umschrift „COMMISSARIIS AD CONSTIT: REMPUBL: CRACOVIENSEM PER AUG: EIUS PROTEC: DELEGAT:".
1818. – D. 6.3 cm (2 1/2 in.). – 32.0 g.
Lamprecht 420M. – Inv. 1986.495.1.

240 Medal commemorating the Passing of Time / Medaille auf das Verrinnen der Zeit

Obv./Vs.: A young man attempting to catch the fleeing Chronos (with bill hook). / Junger Mann bei dem Versuch, den davoneilenden geflügelten Kronos (mit Hippe) zu ergreifen. / Ins. around/Umschrift „ERGREIF DEN AUGENBLICK".
Rev./Rs.: A figure being carried by the winged Chronos. / Figur von dem fliegenden Kronos getragen. / Ins. around/Umschrift „DIE ZUKUNFT LOHNT".
1820-25. – Mod. Gottfried Bernhard Loos and/und Karl Friedrich Voigt. – D. 3.8 cm (1 1/2 in.). – 23.7 g. – Sign. on the obv. /

Cat. 241 (Obv./Vs.)

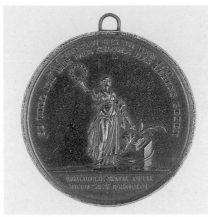

Cat. 241 (Rev./Rs.)

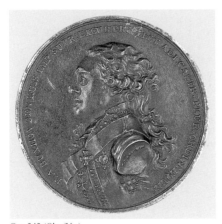

Cat. 242 (Obv./Vs.)

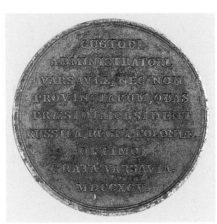

Cat. 242 (Rev./Rs.)

Cat. 243 (Obv./Vs.)

Cat. 243 (Rev./Rs.)

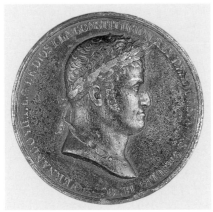

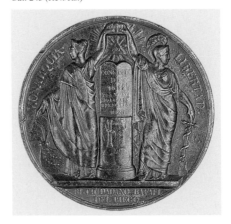

auf der Vs. „G. LOOS DIR"; Rev./Rs. „G. VOIGT FEC.".
Lamprecht 422M. – Inv. 1986.495.3.

241 Confirmation Medal / Konfirmationsmedaille
Obv./Vs.: Scene from the *Last Supper* / Abendmahlszene. / Ins. „SOLCHES THUT ZU MEINEM GEDAECHTNISS".
Rev./Rs.: Allegory of Faith holding in her right hand a wreath of stars and in her left a cross. / Allegorie der Religion, die in der Rechten einen Sternenkranz und in der Linken ein Kreuz hält. / Ins. around/Umschrift „SEY GETREU BIS AN DEN TOD SO WILL ICH DIR DIE KRONE DES LEBENS GEBEN" and/und „WANDLE VOR MIR UND SEY FROMM".
N. d./o. J. – Mod. Daniel Friedrich Loos and/und Johann Veit Döll. – D. 4.9 cm (1 15/16 in.). – 42.0 g.
Lamprecht 423M. – Inv. 1986.495.4.
Lit.: Sommer 1981, B5.

242 Friedrich Wilhelm von Buxhoevden (1750-1811). Dedication from the City of Warsaw for its Commander / Widmung der Stadt Warschau ihrem Kommandanten
Obv./Vs.: Bust in profile left. / Brustbild im Profil nach links. / Ins. around/Umschrift „F. A. BUXHÖVDEN RUSS: IMP: SUPR: EXCUB=PRAEFECT: ADI: CASTR: PLUR: ORDIN: EQUES".
Rev./Rs.: Ins. „CUSTODI, / ADMINISTRATORI, / VARSAVIÆ, NEC NON / PROVINCIARUM. QUAS / PRÆSIDIA OBSIDENT / RUSSICA, REGNI POLONIÆ, / OPTIMO, / GRATA VARSAVIA. / MDCCXCV".
1795. – Mod. Jan Regulski. – F./G. Alexanderhütte (?).– D. 6 cm (2 3/8 in.). – 68.9 g. – Sign. on truncation / am Armabschnitt „F. J. REGULSKI".
Lamprecht 424M, Photo 61. – Inv. 1986.495.5.
Buxhoevden was a Russian general, who became governor of Warsaw in 1795. / Buxhoevden war ein russischer General, der 1795 Gouverneur von Warschau wurde.

243 Ferdinand VII, King of Spain (1784-1833; 1813 King) / Ferdinand VII., König von Spanien (1813 König)
Obv./Vs.: Bust in profile right. / Brustbild im Profil nach rechts. / Ins. around/Umschrift „FERNANDO VII. L. G. DE DIOSY LA CONSTITUCION REY DE LAS ESPAÑAS. 9 DE JULIO 1820".

Rev./Rs.: Two allegorical figures on both sides of a small column with tablets of the law. / Zwei allegorische Gestalten beidseitig eines Säulenstumpfes mit Gesetzestafeln. / Ins. *„MONARQUIA LIBERTAD / EL CIU-DADANO RAFAFI / DEL RIEGO"* and/und *„CONSTIT. DE 1812".*
1820. – D. 5.5 cm (2 3/16 in.). – 73.2 g.
Lamprecht 425M, Photo 61. – Inv. 1986.495.6.
After the revolution of 1820, King Ferdinand VII was forced to recognize the Constitution of Cadiz of 1812. / Nach der Revolution von 1820 wurde König Ferdinand VII. dazu gezwungen, die Cadizer Verfassung von 1812 anzuerkennen.

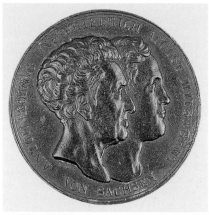
Cat. 244 (Obv./Vs.)

Cat. 244 (Rev./Rs.)

244 Anton, King of Saxony (1755-1836; 1827 King), and Friedrich August (1797-1854; as Friedrich August II 1836 King), Constitution of Saxony 1831 / Anton, König von Sachsen (1827 König), und Friedrich August (als Friedrich August II. 1836 König), Verfassung von Sachsen 1831
Obv./Vs.: Conjoined heads right. / Köpfe nach rechts. / Ins. around/Umschrift *„AN-TON KOENIG UND FRIEDRICH AUGUST MITREGENT VON SACHSEN".*
Rev./Rs.: The rolled Constitution within a wreath of crossed laurel and oak branches. / Verfassungsrolle, umschlossen von einem Kranz jeweils zur Hälfte aus Lorbeer- und Eichenlaubzweigen bestehend. / Ins. around/ Umschrift *„VEREINTEN SICH MIT DEN GETREUEN STÄNDEN ZU NEUER VER-FASSUNG DES STAATS."* and/und *„AM 4. SEPTBR. 1831".*
1831. – Mod. Anton Friedrich König the Younger/d. J. – F./G. Lauchhammer (?). – D. 4.7 cm (1 7/8 in.). – 27.2 g. – Sign. on truncation / am Halsabschnitt *„F. KÖ. F".*
Lamprecht 426M, Photo 61. – Inv. 1986.495.7.
Lit.: Auktion Künker, no. 5481. – Cat. Leipzig 1915, 130, no. 159.

245 Carl XIV Johann, King of Sweden and Norway (1763-1844; 1818 King) / Carl XIV. Johann, König von Schweden und Norwegen (1818 König)
Obv./Vs.: Bust as Roman emperor in profile right. / Brustbild als römischer Kaiser im Profil nach rechts. / Ins. around/Umschrift *„CAROLUS XIV JOHANNES D. G. REX. SVEC. NORV. GOTH. VAND. PATER CA-STRORUM ANNO IMPER XXV".*
Rev./Rs.: The army and navy paying homage to the king. / Die Armee und die Mari-

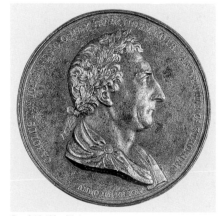
Cat. 245 (Obv./Vs.)

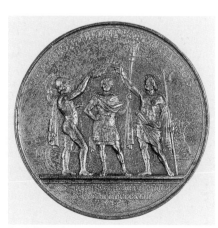
Cat. 245 (Rev./Rs.)

ne huldigen dem König. / Ins. around/Umschrift *„ET VIRTUS BELLI ET SAPIENTIA PACIS. EXERCITUS SVEC. TERRA MARI-QUE D. V. FEBR. MDCCCXLIII".*
1843. – Mod. Ludwig Peterssen Lundgren. – D. 8.1 cm (3 3/16 in.). – 182.9 g. – Sign. on truncation / am Brustabschnitt *„L. P. Lundgren fec.".*
Lamprecht 427M, Photo 61. – Inv. 1986.495.8.
Lit.: Hildebrand, 347, no. 37.
Commemorating the 25th anniversary of Carl XIV Johann's reign on February 5, 1843. / Auf das 25. Regierungsjubiläum des Königs Carl XIV. Johann am 5. Februar 1843.

246 Confirmation Medal / Konfirmationsmedaille
Obv./Vs.: The Entombment. / Die Grablegung Christi. / Ins. around/Umschrift *„ER STARB FÜR UNS".*
Rev./Rs.: Symbols of work and diligence, an altar with the Bible, and a skull on which a butterfly rests. / Sinnbilder der Arbeit und des Fleißes, ein Altar mit der Bibel und einem Totenkopf, auf dem ein Schmetterling sitzt. / Ins. around/Umschrift *„LASST IHM UNS LEBEN! / LEBE, WIE DU, WENN DU STIRBST, WÜNSCHEN WIRST GELEBT ZU HABEN".*
N. d./o. J. – Mod. Johann Veit Döll and/und

Daniel Friedrich Loos. – F./G. KPEG Berlin. – D. 5.1 cm (2 in.). – 57.8 g. – Sign. on the obv. lower center / auf der Vs. unten „LOOS".
Lamprecht 428M. – Inv. 1986.495.9.
Lit.: Sommer 1981, B7.

247 Prince Leopold III Friedrich Franz of Anhalt-Dessau (1740-1817), Golden Jubilee / Fürst Leopold III. Friedrich Franz von Anhalt-Dessau, Regierungsjubiläum.
Obv./Vs.: Bust in profile left in uniform. / Brustbild im Profil nach links in Uniform. / Ins. around/Umschrift „LEOP. FRIEDR. FRANZ SENIOR D. HAUSES ANHALT OB. DIRECTOR D. LANDSCHAFT 50 JAHRE REGIERENDER FÜRST ZU DESSAU".
Rev./Rs.: The seated Minerva supports the Anhalt-Dessau coat of arms, in her right hand she holds a wreath, a bear rests at her feet; and she is surrounded with symbols of justice, the arts, and sciences. / Die sitzende Minerva stützt sich auf den Anhalt-Dessauischen Wappenschild, in ihrer Rechten einen Kranz haltend, ein Bär ruht zu ihren Füßen und sie ist von den Symbolen der Staatsklugheit, der Gerechtigkeit, sowie der Künste und der Wissenschaften umgeben. / Ins. around/Umschrift „DEM VERDIENSTE SEINE KRONEN" and/und „GEWIDMET V.D. RITTERSCHAFT D. GESAMMT. FÜRSTENTHUMS D. 16 DEC. 1801".
1801. – Mod. Daniel Friedrich Loos and/ und Johann Veit Döll. – F./G. KPEG Berlin. – D. 4.4 cm (1 3/4 in.). – 22.6 g. – Sign. on truncation / am Armabschnitt „LOOS".
Lamprecht 429M, Photo 61. – Inv. 1986.495.10.
Lit.: Loos 1842, no. D.1. – Mann, 200, no. 917. – Menadier 1901, 245. – Sommer 1981, A84.

248 Death of August III, King of Poland (1696-1763; as Friedrich August II, Elector of Saxony) / Auf den Tod des Königs August III. von Polen (als Friedrich August II. Kurfürst von Sachsen)
Obv./Vs.: Bust in profile right. / Brustbild im Profil nach rechts. / Ins. around/Umschrift „AUGUSTUS. / III. / ELECTOR SAXONIÆ.".
Rev./Rs.: Ins. „AUGUSTI II. / FILIUS, ELECTUS / A. D. 1733. CORONATUS / A. D. 1734. PIUS. MAN= / SVETUS. POLONIÆ. QUÆ / BONA OPTAVIT. RUPTIS / CONTINUO XII. / COMITIIS, IMPERTIRI / NEQUIVIT / OBIIT DREDSDÆ A. D. / 1763 ÆTAT: 67 A 30 / D. 6. OCTOB:".

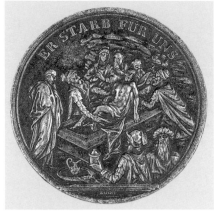

Cat. 246 (Obv./Vs.)

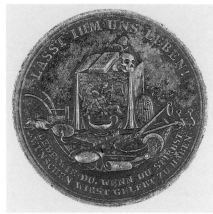

Cat. 246 (Rev./Rs.)

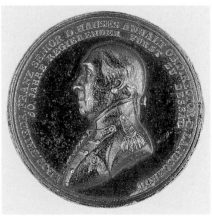

Cat. 247 (Obv./Vs.)

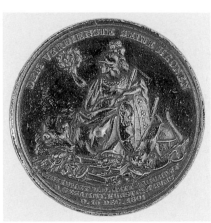

Cat. 247 (Rev./Rs.)

Cat. 248 (Obv./Vs.)

Cat. 248 (Rev./Rs.)

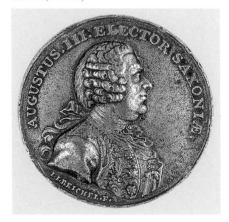

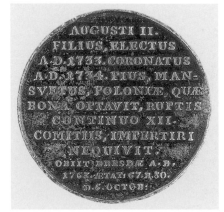

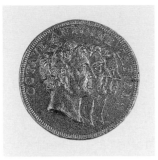

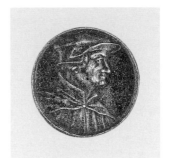

Cat. 249 (Obv./Vs.) Cat. 249 (Rev./Rs.) Cat. 250 (Obv./Vs.) Cat. 250 (Rev./Rs.)

Cat. 249-50 Original size/Originalgröße

1763. – Mod. Jan Jakób Reichel. – D. 4.5 cm (1 3/4 in.). – 36.9 g. – Sign. below truncation / unterhalb des Brustabschnitts „*I. I. Reichel. F* ".
Lamprecht 430M, Photo 61. – Inv. 1986.495.11.
Lit.: Forrer V, 72. – Wurzbach-Tannenberg, no. 2910.
Jan Jakób Reichel was court medallist at the Warsaw Mint from 1792 to 1795. / Jan Jakób Reichel war Hofmedailleur an der Warschauer Münze von 1792 bis 1795.

249 Octavian (Augustus), Antony, and Lepidus, the Members of the Official Three-Man Government Called the "Second Triumvirate," formed in 43 B. C. / Octavian (Augustus), Antonius und Lepidus, die Mitglieder des zweiten römischen Triumvirats 43 vor Christus
Obv./Vs.: Triple conjoined portraits staggered in profile right. / Die drei Köpfe gestaffelt im Profil nach rechts. / Ins. „*OCTAVE. ANTOINE. LEPIDE* ".
Rev./Rs.: The three members of the triumvirate at a table with a map dividing the Roman world between them. / Die drei Mitglieder (Triumviri) an einem Tisch auf einer Landkarte die römischen Provinzen neu

verteilend. / Ins. „*PART* [...] *DE EMPIRE Y. R. 711* ".
Ca. 1800 (?). – Probably cast after a French medal. / Wohl Abguß einer französischen Medaille. – D. 3.1 cm (1 1/4 in.). – 8.6 g. Lamprecht 362M. – Inv. 1986.481.163.

250 Ulrich Zwingli (1484-1531), Swiss Reformer / Schweizer Reformator
Obv./Vs.: Bust almost front, the head in profile right. / Brustbild fast von vorn, der Kopf im Profil nach rechts.
Rev./Rs.: „*HULRICUS / ZWINGLIUS / HELVETIUS THEOLOGUS / TIGURINAE ECCLESIAE / PASTOR CAESUS EST AC MORTUUS / CREMATUS / AN 1531 / AET. 45* ".
First quarter of the 19th century / 1. Viertel des 19. Jh. – After a medal (1720) by / nach einer Medaille (1720) von Jean Dassier. – F./G. probably/wahrscheinlich KPEG Gleiwitz. – D. 2.8 cm (1 1/8 in.). – 8.5 g. – Sign. obverse left / Vs. links „*J. D.* ".
Lamprecht 432M. – Inv. 1986.495.13.
Lit.: Forrer I, 512 ff. – Schnell, 302, no. 463. – Whiting, no. 44.
This medal and the following for Nicholas Ridley were created by Jean Dassier between 1720 and 1728 as part of a suite. /

Diese Medaille und die folgende auf Nicholas Ridley wurden von Jean Dassier als Teil einer Serie 1720-28 geschaffen. / (s. Klauss 2000, no. 1556 for a bronze example / für ein Bronze-Exemplar).

251 Nicholas Ridley (1503-55), Bishop of Lincoln / Bischof von Lincoln
Obv./Vs.: Bust in profile right. / Brustbild im Profil nach rechts.
Rev./Rs.: „*NICOLAUS / RIDLEUS / ANGLUS / LONDINENSIS / EPISCOPUS / CREMATUS VIVUS / OXONIAE / AN. 1655* ".
First quarter of the 19th century / 1. Viertel des 19. Jh. – After a medal (1720) by / nach einer Medaille (1720) von Jean Dassier. – F./G. probably/wahrscheinlich KPEG Gleiwitz. – D. 2.8 cm (1 1/8 in.). – 7.9 g. – Sign. on the obverse right / auf der Vs. rechts „*J.D.* ".
Lamprecht 433M. – Inv. 1986.495.14.
Lit.: Forrer I, 512 ff. – Whiting, no. 37 (erroneously identified as Martin Luther / irrtümlich als Martin Luther identifiziert). This medal and that for Ulrich Zwingli (Cat. 250) were created by Jean Dassier between 1720 and 1728 as part of a suite. Ridley was a Latin and Greek scholar who be-

Cat. 251-52 Original size/Originalgröße

Cat. 251 (Obv./Vs.) Cat. 251 (Rev./Rs.) Cat. 252 (Obv./Vs.) Cat. 252 (Rev./Rs.)

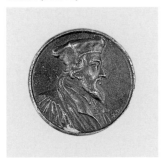

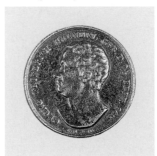
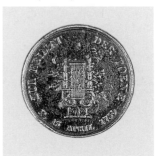

came a speaker for the Protestants. He pub-
licly denounced Queen Mary I in a sermon.
As a result he was declared a heretic and
burned at the stake in 1555. /
Diese Medaille und die auf Ulrich Zwingli
(Cat. 250) wurden von Jean Dassier als Teil
einer Serie 1720-28 geschaffen. Ridley war
Gelehrter in Latein und Griechisch und
wurde Sprecher für die Protestanten. Er hat
Mary I. während einer Predigt öffentlich
denunziert. Als Folge wurde er zum Ketzer
erklärt und 1555 auf dem Scheiterhaufen
verbrannt.

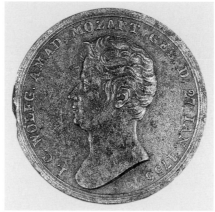
Cat. 253 (Obv./Vs.)

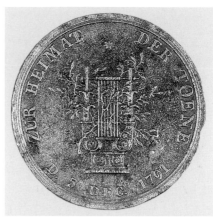
Cat. 253 (Rev./Rs.)

252 Death of Georg Friedrich Händel (1685-1759) / Auf den Tod von Georg Friedrich Händel

(Fig. p./Abb. S. 135)
Obv./Vs.: Head in profile left. / Kopf im
Profil nach links. / Ins. around/Umschrift
„GEORG FRIEDRICH HAENDEL GEB.
D. 24 FEBR. 1685".
Rev./Rs.: In the center a lyre with laurel
branches. / In der Mitte eine Leier mit Lor-
beerzweigen. / Ins. around/Umschrift „ZUR
HEIMAT DER TOENE D. 13. APRIL 1759".
1820. – Mod. Carl Friedrich Voigt, Chris-
toph Carl Pfeuffer and/und Gottfried Bern-
hard Loos. – F./G.KPEG Berlin. – D. 2.9 cm
(1 1/8 in.). – 8.5 g. – Sign. below truncation /
unter dem Halsabschnitt „G. L. DIR" (?).
Lamprecht 434M. – Inv. 1986.495.15.
Lit.: Cat. Leipzig 1915, 131, no. 167. –
Niggl, 99, no. 808. – Sommer 1986, P2. –
Wurzbach-Tannenberg, no. 3488.
The composer's correct birthdate is Febru-
ary 23, 1685, and the correct date of his
death is April 14, 1759. This and the follow-
ing medal (Cat. 253) were created as part
of a suite of four commemorating the
composers Händel, Mozart, Gluck, and
Haydn. / Das eigentliche Geburtsdatum des
Komponisten ist der 23. Februar 1685 und
das seines Todes der 14. April 1759. Diese
und die folgende Medaille (Cat. 253) gehö-
ren zu einer Serie auf die Komponisten
Händel, Mozart, Gluck und Haydn.

253 Death of Wolfgang Amadeus Mozart (1756-91) / Auf den Tod von Wolfgang Amadeus Mozart

Obv./Vs.: Head in profile left. / Kopf im
Profil nach links. / Ins. around/Umschrift
„WOLFG. AMAD. MOZART GEB. D. 27
IAN. 1756".
Rev./Rs.: In the center a lyre with laurel
branches. / In der Mitte eine Leier mit Lor-
beerzweigen. / Ins. around/Umschrift „ZUR
HEIMAT DER TOENE D. 5. DEC. 1791".

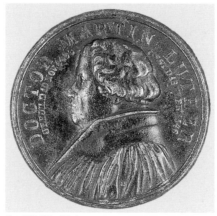
Cat. 254 (Obv./Vs.)

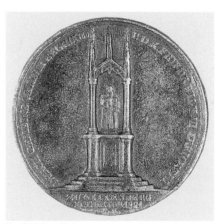
Cat. 254 (Rev./Rs.)

1820. – Mod. Carl Friedrich Voigt, Chri-
stoph Carl Pfeuffer and/und Gottfried
Bernhard Loos. – F./G. KPEG Berlin. – D.
2.8 cm (1 1/8 in.). – 6.8 g.
Lamprecht 435M. – Inv. 1986.495.16.
Lit.: Aus einem Guß, 196, no. 734. – Cat.
Leipzig 1915, 131, no. 168. – Niggl, 162,
no. 1453. – Schuette 1916, 283, fig./Abb. 11.
– Sommer 1986, P1/4.

254 Dedication of the Luther Monument in Wittenberg / Zur Einweihung des Luther-Denkmals in Wittenberg

Obv./Vs.: Bust in profile left. / Brustbild im
Profil nach links. / Ins. around/Umschrift

„DOCTOR MARTIN LUTHER / GEBOR. D.
10. NOV. 1485 GEST. D. 18. FEBR. 1546".
Rev./Rs.: The Luther Monument in Witten-
berg. / Das Luther-Denkmal in Wittenberg. /
Ins. around/Umschrift „DURCH GEMEINS.
VEREHR. BEGRÜND U.D.K. FRIEDR.
WILH. III ERRICHTET" and/und „ZU
WITTENBERG / D. 31. OCTOB. 1821".
1821. – Mod. Anton Friedrich König the
Younger/d. J. – F./G. KPEG Berlin. – D. 4.1
cm (1 5/8 in.). – 16.0 g. – Sign. on reverse /
auf der Rs. „F.K.".
Lamprecht 436M. – Inv. 1986.495.17.
Lit.: Cat. Leipzig 1915, 130, no. 163. –
Schnell, 344, no. 546 (here attributed to Carl

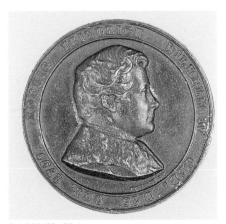

Cat. 255 (Obv./Vs.)

Cat. 255 (Rev./Rs.)

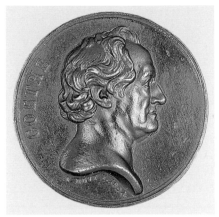

Cat. 256 (Obv./Vs.)

Cat. 256 (Rev./Rs.)

Cat. 257 (Obv./Vs.)

Cat. 257 (Rev./Rs.)

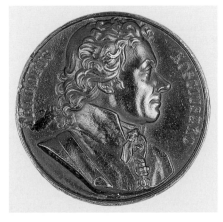

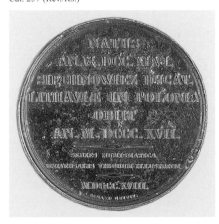

Reinhard Krüger, student of Daniel Friedrich Loos and court medallist at the Dresden Mint / hier Carl Reinhard Krüger, Schüler von Daniel Friedrich Loos und Hofmedailleur an der Dresdner Münze, zugeschrieben). – Whiting, no. 628.

255 Johann Wolfgang von Goethe (1749-1832)

Obv./Vs.: Head in profile right. / Kopf im Profil nach rechts. / Ins. „*GOETHE*".

Rev./Rs.: Eagle with laurel branch. / Adler mit Lorbeerzweig.

1824. – Mod. Jean François Antoine Bovy. – F./G. KPEG. – D. 4.1 cm (1 5/8 in.). – 28.0 g. – Sign. below truncation / unterhalb des Halsabschnitts „*A. BOVY F. 1824*".

Lamprecht 437M, Photo 61. – Inv. 1986.495.18.

Lit.: Förschner, 96, no. 99. – Frede 1932, pl./Taf 127. – Frede 1959, 89, no. 71 (pl./Taf. XV). – Kippenberg, no. 7560. – Klauss 1994, 190, no. 132. – Klauss 2000, 1456. – Köcke, 29 f., fig./Abb. 230 f. – Salaschek, 34, no. 139.

The portrait is based on the bust created by Christian Daniel Rauch in 1820. The obverse is after a medal (about 1775) by Hans Heinrich Boltshauser. / Das Porträt wurde nach einer Büste von Christian Daniel Rauch (1820) modelliert, die Rs. nach einer Medaille (um 1775) von Hans Heinrich Boltshauser.

256 Homage to Friedrich Wilhelm IV (1795-1861; 1840 King) on October 15, 1840 in Berlin / Auf die Huldigung von Friedrich Wilhelm IV. (1840 König) am 15. Oktober 1840 in Berlin

Obv./Vs.: Bust in profile right. / Brustbild im Profil nach rechts. / Ins. around/Umschrift „*KOENIG FRIEDRICH WILHELM IV GEB. D. 15. OCT. 1795.*".

Rev./Rs.: A crown above a scepter and sword (crossed) with oak branches left and laurel branches right. / Krone über Zepter und Schwert (gekreuzt), begleitet links von Eichenlaub und recht von Lorbeerzweigen. / Ins. around/Umschrift „*AM FESTE DER HULDIGUNG. BERLIN D. 15. OCT. 1840*".

1840. – After a medal by / nach einer Medaille von Cossmann. – F./G. KPEG Berlin. – D. 4.7 cm (1 7/8 in.). – 32.3 g. – Sign. below truncation / unterhalb des Brustabschnitts „*COSSMANN FEC.*".

Lamprecht 438M. – Inv. 1986.495.19.

Lit.: S. Forrer I, 459. – Loos 1842 2, no. E.143. – Weyl, no. 2484. – Wurzbach-Tannenberg, no. 2973.

257 Tadeusz Andrezej Bonaventura Kościuszko (1746-1817), Polish National Hero / polnischer Nationalheld
(Fig. p./Abb. S. 137)
Obv./Vs.: Bust in profile right. / Brustbild im Profil nach rechts. / Ins. around/Umschrift „*THADDEUS KOSCIUSZKO*".
Rev./Rs.: „*NATUS / .AN.MDCCXLVI. / SIECHNOWIEZ DUCAT. / LITHAVIÆ IN POLONIA / OBIT / AN.MDCCCXVII. / SERIES NUMISMATICA / UNIVERSALIS VERORUM ILLUSTRIUM / MDCCCXVIII*".
1818. – Mod. François Augustin Caunois. – F./G. Alexanderhütte (?). – D. 4.1 cm (1 5/8 in.). – 30.2 g. – Sign. on truncation / am Brustabschnitt „*CAUNOIS*".
Lamprecht 439M, Photo 61. – Inv. 1986.495.20.
Lit.: Bramsen, no. 1812. – Cat. Leipzig 1915, 129, no. 151. – Wurzbach-Tannenberg, no. 4705.
Part of suite commemorating illustrious contemporary figures. / Gehört zu einer Serie auf wichtige zeitgenössische Personen.

258 Death of Friedrich II, King of Prussia (1712-86) / Auf den Tod von Friedrich II., König von Preußen
Obv./Vs.: Bust in profile left. / Brustbild im Profil nach links. / Ins. around/Umschrift „*FRIED. INCOMPARABILIS DEI GRATIA REX BORVSS ETC.*".
Rev./Rs.: A smoking urn on pedestal with symbols of art, science, commerce, and war below a wreath of stars with eagle. / Rauchende Urne auf Sockel mit Symbolen der Kunst und der Wissenschaft, des Handels und des Kriegs unter einem Sternenkranz mit Adler. / Ins. „*1712/1786*" and/ und „*RE STABAT A LIUD NIHIL*".
First quarter of the 19th century / 1. Viertel des 19. Jh. – After a medal (1786) by / nach einer Medaille (1786) von Johann Georg Holtzhey. – F./G. KPEG Gleiwitz. – D. 4.4 cm (1 3/4 in.). – 19.7 g. – Sign. on truncation / am Armabschnitt „*I.G.H.*".
Lamprecht 440M. – Inv. 1986.495.21.
Lit.: S. Forrer II, 536. – Jaschke and Maercker, no. 2147. – Menadier 1901, 319. – Olding, 190, no. 753.

259 300th Anniversary of the Protest at Speyer April 19, 1529 / Auf die 300jährige Wiederkehr der „Protestation" vom 19. April 1529 auf dem Reichstag zu Speyer
Obv./Vs.: Five protesting princes. / Fünf protestierende Fürsten. / Ins. around/Umschrift „*HERZ. ERNST v. LÜN. MGR. GE-*

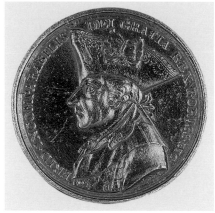
Cat. 258 (Obv./Vs.)

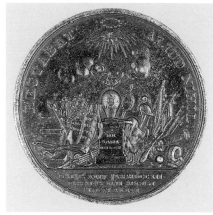
Cat. 258 (Rev./Rs.)

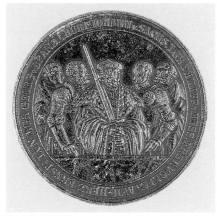
Cat. 259 (Obv./Vs.)

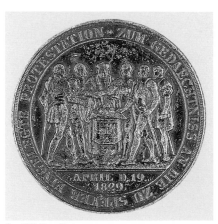
Cat. 259 (Rev./Rs.)

ORG. v. BRAND. CHURF. IOHANN v. SACHS. LGR. PHILIPP v. HESS. FRST. WOLFG. v. ANH.".
Rev./Rs.: Five protesting princes, in the middle a "Bürgermeister" as representative of the fourteen, also protesting, cities, holding hands over an open Bible. / Fünf protestierende Fürsten, in der Mitte ein Bürgermeister als Repräsentant der vierzehn ebenfalls protestierenden Städte, sich die Hände reichend über einer Bibel. / Ins. around/Umschrift „*ZUM GEDAECHTNISS AN DIE ZU SPEYER EINGELEGTE PROTESTATION*" and/und „*APRIL D. 19. / 1829*".

1829. – Mod. Gottfried Bernhard Loos and/und Christoph Carl Pfeuffer. – F./G. KPEG Berlin. – D. 4.1 cm (1 5/8 in.). – 31.3 g.
Lamprecht 441M. – Inv. 1986.495.22.
Lit.: Bahrfeldt, no. 3821. – Loos 1842, 64, no. F.19. – Schnell, 249, no. 321. – Sommer 1986, P30/2.
Commemorating the 300th anniversary of the imperial diet held in Speyer in 1529 at which five Lutheran princes issued a strong protest against the anti-Lutheran measures of Emperor Carl V as he sought to reverse the policy of religious tolerance adopted in 1526. The word "Protestant" originated from

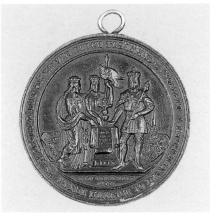

Cat. 260 (Obv./Vs.)

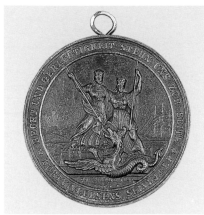

Cat. 260 (Rev./Rs.)

Sonne und ein Schiff. / Ins. around/Umschrift „RECHT UND GERECHTIGKEIT STEHN UNS ZUR SEITE / FORT-VIVLELSENES SELVHJÆLP" below the figures / und im Feld unten „24. MAERZ 1848".

1848. – Mod. Gottfried Bernhard Loos. – F./G. KPEG. – D. 4.4 cm (1 3/4 in.). – 32.2 g. Lamprecht 442M. – Inv. 1986.495.23.

In 1460, King Christian I of Denmark incorporated the German-speaking Holstein and the Danish-speaking Duchy of Schleswig into Denmark. In March 1848 the Holstein leaders demanded a free, joint constitution for Schleswig and Holstein, while the Danish National Liberals advocated a free constitution for Denmark and Schleswig and the separation of Holstein from Schleswig. With Prussian support, the Germans in Holstein revolted and the ensuing war between Denmark and Holstein 1848-50 had great international ramifications. / 1460 hatte König Christian I. von Dänemark das deutschsprachige Land Holstein und das dänischsprachige Herzogtum Schleswig mit Dänemark vereinigt. Im März 1848 forderten die holsteinischen Führer eine freie, gemeinsame Verfassung für Schleswig und Holstein, während die dänischen Nationalliberalen eine freie Verfassung für Dänemark und Schleswig und die Trennung Holsteins von Schleswig wollten. Mit Hilfe Preußens erhoben sich die Holsteiner dagegen, und der folgende Krieg zwischen Dänemark und Holstein 1848-50 hatte internationale Auswirkungen.

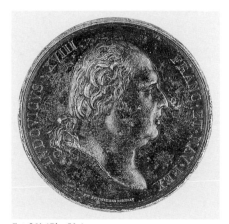

Cat. 261 (Obv./Vs.)

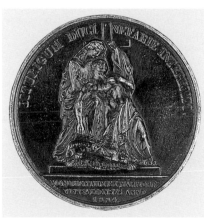

Cat. 261 (Rev./Rs.)

261 Erection of a Monument at Versailles in Honor of the Murdered Duke of Berry / Errichtung eines Denkmals in Versailles zu Ehren des ermordeten Herzogs von Berry
Obv./Vs.: Head of King Louis XVIII of France (1755-1824; 1814 King) in profile right. / Kopf des Königs Ludwig XVIII. von Frankreich (1814 König) im Profil nach rechts. / Ins. around/Umschrift „LVDO-VICVS XVIII FRANC ET NAV. REX.".
Rev./Rs.: The marble statue at Versailles depicting the Duke of Berry as a dying warrior in the arms of Faith. / Das Marmordenkmal in Versailles mit dem Herzog von Berry als sterbender Krieger in den Armen des Glaubens. / Ins. around/Umschrift „BITURIGUM DUCI NEFARIE INTEREMTIO" and below the figures / und im Feld unten „MONUMENTUM EX MARMORE VERSALIENSES ANNO 1824".

this incident. / Auf die 300. Jahresfeier des deutschen Reichstags 1529 in Speyer, wo fünf lutherische Fürsten gegen das Wormser Edikt von Kaiser Karl V. protestierten. Das Wort „Protestant" stammt daher.

260 Unity of Schleswig and Holstein with Denmark / Auf die Vereinigung von Schleswig und Holstein mit Dänemark
Obv./Vs.: Two figures representing Schleswig and Holstein with King Christian I of Denmark (1426-81; 1448 King) at an altar, each pointing to a document from 1460 that refers to the alliance of the two duchies with the kingdom of Denmark. / Die Perso-

nifikationen von Schleswig und von Holstein stehen mit König Christian I. von Dänemark (1448 König) um einen Altar, ihre Schwurfinger auf eine Urkunde von 1460 legend, die die Verbindung der beiden Herzogtümer mit dem Königreich betrifft. / Ins. around/Umschrift „DAT SE BLIVEN EWICH TOSAMENDE UNGEDELT • NICHT ALSE ENEME KONINGE TO DENNEMARKEN" and below the figures / und im Feld unten „MITTWOCH [...] 1460".
Rev./Rs.: Schleswig and Holstein slaying a dragon with a rising sun and ship in background. / Schleswig und Holstein töten einen Drachen, im Hintergrund eine aufgehende

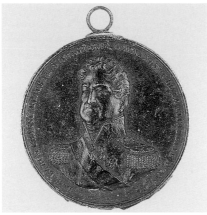

Cat. 262 (Obv./Vs.) Cat. 262 (Rev./Rs.)

Der in Holland geborene General David
Hendrik Chassé war Befehlshaber der 3. nie-
derländischen Infantriedivision im Kampf
bei Belle-Alliance (Waterloo). 1832 vertei-
digte er die Zitadelle von Antwerpen gegen
die Franzosen, wurde aber am 23. Dezem-
ber zur Kapitulation gezwungen. Zwei Ta-
ge später bekam er das Großkreuz des Mi-
litär-Wilhelm-Ordens der Niederlande für
seine Leistung.

**263 Visit of the Prussian Royal Couple
to Tarnowitz on June 25, 1798 / Auf den
Besuch des preußischen Königspaars in
Tarnowitz am 25. Juni 1798**
Obv./Vs.: The conjoined busts of King
Friedrich Wilhelm III (1773-1840; 1797
King) and Queen Luise of Prussia (1776-
1810) in profile left on a pedestal deco-
rated with oak leaves. / Die Brustbilder Kö-
nig Friedrich Wilhelms III. (1797 König)
und Königin Luises von Preußen im Profil
nach links, auf einem mit Eichenblättern
verzierten Postament. / Ins. „FR. WILH. III
LUISE K.U.K. V. PREUSSEN" and/und
„DEN 25 IUN 1798".
Rev./Rs.: Goddess of Nature seated while a
winged genius of the mining industry lifts
her veil, lions lie at her feet. / Die sitzende
Göttin der Natur, der ein geflügelter Ge-
nius das Gesicht entschleiert, Löwen liegen
ihr zu Füßen. / Ins. around/Umschrift „WAS
KUNST UND FLEISS IN TARNOWITZ
GEWANN" and below the relief / und im
Feld unten „BRINGT SCHLESIEN DEM
KOENIGLICHEN PAARE".

1824. – Mod. Bertrand Andrieu and/und
Auguste-François Michaut. – F./G. KPEG
Berlin. – D. 5.1 cm (2 in.). – 28.1 g.
Sign. on truncation / am Halsabschnitt „AN-
DRIEU f.", below portrait / unterhalb des
Porträts „DE PUYMAURIN DI." and on
reverse lower right / und auf der Rs. unten
rechts „MICHAUT".
Lamprecht 443M. – Inv. 1986.495.24.
Lit.: Wurzbach-Tannenberg, no. 5645.
Charles Ferdinand de Bourbon, Duke of Ber-
ry (1778-1820), was murdered on February
13, 1820, by the fanatic Louis-Pierre Lou-
vel. Jean-Pierre Casimir de Marcassus, Bar-
on de Puymaurin (1757-1841) was director
of the Paris Mint from 1816 to 1830. /
Charles Ferdinand de Bourbon, Herzog von
Berry (1778-1820), wurde am 13. Februar
1820 von dem Fanatiker Louis-Pierre Lou-
vel ermordet. Jean-Pierre Casimir de Mar-
cassus, Baron de Puymaurin, war Direktor
der Pariser Münze von 1816 bis 1830.

DÉFENDANT GÉNÉRÉUX EN ÉPAR-
GNANT" and below relief / und im Feld
unten „DEC MDCCCXXXII".
1832. – D. 4.7 cm (1 7/8 in.). – 37.4 g.
Lamprecht 444M, Photo 60. – Inv.
1986.495.26.
Lit.: Wurzbach-Tannenberg, no. 1286.
The Dutch-born General David Hendrik
Chassé was commander of the Third Dutch-
Belgian infantry division at Waterloo. In
1832 he defended the citadel of Antwerp
against the French, but was forced to capi-
tulate on December 23, 1832. Two days la-
ter he received the Knights Grand Cross of
the Military William Order for his defense. /

**262 General Baron David Hendrik
Chassé (1765-1849), Defense of the Cita-
del of Antwerp in December 1832 / Auf
die Verteidigung der Zitadelle von Ant-
werpen im Dezember 1832**
Obv./Vs.: Bust almost front. / Brustbild fast
von vorn. / Ins. around/Umschrift „D. H.
BARON CHASSE. GENERAL D. INFAN-
TERIE. COMMANDANT DE LA CITA-
DELLE D'ANVERS".
Rev./Rs.: Citadel of Antwerp with laurel
wreath and coat of arms. / Die Zitadelle von
Antwerpen mit Lorbeerkranz und Wappen. /
Ins. around/Umschrift „VALEUREUX EN

Cat. 263 (Obv./Vs.) Cat. 263 (Rev./Rs.)

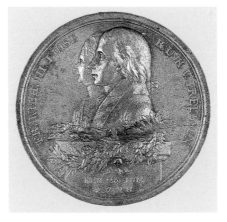

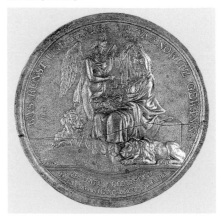

1798. – Mod. Daniel Friedrich Loos. –
F./G. KPEG Gleiwitz. – D. 5.1 cm (2 in.). –
34.3 g. – Sign. on reverse / auf der Rs.
„LOOS".
Lamprecht 449M, Photo 60. – Inv.
1986.495.31.
Lit.: Cat. Leipzig 1915, 130, no. 154. –
Jaschke and Maercker, no. 2158. – Loos
1842, 1, B.5. – Menadier 1901, 394. – Mü-
seler 49.1/12. – Schuette 1916, 283, fig./
Abb. 8. – Sommer 1981, A64.

**264 72nd Birthday of Johann Friedrich
von Seegebarth (1747-1821), Prussian
Postmaster General / Auf den 72. Ge-
burtstag von Johann Friedrich von See-
gebarth, preußischer Generalpostmeister**
Obv./Vs.: Bust in profile left. / Brustbild im
Profil nach links. / Ins. „IOHANN FRIED-
RICII VON SEEGEBARTH / GEBOREN
DEN 3. AUGUST 1747 / DIENT DEM
PREUSS STAAT / SEIT DEM 24. NOVEM-
BER 1767".
Rev./Rs.: Wreath of ivy leaves. / Kranz aus
Efeublättern. / Ins. „DEM / GENERAL /
POSTMEISTER / ZUM / 72. GEBURTSTA-
GE / GEWIDMET / VON EINEM / SEINER
TREUEN / DIENER".
1819. – Mod. Leonhard Posch and/und Da-
niel Friedrich Loos. – KPEG Berlin. – D.
4.7 cm (1 7/8 in.). – 17.3 g. – Sign. on trun-
cation / am Brustabschnitt „LOOS".
Lamprecht 450M, Photo 60. – Inv.
1986.495.32.
Lit.: Cat. Leipzig 1915, 129, no. 153. – cp./
vgl. Forschler-Tarrasch, no. 392. – Hintze

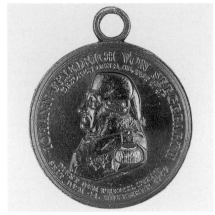

Cat. 264 (Obv./Vs.)

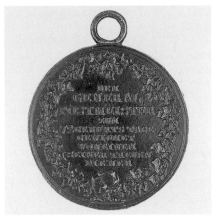

Cat. 264 (Rev./Rs.)

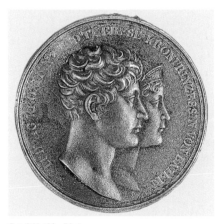

Cat. 265 (Obv./Vs.)

1928a, 105, pl./Taf. 84, no. 105. – cp./vgl.
Sommer 1981, A207.

**265 Visit of the Bavarian Royal Couple
to Innsbruck on October 27, 1810 / Auf
den Besuch des bayerischen Kronprinzen-
paars in Innsbruck am 27. Oktober 1810**
Obv./Vs.: The heads of Crown Prince Lud-
wig (1786-1868; 1825-48 King) and Crown
Princess Theresa (1792-1854) of Bavaria in
profile right. / Die Köpfe des Kronprinzen
Ludwig (1825-48 König) und der Kron-
prinzessin Theresa von Bayern im Profil
nach rechts. / Ins. around/Umschrift „LUD-
WIG KRONPRINZ UND THERESA KRON
PRINZESSIN VON BAIERN".
Rev./Rs.: –
1810. – Mod. Joseph Losch. – F./G. Boden-
wöhr (?). – D. 4.5 cm (1 3/4 in.). – 8.7 g. –
Sign. on truncation / am Halsabschnitt
„LOSCH".
Lamprecht 451M, Photo 62. – Inv.
1986.495.33.
Lit.: Cp./vgl. Auktion Künker, lot/Losnr.
5186 (for two-sided medal with the above
as obverse and the reverse with a nine-line
inscription / Zu einer zweiseitigen Medaille
mit der o.g. Medaille als Vs. und mit der
rückseitigen neunzeiligen Inschrift „WAS
IN METALL DER GRIFFEL DER GE-
SCHICHTE SCHRIEB DANK UND LIEBE
DAUERNDER IN UNSER UND UNSRER
KINDER HERZ DEN TAG DA SIE IN
UNSRE MITTE KAMEN. INNSBRUCK
DEN 27. OCTOB. 1810"). – Beierlein
2620. – Cat. Leipzig 1915, 130, no. 155. –
Schuette 1916, 283, fig./Abb. 3.

Cat. 266 (Obv./Vs.)

Cat. 266 (Rev./Rs.)

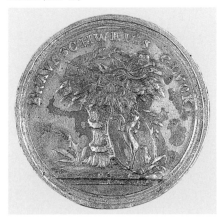

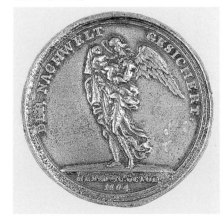

266 Birth of Karl II of Brunswick-Wolfenbüttel (1804-73) / Auf die Geburt Karls II. von Braunschweig-Wolfenbüttel (Fig. p./Abb. S. 141)
Obv./Vs.: Emblems of agriculture and commerce with Brunswick's coat of arms. / Symbole von Landwirtschaft und Handel mit dem Braunschweiger Wappen. / Ins. around/ Umschrift „BRAUNSCHWEIGS GLÜCK".
Rev./Rs.: A baby in the arms of an angel. / Ein Säugling in den Armen eines Engels. / Ins. around/Umschrift „DER NACHWELT GESICHERT" and below / und im Feld unten „GEB. D. 30. OCTOBER 1804".
1804. – Mod. Paul Merker. – D. 3.8 cm (1 1/2 in.). – 12.9 g. – Sign. on reverse lower right / Rs. unten rechts „P. MERKER F.".
Lamprecht 454M. – Inv. 1986.495.36.
Lit.: Auktion Künker, lot/Losnr. 5274. – Brockmann, no. 551. – Schuette 1916, 283, fig./Abb. 7.
Son of Friedrich Wilhelm, Duke of Brunswick-Oels (1771-1815) / Sohn von Friedrich Wilhelm, Herzog von Braunschweig-Oels.

267 Nicholas I, Emperor of Russia (1796-1855; 1825 Emperor), Battle of Schumla on May 30, 1829 / Nikolaus I., Kaiser von Rußland (1825 Kaiser), auf die Schlacht von Schumla 30. Mai 1829
Obv./Vs.: Laureate head in profile right. / Kopf im Profil nach rechts mit Lorbeer-

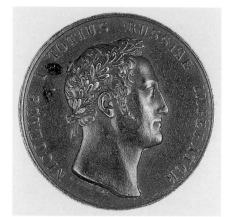

Cat. 267 (Obv./Vs.)

Cat. 267 (Rev./Rs.)

kranz. / Ins. around/Umschrift „NICOLAUS I. TOTIUS RUSSIAE IMPERATOR".
Rev./Rs.: Within laurel wreath the inscription / innerhalb eines Lorbeerkranzes die Inschrift „AVSPIC / AVVVSTISS / ET DVCTV / COM DE DIEBITSCH / TVRC FEROX EXERC. / SVB PRIMO VISIR. / CONCISVS / SPVD SCHVMLAM / D XXX. MAI. ST. V. / MDCCCXXIX".
1829. – Mod. Gottfried Bernhard Loos. –

F./G. KPEG Berlin. – D. 3.8 cm (1 1/2 in.). – 30.4 g. – Sign. on truncation / am Halsabschnitt „G. LOOS DIR.".
Lamprecht 455M, Photo 62. – Inv. 1986.495.37.
Lit.: Cat. Leipzig 1915, 129, no. 152. – Loos 1842, 4, no. F.20.c. – Ostergard 1994, 182 f., no. 13.
The Battle of Schumla was fought between Russia and Turkey over the fate of the Or-

Cat. 268 (Obv./Vs.)

Cat. 268 (Rev./Rs.)

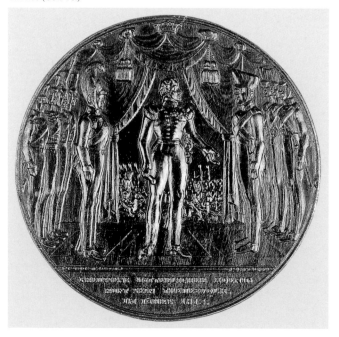

thodox Christian population in the Balkans. /
Die Schlacht von Schumla zwischen Ruß-
land und der Türkei sollte über das Schick-
sal der Orthodoxen Christen auf dem Bal-
kan entscheiden.

268 Wars of Liberation, 1813-15 / Auf die Befreiungskriege 1813-15

Obv./Vs.: King Friedrich Wilhelm III of
Prussia and his troops under a canopy. /
König Friedrich Wilhelm III. von Preußen
in einem Zelt bei seinen Truppen. / Ins.
*„PREUSSENS RITTERLICHER KOENIG /
RUFT SEIN TREUES VOLK. / IM IAHRE
1813.".*
Rev./Rs.: Laurel wreath. / Lorbeerkranz. /
Ins. *„ANDENKEN / AN DEN / FREIHEITS-
KRIEG / IN DEN IAHREN / 1813.14.15.".*
1815. – Mod. C. Jacob after a drawing by /
nach einer Zeichnung von Wilhelm and/
und Moritz Henschel. – F./G. KPEG Berlin
or/oder Gleiwitz (Later cast / Nachguß ?).
D. 7.3 cm (2 7/8 in.). – 86.0 g. Sign. on
obv. right / auf der Vs. rechts *„C. IACOB
FEC."* and left / und links *„GB HEN-
SCHEL D.".* Sign. on reverse / auf der Rs.
„GB: H. D. and/und C IACOB FEC".
Lamprecht 456M, Photo 60. – Inv.
1986.495.38.
Lit.: Arenhövel 1982, 77, no. 155. – Beth-
mann Hollweg and Westphal, 18 f., no. 5. –
Cat. Leipzig 1915, 129, no. 148. – Forrer

III, 41. – Hintze 1928a, 105 f., pl./Taf. 84,
no. 5. – Ostergard 1994, 183, no. 15. – Weyl
2206. – Wruck, no. 533.

269 Wars of Liberation, 1813-15 / Auf die Befreiungskriege 1813-15

S. Cat. 268. – F./G. KPEG Berlin. – D. 7.6
cm (3 in.). – 96.0 g.
Inv. 1962.87. – Gift of / Schenkung von Dr.
and Mrs. Maurice Garbáty.
Lit.: S. Cat. 268.

270 Dedication of the Kreuzberg Monument on March 30, 1821 / Auf die Einweihung des Kreuzbergdenkmals am 30. März 1821

Obv./Vs.: The Kreuzberg Monument with
the city of Berlin in the background. / Das
Kreuzbergdenkmal mit der Stadt Berlin im
Hintergrund. / Ins. around/Umschrift *„Gr:
Görschen. Katzbach. Gr: Beeren. Belle-Alli-
ance. Laon. Bar sur aube. Paris. Larothiére.
Wartenburg. Leipzig. Dennewitz. Culm.".*
Rev./Rs.: *„Der König / dem Volke das auf /
seinen Ruf hochherzig Gut / und Blut dem
Vaterlande / darbrachte den Gefallenen /
zum Gedächtnis den Lebenden / zur Aner-
kennung den künf= / tigen Geschlechtern
zur Nacheiferung"* and ins. around/und
Umschrift *„Denkmal zu Berlin. Gefertigt in
der Königl: Eisengiesserei zu Berlin. Er-*

Cat. 269 (Obv./Vs.)

*richtet im Jahr 1820. Eingeweiht den 30ten
März 1821.".*
1821. – Mod. Louis Beyerhaus after a de-
sign by / nach einem Entwurf von Karl
Friedrich Schinkel. – F./G. KPEG Berlin. –
D. 9.8 cm (3 7/8 in.). – 113.4 g.
Lamprecht 457M, Photo 60. Inv.
1986.495.39.
Lit.: Arenhövel, 78, no. 156. – Cat. Leipzig
1915, 124, no. 99. – Nungesser, 39 ff., fig./

Cat. 270 (Obv./Vs.)

Cat. 270 (Rev./Rs.)

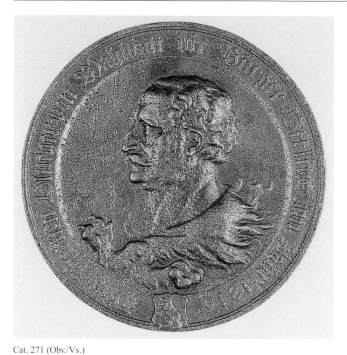

Cat. 271 (Obv./Vs.) Cat. 271 (Rev./Rs.)

Abb. 31 f. – Ostergard 1994, 186 f., no. 22. – Schmidt 1976, fig./Abb. 47. – Schmidt 1981, 132, fig./Abb. 121.

271 Gebhard Leberecht Blücher, Prince of Wahlstatt (1742-1819) / Fürst von Wahlstatt

Obv./Vs.: Bust in profile left as Hercules draped in lion skin. / Brustbild im Profil nach links als Herkules mit einem Löwenfell. / Ins. around/Umschrift „*Dem Fürsten Blücher von Wahlstatt die Bürger Berlins im Jahr 1816*".

Rev./Rs.: St. Michael slaying the dragon. / St. Michael tötet den Drachen. / Ins. around/ Umschrift „•1813• / •1815• / •1814•".

1816. – Mod. Anton Friedrich König the Younger/d. J. based on a design by / nach einem Entwurf von Karl Friedrich Schinkel. – F./G. KPEG Berlin. – D. 8.2 cm (3 1/4 in.). – 134.6 g. – Sign. on the obverse below the bust / auf der Vs. unterhalb des Brustbilds „*Schinkel inv:*" and/und „*König fec:*".

Lamprecht 458M, Photo 60. – Inv. 1986.495.40.

Lit.: Arenhövel 1982, 77, no. 154. – Bartel 2004, 124, no. 447. – Cälian, 252, no. 273. – Cat. Leipzig 1915, 129, no. 149. – Salaschek 793. – Wurzbach-Tannenbach, no. 830.

Commissioned by the citizens of Berlin and given to Blücher in commemoration of his victories over Napoleon. / Von Bürgern Berlins in Auftrag gegeben und Blücher als Andenken an die Siege über Napoleon überreicht.

272 Confirmation Medal / Konfirmationsmedaille

Obv./Vs.: A lighthouse and ship with cloudy horizon. / Leuchtturm und Schiff mit Wolken. / Ins. around/Umschrift „*WIE WIRD EIN JÜNGLING SEINEN WEG UN-*

STRAEFLICH GEHEN?" and below relief / und im Feld unten „*PS. 119 V. 9*".

Rev./Rs.: An altar with an open Bible. / Altar mit aufgeschlagener Bibel. / Ins. around/ Umschrift „*WENN ER SICH HAELT NACH DEINEM WORT*".

First quarter of the 19th century / 1. Viertel des 19. Jh. – Mod. Daniel Friedrich Loos. – F./G. KPEG Berlin. – D. 3.1 cm (1 1/4 in.). – 6.3 g.

Lamprecht 459M. – Inv. 1986.495.41.

Lit.: Sommer 1981, B 74/2.

Cat. 272 (Obv./Vs.) Cat. 272 (Rev./Rs.)

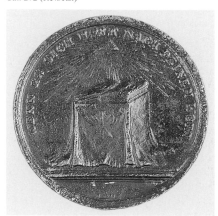

273 Battle of Leipzig 1813 / Leipziger Völkerschlacht 1813

Obv./Vs.: Cossack on horseback. / Reitender Kosak. / Ins. around/Umschrift „DER 16. BIS 19. OCTOBER 1813".

Rev./Rs.: –

1813. – Mod. Daniel Friedrich Loos. – F./G. KPEG Berlin or/oder Gleiwitz. – 2.5 x 1.9 cm (1 x 3/4 in.). – 2.5 g.

Lamprecht 460M, Photo 51. – Inv. 1986.495.42.

Lit.: Cat. Leipzig 1915, 131, no. 171. – Schuette 1916, 283, fig./Abb. 14. – cp./vgl. Sommer 1981, A 166/1-2.

Similar model used as a ring plate / Ähnliches Modell auch als Ringplatte benutzt (Marquardt 1984, 272, no. 488).

274 Battle of Leipzig 1813 / Leipziger Völkerschlacht 1813

S. Cat. 273. – 2.5 x 1.9 cm (1 x 3/4 in.). – 3.4 g.

Inv. 1962.95. – Gift of / Schenkung von Dr. and Mrs. Maurice Garbáty.

Lit.: S. Cat. 273.

275 Emperor Alexander I of Russia's Visit to the Alexander Foundry in Poland 1817 / Besuch des Kaisers Alexander I. von Rußland in der Alexanderhütte in Polen 1817

Obv./Vs.: Laureate bust in profile right. / Brustbild im Profil nach rechts mit Lorbeerkranz. / Ins. around/Umschrift „DAWCA POKOIU NARODOW WSKRZESICIEL POLSKI".

Rev./Rs.: View of the Alexander foundry. / Ansicht der Alexanderhütte. / Ins. around/ Umschrift „I KRUSZCOM POLSKI ZAIASNIALO SŁONCE" and below / und im Feld unten „HUTA ALEXANDRA W BIAŁO GONACH 1817".

1817. – Mod. Franciszek Ksawery Stuckhart. – F./G. Alexanderhütte. – D. 5.1 cm (2 in.). – 37.7 g. – Sign. on truncation illegible / am Brustabschnitt unleserlich.

Lamprecht 463M, Photo 61. – Inv. 1986.495.45.

Lit.: Müseler 54/5. – Wiecek, 194, no. 106.

276 Carl Philipp, Prince of Schwarzenberg (1771-1820), Austrian Field Marshal / Fürst von Schwarzenberg, österreichischer Feldmarschall

Obv./Vs.: Bust in profile right. / Brustbild im Profil nach rechts. / Ins. around/Umschrift „CAROLUS PRINCEPS A SCHWARZENBERG".

Cat. 273 (Obv./Vs.)

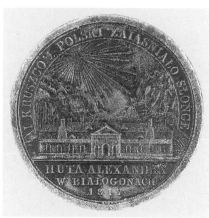
Cat. 274 (Obv./Vs.)

Cat. 275 (Obv./Vs.)

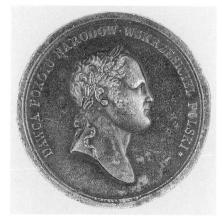
Cat. 275 (Rev./Rs.)

Cat. 276 (Obv./Vs.)

Cat. 276 (Rev./Rs.)

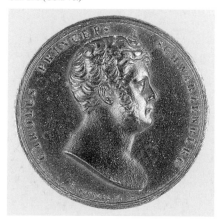

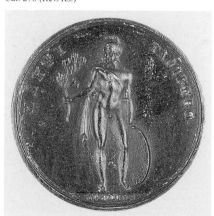

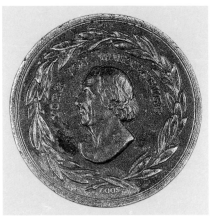

Cat. 277 (Obv./Vs.)

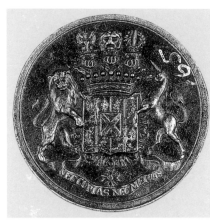

Cat. 277 (Rev./Rs.)

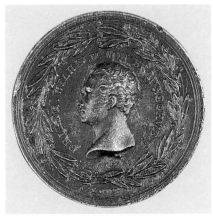

Cat. 278 (Obv./Vs.)

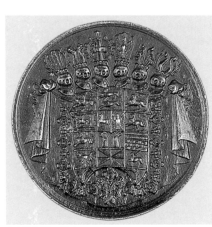

Cat. 278 (Rev./Rs.)

Cat. 279 (Obv./Vs.)

Cat. 279 (Rev./Rs.)

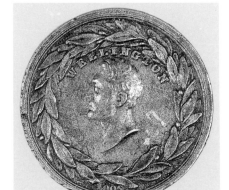

Rev./Rs.: Mars with olive branch. / Mars mit Olivenzweig. / Ins. around/Umschrift „MAR-TI PACIFERO" and below / und im Feld unten „SUPERSTITES".
First quarter of the 19th century / 1. Viertel des 19. Jh. – Mod. Luigi Pichler. – D. 4.7 cm (1 7/8 in.). – 41.6 g. – Sign. below truncation / unterhalb des Brustabschnitts „L. PICH-LER F.".
Lamprecht 464M, Photo 60. – Inv. 1986.495.46.
Lit.: Forrer IV, 522 ff.
Pichler was professor of engraving at the Academy of Art in Vienna from 1818 to 1850. / Pichler war Professor der Graveurkunst an der Kunstakademie in Wien von 1818 bis 1850.

277 Hans Ludwig David Graf Yorck von Wartenburg (1759-1830), Prussian General / Preußischer General
Obv./Vs.: Head in profile left within a closed and tied laurel wreath. / Im Lorbeerkranz Kopf im Profil nach links. / Ins. around/ Umschrift „YORK VON WARTENBURG".
Rev./Rs.: Coat of arms / Wappen.
Ca. 1815. – Mod. Daniel Friedrich Loos. – F./G. KPEG Berlin or/oder Gleiwitz. – D. 2.8 cm (1 1/8 in.). – 9.2 g. – Sign. on the obverse below wreath / auf der Vs. unterhalb des Kranzes „LOOS".
Lamprecht 465M. – Inv. 1986.495.47 a.
Lit.: Cat. Leipzig 1915, 130, no. 162. – Loos 1842, 10, no. Ha.12.6. – Sommer 1981, A 173.
From a suite created by Loos to commemorate the heroes of the forces against Napoleon during the Wars of Liberation 1813-15. / Von einer Serie von Loos auf die Helden der Befreiungskriege 1813-15.

278 Friedrich Wilhelm, Duke of Bruns-wick-Oels (1771-1815) / Herzog von Braunschweig-Oels
Obv./Vs.: Head in profile left within a closed and tied laurel wreath. / Im Lorbeer-kranz Kopf im Profil nach links. / Ins. around/Umschrift „FRIEDR. WILHELM VON BRAUNSCHWEIG".
Rev./Rs.: Coat of arms / Wappen.
Ca. 1815. – Mod. Daniel Friedrich Loos. – F./G. KPEG Berlin or/oder Gleiwitz. – D. 2.8 cm (1 1/8 in.). – 8.7 g. – Sign. on the obverse below wreath / auf der Vs. unter-halb des Kranzes „LOOS".
Lamprecht 466M. – Inv. 1986.495.47 b.
Lit.: Brockmann 545. – Cat. Leipzig 1915, 130, no. 161. – Loos 1842, 6, no. H.a.12/4.

– Sommer 1981, A 176 (without ill. / ohne Abb.).

S. note / Notiz Cat. 36.

279 Sir Arthur Wellesley, Duke of Wellington, Prince of Waterloo (1769-1852) / Herzog von Wellington, Fürst von Waterloo

Obv./Vs.: Head in profile left within a closed and tied laurel wreath. / Im Lorbeerkranz Kopf im Profil nach links. / Ins. „WELLING-TON".

Rev./Rs.: Coat of arms / Wappen.

Ca. 1815. – Mod. Daniel Friedrich Loos. – F./G. KPEG Berlin or/oder Gleiwitz. – D. 2.8 cm (1 1/8 in.). – 8.7 g. – Sign. on the obverse below wreath / auf der Vs. unterhalb des Kranzes „LOOS".

Lamprecht 467M. – Inv. 1986.495.47 c.

Lit.: Aus einem Guß, 197, no. 738. – Eimer, no. 91. – Loos 1842, 10, no. H.a.12.2. – Sommer 1981, A 178.

280 Dedication of the Cornerstone of the Kreuzberg Monument on September 19, 1818 / Auf die Grundsteinlegung des Kreuzbergdenkmals zu Berlin am 19. September 1818

Obv./Vs.: The conjoined heads of Alexander I, Emperor of Russia, and Friedrich Wilhelm III, King of Prussia, in profile left. / Die Köpfe der Herrscher Alexander I. von Rußland und Friedrich Wilhelm III. von Preußen im Profil nach links. / Ins. „ALEXANDER I." and/und „FRIED. WILHELM III.".

Rev./Rs.: Kreuzberg Monument / Kreuzbergdenkmal. / Ins. around/Umschrift „DANKBAR GEGEN GOTT EINGEDENK SEINER TREUEN VERBÜNDETEN UND EHREND DIE TAPFERKEIT SEINES VOLKES LEGTE IN / GEMEINSCHAFT MIT ALEXANDER I KAISER VON RUSSLAND FRIEDRICH WILHELM III DEN 19. / SEPTEMBER 1818 DEN GRUNDSTEIN DES DENKMALS FÜR DIE RUHMVOLLEN EREIGNISSE IN DEN JAHREN / 1813 / 1814 / 1815".

Bronze. – Ca. 1819. – Mod. Henri François Brandt after a design by / nach einem Entwurf von Karl Friedrich Schinkel. – F./G. Royal Mint Berlin (?) / Kgl. Münze Berlin (?). – D. 5.1 cm (2 in.). – Sign. on truncation / am Halsabschnitt „BRANDT F."; sign. on reverse under the monument / auf der Rs. unterhalb des Denkmals „SCHINKEL ARC.".

Lamprecht 563M. – Inv. 1986.495.51.

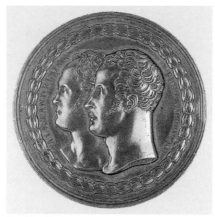

Cat. 280 (Obv./Vs.)

Cat. 280 (Rev./Rs.)

Lit.: Bolzenthal, 91. – Lehnert, 51, no. 25 (pl./Taf. IV). – Nungesser, 39 f., fig./Abb. 29 f. – Schmidt 1981, 132 f.

In 1818 Brandt was named chief engraver at the Berlin Mint. / 1818 wurde Brandt Erster Modelleur der Münze Berlin.

281 Virgin Mary / Jungfrau Maria

Obv./Vs.: Bust in profile right. / Brustbild im Profil nach rechts. / Ins. around/Umschrift „MATER SALVATORIS ORA. PR. N".

Rev./Rs.: –

N. d./o. J. – 3.7 x 3.1 cm (1 7/16 x 1 1/4 in.). – 21.8 g.

Lamprecht 564M. – Inv. 1986.497.1.

Cat. 281 (Obv./Vs.)

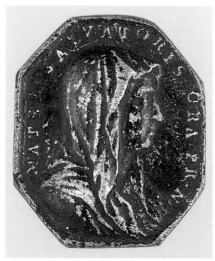

282-84 From a Suite of Medals Commemorating the History of the Roman Empire. After Medals (about 1750) by Jean and Jacques Antoine Dassier. / Von einer Serie zur Geschichte des Römischen Reiches. Nach Medaillen (um 1750) von Jean und Jacques Antoine Dassier.

Ca. 1800. – F./G. KPEG Gleiwitz (cp./vgl. Hintze 1928 a, 101, pl./Taf. 2, no. 4-9, about the suite / über die Serie).

282 Augustus (63 B.C.-14 A.D.), Emperor of Rome / römischer Kaiser

Obv./Vs.: Bust in profile left. / Brustbild im Profil nach links. / Ins. „AUGUSTE".

Rev./Rs.: –

Cat. 282 (Obv./Vs.)

D. 3.1 cm (1 1/4 in.). – 9.0 g.
Lamprecht 565M. – Inv. 1986.497.2.

283 Marcus Agrippa (63-12 B.C.), Roman Statesman and General / römischer Staatsmann und General, and/und Maecenas (70-8 B.C.), Adviser to Augustus / Berater von Augustus

Obv./Vs.: Head in profile right. / Kopf im Profil nach rechts. / Ins. „MARC AGRIPPA.".

Rev./Rs.: Head in profile right. / Kopf im Profil nach rechts. / Ins. „MECENAS.".

D. 3.1 cm (1 1/4 in.). – 10.0 g.
Lamprecht 566M. – Inv. 1986.497.3.

284 Gaius Marius (157-86 B.C.) and the Triumph over the Cimbri at Vercellae / und der Sieg über die Kimbern bei Vercellae

Obv./Vs.: Head in profile left. / Kopf im Profil nach links. / Ins. „C. MARIUS.".

Rev./Rs.: Winged Victory with palm frond and eagle scepter, at her feet the figure of a conquered Cimbri and war trophies. / Geflügelte Siegesgöttin mit Palmzweig und Adlerzepter, zu ihren Füßen ein Besiegter und Siegesbeute. / Ins. „DEFAITE DES CIMBRES A. R. 651".

D. 3.1 cm (1 1/4 in.). – 10.5 g.
Lamprecht 567M. – Inv. 1986.497.4.
Lit.: Bekker 2001, 85, no. 617. – Hintze 1928a, 101, pl./Taf. 2, no. 8 (rev./Rs.).

285 Dedication of the Monument to the Opening of the Transit Route Between Vilshof and Passau on May 27, 1823 / Auf die Einweihung des Denkmals zur Eröffnung der neuen Straße von Vilshofen nach Passau 1823

Obv./Vs.: A monument with recumbent lions on a tall pedestal on a street. / Denkmal mit ruhendem Löwen auf hohem Sockel an einer Straße. / Ins. around/Umschrift „ZUR FEYER DER ERRICHTUNG AN DER / VILSHOFER PASSAUER / STRASSE" and below / und im Feld unten „D. 27. MAI 1823".

Rev./Rs.: „MAXIMILIAN I. / KOENIG DER BAIERN / OEFFNETE HIER ÜBER VON KEINEM / WANDERER JE BETRETTENE FELSEN DEM OEFFENTLICHEN VERKEHR / DIESE SICHERE BAHN. – ZUM / DENKMALE SEINER FÜRSORGE / VON DEN BEWOHNERN DES / UNTER DONAU KREISES / 1823.".

1823. – Mod. Johann Jakob Neuss. – F./G. Bodenwöhr (?). – D. 4.1 cm (1 5/8 in.). – 21.2 g. – Sign. on the obverse / auf der Vs. „NEUSS F.".
Lamprecht 572M. – Inv. 1986.497.9.

Cat. 283 (Obv./Vs.)

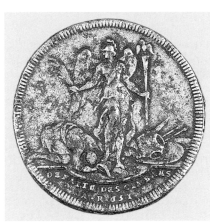
Cat. 283 (Rev./Rs.)

Cat. 284 (Obv./Vs.)

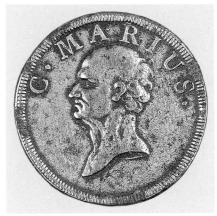
Cat. 284 (Rev./Rs.)

Cat. 285 (Obv./Vs.)

Cat. 285 (Rev./Rs.)

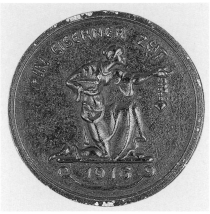

Cat. 286 (Obv./Vs.)

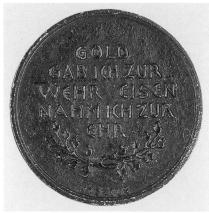

Cat. 286 (Rev./Rs.)

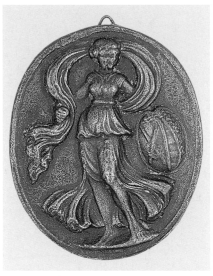

Cat. 287 (Obv./Vs.)

Lit.: Beierlein, no. 2518. Forrer IV, 252 f.
The passage, opened by King Maximilian I
of Bavaria on May 27, 1823, was created in
part by blasting into the rocky cliffs. / Die
durch König Maximilian I. von Bayern am
27. Mai 1823 eröffnete Straße wurde zum
Teil in die Felsen gesprengt.
Neuss was royal Bavarian court engraver
and medallist for the City of Augsburg. He
was also the owner of a private mint in
Augsburg. /
Neuss war königlicher bayerischer Hofgra-
veur und Medailleur in Augsburg. Er besaß
eine private Münze in Augsburg.

**286 Reward for Donating Gold for the
War Effort / Medaille als Gegengabe für
die Spender von Wertsachen aus Gold**
Obv./Vs.: A woman kneeling right offering
her gold jewelry to the war effort. / Knien-
de Frau, ihren Schmuck überreichend. / Ins.
around/Umschrift „IN EISERNER ZEIT"
and below / und unten „1916".
Rev./Rs.: „GOLD / GAB ICH ZUR / WEHR
EISEN / NAHM ICH ZUR / EHR" above
oak branches / über Eichenzweigen.
1916. – Mod. Hermann Hosaeus. – F./G.
probably/wahrscheinlich Gladenbeck. – D.
4.1 cm (1 5/8 in.). – 19.1 g. – Sign. on re-
verse / auf der Rs. „HOSAEUS".
Inv. 00.294. – Anonymous gift. / Unbekann-
te Stiftung.
Lit.: Bartel 2004, 145, no. 697 (brooch/
Brosche). – Bekker 2001, 125, no. 731. –
Ferner and Genée, 10, fig./Abb. 2. – Gott-
schalk, 136, no. 102. – Malkowsky, 129. –
Salaschek, no. 735-37. – Schmidt 1981, 194,

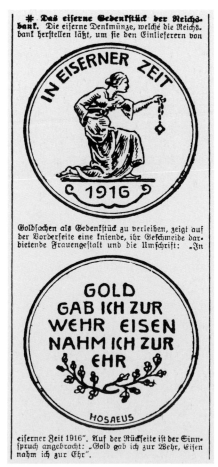

Fig./Abb. 40 Advertisement for the medal / Bekannt-
machung der Medaille von Cat. 286, in *Berliner Lokal-
Anzeiger*, August 15, 1916.

fig./Abb. 200. – Stummann-Bowert, 67, no.
52.
In 1916, every citizen that donated gold in
value of at least five marks received this
medal from the Reichsbank as recompense.
The provenance of this medal is unknown.
It probably came to the Museum through
ACIPCO. / 1916 erhielt jeder, der Gold im
Wert von mindestens fünf Mark ablieferte,
diese Medaille von der Reichsbank als Ge-
gengabe. Die Provenienz dieser Medaille
ist unbekannt. Sie kam wahrscheinlich als
Geschenk der ACIPCO ins Museum.

**287 Allegorical Medal / Medaille mit
Allegorie**
Obv./Vs.: Female figure with banner. / Weib-
liche Figur mit Fahne.
Rev./Rs.: –
N. d./o. J. . – 4.7 x 4.1 cm (1 7/8 x 1 5/8
in.). – 35.9 g.
Lamprecht 476. – Inv. 1986.470.

Honorary and Military
Medals / Denkmünzen und
Orden (Cat. 288-94)

**288 Honorary Medal for Noncombat-
ants of the Wars of Liberation 1813 /
Denkmünze für Nichtkombattanten der
Befreiungskriege 1813**
Obv./Vs.: In the center a laurel wreath. Ins.
on the arms / In der Mitte ein Lorbeerkranz.
Inschrift auf den Kreuzarmen „Heil / Ger /
ma / nien".

Cat. 288 (Obv./Vs.)

Cat. 288 (Rev./Rs.)

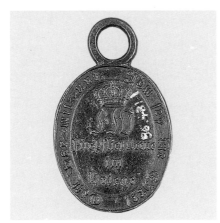

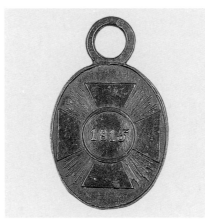

Cat. 289 (Obv./Vs.)

Cat. 289 (Rev./Rs.)

Cat. 290 (Obv./Vs.)

Cat. 290 (Rev./Rs.)

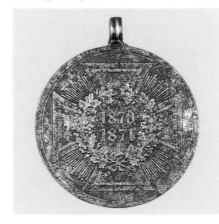

Rev./Rs.: In the center a bundle of arrows. Ins. on the arms / In der Mitte gebundene Pfeile. Ins. auf den Kreuzarmen „*Gott / mit / uns / 1813*".
1813. – F./G. KPEG Berlin. – 2.5 x 1.9 cm (1 x 3/4 in.). – 4.3 g.
Lamprecht 472S, Photo 51. – Inv. 1986.327.6.
Lit.: Schuette 1916, 286, fig./Abb. 18.

289 Honorary Medal for Noncombatants of the Wars of Liberation 1815 / Preußische Denkmünze für Nichtkombattanten der Befreiungskriege 1815
Obv./Vs.: In the middle a crown with the initials *"FW"* of Friedrich Wilhelm III. / In der Mitte eine Krone und die Initialen „*FW*". / Ins. „*Für Pflichttreue / im / Kriege*" and ins. around / und Umschrift „*Gott war mit uns. Ihm sey die Ehre*".
Rev./Rs.: Radiant Iron Cross. / Eisernes Kreuz mit Strahlen. / Ins. „*1815*".
1815. – F./G. KPEG Gleiwitz. – 4.1 x 2.5 cm (1 5/8 x 1 in.). – 6.5 g.
Lamprecht 475S, Photo 51. – Inv. 1986.495.50.
Lit.: Arenhövel 1982, 80, no. 161. – Hintze 1928a, 105, pl./Taf. 84, no. 3-4. – Ostergard 1994, 184, no. 17. – Schmidt 1981, 135.

290 Honorary Medal for Noncombatants of the Franco-Prussian War 1870/71 / Denkmünze für Nichtkombattanten des Deutsch-Französischen Kriegs 1870/71
Obv./Vs.: Crown and the initial *"W"* of Emperor Wilhelm I. / Krone und die Initiale „*W*". / Ins. „*Für Pflichttreue / im Kriege*" and ins. around / und Umschrift „*Gott war mit uns. Ihm sei die Ehre*".
Rev./Rs.: Radiant Iron Cross with oak wreath. / Eisernes Kreuz mit Strahlen und Eichenkranz. / Ins. „*1870*" and/und „*1871*".
Ca. 1871. – Mod. Wilhelm Kullrich. – F./G. KPEG Gleiwitz. – D. 2.9 cm (1 1/8 in.). – 12.4 g.
Lamprecht 552S. – Inv. 1986.495.56.
Lit.: Sommer 1986, K 134.

291 Iron Cross Second Class of the Franco-Prussian War 1870/71 / Eisernes Kreuz 2. Klasse des Deutsch-Französischen Kriegs 1870/71
Obv./Vs.: Crown and the initial *"W"* with the date *"1870"*. / Krone und die Initiale „*W*" mit der Jahreszahl „*1870*".
Rev./Rs.: Crown and the initials *"FW"* with the date *"1813"*. / Krone und die Initialen „*FW*" mit der Jahreszahl „*1813*".
1870. – Mod. Friedrich Wilhelm Ludwig

Beyerhaus after a design by / nach einem Entwurf von Karl Friedrich Schinkel. – F./G. KPEG Gleiwitz. – 4.1 x 3.8 cm (1 5/8 x 1 1/2 in.). – 10.8 g.
Lamprecht 553S. – Inv. 1986.496.1.
Lit.: Cp./vgl. Arenhövel 1982, 80, no. 160. – Godehard Janzig. "'Das zarteste, reinste, keuscheste Metall schließt das kräftigste, männlichste, stärkste ein' – Karl Friedrich Schinkels Entwurf des Eisernen Kreuzes," in Schreiter and Pyritz, S. 151-69. – Neubecker.

292 Iron Cross Second Class of World War I 1914 / Eisernes Kreuz 2. Klasse des Ersten Weltkriegs 1914
(Fig. p. / Abb. S. 152)
Obv./Vs.: A crown above with *"W"* in the middle and *"1914"* below. / Oben eine Krone, in der Mitte „*W*", unten „*1914*".
Rev./Rs.: A crown above with *"FW"* above a laurel branch, and below *"1813"*. / Oben eine Krone mit den Initialen „*FW*" über einem Lorbeerzweig, unten „*1813*".
1813/1914. – Mod. Friedrich Wilhelm Ludwig Beyerhaus after a design by / nach einem Entwurf von Karl Friedrich Schinkel. – 4.7 x 4.3 cm (1 7/8 x 1 11/16 in.). – 15.4 g.
Lamprecht 476S, Photo 51. – Inv. 1986.496.4.
Lit.: S. Cat. 291.

293 Honorary Medal Eckernförde April 5, 1849 / Denkmünze Eckernförde 5. April 1849
(Fig. p. / Abb. S. 152)
Obv./Vs.: The ligated initials *"FHR"* above, an anchor below. / Oben die ligierten Initialen „*FHR*", unten ein Anker. / Ins. „*ECKERN-FOERDE*".
Rev./Rs.: The ligated initials *"FHR"* above, in the middle *"D. 5 APRIL 1849"* and below a laurel wreath / Oben die ligierten Initialen „*FHR*", in der Mitte „*D. 5 APRIL 1849*", und unten ein Lorbeerkranz.
1849. – 3.9 x 3.6 cm (1 9/16 x 1 7/16 in.). – 17.1 g.
Lamprecht 554S. – Inv. 1986.496.2.
Lit.: Stolz, 66 f., fig./Abb. 1.
The medal was originated by the princes Heinrich XX, older line, and Heinrich LXII, younger line, of the Reuss princedom in 1849 as a commemorative medal for those officers and troops of the Reuss battalion, who took part in the battle of Eckernförde on April 5, 1849, during the revolt of the provinces Schleswig and Holstein against Denmark. / Gemeinschaftlich stifteten die Fürsten Heinrich XX. ältere Linie und Heinrich LXII. jüngere Linie der beiden Fürsten-

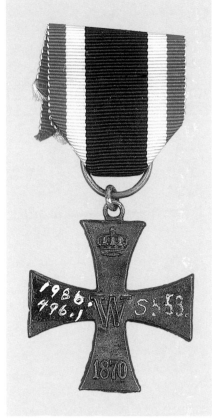
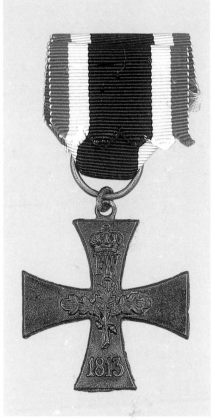

Cat. 291 (Obv./Vs.) Cat. 291 (Rev./Rs.)

Fig./Abb. 41 Karl Friedrich Schinkel, design for the Iron Cross / Entwurf für das Eiserne Kreuz, 1813; pen and ink drawing / Federzeichnung; Berlin, Kupferstichkabinett, SMB, Inv. SM 39, 202.

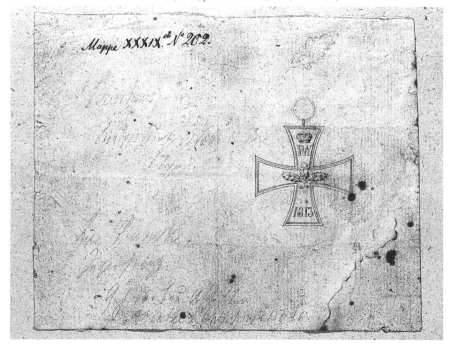

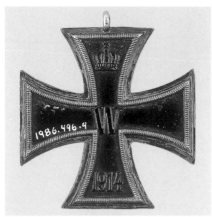

Cat. 292 (Obv./Vs.)

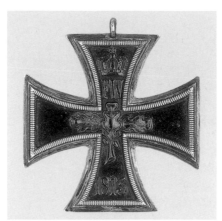

Cat. 292 (Rev./Rs.)

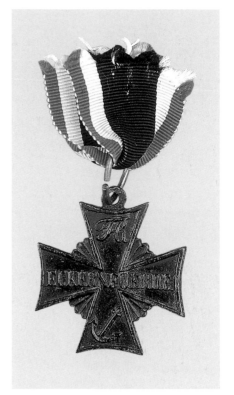

Cat. 293 (Obv./Vs.)

Cat. 293 (Rev./Rs.)

Cat. 294 (Obv./Vs.)

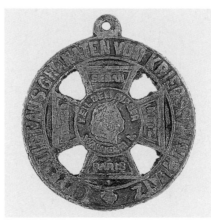

Cat. 294 (Rev./Rs.)

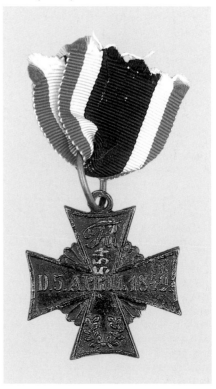

tümer Reuss 1849 ein Erinnerungskreuz für Offiziere und Mannschaften des Bataillons Reuss, die am Gefecht von Eckernförde am 5. April 1849 teilgenommen hatten, als die Provinzen Schleswig und Holstein sich gegen Dänemark erhoben hatten.

294 Honorary Medal of the Franco-Prussian War 1870/71 / Denkmünze des Deutsch-Französischen Kriegs 1870/71
(raw cast / Rohling)
Obv./Vs.: Within a wheel, an Iron Cross with a crown and the initials *"F.W."* above and a crown and the initials *"W.I."* below, with the dates *"1813"* and *"1870"*. / Innerhalb eines Kreisrings ein Eisernes Kreuz, oben mit Krone und „F.W.", unten mit Kro-

ne und „W.I.", links „1813", rechts „1870". / Ins. around/Umschrift „ZUR ERINNR. AN DEUTSCHLANDS HELDENKAMPF GEGEN FRANKREICH 1870".
Rev./Rs.: In the middle the portrait head of Wilhelm I and the inscription around, *"HEIL DEM SIEGER WILHELM I."* in the arms of the cross *"SEDAN", "METZ", "PARIS"* and [?]. / In der Mitte der Porträtkopf Wilhelms I. mit der Umschrift „HEIL DEM SIEGER WILHELM I.", in den Kreuzarmen „SEDAN", „METZ", „PARIS" und [?]. / Ins. around/Umschrift „GEFERTIGT AUS GRANATEN VOM KRIEGSSCHAUPLATZ".
Ca. 1870. – F./G. KPEG Gleiwitz. – D. 4.1 cm (1 5/8 in.). – 30.5 g.
Lamprecht 562S. – Inv. 1986.496.3.

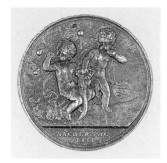

Cat. 295 (Obv./Vs.) Cat. 295 (Rev./Rs.) Cat. 297 (Obv./Vs.) Cat. 297 (Rev./Rs.)

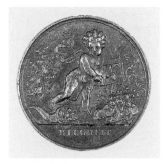

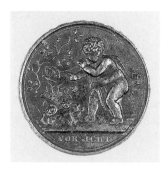

Cat. 296 (Obv./Vs.) Cat. 296 (Rev./Rs.) Cat. 298 (Obv./Vs.) Cat. 298 (Rev./Rs.)

Game Tokens / Spielmarken (Cat. 295-99)

295 Game Token / Spielmarke

Obv./Vs.: Seated Harpocrates with finger to lips, with cornucopia in right hand and dog and owl at feet. / Sitzender Harpokrates mit Füllhorn in der rechten Hand und mit Hund und Eule zu seinen Füßen.
Rev./Rs.: „DEN / FINGER / AUF / DEN MUND".
Ca. 1803. – Mod. Johann Veit Döll and/und Daniel Friedrich Loos. – F./G. KPEG Berlin. – D. 2.7 cm (1 1/16 in.). – 4.4 g.
Sign. obverse below figure / auf der Vs. unterhalb der Figur „LOOS".
Lamprecht 56. – Inv. 1986.317.3.
Lit.: Arenhövel 1982, 81, no. 163. – Bartel 2004, 102, no. 133. – Salaschek, no. 1009. – Sommer 1981, B 80a.
Originally coined in silver at the private mint of Daniel Friedrich Loos in Berlin. Part of a series of four game tokens. / Ursprünglich in Silber in der Berliner Medaillen-Münze Daniel Friedrich Loos in Berlin geprägt; eine von vier zusammengehörigen Spielmarken / (s. Bekker 2001, 84, no. 613a-c).

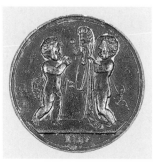

Cat. 299 (Obv./Vs.) Cat. 299 (Rev./Rs.)

296-99 Four Game Tokens / Vier Spielmarken

These four game tokens, which form a set, were originally kept in a small cast-iron box (now missing; s. Cat. 938). / Die vier zusammengehörigen Spielmarken wurden ursprünglich in einem Döschen aus Eisenguß aufbewahrt (fehlt heute; s. Cat. 938). 1810-20. – F./G. KPEG Berlin.
Lit.: Arenhövel 1982, 81, no. 163.

296 Game Token / Spielmarke

Obv./Vs.: Cherub with basket in landscape and cornucopia at feet. / Putto mit Korb in Landschaft und ein Füllhorn zu den Füßen. / Ins. „KLUGHEIT".
Rev./Rs.: „0" and/und „QUADRUPLE".
D. 2.5 cm (1 in.). – 5.3 g.
Lamprecht 222. – Inv. 1986.319.3.

297 Game Token / Spielmarke

Obv./Vs.: Pair of cherubs blowing bubbles. / Zwei mit Seifenblasen spielende Putti. / Ins. „NACHLAESSIGKEIT".
Rev./Rs.: „1", „2" and/und „TRIPLE".
D. 2.5 cm (1 in.). – 4.6 g.

Lamprecht 223. – Inv. 1986.319.4.
Lit.: Aus einem Guß, 196, no. 730.

298 Game Token / Spielmarke
Obv./Vs.: Cherub trying to catch butterfly in a rose bush. / Putto versucht einen Schmetterling in einem Rosenstrauch zu fangen. Ins „*VORSICHT*".
Rev./Rs.: „*3*", „*4*" and/und „*DOUBLE*".
D. 2.5 cm (1 in.). – 4.7 g.
Lamprecht 221. – Inv. 1986.319.2.

299 Game Token / Spielmarke
Obv./Vs.: Two cherubs with mask. / Zwei Putti mit Masken. / Ins. „*LIST*".
Rev./Rs.: „*5. 6. 7. / 8. 9*" and/und „*SIMPLE*".
D. 2.5 cm (1 in.). – 4.3 g.
Lamprecht 220. – Inv. 1986.319.1.

Gems / Gemmen (Cat. 300-508)

Heads from Greek and Roman History / Köpfe zur Geschichte der Griechen und Römer (Cat. 300-57)
In sequence following / Reihenfolge nach Hintze 1928 a, 101 f., pl./Taf. 3-11.
Ca. 1800. – F./G. KPEG Gleiwitz.
Lit.: Forschler-Tarrasch 2008. – Hintze 1928a, 6 f., 101 f., pl./Taf. 3-11. – Reilly 1989, vol. II, 680 f.

According to Hintze (1928a, 101 f.) these portrait heads belong to a group of 165 serially numbered gems, which are divided into two groups. The first group, numbers one to 60, shows primarily Greek portraits; the second, numbers 61 to 165, includes mostly Roman heads: statesmen, military leaders, philosophers, orators, or poets. *"Most of the heads are classical works and came to the Gleiwitz foundry in the form of Wedgwood medallions and white glass pastes for the purpose of creating tin models, probably sometime between 1798 and 1800."*

Mining director Friedrich Wilhelm von Reden encouraged the acquisition of these medallions by bringing to Prussia from England, *"a considerable inventory of glass pastes, medallions by Josiah Wedgwood and Thomas Bentley and similar products."* The following gems stem from the early period of the Gleiwitz foundry. The earliest have no markings; later examples are inscribed on the reserve side with Arabic numbers. These portraits were sold individually or in groups. The Kunstgewerbemuseum, Staatliche Museen zu Berlin – Preußischer Kulturbesitz, owns a small case with the por-

Verzeichnis
gegossener eiserner Abdrücke
zur Geschichte
der Römer und Griechen.

Num.		Num.	
1	Moschus.	31	Simonides.
2	Lycurgus.	32	Hippocrates.
3	Alcaeus.	33	Anacreon.
4	Alexander Magnus.	34	Pittacus.
5	Minos.	35	Aristophanes.
6	Demosthenes.	36	Aratus.
7	Euclides.	37	Xenocrates.
8	Pythagoras.	38	Thrasybulus.
9	Aristoteles.	39	Aristippus.
10	Heraclitus.	40	Crates.
11	Eschenies.	41	Leonidas.
12	Pyndar.	42	Curneades.
13	Epicurus.	43	Antisthenes.
14	Socrates.	44	Chrisippus.
15	Diogenes von Sinope.	45	Epimenodes.
16	Phaedon.	46	Callisthenes.
17	Archimedes.	47	Posideppus.
18	Solon.	48	Theocritus.
19	Plato.	49	Posidonius.
20	Theseus.	50	Menander.
21	Xenophon.	51	Apollonius.
22	Apollonius Tyaneus.	52	Pythias.
23	Homer.	53	Thales.
24	Sapho.	54	Chilo.
25	Theophrastus.	55	Aristomachus.
26	Democritus.	56	Zaleucus.
27	Hesiodus.	57	Euripides.
28	Architas.	58	Sophocles.
29	Apulejus.	59	Aristides.
30	Lysander.	60	Isocrates.

Fig./Abb. 42 Index of cast-iron impressions from the History of the Romans and Greeks, page with the numbers one through sixty, enclosure for a small box as in / „*Verzeichnis gegossener eiserner Abdrücke zur Geschichte der Römer und Griechen*", Einzelblatt mit den Nummern 1 bis 60, gehörig als Beilage zu einem Kästchen wie fig./Abb. 43 (cp./vgl. Cat. 300-57); in Hintze 1928 a, 7.

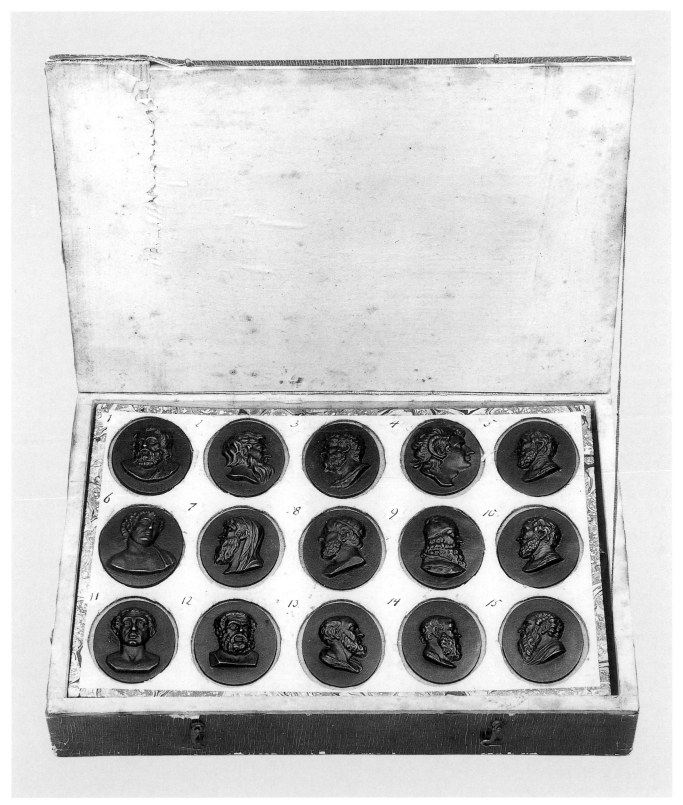

Fig./Abb. 43 Heads from the History of the Romans and Greeks, sixty portrait gems mounted on cardboard in a wooden box / Köpfe zur Geschichte der Römer und Griechen, 60 Bildnisgemmen auf vier Papprahmen in einem Holzkästchen (the Index is missing here / das zugehörige Verzeichnis fehlt hier; cp./vgl. Cat. 300-57, and fig./und Abb. 42); Berlin, Kunstgewerbemuseum, SMB, Inv. W-B I 185.

trait heads numbered one through 60, which rest in recessed, numbered beds on four cardboard tablets. Included is a printed index with the names and numbers of those portrayed (illustrated in Hintze 1928a, 7). / Nach Hintze (1928a, 6, 101 f.) gehören diese Köpfe einer Serie von 165 durchnumerierten Gemmen in zwei Gruppen an. Die erste Gruppe mit den Nummern 1-60 zeigt vorwiegend griechische, die zweite mit den Nummern 61-165 meist römische Bildnisse: Staatsmänner, Heerführer, Philosophen, Redner oder Dichter. „*Sämtliche Köpfe sind klassizistische Arbeiten und kamen als Wedgwood-Reliefs und weiße Glaspasten zur Herstellung von Zinn-Modellen nach der Gleiwitzer Hütte, und zwar wahrscheinlich schon zwischen 1798 und 1800.*"

Veranlaßt hatte diese Anschaffung der Oberbergamtsdirektor Friedrich Wilhelm von Reden, der sich aus England „*einen ansehnlichen Vorrat an Glaspasten, Reliefs von Josiah Wedgwood und Thomas Bentley und ähnlichen Erzeugnissen*" besorgt hatte. Diese Gemmen entstammen der Frühzeit des Gleiwitzer Eisenfeingusses. Die frühesten haben keine Beschriftung, in die späteren sind auf der Rückseite arabische Zahlen eingestochen. In den Handel kamen diese Köpfe einzeln oder in geschlossenen Teilen. So besitzt das Kunstgewerbemuseum, Staatliche Museen zu Berlin – Preußischer Kulturbesitz, einen Kasten mit den Köpfen 1 bis 60, die auf vier Papptafeln in Aussparungen angeordnet und numeriert sind. Dazu gab es ein gedrucktes Verzeichnis mit Namen und Nummern der Dargestellten (bei Hintze 1928a, 7, abgebildet).

300 Moschus
Bust slightly left. / Brustbild leicht nach links gewendet.
4.3 x 3.5 cm (1 11/16 x 1 3/8 in.). – 15.9 g. – Rev./Rs. „*1*".
Lamprecht 225M. – Inv. 1986.481.26.
Lit.: Hintze 1928a, 101 f., pl./Taf. 3, no. 1.

301 Lycurgus
Head in profile right. / Kopf im Profil nach rechts.
4.3 x 3.5 cm (1 11/16 x 1 3/8 in.). – 14.5 g. – Rev./Rs. „*2*".
Lamprecht 200M. – Inv. 1986.481.1.
Lit.: Hintze 1928a, 101 f., pl./Taf. 3, no. 2.

302 Alcaeus
Bust in profile left. / Brustbild im Profil nach links.
4.3 x 3.5 cm (1 11/16 x 1 3/8 in.). – 11.2 g. – Rev./Rs. „*3*".
Lamprecht 230M. – Inv. 1986.481.31.
Lit.: Hintze 1928a, 101 f., pl./Taf. 3, no. 3.

Cat. 300

Cat. 301

Cat. 302

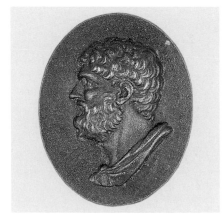

303 Alexander the Great as Jupiter Ammon / Alexander der Große als Jupiter Ammon
Head in profile right. / Kopf im Profil nach rechts.
4.3 x 3.5 cm (1 11/16 x 1 3/8 in.). – 12.3 g.
Lamprecht 264M. – Inv. 1986.481.65.
Lit.: Hintze 1928a, 101 f., pl./Taf. 3, no. 4.

304 Minos
Bust in profile left. / Brustbild im Profil nach links.
4.3 x 3.5 cm (1 11/16 x 1 3/8 in.). – 13.7 g.
Lamprecht 210M. – Inv. 1986.481.11.
Lit.: Hintze 1928a, 101 f., pl./Taf. 3, no. 5.

305 Demosthenes
Bust front. / Brustbild von vorn.
4.3 x 3.5 cm (1 11/16 x 1 3/8 in.). – 12.0 g. – Rev./Rs. „*6*".
Lamprecht 215M. – Inv. 1986.481.16.
Lit.: Hintze 1928a, 101 f., pl./Taf. 3, no. 6.

306 Euclid / Euklid
Bust in profile left. / Brustbild im Profil nach links.
4.3 x 3.5 cm (1 11/16 x 1 3/8 in.). – 13.2 g. – Rev./Rs. „*7*".
Lamprecht 235M. – Inv. 1986.481.36.
Lit.: Hintze 1928a, 101 f., pl./Taf. 3, no. 7.

307 Pythagoras
Bust in profile left. / Brustbild im Profil nach links.
4.3 x 3.5 cm (1 11/16 x 1 3/8 in.). – 8.7 g. – Rev./Rs. „*8*".
Lamprecht 241M. – Inv. 1986.481.42.
Lit.: Hintze 1928a, 101 f., pl./Taf. 3, no. 8.

308 Heracleitus / Heraklit
Bust in profile left. / Brustbild im Profil nach links.
4.3 x 3.5 cm (1 11/16 x 1 3/8 in.). – 13.4 g. – Rev./Rs. „*10*".
Lamprecht 228M. – Inv. 1986.481.29.
Lit.: Aus einem Guß, 223, no. 1706. – Hintze 1928a, 101 f., pl./Taf. 3, no. 10.

309 Aeschines
Bust front. / Brustbild von vorn.
4.3 x 3.5 cm (1 11/16 x 1 3/8 in.). – 11.7 g. – Rev./Rs. „*11*".
Lamprecht 204M. – Inv. 1986.481.5.
Lit.: Hintze 1928a, 101 f., pl./Taf. 3, no. 11.

310 Pindar
Bust front. / Brustbild von vorn.
4.3 x 3.5 cm (1 11/16 x 1 3/8 in.). – 14.2 g. – Rev./Rs. „*12*".
Lamprecht 223M. – Inv. 1986.481.24.
Lit.: Hintze 1928a, 101 f., pl./Taf. 3, no. 12.

311 Diogenes
Bust in profile left. / Brustbild im Profil nach links.
4.3 x 3.5 cm (1 11/16 x 1 3/8 in.). – 13.2 g. – Rev./Rs. „*15*".

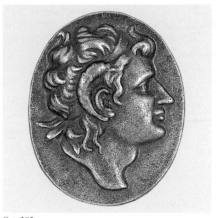

Cat. 303

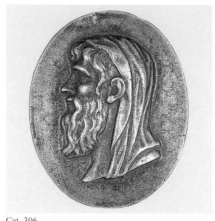

Cat. 306

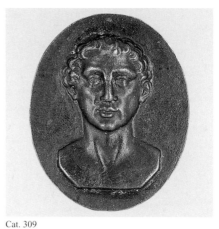

Cat. 309

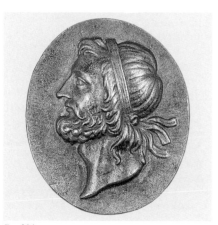

Cat. 304

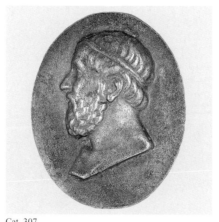

Cat. 307

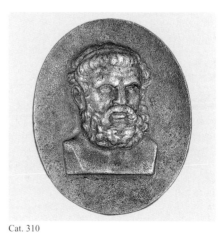

Cat. 310

Cat. 305

Cat. 308

Cat. 311

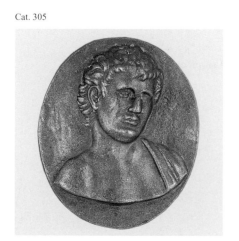

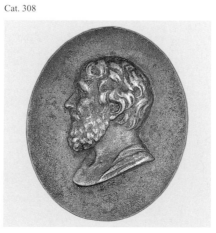

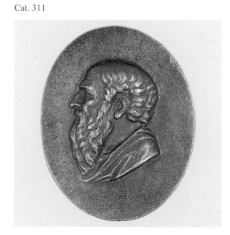

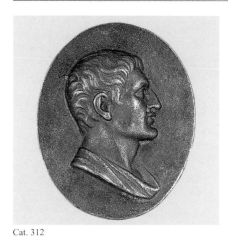

Cat. 312

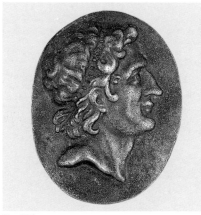

Cat. 315

Lamprecht 236M. – Inv. 1986.481.37.
Lit.: Aus einem Guß, 223, no. 1701. – Hintze 1928a, 101 f., pl./Taf. 3, no. 15.

312 Phaedon
Bust in profile right. / Brustbild im Profil nach rechts.
4.3 x 3.5 cm (1 11/16 x 1 3/8 in.). – 10.0 g. – Rev./Rs. „16".
Lamprecht 243M. – Inv. 1986.481.44.
Lit.: Hintze 1928a, 101 f., pl./Taf. 3, no. 16.

313 Archimedes
Bust in profile right. / Brustbild im Profil nach rechts.
4.3 x 3.5 cm (1 11/16 x 1 3/8 in.). – 10.1 g. – Rev./Rs. „17".
Lamprecht 209M. – Inv. 1986.481.10.
Lit.: Hintze 1928a, 101 f., pl./Taf. 4, no. 17.

314 Solon
Bust in profile right. / Brustbild im Profil nach rechts.
4.3 x 3.5 cm (1 11/16 x 1 3/8 in.). – 13.5 g. – Rev./Rs. „18".
Lamprecht 214M. – Inv. 1986.481.15.
Lit.: Hintze 1928a, 101 f., pl./Taf. 4, no. 18.

315 Plato
Bust in profile left. / Brustbild im Profil nach links.
4.3 x 3.5 cm (1 11/16 x 1 3/8 in.). – 10.6 g. – Rev./Rs. „19".
Lamprecht 227M. – Inv. 1986.481.28.
Lit.: Aus einem Guß, 223, no. 1707. – Hintze 1928a, 101 f., pl./Taf. 4, no. 19.

316 Xenophon
Head in profile right. / Kopf im Profil nach rechts.
4.3 x 3.5 cm (1 11/16 x 1 3/8 in.). – 10.2 g.
Lamprecht 201M. – Inv. 1986.481.2.

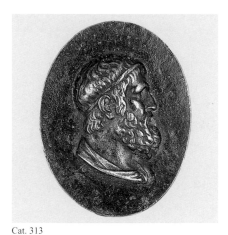

Cat. 313

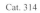

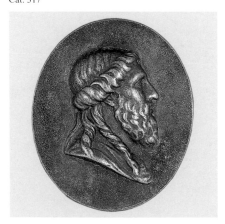

Cat. 316

Cat. 314

Cat. 317

Cat. 318

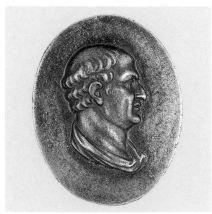

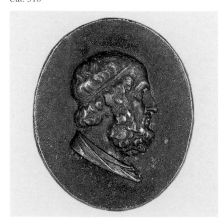

Lit.: Hintze 1928a, 101 f., pl./Taf. 4, no. 21.

317 Apollonius of Tyana / Apollonius von Tyana
Bust in profile right. / Brustbild im Profil nach rechts.
4.3 x 3.5 cm (1 11/16 x 1 3/8 in.). – 13.8 g. – Rev./Rs. „22".
Lamprecht 231M. – Inv. 1986.481.32.
Lit.: Aus einem Guß, 223, no. 1702. – Hintze 1928a, 101 f., pl./Taf. 4, no. 22.

318 Homer
Bust in profile right. / Brustbild im Profil nach rechts.
4.3 x 3.5 cm (1 11/16 x 1 3/8 in.). – 16.9 g.
Lamprecht 208M. – Inv. 1986.481.9.
Lit.: Hintze 1928a, 101 f., pl./Taf. 4, no. 23.

319 Sappho
Bust in profile left. / Brustbild im Profil nach links.
4.3 x 3.5 cm (1 11/16 x 1 3/8 in.). – 10.8 g. – Rev./Rs. „24".
Lamprecht 304M. – Inv. 1986.481.105.
Lit.: Hintze 1928a, 101 f., pl./Taf. 4, no. 24.

320 Theophrastus
Bust in profile right. / Brustbild im Profil nach rechts.
4.3 x 3.5 cm (1 11/16 x 1 3/8 in.). – 13.0 g. – Rev./Rs. „25".
Lamprecht 211M. – Inv. 1986.481.12.
Lit.: Hintze 1928a, 101 f., pl./Taf. 4, no. 25.

321 Democritus
Bust in profile right. / Brustbild im Profil nach rechts.
4.3 x 3.5 cm (1 11/16 x 1 3/8 in.). – 13.0 g. – Rev./Rs. „26".
Lamprecht 218M. – Inv. 1986.481.19.
Lit.: Hintze 1928a, 101 f., pl./Taf. 4, no. 26.

322 Hesiod
Bust in profile left. / Brustbild im Profil nach links.
4.3 x 3.5 cm (1 11/16 x 1 3/8 in.). – 10.8 g.
Lamprecht 229M. – Inv. 1986.481.30.
Lit.: Hintze 1928a, 101 f., pl./Taf. 4, no. 27.

323 Archytas
Bust in profile left. / Brustbild im Profil nach links.
4.3 x 3.5 cm (1 11/16 x 1 3/8 in.). – 9.0 g. – Rev./Rs. „28".
Lamprecht 217M. – Inv. 1986.481.18.
Lit.: Hintze 1928a, 101 f., pl./Taf. 4, no. 28.

324 Apuleius
Bust in profile left. / Brustbild im Profil nach links.
4.3 x 3.5 cm (1 11/16 x 1 3/8 in.). – 10.2 g. – Rev./Rs. „29".
Lamprecht 238M. – Inv. 1986.481.39.
Lit.: Hintze 1928a, 101 f., pl./Taf. 4, no. 29.

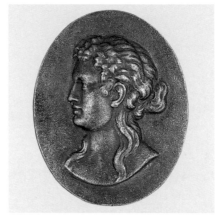
Cat. 319
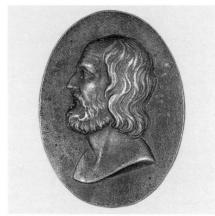
Cat. 322
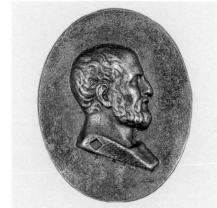
Cat. 320
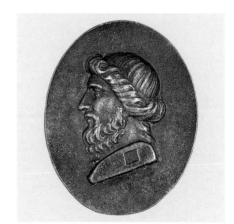
Cat. 323
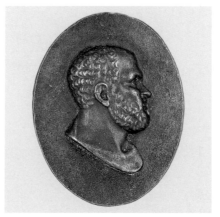
Cat. 321
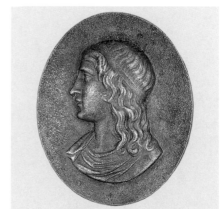
Cat. 324
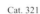

325 Lysander
Bust in profile left. / Brustbild im Profil nach links.
4.3 x 3.5 cm (1 11/16 x 1 3/8 in.). – 12.6 g. – Rev./Rs. „30".
Lamprecht 213M. – Inv. 1986.481.14.
Lit.: Hintze 1928a, 101 f., pl./Taf. 4, no. 30.

326 Simonides
Bust in profile left. / Brustbild im Profil nach links.
4.3 x 3.5 cm (1 11/16 x 1 3/8 in.). – 13.1 g. – Rev./Rs. „31".
Lamprecht 242M. – Inv. 1986.481.43.
Lit.: Aus einem Guß, 224, no. 1724. – Hintze 1928a, 101 f., pl./Taf. 4, no. 31.

327 Hippocrates
Bust in profile left. / Brustbild im Profil nach links.
4.3 x 3.5 cm (1 11/16 x 1 3/8 in.). – 9.7 g. – Rev./Rs. „32".
Lamprecht 248M. – Inv. 1986.481.49.
Lit.: Aus einem Guß, 224, no. 1712. – Hintze 1928a, 101 f., pl./Taf. 4, no. 32.

328 Anacreon
Bust in profile left. / Brustbild im Profil nach links.
4.3 x 3.5 cm (1 11/16 x 1 3/8 in.). – 14.4 g. – Rev./Rs. „33".
Lamprecht 221M. – Inv. 1986.481.22.
Lit.: Hintze 1928a, 101 f., pl./Taf. 5, no. 33.

329 Pittacus
Bust in profile left. / Brustbild im Profil nach links.
4.3 x 3.5 cm (1 11/16 x 1 3/8 in.). – 11.4 g. – Rev./Rs. „34".
Lamprecht 244M. – Inv. 1986.481.45.
Lit.: Hintze 1928a, 101 f., pl./Taf. 5, no. 34.

330 Aristophanes
Bust slightly left. / Brustbild leicht nach links gewendet.
4.3 x 3.5 cm (1 11/16 x 1 3/8 in.). – 12.2 g. – Rev./Rs. „35".
Lamprecht 207M. – Inv. 1986.481.8.
Lit.: Aus einem Guß, 224, no. 1722. – Hintze 1928a, 101 f., pl./Taf. 5, no. 35.

331 Aratus
Bust in profile right. / Brustbild im Profil nach rechts.
4.3 x 3.5 cm (1 11/16 x 1 3/8 in.). – 11.3 g. – Rev./Rs. „36".
Lamprecht 216M. – Inv. 1986.481.17.
Lit.: Hintze 1928a, 101 f., pl./Taf. 5, no. 36.

332 Xenocrates
Bust in profile right. / Brustbild im Profil nach rechts.
4.3 x 3.5 cm (1 11/16 x 1 3/8 in.). – 11.1 g. – Rev./Rs. „37".
Lamprecht 206M. – Inv. 1986.481.7.

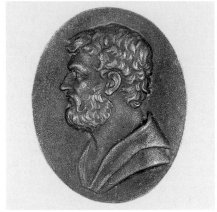

Cat. 325

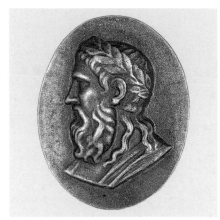

Cat. 328

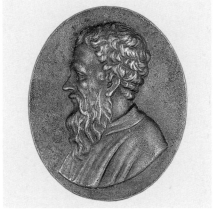

Cat. 326

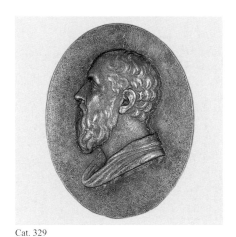

Cat. 329

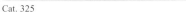

Cat. 327

Cat. 330

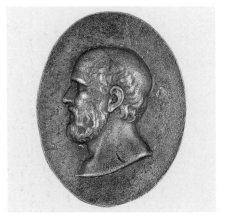

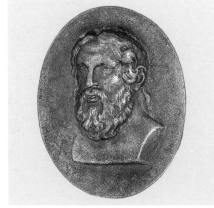

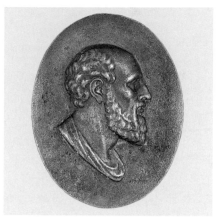

Cat. 331

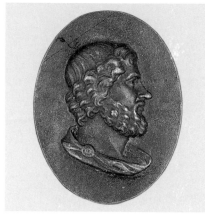

Cat. 334

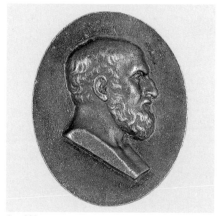

Cat. 332

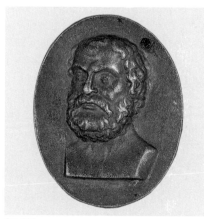

Cat. 335

Lit.: Aus einem Guß, 223, no. 1709. – Hintze 1928a, 101 f., pl./Taf. 5, no. 37.

333 Thrasybulus
Head in profile right. / Kopf im Profil nach rechts.
4.3 x 3.5 cm (1 11/16 x 1 3/8 in.). – 10.9 g. – Rev./Rs. „38".
Lamprecht 220M. – Inv. 1986.481.21.
Lit.: Hintze 1928a, 101 f., pl./Taf. 5, no. 38.

334 Aristippus
Bust in profile right. / Brustbild im Profil nach rechts.
4.3 x 3.5 cm (1 11/16 x 1 3/8 in.). – 15.0 g. – Rev./Rs. „39"
Lamprecht 202M. – Inv. 1986.481.3.
Lit.: Aus einem Guß, 223, no. 1704. – Hintze 1928a, 101 f., pl./Taf. 5, no. 39.

335 Leonidas
Bust slightly left. / Brustbild leicht nach links gewendet.
4.3 x 3.5 cm (1 11/16 x 1 3/8 in.). – 10.4 g. – Rev./Rs. „41".
Lamprecht 205M. – Inv. 1986.481.6.
Lit.: Aus einem Guß, 223, no. 1711. – Hintze 1928a, 101 f., pl./Taf. 5, no. 41.

336 Carneades
Bust in profile right. / Brustbild im Profil nach rechts.
4.3 x 3.5 cm (1 11/16 x 1 3/8 in.). – 12.6 g. – Rev./Rs. „42".
Lamprecht 212M. – Inv. 1986.481.13.
Lit.: Aus einem Guß, 224, no. 1716. – Hintze 1928a, 101 f., pl./Taf. 5, no. 42.

337 Antisthenes
Bust in profile right. / Brustbild im Profil nach rechts.
4.3 x 3.5 cm (1 11/16 x 1 3/8 in.). – 8.6 g. –

Cat. 333

Cat. 336

Cat. 337

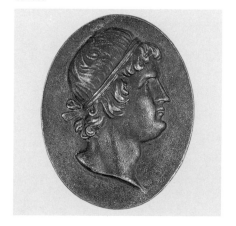

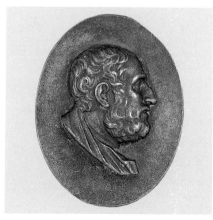

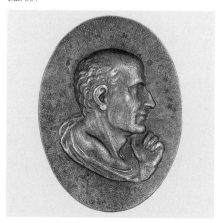

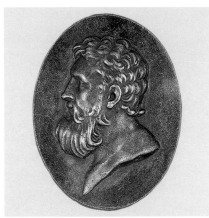

Cat. 338

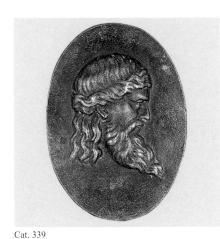

Cat. 339

Cat. 340

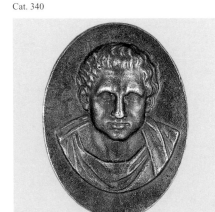

Rev./Rs. „43".

Lamprecht 234M. – Inv. 1986.481.35.

Lit.: Aus einem Guß, 224, no. 1713. – Hintze 1928a, 101 f., pl./Taf. 5, no. 43.

338 Epimenides

Bust in profile left. / Brustbild im Profil nach links.

4.3 x 3.5 cm (1 11/16 x 1 3/8 in.). – 13.0 g. – Rev./Rs. „45".

Lamprecht 247M. – Inv. 1986.481.48.

Lit.: Aus einem Guß, 223, no. 1708. – Hintze 1928a, 101 f., pl./Taf. 5, no. 45.

339 Callisthenes

Head in profile right. / Kopf im Profil nach rechts.

4.3 x 3.5 cm (1 11/16 x 1 3/8 in.). – 9.9 g. – Rev./Rs. „46".

Lamprecht 219M. – Inv. 1986.481.20.

Lit.: Hintze 1928a, 101 f., pl./Taf. 5, no. 46.

340 Posidippus

Bust front. / Brustbild von vorn.

4.3 x 3.5 cm (1 11/16 x 1 3/8 in.). – 10.2 g. – Rev./Rs. „47".

Lamprecht 232M. – Inv. 1986.481.33.

Lit.: Aus einem Guß, 224, no. 1714. – Hintze 1928a, 101 f., pl./Taf. 5, no. 47.

341 Theocritus

Bust in profile left. / Brustbild im Profil nach links.

4.3 x 3.5 cm (1 11/16 x 1 3/8 in.). – 13.7 g. – Rev./Rs. „48".

Lamprecht 222M. – Inv. 1986.481.23.

Lit.: Aus einem Guß, 224, no. 1715. – Hintze 1928a, 101 f., pl./Taf. 5, no. 48.

342 Menander

Bust front, head slightly left. / Brustbild von vorn, Kopf leicht nach links gewendet.

4.3 x 3.5 cm (1 11/16 x 1 3/8 in.). – 13.1 g. – Rev./Rs. „50".

Lamprecht 249M. – Inv. 1986.481.50.

Lit.: Hintze 1928a, 101 f., pl./Taf. 6, no. 50.

343 Apollonius of Rhodes / von Rhodos

Bust in profile left. / Brustbild im Profil nach links.

4.3 x 3.5 cm (1 11/16 x 1 3/8 in.). – 8.3 g.

Lamprecht 233M. – Inv. 1986.481.34.

Lit.: Aus einem Guß, 224, no. 1717. – Hintze 1928a, 101 f., pl./Taf. 6, no. 51.

344 Pythias

Bust in profile right. / Brustbild im Profil nach rechts.

4.3 x 3.5 cm (1 11/16 x 1 3/8 in.). – 9.2 g. – Rev./Rs. „52".

Lamprecht 203M. – Inv. 1986.481.4.

Lit.: Hintze 1928a, 101 f., pl./Taf. 6, no. 52.

345 Thales

Bust slightly left. / Brustbild leicht nach links gewendet.

4.3 x 3.5 cm (1 11/16 x 1 3/8 in.). – 11.0 g.

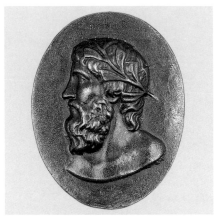

Cat. 341

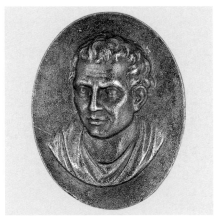

Cat. 342

Cat. 343

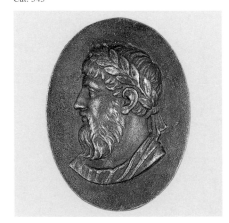

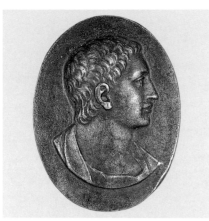

Cat. 344

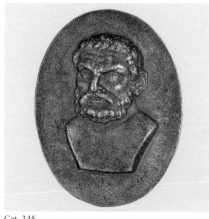

Cat. 345

– Rev./Rs. „53".
Lamprecht 224M. – Inv. 1986.481.25.
Lit.: Aus einem Guß, 224, no. 1719. – Hintze 1928a, 101 f., pl./Taf. 6, no. 53.

346 Chilo
Bust in profile left. / Brustbild im Profil nach links.
4.3 x 3.5 cm (1 11/16 x 1 3/8 in.). – 9.3 g.
Lamprecht 226M. – Inv. 1986.481.27.
Lit.: Hintze 1928a, 101 f., pl./Taf. 6, no. 54.

347 Aristomachus
Bust in profile right. / Brustbild im Profil nach rechts.
4.3 x 3.5 cm (1 11/16 x 1 3/8 in.). – 11.1 g.
– Rev./Rs. „55".
Lamprecht 240M. – Inv. 1986.481.41.
Lit.: Hintze 1928a, 101 f., pl./Taf. 6, no. 55.

348 Zaleucus
Bust in profile left. / Brustbild im Profil nach links.
4.3 x 3.5 cm (1 11/16 x 1 3/8 in.). – 9.6 g. -
Rev./Rs. „56".
Lamprecht 245M. – Inv. 1986.481.46.
Lit.: Hintze 1928a, 101 f., pl./Taf. 6, no. 56.

349 Euripides
Bust slightly left. / Brustbild leicht nach links gewendet.
4.3 x 3.5 cm (1 11/16 x 1 3/8 in.). – 11.9 g.
– Rev./Rs. „57".
Lamprecht 239M. – Inv. 1986.481.40.
Lit.: Hintze 1928a, 101 f., pl./Taf. 6, no. 57.

350 Aristides
Bust slightly left. / Brustbild leicht nach links gewendet.
4.3 x 3.5 cm (1 11/16 x 1 3/8 in.). – 11.1 g.
– Rev./Rs. „59".
Lamprecht 246M. – Inv. 1986.481.47.

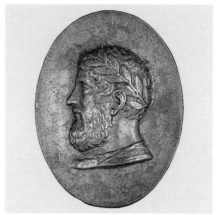

Cat. 348

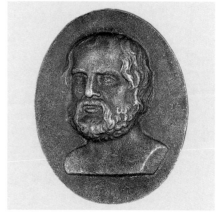

Cat. 349

Cat. 346

Cat. 347

Cat. 350

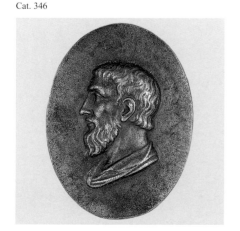

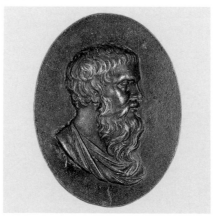

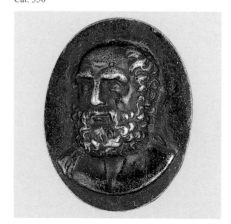

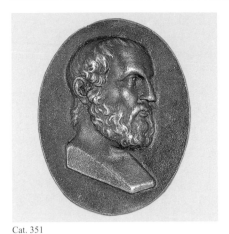

Cat. 351

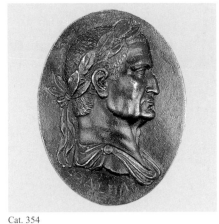

Cat. 354

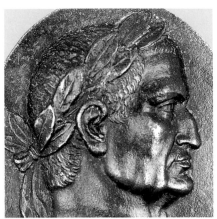

Cat. 354 (Detail)

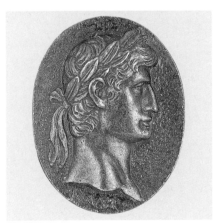

Cat. 352

Cat. 355

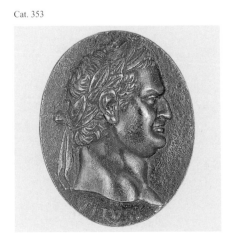

Cat. 353

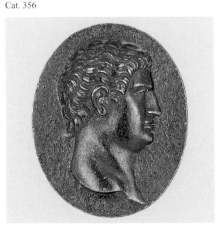

Cat. 356

Lit.: Aus einem Guß, 224, no. 1718. – Hintze 1928a, 101 f., pl./Taf. 6, no. 59.

351 Isocrates / Isokrates
Bust in profile right. / Brustbild im Profil nach rechts.
4.3 x 3.5 cm (1 11/16 x 1 3/8 in.). – 9.8 g. – Rev./Rs. „60".
Lamprecht 237M. – Inv. 1986.481.38.
Lit.: Hintze 1928a, 101 f., pl./Taf. 6, no. 60.

352 Augustus Caesar
Laureate head in profile right. / Kopf im Profil nach rechts mit Lorbeerkranz. / Ins. „AVGVST".
4.8 x 3.8 cm (1 7/8 x 1 1/2 in.). – 28.6 g.
Lamprecht 568M. – Inv. 1986.497.5.
Lit.: Hintze 1928a, 101 f., pl./Taf. 6, no. 63. – Wedgwood 1992, 365, no. 950.

353 Titus
Laureate head in profile right. / Kopf im Profil nach rechts mit Lorbeerkranz. / Ins. „TITVS".
4.8 x 3.8 cm (1 7/8 x 1 1/2 in.). – 29.6 g.
Lamprecht 569M. – Inv. 1986.497.6.
Lit.: Hintze 1928a, 101 f., pl./Taf. 6, no. 64. – Wedgwood 1992, 367, no. 959.

354 Galba
Laureate bust in profile right. / Brustbild im Profil nach rechts mit Lorbeerkranz. / Ins. „GALBA".
5.4 x 4.1 cm (2 1/8 x 1 5/8 in.). – 15.4 g.
Lamprecht 258M, Photo 59. – Inv. 1986.481.59.
Lit.: Hintze 1928a, 101 f., pl./Taf. 7, no. 71.

355 Hannibal
Bust left, head slightly front with shield. / Brustbild nach links, der Kopf leicht nach vorn gewendet, mit Schild.

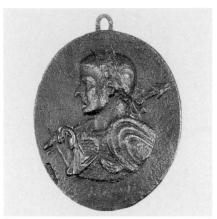

Cat. 357

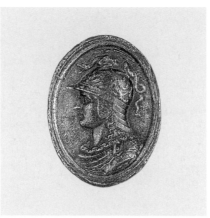

Cat. 359 (Original size / Originalgröße)

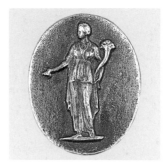

Cat. 358

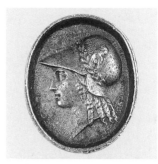

Cat. 360

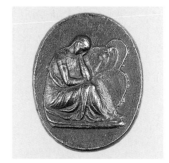

Cat. 361

Cat. 362

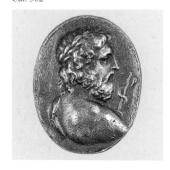

2.7 x 2 cm (1 1/16 x 13/16 in.). – 3.8 g.
Lamprecht 291M. – Inv. 1986.481.92.
Lit.: Hintze 1928a, 101 f., pl./Taf. 9, no. 106.
– Planiscig, 169, pl./Taf. 3, no. 294. – Wedg-
wood 1992, 380, no. 1046.

356 Otho
Head in profile right. / Kopf im Profil nach
rechts. / Ins. „OTHO".
4.8 x 3.8 cm (1 7/8 x 1 1/2 in.). – 23.4 g.
Lamprecht 570M. – Inv. 1986.497.7.
Lit.: Hintze 1928a, 101 f., pl./Taf. 10, no.
126 (here laureate / hier mit Lorbeerkranz).
– Wedgwood 1992, 366, no. 956 (here lau-
reate / hier mit Lorbeerkranz).

357 Probus
Laureate bust in profile left. / Brustbild im
Profil nach links mit Lorbeerkranz.
5.4 x 4.4 cm (2 1/8 x 1 3/4 in.). – 55.2 g.
Lamprecht 571M. – Inv. 1986.497.8.
Lit.: Hintze 1928a, 101 f., pl./Taf. 11, no.
158.

**Gems of Various Subject Matter / Gem-
men verschiedenen Inhalts (Cat. 358-508)**

358 Abundantia
Ca. 1800. – F./G. KPEG Gleiwitz. – 1.8 x
1.5 cm (11/16 x 9/16 in.). – 1.2 g.
Lamprecht 350M, Photo 55. – Inv.
1986.481.151.
Lit.: Hintze 1928a, IV. – Wedgwood 1992,
349, no. 853.
After a Wedgwood model, based on a design
in Montfaucon. / Nach einem Wedgwood-
Modell, dem eine Abbildung in Montfaucon

zugrunde liegt. / (Montfaucon, vol./Bd. 3,
pl./Taf. 36, no. 7).

359 Achilles
Bust in profile left. / Brustbild im Profil nach
links.
Ca. 1800. – F./G. KPEG Gleiwitz. – 4 x 3 cm
(1 9/16 x 1 3/16 in.). – 16.0 g.
Lamprecht 286M. – Inv. 1986.481.87.

360 Achilles
Bust in profile left with helmet. / Brustbild
im Profil nach links mit Helm.
Ca. 1800. – F./G. KPEG Gleiwitz. – 2.3 x
1.9 cm (7/8 x 3/4 in.). – 2.6 g.
Lamprecht 294M. – Inv. 1986.481.95.

**361 A Conquered Province / Eine unter-
worfene Provinz**
Ca. 1800. – F./G. KPEG Gleiwitz. – 2.6 x
2.1 cm (1 x 13/16 in.). – 6.4 g.
Lamprecht 308M, Photo 55. – Inv.
1986.481.109.
Lit.: Reilly 1989, vol./Bd. II, 740, fig./Abb. 1,
230.
After a Wedgwood model. / Nach einem
Wedgwood-Modell.

362 Aesculapius
Bust in profile right. / Brustbild im Profil
nach rechts.
Ca. 1800. – F./G. KPEG Gleiwitz. – 2.4 x
1.9 cm (15/16 x 3/4 in.). – 2.9 g.
Lamprecht 270M, Photo 59. – Inv.
1986.481.71.

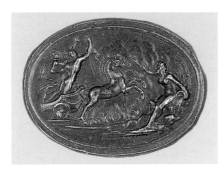

Cat. 365 (Original size / Originalgröße)

363 Aesculapius

Ca. 1800. – F./G. KPEG Gleiwitz. – 2 x
1.4 cm (13/16 x 9/16 in.). – 1.4 g.
Lamprecht 369M. – Inv. 1986.481.170.
Lit.: Wedgwood 1992, 342 f., no. 814 f.
After a Wedgwood model. / Nach einem
Wedgwood-Modell.

364 Alexander the Great as Jupiter Ammon / Alexander der Große als Jupiter Ammon

Head in profile left. / Kopf im Profil nach
links.
Ca. 1800. – F./G. KPEG Gleiwitz. – 2 x
1.6 cm (13/16 x 5/8 in.). – 2.1 g.
Lamprecht 279M. – Inv. 1986.481.80.

365 Rape of Persephone / Entführung der Persephone

Ca. 1800. – F./G. KPEG Gleiwitz. – 3.7 x 5
cm (1 7/16 x 1 15/16 in.). – 20.7 g.
Lamprecht 313M, Photo 56. – Inv.
1986.481.114.

366 Athena Presenting the Heart of Zagreus to Zeus / Athena übergibt Zeus das Herz von Zagreus

Ca. 1800. – F./G. KPEG Gleiwitz. – 1.4 x
2.1 cm (9/16 x 13/16 in.). – 2.0 g.
Lamprecht 315M, Photo 55. – Inv.
1986.481.116.

367 Allegory of Time (Cupid with Scythe) / Allegorie der Zeit (Amor mit Sense)

Ca. 1800. – F./G. KPEG Gleiwitz. – 2.2 x
1.8 cm (7/8 x 11/16 in.). – 3.6 g.
Lamprecht 395M, Photo 57. – Inv.
1986.481.196.

368 A Man Making a Vase / Ein Mann formt eine Vase

Ca. 1800. – F./G. KPEG Gleiwitz. – D.
1.7 cm (11/16 in.). – 1.6 g.

Lamprecht 391M. – Inv. 1986.481.192.
Lit.: Reilly 1989, vol./Bd. 1, 475, fig./Abb.
683 (for an intaglio of the same design / zu
einem Intaglio des gleichen Motivs).
After a Wedgwood model. / Nach einem
Wedgwood-Modell.

369 Andromache Mourning Hector's Death / Andromache betrauert Hektors Tod

Ca. 1800. – F./G. KPEG Gleiwitz. – 2.5 x
1.6 cm (1 x 5/8 in.). – 2.2 g.
Lamprecht 385M. – Inv. 1986.481.186.
Lit.: Book of Wedgwood, fig./Abb. 1. –
Wedgwood 1992, 356, no. 894.
After a Wedgwood model. / Nach einem
Wedgwood-Modell.

370 Antinous

Half figure front, head inclined left. / Halb-
figur von vorn, der Kopf nach unten links
gewendet.
Ca. 1800. – F./G. KPEG Gleiwitz. – 3.8 x
3 cm (1 1/2 x 1 3/16 in.). – 10.8 g.
Lamprecht 272M, Photo 59. – Inv.
1986.481.73.
Lit.: Bange 1922, no. 197. – Hintze 1928a,
19, pl./Taf. 14, no. IV 45.

371 Aphrodite

Ca. 1800. – F./G. KPEG Gleiwitz. – 2.5 x
3.1 cm (1 x 1 1/4 in.). – 9.5 g.
Lamprecht 344M, Photo 56. – Inv.
1986.481.145.
Lit.: Furtwängler, vol./Bd. 1, pl./Taf. XLI,
no. 43.

372 Apollo

Bust front, head in profile right. / Brustbild
von vorn, der Kopf im Profil nach rechts.
Ca. 1800. – F./G. KPEG Gleiwitz. – 2.8 x
2 cm (1 1/8 x 13/16 in.). – 6.0 g.
Lamprecht 278M, Photo 59. – Inv.
1986.481.79.
Lit.: Hintze 1928a, 19, pl./Taf. 14, no. IV 28.

373 Apollo Belvedere / Apollon vom Belvedere

Ca. 1800. – F./G. KPEG Gleiwitz. – 2.9 x
2 cm (1 1/8 x 13/16 in.). – 3.7 g.
Lamprecht 340M, Photo 57. – Inv.
1986.481.141.
Lit.: Hintze 1928a, 19, pl./Taf. 14, no. IV 5.

374 Apotheosis of Titus / Apotheose des Titus

Ca. 1800. – F./G. KPEG Gleiwitz. – 2 x
1.8 cm (13/16 x 11/16 in.). – 2.0 g.
Lamprecht 347M. – Inv. 1986.481.148.

Lit.: Hintze 1928a, 17, pl./Taf. 14, no. III 10.
After the relief on the Titus Arch in Rome. /
Nach dem Relief auf dem Titus-Bogen in
Rom. / S. Reinach, I, 276.

375 Arnolfo

Head in profile right. / Kopf im Profil nach
rechts. / Ins. „VEST. W. P. Y.".
Ca. 1800. – F./G. KPEG Gleiwitz. – 3.5 x
2.6 cm (1 3/8 x 1 in.). – 8.4 g.
Lamprecht 253M. – Inv. 1986.481.54.

376 Artemisia Contemplating the Ashes of her Husband Mausolus / Artemisia betrachtet die Asche Ihres Ehemanns Maussollos

Ca. 1800. – F./G. KPEG Gleiwitz. – 1.4 x
1.8 cm (9/16 x 11/16 in.). – 2.2 g.
Lamprecht 360M, Photo 52. – Inv.
1986.481.161.

377 Athena

Bust in profile right. / Brustbild im Profil
nach rechts.
Ca. 1800. – F./G. KPEG Gleiwitz. – 3.1 x
2.4 cm (1 1/4 x 15/16 in.). – 4.6 g.
Lamprecht 300M, Photo 59. – Inv.
1986.481.101.
Lit.: Hintze 1928a, 19, pl./Taf. 14, no. IV 38.
The prototype for this gem can be found in /
Das Vorbild für diese Gemme befindet sich
in: Lippold, pl./Taf. CXVIII, fig./Abb. 3.

378 Athena Parthenos

Bust in profile right with helmet. / Brust-
bild im Profil nach rechts mit Helm.
Ca. 1800. – F./G. KPEG Gleiwitz. – 3.3 x
2.4 cm (1 5/16 x 15/16 in.). – 11.7 g.
Lamprecht 301M. – Inv. 1986.481.102.
Lit.: Furtwängler, pl./Taf. XLIX, no. 12. –
cp./vgl. Planiscig, 167, pl./Taf. 3, no. 279.

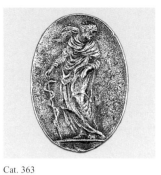

Cat. 363

Cat. 367

Cat. 371

Cat. 375

Cat. 364

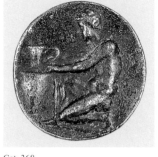

Cat. 368

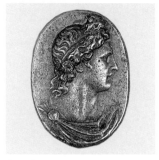

Cat. 372

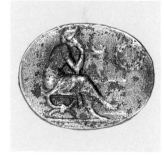

Cat. 376

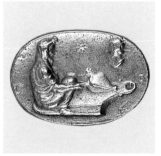

Cat. 366

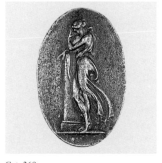

Cat. 369

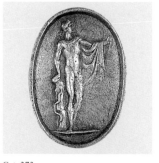

Cat. 373

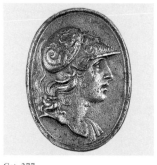

Cat. 377

Cat. 370

Cat. 370 (Detail)

Cat. 374

Cat. 378

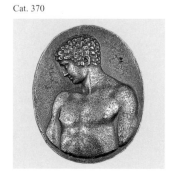

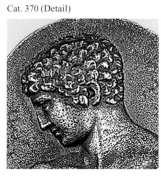

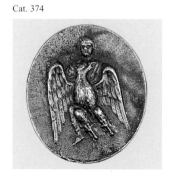

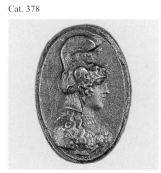

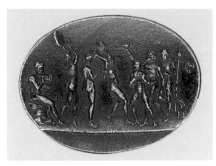

Cat. 380

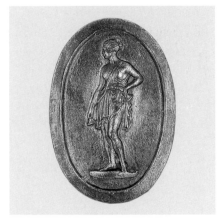

Cat. 381 (Original size / Originalgröße)

379 Bacchanalian Scene / Bacchanalienszene
Ca. 1800. – F./G. KPEG Gleiwitz. – 1.8 x 2.2 cm (11/16 x 7/8 in.). – 4.4 g. Lamprecht 417M, Photo 57. – Inv. 1986.481.218.

Cat. 385

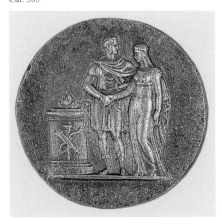

380 Bacchanalian Procession / Bacchanalienzug
Ca. 1800. – F./G. KPEG Gleiwitz. – 3.4 x 4.6 cm (1 5/16 x 1 13/16 in.). – 14.4 g. Inv. 1962.91. – Gift of / Schenkung von Dr. and Mrs. Maurice Garbáty.

381 Artemis
Ca. 1800. – F./G. KPEG Gleiwitz. – 4.9 x 3.4 cm (1 15/16 x 1 5/16 in.). – 20.7 g. Lamprecht 329M, Photo 57. – Inv. 1986.481.130.

382 Sacrificial Scene / Opferszene
Ca. 1800. – F./G. KPEG Gleiwitz. – 2.6 x 2.1 cm (1 x 13/16 in.). – 2.9 g. Lamprecht 352M. – Inv. 1986.481.153.

383 Classical Battle Scene / Antike Kampfszene
Ca. 1800. – F./G. KPEG Gleiwitz. – 1.5 x 2.3 cm (9/16 x 7/8 in.). – 2.5 g. Lamprecht 318M. – Inv. 1986.481.119.

384 Electra / Elektra
Ca. 1800. – F./G. KPEG Gleiwitz. – 2.9 x 2.2 cm (1 1/8 x 7/8 in.). – 9.4 g. Lamprecht 317M, Photo 56. – Inv. 1986.481.118.

385 Classical Marriage Scene / Antike Hochzeitsszene
Ca. 1800. – F./G. KPEG Gleiwitz. – D. 4.4 cm (1 3/4 in.). – 26.5 g. Lamprecht 309M, Photo 56. – Inv. 1986.481.110.

386 Classical Warrior Collapsing in Front of a City Gate / Antiker Krieger, zusammenbrechend vor einem Stadttor
Ca. 1800. – F./G. KPEG Gleiwitz. – 1.4 x 1.7 cm (9/16 x 11/16 in.). – 1.8 g. Lamprecht 312M. – Inv. 1986.481.113.

387 Classical Warrior on Horseback / Antiker Krieger zu Pferde
Ca. 1800. – F./G. KPEG Gleiwitz. – 2.2 x 2.5 cm (7/8 x 1 in.). – 2.7 g. Lamprecht 365M. – Inv. 1986.481.166. Lit.: Wedgwood 1992, 381, no. 1051. After a Wedgwood model. / Nach einem Wedgwood-Modell.

388 Classical Warriors on Horseback / Antike Krieger zu Pferde
Ca. 1800. – F./G. KPEG Gleiwitz. – 2.9 x 2.4 cm (1 1/8 x 15/16 in.). – 5.1 g. Lamprecht 310M, Photo 57. – Inv. 1986.481.111.

389 Coriolanus and/und Volumnia
Ca. 1800. – F./G. KPEG Gleiwitz. – D. 5 cm (1 15/16 in.). – 14.0 g. Lamprecht 334M, Photo 57. – Inv. 1986.481.135. Lit.: Flaxman, no. 42. After a Wedgwood model by John Flaxman Jr. made in 1784. Flaxman took this motif from Baron Pierre d'Hancarville's catalogue of Sir William Hamilton's antique vase collection. / Nach einem Wedgwood-Modell von John Flaxman, d. Ä., 1784 modelliert. Flaxman nahm das Motiv aus Baron Pierre d'Hancarvilles Katalog zu Sir William Hamiltons Sammlung antiker Vasen. / S. Book of Wedgwood, fig./Abb. 13.

390 Cupid / Amor
Ca. 1800. – F./G. KPEG Gleiwitz. – 1.7 x 1.3 cm (11/16 x 1/2 in.). – 3.1 g. Lamprecht 330M. – Inv. 1986.481.131.

391 Cupid / Amor
Ca. 1800. – F./G. KPEG Gleiwitz. – 1.9 x 1.5 cm (3/4 x 9/16 in.). – 3.1 g. Lamprecht 338M. – Inv. 1986.481.139.

392 Cupid / Amor
Ins. around/Umschrift „SAGE D'AMOUR". Early 19th century / Anfang des 19. Jh. – 2.3 x 1.7 cm (7/8 x 11/16 in.). – 2.5 g. Lamprecht 381M. – Inv. 1986.481.182.

Cat. 389 (Original size / Originalgröße)

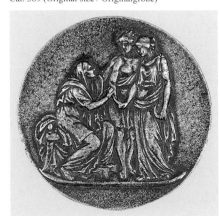

Cat. 379

Cat. 384

Cat. 388

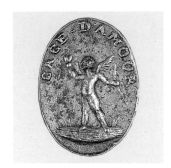

Cat. 392

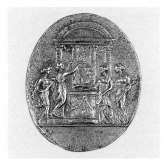

Cat. 382

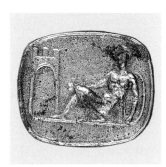

Cat. 386

Cat. 390

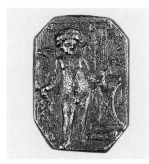

Cat. 393

Cat. 383

Cat. 387

Cat. 391

Cat. 394

Cat. 395

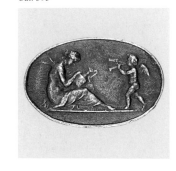

393 Cupid / Amor
Ca. 1800. – F./G. KPEG Gleiwitz. – 1.8 x
1.3 cm (11/16 x 1/2 in.). – 1.6 g.
Lamprecht 396M, Photo 52. – Inv.
1986.481.197.

394 Cupid and Psyche / Amor und Psyche
Ca. 1800. – F./G. KPEG Gleiwitz. – 1.8 x
2.5 cm (11/16 x 1 in.). – 2.0 g.

Lamprecht 323M, Photo 52. – Inv.
1986.481.124.
Cp./vgl. Cat. 395.

395 Cupid and Psyche / Amor und Psyche
Ca. 1800. – Mod. after a cut stone by / nach
einem geschnittenen Stein von Charles
Brown. – F./G. KPEG Gleiwitz. – 1.5 x 2.3
cm (9/16 x 7/8 in.). – 1.6 g.

Lamprecht 415M. – Inv. 1986.481.216.
Cp./vgl. Cat. 394.
Lit.: Marquardt 1983, 274, no. 494 (for a
necklace with gem of same design signed by
Brown / zu einer Halskette mit einer Gem-
me mit dem gleichen Motiv, von Brown
signiert).

396 The Marriage of Cupid and Psyche / Die Hochzeit von Amor und Psyche

Ca. 1800. – F./G. KPEG Gleiwitz. – 3.1 x
4.1 cm (1 1/4 x 1 5/8 in.). – 12.7 g.
Lamprecht 357M, Photo 57. – Inv.
1986.481.158.
Lit.: Book of Wedgwood, fig./Abb. 54. –
Wedgwood 1992, 359, no. 910, 912, 914 f.
After a Wedgwood model by William Hack-
wood and John Flaxman Jr. (about 1774),
based on Montfaucon's rendition of a first
century A.D. gem then in the collection of
the Earl of Arundel. The gem later passed
to the collection of the third Duke of Marl-
borough and is now in the Museum of Fine
Arts Boston. / Nach einem Wedgwood-Mo-
dell von William Hackwood und John Flax-
man Jr. (um 1774), das auf einem Stich
einer Gemme in Montfaucon beruht, die
aus dem ersten Jahrhundert nach Christus
stammt und sich ehemals in der Sammlung
des Earls of Arundel befand. Die Gemme
gelangte später in die Sammlung des 3. Her-
zogs von Marlborough und gehört heute dem
Museum of Fine Arts Boston.

397 Cupid Riding Pegasus / Amor reitet auf Pegasus

Ca. 1800. – Mod. after a cut stone by / nach
einem geschnittenen Stein von Giovanni
Pichler. – F./G. KPEG Gleiwitz. – 1.9 x 2.2
cm (3/4 x 7/8 in.). – 3.0 g.

Cat. 396

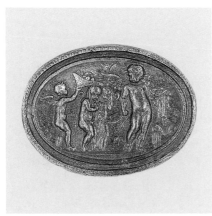

Lamprecht 411M, Photo 55. – Inv.
1986.481.212.
Lit.: Hintze 1928a, 17, pl./Taf. 14, no. III 34.
– cp./vgl. Lippold, pl./Taf. CXXV, fig./
Abb. 4.

398 Dance of a Satyr and a Nymph / Tanz eines Satyrs und einer Nymphe

Ca. 1800. – F./G. KPEG Gleiwitz. – 2.5 x 2
cm (1 x 13/16 in.). – 3.2 g.
Lamprecht 354M, Photo 57. – Inv.
1986.481.155.
Lit.: Cp./vgl. Furtwängler, pl./Taf. LVII, no.
24.
The prototype for this motif was originally
in the collection of Sir William Hamilton. /
Das Vorbild dieses Motivs gehörte ursprüng-
lich in die Sammlung von Sir William Ha-
milton.

399 Dancing Figure / Tanzende Figur

Ca. 1800. – F./G. KPEG Gleiwitz. – 2.5 x
1.3 cm (1 x 1/2 in.). – 2.2 g.
Lamprecht 356M. – Inv. 1986.481.157.

400 Dancing Figure / Tanzende Figur

Ca. 1800. – F./G. KPEG Gleiwitz. – 2.1 x
1.5 cm (13/16 x 9/16 in.). – 1.9 g.
Lamprecht 376M. – Inv. 1986.481.177.

401 Dante Alighieri (1265-1321), Italian Poet / italienischer Dichter

Bust in profile right. / Brustbild im Profil
nach rechts.
Ca. 1800. – F./G. KPEG Gleiwitz. – 3 x
2.2 cm (1 3/16 x 7/8 in.). – 8.0 g.
Lamprecht 573M. – Inv. 1986.497.10.

402 Demeter Searching for Persephone / Demeter sucht nach Persephone

Ca. 1800. – F./G. KPEG Gleiwitz. – 3.1 x
2.5 cm (1 1/4 x 1 in.). – 7.9 g.
Lamprecht 320M, Photo 57. – Inv.
1986.481.121.

403 Diana

Ca. 1800. – F./G. KPEG Gleiwitz. – 3.7 x
2.9 cm (1 7/16 x 1 1/8 in.). – 11.8 g.
Lamprecht 314M, Photo 56. – Inv.
1986.481.115.

404 Dionysus as a Bull / Dionysos als Stier

Ca. 1800. – F./G. KPEG Gleiwitz. – 2 x
2.8 cm (13/16 x 1 1/8 in.). – 7.2 g.
Lamprecht 414M, Photo 56. – Inv.
1986.481.215.

Lit.: Cp./vgl. Furtwängler, pl./Taf. XLV, no.
11. – Hintze 1928a, 19, pl./Taf. 14, no. IV
12. – Reilly 1989, vol./Bd. 1, 540, fig./Abb.
755.
After a Wedgwood model. / Nach einem
Wedgwood-Modell.

405 Dog / Hund

Ca. 1800. – F./G. KPEG Gleiwitz. – 1.6 x
2 cm (5/8 x 13/16 in.). – 3.1 g.
Lamprecht 332M. – Inv.1986.481.133.

406 The Dying Gaul / Der sterbende Gallier

Ca. 1800. – Mod. after a gem by / nach einer
Gemme von Charles Brown. – F./G. KPEG
Gleiwitz. – 2.2 x 2.8 cm (7/8 x 1 1/8 in.). –
4.8 g.
Lamprecht 345M. – Inv. 1986.481.146.
Lit.: Marquardt 1983, 274, no. 494 (for a
necklace that includes a gem with the same
motif signed by Charles Brown / zu einer
Halskette mit einer Gemme mit dem glei-
chen Motiv, von Charles Brown signiert).
The sculpture, now in the Capitoline Mu-
seum in Rome, is a Roman copy of one of
the bronze statues dedicated at Pergamon –
in modern-day Turkey – by Attalos I in
commemoration of his victories over the
Gauls who had invaded Asia Minor in 239
B.C. / Das Bildwerk, heute im kapitolini-
schen Museum in Rom, ist eine römische
Nachbildung einer der Bronzen, die in Per-
gamon – heute in der Türkei – von Attalos I.
gestiftet wurden, zum Gedenken an seine
Siege über die Gallier, die 239 v. Chr. bis
nach Kleinasien vorgedrungen waren.

407 Emperor Constantine Receives a Germanic King / Kaiser Konstantin emp-fängt einen germanischen König

Ca. 1800. – F./G. KPEG Gleiwitz. – 3 x 3.4
cm (1 3/16 x 1 5/16 in.). – 10.4 g.
Lamprecht 351M, Photo 56. – Inv.
1986.481.152.
Lit.: Hintze 1928a, 19, pl./Taf. 14, no. IV 36.
After a relief on the triumphal Arch of Con-
stantine in Rome. The Gleiwitz model after
a cut chalcedony (formerly in the Ober-
schlesisches Museum in Gleiwitz). / Nach
einem Relief auf dem Triumphbogen Kon-
stantins in Rom. Das Gleiwitzer Modell
wurde nach einem geschnittenen Chalzedon
gefertigt (ehemals Oberschlesisches Mu-
seum in Gleiwitz).

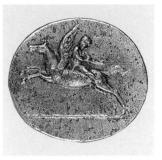

Cat. 397

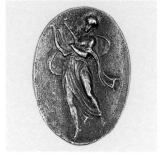

Cat. 400

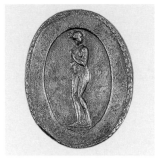

Cat. 403

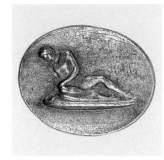

Cat. 406

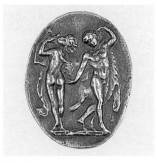

Cat. 398

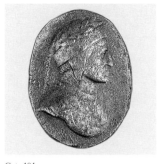

Cat. 401

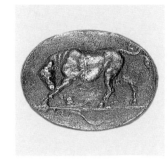

Cat. 404

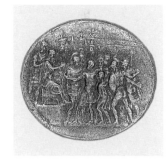

Cat. 407

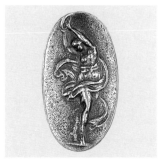

Cat. 399

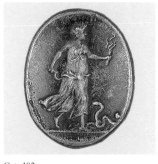

Cat. 402

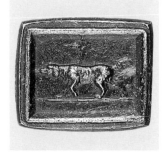

Cat. 405

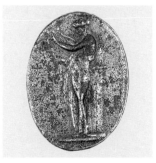

Cat. 408

Cat. 409

408 Erato, the Muse of Song, Dance, and Amorous Poetry / Erato, Muse des Gesangs, des Tanzes und der Liebesdichtung
Ca. 1800. – F./G. KPEG Gleiwitz. – 2 x 1.5 cm (13/16 x 9/16 in.). – 2.2 g.
Lamprecht 407M, Photo 55. – Inv. 1986.481.208.
Lit.: Wedgwood 1992, 353, no. 879.
After a Wedgwood model. / Nach einem Wedgwood-Modell.

409 Hebe and the Eagle of Jupiter / Hebe tränkt den Adler Jupiters
Ca. 1800. – F./G. KPEG Gleiwitz. – 2.2 x 1.7 cm (7/8 x 11/16 in.). – 4.3 g.
Lamprecht 400M. – Inv. 1986.481.201.
Lit.: Cp./vgl. Marquardt 1983, 48, fig./ Abb. 31 (scene identified here as Leda and the swan / hier identifiziert als Leda mit dem Schwan).

Cat. 410

Cat. 414

Cat. 417

Cat. 421

Cat. 411

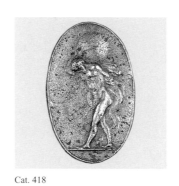

Cat. 418

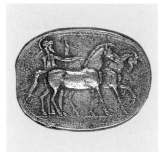

Cat. 422

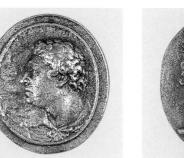

Cat. 412

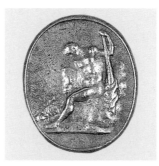

Cat. 415

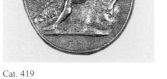

Cat. 419

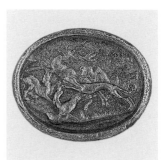

Cat. 423

Cat. 413

Cat. 416

Cat. 420

Cat. 424

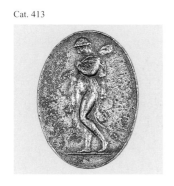

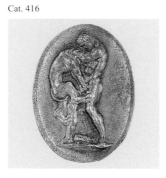

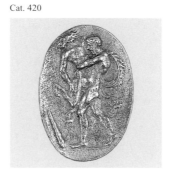

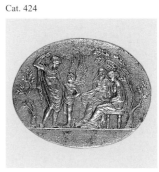

410 Hebe and the Eagle of Jupiter / Hebe tränkt den Adler Jupiters
Ca. 1800. – F./G. KPEG Gleiwitz. – 1.8 x 1.5 cm (11/16 x 9/16 in.). – 1.6 g. Lamprecht 403M, Photo 52. – Inv. 1986.481.204.
Lit.: Hintze 1928a, 18, pl./Taf. 14, no. III 119.

411 Hector Taking Leave of Andromache / Hektor verläßt Andromache
Ca. 1800. – Mod. after a cut stone by / nach einem geschnittenen Stein von Luigi Pichler. – F./G. KPEG Gleiwitz. – 3.3 x 5.2 cm (1 5/16 x 2 1/16 in.). – 17.6 g. Lamprecht 305M, Photo 57, 75. – Inv. 1986.481.106.
Lit.: Forrer IV, 527. – Redslob, 60.

412 Hercules / Herkules
Ca. 1800. – F./G. KPEG Gleiwitz. – 2.2 x 2 cm (7/8 x 13/16 in.). – 2.8 g. Lamprecht 384M, Photo 55. – Inv. 1986.481.185.

413 Omphale with the Lion Skin and Club of Hercules / Omphale mit dem Löwenfell und der Keule von Herkules
Ca. 1800. – F./G. KPEG Gleiwitz. – 2.5 x 1.8 cm (1 x 11/16 in.). – 1.8 g. Lamprecht 390M. – Inv. 1986.481.191.
Lit.: Cp./vgl. Wedgwood 1992, 361, no. 922.

414 Hercules and Omphale / Herkules und Omphale
Ca. 1800. – F./G. KPEG Gleiwitz. – 2.5 x 1.9 cm (1 x 3/4 in.). – 3.0 g. Lamprecht 405M. – Inv. 1986.481.206.
Lit.: Furtwängler, pl./Taf. XLIX, no. 25. – Hintze 1928a, 19, pl./Taf. 14, no. IV 50. – cp./vgl. Stummann-Bowert, 136, no. 66.

415 Hercules and the Hydra / Herkules und die Hydra
Ca. 1800. – F./G. KPEG Gleiwitz. – 3.9 x 3.3 cm (1 9/16 x 1 5/16 in.). – 17.0 g. Lamprecht 333M, Photo 56. – Inv. 1986.481.134.

416 Hercules and the Nemean Lion / Herkules und der Nemeische Löwe
Ca. 1800. – F./G. KPEG Gleiwitz. – 3.8 x 2.7 cm (1 1/2 x 1 1/16 in.). – 7.9 g. Lamprecht 328M, Photo 56. – Inv. 1986.481.129.

Lit.: Bange 1922, pl./Taf. 23, no. 127. – Hintze 1928a, 102, pl./Taf. 13, no. 3. – Reilly 1989, vol./Bd. 1, 475, fig./Abb. 683 (for a Wedgwood intaglio of the same motif / zu einem Wedgwood Intaglio mit dem selben Motiv).
After a Wedgwood model. / Nach einem Wedgwood-Modell.

417 Hercules Holding the World / Herkules trägt die Welt
Ca. 1800. – F./G. KPEG Gleiwitz. – 2.1 x 1.6 cm (13/16 x 5/8 in.). – 4.2 g. Lamprecht 319M. – Inv. 1986.481.120.
Lit.: Wedgwood 1992, 84, pl./Taf. 61 (no. 691).
After a Wedgwood model. / Nach einem Wedgwood-Modell.

418 Hercules Holding the World / Herkules trägt die Welt
Ca. 1800. – F./G. KPEG Gleiwitz. – 2.5 x 1.5 cm (1 x 9/16 in.). – 1.9 g. Lamprecht 378M. – Inv. 1986.481.179.

419 Hercules Reclining / Ruhender Herkules
Ca. 1800. – F./G. KPEG Gleiwitz. – 2.4 x 2 cm (15/16 x 13/16 in.). – 3.2 g. Lamprecht 398M. – Inv. 1986.481.199.

420 Hercules Wrestling Antaeus / Herkules kämpft mit Antaeus
Ca. 1800. – F./G. KPEG Gleiwitz. – 2.9 x 2 cm (1 1/8 x 13/16 in.). – 4.2 g. Lamprecht 418M, Photo 56. – Inv. 1986.481.219.
Lit.: Cp./vgl. Bange 1922, pl./Taf. 47, no. 480.

421 Reclining Hermaphrodite / Ruhender Hermaphrodit
Ca. 1800. – F./G. KPEG Gleiwitz. – 1.9 x 2.5 cm (3/4 x 1 in.). – 2.3 g. Lamprecht 412M, Photo 55. – Inv. 1986.481.213.
Lit.: Hintze 1928a, 18, pl./Taf. 14, no. III 143.

422 Two Horses with a Man / Zwei Pferde mit Mann
Ca. 1800. – F./G. KPEG Gleiwitz. – 1.8 x 2.2 cm (11/16 x 7/8 in.). – 2.3 g. Lamprecht 410M, Photo 52. – Inv. 1986.481.211.

423 Hunting Scene / Jagdszene
Ca. 1800. – F./G. KPEG Gleiwitz. – 2.9 x 3.6 cm (1 1/8 x 1 7/16 in.). – 14.2 g. Lamprecht 311M. – Inv. 1986.481.112.

424 Icarus and Daedalus / Ikarus und Daedalus
Ca. 1800. – F./G. KPEG Gleiwitz. – 2.6 x 3.2 cm (1 x 1 1/4 in.). – 4.2 g. Lamprecht 321M. – Inv. 1986.481.122.
Lit.: Book of Wedgwood, fig./Abb. 52.
After a Wedgwood model. / Nach einem Wedgwood-Modell.

425 Io in the Form of a Cow Guarded by Argus / Io in Gestalt einer Kuh von Argus bewacht
Ca. 1800. – F./G. KPEG Gleiwitz. – 1.7 x 2.3 cm (11/16 x 7/8 in.). – 1.7 g. Lamprecht 364M, Photo 57. – Inv. 1986.481.165.

426 Jesus Blesses the Children / Jesus segnet die Kinder
Ca. 1800. – F./G. KPEG Gleiwitz. – 2.8 x 3.3 cm (1 1/8 x 1 5/16 in.). – 4.0 g. Lamprecht 307M, Photo 57. – Inv. 1986.481.108.

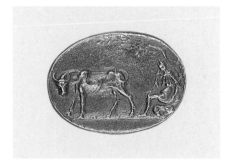

Cat. 425

Cat. 426

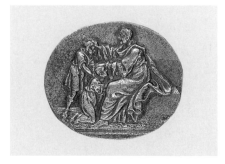

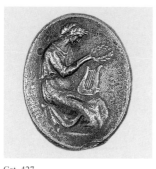

Cat. 427

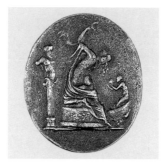

Cat. 431

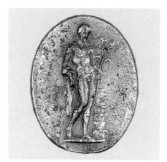

Cat. 435

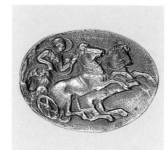

Cat. 439

Cat. 428

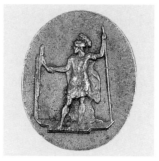

Cat. 432

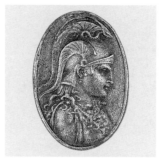

Cat. 436

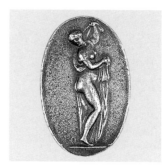

Cat. 440

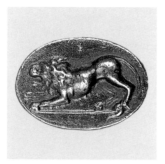

Cat. 429

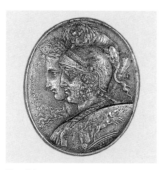

Cat. 433

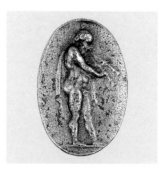

Cat. 437

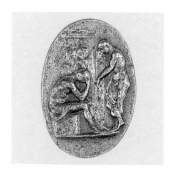

Cat. 441

Cat. 430

Cat. 434

Cat. 438

Cat. 442

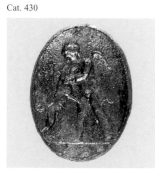

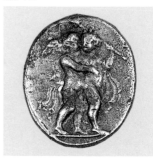

427 Erato (?)
Ca. 1800. – F./G. KPEG Gleiwitz. – 2.5 x
2.2 cm (1 x 7/8 in.). – 4.8 g.
Lamprecht 409M, Photo 56. – Inv.
1986.481.210.

428 Lion / Löwe
Ca. 1800. – F./G. KPEG Gleiwitz. – 1.2 x
1.5 cm (1/2 x 9/16 in.). – 0.9 g.
Lamprecht 326M. – Inv. 1986.481.127.
Lit.: Book of Wedgwood, fig./Abb. 93.
After a Wedgwood model. / Nach einem
Wedgwood-Modell.

429 Lion / Löwe
Ca. 1800. – F./G. KPEG Gleiwitz. – 1.3 x
2 cm (1/2 x 13/16 in.). – 1.9 g. – / Ins. illeg-
ible/unleserlich.
Lamprecht 363M, Photo 56. – Inv.
1986.481.164.

430 Love and Fidelity / Liebe und Treue
Ca. 1800. – F./G. KPEG Gleiwitz. – 1.3 x
1 cm (1/2 x 3/8 in.). – 0.8 g.
Lamprecht 327M. – Inv. 1986.481.128.
An example of a cameo with this same mo-
tif by Benedetto Pistrucci was offered by
Sotheby's London (December 12, 2003, lot.
103). This scene is also found on an engraved
gem attributed to Nathaniel Marchant
(G. Seidmann, "Nathaniel Marchant, gem
engraver, 1739-1816," The Walpole Socie-
ty, vol. LIII, no. 39 [1987], fig. 47). / Eine
Kamee mit dem selben Motiv von Benedet-
to Pistrucci wurde von Sotheby's London
(12. Dezember 2003, Losnr. 103) angebo-
ten. Die selbe Szene befindet sich auch auf
einer Gemme, die Nathaniel Marchant zu-
geschrieben wird (s. G. Seidmann, "Nutha-
niel Marchant, gem engraver, 1739-1816,"
The Walpole Society, Jg. LIII, Nr. 39 [1987],
Abb. 47).

431 Maenad with the Statue of Priapus / Mänade mit Priapusherme
Ca. 1800. – F./G. KPEG Gleiwitz. – 2.3 x
2 cm (7/8 x 13/16 in.). – 3.5 g.
Lamprecht 348M, Photo 57 f. – Inv.
1986.481.149.
Lit.: Macht, 38 f.
After a Wedgwood model. / Nach einem
Wedgwood-Modell.

432 Mars
Ca. 1800. – F./G. KPEG Gleiwitz. – 2.2 x
1.8 cm (7/8 x 11/16 in.). – 2.0 g.
Lamprecht 402M. – Inv. 1986.481.203.
Lit.: Cp./vgl. Reilly 1989, vol./Bd. 1, 475,
fig./Abb. 683.

After a Wedgwood model. / Nach einem
Wedgwood-Modell.

433 Mars and/und Bellona
Conjoined busts in profile left. / Brustbil-
der im Profil nach links.
Ca. 1800. – Mod. after a cut stone (1785)
by / nach einem geschnittenen Stein von
Charles Brown. – F./G. KPEG Gleiwitz. –
3.6 x 3.1 cm (1 7/16 x 1 1/4 in.). – 10.3 g. –
Sign. at left edge / am Rand links „BROWN".
Lamprecht 255M. – Inv. 1986.481.56.
Lit.: Stummann-Bowert, 131, no. 22.
This gem was also used in jewelry. / Diese
Gemme wurde auch als Schmuck verwen-
det. / (Genée 1992, 89, for a necklace made
with this gem / für ein Halsband mit dieser
Gemme).

434 Medusa
Head front. / Kopf von vorn.
Ca. 1800. – F./G. KPEG Gleiwitz. – 3.2 x
2.6 cm (1 1/4 x 1 in.). – 18.2 g.
Lamprecht 275M. – Inv. 1986.481.76.

435 Mercury / Merkur
Ca. 1800. – F./G. KPEG Gleiwitz. – 2 x
1.6 cm (13/16 x 5/8 in.). – 2.3 g.
Lamprecht 387M. – Inv. 1986.481.188.

436 Minerva
Bust in profile right with helmet. / Brust-
bild im Profil nach rechts mit Helm.
Ca. 1800. – F./G. KPEG Gleiwitz. – 3.6 x
2.5 cm (1 7/16 x 1 in.). – 12.2 g.
Lamprecht 252M, Photo 59. – Inv.
1986.481.53.

437 Marsyas Playing the Double Flute (aulos) / Marsyas, Doppelaulos blasend
Ca. 1800. – F./G. KPEG Gleiwitz. – 2 x
1.3 cm (13/16 x 1/2 in.). – 1.9 g.
Lamprecht 380M, Photo 55. – Inv.
1986.481.181.

438 Neptune / Neptun
Ca. 1800. – F./G. KPEG Gleiwitz. – 4.4 x
3.4 cm (1 3/4 x 1 5/16 in.). – 12.1 g.
Lamprecht 335M, Photo 57. – Inv.
1986.481.136.

439 Nike Driving a Chariot / Nike fährt einen Triumphwagen
Ca. 1800. – F./G. KPEG Gleiwitz. – 1.7 x
2.2 cm (11/16 x 7/8 in.). – 2.9 g.
Lamprecht 361M, Photo 56. – Inv.
1986.481.162.
Lit.: Cp./vgl. Furtwängler, pl./Taf. LVII,
no. 5.

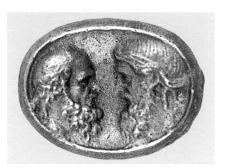

Cat. 443

440 Omphale
Ca. 1800. – F./G. KPEG Gleiwitz. – 2.3 x
1.5 cm (7/8 x 9/16 in.). – 1.7 g.
Lamprecht 306M, Photo 52. – Inv.
1986.481.107.

441 Orestes and/und Pylades
Ca. 1800. – F./G. KPEG Gleiwitz. – 2.7 x
1.9 cm (1 1/16 x 3/4 in.). – 3.6 g.
Lamprecht 358M. – Inv. 1986.481.159.
Lit.: Hintze 1928a, 18, pl./Taf. 14, no. IV 3.
After a glass paste by / Nach einer Glaspa-
ste von Nathaniel Marchant (Furtwängler,
Taf. LXVII, Abb. 24).

442 Two Cherubs / Zwei Putti
Ca. 1800. – F./G. KPEG Gleiwitz. – 1.3 x
1.2 cm (1/2 x 1/2 in.). – 1.0 g.
Lamprecht 408M, Photo 52. – Inv.
1986.481.209.

443 Two Unknown Men / Zwei unbe-kannte Männer
Heads in profile facing one another. / Köp-
fe im Profil sich einander anschauend.
Ca. 1800. – F./G. KPEG Gleiwitz. – 1.3 x
1.7 cm (1/2 x 11/16 in.). – 2.5 g.
Lamprecht 261M, Photo 52. – Inv.
1986.481.62.

444 Two Winged Cupids / Zwei geflügel-te Putti
(Fig. p. / Abb. S. 176)
Ca. 1800. – F./G. KPEG Gleiwitz. – 1.3 x
1 cm (1/2 x 3/8 in.). – 1.4 g.
Lamprecht 316M, Photo 52. – Inv.
1986.481.117.

445 Papyrius and his Mother / Papyrius und seine Mutter
Ca. 1800. – F./G. KPEG Gleiwitz. – 2.2 x
1.8 cm (7/8 x 11/16 in.). – 2.4 g.
Lamprecht 401M. – Inv. 1986.481.202.

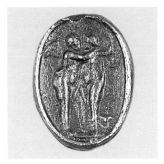

Cat. 444

Cat. 445

After a Wedgwood model. / Nach einem
Wedgwood-Modell.

**446 Priam Begs for the Body of his Son
Hector / Priamus bittet um die Heraus-
gabe des Leichnams seines Sohns Hektor**
Ca. 1800. – F./G. KPEG Gleiwitz. – 2.5 x
3 cm (1 x 1 3/16 in.). – 14.4 g.
Lamprecht 355M. – Inv. 1986.481.156.
Lit.: Book of Wedgwood, fig./Abb. 65.
After a Wedgwood model of about 1789 at-
tributed to John Flaxman Jr. / Nach einem
Wedgwood-Modell der Zeit um 1789, das
John Flaxman Jr. zugeschrieben wird.

**447 Pyrrhus Presented to Glaucias /
Pyrrhus bei Glaukias eingeführt**
Ca. 1800. – F./G. KPEG Gleiwitz. – 3.1 x
3.8 cm (1 1/4 x 1 1/2 in.). – 17.6 g.
Lamprecht 349M. – Inv. 1986.481.150.
Lit.: Wedgwood 1992, 381, no. 1054.
After a Wedgwood model, based on a gem
by Charles Brown. / Nach einem Wedgwood-
Modell nach einer Gemme von Charles
Brown.

448 Sacrificial Scene / Opferszene
Ca. 1800. – F./G. KPEG Gleiwitz. – 2.2 x
1.7 cm (7/8 x 11/16 in.). – 1.7 g.
Lamprecht 389M. – Inv. 1986.481.190.
Lit.: Wedgwood 1992, 354, no. 881.
After a Wedgwood model. / Nach einem
Wedgwood-Modell.

449 Sacrificial Scene / Opferszene
Ca. 1800. – F./G. KPEG Gleiwitz. – 2.5 x
3 cm (1 x 1 3/16 in.). – 3.0 g.
Lamprecht 413M. – Inv. 1986.481.214.

450 Sacrificial Scene / Opferszene
Ca. 1800. – F./G. KPEG Gleiwitz. – 2.4 x
1.6 cm (15/16 x 5/8 in.). – 1.6 g.
Lamprecht 337M. – Inv. 1986.481.138.

**451 Aphrodite with her Attendant /
Aphrodite mit ihrer Dienerin**
Ca. 1800. – F./G. KPEG Gleiwitz. – 2.4 x
1.9 cm (15/16 x 3/4 in.). – 2.4 g.
Lamprecht 341M. – Inv. 1986.481.142.

**452 Procession to Sacrifical Alter / Pro-
zession zur Opferstätte**
Ca. 1800. – F./G. KPEG Gleiwitz. – D.
3.5 cm (1 3/8 in.). – 10.1 g.
Lamprecht 353M, Photo 56. – Inv.
1986.481.154.

453 Sacrificial Scene / Opferszene
Ca. 1800. – F./G. KPEG Gleiwitz. – 2.3 x
1.9 cm (7/8 x 3/4 in.). – 2.3 g.
Lamprecht 366M, Photo 58. – Inv.
1986.481.167.

**454 Sacrifice to Hymen / Opfer an Hy-
men**
Ca. 1800. – F./G. KPEG Gleiwitz. – 4.6 x
3.7 cm (1 13/16 x 1 7/16 in.). – 24.3 g.
Lamprecht 339M, Photo 57. – Inv.
1986.481.140.
Lit.: Wedgwood 1992, 359, no. 911. – Cp./
vgl. Reilly 1989, vol./Bd. 1, 587, fig./Abb.
851b.
A companion piece to the Marriage of Cu-
pid and Psyche (Cat. 396). After a 1774
Wedgwood model by John Flaxman Jr. based
on an engraving by Francesco Bartolozzi
after another by Giovanni Battista Cipriani. /
Gegenstück zu der Hochzeit von Amor
und Psyche (Cat. 396). Als Vorlage diente
ein Wedgwood-Modell von 1774 von
John Flaxman Jr., dem ein Stich von
Francesco Bartolozzi nach einem anderen
Stich von Giovanni Battista Cipriani zu-
grunde liegt.

455 Slave / Sklave
Ca. 1800. – F./G. KPEG Gleiwitz. – 2.5 x
1.9 cm (1 x 3/4 in.). – 5.7 g.
Lamprecht 377M, Photo 57. – Inv.
1986.481.178.
Lit.: L. Richard Smith, *Josiah Wedgwood's
Slave Medallion* (2nd revised ed.). Sydney:
The Wedgwood Society of New South
Wales Inc, 1999. – S. also Tattersall, 116 f.
– Wedgwood 1992, 327, no. 724 f.
Based on a Wedgwood model that was first
produced in December 1787 in both basalt
and jasper after the seal of the Committee
for the Abolition of the Slave Trade (later
the Society for the Abolition of the Slave
Trade). The original model is attributed to
William Hackwood and includes the in-
scription *"AM I NOT A MAN AND A
BROTHER?"* The inscription was taken
from a poem by Thomas Day, written in
1773, entitled "The Dying Negro". /
Nach dem Wedgwood-Medaillon, das zuerst
im Dezember 1787 in Basalt und Jasper
hergestellt worden war und auf dem Siegel
des „Committee for the Abolition of the
Slave Trade" (später die „Society for the
Abolition of the Slave Trade") beruhte. Das
originale Modell wird William Hackwood
zugeschrieben. Es hat die Umschrift *„AM I
NOT A MAN AND A BROTHER?"*, die aus
dem Gedicht „The Dying Negro" von Tho-
mas Day stammt (1773 geschrieben).

456 Hermes
Ca. 1800. – F./G. KPEG Gleiwitz. – 2 x
1.4 cm (13/16 x 9/16 in.). – 1.8 g.
Lamprecht 374M. – Inv. 1986.481.175.

457 Thanatos
Ca. 1800. – F./G. KPEG Gleiwitz. – 4 x
3.2 cm (1 9/16 x 1 1/4 in.). – 6.5 g.
Inv. 1962.90. – Gift of / Schenkung von Dr.
and Mrs. Maurice Garbáty.

458 Seated Figure / Sitzende Figur
Ca. 1800. – F./G. KPEG Gleiwitz. – 2.3 x
1.8 cm (7/8 x 11/16 in.). – 4.9 g.
Lamprecht 331M. – Inv. 1986.481.132.

459 Unidentified / Unidentifiziert
Ca. 1800. – F./G. KPEG Gleiwitz. – 1.6 x
2 cm (5/8 x 13/16 in.). – 4.4 g. – / Ins. around
illegible / Umschrift unleserlich.
Lamprecht 336M. – Inv. 1986.481.137.

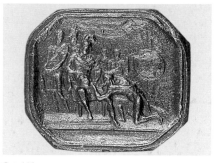

Cat. 446

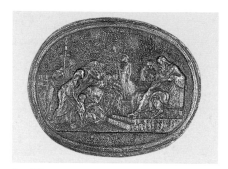

Cat. 447

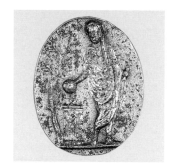

Cat. 448

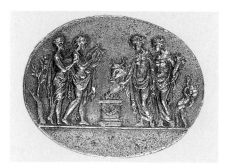

Cat. 449

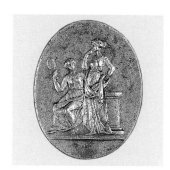

Cat. 450

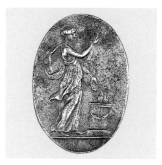

Cat. 451

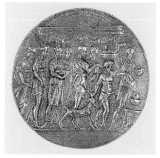

Cat. 452

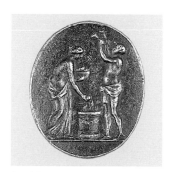

Cat. 453

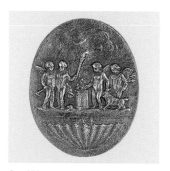

Cat. 454

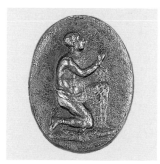

Cat. 455

Cat. 456

Cat. 457

Cat. 458

Cat. 459

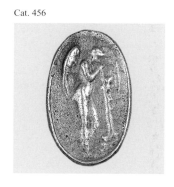

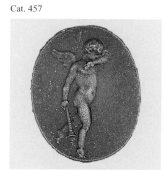

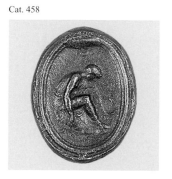

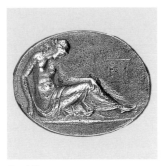

Cat. 460

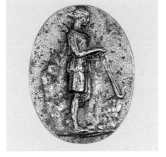

Cat. 464

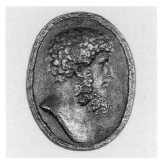

Cat. 468

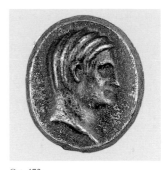

Cat. 472

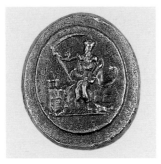

Cat. 461

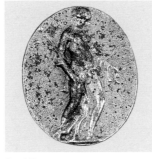

Cat. 465

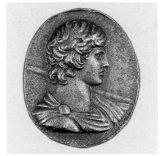

Cat. 469

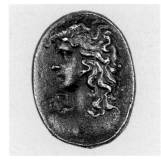

Cat. 473

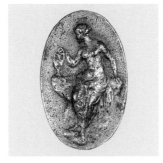

Cat. 462

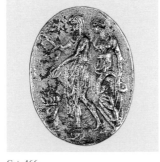

Cat. 466

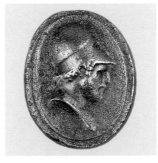

Cat. 470

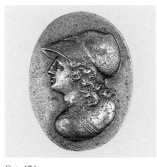

Cat. 474

Cat. 463

Cat. 467

Cat. 471

Cat. 475

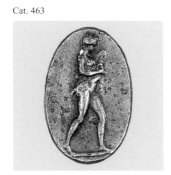

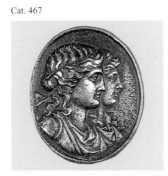

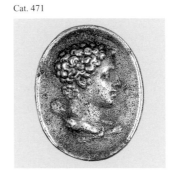

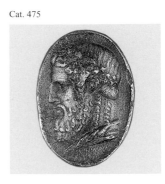

460 Seated Figure / Sitzende Figur
Ca. 1800. – F./G. KPEG Gleiwitz. – 1.6 x
2.2 cm (5/8 x 7/8 in.). – 2.7 g.
Lamprecht 343M, Photo 55. – Inv.
1986.481.144.

461 Seated Figure / Sitzende Figur
Ca. 1800. – F./G. KPEG Gleiwitz. – 2.1 x
1.9 cm (13/16 x 3/4 in.). – 4.9 g.
Lamprecht 346M. – Inv. 1986.481.147.

**462 Female Figure with Amphora /
Weibliche Figur mit Amphora**
Ca. 1800. – F./G. KPEG Gleiwitz. – 2.5 x
1.6 cm (1 x 5/8 in.). – 3.5 g.
Lamprecht 379M. – Inv. 1986.481.180.

**463 Amalthea and the Infant Zeus / und
der junge Zeus**
Ca. 1800. – F./G. KPEG Gleiwitz. – 2.3 x
1.5 cm (7/8 x 9/16 in.). – 2.7 g.
Lamprecht 386M. – Inv. 1986.481.187.

464 Artemis
Ca. 1800. – F./G. KPEG Gleiwitz. – 1.9 x
1.4 cm (3/4 x 9/16 in.). – 1.4 g.
Lamprecht 399M. Inv. 1986.481.200.
Lit.: Cp./vgl. Berlin und die Antike 1979,
no. 463. – Marquardt 1983, 273, no. 492
(for a necklace with a gem of the same
scene / zu einer Halskette mit einer Gemme
mit dem gleichen Motiv).
After an antique Roman gem. / Nach einer
antiken römischen Gemme.

**465 Standing Female Figure / Stehende
weibliche Figur**
Ca. 1800. – F./G. KPEG Gleiwitz. – 1.8 x
1.5 cm (11/16 x 9/16 in.). – 2.1 g.
Lamprecht 404M. – Inv. 1986.481.205.

466 Sacrificial Scene / Opferszene
Ca. 1800. – F./G. KPEG Gleiwitz. – 2.2 x
1.5 cm (7/8 x 9/16 in.). – 2.1 g.
Lamprecht 406M. – Inv. 1986.481.207.

**467 Unknown Couple / Unbekanntes
Paar**
Pair of conjoined busts in profile right. /
Zwei Brustbilder im Profil nach rechts.
Ca. 1800. – F./G. KPEG Gleiwitz. – 2.9 x
2.4 cm (1 1/8 x 15/16 in.). – 6.6 g.
Lamprecht 297M. – Inv. 1986.481.98.

**468 Unknown Man / Unbekannter
Mann**
Bust in profile right. / Brustbild im Profil
nach rechts.

Ca. 1800. – F./G. KPEG Gleiwitz. – 2.9 x
2.3 cm (1 1/8 x 7/8 in.). – 8.2 g.
Lamprecht 251M. – Inv. 1986.481.52.

**469 Unknown Man / Unbekannter
Mann**
Bust in profile right. / Brustbild im Profil
nach rechts.
Ca. 1800. – F./G. KPEG Gleiwitz. – 3.7 x
3.1 cm (1 7/16 x 1 1/4 in.). – 22.1 g.
Lamprecht 259M, Photo 59. – Inv.
1986.481.60.

**470 Unknown Man / Unbekannter
Mann**
Bust in profile right with helmet. / Brust-
bild im Profil nach rechts mit Helm.
Ca. 1800. – F./G. KPEG Gleiwitz. – 2.9 x
2.4 cm (1 1/8 x 15/16 in.). 11.0 g.
Lamprecht 260M. – Inv. 1986.481.61.

**471 Unknown Man / Unbekannter
Mann**
Bust in profile right. / Brustbild im Profil
nach rechts.
Ca. 1800. – F./G. KPEG Gleiwitz. – 1.8 x
1.4 cm (11/16 x 9/16 in.). – 1.3 g.
Lamprecht 262M, Photo 59. – Inv.
1986.481.63.

**472 Unknown Man / Unbekannter
Mann**
Bust in profile right. / Brustbild im Profil
nach rechts.
Ca. 1800. – F./G. KPEG Gleiwitz. – 1.7 x
1.5 cm (11/16 x 9/16 in.). – 2.7 g.
Lamprecht 263. – Inv. 1986.481.64.

**473 Unknown Man / Unbekannter
Mann**
Bust front, head in profile left. / Brustbild
von vorn, der Kopf im Profil nach links.
Ca. 1800. – F./G. KPEG Gleiwitz. – 1.6 x
1.2 cm (5/8 x 1/2 in.). – 1.4 g.
Lamprecht 265M. – Inv. 1986.481.66.

**474 Unknown Man / Unbekannter
Mann**
Bust in profile left with helmet. / Brustbild
im Profil nach links mit Helm.
Ca. 1800. – F./G. KPEG Gleiwitz. – 2.8 x
2.2 cm (1 1/8 x 7/8 in.). – 4.6 g.
Lamprecht 267M. – Inv. 1986.481.68.

Cat. 476

Cat. 477

**475 Unknown Man / Unbekannter
Mann**
Head in profile left. / Kopf im Profil nach
links.
Ca. 1800. – F./G. KPEG Gleiwitz. – 3.8 x
2.7 cm (1 1/2 x 1 1/16 in.). – 16.8 g.
Lamprecht 268M. – Inv. 1986.481.69.

**476 Unknown Man / Unbekannter
Mann**
Bust in profile right. / Brustbild im Profil
nach rechts.
Ca. 1800. – F./G. KPEG Gleiwitz. – 2.2 x
1.8 cm (7/8 x 11/16 in.). – 3.3 g.
Lamprecht 269M, Photo 59. – Inv.
1986.481.70.

**477 Unknown Man / Unbekannter
Mann**
Bust front, head in profile right with hel-
met. / Brustbild von vorn, der Kopf im Pro-
fil nach rechts mit Helm.
Ca. 1800. – F./G. KPEG Gleiwitz. – 3.3 x
2.5 cm (1 5/16 x 1 in.). – 4.4 g.
Lamprecht 271M, Photo 59. – Inv.
1986.481.72.

Cat. 478

478 Unknown Man / Unbekannter Mann
Head in profile right above a helmet between two swords. / Kopf im Profil nach rechts über einem Helm zwischen zwei Dolchen. / Ins. illegible/unleserlich.
Ca. 1800. – F./G. KPEG Gleiwitz. – 1.9 x 1.7 cm (3/4 x 11/16 in.). – 1.5 g.
Lamprecht 274M, Photo 59. – Inv. 1986.481.75.

479 Unknown Man / Unbekannter Mann
Bust in profile right. / Brustbild im Profil nach rechts.
Ca. 1800. – F./G. KPEG Gleiwitz. – 2.6 x 2 cm (1 x 13/16 in.). – 8.5 g.
Lamprecht 276M. – Inv. 1986.481.77.

480 Unknown Man / Unbekannter Mann
Bust in profile right. / Brustbild im Profil nach rechts.
Ca. 1800. – F./G. KPEG Gleiwitz. – 3.4 x 2.7 cm (1 5/16 x 1 1/16 in.). – 11.2 g.
Lamprecht 277M. – Inv. 1986.481.78.

481 Unknown Man / Unbekannter Mann
Bust in profile right. / Brustbild im Profil nach rechts.
Ca. 1800. – F./G. KPEG Gleiwitz. – 2.2 x 1.8 cm (7/8 x 11/16 in.). – 3.2 g.
Lamprecht 280M, Photo 59. – Inv. 1986.481.81.

482 Unknown Man / Unbekannter Mann
Head in profile right. / Kopf im Profil nach rechts.

Ca. 1800. – F./G. KPEG Gleiwitz. – 2.7 x 2.2 cm (1 1/16 x 7/8 in.). – 4.4 g.
Lamprecht 281M. – Inv. 1986.481.82.

483 Unknown Man / Unbekannter Mann
Bust in profile right. / Brustbild im Profil nach rechts.
Ca. 1800. – F./G. KPEG Gleiwitz. – 2.5 x 1.8 cm (1 x 11/16 in.). – 2.9 g.
Lamprecht 288M. – Inv. 1986.481.89.

484 Unknown Man / Unbekannter Mann
Bust in profile left. / Brustbild im Profil nach links.
Ca. 1800. – F./G. KPEG Gleiwitz. – 2.1 x 1.8 cm (13/16 x 11/16 in.). – 3.9 g.
Lamprecht 289M. – Inv. 1986.481.90.

485 Unknown Man / Unbekannter Mann
Crowned bust in profile right. / Brustbild im Profil nach rechts mit Krone.
Ca. 1800. – F./G. KPEG Gleiwitz. – 2.6 x 2.1 cm (1 x 13/16 in.). – 7.6 g.
Lamprecht 290M. – Inv. 1986.481.91.

486 Unknown Man / Unbekannter Mann
Bust in profile right. / Brustbild im Profil nach rechts.
Ca. 1800. – F./G. KPEG Gleiwitz. – 2.1 x 1.6 cm (13/16 x 5/8 in.). – 2.5 g.
Lamprecht 292M. – Inv. 1986.481.93.

487 Unknown Man / Unbekannter Mann
Head in profile left. / Kopf im Profil nach links.
Ca. 1800. – Mod. after a cut stone by / nach einem geschnittenen Stein von Luigi Pichler. – F./G. KPEG Gleiwitz. – 2.4 x 1.9 cm (15/16 x 3/4 in.). – 7.1 g.
Lamprecht 293M. – Inv. 1986.481.94.
Lit.: Berlin und die Antike, no. 463. – S. also/auch Marquardt 1983, 273, no. 492 (for a necklace with an identical portrait / zu einer Halskette mit identischem Porträt).

488 Unknown Man / Unbekannter Mann
Bust in profile right with helmet. / Brustbild im Profil nach rechts mit Helm.

Ca. 1800. – F./G. KPEG Gleiwitz. – 4.5 x 3.7 cm (1 3/4 x 1 7/16 in.). – 32.8 g.
Lamprecht 296M. – Inv. 1986.481.97.

489 Unknown Man / Unbekannter Mann
Head in profile right. / Kopf im Profil nach rechts.
Ca. 1800. – F./G. KPEG Gleiwitz. – 2.6 x 2.2 cm (1 x 7/8 in.). – 4.0 g.
Lamprecht 298M. – Inv. 1986.481.99.

490 Unknown Man / Unbekannter Mann
Bust in profile left with helmet. / Brustbild im Profil nach links mit Helm.
Ca. 1800. – F./G. KPEG Gleiwitz. – 3 x 2.4 cm (1 3/16 x 15/16 in.). – 10.8 g.
Lamprecht 302M, Photo 59. – Inv. 1986.481.103.

491 Unknown Man / Unbekannter Mann
Bust front with beard. / Brustbild von vorn mit Bart.
Ca. 1800. – F./G. KPEG Gleiwitz. – 2.2 x 1.8 cm (7/8 x 11/16 in.). – 2.1 g.
Lamprecht 394M. – Inv. 1986.481.195.

492 Three Unknown Men / Drei unbekannte Männer
Conjoined heads in profile left. / Brustbilder im Profil nach links.
Ca. 1800. – F./G. KPEG Gleiwitz. – 1.8 x 2.2 cm (11/16 x 7/8 in.). – 5.2 g.
Lamprecht 266M, Photo 55. – Inv. 1986.481.67.

493 Unknown Man / Unbekannter Mann
Bust front. / Brustbild von vorn.
Ca. 1800. – F./G. KPEG Gleiwitz. – 2.1 x 1.8 cm (13/16 x 11/16 in.). – 2.7 g.
Lamprecht 283M. – Inv. 1986.481.84.

494 Unknown Woman / Unbekannte Frau
Head in profile right. / Kopf im Profil nach rechts.
Ca. 1800. – F./G. KPEG Gleiwitz. – 3.8 x 3 cm (1 1/2 x 1 3/16 in.). – 14.8 g.
Lamprecht 254M. – Inv. 1986.481.55.

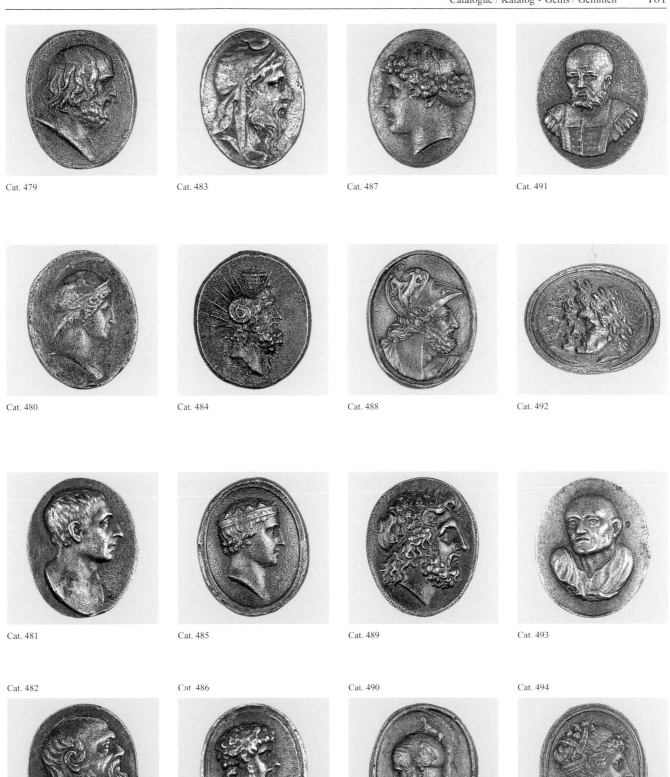

Cat. 479

Cat. 483

Cat. 487

Cat. 491

Cat. 480

Cat. 484

Cat. 488

Cat. 492

Cat. 481

Cat. 485

Cat. 489

Cat. 493

Cat. 482

Cat. 486

Cat. 490

Cat. 494

495 Unknown Woman / Unbekannte Frau

Bust in profile left. / Brustbild im Profil nach links.
Ca. 1800. – F./G. KPEG Gleiwitz. – 2.6 x 2.1 cm (1 x 13/16 in.). – 7.9 g.
Lamprecht 256M. – Inv. 1986.481.57.

496 Unknown Woman / Unbekannte Frau

Bust in profile left. / Brustbild im Profil nach links.
Ca. 1800. – F./G. KPEG Gleiwitz. – 3.1 x 2.4 cm (1 1/4 x 15/16 in.). – 11.4 g.
Lamprecht 257M, Photo 59. – Inv. 1986.481.58.

497 Unknown Woman / Unbekannte Frau

Bust in profile right with diadem. / Brustbild im Profil nach rechts mit Diadem.
Ca. 1800. – F./G. KPEG Gleiwitz. – 2.3 x 1.9 cm (7/8 x 3/4 in.). – 3.4 g.
Lamprecht 282M. – Inv. 1986.481.83.

498 Unknown Woman / Unbekannte Frau

Bust in profile right. / Brustbild im Profil nach rechts.
Ca. 1800. – F./G. KPEG Gleiwitz. – 4.9 x 4.1 cm (1 15/16 x 1 5/8 in.). – 21.1 g.
Lamprecht 250M, Photo 59. – Inv. 1986.481.51.

499 Unknown Woman / Unbekannte Frau

Head in profile right. / Kopf im Profil nach rechts.
Ca. 1800. – F./G. KPEG Gleiwitz. – 3 x 2.3 cm (1 3/16 x 7/8 in.). – 6.0 g.
Lamprecht 287M. – Inv. 1986.481.88.

500 Unknown Woman / Unbekannte Frau

Bust in profile right. / Brustbild im Profil nach rechts.
Ca. 1800. – F./G. KPEG Gleiwitz. – 2.4 x 2 cm (15/16 x 13/16 in.). – 5.1 g.
Lamprecht 299M. – Inv. 1986.481.100.

501 Unknown Woman / Unbekannte Frau

Bust in profile left with veil. / Brustbild im Profil nach links mit Schleier.
Ca. 1800. – F./G. KPEG Gleiwitz. – 3.2 x 2.4 cm (1 1/4 x 15/16 in.). – 11.9 g.
Lamprecht 303M. – Inv. 1986.481.104.

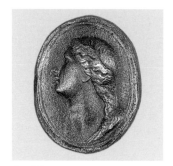

Cat. 495

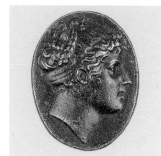

Cat. 499

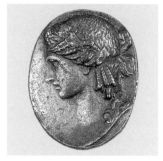

Cat. 496

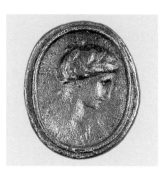

Cat. 500

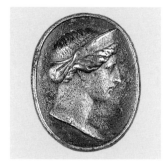

Cat. 497

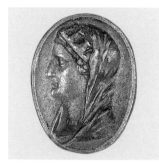

Cat. 501

Cat. 498

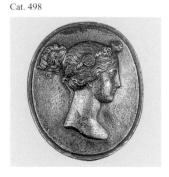

Cat. 502

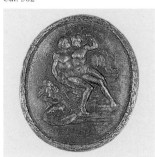

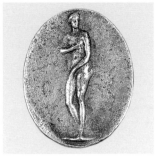

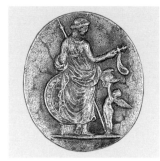

Cat. 503 Cat. 506

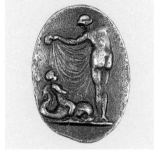

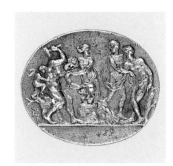

Cat. 504 Cat. 507

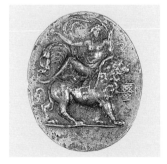

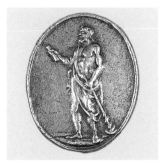

Cat. 505 Cat. 508

504 Venus Hiding Cupid, who Rides a Dolphin / Venus versteckt Amor, der auf einem Delphin reitet
Ca. 1800. – Mod. after a gem by / nach einer Gemme von Luigi Pichler. – F./G. KPEG Gleiwitz. – 2 x 1.5 cm (13/16 x 9/16 in.). – 2.0 g.
Lamprecht 368M, Photo 52. – Inv. 1986.481.169.
Lit.: Marquardt, 273, no. 492 (for a necklace that incorporates a gem of the same design, attributed to Luigi Pichler / zu einer Halskette mit einer Gemme des gleichen Motivs, Luigi Pichler zugeschrieben). – Wedgwood 1992, 84, pl./Taf. 61 (no. 684 f.).

505 Venus Riding a Lion / Venus auf einem Löwen reitend
Ca. 1800. – F./G. KPEG Gleiwitz. – 2.3 x 1.9 cm (7/8 x 3/4 in.). – 2.9 g.
Lamprecht 367M. – Inv. 1986.481.168.
Lit.: Hintze 1928a, 17, pl./Taf. 14, no. II 85.

506 Venus Victrix
Ca. 1800. – F./G. KPEG Gleiwitz. – 2.4 x 2.1 cm (15/16 x 13/16 in.). 2.0 g.
Lamprecht 342M. – Inv. 1986.481.143.
Lit.: S. Book of Wedgwood, fig./Abb. 87. – S. also/auch Reilly 1989, vol./Bd. 1, 475, fig./Abb. 683 (for an intaglio of the same design / zu einem Intaglio des gleichen Modells).
After a Wedgwood model attributed to William Hackwood, about 1773. Venus, the goddess of love, was given the name "Venus Victrix" by Julius Caesar, a title meant to convey her resistless power on the mind. / Nach einem Wedgwood-Modell (um 1773), William Hackwood zugeschrieben. Venus, die Göttin der Liebe, wurde von Julius Caesar „Venus Victrix", die Siegreiche genannt.

507 Vulcan's Forge / Vulkans Schmiede
Ca. 1800. – F./G. KPEG Gleiwitz. – 1.8 x 2.2 cm (11/16 x 7/8 in.). – 1.5 g.
Lamprecht 416M, Photo 55. – Inv. 1986.481.217.

508 Zeus
Ca. 1800. – F./G. KPEG Gleiwitz. – 2.7 x 2.3 cm (1 1/16 x 7/8 in.). – 4.6 g.
Lamprecht 325M, Photo 56. – Inv. 1986.481.126.

502 Venus and/und Adonis
Ca. 1800. – F./G. KPEG Gleiwitz. – 3.1 x 2.6 cm (1 1/4 x 1 in.). – 10.2 g.
Lamprecht 322M, Photo 57. – Inv. 1986.481.123.

503 Venus de/von Medici
Ca. 1800. – F./G. KPEG Gleiwitz. – 2.5 x 1.9 cm (1 x 3/4 in.). – 3.1 g.
Lamprecht 359M. – Inv. 1986.481.160.
Lit.: S. Wedgwood 1992, 363, no. 934.

After a Wedgwood model based on a design from / Nach einem Wedgwood-Modell nach einem Entwurf von Joseph Spence, *Mr. Polymetis; or, An Enquiry Concerning the Agreement between the Works of the Roman Poets and the Remains of the Antient Artists.* London: Prints for R. and J. Dodsley, 1755, pl./Taf. 5.

Jewelry / Schmuck
(Cat. 509-84)

509 Necklace with Cross Pendant / Halskette mit Kreuzanhänger

The chain of intertwined links, with a link of acanthus foliage flanking a central medallion of a Sistine cherub on polished steel plate; the cross pendant with scrolling arms and central rosette on polished steel plate. / Die Kette besteht aus verflochtenen Stahlringen und einem Medaillon mit einem sixtinischen Engel auf einer polierten Stahlplatte. Der durchbrochene Kreuzanhänger zeigt Ranken und Voluten, in der Mitte eine Rosette auf einer polierten Stahlplatte.

1815-20. – F./G. possibly/vielleicht Johann Conrad Geiss. – L. 40 cm (15 3/4 in.) with pendant / mit Anhänger. – 36.2 g.
Lamprecht 518S, Photo 52. – Inv. 1986.331.1.
Lit.: Cp./vgl. Andrews, 427, fig./Abb. 17. – H. v. Sp., frontispiece/Frontispiz. – Hintze 1928b, 153. – Marquardt 1983, 77, fig./Abb. 58. – S. Ostergard 1994, 285, no. 164 (for a painting of a woman wearing a similar necklace / zu einem Gemälde einer Frau mit ähnlicher Halskette).

510 Necklace / Halskette

The mesh chain with three small oval medallions set in gold, the clasp a larger oval medallion set in gold, all with antique reliefs. / Die Kette besteht aus tüllartig geflochtenem Stahldraht mit vier in Gold gefaßten Medaillons, die mit antikisierenden Reliefs verziert sind.

1810-20. – F./G. KPEG Berlin or/oder Gleiwitz. – L. 39.5 cm (15 9/16 in.). – 10.6 g.
Lamprecht 493S, Photo 53. – Inv. 1986.331.2.
Lit.: Matzdorf, 1659. – Schuette 1916, 286, fig./Abb. 18. – Simpson, 144, fig./Abb. 129.

511 Necklace / Halskette
(Fig. p. / Abb. S. 186)

Filigree, with links of graduated sizes in the shape of circles and ovals, at each end a rosette, the clasp an oval, pierced medallion with rose bush motif. / Stahldraht, die Glieder aus kreisförmigen und spitzovalen Motiven, am Ende eine Rosette, das Verschlußstück ein ovales, durchbrochenes Medaillon mit Rosenstrauch.

Ca. 1820. – F./G. probably/wahrscheinlich KPEG Berlin. – L. 58.4 cm (23 in.). – 39.4 g.
Lamprecht 494S, Photo 53. – Inv. 1986.331.3.
Lit.: Matzdorf, 1659.

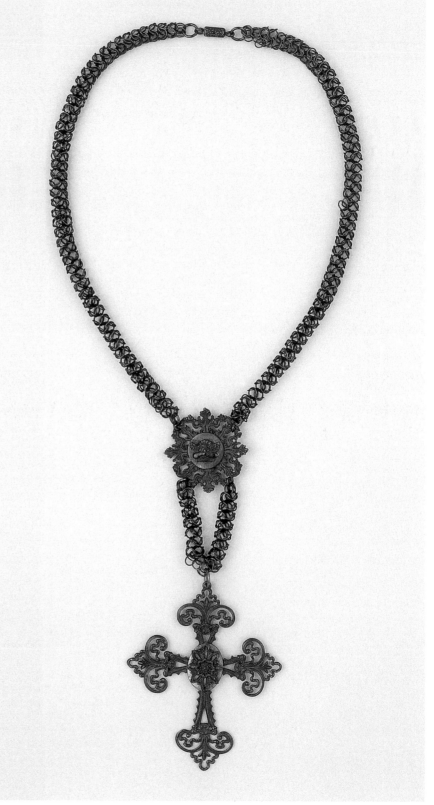

Cat. 509

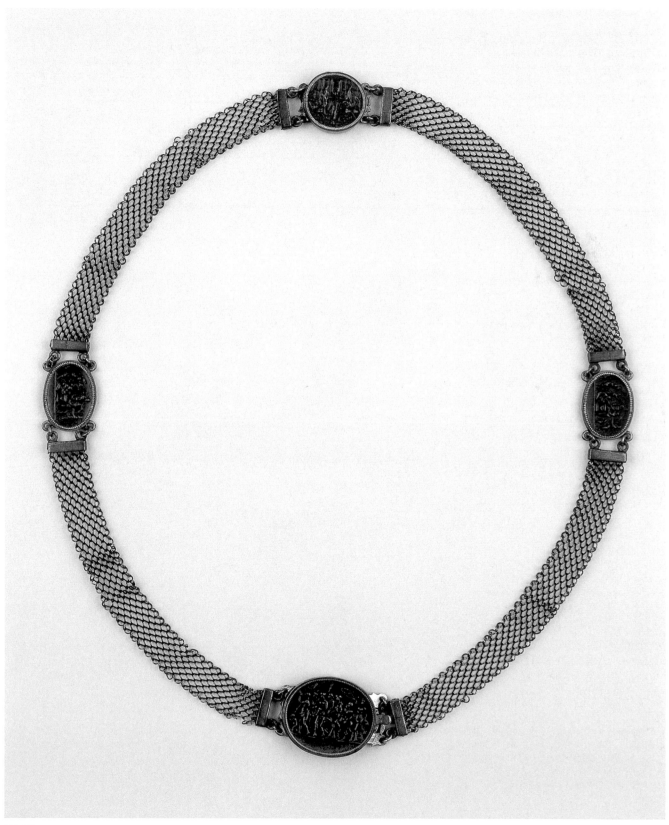

Cat. 510

512 Necklace (Fragment) / Halsketten-fragment

Nine large links of pierced rosettes and eight smaller links in the form of four adjoined fleurs de lis. / Neun große Glieder aus durchbrochenen Rosetten und acht kleinere Glieder aus vier kreuzförmig verbundenen fleurs de lis.

1820-30. – F./G. probably/wahrscheinlich Devaranne. – L. 38.8 cm (15 1/4 in.). – 15.1 g. – The clasp is missing. / Verschluß fehlt.

Lamprecht 531S, Photo 54. – Inv. 1986.331.4.

Lit.: Cp./vgl. H. v. Sp., 300. – Hintze 1928b, pl./Taf. XIV. – Marquardt 1983, 79, fig./Abb. 59. – Simpson, 144, fig./Abb. 129.

513 Necklace (Fragment) / Halsketten-fragment

(Fig. p. / Abb. S. 188)

Nine links in the form of pierced grape leaves of graduated size after a design by Johann Conrad Geiss; probably a new assembly of links taken from a necklace. / Neun der Größe nach angeordnete Weinblätter nach dem Entwurf von Johann Conrad Geiss; wohl Neumontage der von einer Halskette stammenden Weinblätter.

1820-30. – F./G. Johann Conrad Geiss (?). – L. 29 cm (11 7/16 in.). – 17.9 g.

Lamprecht 537S, Photo 54. – Inv. 1986.336.5.

Lit.: Andrews, 427, fig./Abb. 17. – Clifford, pl./Taf. III. – H. v. Sp., 300. – Schuette 1916, 286, fig./Abb. 18. – Simpson, 144, fig./Abb. 129.

The clasp used for this new assembly is missing. / Das ehemals bei der Neumontage angebrachte Verschlußstück fehlt. / Cp./vgl. Marquardt 1983, 281, no. 504 (for a complete necklace / zu einer vollständigen Halskette).

514 Cross Pendant / Kreuzanhänger

Filigree, the center with a medallion in a gold mount with the Madonna of the Chair after Raphael. / Feines Drahtgeflecht, in der Mitte ein in Gold gefaßtes Medaillon mit der Madonna della Sedia nach Raphael.

1820-30. – Mod. Medallion after / Medaillon nach Leonhard Posch. – F./G. KPEG. – 5.9 x 4.1 cm (2 5/16 x 1 5/8 in.). – 7.0 g.

Lamprecht 488S, Photo 51. – Inv. 1986.327.1.

Lit.: Schuette 1916, 286, fig./Abb. 18. – Simpson, 144, fig./Abb. 129.

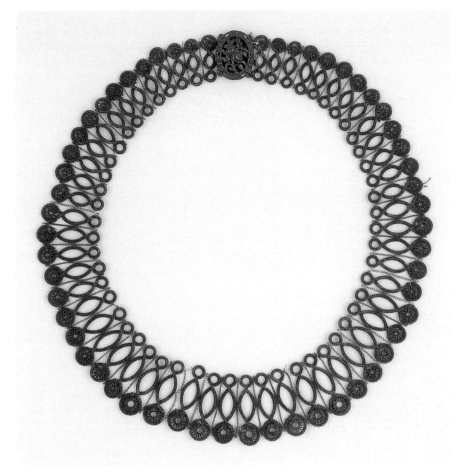

Cat. 511

Cat. 514

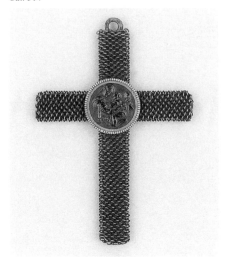

S. Cat. 201-03 for a larger model of the Madonna of the Chair / zu einem größeren Exemplar der Madonna della Sedia.

515 Cross Pendant / Kreuzanhänger

Each arm is decorated with a central rosette and gold bead, the horizontal arms each end in a larger gold bead; a gilt medallion with a central turquoise bead is in the middle. / Jeder Balken ist mit einer Blüte und einem vergoldeten Kügelchen verziert. Die waagerechten Balken enden jeweils mit einem etwas größeren Kügelchen. Die Mitte trägt ein vergoldetes Medaillon mit einer Perle aus Türkis.

1830-40. – F./G. Horowitz. – 3.2 x 3.6 cm (1 1/4 x 1 7/16 in.). – 4.5 g. – A small section of the lower arm is broken off. / Ein

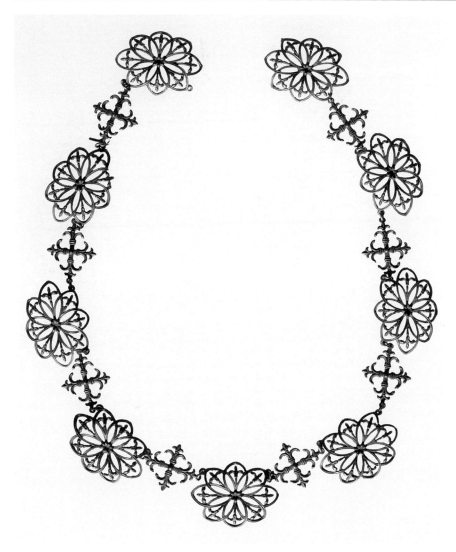

Cat. 512

Cat. 516

men Johann Richters ausgestellt (Schmuttermeier in Ostergard 1994, 83).

516 Cross Pendant / Kreuzanhänger
The arms each of three-part, pierced Gothic tracery motifs; the central medallion is in the form of a gold-mounted rosette. / Jeder Balken besteht aus je drei lanzettförmigen, durchbrochenen Motiven. Die Mitte ist durch ein rundes, goldgefaßtes Medaillon mit einer Blüte betont.
Ca. 1820. – F./G. KPEG Berlin or/oder Johann Conrad Geiss. – 8.1 x 6.8 cm (3 3/16 x 2 11/16 in.). – 8.7 g.
Lamprecht 470S, Photo 51. – Inv. 1986.327.4.
Lit.: Schuette 1916, 286, fig./Abb. 18. – Simpson, 144, fig./Abb. 129.

517 Cross Pendant / Kreuzanhänger
(Fig. p. / Abb. S. 188)
In the shape of a Maltese cross (s. Cat. 518) with a central compartment that holds a lock of hair tied with green yarn under glass. / In Form eines Malteser Kreuzes (wie Cat. 518), in der Mitte ein Oval mit einer mit grünem Garn gebundenen Haarlocke unter gewölbtem Glas.
1830-40. – F./G. possibly/vielleicht KPEG. – 3.5 x 3 cm (1 3/8 x 1 1/16 in.). – 4.8 g.
Lamprecht 471S, Photo 51. – Inv. 1986.327.5.

518 Cross Pendant / Kreuzanhänger
In the shape of a Maltese cross (s. Cat. 517) the central medallion with a portrait bust of Queen Luise of Prussia (1776-1810) in

Cat. 515

kleiner Teil des unteren Balkens ist abgebrochen.
Lamprecht 490S. – Inv. 1986.327.2.
Johann Richter, a goldsmith from Prague, may be credited with the innovation of adding turquoise as a colorful accent to cast-iron jewelry, used only at Horowitz. In the industrial exhibitions of 1829 and 1831 in Prague, the jewelry from Horowitz was displayed under the name Johann Richter (Schmuttermeier in Ostergard 1994, 83). / Johann Richter, Goldschmied in Prag, hat wohl mit der Neuerung angefangen, Türkis als bunten Akzent zum Eisenschmuck zu verwenden, was allerdings nur von Horowitz bekannt ist. Bei den Industrie-Ausstellungen von 1829 und 1831 in Prag wurde der Schmuck aus Horowitz unter dem Na-

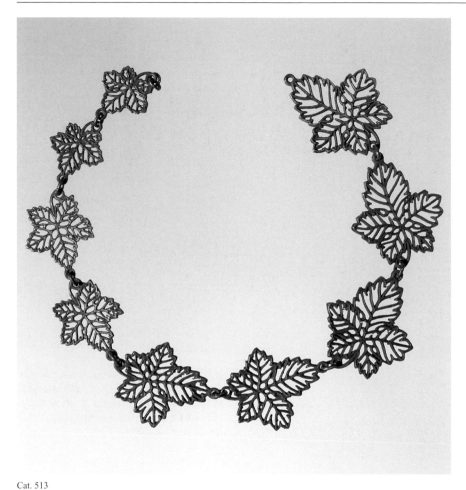

Cat. 513

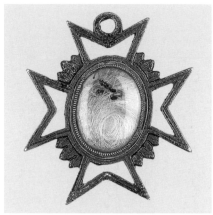

Cat. 517

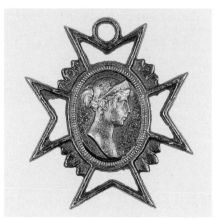

Cat. 518

Cat. 519 (Obv./Vs.) Cat. 519 (Rev./Rs.)

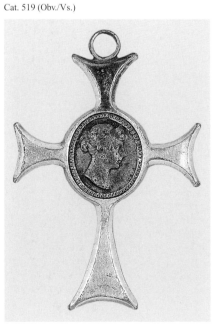 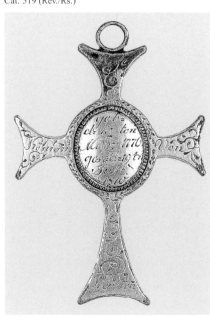

profile right in silver mount. / In Form eines Malteser Kreuzes (wie Cat. 517), in der Mitte ein Medaillon mit dem Brustbild der Königin Luise von Preußen nach rechts in silberner Fassung.
After/nach 1810. – F./G. KPEG Berlin. – 3.5 x 3 cm (1 3/8 x 1 3/16 in.). – 4.2 g.
Lamprecht 473S, Photo 51. – Inv. 1986.327.7.
Lit.: Marquardt 1983, 269, no. 477. – Schuette 1916, 286, fig./Abb. 18.

519 Cross Pendant / Kreuzanhänger
A gold cross with a central cast-iron portrait medallion of Queen Luise of Prussia in profile right. / Goldkreuz, in der Mitte ein eisernes Porträtmedaillon der Königin Luise von Preußen im Profil nach rechts. Rev./Rs. „Luise / Königin / Von / Preußen / geb= d= 10ten / Merz 1776 / gest= d= 19tn / Juli / 1810".

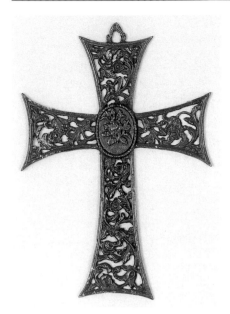

Cat. 520

Cat. 521

Cat. 522

After/nach 1810. – F./G. KPEG Berlin (?). – 5.5 x 3.7 cm (2 3/16 x 1 7/16 in.). – 8.6 g. Inv. 1962.94. – Gift of / Schenkung von Dr. and Mrs. Maurice Garbáty.

520 Cross Pendant / Kreuzanhänger
The pierced arms with scrolling foliage, the central medallion with a rosette. / Die durchbrochenen Balken haben jeweils einschwingende Seiten mit Voluten und Blumen, in der Mitte befindet sich ein Medaillon mit Blüten.
1820-30. – F./G. KPEG Berlin or/oder Gleiwitz. – 8.5 x 5.9 cm (3 3/8 x 2 5/16 in.). – 11.5 g.
Lamprecht 474S, Photo 51. – Inv. 1986.327.8.
Lit.: Schuette 1916, 286, fig./Abb. 18. – Simpson, 144, fig./Abb. 129.

521 Cross Pendant / Kreuzanhänger
Pendant with Corpus Christi, radiant, each arm terminating in scrolled foliate motif. / Anhänger mit Korpus Christi. Oben die Andeutung von Strahlen, jeder Kreuzbalken mit Voluten am Ende. / Ins. „INRI".
1810-20. – 4.2 x 2.5 cm (1 5/8 x 1 in.). – 3.0 g.
Lamprecht 485S, Photo 51. – Inv. 1986.327.9.

522 Cross Pendant / Kreuzanhänger
Pendant with Corpus Christi. The arms decorated in relief, the upper arm terminating

in a winged cherub. / Anhänger mit Korpus Christi. Die Kreuzbalken mit Reliefdekoration, der obere Balken mit geflügeltem Putti. / Ins. „INRI".
1810-20. – 8.9 x 4.7 cm (3 1/2 x 1 7/8 in.). – 11.4 g.
Lamprecht 478S, Photo 51. – Inv. 1986.327.10.

523 Pendant / Anhänger
Portrait of Friedrich Wilhelm III, King of Prussia (1770-1840; 1797 King). Bust in profile left in uniform. / Porträt König Friedrich Wilhelms III. von Preußen (1797 König). Brustbild im Profil nach links in Uniform.
Ca. 1815. – Mod. after/nach Leonhard Posch. – F./G. KPEG Berlin or/oder Gleiwitz. – 1.9 x 1.4 cm (3/4 x 9/16 in.). – 3.3 g.
Lamprecht 480S, Photo 51. – Inv. 1986.328.2.

524 Pendant / Anhänger
Portrait of Alexander I Pavlovich, Emperor of Russia (1777-1825; 1801 Emperor). Bust in profile left in uniform. / Bildnis Alexanders I. Pawlowitsch, Kaiser von Rußland (1801 Kaiser). Brustbild im Profil nach links in Uniform.
Ca. 1805. – Mod. after/nach Leonhard Posch. – F./G. KPEG Berlin or/oder Gleiwitz. – 1.9 x 1.2 cm (3/4 x 1/2 in.). – 1.2 g.
Lamprecht 486S, Photo 51. – Inv. 1986.328.6.

Lit.: Cp./vgl. Forschler-Tarrasch, no. 158. This portrait was made during Alexander's visit to Berlin in 1805. / Das Porträt wurde während eines Besuchs Alexanders in Berlin 1805 modelliert.

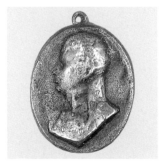

Cat. 523

Cat. 524

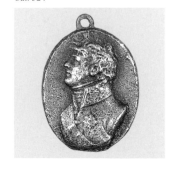

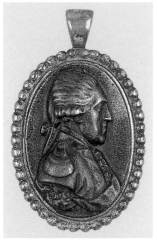

Cat. 525

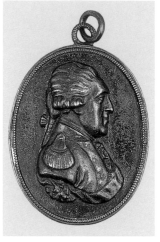

Cat. 526

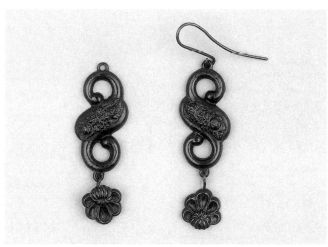

Cat. 527

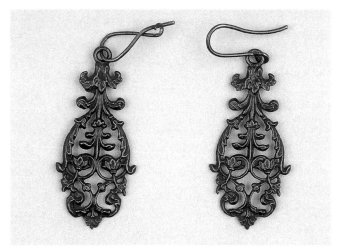

Cat. 528

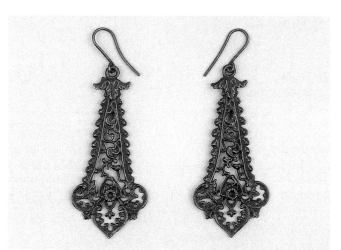

Cat. 529

Cat. 530

Cat. 531

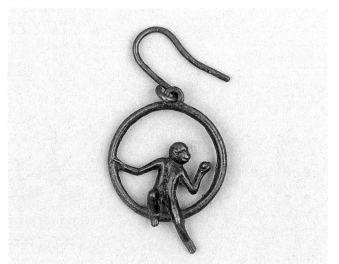

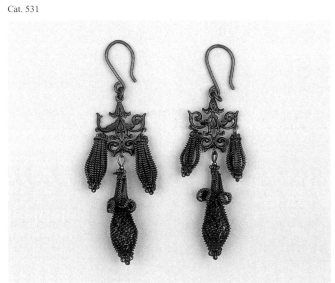

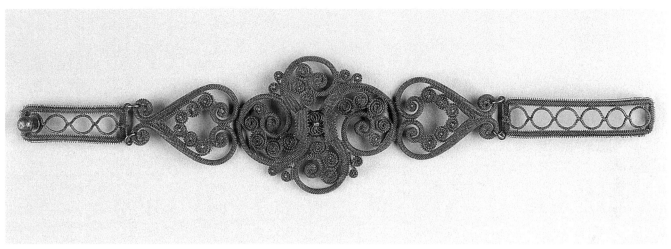

Cat. 532

525 Pendant / Anhänger
Portrait of Friedrich August I, King of Saxony (1750-1827; 1806 King). Bust in profile right, in beaded gold mount. / Bildnis Friedrich Augusts I. von Sachsen (1806 König). Brustbild im Profil nach rechts, in mit Perlstab verzierter vergoldeter Fassung.
Ca. 1810. – F./G. Lauchhammer (?). – 3.4 x 2.1 cm (1 5/16 x 13/16 in.). – 7.6 g.
Lamprecht 477S, Photo 51. – Inv. 1986.495.52.

526 Pendant / Anhänger
Portrait of Friedrich August I, King of Saxony (1750-1827; 1806 King). Bust in profile right, in silver mount. / Bildnis Friedrich Augusts I. von Sachsen (1806 König). Brustbild im Profil nach rechts, in Silberfassung.
Ca. 1810. – F./G. Lauchhammer (?). – 3.2 x 2.2 cm (1 1/4 x 7/8 in.). – 5.1 g.
Lamprecht 548S, Photo 51. – Inv. 1986.495.53.

527 Pair of Earrings / Paar Ohrgehänge
Of S-scroll shape with a central floral element, with shell-shaped bauble hanging below. / S-förmig mit zentraler Blume, mit angehängter Blüte.
Ca. 1830. – F./G. Horowitz. – Without hook / Ohne Brisur 4.7 x 1.6 cm (1 7/8 x 5/8 in.). – 4.2 g; 3.8 g.
Lamprecht 528S, Photo 54. – Inv. 1986.332.1 a-b.
Lit.: H. v. Sp., 300. – cp./vgl. Marquardt 1983, 288, no. 517. – Schuette 1916, 286, fig./Abb. 18.

The hook missing on one of the pair. / Die Brisur des einen Ohrgehänges fehlt.

528 Pair of Earrings / Paar Ohrgehänge
Pierced, with scrolling foliage. / Durchbrochen, mit Rankenmotiven.
1820-30. – F./G. KPEG Berlin or/oder Gleiwitz. – Without hook / Ohne Brisur 4.2 x 1.9 cm (1 5/8 x 3/4 in.). – 2.5 g; 2.3 g.
Lamprecht 529S, Photo 54. – Inv. 1986.332.2 a-b.
Lit.: H. v. Sp., 300. – Schuette 1916, 286, fig./Abb. 18. – Simpson, 144, fig./Abb. 129.
The hook damaged on one of the pair. / Die Brisur bei einem ist beschädigt.

529 Pair of Earrings / Paar Ohrgehänge
Lozenge-shaped with the end in the form of Gothic tracery with crockets, scrolled foliage, and a small central rosette. / Rautenförmig mit Ende in Form von gotisierendem Maßwerk mit Krabben, Ranken; in der Mitte kleine Rosette.
1820-30. – F./G. possibly/vielleicht Johann Conrad Geiss. – 5.5 x 2.6 cm (2 3/16 x 1 in.). – 3.3 g; 3.2 g.
Lamprecht 530S, Photo 54. – Inv. 1986.332.3 a-b.
Lit.: H. v. Sp., 300. – Schuette 1916, 286, fig./Abb. 18. – Simpson, 144, fig./Abb. 129.

530 Earring / Ohrgehänge
Circular, with the figure of a small, seated monkey. / Ring mit sitzendem Affen.
Ca. 1890-1900. – F./G. Horowitz(?). – D. 1.7 cm (11/16 in.). – 1.2 g.

Lamprecht 533S, Photo 54. – Inv. 1986.332.4 a.
Lit.: H. v. Sp., 300. – Schuette 1916, 286, fig./Abb. 18.
Originally one of a pair. / Ursprünglich zu einem Paar gehörig.

531 Pair of Earrings / Paar Ohrgehänge
From a central pierced element hang two filigree tassels flanking a central, larger tassel also of filigree. / Einem zentralen Rankenzierstück sind drei tropfenförmige Glieder aus Stahldraht angehängt.
1820-30. – F./G. KPEG Berlin. – 8.6 x 1.9 cm (3 3/8 x 3/4 in.). – 4.0 g; 4.7 g.
Lamprecht 491S, Photo 53. – Inv. 1986.332.7 a-b.
Lit.: Andrews, 427, fig./Abb. 17.

532 Bracelet / Armband
Filigree, with four-part central link with scrolling elements flanked by two heart-shaped links and band made up of circles. / Ornamente aus fein gewendeltem Stahldraht, in der Mitte ein vierteiliges Glied mit Ranken zwischen zwei herzförmigen und kreisverzierten Gliedern.
Ca. 1820. – F./G. KPEG Berlin. – 19.4 x 4.4 cm (7 5/8 x 1 3/4 in.). – 9.5 g.
Lamprecht 496S, Photo 53. – Inv. 1986.330.1.
Lit.: Matzdorf, 1659.

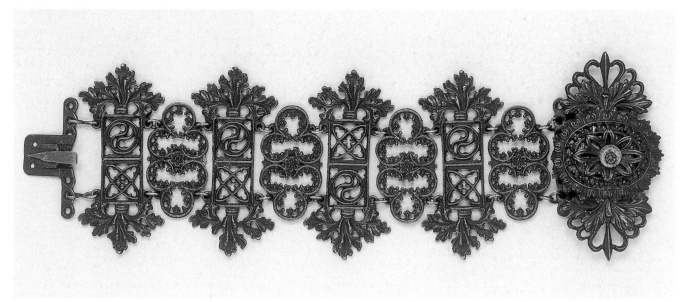

Cat. 533

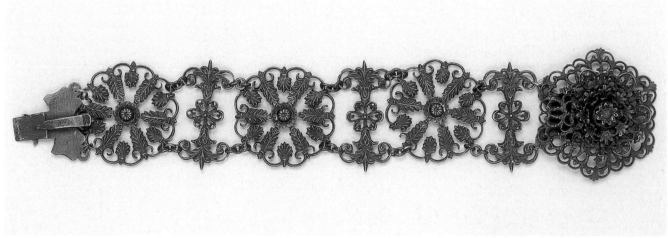

Cat. 534

Cat. 535

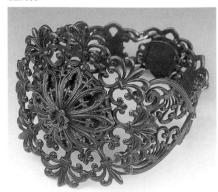

533 Bracelet / Armband
Nine parts consisting of a clasp and eight pierced links of alternating acanthus foliage and Gothic trefoils, the clasp pierced with palmettes flanking a central rosette. / Neunteilig aus Verschlußstück und acht alternierend angeordneten Gliedern aus gotisierenden Dreipässen und aus Kreuzblumenblättern, die Maßwerk einschließen; das Verschlußstück zeigt eine Rosette zwischen Palmetten.
Ca. 1820. – F./G. probably/wahrscheinlich Johann Conrad Geiss. – 18.5 x 6 cm (7 5/16 x 2 3/8 in.). – 39.5 g.

Lamprecht 507S, Photo 55. – Inv. 1986.330.2.
Lit.: Jailer-Chamberlain, A1/A13. – cp./vgl. Marquardt 1983, 301, no. 552. – Simpson, 144, fig./Abb. 129.

534 Bracelet / Armband
Three large circular links with pierced motifs of acanthus leaves and a central rosette between three smaller links of pierced foliage with a central floral element; the clasp a large, pierced, and layered floral element. / Drei große runde Glieder mit durchbrochenen Blattmotiven im Wechsel mit drei klei-

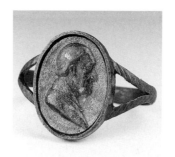

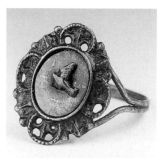

Cat. 537 | Cat. 538 | Cat. 539 | Cat. 540

neren Gliedern von durchbrochenen Ranken mit Blumen, das Verschlußstück zeigt eine große durchbrochene und mehrschichtige Blume.
1820-30. – F./G. KPEG Berlin or/oder Gleiwitz. – 22 x 4.5 cm (8 11/16 x 1 3/4 in.). – 40.9 g.
Lamprecht 516S, Photo 52. – Inv. 1986.330.4.
Lit.: H. v. Sp., frontispiece/Frontispiz. – Simpson, 144, fig./Abb. 129.

535 Bracelet / Armband
Three small links of scrolls bound by beaded elements, the large central link pierced with palmettes, scrolls, and foliage, in the middle a rosette mounted on polished steel plate. / Drei kleine Glieder aus Ranken und

Perlstab, das große, mittlere Glied ist durchbrochen und zeigt Ranken, Voluten und Palmetten, in der Mitte eine Rosette auf einer Stahlplatte.
1820-30. – F./G. KPEG Berlin or/oder Gleiwitz. – 16.5 x 5.7 cm (6 1/2 x 2 1/4 in.). – 31.8 g.
Lamprecht 549S, Photo 55. – Inv. 1986.330.7.

536 Pair of Cuffs / Paar Armbänder
Each of five links in the form of pierced Gothic tracery. / Mit jeweils fünf Gliedern in Form von durchbrochenem gotisierenden Maßwerk.
1820-30. – F./G. Johann Conrad Geiss. – 4.9 x 15 cm (1 15/16 x 5 7/8 in.). – 26.6 g; 25.0 g.

Lamprecht 550S, Photo 54. – Inv. 1986.303 a-b.
Probably reworked into current form from another object. / Wahrscheinlich wurde ein anderes Objekt in Armbänder umgearbeitet.

537 Signet Ring / Siegelring
The tapered band with relief decoration of birds and foliage, the plate with a coat of arms. / Der zur Siegelplatte hin breiter werdende Reif mit Reliefmotiven aus Vögeln und Pflanzen, die Siegelplatte mit Schild und Krone.
1810-25. – F./G. possibly/vielleicht KPEG. – D 2.3 cm (7/8 in.). – 5.0 g.
Lamprecht 499S. – Inv. 1986.334.2.

Cat. 536

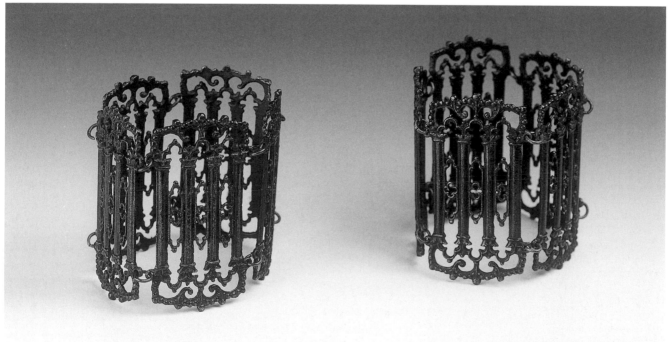

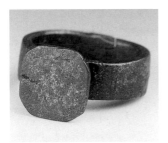

Cat. 541

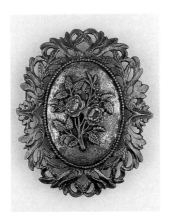

Cat. 542

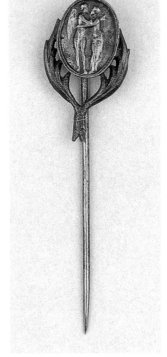

Cat. 543

Cat. 544

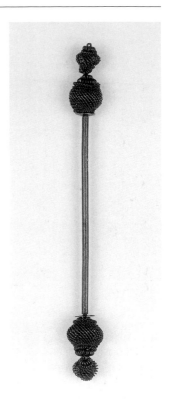

Cat. 545

538 Ring / Fingerring
(Fig. p. / Abb. S. 193)
The plain band with split shoulder, the face
with an oval portrait bust of Friedrich Au-
gust I, King of Saxony (1750-1827; 1806
King), in profile right. / Einfacher Reif mit
geteilter Schulter, die Platte mit dem Brust-
bild König Friedrich Augusts I. von Sach-
sen (1806 König) im Profil nach rechts.
1810-20. – F./G. possibly/vielleicht Lauch-
hammer. – D. 2.2 cm (7/8 in.). – 1.9 g.
Lamprecht 500S. – Inv. 1986.334.3.

539 Ring / Fingerring
(Fig. p. / Abb. S. 193)
The ribbed band with split shoulder, the
face an oval medallion with a portrait of
Christoph Martin Wieland (1733-1813) in
profile right. / Der geriffelte Reif mit ge-
teilter Schulter, die ovale Platte mit dem
Brustbild Christoph Martin Wielands im
Profil nach rechts.
1810-20. – Portrait after a model (1809) by /
Porträt nach einem Modell (1809) von Leon-
hard Posch. – F./G. KPEG Berlin. – D. 2.5 cm
(1 in.). – 6.1 g.
Lamprecht 505S, Photo 55. – Inv.
1986.334.8.
Lit.: Cp./vgl. Forschler-Tarrasch, no. 410.

540 Ring / Fingerring
(Fig. p. / Abb. S. 193)
The plain band with split shoulder, the face
with a pierced frame in the form of a ro-
sette, in the middle a dove with outstretched
wings. / Einfacher Reif mit geteilter Schul-
ter, die Platte mit durchbrochenem Rahmen
in Form einer Rosette, in der Mitte eine
Taube mit ausgebreiteten Flügeln.
Ca. 1830. – F./G. Horowitz (?). – D. 2.2 cm
(7/8 in.). – 1.6 g.
Lamprecht 506S. – Inv. 1986.334.9.

541 Ring / Fingerring
Made from a horseshoe nail, the wide,
hinged band supports a plate with truncated
edges. Originally with a mounted stone. /
Aus einem Hufeisennagel hergestellt; der
breite, aufklappbare Reif trägt eine Platte
mit beschnittenen Ecken. Ursprünglich mit
einem montierten Stein.
Wrought iron / Geschmiedetes Eisen. – End
19th century / Ende des 19. Jh. (?). – 3.2 x
2.7 cm (1 1/4 x 1 1/16 in.). – 14.2 g.
Lamprecht 481S. – Inv. 1986.334.10.

542 Brooch / Brosche
Oval, the pierced frame of scrolling foli-
age, the central medallion with applied rose

branches on a polished steel plate. / Oval,
der Rahmen mit durchbrochenen Voluten,
in der Mitte ein Medaillon mit aufgelegtem
Rosenzweig auf polierter Stahlplatte.
1820-30. – F./G. KPEG Berlin or/oder
Gleiwitz. – 5.4 x 4.4 cm (2 1/8 x 1 3/4 in.).
– 17.3 g.
Lamprecht 510S, Photo 55. – Inv.
1986.336.10.

543 Pin / Anstecknadel
Between two palm fronds a central oval
medallion with the image of Cupid and
Psyche. / Zwischen zwei Palmwedeln ein
zentrales ovales Medaillon mit Amor und
Psyche.
1820-30. – F./G. KPEG Berlin or/oder Glei-
witz. – 5.1 x 1.3 cm (2 x 1/2 in.). – 1.9 g.
Lamprecht 532S, Photo 54. – Inv.
1986.333.1.
Lit.: H. v. Sp., 300.

544 Pin / Anstecknadel
In the form of a fox head. / In Form eines
Fuchskopfes.
1820-30. – F./G. KPEG Berlin or/oder Glei-
witz. – 6.4 x 1.2 cm (2 1/2 x 1/2 in.). – 1.7 g.
Lamprecht 547S. – Inv. 1986.333.2.

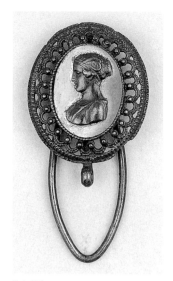

Cat. 546 Cat. 547 Cat. 548 Cat. 550

545 Hair Pin / Haarnadel
A central rod with filigree balls on each side, from which hang small filigree tassels. / Ein runder Stab mit jeweils zwei Ellipsoiden aus Stahldraht an beiden Enden.
1820-30. – F./G. KPEG Berlin. – L. 12.5 cm (4 15/16 in.). – 9.4 g.
Lamprecht 495S, Photo 53. – Inv. 1986.336.8.

546 Buckle / Schnalle
Pierced at each end with rosettes, acanthus leaves, and stars. / Durchbrochen an beiden Enden mit Rosetten, Laubwerk und Sternen.
1820-30. – F./G. possibly/vielleicht Horowitz. – 9.6 x 4.1 cm (3 3/4 x 1 5/8 in.). – 23.0 g.
Lamprecht 515S, Photo 52. – Inv. 1986.329.1.
Lit.: H. v. Sp., frontispiece/Frontispiz.

547 Buckle / Schnalle
With rosettes and acanthus leaves, the prongs gold. / Mit Rosetten und Laubwerk, die Dornvorrichtung aus Gold.
1820-30. – F./G. probably/wahrscheinlich Horowitz. – 5.8 x 3.4 cm (2 5/16 x 1 5/16 in.). – 13.2 g.
Lamprecht 527S, Photo 52. – Inv. 1986.329.5.
Lit.: Andrews, 427. fig./Abb. 17. – H. v. Sp., frontispiece/Frontispiz. – Simpson, 144, fig./Abb. 129.

548 Buckle / Schnalle
Cut steel in the shape of a lyre with a stylized plant in a flower pot. / Cut steel in

Form einer Lyra mit stilisierter Pflanze in einem Blumentopf.
1810-20. – 6.4 x 3 cm (2 1/2 x 1 3/16 in.). – 17.4 g.
Lamprecht 561S. – Inv. 1986.329.6.

549 Pair of Buckles / Paar Schnallen
Cut steel, pierced with swags and beading. / Cut steel, durchbrochen mit Blatt- und Perlmotiven.
1820-30. – F./G. KPEG. – 6.8 x 6.8 cm (2 11/16 x 2 11/16 in.). – a) 40.3 g; b) 41.3 g.
Lamprecht 560S a-b. – Inv. 1986.329.8 a-b.

550 Key Hook / Schlüsselhalter
Oval medallion with pierced and beaded frame, with the bust of a classical woman in profile left on polished steel plate. / Ovales Medaillon mit durchbrochenem und mit Perlen verziertem Rahmen, darauf das Brustbild einer Frau im Profil nach links auf polierter Stahlplatte.
1810-20. – F./G. KPEG Berlin or/oder Gleiwitz. – 5.6 x 2.9 cm (2 3/16 x 1 1/8 in.). – 10.1 g.
Lamprecht 517S, Photo 52. – Inv. 1986.337.1.
Lit.: H. v. Sp., frontispiece/Frontispiz.

Cat. 549

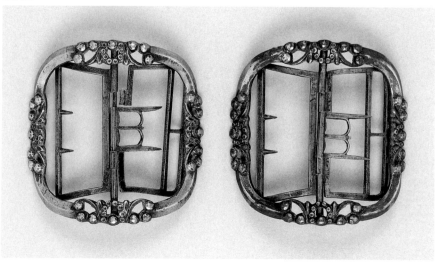

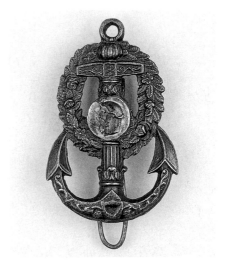

Cat. 551

Cat. 552

Cat. 553

Cat. 554

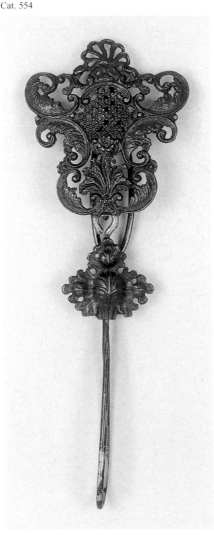

551 Key Hook / Schlüsselhalter

A lyre-shaped steel plate inset with mother-of-pearl in a shell-like pattern, with three cut steel "diamonds". / Lyraförmige Stahlplatte mit einem Medaillon mit Muschelmotiv aus Perlmutt und mit Cut steel.
First quarter of the 19th century / 1. Viertel des 19. Jh. – 5.9 x 2.4 cm (2 5/16 x 15/16 in.). – 13.0 g.
Lamprecht 557S. – Inv. 1986.337.2.

552 Key Hook / Schlüsselhalter

Lozenge-shaped with a decorative gilt border surrounding the initial "G" in gold. / Rautenförmig, mit vergoldeter feiner Zickzacklinie als Umrandung, in der Mitte die Initiale „G".
First half of the 19th century / 1. Hälfte des 19. Jh. – 6.5 x 2.9 cm (2 9/16 x 1 1/8 in.). – 15.2 g.
Lamprecht 558S. – Inv. 1986.337.3.

553 Key Hook / Schlüsselhalter

In the form of an anchor with a floral wreath hanging from it, in the center a medallion with the portrait head of a classical man in profile left on a polished steel plate. / In Form eines Ankers vor einem Blumenkranz, in der Mitte ein Medaillon mit dem antikisierenden Porträtkopf eines Mannes im Profil nach links auf einer polierten Stahlplatte.
1810-20. – F./G. KPEG Berlin or/oder Gleiwitz. – 6 x 3.5 cm (2 3/8 x 1 3/8 in.). – 11.0 g.
Lamprecht 508S, Photo 53. – Inv. 1986.337.4.

554 Key Hook / Schlüsselhalter

In the shape of a cartouche, pierced, with scrolling foliage and shell motifs, from this hangs an acanthus leaf pendant and hook. / In Form einer Kartusche, durchbrochen, mit Voluten und Muschelmotiven, daran hängend ein Ziermotiv aus Akanthusblättern.
1820-30. – F./G. KPEG Berlin or/oder Gleiwitz. – 11.5 x 4 cm (4 1/2 x 1 9/16 in.). – 10.8 g.
Lamprecht 509S. – Inv. 1986.337.5.

555 Key Hook / Schlüsselhalter

In the form of lyre-shaped S-scrolls and stylized palmettes, in the center a medallion with the portrait head of a man in profile left. / In Form einer Leier mit S-Voluten und stilisierten Palmetten, in der Mitte ein Medaillon mit Porträtkopf eines Mannes im Profil nach links.
1820-30. – F./G. KPEG Berlin or/oder Gleiwitz. – 6.1 x 3.8 cm (2 3/8 x 1 1/2 in.). – 12.0 g.
Lamprecht 512S, Photo 53. – Inv. 1986.337.6.

556 Key Hook / Schlüsselhalter

In the form of an anchor with a floral wreath and cross, in the center a small medallion with a rosette. / In Form eines Ankers mit Blumenkranz und Kreuz, in der Mitte ein kleines Medaillon mit Rosette.
1820-30. – F./G. KPEG Berlin or/oder Gleiwitz. – 6.4 x 3.5 cm (2 1/2 x 1 3/8 in.). – 14.5 g.
Lamprecht 513S. – Inv. 1986.337.7.

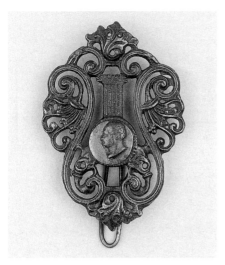

Cat. 555

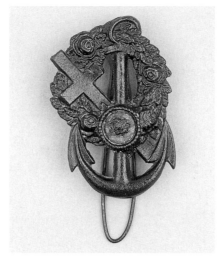

Cat. 556

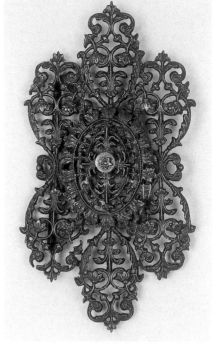

Cat. 557

557 Clasp for a Bracelet / Verschluß-stück für Armband
Pierced, of scrolling foliage with a small central medallion with a rosette on a steel plate. / Durchbrochen, mit Voluten und Laubwerk, in der Mitte ein kleines Medaillon mit Rosette auf Stahlplatte.
1820-30. – F./G. KPEG Berlin or/oder Glci-witz. – 9 x 5.1 cm (3 9/16 x 2 in.). – 22.2 g.
Lamprecht 521S, Photo 52. – Inv. 1986.329.2.
Lit.: H. v. Sp., frontispiece/Frontispiz.

558 Clasp, Probably for a Necklace / Verschlußstück wohl für Kette
Pierced with beading, in the middle a medallion with a cherub after the Sistine Madonna by Raphael, on a steel plate. / Durchbrochen mit Perlen, in der Mitte ein Medaillon mit Putto nach der Sixtinischen Madonna von Raphael auf Stahlplatte.
1815-20. – F./G. probably/wahrscheinlich KPEG Berlin. – 2.7 x 1.9 cm (1 1/16 x 3/4 in.). – 3.3 g.
Lamprecht 522S, Photo 52. – Inv. 1986.329.3.
Lit.: H. v. Sp., frontispiece/Frontispiz.

559 Clasp for a Bracelet / Verschluß-stück eines Armbands
Pierced with scrolling foliage, the central oval medallion with a portrait of Hermes in profile right. / Durchbrochen mit Laubwerk, in der Mitte Medaillon mit Porträt von Hermes im Profil nach rechts.

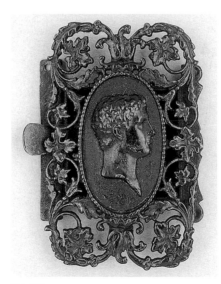

Cat. 559

Cat. 558

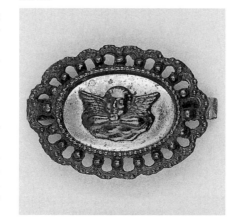

1820-30. – F./G. KPEG Berlin or/oder Glei-witz. – 4.8 x 3.6 cm (1 7/8 x 1 7/16 in.). – 19.5 g.
Lamprecht 526S, Photo 52. – Inv. 1986.329.4.
Lit.: H. v. Sp., frontispiece/Frontispiz. – Simpson, 144, fig./Abb. 129.

560 Clasp / Verschlußstück
Pierced wave-and-bead motif, in the middle the portrait head of Anton, King of Saxony (1755-1836; 1827-30 King) in profile

Cat. 560

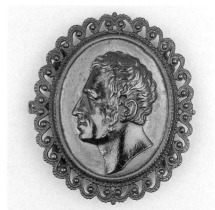

Cat. 561

Cat. 562

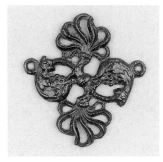
Cat. 563

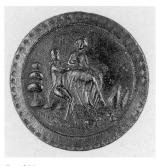
Cat. 564

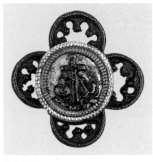
Cat. 565

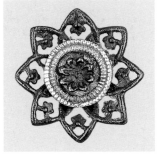
Cat. 566

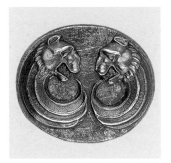
Cat. 567

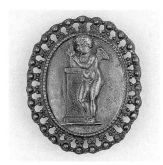
Cat. 568

left on steel plate. / Durchbrochen mit Wellen- und Perlstab-Motiv, in der Mitte ein Porträtkopf Antons, König von Sachsen (1827-30 König), im Profil nach links auf einer Stahlplatte.
1825-30. – F./G. possibly/vielleicht Lauchhammer. – 5.4 x 4.7 cm (2 1/8 x 1 7/8 in.). – 29.0 g.
Lamprecht 492S, Photo 53. – Inv. 1986.329.9.

561 Bracelet Link / Glied eines Armbands
Pierced foliage. / Durchbrochene Ranken.
1830-40. – F./G. possibly/vielleicht Devaranne. – 4 x 2.2 cm (1 9/16 x 7/8 in.). – 2.8 g.
Lamprecht 539S, Photo 54. – Inv. 1986.330.5.
Lit.: H. v. Sp., 300. – Schuette 1916, 286, fig./Abb. 18.

562 Bracelet Link / Glied eines Armbands
Pair of Gothic trefoils with crockets joined by a rosette. / Zwei gotisierende Dreiblätter mit Krabben, in der Mitte Rosette.
1820-30. – F./G. probably/wahrscheinlich

Johann Conrad Geiss. – 3.5 x 1.8 cm (1 3/8 x 11/16 in.). – 1.8 g.
Lamprecht 541S, Photo 54. – Inv. 1986.330.6.
Lit.: Cp./vgl. Clifford, fig./Abb. 48. – H. v. Sp., 300. – Marquardt 1983, 77, fig./Abb. 58. – Schuette 1916, 286, fig./Abb. 18.

563 Necklace Link / Glied einer Halskette
With scrolling foliage and two stylized palmettes. / Mit Voluten und zwei stilisierten Palmetten.
1815-20. – F./G. possibly/vielleicht Devaranne. – 2.9 x 2.6 cm (1 1/8 x 1 in.). – 1.8 g.
Lamprecht 538S, Photo 54. – Inv. 1986.331.5.
Lit.: Cp./vgl. H. v. Sp., 300. – Schuette 1916, 286, fig./Abb. 18.

564 Button / Knopf
Round, with decorative edge, the central medallion with a scene of two seated lovers in a landscape. / Rund mit verziertem Rand, in der Mitte ein Medaillon mit einem Liebespaar in einer Landschaft.
Metal Alloy / Gelbguß. – 1830-40. – F./G.

Horowitz (?). – D. 3.5 cm (1 3/8 in.). – 8.9 g.
Lamprecht 523S, Photo 52. – Inv. 1986.335.1.
Lit.: H. v. Sp., frontispiece/Frontispiz.

565 Cuff Link / Manschettenknopf
The central medallion with the symbols of faith, love, and hope – a cross, heart, and anchor – mounted on a polished steel plate and set in gold, surrounded by four Gothic tracery elements. / In der Mitte ein Medaillon mit den Symbolen für Glaube, Liebe und Hoffnung – Kreuz, Herz und Anker – auf einer polierten Stahlplatte in Gold gefaßt, umgeben von vier gotisierenden Maßwerk-Motiven.
1820-30. – F./G. KPEG Berlin or/oder Gleiwitz. – D. 1.6 cm (5/8 in.). – 1.5 g.
Lamprecht 535S, Photo 54. – Inv. 1986.335.2.
Lit.: H. v. Sp., 300.

566 Cuff Link / Manschettenknopf
Star-shaped with pierced points, the central rosette set in gold. / In der Form eines Sterns mit durchbrochenen Spitzen, in der Mitte eine Rosette in Gold gefaßt.

1820-30. – F./G. Horowitz (?). – D. 1.4 cm (9/16 in.). – 1.2 g.
Lamprecht 536S, Photo 54. – Inv. 1986.335.3.
Lit.: H. v. Sp., 300. – cp./vgl. Schmutter-meier, 67, no. 115.

567 Jewelry Fragment / Schmuckele-ment
Oval, with a silver overlay of two Etruscan lions. / Oval mit silbernem Überzug in Form von zwei etruskischen Löwen.
First half of the 19th century / 1. Hälfte des 19. Jh. – 1.8 x 2.2 cm (11/16 x 7/8 in.). – 6.4 g.
Lamprecht 551S. – Inv. 1986.336.6.

568 Jewelry Fragment / Schmuckele-ment
Oval, with a pierced and beaded frame, the central medallion with the figure of a winged cherub standing at an altar. / Oval, durch-brochen mit Perlstabverzierung, in der Mit-te ein Medaillon mit einem stehenden ge-flügelten Putto neben einem Altar.
1810-20. – F./G. KPEG Berlin. – 3.2 x 2.7 cm (1 1/4 x 1 1/16 in.). – 6.6 g.
Lamprecht 524S, Photo 52. – Inv. 1986.336.9.
Lit.: H. v. Sp., frontispiece/Frontispiz.

569 Bracelet Link / Glied eines Arm-bands
The square frame of pierced scrolling foli-age, with an empty central oval medallion. / Rechteckiger durchbrochener Rahmen aus Voluten, in der Mitte ein leeres ovales Me-daillon.
1810-20. – F./G. KPEG Berlin or/oder Glei-witz. – 2.4 x 2.3 cm (15/16 x 7/8 in.). – 2.1 g.
Lamprecht 525S, Photo 52. – Inv. 1986.336.11.
Lit.: H. v. Sp., frontispiece/Frontispiz.
The central oval medallion originally held a cast relief. / Ursprünglich mit einem Relief in der Mitte.

570 Jewelry Fragment / Schmuckele-ment
Five pierced elements with Gothic arches and quatrefoils extend from a middle sec-tion richly decorated with foliate motifs (the lower section is broken off), the central me-dallion with cross, heart, and anchor on a steel plate in gold mount. / Jeweils fünf durchbrochene Lanzettblätter erstrecken sich von einem reich mit Pflanzen verzierten Mittelteil nach oben und unten (die unteren weggebrochen); in der Mitte ein Medaillon

Cat. 569

Cat. 570

mit Kreuz, Herz und Anker auf Stahlplatte in Gold gefaßt.
1820-30. – F./G. Johann Conrad Geiss. – 6 x 3.2 cm (2 3/8 x 1 1/4 in.). – 9.3 g.
Inv. 1986.1168.
Purchased by ACIPCO in 1961 as an ad-dition to the Lamprecht Collection. / Von ACIPCO 1961 als Zusatz zur Lamprecht-Sammlung angekauft.

571 Jewelry Fragment / Schmuckele-ment
Skull and crossbones. / Totenkopf mit ge-kreuzten Knochen.
First half of the 19th century / 1. Hälfte des 19. Jh. – 1.6 x 1.6 cm (5/8 x 5/8 in.). – 0.7 g.
Lamprecht 545S. – Inv. 1986.336.4.

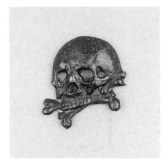

Cat. 571

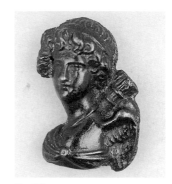

Cat. 572

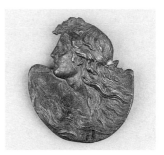

Cat. 573

572 Jewelry Fragment / Schmuckele-ment
In the shape of an angel to be applied to a small medallion / Relief einer Engelsbüste zum Auflegen auf ein Plättchen.
1810-20. – F./G. KPEG Berlin or/oder Glei-witz. – 2.5 x 1.6 cm (1 x 5/8 in.). – 4.6 g.
Lamprecht 511S, Photo 55. – Inv. 1986.495.54.
Lit.: Tewes, 45, no. 23 (Used on a bracelet / Verwendung bei einem Armband).

573 Button / Knopf
In the shape of a portrait bust of a woman in profile left. / In Form des Brustbilds einer Frau im Profil nach links.

Cat. 574

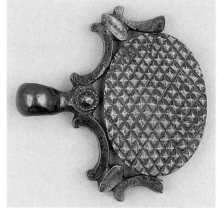

Cat. 575 (a)

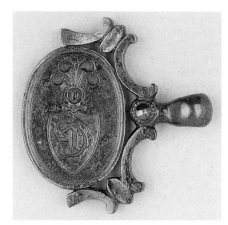

Cat. 575 (b)

End of the 19th century (?). / Ende des 19. Jh.
(?). – 2.6 x 2.2 cm (1 x 7/8 in.). – 2.7 g.
Lamprecht 520S, Photo 52. – Inv.
1986.495.55 b.
Lit.: H. v. Sp., frontispiece/Frontispiz.

574 Seal / Petschaft
With bust of Napoleon I Bonaparte as grip. /
Mit Büste Napoleon I. Bonaparte als Griff.
1815-25. – F./G. KPEG. – H. 3.2 cm (1 1/4
in.); D. 2.7 cm (1 1/16 in.). – 23.0 g.
Lamprecht 14. – Inv. 1986.224.3.
Lit.: Cat. Leipzig 1915, 116, no. 29.

575 Seal / Petschaft
Ornate grip with an oval plate, on it a shield
and feathered helmet, and the initial "D". /
Verzierter Griff mit ovaler Platte, darauf
ein Wappenschild und Helm mit Feder und
die Initiale „D".
1810-30. – F./G. KPEG. – 3.5 x 3.5 cm
(1 3/8 x 1 3/8 in.). – 16.0 g.
Lamprecht 555S. – Inv. 1986.336.7.

Cat. 576

Cat. 577

576 Seal / Petschaft
The grip in the form of the conjoined heads
of six bearded men, on slender foot, the plate
with the initials "JN". / Der Griff in Form
von sechs ineinanderübergehenden bärtigen
Männerköpfen, auf schmalem Fuß, die Plat-
te mit den Initialen „JN".
First quarter of the 19th century / 1. Viertel
des 19. Jh. – F./G. KPEG. – H. 8.2 cm (3 1/4
in.); D. 3.7 cm (1 7/16 in.). – 147.9 g.
Lamprecht 227. – Inv. 1986.338.1.
Lit.: Cat. Leipzig 1915, 116, no. 23. – Cp./
vgl. Rasl 1980, no. 119, fig./Abb. 60.

577 Seal / Petschaft
The grip of two interlaced scrolls, the oval
plate inscribed with an urn, winged head of
Chronos, and the initials "CB". / Der Griff
in Form von zwei verschlungenen Voluten,
die ovale Platte mit Urne, geflügeltem Kopf
von Kronos und den Initialen „CB".
First quarter of the 19th century / 1. Viertel
des 19. Jh. – F./G. Horowitz (?). – 3.5 x 2.4 x
2.2 cm (1 3/8 x 15/16 x 7/8 in.). – 19.3 g.
Lamprecht 230. – Inv. 1986.338.4.

578 Seal / Petschaft
The octagonal grip tapered (cp. Cat. 579),
the oval plate with the head of Hebe. / Sich
verjüngender achtseitiger Griff (wie Cat.
579), die ovale Platte mit dem Kopf der
Hebe.
1820-40. – F./G. Horowitz (?). – 4.1 x 2.3 x
1.9 cm (1 5/8 x 7/8 x 3/4 in.). – 29.3 g.
Lamprecht 231. – Inv. 1986.338.5.

579 Seal / Petschaft
The octagonal grip tapered (cp. Cat. 578), the oval plate with the head of Euripides. / Sich verjüngender achtseitiger Griff (wie Cat. 578), die ovale Platte mit dem Kopf von Euripides.
1820-40. – F./G. Horowıtz (?). – 4.3 x 2.5 x 1.9 cm (1 11/16 x 1 x 3/4 in.). – 33.6 g.
Lamprecht 232. Inv. 1986.338.6.

580 Seal / Petschaft
The tapered, block grip with truncated edges, the oval plate with a ship, a cross, and an anchor, and the initials *"JAO"* (ligated) within an oval, with illegible inscrip-

tion. / Sich verjüngender quadratischer Griff mit gefasten Kanten, die ovale Platte mit einem Schiff, Kreuz und Anker sowie den Initialen „JAO" (ligiert) innerhalb eines Ovals, mit unleserlicher Inschrift.
1830-40. – F./G. Horowitz (?). – 5.4 x 2.3 x 2.1 cm (2 1/8 x 7/8 x 13/16 in.). – 108.9 g.
Lamprecht 233. – Inv. 1986.338.7.

581 Seal / Petschaft
The grip octagonal, the oval plate inscribed with a shield and Mercury helmet, and laurel branches leaning against a cask, with the initial *"J"*. On the cask on both sides of an anchor shank the initials *"P"* (*"B"*?) and

"B". / Achtseitiger Griff, die ovale Platte mit Schild, Merkurhelm, Lorbeerzweigen, Faß und dem Initial „J". Auf dem Faß beidseitig eines Ankerschafts die Initialen „P" („B"?) und „B".
1820-30. – F./G. Horowitz (?). – 5.3 x 2.3 x 2 cm (2 1/16 x 7/8 x 13/16 in.). – 67.8 g.
Lamprecht 234. – Inv. 1986.338.8.

582 Seal / Petschaft
The grip octagonal, the oval plate inscribed with a coat of arms and helmet, a shield and helmet, with a beaming sun. / Achtseitiger, leicht bauchiger Griff, die ovale Platte mit

Cat. 578 (a)

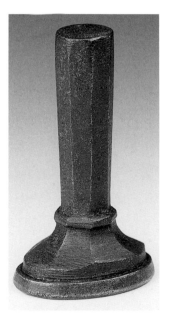

Cat. 579 (a)

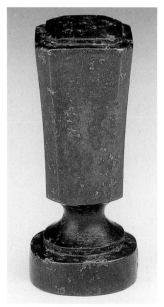

Cat. 580 (a)

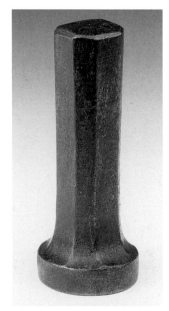

Cat. 581 (a)

Cat. 578 (b)

Cat. 579 (b)

Cat. 580 (b)

Cat. 581 (b)

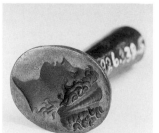

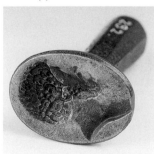

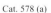

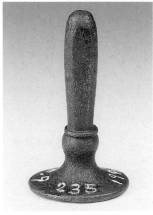

Cat. 582 (a)

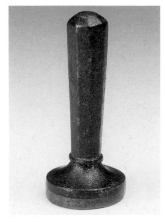

Cat. 583 (a)

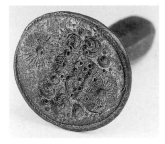

Cat. 582 (b)

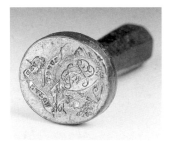

Cat. 583 (b)

Cat. 584

Sculpture / Skulpturen (Cat. 585-651)

585 Gebhard Leberecht Blücher, Prince of Wahlstatt (1742-1819), Prussian Field Marshal / Fürst von Wahlstatt, preußischer Feldmarschall
Bust on tall plinth. / Büste auf hohem Sokkel.
Ca. 1820. – Mod. after a model (1815) by / nach einem Modell von Christian Daniel Rauch. – F./G. KPEG Berlin. – H. 28.2 cm (11 1/8 in.); base/Sockel 9.9 x 9.9 cm (3 7/8 x 3 7/8 in.). – 5 pcs./T.
Lamprecht 36, Photo 24. – Inv. 1986.223.3.
Lit.: Aus einem Guß, 94, no. 177. – Cat. Köln 1979, no. 294. – Cat. Leipzig 1915, 116, no. 20. – Ruthenberg, pl./Taf. 37. – Schmidt 1976, fig./Abb. 41. – Schmidt 1981, 98, fig./Abb. 88.

586 Robert Blum (1807-48), Leader of Liberal Movement in Saxony During the Revolutions of 1848 / politischer Führer während der national-liberalen Bewegung in Sachsen 1848
(Fig. p./Abb. S. 204)
Bust / Büste.
1845-55. – Mod. Friedrich Malchow. – F./G. Zimmermann. – H. 11 cm (4 5/16 in.). – Obv./Vs.: Ins. „Robert Blum". – Rev./Rs.: Sign. „Malchow fct. Zimermann".
Lamprecht 132. – Inv. 1986.223.11.
Lit.: Cat. Leipzig 1915, 117, no. 35. – Hanauer Eisen, 33, no. 2.3. – Reuel 2004, 78 f., fig./Abb. 3.
Blum was a member of the Frankfurt National Assembly in 1848. When revolutionary fighting broke out in Vienna, he traveled there and joined the revolutionary forces. Because of this he was arrested, sentenced to death, and shot on November 9. / Blum war Mitglied der Frankfurter Nationalversammlung und wurde aufgrund seiner Beteiligung an den Kämpfen der Aufständischen in Wien zum Tode verurteilt und am 9. November erschossen.
Friedrich Malchow (1815-88) was a modeler and chaser at the Berlin foundry, and also worked for Seebass and later for Zimmermann in Hanau, where he relocated in 1840. From 1834 to 1836 he studied with the sculptor Theodor Kalide. Works by Malchow were shown at the Berlin Academy exhibitions of 1836, 1842, and 1844. / Friedrich Malchow war Modelleur und Ziseleur bei der Berliner Eisengießerei, arbeitete aber auch für Seebaß und später für

einem Wappen und Helm, Schild und Helm, mit strahlender Sonne.
Ca. 1850. – 3.9 x 2.2 x 2.0 cm (1 9/16 x 7/8 x 13/16 in.). – 16.2 g.
Lamprecht 235. – Inv. 1986.338.9.

583 Seal / Petschaft
The octagonal grip tapered, the brass plate inscribed with a shield and the initials "LTG" (ligated), with emblems of art and science, a ribbon, and the motto "KUNST / UND / NATUR". / Sich verjüngender achtseitiger Griff, die Messingplatte mit einem Schild und den Initialen „LTG" (ligiert) sowie mit Symbolen für Kunst und Wissen-

schaft, einem Band und dem Motto „KUNST / UND / NATUR".
1810-20. – F./G. KPEG. – 6.5 x 2.9 x 2.5 cm (2 9/16 x 1 1/8 x 1 in.). – 87.1 g.
Lamprecht 236. – Inv. 1986.338.10.

584 Seal / Petschaft
The grip octagonal with a knob in the form of a mushroom, the oval plate inscribed with the initials "EM". / Achtseitiger Griff mit dem Ende in Form eines Pilzes, die ovale Platte mit den Initialen „EM".
1810-20. – F./G. KPEG. – 8.4 x 2.4 x 2.1 cm (3 5/16 x 15/16 x 13/16 in.). – 88.0 g.
Lamprecht 256. – Inv. 1986.338.11.

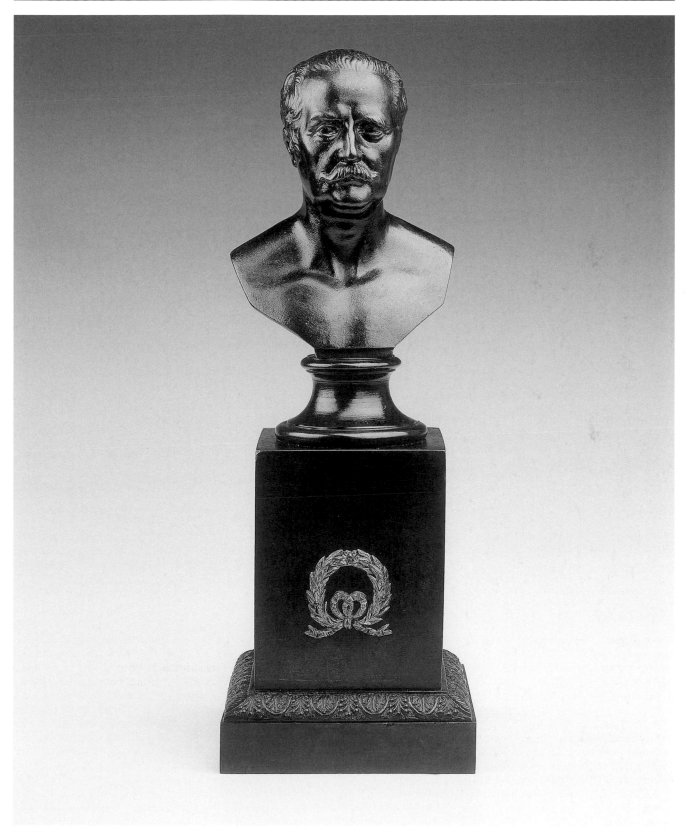

Cat. 585

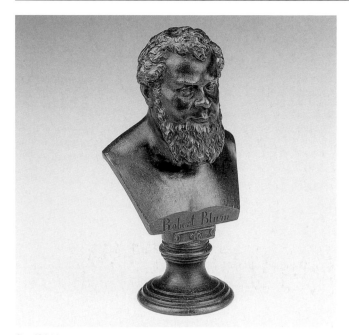

Cat. 586 (a)

Cat. 586 (b; Detail, Rev./Rs.)

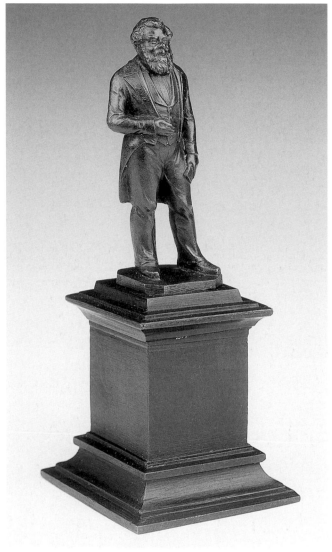

Cat. 587

Zimmermann in Hanau, wohin er nach 1840 umsiedelte. 1834 bis 1836 erfolgte seine Ausbildung als Bildhauer bei Theodor Kalide. Entwürfe von Malchow wurden auf den Berliner Akademie-Ausstellungen 1836, 1842 und 1844 gezeigt.

587 Robert Blum
Statuette on tall plinth / auf hohem Sockel. Third quarter of the 19th century / 3. Viertel des 19. Jh. – H. 13.9 cm (5 1/2 in.); base/ Sockel 5.5 x 5.5 cm (2 3/16 x 2 3/16 in.). Lamprecht 131. – Inv. 1986.234.
Lit.: Aus einem Guß, 210, no. 905. – Cat. Leipzig 1915, 117, no. 36.

588 Napoleon I Bonaparte, Emperor of the French (1769-1821; 1804-14 Emperor) / Napoleon I. Bonaparte, Kaiser der Franzosen (1804-14 Kaiser)
Statuette on tall plinth / auf hohem Sockel. 1820-30. – F./G. KPEG Berlin or/oder Gleiwitz. – H. 30.7 cm (12 1/16 in.); base/Sockel 9.2 x 9.2 cm (3 5/8 x 3 5/8 in.).
Lamprecht 10, Photo 21-22. – Inv. 1986.224.1.
Lit.: Arenhövel 1982, 113, no. 230. – Cat. Leipzig 1915, 115, no. 19 (here erroneously attributed to Leonhard Posch / hier irrtümlich Leonhard Posch zugeschrieben). – Schuette 1916, 282, fig./Abb. 2.

589 Napoleon I Bonaparte, Emperor of the French / Napoleon I. Bonaparte, Kaiser der Franzosen
Statuette on tall plinth with an eagle on the front and a large "N" on each of the sides. / auf hohem Sockel mit einem Adler an der Vorderseite und jeweils einem großen „N" an den Seitenflächen.
1820-25. – F./G. KPEG Berlin or/oder Gleiwitz. – H. 6.5 cm (2 9/16 in.); base/Sockel 2 x 2 cm (13/16 x 13/16 in.).
Lamprecht 13. – Inv. 1986.224.2.
Lit.: Cp./vgl. Arenhövel 1982, 112, no. 226.

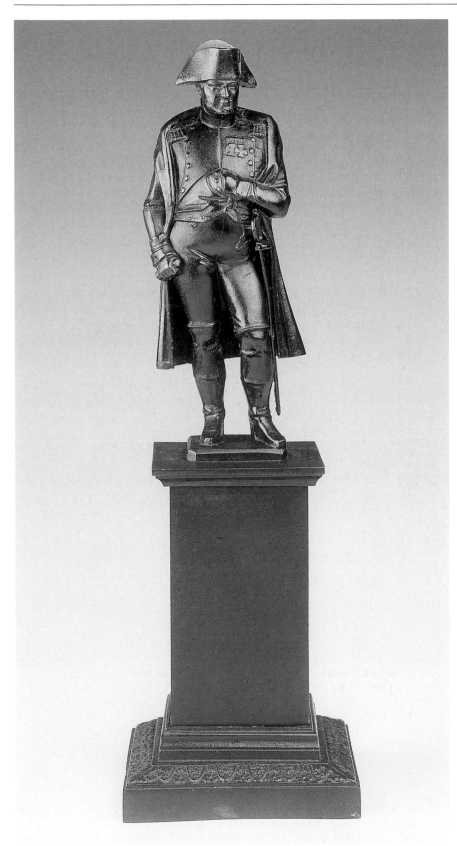

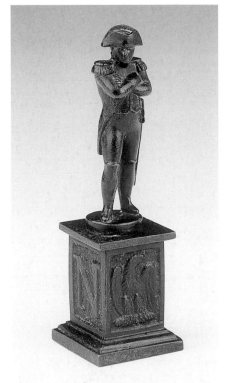

Cat. 589

◀ Cat. 588

Cat. 590

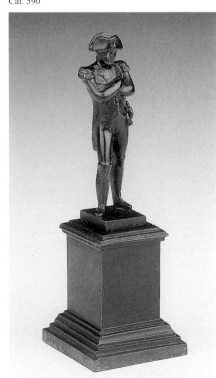

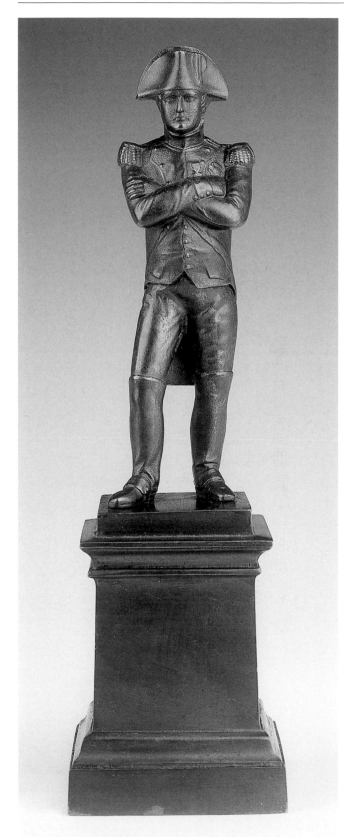

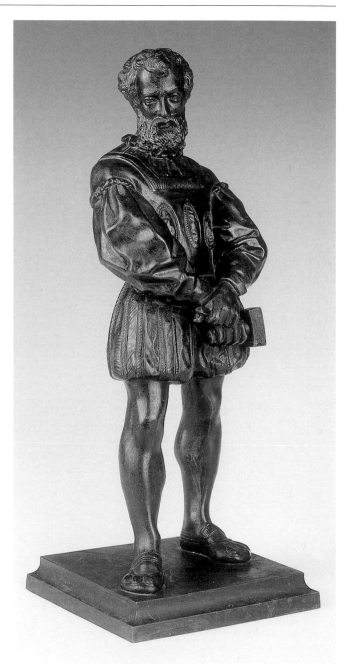

Cat. 592

◀ Cat. 591

590 Napoleon I Bonaparte, Emperor of the French / Napoleon I. Bonaparte, Kaiser der Franzosen (Fig. p./Abb. S. 205)
Statuette on tall plinth / auf hohem Sockel.
1820-25. – Mod. Wilhelm August Stilarsky (?). – F./G. KPEG. – H. 11.9 cm (4 11/16 in.); base/Sockel 4 x 4 cm (1 9/16 x 1 9/16 in.).
Inv. 1962.117. – Gift of / Schenkung von Dr. and Mrs. Maurice Garbáty.
Lit.: Cp./vgl. Arenhövel, 112, no. 226. – Aus einem Guß, 210, no. 913.

591 Napoleon I Bonaparte, Emperor of the French / Napoleon I. Bonaparte, Kaiser der Franzosen
Statuette on tall plinth / auf hohem Sockel.
First quarter of the 19th century / 1. Viertel des 19. Jh. – F./G. probably a private foundry / wahrscheinlich eine private Gießerei. – H. 24.6 cm (9 11/16 in.); base/Sockel 6.9 x 6.9 cm (2 11/16 x 2 11/16 in.). – 3 pcs./T.
Inv. 1962.118. – Gift of / Schenkung von Dr. and Mrs. Maurice Garbáty.
Lit.: Arenhövel 1982, 112, no. 227. – Ostergard 1994, 175, no. 3.

592 Michelangelo Buonarroti (1475-1564), Italian Sculptor, Painter, and Architect / italienischer Bildhauer, Maler und Architekt
Statuette.
Second quarter of the 19th century / 2. Viertel des 19. Jh. – H. 32 cm (12 5/8 in.); base/Sockel 12.4 x 12.4 cm (4 7/8 x 4 7/8 in.).
Lamprecht 249. – Inv. 1986.240.

593 Franz I, Emperor of Austria, King of Bohemia and Hungary (1768-1836; 1804 Emperor; as Franz II Holy Roman Emperor 1792-1806) / Franz I., Kaiser von Österreich, König von Böhmen und Ungarn (1804 Kaiser; 1792-1806 als Franz II. Kaiser des Heiligen Römischen Reiches Deutscher Nation)
Gilt-bronze bust on stepped pedestal with tall plinth of cast iron, on the front the gilded coat of arms of Austria. / Vergoldete Bronzebüste auf vielfach gestuftem Sockel aus Eisenguß, dessen Vorderseite das vergoldete Wappen Österreichs zeigt.
1831-35. – Mod. Joseph Glanz. – F./G. Glanz. – H. 18.3 cm (7 3/16 in.); base/Sockel 9.7 x 9.7 cm (3 13/16 x 3 13/16 in.). – Sign. on back under bust / auf der Rs. unterhalb der Büste „bei / J. Glanz / in / Wien".
Lamprecht 16, Photo 23. – Inv. 1986.223.1.
Lit.: Aus einem Guß, 90, no. 183. – Cat.

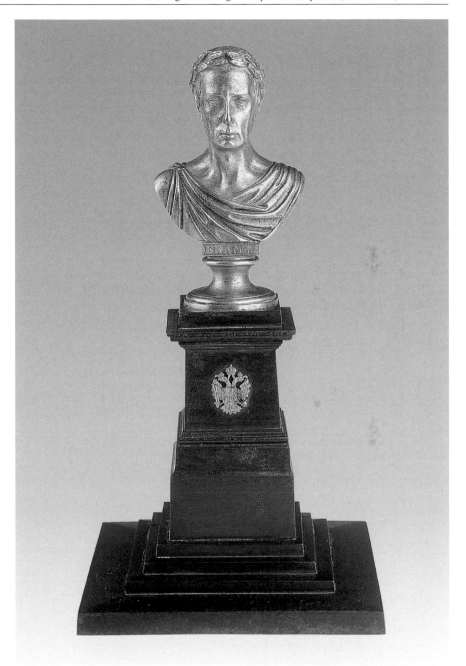

Cat. 593 (a)

Leipzig 1915, 117, no. 43. – Ostergard 1994, 172 f., no. 1. – Schmitz 1917, 54, pl./Taf. 19. – Schuette 1916, 284, fig./Abb. 16.
Glanz moved from Berlin to Vienna in 1831 and opened a bronze and iron foundry. / Glanz zog 1831 von Berlin nach Wien und eröffnete dort eine Bronze- und Eisengießerei. / S. Schmidt 1981, 209 f.

Cat. 593 (b; Detail, Rev./Rs.)

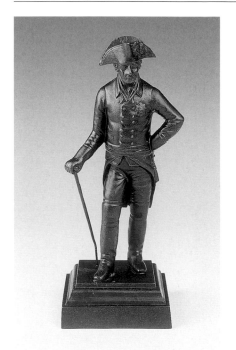

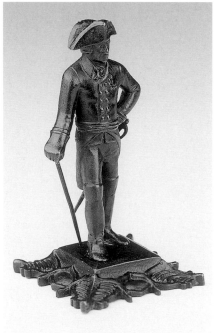

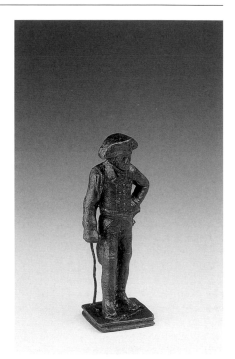

Cat. 594 Cat. 595 Cat. 596

Cat. 597

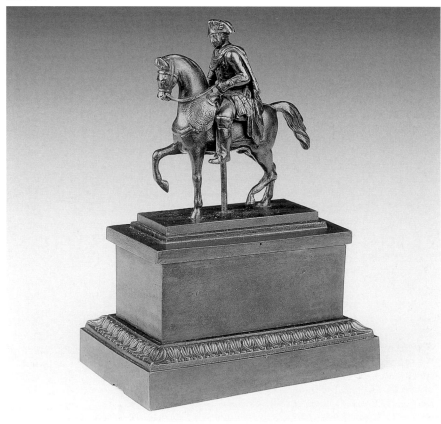

594 Friedrich II, King of Prussia (1712-86; 1740 King) / Friedrich II., König von Preußen (1740 König)
Statuette.
Ca. 1820. – Mod. possibly/vielleicht August Kiss. – F./G. KPEG Berlin or/oder Gleiwitz. – H. 8.4 cm (3 5/16 in.); base/Sockel 7 x 7 cm (2 3/4 x 2 3/4 in.). – 3 pcs./T.
Lamprecht 113, Photo 21 f. – Inv. 1986.226.1.
Lit.: Arenhövel 1982, 105, no. 213. – Bartel 2004, 86, no. 32. – Cat. Leipzig 1915, 115, no. 18. – Hintze 1928a, 78, pl./Taf. VIII, no. 6 (Gleiwitz P.-C. 1847). – Schuette 1916, 282, fig./Abb. 2.
The sword is missing. / Der Degen fehlt.

595 Friedrich II, King of Prussia / Friedrich II., König von Preußen
Statuette.
1830-40. – Mod. possibly/vielleicht August Kiss. – F./G. possibly/vielleicht Devaranne. – H. 7.7 cm (3 1/16 in.); base/Sockel 4.2 x 4.2 cm (1 5/8 x 1 5/8 in.).
Lamprecht 114, Photo 4. – Inv. 1986.226.2.
Lit.: Cat. Leipzig 1915, 116, no. 25.
The size of and decoration on this base relate to that of the statuette in Cat. 609. Both bases have motifs similar to those on the base of a pocket watch holder that can be

attributed to Devaranne. / Nach Maßen und Ornament stimmt dieser Sockel mit dem der Statuette von Cat. 609 überein. Beide Sockel zeigen ähnliche Motive wie der Sockel eines Taschenuhrhalters, der wohl von Devaranne stammt. / (Cp./vgl. Arenhövel 1982, 218, no. 470).

596 Friedrich II, King of Prussia / Friedrich II., König von Preußen
Statuette.
First quarter of the 19th century / 1. Viertel des 19. Jh. – Mod. possibly/vielleicht August Kiss. – H. 4 cm (1 9/16 in.); base/Sockel 1.3 x 1.3 cm (1/2 x 1/2 in.).
Lamprecht 115. – Inv. 1986.226.3.
The small holes in the base suggest that this piece was originally mounted on another object. / Die kleinen Löcher im Sockel lassen vermuten, daß die Statuette ursprünglich auf einem anderen Objekt montiert war.

597 Friedrich II, King of Prussia on Horseback / Friedrich II., König von Preußen zu Pferde
1840-50. – Based on a model by / nach einem Modell von Christian Daniel Rauch. – H. 15.6 cm (6 1/8 in.); base/Sockel 11.4 x 7 cm (4 1/2 x 2 3/4 in.).
Lamprecht 116, Photo 4. – Inv. 1986.226.4.
Lit.: Cp./vgl. Arenhövel 1982, 107, no. 217. – Cat. Leipzig 1915, 117, no. 33. – Ostergard 1994, 174, no. 2.
This model is based on Rauch's monument for Friedrich II in Berlin. / Nach dem von Christian Daniel Rauch errichteten Denkmal für Friedrich II. in Berlin.

598 Friedrich August I, King of Saxony (1750-1827; 1806 King) / Friedrich August I., König von Sachsen (1806 König)
Bust / Büste.
Ca. 1810. – F./G. Lauchhammer. – H. 18.8 cm (7 3/8 in.); base/Sockel 9.7 x 7.4 cm (3 13/16 x 2 15/16 in.). – On the front of the base / Auf der Vorderseite des Sockels „FAR" (ligated/ligiert).
Lamprecht 30, Photo 26. – Inv. 1986.223.2.
Lit.: Aus einem Guß, 209, no. 869. – Cat. Leipzig 1915, 115, no. 11.
At the Peace of Posen on December 11, 1806, Friedrich August joined the Rheinbund, which was founded by Emperor Napoleon of France on July 17, 1806. At the same time, Napoleon made Friedrich August King of Saxony. After the Battle of Leipzig in 1813, at which Friedrich August fought alongside the French and lost, he

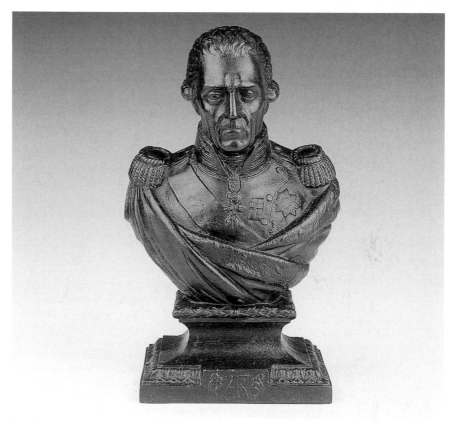

Cat. 598

was captured and imprisoned in Friedrichsfelde near Berlin. / Mit dem Frieden von Posen am 11. Dezember 1806 trat Friedrich August dem am 17. Juli 1806 gestifteten Rheinbund bei und wurde von Napoleon zum König erhoben. Nach der Völkerschlacht bei Leipzig wurde Friedrich August, der an der Seite Napoleons kämpfte und verlor, festgenommen und als Kriegsgefangener nach Friedrichsfelde bei Berlin gebracht.

599 Friedrich Wilhelm III, King of Prussia (1770-1840; 1797 King) / Friedrich Wilhelm III., König von Preußen (1797 König)
(Fig. p./Abb. S. 11)
Bust on tall base. / Büste auf hohem Sockel.
Ca. 1818. – Mod. Wilhelm August Stilarsky after a model (1815) by / nach einem Modell (1815) von Christian Daniel Rauch. – F./G. KPEG Berlin or/oder Gleiwitz. – H. 33.2 cm (13 1/16 in.); base/Sockel 14.5 x 10 cm (5 11/16 x 3 15/16 in.).
Lamprecht 101, Photo 24. – Inv. 1986.223.4.
Lit.: ACIPCO 1941a, fig./Abb. 4. – An-

drews, 426, fig./Abb. 14. – cp./vgl. Aus einem Guß, 94, no. 189. – Bartel 2004, 88, no. 43. – Cat. Leipzig 1915, 114, no. 9. – Ostergard 1994, 181, no. 11. – Schmitz 1917, 54, pl./Taf. 19. – Schuette 1916, 285, fig./Abb. 17.

600 Friedrich Wilhelm III, King of Prussia / Friedrich Wilhelm III., König von Preußen
Statuette.
Ca. 1849. – Mod. after the monument by / nach dem Denkmal von Johann Friedrich Drake. – F./G. KPEG Berlin. – H. 19.6 cm (7 11/16 in.); base/Sockel 7 x 7 cm (2 3/4 x 2 3/4 in.). – 2 pcs./T.
Inv. 1962.119. – Gift of / Schenkung von Dr. and Mrs. Maurice Garbáty.
Lit.: Arenhövel 1982, 109, no. 221.
The surface has a green patina. This model was based on Drake's design for the monument to King Friedrich Wilhelm III in Berlin's Tiergarten. The monument was given by the people of Berlin in gratitude to the late king for converting the former royal

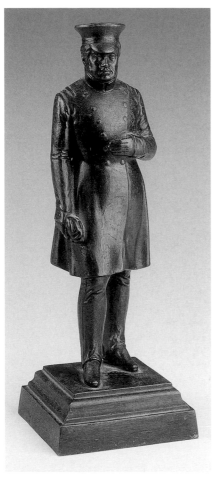

Cat. 600

An article written by Julius Vogel of the Museum der bildenden Künste in Leipzig, published in the Illustrirte Zeitung on March 22, 1906 (p. 451), compares this statuette to Rauch's statuette of Goethe "im Hausrock" and quotes Friedrich Zarncke (Verzeichnis der Originalaufnahmen von Goethes Bildnis, Leipzig 1888): *"Rauch hat noch eine zweite Statuette von Goethe entworfen, die verschollen ist."* The article further states that in 1825 Rauch indicated that he created a second small figure of Goethe, which he sent to Berlin's Gießereischule, and which was shown at the Academy Exhibition in Berlin in 1826. The article goes on to suggest that this model could be an example of Rauch's missing Goethe statuette. /

Ein Artikel von Julius Vogel vom Museum der bildenden Künste in Leipzig in der Illustrirten Zeitung vom 22. März 1906 (S. 451) vergleicht diese Statuette mit der von Rauch entworfenen Statuette von Goethe „im Hausrock" und zitiert Friedrich Zarncke (Verzeichnis der Originalaufnahmen von Goethes Bildnis, Leipzig 1888): *„Rauch hat noch eine zweite Statuette von Goethe entworfen, die verschollen ist."* Der Artikel behauptet ferner, daß Rauch 1825 angab, er habe eine zweite kleine Figur von Goethe geschaffen, die er an die Berliner Gießereischule gesendet habe. Diese wurde auf der Berliner Akademie-Ausstellung 1826 gezeigt. Der Artikel deutet darauf hin, daß die Statuette vielleicht Rauchs verschollene Statuette Goethes sein könnte.

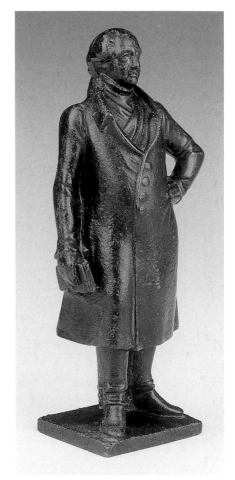

Cat. 601

hunting grounds into a public park. / Die Oberfläche hat eine grüne Patina. Nach Drakes Entwurf für das Denkmal für König Friedrich Wilhelm III. im Berliner Tiergarten. Das Denkmal wurde von Bürgern Berlins gestiftet, als Dank für die Umwandlung des ehemaligen königlichen Jagdgebiets in einen öffentlichen Park durch den verstorbenen König.

601 Johann Wolfgang von Goethe (1749-1832), German Writer and Statesman / deutscher Dichter und Staatsmann
Statuette.
1825/26. – Possibly after a model by / vielleicht nach einem Modell von Christian Daniel Rauch. – H. 15.5 cm (6 1/8 in.); base/Sockel 6 x 3.9 cm (2 3/8 x 1 9/16 in.). Lamprecht 118. – Inv. 1986.228.
Lit.: Cat. Leipzig 1915, 117, no. 41. – Spiegel, 133, fig./Abb. 23.

602 Luise, Queen of Prussia (1776-1810), Wife of Friedrich Wilhelm III / Luise, Königin von Preußen, Gattin des Königs Friedrich Wilhelm III.
(Fig. p./Abb. S. 10)
Bust on tall base. / Büste auf hohem Sockel.
Ca. 1818. – Mod. Wilhelm August Stilarsky after a model by / nach einem Modell von Christian Daniel Rauch. – F./G. KPEG Berlin or/oder Gleiwitz. – H. 32.3 cm (12 11/16 in.); base/Sockel 14.2 x 10 cm (5 9/16 x 3 15/16 in.).
Lamprecht 102, Photo 24. – Inv. 1986.223.5. Lit.: ACIPCO 1941a, Fig./Abb. 4. – Andrews, 426, fig./Abb. 14. – Arenhövel 1982, 107, no. 218. – Aus einem Guß, 94, no. 179. – Bartel 2004, 91, no. 61. – Cat. Leipzig 1915, 114, no. 10. – Ostergard 1994, 180, no. 10. – Schmidt 1981, 96, fig./Abb. 86. – Schmitz 1917, 54, pl./Taf. 19. – Schuette 1916, 285, fig./Abb. 17.

Pendant to Cat. 599. This model was shown at the Academy Exhibition in Berlin in 1818. / Gegenstück zu Cat. 599. Dieses Modell wurde auf der Berliner Akademie-Ausstellung 1818 gezeigt.

603 Martin Luther (1483-1546), German Theologian and Reformation Leader / deutscher Theologe und Reformator
Bust / Büste.
Second quarter of the 19th century / 2. Viertel des 19. Jh. – F./G. KPEG (?). – 15.2 x 8.4 x 7.3 cm (6 x 3 5/16 x 2 7/8 in.).
Lamprecht 246, Photo 26. – Inv. 1986.223.12.
Probably based on Johann Gottfried Schadow's design of 1821 for the Wittenberg Luther Monument. / Wahrscheinlich nach dem Entwurf Johann Gottfried Schadows von 1821 für das Luther-Denkmal in Wittenberg.

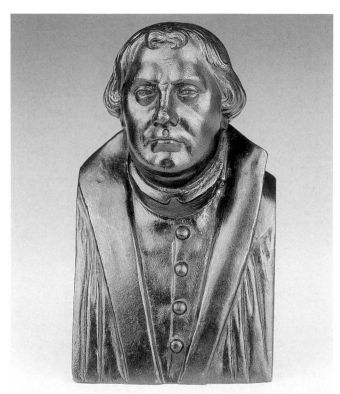

Cat. 603

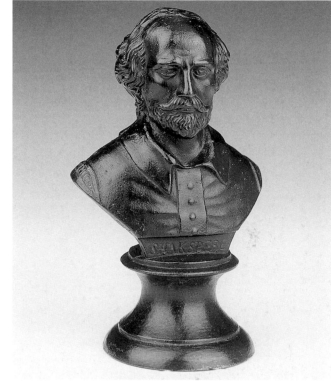

Cat. 605

Cat. 604

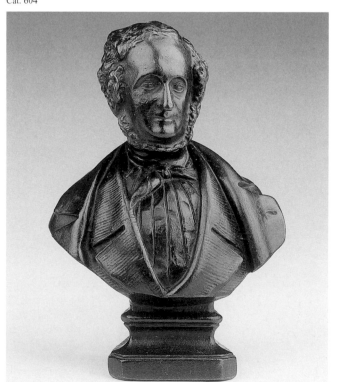

Cat. 606

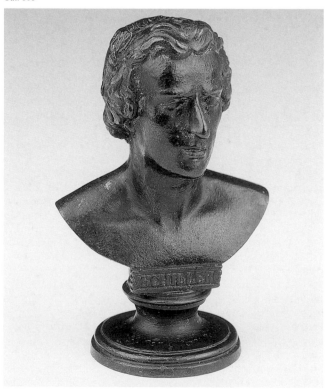

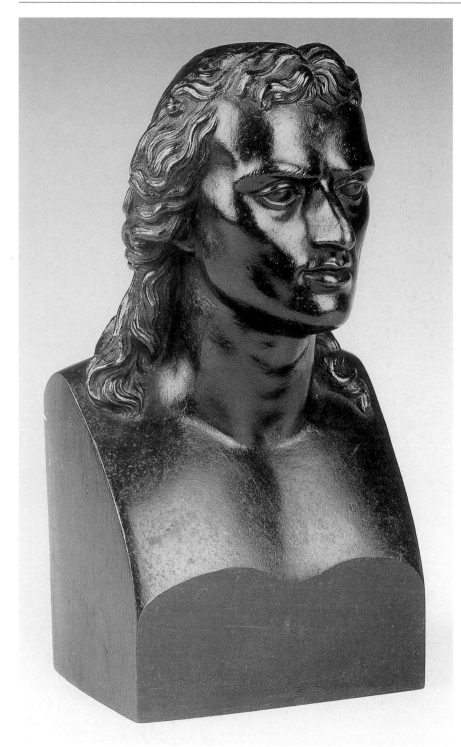

Cat. 607

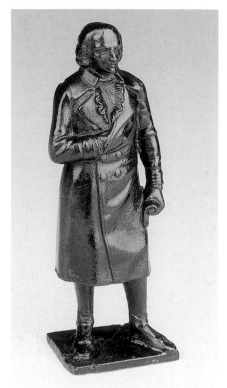

Cat. 608

Cat. 609

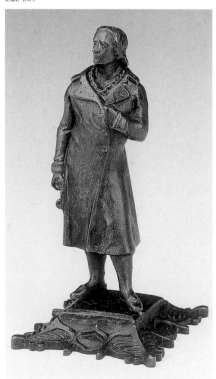

604 Jacob Ludwig Felix Mendelssohn-Bartholdy (1809-47), German Composer, Pianist, and Conductor / deutscher Komponist, Pianist und Dirigent
(Fig. p. /Abb. S. 211)
Bust / Büste.
Late 19th century / Ende des 19. Jh. – F./G.
Gustav Harkort, Leipzig. – 17.8 x 13 x 7 cm
(7 x 5 1/8 x 2 3/4 in.).
Lamprecht 124, Photo 26. – Inv.
1986.223.10.
Lit.: Cat. Leipzig 1915, 115, no. 12.

605 William Shakespeare (1564-1616), English Playwright and Poet / englischer Dramatiker und Dichter
(Fig. p. /Abb. S. 211)
Bust / Büste.
First quarter of the 19th century / 1. Viertel
des 19. Jh. – 14.5 x 8.9 x 6.4 cm (5 11/16 x
3 1/2 x 2 1/2 in.).
Lamprecht 920. – Inv. 1986.223.14.

606 Friedrich von Schiller (1759-1805), German Writer and Historian / deutscher Dichter und Historiker
(Fig. p. /Abb. S. 211)
Bust / Büste. – Obv./Vs. „SCHILLER“.
1810-20. – F./G. KPEG. – 7.3 x 4.7 x 3.5 cm
(2 7/8 x 1 7/8 x 1 3/8 in.). –
Lamprecht 122, Photo 4. – Inv. 1986.223.8.
Lit.: Cat. Leipzig 1915, 118, no. 45.

607 Friedrich von Schiller
Bust / Büste.
Before/vor 1821. – Mod. after the bust
(1805) by / nach der Büste (1805) von Johann Heinrich Dannecker. – F./G. Wasseralfingen. – 27 x 13 x 13.5 cm (10 5/8 x 5 1/8
x 5 5/16 in.).
Lamprecht 123, Photo 25. – Inv. 1986.223.9.
Lit.: Cat. Leipzig 1915, 114, no. 7. – S. Eigler 2003, 708-10. – Eigler 2006, 8, fig./
Abb. 12. – Holst, 294 ff., no. 102. – Ostergard 1994, 190, no. 27.

608 Friedrich von Schiller
Statuette.
Second quarter of the 19th century / 2. Viertel des 19. Jh. – H. 15.4 cm (6 1/16 in.);
base/Sockel 5.2 x 3.9 cm (2 1/16 x 1 9/16 in.).
Lamprecht 119. – Inv. 1986.229.1.
Lit.: Cat. Leipzig 1915, 117, no. 42.

609 Friedrich von Schiller
Statuette.
1830-40. – F./G. possibly/vielleicht Devaranne. – H. 8.6 cm (3 3/8 in.); base/Sockel
4.2 x 4.2 cm (1 5/8 x 1 5/8 in.).

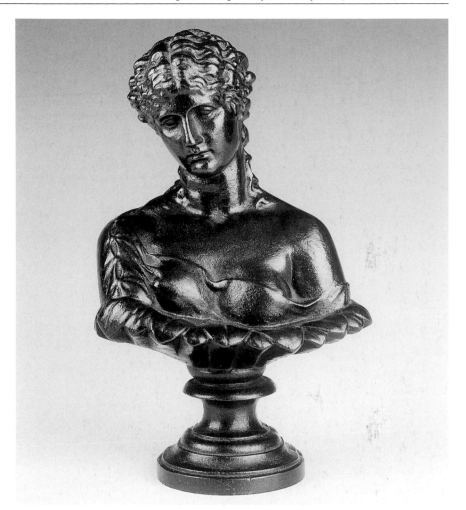

Cat. 611

Lamprecht 120. – Inv. 1986.229.2.
Lit.: Aus einem Guß, 210, no. 906. – Cat.
Leipzig 1915, 116, no. 24.
The base is identical to that of Cat. 595 and
has motifs similar to those of a watch stand
holder made by Devaranne (Arenhövel 1982,
218, no. 470). / Der Sockel ist identisch mit
dem von Cat. 595 und zeigt ähnliche Motive wie der Sockel eines Taschenuhrhalters,
der wohl von Devaranne stammt (Arenhövel
1982, 218, no. 470).

610 Abraham Gottlob Werner (1750-1817), Prussian Mining Inspector and Professor of Mineralogy and Mining Technology at the Freiberg Mining Academy / preußischer Berginspektor und Professor der Mineralogie und des Bergwesens an der Freiberger Bergakademie
Bust / Büste.

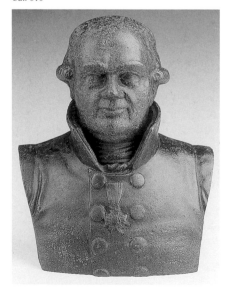

Cat. 610

Ca. 1817. – Mod. Johann Carl Friedrich Riese after a portrait / nach einem Porträt von Gerhard von Kügelgen. – F./G. KPEG Gleiwitz. – 23 x 18.2 x 11.5 cm (9 1/16 x 7 3/16 x 4 1/2 in.).
Lamprecht 106, Photo 25. – Inv. 1986.223.6.
Lit.: Aus einem Guß, 94, no. 172. – Bartel 2004, 94, no. 93. – Cat. Leipzig 1915, 114, no. 8 (here identified as the bust of a Prussian general / hier als Büste eines preußischen Generals identifiziert). – Schmidt 1976, 49. – Schmitz 1917, 54, pl./Taf. 19. – Stummann-Bowert, 35, no. 52, pl./Taf. 8. Hintze refers to another bust of Werner, only instead of a uniform, the sitter wears Roman drapery (Hintze 1928a, 107, pl. 89, no. 1). A bust of Werner was shown at the

1820 Academy Exhibition in Berlin (no. 332) as a Gleiwitz cast. / Hintze nennt eine ähnliche Büste von Werner, nur trägt der Dargestellte hier eine antikisierende Draperie. Eine Büste von Werner wurde 1820 als Gleiwitzer Guß auf der Berliner Akademie-Ausstellung gezeigt (no. 332).

611 Clytie (Fig. p./Abb. S. 213)
Bust / Büste.
Fourth quarter of the 19th century / 4. Viertel des 19. Jh. – F./G. Kasli (?). – 21.9 x 13.9 x 9.9 cm (8 5/8 x 5 1/2 x 3 7/8 in.).
Lamprecht 255. – Inv. 1986.223.13.
Lit.: Cp./vgl. Peshkova, vol./Bd. 2, fig./Abb. 82 f. (for a similar type bust / zu einem ähnlichen Büstentypus).

Clytie, here emerging from a calyx of leaves, was a water nymph loved by the sun god Apollo, who was turned into a sunflower. This bust is a copy of the Roman marble bust of Clytie, dating to about A.D. 40-50, now in the British Museum. The marble bust was acquired by British collector Charles Townley (1737-1805) during a stay in Italy in 1771-74. It was well loved by Townley and extremely popular with the public. It figures prominently in Johan Zoffany's painting of Townley in his gallery in London. / Clytie, hier auf einem Kranz von Blütenblättern, war eine von den vom Sonnengott Apollo geliebten Wassernymphen, die in eine Sonnenblume verwandelt wurde. Die Büste ist eine Kopie der römischen Mar-

Cat. 613

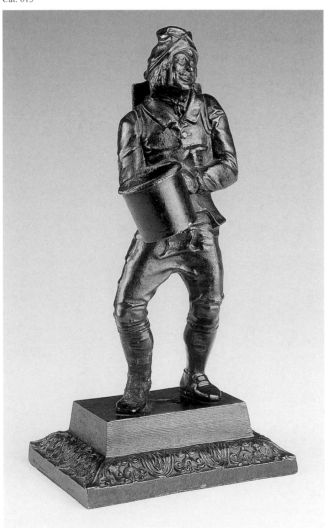

Cat. 612

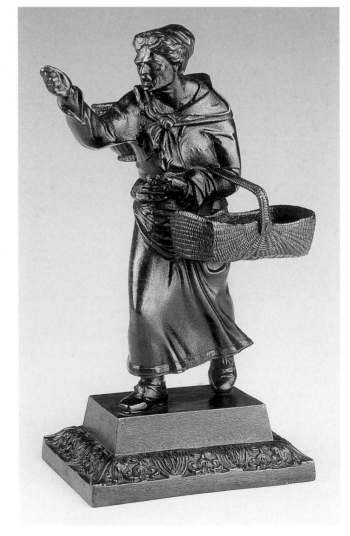

morbüste von Clytie, datiert um 40-50 n. Chr., die heute im British Museum aufbewahrt wird. Die Marmorbüste wurde vom britischen Sammler Charles Townley (1737-1805) während eines Aufenthalts in Italien 1771-74 erworben. Die Büste war bei Townley sehr beliebt und beim Publikum extrem populär. Sie steht im Mittelpunkt des Gemäldes von Johan Zoffany, das Townley's Galerie in London zeigt (S. B. F. Cook, *The Townley Marbles* (London: The British Museum Press, 1985).

612 Peasant Woman / Keifendes Weib
Statuette.
Ca. 1840. – Mod. Johann Carl Wilhelm Kratzenberg. – F./G. Devaranne. – 18.6 x 12.3 x 7 cm (7 5/16 x 4 13/16 x 2 3/4 in.). – 4 pcs./T.
Lamprecht 63, Photo 9. – Inv. 1986.225.1 a.
Lit.: Arenhövel 1982, 114, no. 234. – Aus einem Guß, 96, no. 195. – Cat. Leipzig 1915, 119, no. 62. – H. v. Sp., 299. – Hintze 1928b, 159. – Ostergard 1994, 194, no. 33. – cp./vgl. Schmidt 1981, 208, fig./Abb. 213. – Stamm, 41, fig./Abb. 32. – Stummann-Bowert, 98, no. 45.
This statuette is a pendant to Cat. 613 from a series of "Berliner Straßentypen" or Berlin street peddlers or peasants. The same figure holding a switch in her right hand is in the Hanns Schell Collection in Graz (Langer 2003, 39, no. 40). / Die Statuette ist ein Gegenstück zu Cat. 613 und gehört zu einer Reihe von „Berliner Straßentypen". Die gleiche Statuette mit einer Rute in der Rechten gehört der Hanns Schell Collection in Graz (Langer 2003, 39, no. 40).

613 Peasant Man / Korbträger
Statuette.
Ca. 1840. – Mod. Johann Carl Wilhelm Kratzenberg. – F./G. Devaranne. – 19.1 x 9.7 x 7.1 cm (7 1/2 x 3 13/16 x 2 13/16 in.). – 4 pcs./T.
Lamprecht 64, Photo 9. – Inv. 1986.225.1 b.
Lit.: Cp./vgl. Arenhövel 1982, 114, no. 233. – Cat. Leipzig 1915, 119, no. 61. – H. v. Sp., 299. – Hintze 1928b, 159. – cp./vgl. Schmidt 1981, 208, fig./Abb. 212. – Stamm, 41, fig./Abb. 32.
This statuette is a pendant to Cat. 612 from a series of "Berliner Straßentypen", or Berlin street peddlers or peasants. The figure originally carried a basket over his left arm. / Die Statuette ist ein Gegenstück zu Cat. 612 und gehört zu einer Reihe von „Berliner Straßentypen". Ursprünglich trug der Mann einen Korb über dem linken Arm.

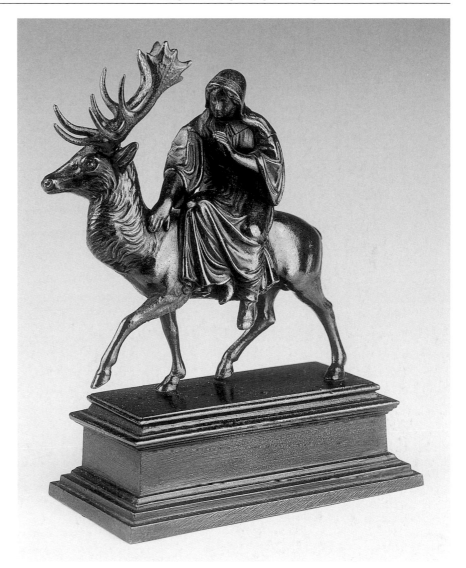

Cat. 614

614 Virgin Laurentia von Tangermünde with Stag / Jungfrau Laurentia von Tangermünde mit Hirsch
Statuette.
After/nach 1834. – Mod. Christian Daniel Rauch. – F./G. KPEG Berlin or/oder Gleiwitz. – 18.4 x 15 x 7.1 cm (7 1/4 x 5 7/8 x 2 13/16 in.). – 4 pcs./T.
Lamprecht 117. – Inv. 1986.227.
Lit.: Arenhövel 1982, 119, no. 240. – Bartel 2004, 94 f., no. 98. – Gleiwitzer Kunstguß 1935, 19. – Hintze 1928a, 96, pl./Taf. XXXXIII, no. 1 (Gleiwitz P.-C. 1847). – Historismus 1989, 147, no. 151a-b. – Ostergard 1994, 193, no. 31. – Schmidt 1981,

97 f., fig./Abb. 87a. – Simson, 322-24, no. 203. – Simpson, 143, fig./Abb. 128. – Stummann-Bowert, 98, no. 41.
Traces of bronze patina. This model, originally created by Rauch in 1832, is shown on the royal Berlin foundry's 1834 New Year's card. According to legend, the virgin Laurentia lived in the village of Tangermünde. One day she lost her way in the forest and prayed for deliverance. In that moment, a stag appeared to carry her back to her village. Rauch learned of this legend while staying in Tangermünde during the autumn of 1831 and from December 1831 to July 1832. /

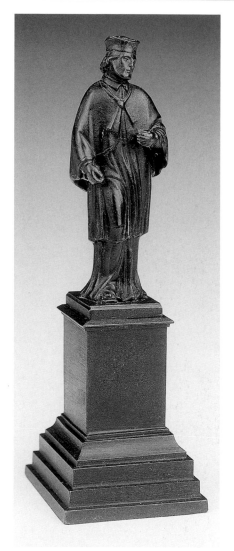

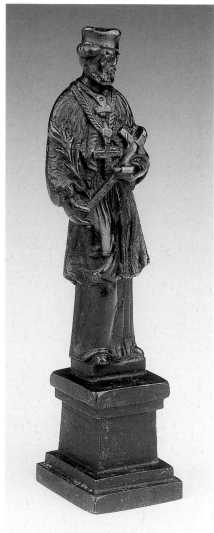

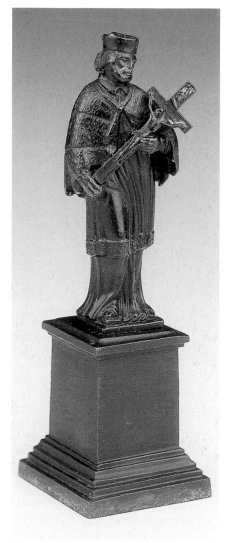

Cat. 615

Cat. 616

Cat. 617

Reste von Bronzepatina. Dieses Modell, ursprünglich von Rauch 1832 entworfen, wurde auf der Neujahrskarte der Königlichen Eisengießerei zu Berlin 1834 abgebildet. Nach einer Legende lebte die Jungfrau Laurentia im Dorf Tangermünde. Eines Tages verirrte sie sich im Wald und betete um Rettung, woraufhin ihr ein Hirsch erschien, der sie zurück ins Dorf trug. Rauch brachte die Legende von seinem Aufenthalt in Tangermünde im Herbst 1831 und von Dezember 1831 bis Juli 1832 mit.

615 St. John of Nepomucene, Patron Saint of Bohemia / Heiliger Johannes von Nepomuk, Schutzheiliger von Böhmen
Statuette on tall base / auf hohem Sockel.

Second quarter of the 19th century / 2. Viertel des 19. Jh. – F./G. KPEG Gleiwitz. – 14.6 x 4.7 x 4.7 cm (5 3/4 x 1 7/8 x 1 7/8 in.). Lamprecht 126. – Inv. 1986.230.1.
Lit.: Aus einem Guß, 211, no. 916. – Hintze 1928a, 83, pl./Taf. XIII, no. 11 (Gleiwitz P.-C. 1847).
This figure originally held a cross in his hands. / Ursprünglich mit Kreuz in den Händen.

616 St. John of Nepomucene / Heiliger Johannes von Nepomuk
Statuette on tall base / auf hohem Sockel.
Second quarter of the 19th century / 2. Viertel des 19. Jh. – 11.5 x 2.8 x 2.8 cm (4 1/2 x 1 1/8 x 1 1/8 in.).

Lamprecht 127. – Inv. 1986.230.2.
This model is a slight variation of the Gleiwitz model in Cat. 615 (cp. also Cat. 617). / Bei dieser Statuette handelt es sich um eine leicht veränderte Nachbildung des Gleiwitzer Modells von Cat. 615 (vgl. auch Cat. 617).

617 St. John of Nepomucene / Heiliger Johannes von Nepomuk
Statuette.
Second quarter of the 19th century / 2. Viertel des 19. Jh. – F./G. KPEG. – 13.3 x 4.1 x 4.1 cm (5 1/4 x 1 5/8 x 1 5/8 in.).
Inv. 1962.116. – Gift of / Schenkung von Dr. and Mrs. Maurice Garbáty.
This model is a slight variation of the Glei-

Fig./Abb. 44 Albert Christoph Reindel, Peter Vischer the Elder / der Ältere, engraving/Kupferstich, 1827 (cp./vgl. Cat. 618).

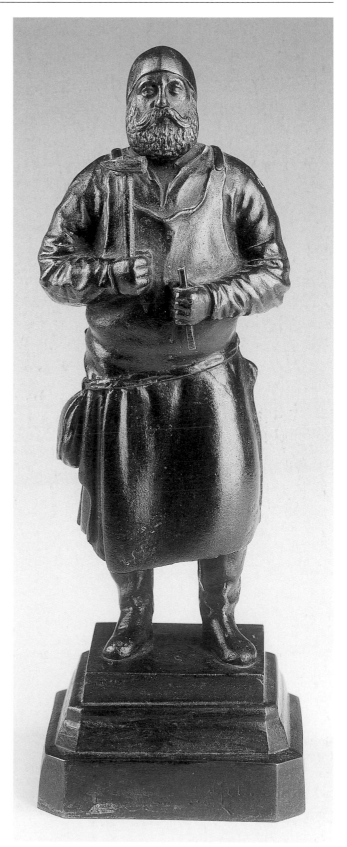

witz model in Cat. 615 (cp. also Cat. 616). /
Bei dieser Statuette handelt es sich um eine
leicht veränderte Nachbildung des Glei-
witzer Modells von Cat. 615 (vgl. auch
Cat. 616).

**618 Peter Vischer the Elder (1460-1529),
Sculptor and Bronze Caster / der Ältere,
Bildhauer und Erzgießer**
Statuette.
Second quarter of the 19th century / 2. Vier-
tel des 19. Jh. – Mod. after the statuette of
Vischer on the Sebaldus Tomb in the Church
of St. Sebald in Nuremberg, possibly after
the engraving by Albert Christoph Reindel
(1827), or after an impression taken by Ja-
kob Daniel Burgschmiet in 1830. / Mod.

Cat. 618 ▶

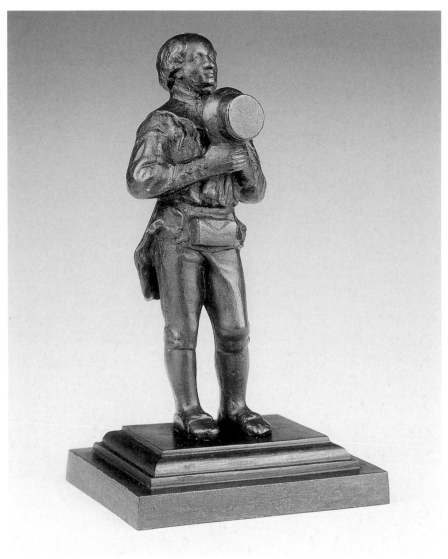

Cat. 619

nach der Statuette Vischers am Sebaldusgrab in der Kirche St. Sebald zu Nürnberg, vielleicht nach dem Kupferstich von Albert Christoph Reindel (1827) oder nach einer Abformung durch Jakob Daniel Burgschmiet von 1830. – 19.5 x 6.9 x 6.9 cm (7 11/16 x 2 11/16 x 2 11/16 in.). – 4 pcs./T.
Lamprecht 128, Photo 26. – Inv. 1986.231.
Lit.: Cp./vgl. Bloch 1990, 164 f., no. 82. – Cp./vgl. Heinz Stafski. *Der jüngere Peter Vischer*. Nuremberg: Verlag Hans Carl, 1962, fig./Abb. 44. – A. Reindel. *Die wichtigsten Bildwerke am Sebaldusgrabe zu Nuernberg von Peter Vischer*, *Achtzehn Blätter*. Nuremberg: Johann Leonhard Schrag, n. d./o. J. [about/um 1835], no p./o. S.
In contrast to the prototype, the tools have been added to this statuette. / Im Gegensatz zum Vorbild sind hier die Werkzeuge ergänzt.

619 Miner / Bergmann
Statuette.
Mid 19th century / Mitte des 19. Jh. – F./G. probably/wahrscheinlich Mariazell. – 21.1 x 12 x 9.2 cm (8 5/16 x 4 3/4 x 3 5/8 in.). – 2 pcs./T.
Lamprecht 129, Photo 26. – Inv. 1986.232.
Lit.: Pichler, fig./Abb. 14 (here described as / hier beschrieben als „Bergmann vor der Anfahrt" and further / und weiter „Der betende Knappe trägt die Züge Peter Tunners, und läßt ein Vorbild Heuchlers erkennen").
In the list of his collection, Lamprecht indicates that this statuette was cast in Tyrol and that he bought it in Innsbruck. / In der Liste seiner Sammlung gibt Lamprecht an, daß die Statuette in Tirol gegossen wurde, und daß er sie in Innsbruck gekauft habe.

620 Frisian Fisherwoman / Friesische Fischerfrau
Statuette.
Third quarter of the 19th century / 3. Viertel des 19. Jh. – H. 3.6 cm (1 7/16 in.).
Lamprecht 133. – Inv. 1986.235 a.
Lit.: Cat. Leipzig 1915, 118, no. 46.
Perhaps originally part of a chess set. / Vielleicht ursprünglich zu einem Schachspiel gehörig.

621 Frisian Fisherman / Friesischer Fischer
Statuette.
Third quarter of the 19th century / 3. Viertel des 19. Jh. – H. 3.7 cm (1 7/16 in.).
Lamprecht 134. – Inv. 1986.235 b.
Lit.: Cat. Leipzig 1915, 118, no. 46.

Cat. 620 Cat. 621 Cat. 622

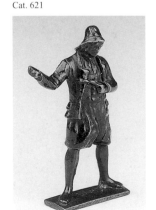

Perhaps originally part of a chess set. / Vielleicht ursprünglich zu einem Schachspiel gehörig.

622 French Peasant / Französischer Bauer
Statuette.
Third quarter of the 19th century / 3. Viertel des 19. Jh. – H. 3.8 cm (1 1/2 in.).
Lamprecht 135. – Inv. 1986.235 c.
Lit.: Cat. Leipzig 1915, 118, no. 48.
This figure was adapted from a chess piece from the set positioning Friedrich II against Napoleon. / Diese Statuette wurde wohl in Anlehnung an eine Figur des Schachspiels Friedrichs II. gegen Napoleon modelliert. / (Hanauer Eisen, 20, Spiel 2).

623 Knight / Ritter
Statuette.
Third quarter of the 19th century / 3. Viertel des 19. Jh. – 18.5 cm (7 5/16 in.); base/Sockel 6.8 x 6.8 cm (2 11/16 x 2 11/16 in.). – 3 pcs./T.
Lamprecht 214. – Inv. 1986.236 a.
Companion piece to / Gegenstück zu Cat. 624.

624 Noblewoman / Edelfrau
Statuette.
Third quarter of the 19th century / 3. Viertel des 19. Jh. – 18.3 cm (7 3/16 in.); base/Sockel 7 x 7 cm (2 3/4 x 2 3/4 in.). – 2 pcs./T.
Lamprecht 215. – Inv. 1986.236 b.

Companion piece to / Gegenstück zu Cat. 623.

625 Woman with a Mandolin / Frau mit Mandoline
(Fig. p. /Abb. S. 220)
Statuette.
Third quarter of the 19th century / 3. Viertel des 19. Jh. – H. 9.9 cm (3 7/8 in.); base/Sockel D. 3.5 cm (1 3/8 in.).
Lamprecht 217. – Inv. 1986.238.

626 French Infantryman with Rifle / Französischer Infantrist mit Gewehr
(Fig. p. /Abb. S. 220)
Statuette.
Third quarter of the 19th century / 3. Viertel

Cat. 624

Cat. 623

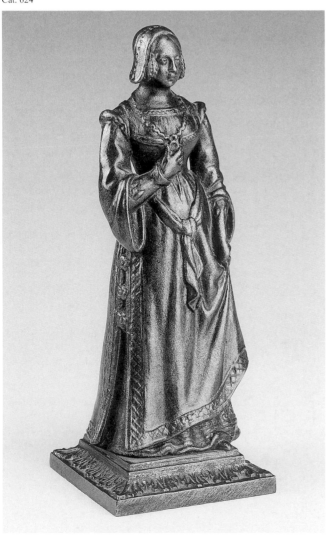

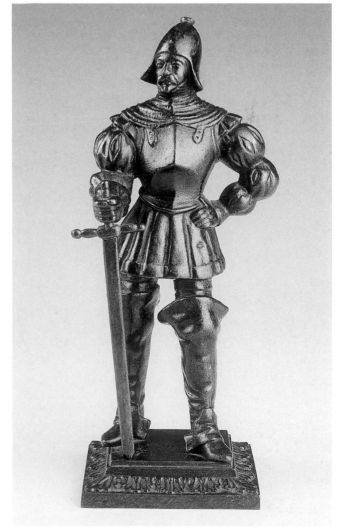

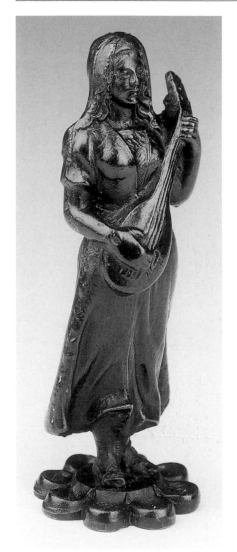

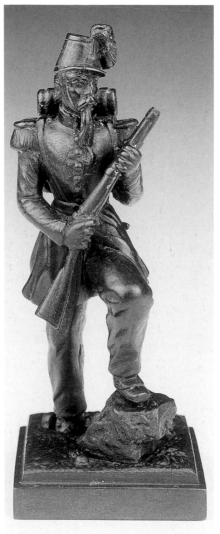

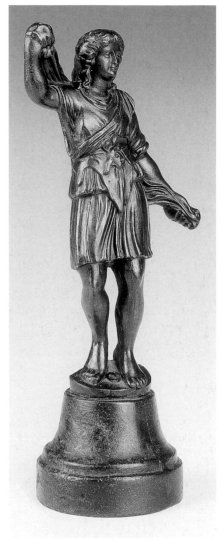

Cat. 625 Cat. 626 Cat. 627

des 19. Jh. – 13 cm (5 1/8 in.); base/ Sockel
5 x 5 cm (1 15/16 x 1 15/16 in.).
Lamprecht 242. – Inv. 1986.239.

627 Fortune / Fortuna
Statuette.
Second quarter of the 19th century / 2. Vier-
tel des 19. Jh. – 26.7 x 13.5 cm (10 1/2 x
5 5/16 in.); base/Sockel D. 8.5 cm (3 3/8 in.).
Lamprecht 273. – Inv. 1986.242.

**628 Cossack on Horseback / Kosak zu
Pferde**
Statuette.
1907. – Mod. Vasily Fedorovich Torokin. –
F./G. Kasli. – H. 21 cm (8 1/4 in.); base/

Sockel 18 x 8.5 cm (7 1/16 x 3 3/8 in.). –
5 pcs./T. – Sign. on base in Cyrillic / auf
der Unterseite in kyrillisch „*COSKAC. 8
BTHMOФΓTBБ*" and with foundry mark /
und mit der Gießereimarke „*KAC. 31907*",
with the Imperial Russian eagle in circle /
mit dem russischen Adler im Kreis; / on side
of base the artist's signature / auf einer Sei-
te des Sockels die Künstlersignatur.
Lamprecht 915. – Inv. 1986.243.
Lit.: Simpson, 143, fig./Abb. 128.

629 Peasant / Bauer
Statuette.
Ca. 1840. – Mod. Johann Carl Wilhelm Krat-
zenberg. – F./G. Devaranne. – H. 18.2 cm

(7 3/16 in.); base/Sockel 9.4 x 6.9 cm
(3 11/16 x 2 11/16 in.). – 4 pcs./T.
Lamprecht 916. – Inv. 1986.244.
Lit.: Aus einem Guß, 96, no. 194. – Oster-
gard 1994, 194, no. 33. – Reichmann, 108,
fig./Abb. 38.
This statuette is from a series of "Berliner
Straßentypen", or Berlin street peddlers or
peasants. It was also cast at Mägdesprung
and is listed in the Preis-Courant of 1886 as
a "toothpick holder." / Die Statuette gehört
zu einer Reihe von „Berliner Straßentypen".
Sie wurde auch in Mägdesprung gegossen
und ist in deren Preis-Courant von 1886 als
„Zahnstocherbehälter" aufgelistet.

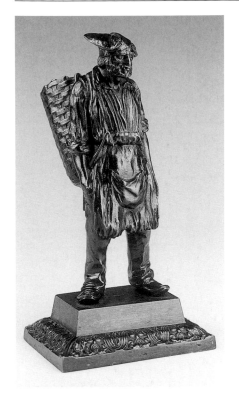

Cat. 629

Cat. 630

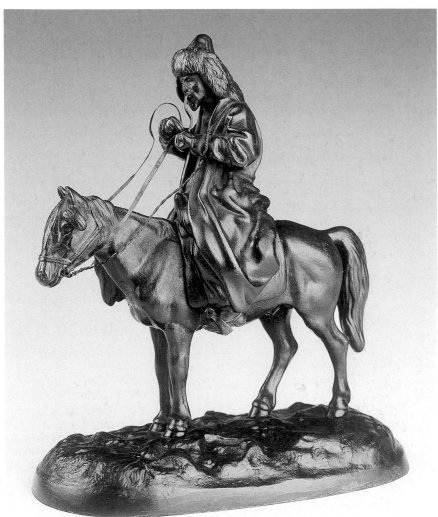

Cat. 628

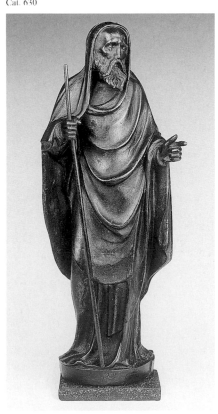

Cat. 631

630 Saint or Prophet / Heiliger oder Prophet
Statuette.
Second half of the 19th century / 2. Hälfte des 19. Jh. – 30 x 11.9 x 6.5 cm (11 13/16 x 4 11/16 x 2 9/16 in.). – 2 pcs./T.
Lamprecht 917. – Inv. 1986.245.
Traces of patina or gilding. / Reste von Patina oder Vergoldung.

631 Matchmaker / Ehevermittler
Three statuettes / Drei Statuetten.
Second quarter of the 19th century / 2. Viertel des 19. Jh. – 3.8 x 3.3 x 2.4 cm (1 1/2 x 1 5/16 x 15/16 in.).
Lamprecht 919. – Inv. 1986.246.

Cat. 632

The figure of the prospective groom was adapted from a chess figure from the set positioning Friedrich II against Napoleon (Hanauer Eisen, 20, Spiel 2). / Die Figur des künftigen Bräutigams wurde wohl in Anlehnung an eine Figur des Schachspiels Friedrichs II. gegen Napoleon modelliert (Hanauer Eisen, 20, Spiel 2).

632 Pair of Eagles / Paar Adler
Statuettes / Statuetten.
Second quarter of the 19th century / 2. Viertel des 19. Jh. – Mod. Christian Friedrich Tieck. – F./G. possibly/vielleicht Mägde-

sprung. – 9.5 x 16 x 5.9 cm (3 3/4 x 6 5/16 x 2 5/16 in.) each.
Lamprecht 283 a-b. – Inv. 1986.247.1 a-b. Another pair of eagles with a different wing position is illustrated in Reichmann (117, fig. 56). S. also Arenhövel 1982 (209, no. 449) for a paperweight with this same eagle, here indicated as a design by Christian Daniel Rauch. / Ein weiteres Paar Adler mit einer anderen Flügelstellung ist in Reichmann (117, Abb. 56) abgebildet. S. auch Arenhövel 1982 (209, no. 449) zu einem Briefbeschwerer mit dem gleichen Adler, hier der Entwurf Christian Daniel Rauch zugeschrieben.

633 Eagle / Adler
Statuette.
First half of the 20th century / 1. Hälfte des 20. Jh. – F./G. Hamilton, Ohio. – 15.2 x 19.3 cm (6 x 7 5/8 in.). – Rev./Rs.: foundry mark "H" in a circle on each wing / Gießereimarke „H" im Kreis auf jedem Flügel and/und „THE HAMILTON FDRY. & MACH. CO. 186-11".
Inv. 00.278. – Anonymous gift. / Unbekannte Stiftung.

634 Eagle / Adler
Statuette.
First half of the 20th century / 1. Hälfte des

Cat. 633a

Cat. 633b

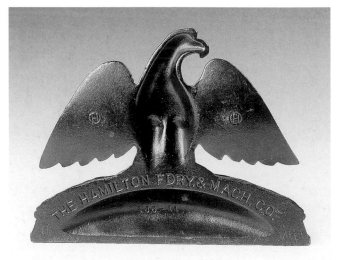

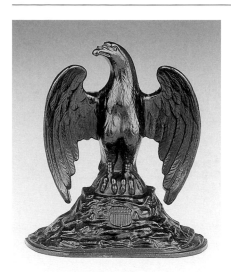

Cat. 634

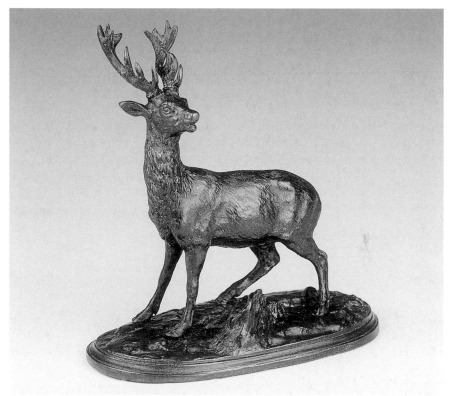

Cat. 635

20. Jh. – F./G. Hamilton, Ohio. – 19.6 x
16.4 cm (7 11/16 x 6 7/16 in.). – Rs./Rs.:
foundry mark *"H"* in a circle on each wing /
Giessereimarke *„H"* im Kreis auf jedem
Flügel and/und *„THE HAMILTON FDRY.
& MACH. CO. 186-11"*.
Inv. 00.279. – Anonymous gift. / Unbekann-
te Stiftung.

635 Stag / Hirsch
Statuette.
1845-55. – Mod. possibly/vielleicht Johann
Heinrich Kureck. – F./G. Mägdesprung. – 13
x 12.2 x 6.7 cm (5 1/8 x 4 13/16 x 2 5/8 in.).
Lamprecht 260. – Inv. 1986.251.
Lit.: Cp./vgl. Reichmann, 124, fig./Abb. 73.

636 Barbary Stallion / Berberhengst
Statuette.
1845-55. – Mod. Johann Heinrich Kureck
after a sculpture by / nach einer Skulptur von
Pierre-Jules Mêne. – F./G. Mägdesprung. –
29.3 cm x 42.1 cm x 14 (11 9/16 x
16 9/16 x 5 1/2 in.).
Lamprecht 276, Photo 28. – Inv. 1986.252.1.
Lit.: Andrews, 427, fig./Abb. 16. – Aus ei-
nem Guß, 220, no. 1602. – Ferner and Ge-
née, 109, fig./Abb. 164. – Howard, 9. – cp./
vgl. Reichmann, 110, fig./Abb. 42. – Simp-
son, 143, fig./Abb. 128.
Johann Heinrich Kureck was an animal
sculptor at Mägdesprung after 1843. This
model was also cast at Kasli Iron Works in
Ekaterinenburg about 1870 and at Mägde-
sprung with the horse enclosed in a small
pen (no. 43 in Mêne's catalogue; Djinn,
Cheval a la Barriere; s. Mackay, The An-

Cat. 636

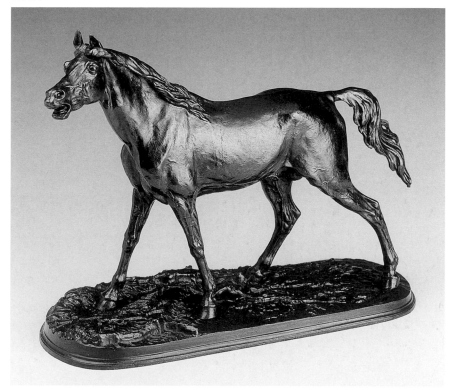

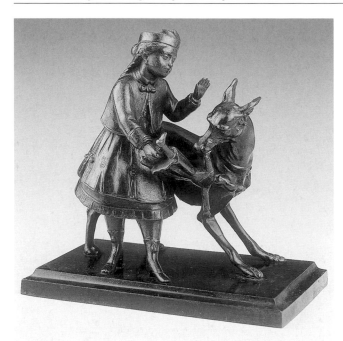

Cat. 639

Cat. 638

Cat. 637

imaliers, 148). A bronze example of this model sold at the auction house Skinner Inc. in Boston on July 13, 2002, lot 392. / Johann Heinrich Kureck war Tierbildhauer in Mägdesprung nach 1843. Dieses Modell wurde auch im Kasliwerk in Ekaterinenburg um 1870 und außerdem in Mägdesprung mit dem Pferd im Gehege gegossen (no. 43 in Mênes Katalog; Djinn, Cheval a la Barriere; s. Mackay, The Animaliers, 148). Ein Exemplar aus Bronze wurde im Auktionshaus Skinner Inc. in Boston am 13. Juli 2002, Lot. 392 verkauft.

Cat. 640

637 Two Horses / Zwei Pferde
Second quarter of the 19th century / 2. Viertel des 19. Jh. – F./G. possibly/vielleicht Mägdesprung. – 22.3 x 27.6 x 11.8 cm (8 3/4 x 10 7/8 x 4 5/8 in.).
Lamprecht 291, Photo 28. – Inv. 1986.252.2.
Lit.: Simpson, 143, fig./Abb. 128.

638 Girl with Dog / Mädchen mit Hund
Statuette.
Third quarter of the 19th century / 3. Viertel des 19. Jh. – 16.8 cm (6 5/8 in.); base/Sockel 16.7 x 9.7 cm (6 9/16 x 3 13/16 in.). – 6 pcs./T.
Lamprecht 292. – Inv. 1986.252.3.
Lit.: Simpson, 143, fig./Abb. 128.
The girl, in regional dress, holds a doll in her right hand with her left arm raised. A large Great Dane holds the doll in its mouth. The dog's tail is missing. / Das Mädchen in Trachtenkleidung hält eine Puppe in der rechten Hand, der linke Arm ist erhoben. Der Hund hält den Arm der Puppe in seinem Maul. Der Schwanz fehlt.

639 Wild Boar / Keiler am Baumstamm
Statuette.
1892/93. – Mod. after a wild boar by / Nach einem Keiler von Pierre-Jules Mêne. – F./G. Ilsenburg or/oder Meves. – 20.9 x 35.3 x 13.9 cm (8 1/4 x 13 7/8 x 5 1/2 in.).
Lamprecht 921. – Inv. 1986.253.
Lit.: Cat. Meves, pl./Taf. 12, no.69. – Ilsenburg b, 57, no. 380. – Ilsenburg c, pl./Taf. 131, fig./Abb. 380.

640 Crucifix / Kruzifix
On tall base. / Auf hohem Sockel.
Ca. 1820. – F./G. KPEG. – 44.7 x 15.2 x 8.5 cm (17 5/8 x 6 x 3 3/8 in.). – 6 pcs./T. – Ins. above/oben „INRI".
Lamprecht 76, Photo 21. – Inv. 1986.326.2.
Lit.: Arenhövel 1982, 121, no. 248. – Aus einem Guß, 97, no. 98. – Gleiwitzer Kunstguß 1935, 27. – Grzimek 1982, 164, no. 45. – Hintze 1928a, 83, pl./Taf. XIII, no. 2 (Gleiwitz P.-C. 1847), 121, pl./Taf. I, no. 7 (Sayn Musterb. 1846).
Probably relacquered. The two wreaths (one wheat, the other grape leaf) symbolize the Eucharist, the body (bread) and blood (wine) of Christ. / Wahrscheinlich neugeschwärzt. Mit den Symbolen der Eucharistie am Sockel, dem Ähren- und dem Weinkranz.

641 Crucifix / Kruzifix
On tall base. / Auf hohem Sockel.
First quarter of the 19th century / 1. Viertel des 19. Jh. – F./G. KPEG. – 20.3 x 7 x 4.3 cm (8 x 2 3/4 x 1 11/16 in.). – Ins. above/oben „INRI".
Lamprecht 156. – Inv. 1986.326.3.

642 Crucifix / Kruzifix
(Fig. p./Abb. S. 226)
On tall base. / Auf hohem Sockel.
First quarter of the 19th century / 1. Viertel des 19. Jh. – F./G. KPEG. – 96.8 x 28 x 16 cm (38 1/8 x 11 x 6 5/16 in.). – Ins. above/oben „INRI".
Lamprecht 201. – Inv. 1986.326.4.

Cat. 641

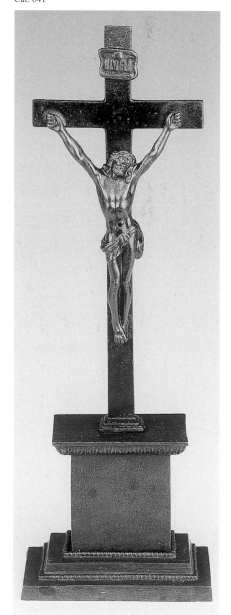

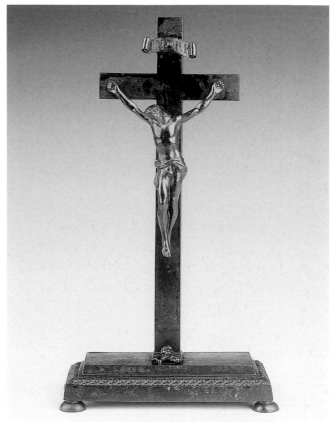

Cat. 643

Cat. 644

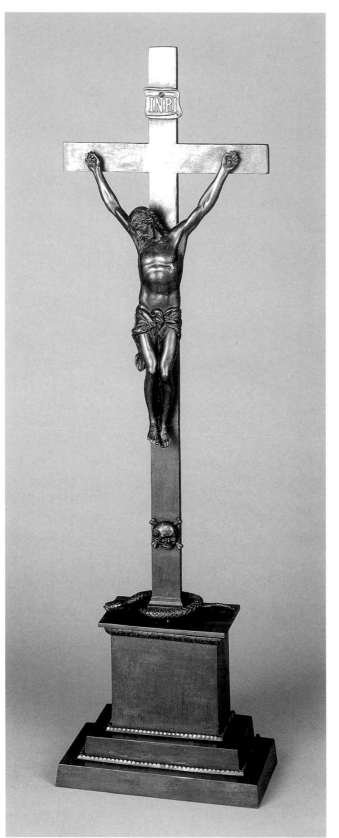

◄ Cat. 642

Cat. 645

Cat. 648

Lit.: Cat. Leipzig 1915, 114, no. 5. – Oster-gard 1994, 195, no. 34.
A skull and crossbones is below Christ and a snake encircles the stand at the base. A brace has been added to the reverse for stability. / Ein Totenkopf vor gekreuzten Knochen auf dem unteren Balken, um des-sen Fuß sich eine Schlange ringelt. Eine Verstärkung wurde auf der Rückseite ange-bracht.

643 Crucifix / Kruzifix
First quarter of the 19th century / 1. Viertel des 19. Jh. – F./G. KPEG (?). – 25.9 x 14.4 x 7 cm (10 3/16 x 5 11/16 x 2 3/4 in.). – Ins. above/oben „INRI".
Lamprecht 258. – Inv. 1986.326.5.
A skull and crossbones lie at the base of the stand. Relacquered. According to Lam-precht's list, this piece was purchased in Vienna / Am Balkenfuß ein Totenkopf mit Knochen. Neu lackiert. Laut Lamprechts Liste wurde dieses Stück in Wien gekauft.

644 Cross / Kreuz
First half of the 19th century / 1. Hälfte des 19. Jh. – F./G. possibly/vielleicht Mariazell. – 23.6 x 12.3 cm (9 5/16 x 4 13/16 in.). Lamprecht 288. – Inv. 1986.326.6.
With central red stone in gilt floral mount. / In der Mitte ein roter Stein in vergoldeter Blumenfassung.

645 Crucifix / Kruzifix
First half of the 19th century / 1. Hälfte des 19. Jh. – F./G. possibly/vielleicht Mariazell. – 33.6 x 13 cm (13 1/4 x 5 1/8 in.). – Ins. above/oben „INRI".
Lamprecht 299. – Inv. 1986.326.7.
Lit.: Ferner and Genée, 59, fig./Abb. 60.

646 Seated Chinese Man / Sitzender Chinese
(Fig. p. /Abb. S. 230)
Statuette.
Second half of the 19th century / 2. Hälfte des 19. Jh. – 9.5 x 11.5 x 7.5 cm (3 3/4 x 4 1/2 x 2 15/16 in.).
Lamprecht 297. – Inv. 1986.509.

647 Squirrel as Nutcracker / Eichhörn-chen als Nußknacker
(Fig. p. /Abb. S. 230)
Mid 19th century / Mitte des 19. Jh. – 18.1 x 13.7 x 6.5 cm (7 1/8 x 5 3/8 x 2 9/16 in.). – 5 pcs./T.
Lamprecht 935. – Inv. 1986.515.
Traces of red paint on squirrel and of green paint on the base. / Reste von roter Farbe am Eichhörnchen und von grüner Farbe am Sok-kel.

648 Porta Nigra in Trier
20th century / 20. Jh. – F./G. Halbergerhüt-te. – 15.2 x 21.3 x 12.7 cm (6 x 8 3/8 x 5 in.). Lamprecht 946. – Inv. 1986.520.
This piece was donated to ACIPCO by W. D. Moore in 1940. The Porta Nigra is a for-tified Roman gateway constructed of sand-stone during the second century A. D. This model is mounted on a wooden base. See also the Sayn New Year's card from 1822 for an image of the Porta Nigra. / Dieses Stück wurde der ACIPCO 1940 von W. D. Moore geschenkt. Die Porta Nigra is ein

Cat. 649

befestigtes römisches Stadttor, das während des 2. Jh. n. Chr. aus Sandstein erbaut wurde. Dieses Modell ist auf einer Holzplatte montiert. Auf der Sayner Neujahrskarte von 1822 ist die Porta Nigra abgebildet.

649 Igel Column near Trier / Igelersäule bei Trier

20th century / 20. Jh. – After a model (1828) by / nach einem Modell (1828) von Heinrich Zumpft. – F./G. Halbergerhütte. – 49.9 x 15.3 x 13.7 cm (19 5/8 x 6 x 5 3/8 in.). – Ins. on base / auf der Vorderseite des Sockels *„RÖMISCHE SÄULE / IGEL BEI TRIER / GEGOSSEN / HALBERGERHÜTTE".*
Lamprecht 947. – Inv. 1986.521.
Lit.: Arenhövel 1982, 115, no. 236. – Beitz, 94 ff. – Cat. Köln 1979, no. 283. – Cat. Rheinromantik 2001, 46 f., no. 27-31. – Ostergard 1994, 192, no. 30. – Osterwald. – Schmidt 1981, 214, fig./Abb. 215. – Spiegel 1981, 133, fig./Abb. 22.
This piece was donated to ACIPCO by W. D. Moore in 1940. The Igel Column was established as a monument to Aventinus and Securus Secundinus during the third century A. D. Zumpft submitted his model of the column to the Berlin Academy, which named him "akademischer Künstler" on May 9, 1829. Osterwald only refers to bronze and plaster copies of this model (p. 60). It is unknown when castings in iron were first produced (bronze castings were produced at the Sayn foundry). In 1875 – while Zumpft lived in Kassel and was encouraged to create copies of his models "in Gyps oder Elfenbeinmasse" – there was again no mention of cast-iron examples (*Kunst-Chronik, Beiblatt zur Zeitschrift für bildende Kunst*, X, no. 13, 1875, 204). / Dieses Exemplar wurde der ACIPCO 1940 von W. D. Moore geschenkt. Die Säule war während des 3. Jhs. n. Chr. als Denkmal für Aventinus und Securus Secundinus errichtet worden. Zumpft legte sein Modell der Königlichen Akademie der Künste in Berlin vor, die ihn daraufhin am 9. Mai 1829 zum „akademischen Künstler" ernannte. Bei Osterwald ist allerdings nur von Bronze- und Gipsabgüssen die Rede (S. 60). Wann die Abformung in Eisen aufgenommen wurde, ist unbekannt (die Bronzeabgüsse wurden in Sayn angefertigt). 1875 – als Zumpft in Kassel ansässig war und zu einer Subskription von Abgüssen *„in Gyps oder Elfenbeinmasse"* aufgefordert wurde – war von Eisengüssen ebenfalls nicht die Rede (*Kunst-Chronik, Beiblatt zur Zeit-*

ROEMISCHES DENKMAL IN IGEL,

bei Trier.

MITTAG. MORGEN. MITTERNACHT. ABEND-SEITE.

Fig./Abb. 45 Carl Osterwald, The four sides of the Igel Column / Die vier Seiten der Igeler Säule; lithography/Lithographie, 1829, sign. „*C. Osterwald Arch.cie del.,*" and/und „*Lith. de Engelmann & C.ie*"; in Osterwald, pl./Taf. IV. (s. Cat. 649 and fig. / und Abb. 46).

60

B e m e r k u n g.

Zur Verbreitung des von uns herausgegebenen Modells von dem Römischen Denk-
male in Igel, verfertigen wir nach demselben *Original-Abgüsse* in Bronze und Gyps,
welche mit der grössten Sorgfalt unter unsern Augen ausgeführt werden. Die Bronze-
Abgüsse werden von einer besondern Legirung *rein* und *sehr scharf* gegossen, so dass
alles Ciseliren und Nacharbeiten, wodurch die Treue der Bilder leiden könnte, vermie-
den wird. Da es indessen nur mit grossen Kosten und Schwierigkeiten verbunden seyn
würde, wenn an alle Buchhandlungen zugleich auch Exemplare der Abgüsse versandt
werden sollten, so haben wir an folgenden Orten Niederlagen derselben errichtet:
 Berlin bei Herren Gebrüder Gropius.
 Frankfurt a. M. bei Hrn. C. Jügel.
 Trier bei Hrn. A. Kauth.
 Bonn bei Hrn. A. Marcus.
 Cölln bei Hrn. M. Dumont Schauberg.
 Düsseldorf bei Herren Arnz et Comp.
 Coblenz bei Hrn. Karl Bædeker.
 Sayn bei den Verfassern.
Der Preis von einem Bronze-Abguss ist . . . Preuss. Court. 20 Thlr. —
 » » » » Gyps-Abguss 3 Thlr. 25 Sgr.
 » » der Beschreibung des Monuments nebst Zeichnungen,
 einschliesslich einer lithographirten Abbildung der 4
 Seiten, gezeichnet von George Osterwald, gedruckt bei
 G Engelmann in Paris 2 Thlr. —
 » » der letztern Abbildung allein 1 Thlr. —
Etwaige Liebhaber der Bronze-oder Gypsabgüsse werden gebeten, sich an eine
der obigen Handlungen mit ihren Bestellungen zu wenden, oder auch an die ihnen zu-
nächst gelegene Buchhandlung, die jedoch für ihre Mühe eine billige Vergütung anrech-
nen müsste. Die oben genannten Handlungen sind in den Stand gesetzt, die Abgüsse
ohne irgend eine Vergütung für den obigen Preis zu liefern.
Damit nun aber auch für die Käufer sowohl wie für uns eine Sicherheit bestehe, dass
nur *Original-Abgüsse* in die Hände der Ersteren kommen, so werden wir jeden Abguss
mit einem, mit unserer Namensunterschrift versehenen Scheine in folgender Art begleiten:

Original-Bronze (Gyps-)-Abguss
von einem Modelle
des
RÖMISCHEN DENKMALS IN IGEL
im verjüngten Maasstabe.
Herausgegeben von

Carl Osterwald *Heinrich Zumpft*

schrift für bildende Kunst, X, no. 13, 1875,
204).

650 St. Barbara
Statuette.
Ca. 1950. – Mod. Heinrich Moshage. –
F./G. Buderus. – H. 38 cm (14 15/16 in.). –
Sign. on back of the base / auf der Rs. des
Sockels *"M"* over/über *"H"*; and with Bu-
derus foundry mark / und mit Buderus Gie-
ßereimarke. – Obv. of the hexagonal base
"BARBARA", left and right on the beveled
edge crossed hammer and gad. / Vs. des
sechsseitigen Sockels *„BARBARA"*, links
und rechts an den Schrägseiten Schlägel und
Eisen.
Inv. 00.275. – Anonymous gift. / Unbekann-
te Stiftung.
Lit.: Buderus Kunstguß 1997, 2.

651 Dog's Head / Hundekopf
First half of the 20th century / 1. Hälfte des
20. Jh. – F./G. Hamilton, Ohio. – 7.6 x 5 cm
(3 x 1 15/16 in.). – Rev./Rs.: foundry mark
"H" in a circle / Gießereimarke *„H"* im
Kreis.
Inv. 00.292. – Anonymous gift. / Unbekann-
te Stiftung.

◄ Fig./Abb. 46 Note regarding the market for repro-
ductions of the Igel Column by / Bemerkung über den
Vertrieb von Reproduktionen der Igeler Säule von Carl
Osterwald and/und Heinrich Zumpft, 1829; in Oster-
wald, 60.

Cat. 647

Cat. 646

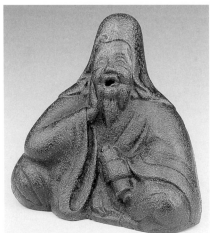

Cat. 651

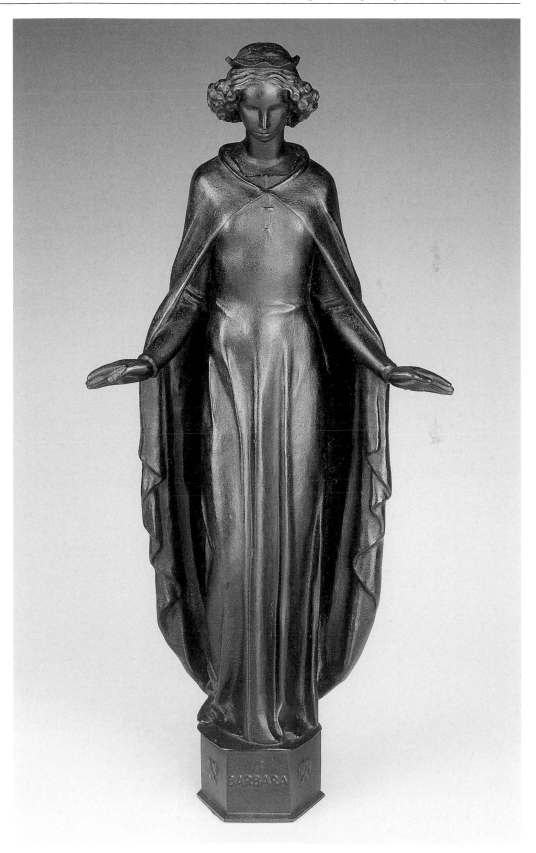

Cat. 650 ▶

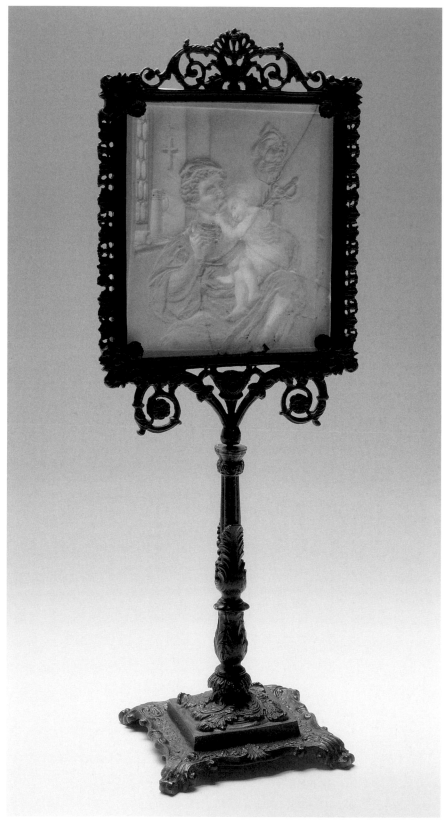

Cat. 652

Lithophanes and Holders / Lichtschirmständer und Lithophanien (Cat. 652-57)

652 Lithophane Holder with Lithophane / Lichtschirmständer mit Lithophanie
Holder/Ständer: ca. 1830. – F./G. KPEG. –
46 x 17 x 12.8 cm (18 1/8 x 6 11/16 x 5 1/16 in.).
Lithophane/Lithophanie: Königliche Porzellan-Manufaktur Meißen. – Rev./Rs. „143 x. 59".
Lamprecht 92. – Inv. 1986.289.1 a-c.
Lit.: Cp./vgl. Carney 2008, 113. – Hintze 1928a, 87, pl./Taf. XVII, no. 2 (Gleiwitz P.-C. 1847).
The rectangular frame with scrolling foliage, stylized acanthus leaves, and shell element as finial, on columnar stem with acanthus-leaf fronds with square base. The lithophane with the scene of a father and child, *"The Warrier and his Child".* / Der Rahmen rechteckig mit Voluten, stilisierten Akanthusblättern und Muschelknauf auf säulenförmigem Stiel mit Akanthuswedeln auf quadratischem Sockel. Die Lithophanie zeigt Vater und Kind *„Der Krieger und sein Kind".*

653 Lithophane Holder with Lithophane / Lichtschirmständer mit Lithophanie
Holder/Ständer: 1820-30. – F./G. KPEG. –
44.8 x 15.8 x 11 cm (17 5/8 x 6 1/4 x 4 5/16 in.).
Lithophane/Lithophanie: Plaue Porzellan-Manufaktur, Thüringen. – Rev./Rs.: „PPM 229".
Lamprecht 93. – Inv. 1986.289.2 a-c.
The rectangular frame with scrolling foliage, stylized acanthus leaves, and shell finial, on a fluted, columnar stem with two stylized acanthus fronds, on square base. The lithophane shows a pair of lovers, *"Courting the Bride"* (I am thankful to Margaret Carney of The Blair Museum of Lithophanes, Toledo, Ohio, for the information). / Der Rahmen rechteckig mit Voluten, stilisierten Akanthusblättern und Muschelknauf auf geriffeltem säulenförmigen Stiel mit zwei stilisierten Akanthuswedeln, auf quadratischem Sockel. Die Lithophanie zeigt ein Liebespaar, die *„Brautwerbung"* genannt (Ich danke Margaret Carney vom Blair Museum of Lithophanes, Toledo, Ohio, für diese Information).

Cat. 654

**654 Frame of a Lithophane Holder with
Lithophane / Rahmen eines Lichtschirm-
ständers mit Lithophanie**
Frame/Rahmen: 1820-30. – F./G. KPEG. –
28.5 x 12.2 cm (11 1/4 x 4 13/16 in.).
Lithophane/Lithophanie: Königliche Porzel-
lan-Manufaktur Meißen. – Rev./Rs.: „108".
Lamprecht 94, Photo 2 (shown with mis-
sing stand / mit verschollenem Halter ge-
zeigt). – Inv. 1986.289.3 b-c.
Lit.: Ostergard 1994, 266, no. 135 (here
shown with another stand / hier mit einem
anderen Halter gezeigt).

Cat. 653

Cat. 655

The rectangular frame with pierced foliate motifs and scrolling foliage at the finial. The lithophane with a Rhenish church. / Der hochrechteckige Rahmen ist mit durchbrochenen blattartigen Motiven verziert. Die Lithophanie zeigt eine Rheinländische Kirche (*„Eine Kirche"*).

655 Lithophane Holder with Lithophane / Lichtschirmständer mit Lithophanie
Holder/Ständer: 1820-30. – F./G. KPEG. – 43.4 x 15 cm (17 1/16 x 5 7/8 in.); D. of base 10.3 cm (4 1/16 in.). – Ins. on back of the frame / auf der Rs. des Rahmens *„XXVIII"*. Lithophane/Lithophanie: Rev./Rs.: *„1782"*. Lamprecht 95. – Inv. 1986.289.7 a-c.

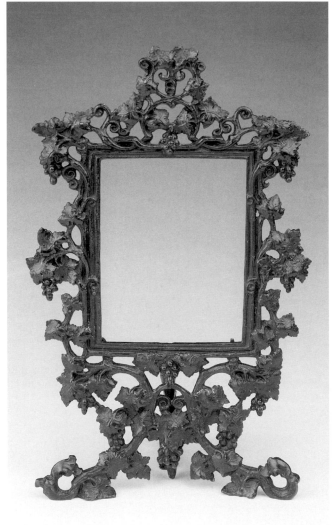

Cat. 657

Cat. 656

The rectangular frame with Gothic tracery on a tapered and fluted stem with round base. The lithophane shows a family scene in an interior. / Der rechteckige Rahmen mit gotisierendem Maßwerk auf einem sich verjüngenden geriffelten Stiel auf rundem Fuß. Die Lithophanie zeigt eine Familie in einem Innenraum.

656 Lithophane / Lithophanie

Porcelain/Porzellan. – First quarter of the 19th century / 1. Viertel des 19. Jh. – Probably/wahrscheinlich Königliche Porzellan-Manufaktur Meißen. – 14.6 x 11.1 cm (5 3/4 x 4 3/8 in.). – Rev. / Rs. „52" and/und „50".
Inv. 1986.289.4.
The portrait bust of Martin Luther front. / Das Brustbild Martin Luthers von vorn.

657 Lithophane Holder / Lichtschirmständer

Ca. 1825. – F./G. KPEG Sayn or/oder Zimmermann. – 28.2 x 17.7 x 10.8 cm (11 1/8 x 6 15/16 x 4 1/4 in.).
Lamprecht 924. – Inv. 1986.289.6.
Lit.: Cp./vgl. Hanauer Eisen, 34, no. 4.17. – Spiegel 1981, 145, fig./Abb. 39.
Rectangular with stylized grape leaves, vines, and grapes on scrolled leafy feet. / Hochrechteckiger Rahmen mit stilisierten Weinblättern und Weintrauben auf Rankenblattfüßen.

Bottle Holders / Flakongestelle (Cat. 658-64)

658 Bottle Holder / Flakongestell

1810-20. – F./G. possibly/vielleicht KPEG Gleiwitz. – H. 16.1 cm (6 5/16 in.); D. 9.9 cm (3 7/8 in.). – 4 pcs./T.
Lamprecht 190. – Inv. 1986.261 a-c.
Lit.: Arenhövel 1982, 193, no. 410. – Aus einem Guß, 121, no. 234.
Pierced with a series of Gothic arches supported by slender columns, on a round base. / Auf rundem Sockel die durchbrochene Wandung mit Kielbögen und Fialen geschmückt.

659 Pair of Bottle Holders / Paar Flakongestelle

(Fig. p. /Abb. S. 236)
1820-30. – F./G. KPEG. – H. 15 cm (5 7/8 in.); D. 9.2 cm (3 5/8 in.) each. – 14 pcs./T.
Lamprecht 4-5, Photo 1. – Inv. 1986.262 a-e. – Lit.: Andrews, 425, fig./Abb. 11. – Arenhövel 1982, 193, no. 412. – Aus einem Guß, 121, no. 233. – Grzimek 1982, 184, no. 119. – Ostergard 1994, 260, no. 127.
Each with four vertical elements in the form of stylized acanthus fronds and leafy vines, at each finial a pair of swans end in a corn or fruit cob, held together by a band decorated with daisies. The decorative round base mounted on four claw feet (s. also Cat. 660); a) relacquered; b) daisies missing. The loose-fitting, pressed-glass bottles may be replacements. / Aus vier durchbrochenen Streifen mit aufwachsenden Akanthusblättern und Weinranken gebildet, die oben jeweils in zwei Schwänen mit einem Fruchtkolben enden und durch ein flaches, mit Rosetten verziertes Band zusammengehalten werden. Vier Klauenfüße tragen den runden profilierten Sockel (s. auch Cat. 660); a) neulackiert; b) Rosetten fehlen. Das Preßglasflakon ist nicht original.

660 Bottle Holder / Flakongestell

(Fig. p. /Abb. S. 236)
1820-30. – F./G. KPEG. – H. 15.6 cm (6 1/8 in.); D. 9.2 cm (3 5/8 in.). – 14 pcs./T.
Inv. 1962.131 a-e. – Gift of / Schenkung von Dr. and Mrs. Maurice Garbáty.
Lit.: s. Cat. 659.
The same model as in Cat. 659. The pressed-glass bottle may be a replacement / Dasselbe Modell wie Cat. 659. Das Preßglasflakon ist nicht original.

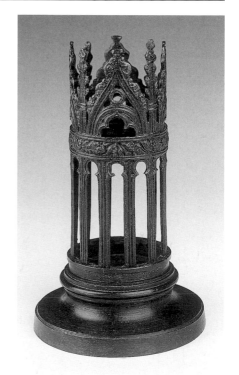

Cat. 658

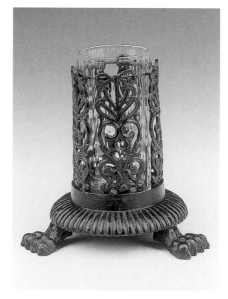

Cat. 663

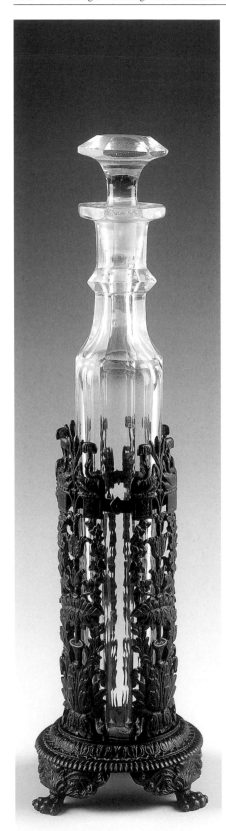

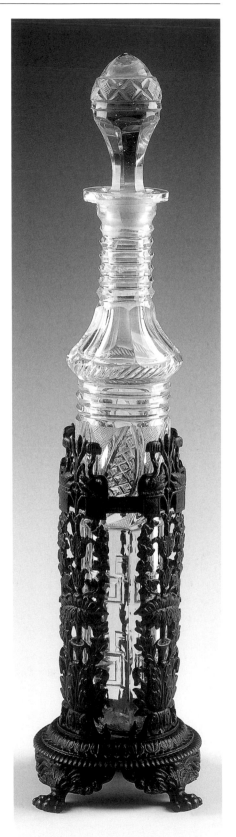

661 Bottle Holder / Flakongestell
1810-20. – F./G. KPEG. – H. 17 cm (6 11/16
in.); D. 9.5 cm (3 3/4 in.). – 12 pcs./T.
Lamprecht 8, Photo 1. – Inv. 1986.264 a-c.
Lit.: H. v. Sp., 299. – Ostergard 1994, 260,
no. 128.
With five pierced elements in the form of
stylized foliage with pinecone finials held
together by a narrow band interspersed with
daisies on a round fluted base with three
claw feet. The pressed glass bottle is not
original. / Mit fünf durchbrochenen Teilen in
Form von stilisiertem Laubwerk mit Kie-
fernzapfenknauf, von einem schmalen Band
mit Rosetten zusammengehalten, auf run-
dem, geriffeltem Sockel auf drei Klauenfü-
ßen. Das Preßglasflakon ist nicht original.

662 Bottle Holder / Flakongestell
1820-30. – F./G. KPEG. – H. 14 cm (5 1/2
in.); D. 9.5 cm (3 3/4 in.). – 10 pcs./T.
Lamprecht 9, Photo 1. – Inv. 1986.265 a-b.
Lit.: H. v. Sp., 299. – Hintze 1928a, 75, pl./
Taf. V, no. 11 (Gleiwitz P.-C. 1847). –
Schmidt 1976, fig./Abb. 13.
With five vertical elements in the form of
stylized foliage with a berry and leaf motif
as finial, held together with a narrow band,
on a round, fluted base mounted on three
claw feet. The pressed-glass bottle is not
original. / Fünf vertikale Teile in Form von
stilisiertem Laubwerk mit Beeren- und
Blattmotiven sind mit einem schmalen Band
zusammengehalten und ruhen auf einem
runden, geriffelten Sockel mit drei Klauen-
füßen. Das Preßglasflakon ist nicht origi-
nal.

663 Bottle Holder / Flakongestell
(Fig. p. /Abb. S. 235)
First quarter of the 19th century / 1. Viertel
des 19. Jh. – F./G. KPEG. – H. 8.9 cm (3 1/2
in.); D. 9 cm (3 9/16 in.).
Lamprecht 298. – Inv. 1986.510 a-b.
Lit.: Hintze 1928a, 75, pl./Taf. V, no. 11
(Gleiwitz P.-C. 1847).
With five vertical elements of pierced scroll-
work held together with a small band, on a
round, fluted base with three claw feet. The
glass beaker is not original. / Fünf vertikale
Teile aus durchbrochenen Voluten sind oben
mit einem schmalen Band verbunden, auf
rundem, geriffeltem Sockel mit drei Klau-
enfüßen. Der Glasbecher ist nicht original.

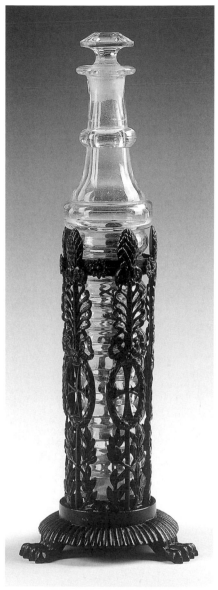

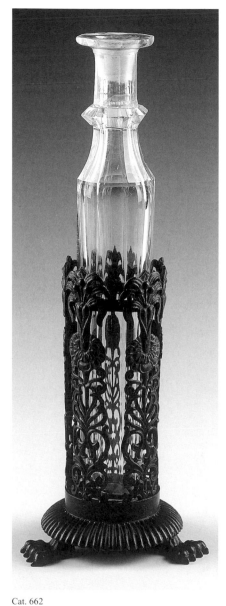

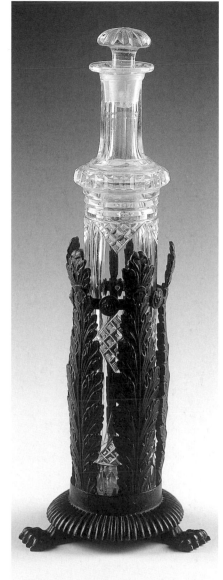

Cat. 661

Cat. 662

Cat. 664

664 Pair of Bottle Holders / Paar Fla-kongestelle

1815-20. – F./G. KPEG. – H. 14.7 cm (5 13/16 in.); D. 8.8 cm (3 7/16 in.). – 15 pcs./T.

Lamprecht 6-7, Photo 1. – Inv. 1986.263 a-d. Lit.: Arenhövel 1982, 194, no. 413. – Hintze 1928a, 75, pl./Taf. V, no. 12 (Gleiwitz P.-C. 1847).

With five vertical elements in the form of stylized acanthus fronds held together by a narrow band interspersed with daisies, on a fluted base mounted on three claw feet. The

pressed-glass bottle may be a replacement. / Fünf durchbrochene vertikale, leicht nach außen schwingende Streifen aus aufwach-senden Akanthusblättern sind oben durch ein schmales, mit Rosetten verziertes Band zusammengehalten; vier Klauenfüße tragen den kreisförmigen geriffelten Sockel. Das Preßglasflakon ist nicht original.

Incense Burners / Räucher-gefäße (Cat. 665-76)

665 Incense Burner / Räuchergefäß
1810-20. – F./G. KPEG. – H. 26 cm (10 1/4
in.); D. 10.2 cm (4 in.). – 19 pcs./T.
Lamprecht 171, Photo 7. – Inv. 1986.290.1.
Lit.: Bartel 2004, 36, fig./Abb. 26, no. 2
(Berlin Abbildungen 1824-30; pl./Taf. IV,
no. 2).
On a round base rests a tripod stand with
ball feet upon which rests an urn supported
by three winged sphinx masks on lion's feet,
the stem is of bound acanthus fronds with a
kneeling cherub holding a broken bow, from
which originally hung a small bowl on a
chain. / Auf runder Platte ein dreiseitig ein-
schwingender Sockel mit Kugelfüßen, dar-
auf das Ölgefäß auf drei Löwenfüßen mit
geflügelten Sphinxmasken, daneben ein
aus zusammengebundenen Akanthusblättern
aufwachsender Ständer, auf dem ein Putto
kniet, dessen Bogen abgebrochen ist, an dem
ursprünglich ein kleines Schälchen an Ket-
ten hing.

**666 Pair of Incense Burners / Paar
Räuchergefäße**
1845-50. – F./G. Meves, Berlin. – H. 16.3 cm
(6 7/16 in.); D. 10.2 cm (4 in.). – 7 pcs./T. –
Marked on base / bez. auf der Unterseite
„6866 A. M. Nachf.".
Lamprecht 268-269, Photo 12. – Inv.
1986.290.2.1 a-d and .2 a-d.
A tripod stand with columnar supports on
hoofed feet terminating in goat masks sup-
ports a central covered vessel with a larger
uncovered brass bowl above. / Auf dreisei-
tig einschwingendem Sockel drei Beine mit
Ziegenmasken und Hufen, in der Mitte ein
Ölgefäß mit aufgelegtem Deckel, darüber
eine offene Schale aus Messing.

667 Incense Burner / Räuchergefäß
1820-30. – F./G. KPEG. – H. 14.9 cm
(5 7/8 in.); D. of base 8.9 cm (3 1/2 in.). –
8 pcs./T.
Lamprecht 930. – Inv. 1986.291.1.
Lit.: Hintze 1928a, 85, pl./Taf. XV, no. 10
(Gleiwitz P.-C. 1847).
In the form of a domed temple with four
columnar supports on a round base, the
dome with stylized floral elements and a
pinecone finial, in the center of the base is a
hollow well with scrolling foliage in relief.
The bowl is missing. / In Form eines ge-
wölbten Tempels mit vier Säulen auf run-
dem Sockel, das Gewölbe mit stilisierten

Cat. 665 ►

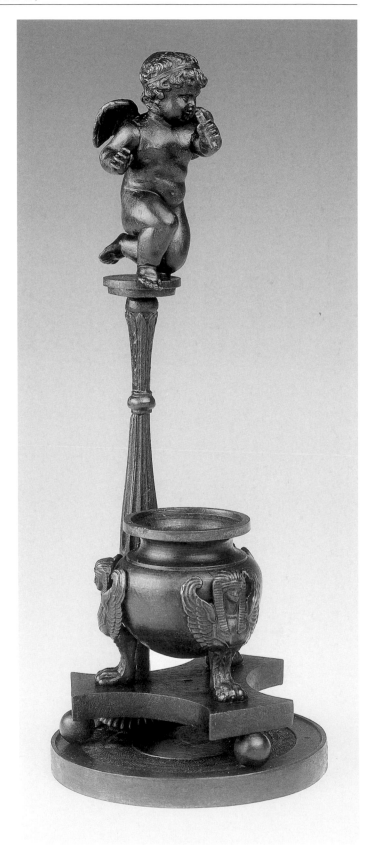

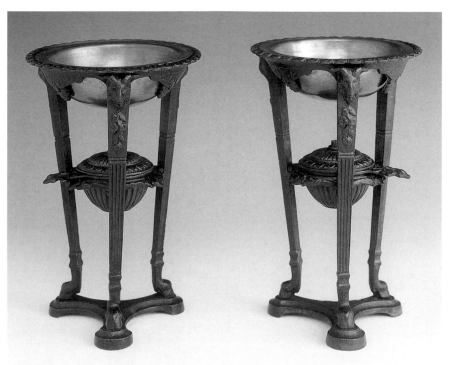

Cat. 666

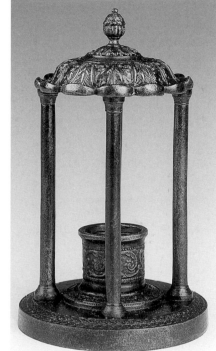

Cat. 667

Cat. 669

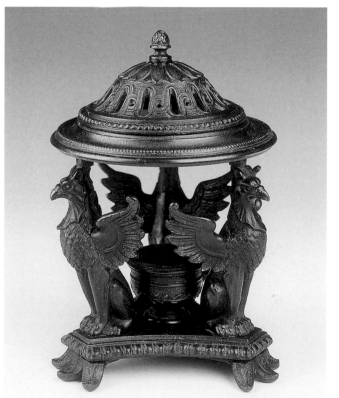

Cat. 6/4

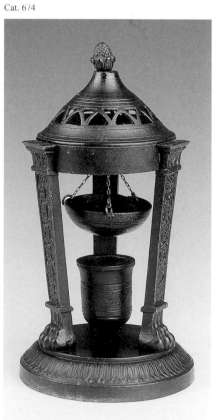

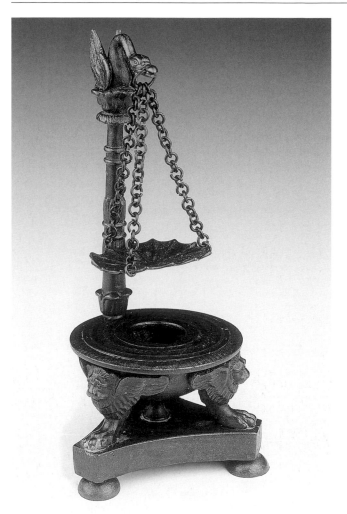

Cat. 668

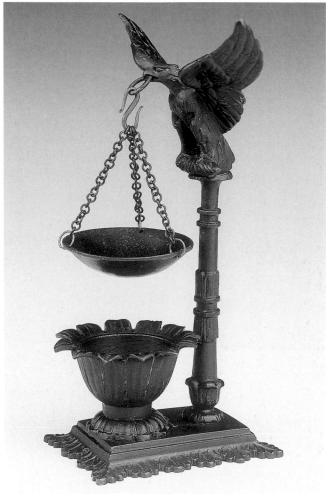

Cat. 676

Blumenmotiven und Tannenzapfenknauf, in der Mitte das Ölgefäß mit Volutenrelief. Die Räucherschale fehlt.

668 Incense Burner / Räuchergefäß
1820-25. – F./G. KPEG. – H. 18.9 cm (7 7/16 in.); D. 8.5 cm (3 3/8 in.). – 16 pcs./T. Lamprecht 29. – Inv. 1986.291.2.
Lit.: Cp./vgl. Cat. Köln 1979, no. 273. – cp/vgl. Grzimek 1982, 183, no. 116. – Ostergard 1994, 261, no. 129. – cp./vgl. Schmidt 1981, 181, fig./Abb. 173 (hier später verändert).
On a tripod base, the round, hollow tripod vessel on claw feet with masks supporting a columnar element with a swan finial in whose outstretched beak a dish hangs from three chains. / Auf dreiseitig einschwingendem Sockel mit runden Füßen drei Löwenprotome, die das Ölgefäß tragen, da-

neben ein Ständer in Form einer Säule mit Schwan, der die Räucherschale an drei Ketten hält.

669 Incense Burner / Räuchergefäß
(Fig. p./Abb. S. 239)
Ca. 1850. – F./G. Vombach. – 16.2 x 11.2 cm (6 3/8 x 4 7/16 in.). – 11 pcs./T. – Marked on the base / bez. auf der Unterseite „F. L. VOMBACH FRANKFURT A/M".
Lamprecht 272, Photo 20. – Inv. 1986.291.3 a-b.
On a tripod base supported by three leafy feet, three winged griffins support a pierced, domed cover with beaded edge, chain motif, and pinecone finial, below this is a small footed urn with handle. / Auf dreiseitig einschwingendem Sockel mit Blätterfüßen stützen drei geflügelte Greifen einen durchbrochenen gewölbten Deckel mit Perlstab und Kettenmotiv, ein Tannenzapfen bildet

den Knauf, darunter das Ölgefäß in Form einer Urne mit Griff.

670 Incense Burner / Räuchergefäß
1820-25. – F./G. KPEG. – H. 14 cm (5 1/2 in.); D. 8.2 cm (3 1/4 in.).
Lamprecht 50. – Inv. 1986.292.1 a-b.
Lit.: Arenhövel 1982, 179 f., no. 380. – Hintze 1928a, 72, pl./Taf. II, no. 11 (Gleiwitz P.-C. 1847). – Schmidt 1981, 181, fig./Abb. 174.
On a tripod base a hollow vessel is supported by three dolphins, the curved stem of an acanthus plant extends upward and holds a round shallow bowl on three chains. / Auf dreiseitig einschwingendem Sockel drei Delphine, die das Ölgefäß tragen, daneben ein aus Akanthusblättern aufwachsender Stamm, an dem die Räucherschale an drei Ketten hängt.

671 Incense Burner / Räuchergefäß
(Fig. p./Abb. S. 242)
1820-30. – F./G. KPEG. – 17.4 x 19.8 x
13 cm (6 7/8 x 7 13/16 x 5 1/8 in.).
Lamprecht 60, Photo 6. – Inv. 1986.292.2
a-b.
Lit.: Aus einem Guß, 212, no. 952. – Bartel
2004, 86, no. 25. – Gleiwitzer Kunstguß
1935, 45. – Hintze 1928a, 76, pl./Taf. VI,
no. 2 (Gleiwitz P.-C. 1847), 123, pl./Taf. III,
no. 27 (Sayn Musterb. 1846). – Ostergard
1994, 263, no. 131. – Widerra, n. p./o. S.
On a flat base with claw feet and stylized
leaves, the central octagonal stem supports
an oval, fluted dish, whose cover has pierced,
heart-shaped designs and a winged griffin
finial. / Auf flachem, vierseitig einschwin-
gendem Sockel mit Klauenfüßen und stil-
isierten Blättern ein achtseitiger Stiel, der
eine ovale geriffelte Schale trägt. Der mit
Herzmuster verzierte Deckel ist durch-
brochen und hat einen geflügelten Greif
als Knauf.

672 Incense Burner / Räuchergefäß
(Fig. p./Abb. S. 242)
1815-20. – F./G. KPEG. – H. 9.3 cm (3 11/16
in.); D. 12.6 cm (4 15/16 in.).
Lamprecht 182. – Inv. 1986.298.1.
Round, footed bowl with stylized leaves and
shell motifs. / Auf rundem Fuß die Schale
mit stilisierten Blätter- und Muschelmotiven.

673 Incense Burner / Räuchergefäß
(Fig. p./Abb. S. 242)
1820-30. – F./G. KPEG. – H. 8.3 cm (3 1/4
in.); D. with handles / mit Henkeln 15.1 cm
(5 15/16 in.).
Lamprecht 243, Photo 3. – Inv. 1986.298.2.
Footed dish with stylized leaves in relief and
repeating quatrefoil pattern, with two flat
shell-and-leaf handles. / Schale auf Fuß mit
stilisierten Blättern und sich wiederholen-
den Vierpaßmotiven, mit zwei flachen Mu-
schel- und Blattgriffen.

674 Incense Burner / Räuchergefäß
(Fig. p./Abb. S. 239)
1820-30. – F./G. KPEG. – H. 16.2 cm
(6 3/8 in.); D. of base / des Sockels 8.5 cm
(3 3/8 in.). – 9 pcs./T.
Inv. 1962.122 a-b. – Gift of / Schenkung von
Dr. and Mrs. Maurice Garbáty.
On a round base three square columns on
claw feet support a pierced domed cover
with pinecone finial from which a shallow,
round bowl hangs from three chains over a
central footed urn. / Auf rundem Sockel
tragen drei Beine mit Klauenfüßen einen

durchbrochenen gewölbten Deckel mit Tan-
nenzapfenknauf, an dem eine runde Räu-
cherschale an drei Ketten hängt, in der Mitte
das Ölgefäß in Form einer Urne.

**675 Stand for an Incense Burner(?) /
Gestell eines Räuchergefäßes(?)**
(Fig. p./Abb. S. 242)
1810-20. – F./G. KPEG. – H. 11.3 cm (4 7/16
in.); D. 12.7 cm (5 in.).
Inv. 1962.126. – Gift of / Schenkung von Dr.
and Mrs. Maurice Garbáty.
On three cabriole legs with scrolled feet
and eagle masks rests a pierced round sup-
port with a hole in the center, the legs are
joined by a narrow band. This stand could
possibly have been used as a tea warmer. /
Auf drei S-förmigen Beinen mit Adlermas-
ken und Volutenfüßen eine durchbrochene
Platte mit einer kreisförmigen Öffnung in
der Mitte. Ein zum Teil weggebrochener
Ring hält im oberen Drittel die Beine zu-

sammen. Bei diesem Gestell könnte es sich
auch um einen Teewärmer handeln.

676 Incense Burner / Räuchergefäß
1815-20. – F./G. KPEG Berlin (?). – 16.5 x
7.6 x 5 cm (6 1/2 x 3 x 1 15/16 in.).
Inv. 1962.127 a-b. – Gift of / Schenkung
von Dr. and Mrs. Maurice Garbáty.
Lit.: Arenhövel 1982, 178, no. 377. – Oster-
gard 1994, 262, no. 130.
A vessel in the form of a leafy goblet rests
on a square base from which rises a column
with foliate motifs, at the top sits an eagle
with outstretched wings holding a ring in
its beak from which hangs a shallow round
bowl on three chains. / Auf rechteckigem
Sockel das Ölgefäß in Form eines Blatt-
kelches, daneben auf einem gegliederten,
vegetabil verzierten Ständer ein Adler mit
ausgebreiteten Schwingen, im Schnabel ein
Ring, von dem die Räucherschale an Ket-
ten hängt.

Cat. 670

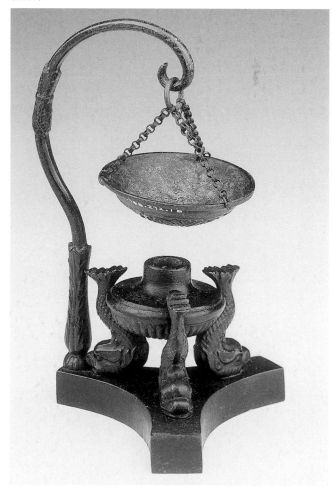

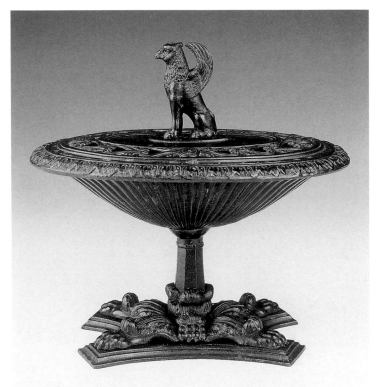

Cat. 671

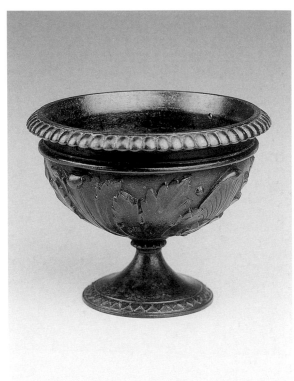

Cat. 672

Cat. 675

Cat. 673

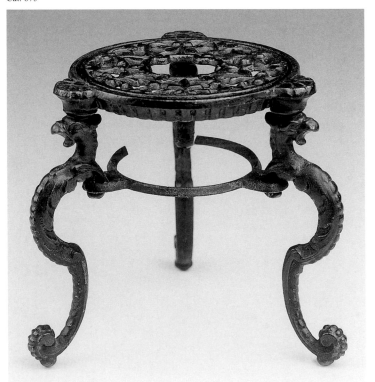

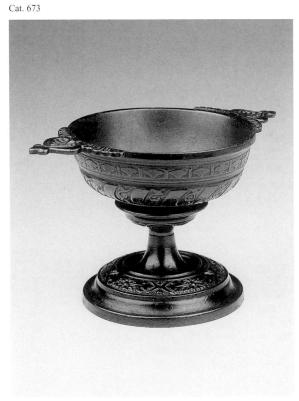

Sewing Utensils / Nähutensilien (Cat. 677-88)

677 Pin Cushion with Thimble Stand / Nadelkissen mit Fingerhutständer

1840-50. – F./G. Seebass. – 13.3 x 7.8 x 7.8 cm (5 1/4 x 3 1/16 x 3 1/16 in.). – Marked on the base / bez. auf der Unterseite *„Seebas à Berlin"*.

Lamprecht 90, Photo 32. – Inv. 1986.255.

On a square base with four leafy feet, the pierced round pin cushion holder with padded pin cushion in the center on a foot with eight stylized leaf supports, atop the pin cushion kneels a winged cherub supporting a padded thimble holder on its head. / Ein quadratischer, pyramidenstumpfartiger, mit acht Blättern verzierter Sockel, der auf vier Füßen ruht, trägt eine durchbrochene Scheibe mit Nadelkissen und einem knienden Putto mit einer Kopfbedeckung zur Aufnahme eines Fingerhuts.

678 Table Clamp with Pin Cushion / Nähschraube mit Nadelkissen

(Fig. p./Abb. S. 244)

1820-30. – F./G. KPEG. – 24 x 7.6 cm (9 7/16 x 3 in.).

Lamprecht 138, Photo 32. – Inv. 1986.256.2 a.

Lit.: Andrews, 424, fig./Abb. 9. – cp./vgl. Arenhövel 1982, 227, no. 493. – Ostergard 1994, 256, no. 123.

On a shell-shaped tray designed to hold pins rests a clamp in the form of a dolphin with a curved tail upon which rests a padded pin cushion (cp. the very similar dolphin in Cat. 679); the screw mechanism with a knob in the form of a winged putto. / Auf einer Schale in Form einer Muschel ein Delphin als Teil einer Klammer, die zum Festhalten von Stoffen dient; sein eingerollter Schwanz trägt das runde Nadelkissen (vgl. den sehr ähnlichen Delphin von Cat. 679); Blattdekor ziert die Klemmschraube.

679 Table Clamp / Nähschraube

(Fig. p./Abb. S. 244)

1820-30. – F./G. KPEG. – 25.4 x 7.5 cm (10 x 2 15/16 in.).

Inv. 1962.130. – Gift of / Schenkung von Dr. and Mrs. Maurice Garbáty.

Lit.: Arenhövel 1982, 227, no. 493.

The dolphin as in Cat. 678; the clamping bracket also, however here with a longer connecting piece between the shell-shaped tray and the screw's simple, foliate knob. The pin cushion is missing. / Der Delphin

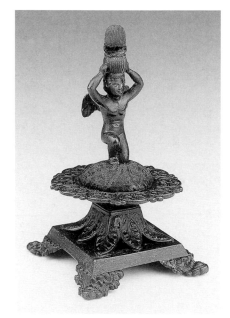

Cat. 677

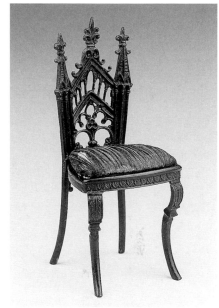

Cat. 688

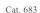

Cat. 683

Cat. 682

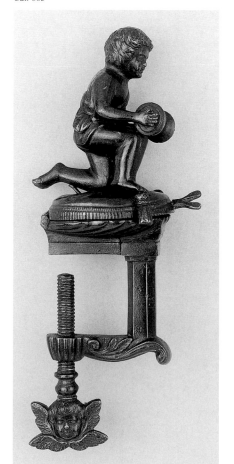

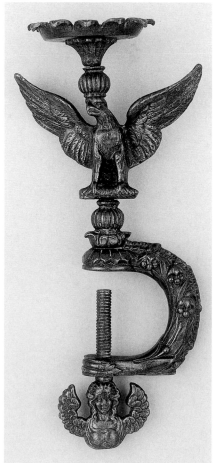

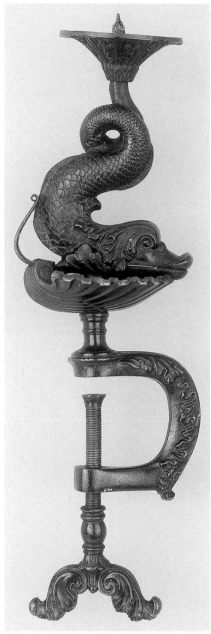

Cat. 679

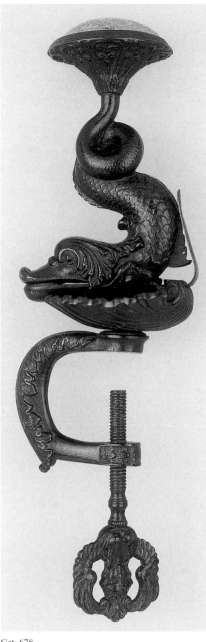

Cat. 678

dient als oberer Teil einer Klammer, er trägt auf dem Kopf das runde Nadelkissen; die blattverzierte Klemmschraube ist mit einem geflügelten Putto geschmückt.

681 Table Clamp / Nähschraube
(Fig. p./Abb. S. 246)
Mid 19th century / Mitte des 19. Jh. – F./G. Mägdesprung (?). – 16.5 x 12.7 cm (6 1/2 x 5 in.).
Lamprecht 931. – Inv. 1986.256.5.
Lit.: Lindner, 2829. – cp./vgl. Reichmann, 271 (for a paper clamp with the same duck's head / zu einer Papierklammer mit dem gleichen Entenkopf).
In the form of a duck's head with glass eyes, on the head a holder for a pin cushion (now missing); the screw with a knob in the form of a winged putto. / In Form eines Entenkopfs mit Glasaugen, auf dem Kopf ein Halter für das Nadelkissen; die Klemmschraube mit geflügeltem Putto geschmückt; das Nadelkissen fehlt.

682 Table Clamp / Nähschraube
(Fig. p./Abb. S. 243)
1820-30. – F./G. KPEG. – 19.6 x 8.5 cm (7 11/16 x 3 3/8 in.).
Lamprecht 254, Photo 32. – Inv. 1986.256.4.
In the form of an eagle with outstretched wings supporting a pin cushion on its head (now missing); the screw with a knob in the form of a winged putto. With traces of bronze patina; the pin cushion is missing. / In Form eines Adlers mit gespreizten Flügeln und dem Nadelkissenhalter auf dem Kopf, die Klemmschraube mit geflügeltem Putto geschmückt. Reste von Bronzierung; das Nadelkissen fehlt.

683 Table Clamp with Pin Tray / Nähschraube mit Nadelschale
(Fig. p./Abb. S. 243)
1810-20. – F./G. KPEG (?). – 18.4 x 9.8 cm (7 1/4 x 3 7/8 in.).
Lamprecht 158, Photo 32. – Inv. 1986.256.3.
In the form of a boy holding a thread spool, kneeling on a cushion that opens to reveal a pin tray; the screw with a knob in the form of a winged putto. / Ein Junge, der eine Garnspule hält, kniet auf einem Kissen, das als Deckel für die Nadelschale dient; die Klemmschraube ist mit geflügeltem Putto geschmückt.

684 Yarn Winder / Garnwinde
Ca. 1830. – F./G. KPEG. – 46.5 x 46 cm (18 5/16 x 18 1/8 in.) open/offen.
Lamprecht 107. – Inv. 1986.257.1.

wie Cat. 678; der Klemmbügel ebenso, jedoch hier mit einem längeren Verbindungsstück zur Muschel und zu einem einfacheren vegetabilen Schraubengriff; das Nadelkissen fehlt.

680 Table Clamp and Pin Cushion / Nähschraube mit Nadelkissen
(Fig. p./Abb. S. 246)
1810-20. – F./G. KPEG. – 15.8 x 14.3 cm (6 1/4 x 5 5/8 in.).

Lamprecht 139, Photo 32. – Inv. 1986.256.2 b.
Lit.: Andrews, 424, fig./Abb. 9. – cp./vgl. Arenhövel 1982, 227, no. 494. – Ostergard 1994, 257, no. 124. – Stummann-Bowert, 101, no. 81.
The clamp in the form of a dolphin with a rolled, extended tail and a pin cushion mounted on its head; the screw mechanism with a knob in the form of a winged putto. / Ein einmal eingerollter, waagerechter Delphin

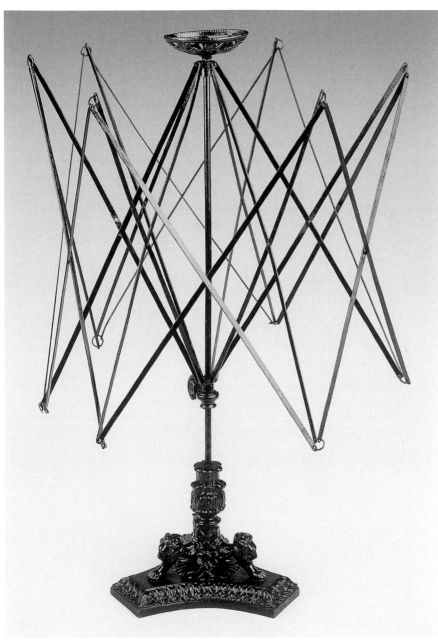

Cat. 684

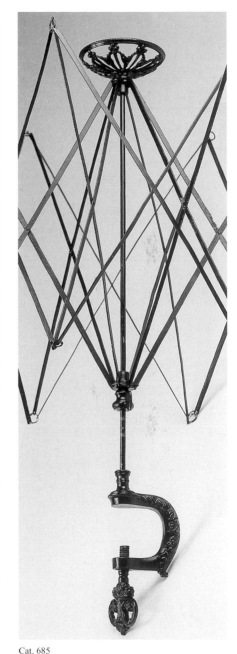

Cat. 685

Lit.: Cp./vgl. Arenhövel 1982, 227, no. 492. – Ostergard 1994, 259, no. 125.
The tripod base is decorated with acanthus leaves and lion heads, with a slender stem with folding arms, the cup-shaped finial with a pierced leaf motif. The yarn winder was used to create a ball of yarn from plies of wool yarn, the cup-shaped finial was used to store the ball during breaks in winding. / Auf dreiseitig einschwingender Sockelplatte ein Dreifuß aus Löwenmasken und Akan-

thusblättern, der die Mittelachse mit dem zusammenschiebbaren Wickelgestell aus schmalen Stahlbändern trägt, die oben in einem flachen Körbchen endet. Die Garnwinde diente zum Aufwickeln eines Knäuels von den damals in Lagen gelieferten Wollgarnen, das flache Körbchen oben zum gelegentlichen Ablegen des Knäuels.

685 Yarn Winder / Garnwinde
(Fig./Abb. Detail)
1830-40. – F./G. KPEG. – 46 x 54 cm (18 1/8 x 21 1/4 in.) open/offen.
Lamprecht 108. – Inv. 1986.257.2.
A clamp with a screw knob in the form of two dolphins, whose tails end in acanthus leaves, supports the winder (cp. Cat. 684). / Eine mit Akanthus verzierte Klemmschraube trägt das Wickelgestell (vgl. Cat. 684).

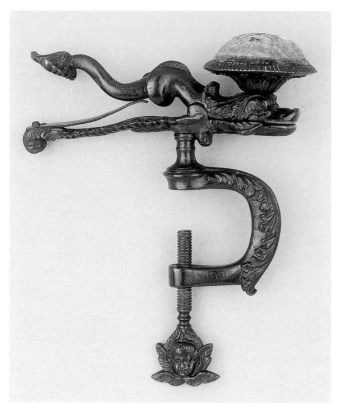

Cat. 680

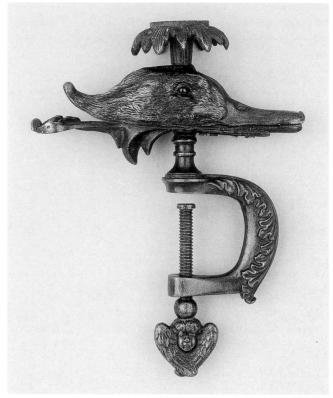

Cat. 681

Cat. 687

Cat. 686

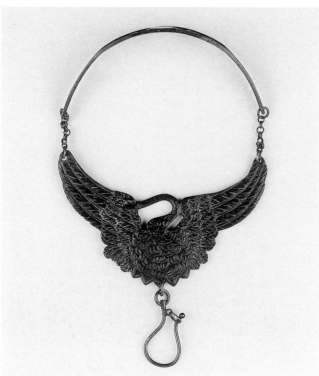

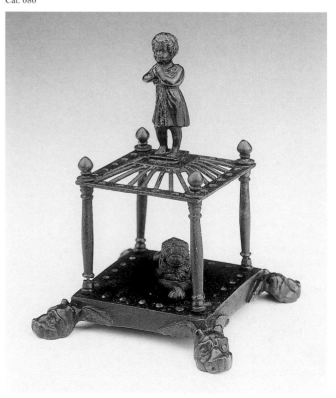

**686 Stand for Knitting Needles (?) /
Ständer für Stricknadeln (?)**
Mid 19th century / Mitte des 19. Jh. – 11.7 x
8.4 x 8.4 cm (4 5/8 x 3 5/16 x 3 5/16 in.).
Lamprecht 152, Photo 32. – Inv. 1986.258.1.
On a square base with four lion's masks as
feet sits a lion with crossed paws in a cov-
ered cage supported by four round columns
with ball finials, on the slatted roof stands
a young girl with hands folded. A series of
holes can be found on the roof and stand
that probably served to hold knitting nee-
dles (Lamprecht); when filled, they create a
cage for the lion. / Auf einem quadratischen
Sockel mit Füßen aus Löwenmasken liegt
ein Löwe mit gekreuzten Pfoten unter ei-
nem von vier Säulen getragenen durchbro-
chenen Dach, das von einem stehenden
Mädchen mit gefalteten Händen bekrönt
wird. Oben und unten sind die Außenseiten
jeweils von einer regelmäßig angelegten Rei-
he von Bohrungen begleitet, die wohl zur
Aufnahme von Stricknadeln dienten (nach

Lamprecht). Waren diese alle gefüllt, saß der
Löwe in einem Käfig.

**687 Bracelet as Holder for a Ball of
Knitting Yarn / Armstrickreif**
Mid 19th century / Mitte des 19. Jh. – 14 5 x
9 cm (5 11/16 x 3 9/16 in.).
Lamprecht 497S, Photo 55 – Inv. 1986.258.2.
The bracelet consists of a narrow band
above and a swan with outstretched wings
below, from which hangs a hook that at one
time supported a mount for a ball of yarn
(now missing). / Den Reif bildet nach oben
ein schmales Band und nach unten ein
Schwan mit gespreizten Flügeln, der einen
gebogenen Haken entläßt, der zur Aufnah-
me eines Gestells für ein Wollknäuel dien-
te, das heute verloren ist.

688 Pin Cushion / Nadelkissen
(Fig. p./Abb. S. 243)
1840-50. – F./G. KPEG. – 12.5 x 5.4 x
5.7 cm (4 15/16 x 2 1/8 x 2 1/4 in.).
Lamprecht 187, Photo 32. – Inv. 1986.504.
Lit.: Andrews, 425, fig./Abb. 10. – Aren-
hövel 1982, 228, no. 496. – Grzimek 1982,
184, no. 120. – Hintze 1928a, 87, pl./Taf.
XVII, no. 1 (Gleiwitz P.-C. 1847). – Mär-
ker, no. 3. – Ostergard 1994, 264, no. 132. –
Stamm, 39, fig./Abb. 29.
In the form of a small side chair in the
Gothic-revival style. / In Form eines kleinen
gotisierenden Stuhls.

Inkwells / Schreibzeuge
(Cat. 689-710)

689 Inkwell / Schreibzeug
(Fig. p./Abb. S. 56)
1820-30. – F./G. KPEG Sayn. – 17.9 x 15.8 x
10.1 cm (7 1/16 x 6 1/4 x 4 in.). – Marked
on base / bez. auf der Unterseite „S.H.“.
Lamprecht 1, Photo 17. – Inv. 1986.221.1 a-e.
Lit.: Cat. Leipzig 1915, 119, no. 60. – Hint-
ze 1928a, 123, pl./Taf. III, no. 4 (here cal-
led ”Sappho“ / hier als „Sappho“ bezeich-
net; Sayn Musterb. 1846). – Jailer-Cham-
berlain, A14. – Ostergard 1994, 240, no.
101. – Schmidt 1981, 183, fig./Abb. 181. –
Schmitz 1917, 55, pl./ Taf. 29. – Schuette
1916, 288, fig./Abb. 22.
The cover in the form of Clio, Muse of
History, seated, holding a book and stylus
on a rectangular, draped base edged with
fringe; the base is mounted on four claw feet,
with glass inkwell and cast-iron sander. /
Der Deckel in Form der sitzenden Clio, Mu-
se der Geschichte, mit Buch und Schreib-
griffel auf einem rechteckigen, drapierten
Boden mit Fransen; der Sockel mit vier Lö-
wentatzen, das Tintenfaß aus Glas, die Streu-
sandbüchse aus Eisen.

690 Inkwell / Schreibzeug
1820-30. – F./G. KPEG. – 14 x 14.2 x 8.2 cm
(5 1/2 x 5 9/16 x 3 1/4 in.).

Cat. 690

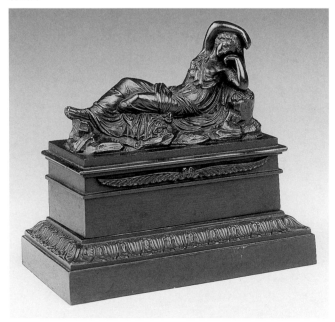

◄ Fig./Abb. 47 The
holder in Cat. 686 filled
with knitting needles;
detail from one of the
photographic plates that
Lamprecht most likely
planned to use for a
publication / Mit Strick-
nadeln gefüllter Ständer
von Cat. 686; Ausschnitt
aus einer der Tafeln mit
Photographien, die Lam-
precht wohl für eine Pu-
blikation vorgesehen hat-
te, ca. 1917; BMA, Lamp-
recht Collection Records.

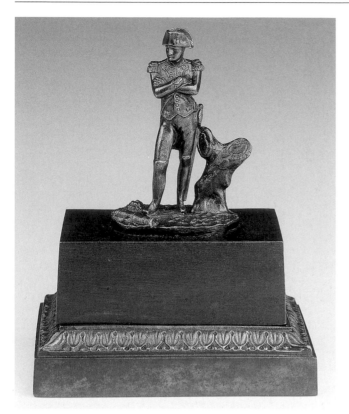

Cat. 691

Cat. 692

Lamprecht 2, Photo 18. – Inv. 1986.221.2
a-e.
Lit.: Arenhövel 1982, 201 f., no. 430. – Fer-
ner and Genée, 23, fig./Abb. 11. – Cat. Leip-
zig 1915, 118, no. 55 (here the figure is de-
scribed as Amor / hier wird die Figur als
Amor identifiziert).
The cover with the figure of the sleeping
Ariadne reclining on a rocky bed mounted
on a pedestal base, with inkwell and sand-
er; with original green patina. After the
Roman marble, now in the Vatican Museum,
Galleria delle Statue, which is a copy of the
Hellenistic original from the early second
century B.C. / Der Deckel mit der Figur der
schlafenden Ariadne auf felsigem Unter-
grund, der Sockel mit Akanthusblättern ver-
ziert, Tintenfaß und Streusandbüchse zu-
gehörig; originale grüne Patina; Modelliert
nach der römischen Marmorstatue, einer Ko-
pie des hellenistischen Originals aus dem
Anfang des 2. Jahrhunderts v. Chr., heute
im Vatikanmuseum (Galleria delle Statue).

691 Inkwell / Schreibzeug
1815-25. – F./G. KPEG. – 12.9 x 10 x 6.3 cm
(5 1/16 x 3 15/16 x 2 1/2 in.).
Lamprecht 12. – Inv. 1986.221.3 a-e.
Lit.: Hintze 1928a, 90, pl./Taf. XX, no. 10
(Gleiwitz P.-C. 1847; cp./vgl. 89, pl./Taf.
XVIIII, no. 7: Paperweight/Briefbeschwe-
rer).
The cover with the figure of Napoleon,
with his right leg slightly bent and his arms
crossed, standing next to a tree stump with
a canon and cannonballs at his feet; on a
rectangular base with a tin inkwell and
sander. / Der Deckel mit Napoleon, der die
Arme verschränkt und neben einem Baum-
stumpf steht, zu seinen Füßen Kanonenrohr
und -kugeln; auf rechteckigem Sockel, Tin-
tenfaß und Streusandbüchse aus Eisenblech.

692 Inkwell / Schreibzeug
1815-20. – Mod. Friedrich Wilhelm Lud-
wig Beyerhaus (?). – F./G. KPEG Gleiwitz.
– 12.7 x 9.2 x 6 cm (5 x 3 5/8 x 2 3/8 in.).
Lamprecht 15. – Inv. 1986.221.4 a-f.
Lit.: Arenhövel 1982, 202, no. 431. – Fer-
ner and Genée, 31, fig./Abb. 21. – Hintze
1928a, 74, pl./Taf. IV, no. 12 (Gleiwitz
P.-C. 1847). – Schmuttermeier, 32, no. 29.
In the form of Napoleon's sarcophagus with
a detachable Napoleon figure under the
inkwell and sander inside; the sarcophagus
cover with a pillow, upon which lie Napole-
on's hat and sword. This model is not an ac-
tual copy of Napoleon's sarcophagus, which
is now in the Invalides in Paris. / In Form

des Sarkophags Napoleons mit der liegen-
den Figur Napoleons unter dem Tintenfaß
und der Streusandbüchse; der Deckel mit
Kissen, Napoleons Hut und Feldherrnstab;
das Modell ist keine Nachbildung von Na-
poleons Sarkophag im Invalidendom zu Pa-
ris.

693　Inkwell / Schreibzeug
1820-30. – F./G. KPEG. – 10.7 x 14.7 x
10.8 cm (4 3/16 x 5 13/16 x 4 1/4 in.).
Lamprecht 33, Photo 17. – Inv. 1986.221.5
a-d.
Lit.: Ostergard 1994, 238, no. 99.
The cover in the form of a sleeping, winged
putto on a classical daybed with a pillow
and fringed cover; the rectangular base with
four stylized shell feet, inside the original
glass inkwell and cast-iron sander. / Der Dek-
kel mit einem schlafenden Putto auf klas-
sizistischer Liege, der Sockel mit vier stili-
sierten Muschelfüßen, das Tintenfaß aus
Glas, die Streusandbüchse aus Eisen, beide
zugehörig.

Cat. 693

Cat. 694

694　Inkwell / Schreibzeug
1820-30. – F./G. KPEG. – 13.8 x 14 x 6.8 cm
(5 7/16 x 5 1/2 x 2 11/16 in.).
Lamprecht 37, Photo 18. – Inv. 1986.221.6
a-d.
Lit.: Cat. Leipzig 1915, 117, no. 34.
In the form of an antique sarcophagus, the
cover with a sword, Roman helmet, and lau-
rel leaves, the sides decorated with snakes,
a staff, and lion mask; with a porcelain ink-
well and cast-iron sander. / In Form eines
antiken Sarkophags, der Deckel mit Schwert,
antikisierendem Helm und Lorbeer, die Sei-
ten mit Schlangen, Stab und Löwenmaske
geschmückt; Porzellan-Tintenfaß und ei-
serne Streusandbüchse sind zugehörig.
Cp./vgl. Hintze 1928a, 86, pl./Taf. XVI, no. 6
(Paperweight/Briefbeschwerer).

695　Inkwell / Schreibzeug
(Fig. p./Abb. S. 250)
Second half of the 19th century / 2. Hälfte des
19. Jh. – 21.2 x 13.7 x 9.5 cm (8 3/8 x 5 3/8 x
3 3/4 in.). – 2 pcs./T.
Lamprecht 41, Photo 26. – Inv. 1986.221.7
a-b.
A standing woman in full court dress (in
the "Sammlung Lamprecht Handexemplar"
identified as Princess Charlotte of Prussia);
traces of red paint; the inkwell and sander
are missing. / Stehende Frau im Hofkleid
(in „Sammlung Lamprecht Handexemplar"

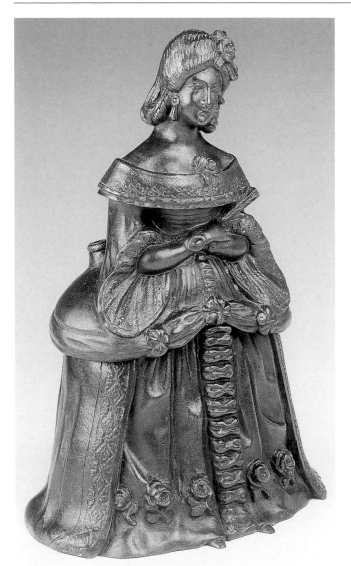

Cat. 695

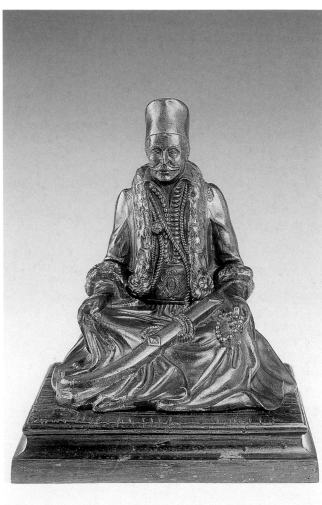

Cat. 703

Cat. 696

Cat. 697

als Prinzessin Charlotte von Preußen iden-
tifiziert); Reste von roter Farbe, Tintenfaß
und Streusandbüchse fehlen.

696 Inkwell / Schreibzeug
1810-20. – F./G. KPEG. – 4.7 x 10.8 x
10.8 cm (1 7/8 x 4 1/4 x 4 1/4 in.).
Lamprecht 66, Photo 19. – Inv. 1986.221.8
a-d.
Rectangular, with an acanthus leaf border
on the base, with an inkwell and sander of
cast-iron; the cover is missing(?). / Recht-
eckig mit Akanthusblattborte auf dem Sok-
kel, mit Tintenfaß, Streusandbüchse und
Ablage (zugehörig); ein Deckel fehlt(?).

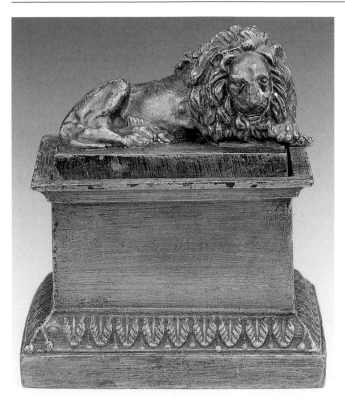

Cat. 706

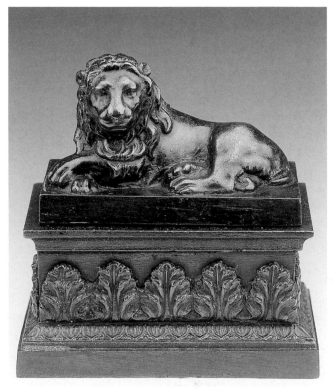

Cat. 698

697 Sander from an Inkwell / Streu-sandbüchse von einem Schreibzeug
1820-30. – F./G. KPEG. – H. 6.2 cm (2 7/16 in.); D. 9.3 cm (3 11/16 in.).
Lamprecht 67, Photo 3. – Inv. 1986.221.9.
Lit.: Cp./vgl. Hintze 1928a, 90, pl./Taf. XX, no. 12 (Gleiwitz P.-C. 1847).
Round, with a pierced top and pinecone finial, the sides with flowers and small putti scenes in relief. / Rund, mit durchbroche-nem Deckel und Knauf in Form eines Tannenzapfens, die Seiten mit Blumen und kleinen Puttenszenen in Relief.

698 Inkwell / Schreibzeug
1820-30. – F./G. KPEG Berlin. – 8.9 x 8.5 x 4.5 cm (3 1/2 x 3 3/8 x 1 3/4 in.).
Lamprecht 79. – Inv. 1986.221.10 a-d.
Lit.: Bartel 2004, 36, fig./Abb. 28, no. 13 (Berlin Abbildungen 1824-30, pl./Taf. VI, no. 13).
The cover in the form of a recumbent lion on a tall pedestal base with stylized acan-thus leaves and anthemion motifs on the sides; with a tin inkwell and sander. / Der Deckel mit einem ruhenden Löwen auf ho-hem Sockel, der mit gereihten Akanthus-blättern auf den Längsseiten und Anthe-mionmotiven auf den Schmalseiten verziert

ist; mit Tintenfaß und Streusandbüchse aus Eisenblech.

699 Inkwell / Schreibzeug
(Fig. p./Abb. S. 252)
1830-40. – F./G. KPEG. – 8.2 x 30 x 11 cm (3 1/4 x 11 13/16 x 4 5/16 in.).
Lamprecht 111, Photo 19. – Inv. 1986.221.11 a-f.
Lit.: Hintze 1928a, 74, pl./Taf. IV, no. 16 (Gleiwitz P.-C. 1847). – Ostergard 1994, 239, no. 100.
The base is a Gothic-style gallery that sup-ports two handles in the shape of scrolling foliage; the inkwell and sander, each with a decorative cover with leaf finial, are on ei-ther side of a central rectangular dish. / Das Unterteil im gotisierenden Stil, durchbro-chen, mit zwei Volutenhenkeln, auf der Plat-te Tintenfaß und Streusandbüchse und in der Mitte ein Kästchen, alle mit dekorati-ven Deckeln und Knäufen.

700 Inkwell / Schreibzeug
(Fig. p./Abb. S. 253)
1830-35. – F./G. KPEG. – 7 x 30.4 x 12.1 cm (2 3/4 x 11 15/16 x 4 3/4 in.).
Lamprecht 151, Photo 19. – Inv. 1986.221.12 a-b.

Lit.: Hintze 1928a, 83, pl./Taf. XIII, no. 18 (Gleiwitzer P.-C. 1847). – Leisching, 204. – Schmuttermeier, 33, no. 30.
The oblong dish with a fluted interior and foliate sides supports an oblong vessel for the inkwell and sander, the hinged lid like-wise fluted and with foliate décor. / Die längliche Unterschale innen geriffelt und zum Teil vegetabil verziert, daraus aufstei-gend das oblonge Oberteil mit Tintenfaß und Streusandbüchse, der Klappdeckel ebenfalls geriffelt und mit Blattmotiven verziert.

701 Inkwell / Schreibzeug
(Fig. p./Abb. S. 253)
1820-30. – F./G. KPEG (?). – 21.5 x 22 x 11 cm (8 7/16 x 8 11/16 x 4 5/16 in.). – 5 pcs./T.
Lamprecht 172. – Inv. 1986.221.13 a-c.
Rectangular, mounted on four elongated claw feet, the base with Gothic elements and modeled relief of trefoil and oval-and-circle design supporting a vertical element in the form of two tapered columns with a finial of Gothic tracery; glass inkwell and cast-iron sander with pinecone finial. / Rechteckig, auf vier Beinen mit Löwentat-zen; das kästchenartige Oberteil an den Sei-ten mit gotisierendem, zum Teil durchbro-

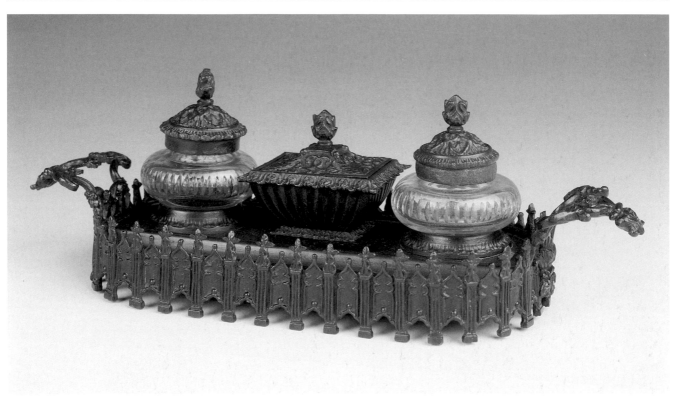

Cat. 699

Cat. 702

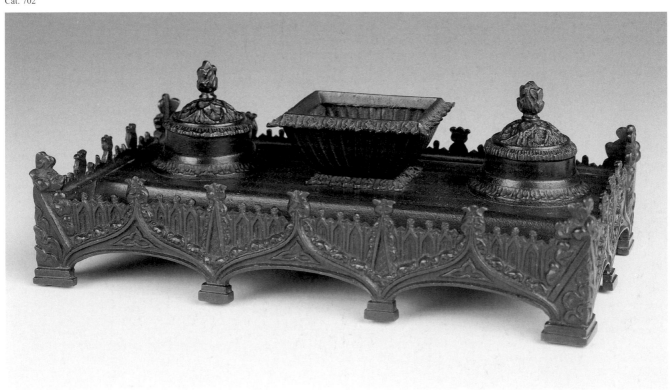

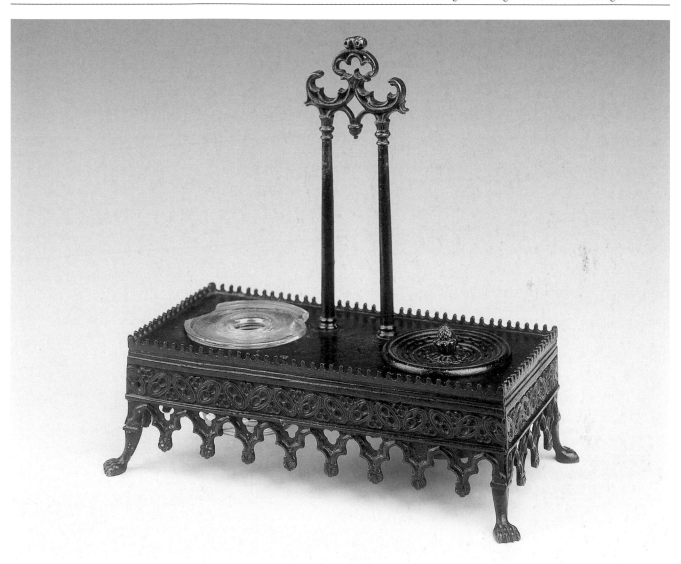

Cat. 701

Cat. 700

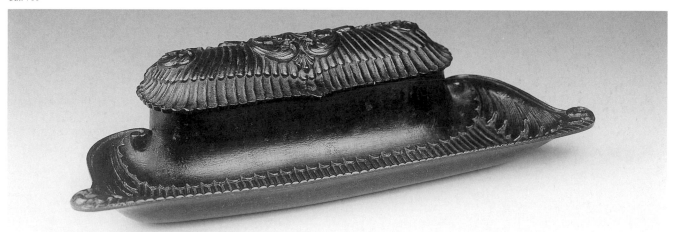

chenem Dekor verziert. Zwischen Tinten-
faß und Streusandbüchse erheben sich zwei
Rundpfeiler, die oben durch gotisierendes
Maßwerk zusammengefaßt sind. Tintenfaß
aus Glas, Streusandbüchse aus Eisen mit
Deckel aus Eisenguß mit Tannenzapfen als
Knauf.

702 Inkwell / Schreibzeug
(Fig. p./Abb. S. 252)
1830-40. – F./G. KPEG. – 10.5 x 22.3 x
13.5 cm (4 1/8 x 8 3/4 x 5 5/16 in.).
Lamprecht 188. – Inv. 1986.221.14 a, c, e.
Lit.: Hintze 1928a, 74, pl./Taf. IV, no. 18
(Gleiwitz P.-C. 1847).
Rectangular with Gothic arches on the sides
supported by a total of ten block feet, the co-
vers for the inkwell and sander (now mis-
sing) of cast iron with pine cone finials, in
the middle a small dish for nibs, its cover
now missing. / Mit gotisierenden Motiven an
den Seiten verziert, an den Langseiten durch
drei Eselsrücken gegliedert, auf insgesamt
zehn Füßen ruhend; Deckel aus Eisenguß, in
der Mitte rechteckiges Kästchen für Schreib-
federn mit geriffelten Seiten, dessen Deckel
fehlt.

703 Inkwell / Schreibzeug
(Fig. p./Abb. S. 250)
1822-25. – 16.1 x 12.5 x 12.6 cm (6 5/16 x
4 15/16 x 4 15/16 in.).
Lamprecht 282. – Inv. 1986.221.15.
Lit.: Cp./Vgl. Cat. Meves, pl./Taf. 12, no. 52
(„Aufsatz, Notis Boccaris, als Chatoulle").
– cp./vgl. Stummann-Bowert, 99, no. 56.
In the form of a Greek freedom fighter in
revolutionary national dress and cap seated

on a square base designed to look like a
carpet, on his belt an "A" within a wreath,
across his knees lies a sword; on the base
is the inscription "NOTIS BOZARIS" as well
as a winged figure holding a banner that
reads "HELLAS"; the inkwell and sander are
missing. Markos Bozzaris (Botzaris, Bot-
saris; ca. 1788-1823) was a Greek freedom
fighter against the Turks. / In Form eines
sitzenden griechischen Freiheitskämpfers
in Nationaltracht auf einem rechteckigen
Sockel, auf der breiten Bauchbinde ein „A"
im hochovalen Blätterkranz, über das Knie
gelegt ein Krummsäbel, auf dem Sockel
die Schrift „NOTIS BOZARIS" sowie eine
geflügelte Figur mit Fahne und dem Wort
„HELLAS"; Tintenfaß und Streusandbüch-
se fehlen. Markos Bozzaris (Botzaris, Bot-
saris; um 1788-1823) war ein griechischer
Freiheitskämpfer gegen die Türken.

704 Inkwell / Schreibzeug
(Fig. p./Abb. S. 35)
Second quarter of the 19th century / 2. Vier-
tel des 19. Jh. – F./G. Devaranne, Berlin. –
10 x 13.5 x 6.4 cm (3 15/16 x 5 5/16 x 2 1/2
in.). – Marked on the base / bez. auf der Un-
terseite „Devaranne Ac: Kunst / à Berlin
225".
Lamprecht 926. – Inv. 1986.221.16 a-c.
Lit.: Hintze 1928a, 93, pl./Taf. XXXVII,
no. 4 (Gleiwitz P.-C. 1847; here called a
match holder / hier „Feuerzeuggestelle"
genannt).
In the form of a winged dragon with two
openings on his back, apparently converted
from a match holder into an inkwell when
the openings were used instead to hold a

brass-and-tin sander and a porcelain ink-
well. / Ein geflügelter Drache auf einem
Sockel mit zwei Öffnungen im Rücken,
wurde offenbar später aus einem Streich-
holzbehälter in ein Schreibzeug umfunktio-
niert, indem man in die Öffnungen ein Tin-
tenfaß aus Porzellan und eine Streusand-
büchse aus Messing und Eisenblech ein-
fügte.

705 Inkwell / Schreibzeug
1820-30. – F./G. KPEG (?). – 7.3 x 12.5 x
8 cm (2 7/8 x 4 15/16 x 3 1/8 in.).
Lamprecht 927. – Inv. 1986.221.17 a-d.
The oblong dish with fluted sides, two shell
handles, and with a central hollow vessel,
the hinged lid is domed and ribbed with a
leaf finial; an inkwell and sander are in-
side. / Die längliche Unterschale geriffelt,
mit zwei Muschelhenkeln, in der Mitte ein
Gefäß mit gewölbtem geriffelten Deckel
mit Blattknauf, innen Tintenfaß und Streu-
sandbüchse.

706 Inkwell / Schreibzeug
(Fig. p./Abb. S. 251)
1820-30. – Tin/Zinn. – F./G. KPEG Berlin.
– 10.3 x 8.7 x 5.4 cm (4 1/16 x 3 7/16 x 2 1/8
in.).
Lamprecht 265. – Inv. 1986.221.18 a-d.
Lit.: Arenhövel 1982, 202, no. 432. – Hintze
1928a, 123, pl./Taf. III, no. 10 (Sayn Mus-
terb. 1846).
In the form of recumbent lion on a tall ped-
estal base; with a break and a piece missing
on the right side of the lid; green patina. /
Ruhender Löwe auf hohem Sockel; auf der

Cat. 705

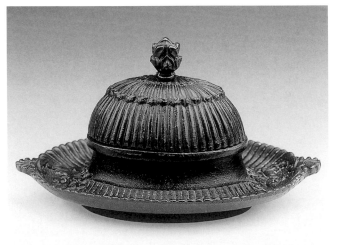

Cat. 707

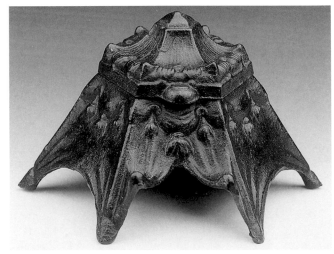

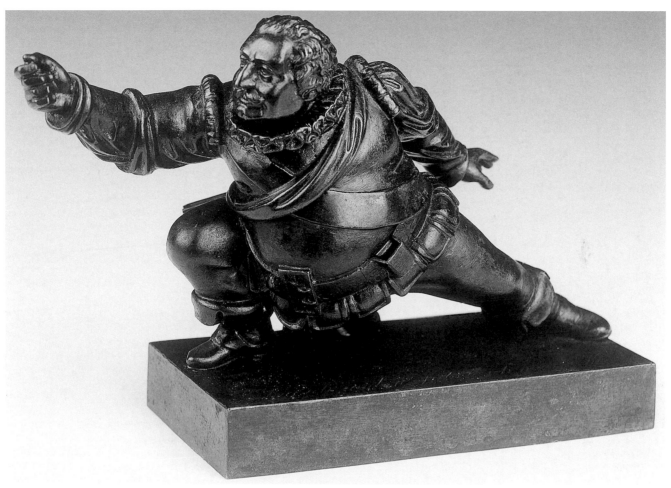

Cat. 708

rechten Seite des Deckels gebrochen, ein Teil fehlt; mit grüner Patina.

707 Inkwell / Schreibzeug
Mid 19th century / Mitte des 19. Jh. – H. 8.2 cm (3 1/4 in.); D. 11.5 cm (4 1/2 in.). Lamprecht 205. – Inv. 1986.221.19 a-b.
In the form of a hexagonal Turkish tent with one side open, the hinged lid opens to reveal a glass inkwell. / In Form eines sechsseitigen türkischen Zelts, auf einer Seite geöffnet, der aufklappbare Deckel enthüllt das gläserne Tintenfaß.

708 Inkwell / Schreibzeug
Ca. 1830. – Mod. Friedrich Wilhelm August Kastner, after a design by / nach einem Entwurf von Wilhelm August Stilarsky. – F./G. KPEG Gleiwitz. – 12.6 x 19 x 7.5 cm (4 15/16 x 7 1/2 x 2 15/16 in.). Lamprecht 130, Photo 26. – Inv. 1986.233 a-c.

Lit.: Arenhövel 1982, 203 f., no. 435. – Cat. Leipzig 1915, 119, no. 68. – Ferner and Genée, 26, fig./Abb. 12. – Hintze 1928a, 85, pl./Taf. XV, no. 12 (Gleiwitz P.-C. 1847). – Ostergard 1994, 241, no. 102. – Schmidt 1981, 117, fig./Abb. 110. – Stummann-Bowert, 99, no. 55.
In the form of Sir John Falstaff from Shakespeare's "King Henry IV" lunging on his right leg with outstretched arms, inscribed on the base *"so lag ich und so führte ich meine Klinge"*. The inscription is quoted from the second act, fourth scene, translated by August Wilhelm Schlegel; originally with a small, folding pen knife. Shown at the Berlin Academy exhibition in 1830 (Börsch-Supan, no. 1223). /
In der Form von Sir John Falstaff aus Shakespeares „König Heinrich IV." in Ausfallstellung mit dem nach vorn ausgestreckten rechten Arm, auf der Oberseite des Sockels beschriftet „*so lag ich und so führte ich mei-*

ne Klinge" aus dem 2. Akt, 4. Szene, übersetzt von August Wilhelm Schlegel; ursprünglich mit Degen, der als ausklappbares Messerchen diente; auf der Akademie-Ausstellung 1830 gezeigt (Börsch-Supan, no. 1223). Cp./vgl. Cat. 716.

709 Inkwell / Schreibzeug
(Fig. p./Abb. S. 256)
Second quarter of the 19th century / 2. Viertel des 19. Jh. – H. 12.5 cm (4 15/16 in.); D. 10.3 cm (4 1/16 in.). Inv. 1962.128 a-c. – Gift of / Schenkung von Dr. and Mrs. Maurice Garbáty. Lit.: Andrews, 425, fig./Abb. 12.
In the form of a globe supported by three legs with winged lion's masks and hoofed feet on a tripod base; glass inkwell. / In Form eines Globus auf drei Beinen mit geflügelten Löwenmasken und Hufen auf dreiseitig einschwingendem Sockel mit Anthemiondekoration; das Tintenfaß aus Glas.

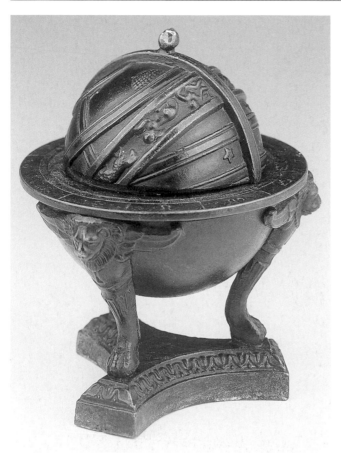

Cat. 709

Cat. 710

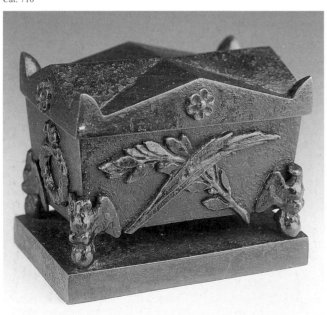

710 Inkwell / Schreibzeug
1810-20. – F./G. KPEG (?). – 6.5 x 8.6 x 5.5 cm (2 9/16 x 3 3/8 x 2 3/16 in.).
Inv. 1962.129 a-c. – Gift of / Schenkung von Dr. and Mrs. Maurice Garbáty.
In the form of a sarcophagus supported by four eagles with outstretched wings resting on ball feet, with crossed laurel branches and bulrushes on the long sides, the short sides with wreaths, the gabled lid with flowers; on slab base. / Ein Sarkophag, der auf vier Füßen ruht, die jeweils aus einem Adler mit gespreizten Flügeln über einer Kugel bestehen. An den Langseiten gekreuzte Palmwedel und Lorbeerzweige, an den Schmalseiten Kränze, der Giebeldeckel mit Blumen verziert.

Paper Clamps / Papierhalter (Cat. 711-15)

711 Paper Clamp / Papierhalter
First half of the 19th century / 1. Hälfte des 19. Jh. – 12.7 x 5 cm (5 x 1 15/16 in.).
Lamprecht 178, Photo 31. – Inv. 1986.340.1.
Two pieces with hinge and steel spring. The lower part with truncated edges and a waffle pattern, the upper part with a relief scene of dogs hunting a stag, with palmette and two flowers. / Zwei Teile mit Scharnier und Stahlfeder. Das Unterteil vorn rechteckig mit abgeschnittenen Ecken und scharriereisenartig aufgerauht, nach hinten zweimal einschwingend bis zur Öse; das Oberteil schuhsohlenartig gewölbt und mit Palmette, Jagdszene und zwei Blüten verziert.

712 Paper Clamp / Papierhalter
First half of the 19th century / 1. Hälfte des 19. Jh. – 15.2 x 6 cm (6 x 2 3/8 in.).
Lamprecht 179, Photo 31. – Inv. 1986.340.2.
Two pieces with hinge and steel spring. The lower part with waffle pattern enclosed by a wide border, the upper part of stylized hanging leaves with a large flower at the top. / Zwei Teile mit Scharnier und Stahlfeder. Das schuhsohlenartige Unterteil vorn scharriereisenartig aufgerauht und seitlich vegetabil verziert. Das Oberteil in Form von stilisierten nach unten hängenden Blättern, oben eine Blume.

713 Paper Clamp / Papierhalter
Mid 19th century / Mitte des 19. Jh. – 10.5 x 16.8 x 8.2 cm (4 1/8 x 6 5/8 x 3 1/4 in.).
Lamprecht 203, Photo 20. – Inv. 1986.340.3.
In the form of two men on a seesaw next to

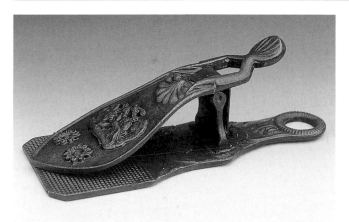

Cat. 711

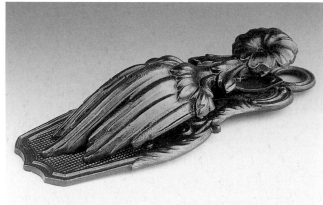

Cat. 712

Cat. 715

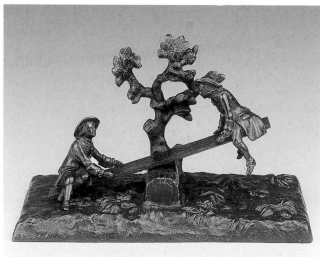

Cat. 713

Cat. 714

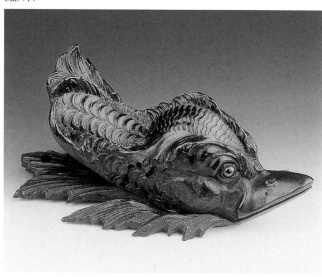

a tree. / Zwei Männer auf einer Wippe neben einem Baum.

714 Paper Clamp / Papierhalter
Second quarter of the 19th century / 2. Viertel des 19. Jh. – 7.5 x 15.8 x 9.8 cm (2 15/16 x 6 1/4 x 3 7/8 in.).
Lamprecht 241. – Inv. 1986.340.4.
Two pieces with hinge and steel spring. In the form of a sea creature with glass eyes (top part; one eye is missing) and outstretched fins (bottom part). / Zwei Teile mit Scharnier und Stahlfeder. Ein Fisch mit Glasaugen (Oberteil) und abgespreizten Flossen (Unterteil); ein Glasauge fehlt.

715 Paper Clamp / Papierhalter
Mid 19th century / Mitte des 19. Jh. – 5.6 x 19 x 6 cm (2 3/16 x 7 1/2 x 2 3/8 in.).
Lamprecht 218. – Inv. 1986.340.5.
Two pieces with hinge and steel spring. In the form of a raven's head with glass eyes and a long beak; the beak originally bronzed. / Zwei Teile mit Scharnier und Stahlfeder. In Form eines Rabenkopfs mit Glasaugen und langem Schnabel; Schnabel ursprünglich bronziert.

Cat. 717

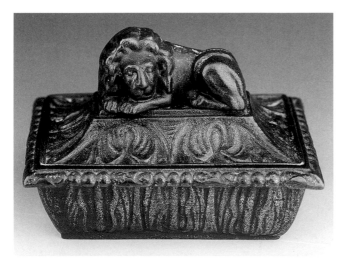

Cat. 718

Cat. 719

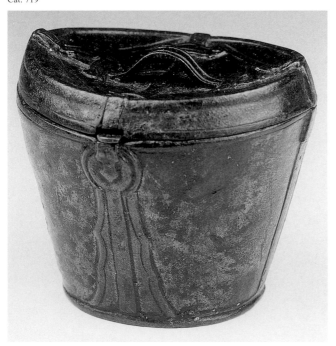

Boxes / Kästen und Dosen (Cat. 716-23)

716 Tobacco Box / Tabakbehälter
(Fig. p./Abb. S. 5)
Ca. 1834. – Mod. Johann Carl Wilhelm Kratzenberg. – F./G. Devaranne or/oder KPEG Berlin. – 29 x 15 x 18,5 cm (11 7/16 x 5 7/8 x 7 5/16 in.). – On left side of the chair / Auf der linken Seite des Stuhls „W. Kratzenberg akad. Künstler in Be[rlin]“. Inv. 2007.16 a-b. – Museum purchase / Museumsankauf.
Lit.: Cp./vgl. Bartel 2004, 38, 100, no. 116. – Schmitz 1917, 54, pl./Taf. 21.
In the form of a seated, bearded Sir John Falstaff from Shakespeare's "King Henry IV" (cp. Cat. 708), his right hand raised holding the handle of a dagger (the blade is missing). / In der Form des sitzenden bärtigen Sir John Falstaff aus Shakespeares „König Heinrich IV." (vgl. Cat. 708), der seinen rechten Arm gehoben hat, dessen Hand den Griff eines Degens hält (die Klinge fehlt).

717 Covered Box / Kästchen
First quarter of the 19th century / 1. Viertel des 19. Jh. – F./G. KPEG (?). – 2.4 x 8.3 x 5.5 cm (15/16 x 3 1/4 x 2 3/16 in.).
Lamprecht 207. – Inv. 1986.343.5 a-b.
In the shape of a tub; the cover with the image of a hound in reeds. / In Form einer rechteckigen Wanne; der Deckel mit einem Jagdhund im Schilf.

718 Covered Box / Kästchen
First quarter of the 19th century / 1. Viertel des 19. Jh. – F./G. KPEG (?). – 5.6 x 8.4 x 5.5 cm (2 3/16 x 3 5/16 x 2 3/16 in.).
Lamprecht 252. – Inv. 1986.343.6 a-b.
In the shape of a tub, the cover with relief decoration and a recumbent lion as knob. / In Form einer rechteckigen Wanne, der Deckel mit Reliefdekor und liegendem Löwen als Knauf.

719 Covered Box / Dose
1830-40. – F./G. KPEG (?). – 6 x 8 x 7.3 cm (2 3/8 x 3 1/8 x 2 7/8 in.).
Lamprecht 284. – Inv. 1986.343.7.
In the form of a belted men's hat box, under the hinged lid is a second, fluted lid. / In Form eines Herrenhutkoffers, unter dem aufklappbaren Deckel ein zweiter geriffelter Deckel.

720 Pair of Tobacco Boxes / Paar Tabak-kästen

Ca. 1825. – F./G. KPEG. – a) 18.5 x 18.3 x 11.5 cm (7 5/16 x 7 3/16 x 4 1/2 in.). – b) 15.9 x 17.7 x 11.2 cm (6 1/4 x 6 15/16 x 4 7/16 in.).
Lamprecht 25-26, Photo 15. – Inv. 1986.498.1 a-b and .2 a-b.
Lit.: Andrews, 426, fig./Abb. 13. – Arenhövel 1982, 195, no. 415. – Aus einem Guß, 122, no. 238. – Cat. Köln 1979, no. 247. – Cat. Leipzig 1915, 119, no. 64 f. – Grzimek 1982, 182, no. 113. – Hintze 1928a, 124, pl./Taf. IV, no. 17 (Sayn Musterb. 1846). – Historismus 1989, 12 f., no. 203. – Lauchhammer Bildguß 1933, 173. – Ostergard 1994, 249, no. 113. – Schmidt 1981, 184, fig./Abb. 176. – Spiegel, 142, fig./Abb. 35. – Stummann-Bowert, 100, no. 60.
Rectangular, supported on four claw feet, with a pair of winged griffins on the long sides flanking a flaming candelabrum, on the short sides a candelabrum with stylized foliage, the cover similarly decorated with a pinecone finial. The size of the second box suggests that it is probably a later cast. This attractive box was very popular and was frequently recast (also in other materials like silver). / Rechteckig auf vier Löwenfüßen, auf den Längsseiten zwei gegenständige Greifen beidseitig eines Kandelabers, auf den Schmalseiten ein Kandelaber mit Voluten und Ranken, der Deckel ähnlich verziert, mit Tannenzapfen als Knauf. Die Maße des zweiten Kastens deuten darauf hin, daß es sich hier um einen Nachguß handelt. Dieser reizvolle Kasten war sehr beliebt und wurde (auch in anderen Werkstoffen wie Silber) nachgegossen.

721 Covered Box / Dose
(Fig. p./Abb. S. 260)
1820-30. – F./G. KPEG. – H. 1.5 cm (9/16 in.); D. 7.5 cm (2 15/16 in.).
Lamprecht 68. – Inv. 1986.501.1-2.
Lit.: Cat. Leipzig 1915, 128, no. 138.
Round, with an image of *The Last Supper* after Leonardo da Vinci (cp. Cat. 220-22). The underside with engraved decorative pattern. / Kreisförmig mit dem „Letzten Abendmahl" nach Leonardo da Vinci (vgl. Cat. 220-22). Die Unterseite mit Guillochierungen verziert.

722 Covered Box / Dose
(Fig. p./Abb. S. 260)
1820-30. – F./G. KPEG. – H. 1.4 cm (9/16 in.); D. 7.5 cm (2 15/16 in.).
Lamprecht 137. – Inv. 1986.502 a-b.

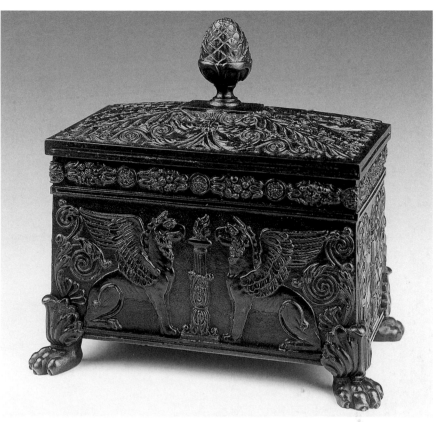

Cat. 720a

Cat. 720b

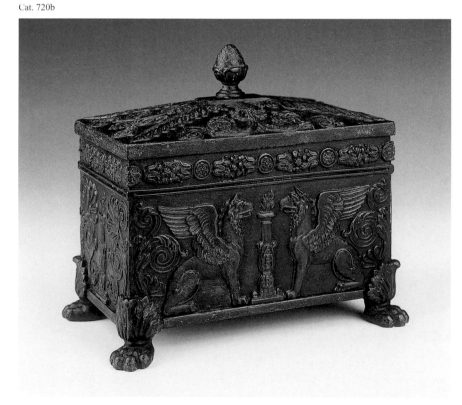

Cat. 721 (a)

Cat. 721 (b)

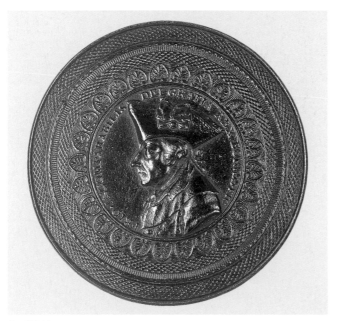

Cat. 722 (a)

Cat. 722 (b)

Lit.: Cat. Leipzig 1915, 128, no. 137. – Ostergard 1994, 245, no. 107.
Round, with the relief portrait of Friedrich II, the portrait medallion is framed with a palmette frieze and engraved decorative pattern; the underside of the same design. / Kreisförmig, mit Porträt Friedrichs II. verziert, umgeben von einem Palmettenfries und Guillochierungen, letztere auch auf der

Unterseite. / Ins. around/Umschrift „FRID. INCOMPARABILIS DEI GRATA REX BORVSS ETC".

723 Tobacco Box / Tabakdose
1840-50. – F./G. KPEG. – H. 14.6 cm (5 3/4 in.); D. 14.4 cm (5 11/16 in.).
Inv. 1962.132 a-b. – Gift of / Schenkung von Dr. and Mrs. Maurice Garbáty.

Cylindrical, with three ball feet and a border of stylized acanthus leaves, the body is plain, the neck with an egg-and-dart motif, the domed cover with stylized foliage and an umbrella finial. / Zylindrisch mit drei Kugelfüßen und gereihten Akanthusblättern, der Körper glattwandig, oben mit Eierstab umzogen, der gewölbte Deckel mit stilisierten Blättern verziert, der Knauf schirmförmig.

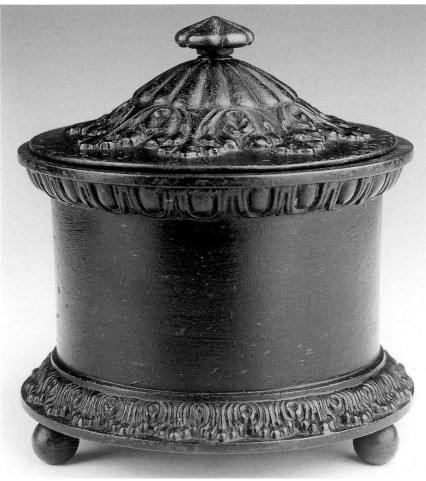

Cat. 723

Mirrors / Spiegel (Cat. 724-34)

724 Mirror / Kippspiegel
(Fig. p./Abb. S. 262)
1820-30. – F./G. KPEG. – 37.6 x 19.6 cm
(14 13/16 x 7 11/16 in.); D. 12.8 cm (5 1/16
in.).
Lamprecht 3, Photo 1. – Inv. 1986.313.1.
Lit.: Cp./vgl. Arenhövel 1982, 224 f., no.
485, 489. – Schmidt 1976, fig./Abb. 13. –
Schmuttermeier, 36, no. 36. – Stummann-
Bowert, 93, no. 9, pl./Taf. 18.
On a round base with grape leaves and
bunches of grapes, sunflowers, roses, and
acanthus leaves, the lyre-shaped stem with
a basket of flowers at the base and on either
side a cornucopia; the mirror holder with
stylized leaves and the frame with a band
of sunflowers and roses. / Der runde Sockel
mit Weinblättern, Weintrauben, Sonnenblu-

men, Rosen und Akanthusblättern verziert,
der Ständer in Form einer Lyra gebildet, de-
ren Seitenteile aus je einem Füllhorn wach-
sen; das Spiegelgestell ist mit stilisierten
Blättern, der Rahmen mit Sonnenblumen
und Rosen geschmückt.

725 Mirror / Kippspiegel
(Fig. p./Abb. S. 262)
1830-40. – F./G. KPEG. – 30.2 x 13.3 x
11.6 cm (11 7/8 x 5 1/4 x 4 9/16 in.).
Lamprecht 28, Photo 2. – Inv. 1986.313.2.
Lit.: Andrews, 425, fig./Abb. 11. – H. v.
Sp., 299.
On a pierced, square base the stand in the
form of a lyre comprised of two birds with
outstretched wings, in the middle a fluted
column from which extend vines, leaves, and
flowers as a support for the mirror frame;
the rim of the mirror frame with an egg and
dart motif, a mask between scrolling foli-
age as finial. / Auf durchbrochenem quadra-

tischen Sockel erhebt sich der lyrenartige
Ständer mit einem kannelierten Pfeiler, aus
dem sich mit Ranken, Blättern und Blüten
die Halterung für das Spiegelgestell ent-
wickelt. Der Spiegelrahmen wird innen von
einem Eierstab begleitet und trägt oben ei-
ne Maske zwischen Rankenwerk.

726 Mirror / Kippspiegel
1820-30. – F./G. KPEG. – 37.6 x 13.8 cm
(14 13/16 x 5 7/16 in.); base/Sockel 9.1 x
9.1 cm (3 9/16 x 3 9/16 in.).
Inv. 1962.113. – Gift of / Schenkung von Dr.
and Mrs. Maurice Garbáty.
On a decorative square plinth the base has
a scrolling leaf motif, the stand is in the

Cat. 726

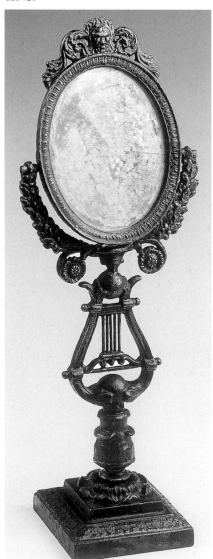

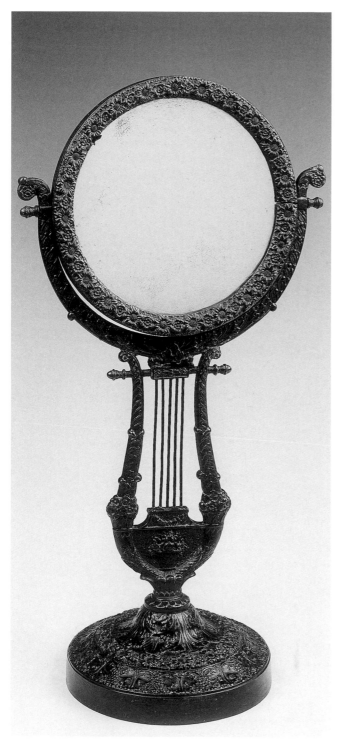

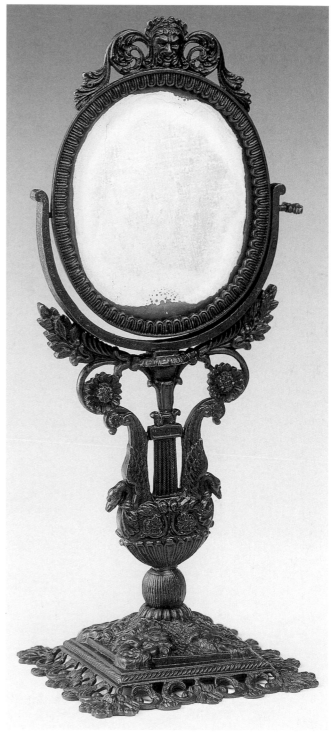

Cat. 724

Cat. 725

shape of a lyre; the support for the mirror frame with two sunflowers and laurel leaves; the oval frame with an egg-and-dart pattern and mask finial (cp. Cat. 724 f., 730 f.); traces of gilding. / Auf quadratischem Sokkel der Ständer aus aufwachsenden Pflanzen, einem lyrenartigen Motiv sowie Voluten und Lorbeerzweigen gebildet. Der eierstabverzierte ovale Spiegelrahmen trägt oben eine von Ranken begleitete Maske (vgl. Cat. 724 f., 730 f.); Reste von Vergoldung.

727 Stand for a Mirror with Jewelry Holder / Kippspiegelgestell mit Schmuckhalter
1820-30. – F./G. KPEG. – 22.7 x 14.4 cm (8 15/16 x 5 11/16 in.); base/Sockel 8.4 x 8.4 cm (3 5/16 x 3 5/16 in.). – 14 pcs./T. Lamprecht 278, Photo 14. – Inv. 1986.314.2. On a square plinth the round base is decorated with flowers and stylized foliage; the stand is in the form of a lyre; the U-shaped mirror support with six prongs to hold jewelry; the round mirror frame is simple and undecorated; the mirror is missing. / Auf quadratischem Sockel der runde Fuß mit Blumen und stilisiertem Laubwerk; der Ständer in Form einer Lyra trägt das halbrunde Spiegelgestell, das auf jeder Seite drei Häkchen für das Anhängen von Schmuck aufweist. Der kreisförmige Spiegelrahmen ist einfach und schmucklos; das Spiegelglas fehlt.

728 Mirror / Kippspiegel
(Fig. p./Abb. S. 264)
1820-30. – F./G. KPEG (?). – 27 x 13.7 cm (10 5/8 x 5 3/8 in.); D. of base / des Sockel 11.8 cm (4 5/8 in.).
Inv. 1962.112. – Gift of / Schenkung von Dr. and Mrs. Maurice Garbáty.
On a decorative round base the fluted, columnar stem with a gilt band at the base and neck; the mirror frame is gilt; with traces of green patina. / Auf verziertem runden Fuß ein kannelierter Rundpfeiler mit Goldband oben und unten, der Spiegelrahmen vergoldet; Reste von grüner Patina.

729 Stand for a Mirror / Spiegelgestell
(Fig. p./Abb. S. 264)
1820-30. – F./G. KPEG. – 35.3 x 17.9 cm (13 7/8 x 7 1/16 in.); D. of base / des Sokkels 8.5 cm (3 3/8 in.).
Inv. 1962.114. – Gift of / Schenkung von Dr. and Mrs. Maurice Garbáty.
On a tripod base supported by three legs with claw feet the stand has a bulbous base and is decorated with stylized acanthus

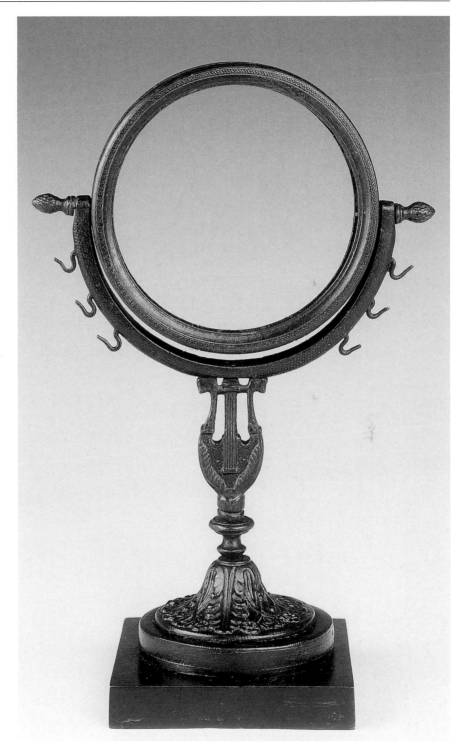

Cat. 727

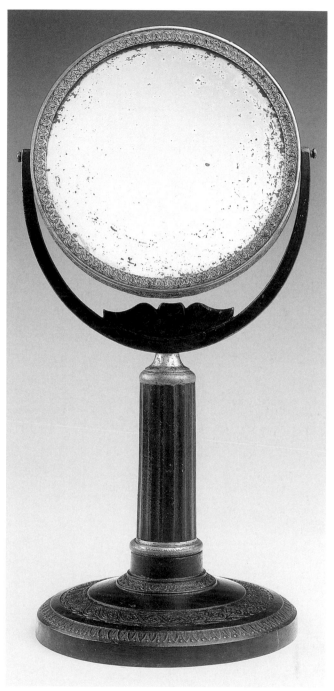

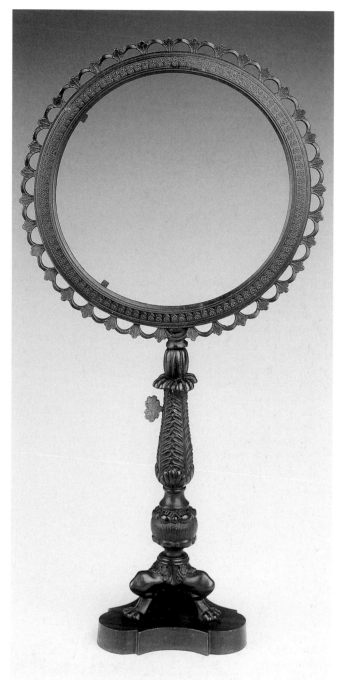

Cat. 728

Cat. 729

Cat. 730 (Rev./Rs.) ▶

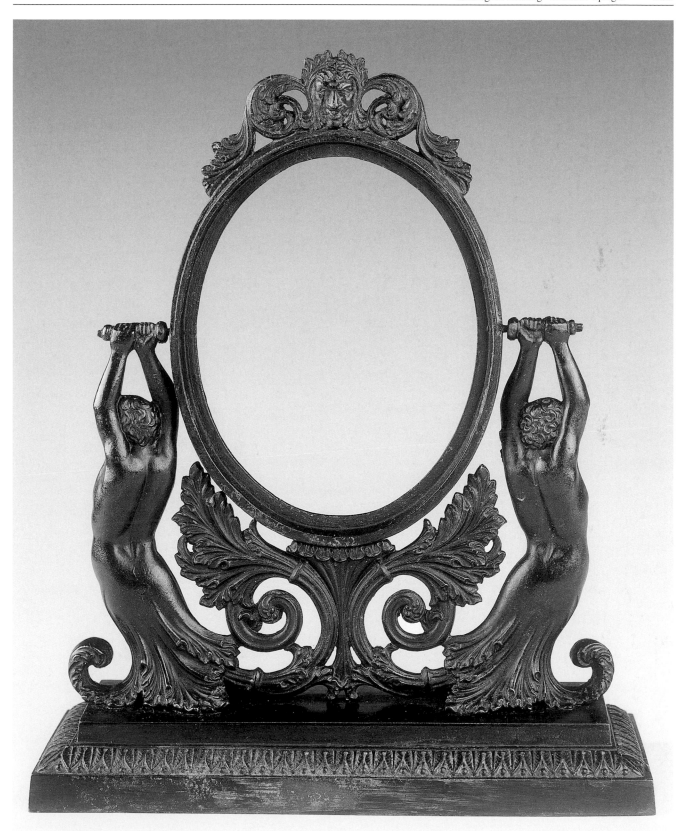

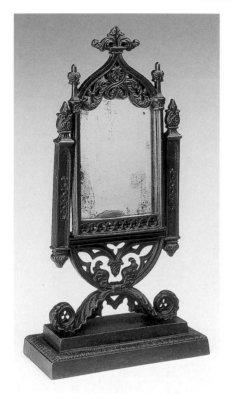

Cat. 732

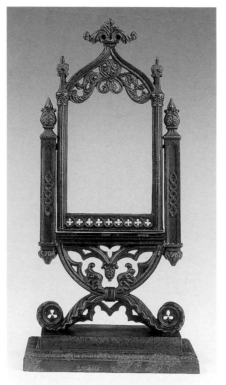

Cat. 733

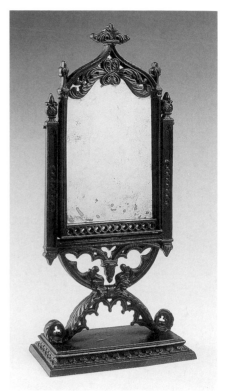

Cat. 734

leaves; the mirror frame (original?) is pierced with a band of foliage. The now empty frame could have been used to hold a lithophane. The stand can also be found as a candleholder (cp. Cat. 820). / Auf Dreifuß-Sockel der durch einen Knauf und durch Akanthus gegliederte Ständer, der Spiegelrahmen (zugehörig?) durchbrochen mit Laubwerk. Der heute leere Rahmen könnte auch zur Aufnahme eines Lichtschirms gedient haben. Der Ständer kommt auch als Kerzenhalter vor (vgl. Cat. 820).

730 Stand for a Mirror / Kippspiegelgestell
(Fig. p./Abb. S. 265)
1825-35. – F./G. KPEG or/oder Lauchhammer. – 24.7 x 20 x 7.7 cm (9 3/4 x 7 7/8 x 3 1/16 in.).
Inv. 1962.109. – Gift of / Schenkung von Dr. and Mrs. Maurice Garbáty.
Lit.: Cp./vgl. Arenhövel 1982, 226, no. 490. – Bartel 2004, 113, no. 268. – Schmitz 1917, 55, pl./Taf. 26. – Spiegel, 141, fig./Abb. 34. – Stamm, 37, fig./Abb. 26.
The stepped, rectangular base with a stylized leaf border supports two grotesque-like

male figures, whose bodies terminate in acanthus leaves; the oval mirror frame is decorated above with a mask between stylized foliage (cp. Cat. 731); the mirror is missing. / Der abgestufte und mit stilisierten Blättern verzierte Sockel trägt zwei groteskenartige Männer, deren Körper in Akanthusblätter übergehen; der ovale Spiegelrahmen ist oben mit einer Maske zwischen Ranken verziert (vgl. Cat. 731); das Spiegelglas fehlt.

731 Mirror / Kippspiegel
(Fig. p./Abb. S. 349)
1825-35. – F./G. Lauchhammer. – 26.3 x 20.4 x 8 cm (10 3/8 x 8 1/16 x 3 1/8 in.). – Marked on the base with Lauchhammer foundry mark in relief and *"11"* / bez. auf der Unterseite mit einer Marke von Lauchhammer in Relief und „*11*".
Inv. 1962.110. – Gift of / Schenkung von Dr. and Mrs. Maurice Garbáty.
Lit.: S. Cat. 730.
The model for this mirror is the same as for Cat. 730, however the base and measurements are different; traces of bronze patina. / Der Entwurf dieses Spiegelhalters beruht

auf demselben Modell wie Cat. 730, jedoch mit etwas anderem Sockel und etwas anderen Maßen; Reste von Bronzierung.

732 Mirror / Kippspiegel
1825-30. – F./G. KPEG. – 23.6 x 12 x 5.8 cm (9 5/16 x 4 3/4 x 2 5/16 in.).
Lamprecht 189, Photo 3. – Inv. 1986.313.3.
Lit.: Cat. Gliwice 1988, no. 58, fig./Abb. 30. – Hintze 1928a, 89, pl./Taf. XVIII, no. 9 (Gleiwitz P.-C. 1847). – Schmitz 1917, 55 f., pl./Taf. 30.
On a rectangular base two scrolled feet support the Gothic-style mirror stand with a pair of columns with leaf finials on either side; a rectangular mirror frame with quatrefoils below and columnar sides with spiral finials, with decorative scrollwork above; the arched top with leaf finial (cp. Cat. 733 f.). / Auf rechteckiger Platte erhebt sich der durchbrochene, aus gotisierenden Motiven gebildete Ständer, der das Spiegelgestell mit zwei seitlichen eckigen Pfeilern trägt; der rechteckige Spiegelrahmen mit zierlichen profilierten Streben ist oben eselsrückenartig mit Pflanzendekor abgeschlossen (vgl. Cat. 733 f.).

733 Stand for a Mirror / Kippspiegelgestell

First quarter of the 19th century / 1. Viertel des 19. Jh. – F./G. KPEG. – 23.6 x 11.5 x 5.9 cm (9 5/16 x 4 1/2 x 2 5/16 in.). Inv. 1962.111. – Gift of / Schenkung von Dr. and Mrs. Maurice Garbáty.

Lit.: S. Cat. 732.

This mirror stand is the same model as that in Cat. 732 (cp. also Cat. 734); the mirror is missing. / Dieses Spiegelgestell beruht auf dem Modell von Cat. 732 (vgl. auch Cat. 734); das Spiegelglas fehlt.

734 Mirror / Kippspiegel

1825-30. – F./G. Lauchhammer. – 29.4 x 13.1 x 7.7 cm (11 9/16 x 5 3/16 x 3 1/16 in.). – Marked on the base with Lauchhammer foundry mark / bez. auf der Unterseite mit der Marke von Lauchhammer. Inv. 1962.115. – Gift of / Schenkung von Dr. and Mrs. Maurice Garbáty.

Lit.: S. Cat. 732.

This mirror stand is a slightly modified version of the model in Cat. 732 f.; traces of gilding. / Diesem Spiegelhalter liegt ein leicht modifiziertes Modell von Cat. 732 f. zugrunde; Reste von Vergoldung.

Clocks / Uhren (Cat. 735-39)

735 Night Clock / Nachtuhr

1820-30. – F./G. KPEG. – 42.7 x 22.7 x 12.5 cm (16 13/16 x 8 15/16 x 4 15/16 in.). Lamprecht 81, Photo 8. – Inv. 1986.293.2 a-c.

On a rectangular base rests a pair of griffins connected by a scrolling foliate motif, the stem is in the form of a round, fluted column. The clock frame is made of a series of Gothic spires, the back of the stand includes a bracket with a candleholder in a metal alloy (possibly not original); the clock is not original. / Auf rechteckigem Sockel zwei vegetabil verbundene gegenständige Greifen, zwischen denen aus einem Blätterkelch ein kannelierter Rundpfeiler aufsteigt. Der Rahmen aus gotisierendem Spitzendekor; auf der Rückseite ein Arm mit Kerzenhalter aus Gelbguß (vielleicht nicht ursprünglich); das Uhrwerk nicht original.

736 Night Clock / Nachtuhr

Mid 19th century / Mitte des 19. Jh. – F./G. Seebass (?; clockworks by / Uhrwerk von Edward Manley, London). – H. 25.6 cm

(10 1/16 in.); base/Sockel 11.5 x 11.5 cm (4 1/2 x 4 1/2 in.). Lamprecht 82. – Inv. 1986.293.3 a-b.

On a square base the foot is fluted and decorated with foliage, the stand is in the form of a striding youth with flowers in his right hand and with his left he supports the clock frame, which rests on his head. The frame is comprised of scrolling foliate motifs and the clock face is of opaque glass, which is painted with flowers in the center. / Auf rechteckiger Platte der Fuß mit Riefen und Blattverzierung, der Ständer in Form eines schreitenden Jungen mit Blumen in der Rechten; der Uhrrahmen mit Voluten verziert, das Zifferblatt aus Milchglas mit Messingzeigern und in der Mitte mit Blumen bemalt.

737 Clock Case / Uhrgehäuse

(Fig. p./Abb. S. 268)

1818-20. – F./G. KPEG Berlin (?). – 41.9 x 19.3 x 11.3 cm (16 1/2 x 7 5/8 x 4 7/16 in.). Lamprecht 110, Photo 11 f. – Inv. 1986.293.5.

Lit.: Schmidt 1981, 177, fig./Abb. 165. – Schmitz 1917, 55 f., pl./Taf. 30.

In the form of a Gothic architectural structure with four columns supporting an arch with scrolling foliate, flower, and acanthus leaf design, below this the case for the clock; the base rests on pierced, bracket feet; with traces of green patina. / In Form einer gotisierenden Architektur aus vier Pfeilern, die einen Bogen mit Voluten, Blumen, Dreipässen und Akanthusblättern tragen, darunter ein Rahmen für ein Uhrwerk; der abgestufte verzierte Sockel mit viereckigen Füßen.

738 Night Clock / Nachtuhr

(Fig. p./Abb. S. 268)

1810-20. – F./G. KPEG. – 33.5 x 17.4 cm (13 3/16 x 6 7/8 in.); base/Sockel 12.4 x 12.4 cm (4 7/8 x 4 7/8 in.). Lamprecht 136, Photo 10. – Inv. 1986.293.6.

On a decorative base with four claw feet, the stand is in the form of a lyre extending from an angel's head with outstretched wings, the round clock frame is decorated with an egg-and-dart motif and the clock face is of porcelain, at the back is a candle holder. The clockworks are not original. / Auf verziertem Sockel mit vier Löwentatzen der Ständer in Form einer Lyra aus einem En-

Cat. 735

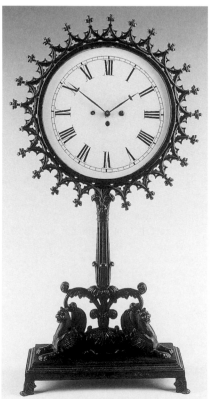

Cat. 736

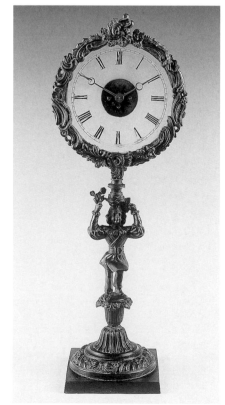

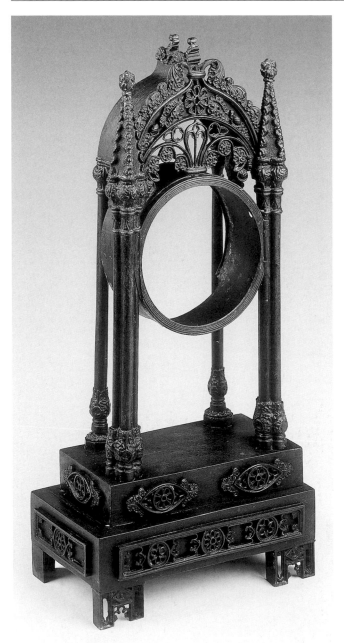

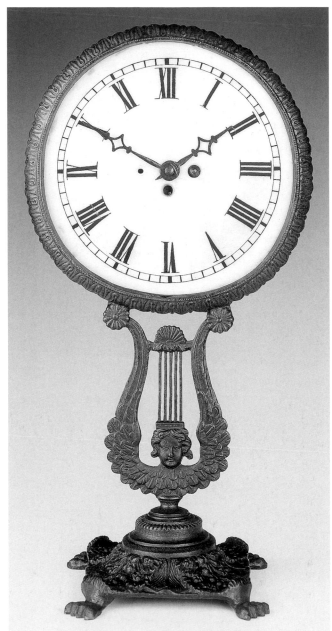

Cat. 737 Cat. 738

gelskopf mit hochgereckten Flügeln, der kreisförmige Uhrrahmen eierstabartig verziert, das Zifferblatt aus Porzellan, hinten ein Halter für eine Kerze. Das Uhrwerk ist nicht original.

739 Clock Case / Uhrgehäuse
1830-40. – 38.5 x 17 cm (15 3/16 x 6 11/16 in.); D. of base / des Sockels 13 cm (5 1/8 in.). – Marked on the base / bez. auf der Unterseite „XXIII".
Inv. 1962.108 a-b. – Gift of / Schenkung von Dr. and Mrs. Maurice Garbáty.
An irregular base of intertwined scrolling elements supports a stand in the shape of a leafy vine; the clock frame of scrolling foliate elements and shell motifs. Remains of green glass where clock has been broken. / Unregelmäßiger Sockel aus zusammengedrehten Voluten, der Ständer aus hochrankenden Blattformen gebildet, der Uhrrahmen mit Laub- und Muschelmotiven geschmückt; Reste des Zifferblatts aus grünem Glas.

Pocket Watch Holders / Taschenuhrhalter (Cat. 740-62)

740 Pocket Watch Holder / Taschenuhrhalter
(Fig. p./Abb. S. 270)
1820-30. – F./G. KPEG (clockworks by / Uhrwerk von Abraham-Louis Brequet, Paris; sign. „Brequet á Paris"). – 26.8 x 13.5 x 6.4 cm (10 9/16 x 5 5/16 x 2 1/2 in.).
Lamprecht 27, Photo 13. – Inv. 1986.293.1.
Lit.: Cp./vgl. Arenhövel 1982, 222 f., no. 482. – Bartel 2004, 102, no. 144. – Grzimek, 172, no. 81. – Hintze 1928a, 80, pl./Taf. X, no. 11 (Gleiwitz P.-C. 1847).
On a rectangular base the clock case is in the form of war trophies including helmets, swords, and a shield, the finial is in the shape of a helmet surmounted by a bird-like creature with outstretched wings; the clock is set in a gilt-bronze mount. Originally a pocket watch holder with the clock a later

addition. For a similar model see Mölbert, 83, fig. 38 (found in Tafelwerk Carlshütte). / Auf rechteckigem Sockel der Uhrhalter in Form eines antiken Tropaions mit Helmen, Schwert, Schild und anderem, oben ein Helm mit einem vogelartigen Wesen mit gespreizten Flügeln; durch die nachträglich etwas unschön eingesetzte Uhr mit vergoldetem Rahmen wurde aus dem Halter eine Standuhr. Ein ähnliches Modell bei Mölbert, 83, Abb. 38 (nach dem Tafelwerk Carlshütte).

741 Pocket Watch Holder / Taschenuhrhalter
(Fig. p./Abb. S. 270)
1830-40. – F./G. Seebass. – 21.8 x 14 x 8 cm (8 9/16 x 5 1/2 x 3 1/8 in.). – 4 pcs./T. – Marked on the base / bez. auf der Unterseite „Seebas Berlin".
Inv. 1962.107. – Gift of / Schenkung von Dr. and Mrs. Maurice Garbáty.
Lit.: Cp./vgl. Arenhövel 1982, 222 f., no.

Cat. 739

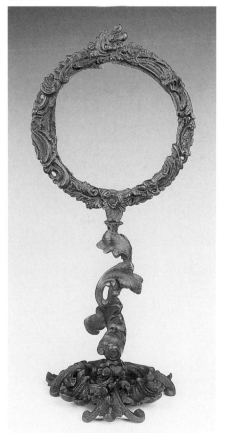

Cat. 743

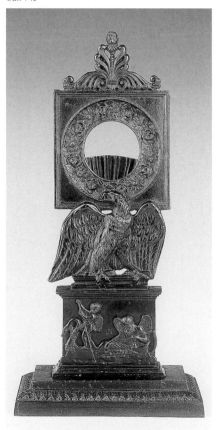

Cat. 744

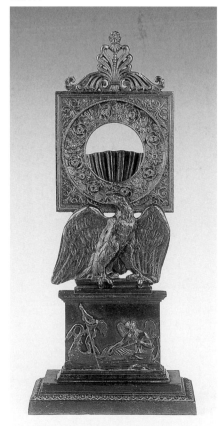

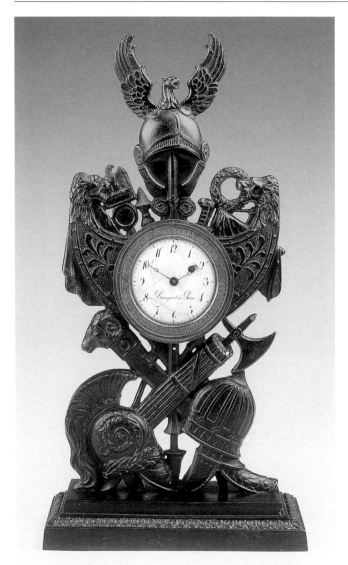

Cat. 740

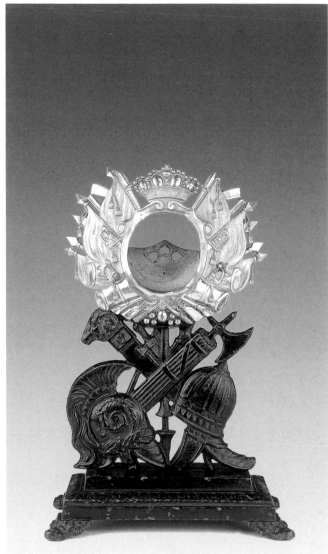

Cat. 741

482. – cp./vgl. Bartel 2004, 102, no. 144. – cp./vgl. Eberle, 26.
On a decorative base the lower body of war trophies (cp. Cat. 740), the upper watch holder is of gilt brass with a series of flags, drums, swords, cannons, and cannonballs; the finial is a crown; traces of green patina. / Das untere Teil beruht auf dem Modell des Tropaions von Cat. 740. Das obere Teil in vergoldetem Gelbguß zeigt Fahnen, Trommeln, Schwerter, Kanonen und Kanonenkugeln sowie oben eine Krone; Reste von grüner Patina.

742 Pocket Watch Holder / Taschenuhrhalter
(Fig. p./Abb. S. 374)
1820-30. – F./G. KPEG. – 25.4 x 13.7 x 6.3 cm (10 x 5 3/8 x 2 1/2 in.). – 5 pcs./T. Lamprecht 42, Photo 13. – Inv. 1986.222.1. Lit.: Arenhövel, 218, no. 473. – Aus einem Guß, 123, no. 246. – Cat. Gliwice 1988, no. 65, fig./Abb. 32. – cp./vgl. Grzimek, 173, no. 84. – Hintze 1928a, 84, pl./Taf. XIV, no. 4 (Gleiwitz P.-C. 1847). – Schmuttermeier, 42 f., no. 48. – Stummann-Bowert, 103, no. 106.
In the form of a winged putto kneeling and holding on his shoulders a large square, dec-orative frame with a holder for the pocket watch, on a pedestal base with a frieze of playful putti. The winged putto was adapted from a motif on a wall plaque on the altar gate of the Berlin Cathedral, after an 1820 design by Karl Friedrich Schinkel. / Ein kniender geflügelter Putto trägt auf den Schultern einen großen quadratischen verzierten Rahmen mit einem Halter für die Taschenuhr; der hohe Sockel zeigt auf der Vorderseite spielende Putten in Relief. Der Putto ist nach einem Motiv auf einem Pfeiler des Altargitters im Berliner Dom nach einem Entwurf Karl Friedrich Schinkels von 1820 modelliert.

743 Pocket Watch Holder / Taschenuhr-halter

(Fig. p./Abb. S. 269)
1825-30. – F./G. KPEG. – 31 x 15.3 x 7.6 cm (12 3/16 x 6 x 3 in.).
Lamprecht 45, Photo 13. – Inv. 1986.222.2.
Lit.: Arenhövel 1982, 222, no. 481. – Aus einem Guß, 219, no. 1587. – Bartel 2004, 104, no. 151. – Hintze 1928a, 85, pl./Taf. XV, no. 5 (Gleiwitz P.-C. 1847). – Mölbert, 86, fig./Abb. 41. – Ostergard 1994, 254, no. 120. – Schmitz 1917, 55, pl./Taf. 29.
In the form of an eagle resting on a pedestal base with a frieze showing an image of Chronos and supporting a large square frame with a decorative border and finial; the eagle is based on a model created by Christian Daniel Rauch for monuments to Johann David von Scharnhorst (1755-1813) and Ludwig Friedrich Victor Hans Graf von Bülow (1774-1825; cp. Simson 1996, 129, oben links, 134, oben). / Ein Adler auf einem hohen Sockel trägt einen großen quadratischen Rahmen mit der runden Öffnung, die durch einen Blumenkranz betont wird, und dem Haltkörbchen sowie oben einem Palmettenabschluß. Auf der Vorderseite des Sockels in Relief eine Darstellung des Kronos; der Adler nach einem Modell von Christian Daniel Rauch für die Denkmäler zu Johann David von Scharnhorst (1755-1813) und Ludwig Friedrich Victor Hans Graf von Bülow (1774-1825; vgl. Simson 1996, 129, oben links, 134, oben).

744 Pocket Watch Holder / Taschenuhr-halter

(Fig. p./Abb. S. 269)
Ca. 1825. – F./G. KPEG Berlin or/oder Gleiwitz. – 30.9 x 13.5 x 6.3 cm (12 3/16 x 5 5/16 x 2 1/2 in.). – 6 pcs./T.
Inv. 1962.104. – Gift of / Schenkung von Dr. and Mrs. Maurice Garbáty.
Lit.: S. Cat. 743.
This pocket watch holder is the same model as in Cat. 743. / Dieser Taschenuhrhalter beruht auf demselben Modell wie Cat. 743.

745 Pocket Watch Holder / Taschenuhr-halter

Ca. 1820-30. – F./G. KPEG. – 22.8 x 10.8 x 4.4 cm (9 x 4 1/4 x 1 3/4 in.). – 4 pcs./T.
Lamprecht 69, Photo 7. – Inv. 1986.222.3.
Lit.: Andrews, 423, fig./Abb. 5. – Arenhövel 1982, 221, no. 478. – Cat. Leipzig 1915, 118, no. 52. – Hintze 1928a, 73, pl./Taf. III, no. 16 (Gleiwitz P.-C. 1847). – S. also/auch Mölbert, 82, fig./Abb. 37 (Tafelwerk Carls-

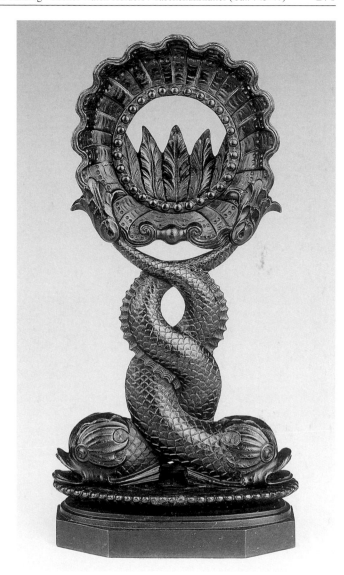

Cat. 745

hütte, pl./Taf. 6, no. 2). – Schmidt 1981, 179, fig./Abb. 169. – Schmitz 1917, 56, pl./Taf. 31. – Stummann-Bowert, 104, no. 109.
On an octagonal base with a surface designed to look like water, a pair of dolphins with intertwined tails support a round shell holder for a pocket watch. An example marked *"Devaranne"* was sold on eBay (USA) in March 2004. / Auf achteckigem Sockel tragen zwei Delphine mit zusammengedrehten Schwänzen eine runde Muschel als Halter für die Taschenuhr. Ein Exemplar mit der Bezeichnung *„Devaranne"* wurde bei eBay (USA) im März 2004 verkauft. Cp./vgl. Cat. 746.

746 Pocket Watch Holder / Taschenuhr-halter

1820-30. – F./G. KPEG. – 23 x 10.8 x 4.5 cm (9 1/16 x 4 1/4 x 1 3/4 in.). – 4 pcs./T.
Inv. 1962.100. – Gift of / Schenkung von Dr. and Mrs. Maurice Garbáty.
Lit.: S. Cat. 745.
This pocket watch holder is the same model as in Cat. 745. / Dieser Taschenuhrhalter beruht auf demselben Modell wie Cat. 745.

747 Pocket Watch Holder / Taschenuhr-halter

First quarter of the 19th century / 1. Viertel des 19. Jh. – F./G. KPEG Gleiwitz (?). –

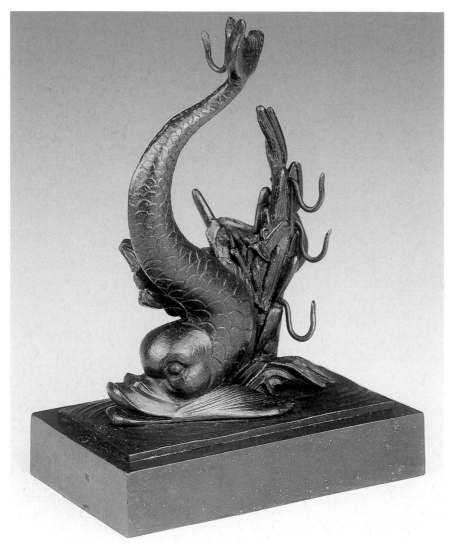

Cat. 747

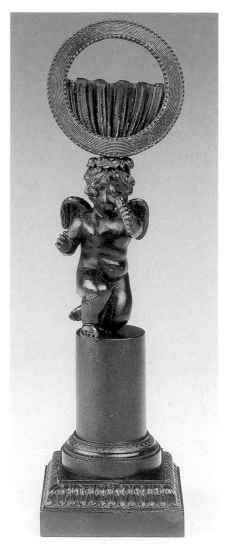

Cat. 748

14.9 x 11 x 6.7 cm (5 7/8 x 4 5/16 x 2 5/8 in.). – 8 pcs./T.
Lamprecht 88, Photo 4. – Inv. 1986.222.7.
Lit.: Hintze 1928a, 81, pl./Taf. XI, no. 10 (Gleiwitz P.-C. 1847).
On a rectangular plinth a dolphin among reeds, its tail with a hook to support the watch chain; additional hooks on the sides. / Auf rechteckiger Platte ein Delphin neben Rohrkolben, an dessen Schwanz ein Haken für die Uhr. Seitlich weitere Haken.

748 Pocket Watch Holder / Taschenuhr-halter
1820-30. – F./G. KPEG Sayn (?). – 24.3 x 6.8 x 6.8 cm (9 9/16 x 2 11/16 x 2 11/16 in.). – 10 pcs./T.
Lamprecht 86, Photo 6. – Inv. 1986.222.5.

Lit.: Arenhövel 1982, 218, no. 472. – Bartel 2004, 104, no. 150.
On a square base, a winged cupid holding a bow kneels on an undecorated column, on his head he carries a round frame with a shell support for the watch; part of the bow is missing. / Auf quadratischem Sockel ein glatter Säulenstumpf mit kniendem Amor, der einen Bogen hält (zum Teil wegge-brochen), auf dem Kopf der ringförmige Halter mit Muschelkörbchen für die Uhr.

749 Pocket Watch and Jewelry Holder with Pin Cushion / Taschenuhr- und Schmuckhalter mit Nadelkissen
1830-40. – F./G. Seebass. – 17 x 8.2 x 8.2 cm (6 11/16 x 3 1/4 x 3 1/4 in.). – Marked on the base / bez. auf der Unterseite „See-

bas à Berlin". – Marked on the watch hold-er / bez. auf dem Uhrhalter „A. R. Sebass".
Inv. 1962.103. – Gift of / Schenkung von Dr. and Mrs. Maurice Garbáty.
Lit.: Cp./vgl. Hanauer Eisen, 40, no. 19.16.
The stylized, foliate base with four leafy feet supporting a decorative, pierced ring with small hooks to hold jewelry, in the middle is a pin cushion, on which a winged putto kneels holding a watch holder in the form of a wreath on its head. Cp. the putto with that in Cat. 750. / Der leicht nach in-nen ansteigende, mit Blättern verzierte Sockel auf vier Füßen trägt eine ornamen-tierte Scheibe mit einem Nadelkissen, auf dem ein geflügelter Putto kniet, der auf sei-nem Kopf den Uhrhalter in Form eines Kranzes trägt. An der Scheibe außen in Ab-

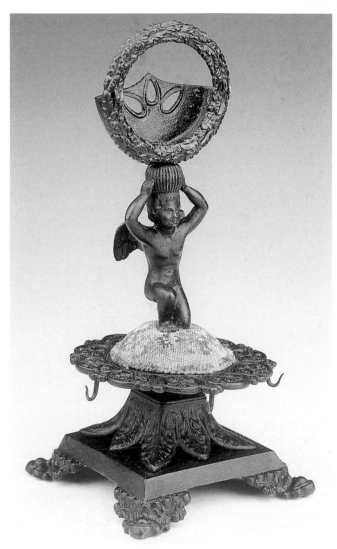

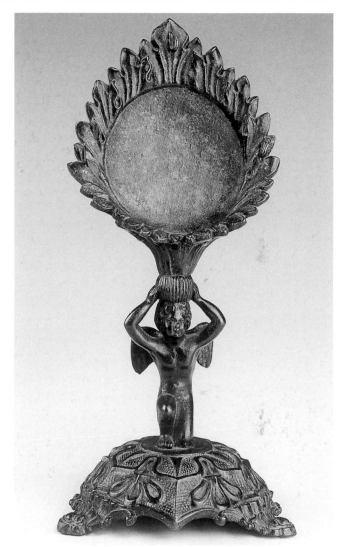

Cat. 749 Cat. 750

ständen kleine Haken für Schmuck. Zu
dem Putto vgl. Cat. 750.

750 Pocket Watch Holder / Taschenuhrhalter

1830-40. – F./G. Meves. – 17.8 x 8 x 8 cm
(7 x 3 1/8 x 3 1/8 in.). – Marked on the
base / bez. auf der Unterseite „*Deponirt A
Meves Berlin*". – 4 pcs./T.
Lamprecht 170. – Inv. 1986.222.10.
Lit.: Cp./vgl. Arenhövel 1982, 220, no. 474
(with different base / mit anderem Sockel).
– Ostergard 1994, 254, no. 121.
On a domed base with a web pattern in re-
lief, a winged cherub kneels, carrying a leafy
holder for the pocket watch on its head.
Cp. the watch holder with that in Cat. 751. /
Auf gewölbtem Sockel mit Netzmotiv in

Relief trägt ein kniender, geflügelter Putto
auf seinem Kopf den Halter aus Blättern.
Zu dem Halter vgl. Cat. 751.

751 Pocket Watch Holder / Taschenuhrhalter

(Fig. p./Abb. S. 274)
1830-40. – F./G. Seebass, Berlin. – 16.9 x 8.7
x 8 cm (6 5/8 x 3 7/16 x 3 1/8 in.). – 3 pcs./T.
– Marked on the base / bez. auf der Unter-
seite „*Seebas à Berlin*".
Lamprecht 279, Photo 14. – Inv.
1986.222.14.
Lit.: Ostergard 1994, 254, no. 121.
On a square base supported by four leafy
feet, the stand with a decorative round foot
and a stem of two scrolling leaves; the
watch holder is in the form of a flower with

leafy petals; at the top is a hook to hold the
watch chain. Cp. the watch holder with that
in Cat. 750. / Auf quadratischem Sockel mit
vier blattförmigen Füßen ein runder Fuß
mit einem Ständer aus zwei volutenartigen
Blättern, die nach oben den blätterumrahm-
ten Uhrhalter entlassen; oben ein Haken für
die Uhrkette. Zu dem Halter vgl. Cat. 750.

752 Pocket Watch Holder(?) / Taschenuhrhalter(?)

(Fig. p./Abb. S. 274)
1820-30. – F./G. KPEG (?). – 18 x 8.8 x
6 cm (7 1/16 x 3 7/16 x 2 3/8 in.). – 3 pcs./T.
Lamprecht 70, Photo 10. – Inv. 1986.222.4.
On an oval base, a vessel in the form of an
antique lamp with an eagle's head supports a
long, scrolled element from which the watch

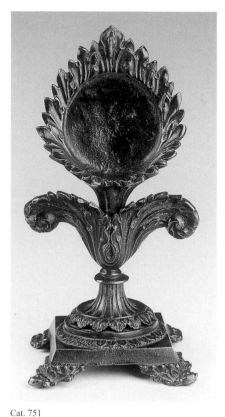

Cat. 751

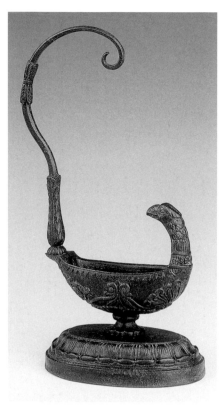

Cat. 752

hung. This piece could originally have been a stand for an incense burner that is now missing. / Auf ovalem Sockel ein Gefäß in Form einer antiken Lampe mit Adlerkopf, das ein langes, gerolltes Element, an dem die Taschenuhr hängt, entläßt. Es könnte sich hier auch um einen Ständer für eine Räucherschale handeln, die allerdings fehlt.

753 Pair of Pocket Watch Holders / Paar Taschenuhrhalter

Ca. 1830. – F./G. KPEG. – 23.7 x 9 x 9 cm (9 5/16 x 3 9/16 x 3 9/16 in.). – 6 pcs./T. Lamprecht 97-98, Photo 15. – Inv. 1986.222.8 a-b.

Lit.: Cp./vgl. Arenhövel 1982, 223, no. 483. – Bartel 2004, 102, no. 141. – cp./vgl. Cat. Leipzig, 118, no. 54. – Hintze 1928a, 73, pl./Taf. III, no. 15 (Gleiwitz P.-C. 1847), 124, pl./Taf. IV, no. 11 (Sayn Musterb. 1846). – Ostergard 1994, 253, no. 119.

Each consisting of a square, stepped plinth upon which rests a square pedestal decorated with a classical scene in relief within a wreath of grape leaves and grapes. The watch holder is likewise decorated with grape leaves and grapes and is crowned with a lyre with a winged putto's head below and

Cat. 753

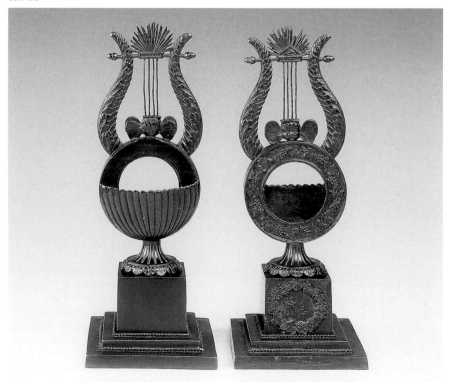

Cat. 754

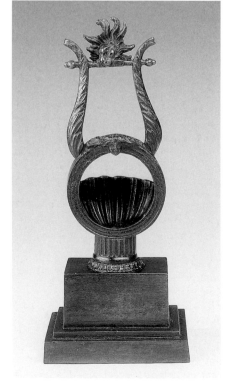

a radiant eye above. / Auf abgestufter Plin-
the ein Kubus mit antikisierender, reliefier-
ter Szene innerhalb eines Kranzes von Wein-
laub und Trauben. Der kreisringförmige
Uhrhalter ist mit Trauben und Weinlaub
verziert und wird bekrönt von einer Lyra mit
einer geflügelten Elfenmaske (unten) und
einem strahlenden Auge (oben).

754 Pocket Watch Holder / Taschenuhr-
halter

Second quarter of the 19th century / 2. Vier-
tel des 19. Jh. – 22.8 x 9.3 x 6.7 cm (9 x
3 11/16 x 2 5/8 in.). – 5 pcs./T.
Inv. 1962.105. – Gift of / Schenkung von
Dr. and Mrs. Maurice Garbáty.
On a rectangular base, the pedestal supports
a columnar foot and a round watch holder,
which is surmounted by a female mask,
above this is a lyre-shaped element of acan-
thus leaves with a crossbar and flame at
top. / Auf rechteckiger Platte ein Sockel, der
über einem kannelierten Säulenstumpf den
kreisringförmigen Uhrhalter mit Frauen-
maske trägt, darüber eine lyrenartige Form
aus Akanthusblättern mit Querbalken und
Flamme oben.

755 Pocket Watch and Jewelry Holder /
Taschenuhr- und Schmuckhalter

Ca. 1830. – F./G. Devaranne. – 21 x 13.6 x
6.5 cm (8 1/4 x 5 3/8 x 2 9/16 in.). –
Marked on the base / bez. auf der Unter-
seite „Dev in Berlin Nr. 18".
Lamprecht 264. – Inv. 1986.222.12.
Lit.: Ostergard 1994, 252, no. 118.
On a rectangular base, the lower stand is of
intricate, scrolling foliage supporting a round
opening for the watch and with three prongs
on each side to hold jewelry; the watch hold-
er is of pierced Gothic tracery and trefoils;
the finial is a pinecone between double
scrolls. / Auf rechteckiger Platte der Ständer
aus kräftigen gegenständigen Voluten; der
kreisringförmige Uhrhalter mit seitlich je-
weils drei Haken für Schmuck versehen und
oben in einem Zapfen zwischen Voluten
endend; das Uhrenkörbchen aus gotisieren-
dem Maßwerk.

756 Pocket Watch Holder / Taschenuhr-
halter

(Fig. p./Abb. S. 2)
Ca. 1830. – F./G. KPEG. – 31 x 16.2 x
8.1 cm (12 3/16 x 6 3/8 x 3 3/16 in.). –
7 pcs./T.
Lamprecht 100, Photo 2. – Inv. 1986.222.18.
Lit.: Arenhövel 1982, 220 f., no. 477. – Aus
einem Guß, 123, no. 247. – Bartel 2004,

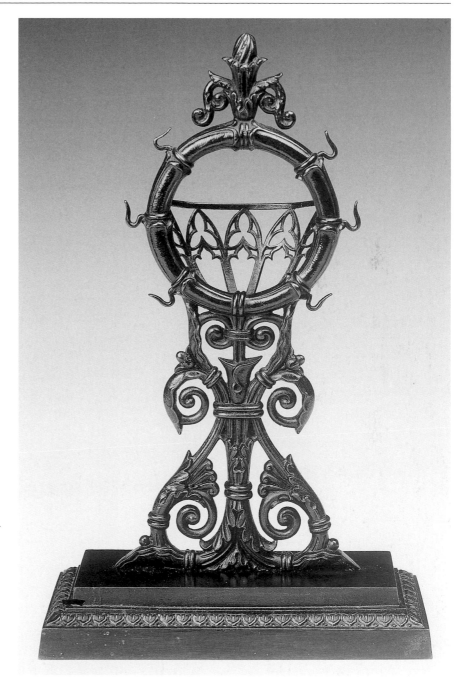

Cat. 755

102 f., no. 145. – Grzimek 1982, 172, no. 83.
– Hintze 1928a, 86, pl./Taf. XVI, no. 2 (Glei-
witz P.-C. 1847). – Mölbert, 89, fig./Abb. 44.
– Ostergard 1994, 252, no. 117. – Schmidt
1981, 178, fig./Abb. 167. – Schmitz 1917,
56, pl. 31.
On a rectangular base supported by four
ball feet, the stand is of scrolling acanthus
leaves with a pair of recumbent greyhounds

on either side of an urn, from which grows
a flowering plant that supports the round
watch holder; above the holder is a pair of
eagles with outstretched wings within scrol-
ling vines; the finial consists of leafy ele-
ments. / Auf rechteckiger Platte mit Kugel-
füßen steht der Ständer aus gerollten Akan-
thusblättern mit zwei gegenständigen ruhen-
den Windhunden beidseitig eines Mittel-

strangs, aus dem zwei Ranken sich nach oben entwickeln, den runden Uhrhalter umschließen und oben in zwei Adlern und Rankenwerk enden.

757 Pocket Watch Holder / Taschenuhrhalter

1825-35. – F./G. KPEG. – 32.8 x 13.5 x 8.6 cm (12 15/16 x 5 5/16 x 3 3/8 in.). Lamprecht 109, Photo 9. – Inv. 1986.293.4. Lit.: Arenhövel 1982, 215-17, no. 466. – Hintze 1928a, 86, pl./Taf. XVI, no. 3 (Gleiwitz P.-C. 1847).

In the form of a Gothic architectural structure with four columns supporting two pierced gables; the holder for the pocket watch was probably removed when a clock was added (of which only the gilt frame remains); with green patina. / In Form einer spitzgiebeligen gotisierenden Architektur aus vier Pfeilern, die zwei durchbrochene Giebel tragen; das Körbchen für die Taschenuhr wurde bei der wohl nachträglich eingefügten Uhr (von der nur noch ein vergoldeter Rahmen vorhanden ist) entfernt; mit grüner Patina.

758 Pocket Watch Holder / Taschenuhrhalter

1820-30. – F./G. KPEG. – 16.4 x 11.1 x 6.1 cm (6 7/16 x 4 3/8 x 2 3/8 in.). – 2 pcs./T. Inv. 1962.106. – Gift of / Schenkung von Dr. and Mrs. Maurice Garbáty. Lit.: Arenhövel 1982, 214, no. 463. – Hintze 1928a, 85, pl./Taf. XV, no. 2 (Gleiwitz P.-C. 1847).

On a rectangular base, the stand in the form of a Gothic architectural structure; the holder for the watch is missing. / Auf rechteckiger Platte ein gotisierender Bogen mit kreisförmiger Öffnung; die Halterung für die Uhr fehlt.

759 Pocket Watch Holder / Taschenuhrhalter

1820-30. – F./G. KPEG Gleiwitz (?). – 23.6 x 13.5 x 6.1 cm (9 5/16 x 5 5/16 x 2 3/8 in.). – 2 pcs./T. Lamprecht 173. – Inv. 1986.222.11. Lit.: Arenhövel 1982, 214, no. 461. – Hintze 1928a, 73, pl./Taf. III, no. 17 (Gleiwitz P.-C. 1847).

On a rectangular base a pair of banded columns on square pedestals supports a Gothic-style arch with a hook to hold the watch; the arch's finial is missing. / Auf rechteckiger Platte eine gotisierende Bogenstellung; die obere Spitze weggebrochen.

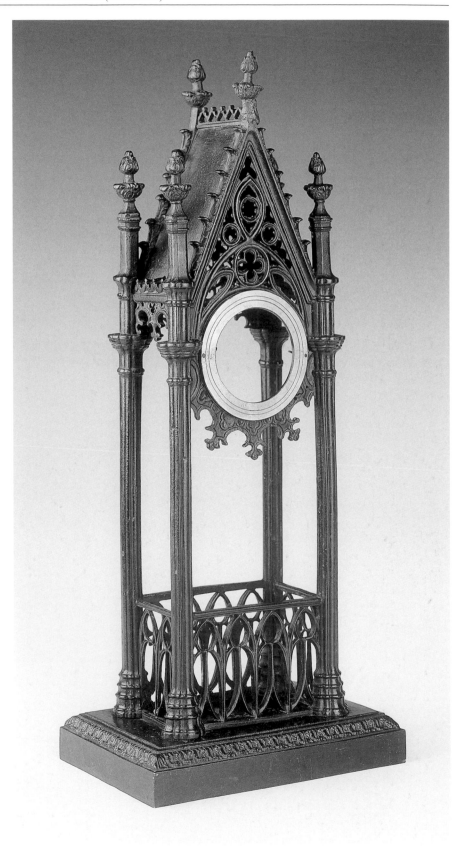

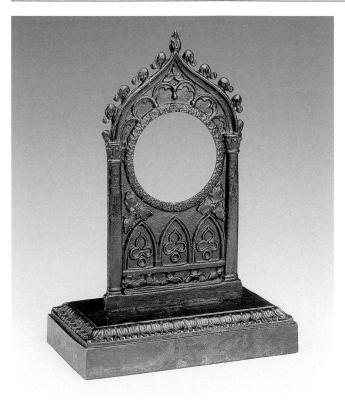

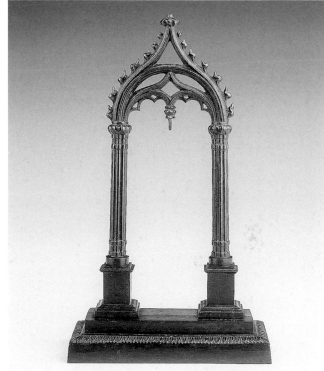

Cat. 758

◄ Cat. 757

Cat. 761

Cat. 762

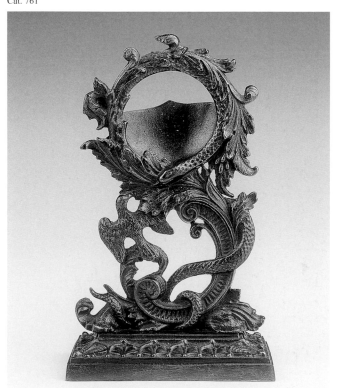

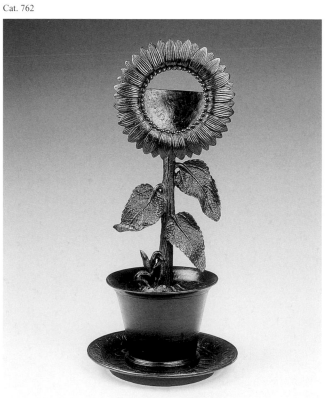

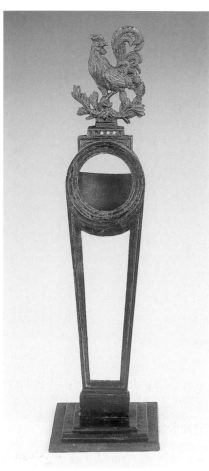

Cat. 760

Lamprecht 277, Photo 14. – Inv. 1986.222.13.
On a decorative base the stand consists of interwined, scrolled elements and foliage with an eagle with outstretched wings, and a snake that winds up the stand and encircles the watch holder. / Auf verziertem Sokkel der Ständer aus Rocaille, Adler, Blattwerk und einer Schlange, die sich vom Sockel über die Rocaille nach oben windet und kreisförmig die Uhrenhalterung umzieht, mit dem Kopf auf den Adler zielend.

762 Pocket Watch Holder / Taschenuhr-halter
(Fig. p./Abb. S. 277)
1830-40. – F./G. KPEG Gleiwitz (?). – H. 27.5 cm (10 13/16 in.); D. of base / des Sockels 12.5 cm (4 15/16 in.).
Inv. 1962.101. – Gift of / Schenkung von Dr. and Mrs. Maurice Garbáty.
Lit.: Hintze 1928a, 81, pl./Taf. XI, no. 2 (Gleiwitz P.-C. 1847). – Ostergard 1994, 250, no. 115.
In the form of a potted sunflower, whose bloom serves as the watch holder. / In einem Topf mit Unterschale eine aufwachsende Sonnenblume, deren Blüte als Uhrhalter dient.

Paperweights / Briefbeschwerer (Cat. 763-87)

763 Paperweight / Briefbeschwerer
Ca. 1840. – 10 x 15.4 x 7.8 cm (3 15/16 x 6 1/16 x 3 1/16 in.).
Lamprecht 112. – Inv. 1986.225.2.
Lit.: Cat. Leipzig 1915, 118, no. 56.
A man with a horse, on a rectangular base. / Ein Mann und ein Pferd, auf rechteckiger Platte.

764 Paperweight / Briefbeschwerer
1815-20. – Mod. after a design by / nach einem Entwurf von Christian Daniel Rauch (?). – F./G. KPEG. – 8.9 x 19.7 x 7.6 cm (3 1/2 x 7 3/4 x 3 in.).
Lamprecht 39, Photo 27. – Inv. 1986.247.2.
Lit.: Arenhövel 1982, 209, no. 449. – Cat. Leipzig 1915, 116, no. 22. – Ilsenburg c, pl./Taf. 129, no. 448. – Ostergard 1994, 236, no. 95. – Schuette 1916, 289, fig./Abb. 23. – Straube 1918, 72.
An eagle with outstretched wings, on a rectangular base. / Ein Adler mit gespreizten Flügeln, auf rechteckiger Platte.

765 Paperweight / Briefbeschwerer
Ca. 1820. – F./G. KPEG. – 9.8 x 8.8 x 7.2 cm (3 7/8 x 3 7/16 x 2 13/16 in.).
Lamprecht 40, Photo 27. – Inv. 1986.248.1.
Lit.: Arenhövel 1982, 210 f., no. 453. – Cat.

Cat. 763

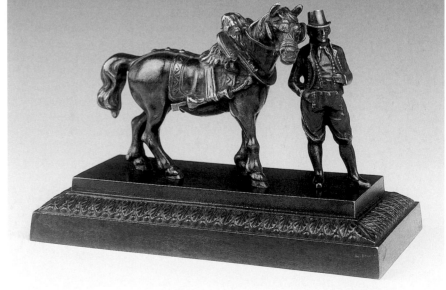

760 Pocket Watch Holder / Taschenuhr-halter
1820-30. – F./G. Mariazell (?). – 39.6 x 10.5 x 10.5 cm (15 9/16 x 4 1/8 x 4 1/8 in.). – 3 pcs./T.
Inv. 1962.102. – Gift of / Schenkung von Dr. and Mrs. Maurice Garbáty.
On a stepped plinth, a tapered tower with the simple, round watch holder at the top is surmounted by a rooster. / Ein schlichter kreisförmiger Uhrhalter zeigt oben einen Hahn und entläßt nach unten zwei leicht zusammenlaufende Streben, die auf einer abgestuften Plinthe stehen.

761 Pocket Watch Holder / Taschenuhr-halter
(Fig. p./Abb. S. 277)
1830-40. – F./G. Seebass, Berlin. – 17.3 x 10 x 5.6 cm (6 13/16 x 3 15/16 x 2 3/16 in.). – Marked on the back / bez. auf der Rückseite „Seebas à Berlin".

Cat. 764

Cat. 779

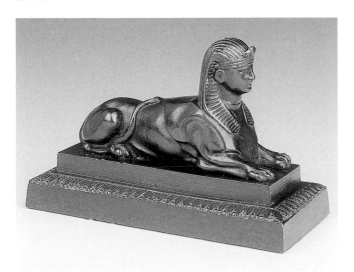

Cat. 767

Cat. 768

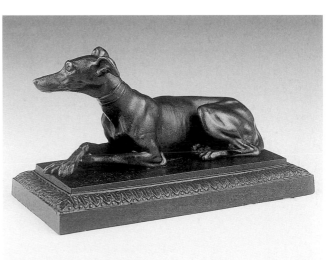

Cat. 765

Cat. 766

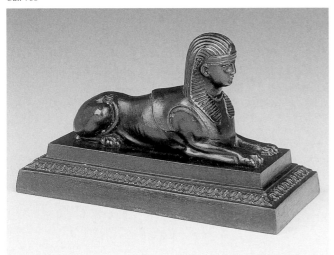

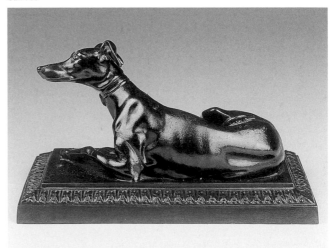

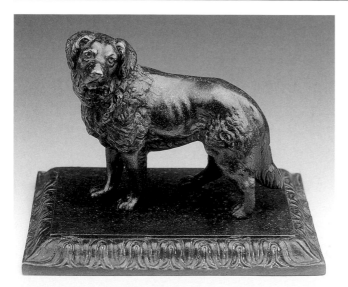

Cat. 769

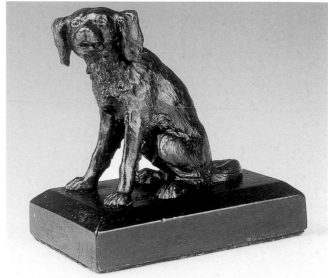

Cat. 770

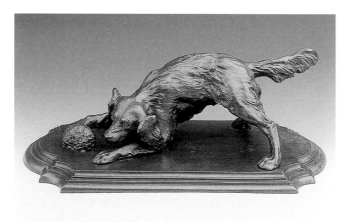

Cat. 771

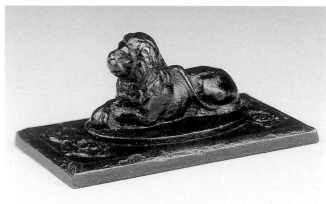

Cat. 774

Gliwice 1988, no. 75, fig./Abb. 36. – Hintze 1928a, 73, pl./Taf. III, no. 8 (Gleiwitz P.-C. 1847; with a different base / mit anderem Sockel), 123, no. 20 (Sayn Musterb. 1846). A recumbent greyhound, on a rectangular base. Pendant to Cat. 766. / Ein ruhender Windhund auf rechteckiger Platte. Gegenstück zu Cat. 766.

766 Paperweight / Briefbeschwerer
(Fig. p./Abb. S. 279)
Ca. 1830. – Mod. after a design by / nach einem Entwurf von Friedrich Drake. – F./G. KPEG. – 9.5 x 17.1 x 8.8 cm (3 3/4 x 6 3/4 x 3 7/16 in.).
Lamprecht 295. – Inv. 1986.248.2.

Lit.: Cat. Leipzig 1915, 117, no. 40. – Hintze 1928a, 73, pl./Taf. III, no. 7 (Gleiwitz P.-C. 1847; with a different base / mit anderem Sockel), 123, no. 16 (Sayn Musterb. 1846). – Ostergard 1994, 237, no. 98. – Schmitz 1917, 56, pl./Taf. 32.
A recumbent greyhound, on a rectangular base. Pendant to Cat. 765. / Ein ruhender Windhund auf rechteckiger Platte. Gegenstück zu Cat. 765.

767 Paperweight / Briefbeschwerer
(Fig. p./Abb. S. 279)
Ca. 1815. – F./G. KPEG. – 8.9 x 13.5 x 6 cm (3 1/2 x 5 5/16 x 2 3/8 in.).
Lamprecht 61. – Inv. 1986.249.1.

Lit.: Arenhövel 1982, 212, no. 457. – Cat. Leipzig 1915, 119, no. 656. – Hintze 1928a, 73, pl./Taf. III, no. 10 (Gleiwitz P.-C. 1847). – Ostergard 1994, 236, no. 96. – Schmitz 1917, 56, pl./Taf. 32.
A sphinx on a rectangular base. Cp./vgl. Cat. 768. / Eine Sphinx auf rechteckiger Platte. Cp./vgl. Cat. 768.

768 Paperweight / Briefbeschwerer
(Fig. p./Abb. S. 279)
Ca. 1815. – F./G. KPEG. – 8.2 x 14 x 6.7 cm (3 1/4 x 5 1/2 x 2 5/8 in.).
Lamprecht 61. – Inv. 1986.249.2.
Lit.: Bartel 2004, 105, no. 161. – Cat. Leipzig 1915, 119, no. 66. – Ostergard 1994, 236, no. 96.

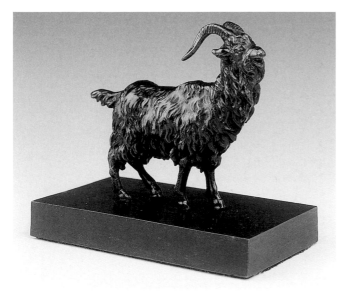

Cat. 773

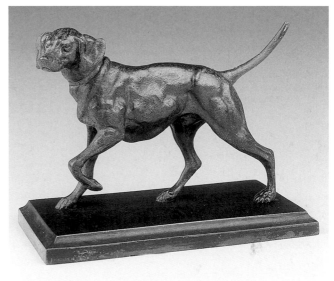

Cat. 772

A sphinx on a rectangular base (like Cat. 767, but with slight variations). / Eine Sphinx auf rechteckiger Platte (wie Cat. 767, jedoch mit leichten Varianten).

769 Paperweight / Briefbeschwerer
1845-55. – Mod. Johann Heinrich Kureck. – F./G. Mägdesprung. – 7.4 x 9.9 x 6.7 cm (2 15/16 x 3 7/8 x 2 5/8 in.).
Lamprecht 183, Photo 27. – Inv. 1986.250.1.
Lit.: Cat. Leipzig 1915, 120, no. 69.
A standing St. Bernard on a rectangular base. / Ein stehender Bernhardinerhund auf rechteckiger Platte.

770 Paperweight / Briefbeschwerer
1830-40. – 10 x 9.6 x 6.5 cm (3 15/16 x 3 3/4 x 2 9/16 in.).
Lamprecht 184, Photo 27. – Inv. 1986.250.2.
Lit.: Aus einem Guß, 216, no. 1539.
A seated dog on a rectangular wooden base. / Ein sitzender Hund auf rechteckiger Holzplatte.

771 Paperweight / Briefbeschwerer
1845-55. – Mod. Johann Heinrich Kureck. – F./G. Mägdesprung. – 5.8 x 7.2 x 8.3 cm (2 5/16 x 2 13/16 x 3 1/4 in.).
Lamprecht 185, Photo 27. – Inv. 1986.250.3.
Lit.: Cat. Leipzig 1915, 120, no. 70.
A hunting dog barking at a hedgehog, on an oblong base. / Ein Jagdhund, der einen eingerollten Igel anbellt, auf länglicher Platte.

772 Paperweight / Briefbeschwerer
1830-40. – 12.3 x 18.7 x 16.4 cm (4 13/16 x 7 3/8 x 6 7/16 in.). – 2 pcs./T.
Lamprecht 922. – Inv. 1986.250.4.
Lit.: Simpson, 143, fig./Abb. 128.
A hunting dog on a rectangular base. / Ein Jagdhund auf rechteckiger Platte.

773 Paperweight / Briefbeschwerer
Ca. 1892. – F./G. Ilsenburg (?). – 11.4 x 12.5 x 7 cm (4 1/2 x 4 15/16 x 2 3/4 in.).
Lamprecht 259, Photo 27. – Inv. 1986.254.
Lit.: Hintze 1928a, 75, pl./Taf. V, no. 6 (Gleiwitz P.-C. 1847). – Ilsenburg c, no. 23.
A standing goat on a rectangular base. / Eine stehende Ziege auf rechteckiger Platte.

774 Paperweight / Briefbeschwerer
1830-40. – 2.8 x 6.9 x 3.3 cm (1 1/8 x 2 11/16 x 1 5/16 in.). – 2 pcs./T.
Lamprecht 169. – Inv. 1986.339.1.
A small recumbent lion with crossed paws on rectangular base. / Ein kleiner, ruhender Löwe mit gekreuzten Pfoten auf rechteckigem Sockel.

775 Paperweight / Briefbeschwerer
(Fig. p./Abb. S. 282)
1840-50. – 6.9 x 13.9 x 9 cm (2 11/16 x 5 1/2 x 3 9/16 in.).
Lamprecht 175, Photo 19. – Inv. 1986.339.2.
Lit.: Grzimek 1982, 166, no. 56.
A horse's head on a highly modeled base. /

Ein Pferdekopf auf vegetabil reliefiertem Sockel.
Cp./vgl. to the base / zum Sockel Cat. 785.

776 Paperweight / Briefbeschwerer
1840-50. – F./G. KPEG Sayn (?). – 14.5 x 16.5 x 8.7 cm (5 11/16 x 6 1/2 x 3 7/16 in.). – 4 pcs./T.
Lamprecht 176, Photo 19. – Inv. 1986.339.3.
Lit.: Hintze 1928a, 123, pl./Taf. III, no. 19 (Sayn Musterb. 1846).
An anchor with a rope mounted on a pierced medallion, on a rectangular marble base. / Ein Anker mit einem Seil auf einem durchbrochenen Plättchen, auf rechteckiger Marmorplatte.

Cat. 776

Cat. 775

Cat. 785

Cat. 777

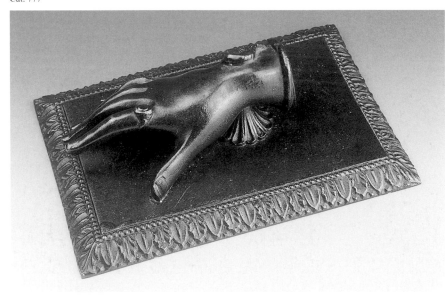

777 Paperweight / Briefbeschwerer
1820-30. – F./G. KPEG. – 3.8 x 12 x 8.2 cm
(1 1/2 x 4 3/4 x 3 1/4 in.).
Lamprecht 192. – Inv. 1986.339.4.
Lit.: Arenhövel 1982, 209, no. 448. – Aus
einem Guß, 217, no. 1555. – cp./vgl. Ferner
and Genée, 72, fig./Abb. 86. – Hintze 1928a,
88, pl./Taf. XVIII, no. 9 (Gleiwitz P.-C.
1847). – Ostergard 1994, 237, no. 97.
A hand with a ring on the index finger and
a serpent bracelet mounted on a rectangular
base. / Eine Hand mit einem Ring am Zei-
gefinger und einem Schlangenarmband auf
einer rechteckigen Platte.

778 Paperweight / Briefbeschwerer
First quarter of the 19th century / 1. Viertel
des 19. Jh. – 5.7 x 11.6 x 8 cm (2 1/4 x
4 9/16 x 3 1/8 in.).
Lamprecht 199. – Inv. 1986.339.5.
An anvil on a rectangular base. / Ein Am-
boß auf rechteckiger Platte.

779 Paperweight / Briefbeschwerer
(Fig. p./Abb. S. 279)
1830-40. – 9.7 x 12.5 x 7 cm (3 13/16 x
4 15/16 x 2 3/4 in.).
Lamprecht 204. – Inv. 1986.339.6.
An eagle with outstretched wings perched
on a tree branch, on a rectangular base. /
Ein Adler mit leicht gespreizten Flügeln auf
einem Ast sitzend, auf rechteckiger Platte.

780 Paperweight / Briefbeschwerer
1830-40. – 3.9 x 10.6 x 6 cm (1 9/16 x
4 3/16 x 2 3/8 in.).
Lamprecht 248. – Inv. 1986.339.7.
A monkey playing with a bee that is perched
on a rose, on a rectangular base. / Ein Affe
mit einer Biene spielend, die sich auf einer
Rose niedergelassen hat, auf rechteckiger
Platte.

781 Paperweight / Briefbeschwerer
1817-27. – F./G. KPEG. – 11.2 x 14.2 x
16.7 cm (4 7/16 x 5 9/16 x 6 9/16 in.).
Lamprecht 31. – Inv. 1986.342.1.
Lit.: Cat. Leipzig 1915, 116, no. 21. – Hintze
1928a, 88, pl./Taf. XVIII, no. 8 (Gleiwitz
P.-C. 1847). – Zick, Amor, schiffend, 14,
fig./Abb. 2.
Cupid, accompanied by a pair of lovebirds,
sails through the clouds on a bow and
quiver, on a rectangular base; traces of
gilding, part of the sail is missing. / Amor
mit einem schnäbelnden Taubenpaar segelt
durch die Wolken auf einem Bogen und

Cat. 781

Cat. 778

Cat. 780

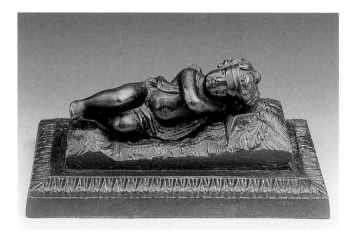

Cat. 782

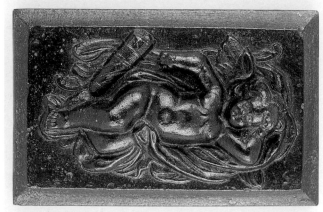

Cat. 783

Cat. 786

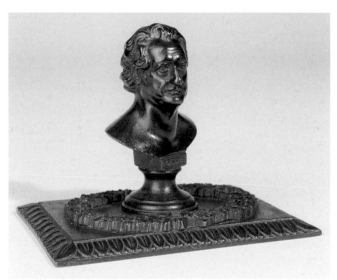

Cat. 787

einem Köcher; Reste von Vergoldung, ein Teil des Segels abgebrochen.

782 Paperweight / Briefbeschwerer
1820-30. – F./G. KPEG. – 4.8 x 10.8 x 6 cm (1 7/8 x 4 1/4 x 2 3/8 in.).
Lamprecht 32. – Inv. 1986.342.2.
A sleeping, winged cherub on a bed of leaves, on a rectangular base. / Schlafender Amor auf einem Bett von Blättern, auf einem rechteckigen Sockel.

783 Paperweight / Briefbeschwerer
Mid 19th century / Mitte des 19. Jh. – 3.7 x 12.2 x 7.8 cm (1 7/16 x 4 13/16 x 3 1/16 in.).
Lamprecht 240. – Inv. 1986.342.3.

A sleeping Cupid with a bow and arrows modeled in high relief on a rectangular base. / Schlafender Amor mit Bogen und Köcher in hohem Relief auf einem rechteckigen Sockel.

784 Paperweight or Base of a Pocket Watch Holder (?) / Briefbeschwerer oder Sockel von einem Taschenuhrhalter (?)
1820-25. – F./G. KPEG. – 3.9 x 9.9 x 7.2 cm (1 9/16 x 3 7/8 x 2 13/16 in.).
Inv. 1962.123. – Gift of / Schenkung von Dr. and Mrs. Maurice Garbáty.
A pair of dolphins facing opposite directions with scrolled and truncated tails, on a rectangular base. Because the top part of this piece is missing, it could also have been

the base of a pocket watch holder. / Zwei gegenständige Delphine mit gerollten und gestutzten Schwänzen, auf rechteckiger Platte. Da ein Oberteil offenbar fehlt, könnte es sich auch um den unteren Teil eines Taschenuhrhalters handeln.

785 Paperweight / Briefbeschwerer
(Fig. p./Abb. S. 282)
Mid 19th century / Mitte des 19. Jh. – 4.6 x 14.1 x 9 cm (1 13/16 x 5 9/16 x 3 9/16 in.).
Handwritten on the base / Handgeschrieben auf der Unterseite „527/I" and/und „an,-".
Inv. 1962.124. – Gift of / Schenkung von Dr. and Mrs. Maurice Garbáty.
Lit.: Bartel 2004, 36, fig./Abb. 28 (Berlin Abbildungen 1824-30; pl./Taf. VI, no. 5).

A snail on a rectangular base modeled in high relief, with traces of red paint. / Auf rechteckigem, vegetabil reliefiertem Sockel eine Schnecke in hohem Relief modelliert; Reste von roter Farbe.
Cp./vgl. to the base / zum Sockel Cat. 775.

786 Paperweight / Briefbeschwerer
1830-40. - F./G. Carlshütte. – 10.2 x 14.1 x 8.6 cm (4 x 5 9/16 x 3 3/8 in.). – Marked on the base / markiert auf der Unterseite „C H" and crossed hammer and gad / und Schlägel und Eisen.
Inv. 1962.125. – Gift of / Schenkung von Dr. and Mrs. Maurice Garbáty.
Lit.: Ferner and Genée, 19, fig./Abb. 6. – Hintze 1928a, 82, pl./Taf. XII, no. 2 (Gleiwitz P.-C. 1847), 123, pl./Taf. III, no. 14 (Sayn Musterb. 1846). – Tafelwerk Carlshütte, pl./Taf. 18, no. 17.
On a rectangular base, an anchor with a rope, cornucopia, bound sack, and a box. / Auf rechteckiger Platte ein Anker mit Seil, Füllhorn, gebundenem Sack und einem Kasten.

787 Paperweight / Briefbeschwerer
Ca. 1830. – Mod. of the bust after Leonhard Posch, based on an original by Christian Daniel Rauch. / Mod. nach der Büste von Leonhard Posch, die er nach dem Original von Christian Daniel Rauch anfertigte. – F./G. KPEG. – 7.6 x 9.8 x 7.3 cm (3 x 3 7/8 x 2 7/8 in.).
Inv. 2006.19. – Gift of / Schenkung von Dr. Graham C. Boettcher in honor of Professor Cyrus Hamlin.
The flat base with a border of stylized leaves, in the middle the bust of Johann Wolfgang von Goethe within a wreath of laurel leaves. / Der flache Sockel mit stilisierten Blättern gerahmt, in der Mitte die Büste Johann Wolfgang von Goethes, umgeben von einem Lorbeerkranz.

Cat. 784

Cat. 788 ▶

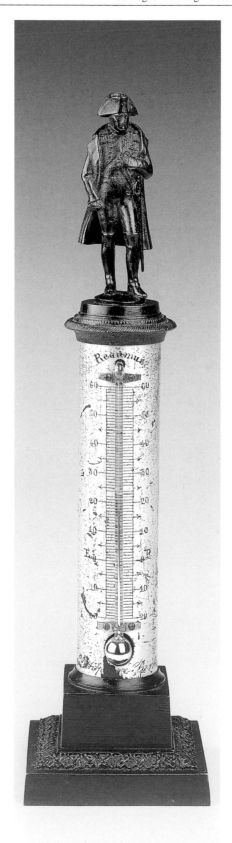

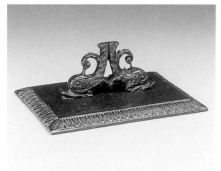

Thermometers / Thermometer (Cat. 788-93)

788 Thermometer
1815-20. – F./G. KPEG Berlin (?; Thermometer by/von E. Petitpierre, Berlin). – 25 x 6.6 x 6.6 cm (9 13/16 x 2 5/8 x 2 5/8 in.). – 5 pcs./T.
Lamprecht 11. – Inv. 1986.294.1.
Lit.: Cat. Leipzig 1915, 118, no. 53. – Ostergard 1994, 268, no. 138.
In the form of the "Colonne d'Austerlitz" with the figure of Napoleon at the Place Vendôme in Paris. / In Form der „Colonne d'Austerlitz" mit dem Standbild Napoleons am Platz Vendôme in Paris.

789 Thermometer
(Fig. p./Abb. S. 286)
1820-30. – F./G. KPEG. – 16.5 x 9.2 x 6.8 cm (6 1/2 x 3 5/8 x 2 11/16 in.). – 3 pcs./T.
Lamprecht 89, Photo 4. – Inv. 1986.294.2.
On a decorative rectangular base, the stand is in the form of a lyre with two scrolled elements of acanthus leaves that end in serpent's heads and a central columnar shaft for the thermometer with a palmette as finial; the head of the right serpent is broken off. / Auf verziertem Sockel der Halter in Form einer Lyra aus Akanthusblättern, die jeweils in einem Schlangenkopf enden und einen mittleren schmalen Rahmen für das Thermometer begleiten, der durch eine Palmette bekrönt wird; der Kopf der rechten Schlange abgebrochen.

790 Thermometer
(Fig. p./Abb. S. 286)
1825-30. – F./G. KPEG (?). – 18.6 x 9.2 x 5.7 cm (7 5/16 x 3 5/8 x 2 1/4 in.). – 3 pcs./T.
Lamprecht 157, Photo 3. – Inv. 1986.294.3.
On a rectangular base with four leafy feet, two elephant heads support a pair of palm trees that flank a central brass thermometer; the finial is in the form of an exotic bird; the head and wing of the bird are missing. / Auf rechteckiger Platte mit vier Füßen tragen zwei gegenständige Elefantenköpfe jeweils eine Palme beiderseits eines Messingthermometers; auf den Palmen ein Vogel, dem Kopf und ein Flügel fehlen.

791 Thermometer
1820-30. – F./G. KPEG. – 13.6 x 7.8 x 3.6 cm (5 3/8 x 3 1/16 x 1 7/16 in.). – 4 pcs./T.

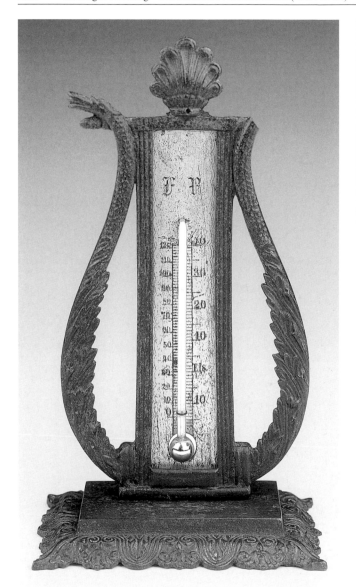

Cat. 789

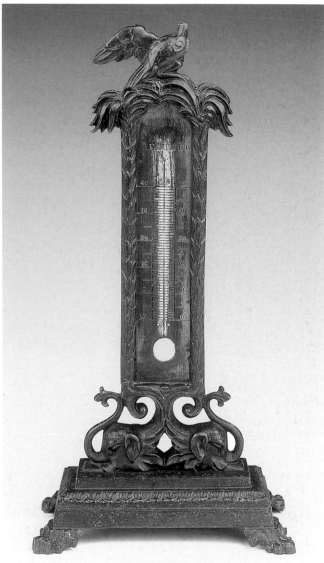

Cat. 790

Lamprecht 928. – Inv. 1986.294.4.
On a rectangular base with four feet, two columns flank a central tin thermometer that is framed by Gothic tracery and quatrefoils, with leaf finial; green patina. / Auf rechteckigem Sockel mit vier Füßen zwei Pfeiler beidseitig eines Zinnthermometers, das von gotisierendem Maßwerk und Vierpässen umrahmt ist; oben eine Blattbekrönung; grünliche Patina.

792 Thermometer
1810-20. – 14.7 x 5,4 x 5,3 cm (5 13/16 x 2 1/8 x 2 1/16 in.). – 6 pcs./T.

Lamprecht 929. – Inv. 1986.294.5.
On a domed base with a mask on each of the four feet, the slightly tapered column in a metal alloy supporting the figure of the Polish patriot and statesman Józef Anton Poniatowski (1763-1813) in uniform; traces of red paint. / Auf gewölbtem Sockel mit Masken an den vier Füßen ein sich leicht nach oben verjüngender Rundpfeiler aus Gelbguß, auf dem eine Figur des polnischen Patrioten und Staatsmannes Józef Anton Poniatowskis (1763-1813) in Uniform steht; Reste von roter Farbe.

793 Thermometer
(Fig. p./Abb. S. 288)
Ca. 1850. – F./G. KPEG (?). – 30.0 x 10.8 x 10.8 cm (11 13/16 x 4 1/4 x 4 1/4 in.).
Inv. 1962.121. – Gift of / Schenkung von Dr. and Mrs. Maurice Garbáty.
On a marble base, a decorative fence encloses a column comprised of four drums surmounted by an eagle with outstretched wings, probably based on the Invalidensäule in Berlin (destroyed); the thermometer is missing. The Invalidensäule that once stood in Berlin's Invalidenpark was erected in 1850-54 after a design by Berthold Brun-

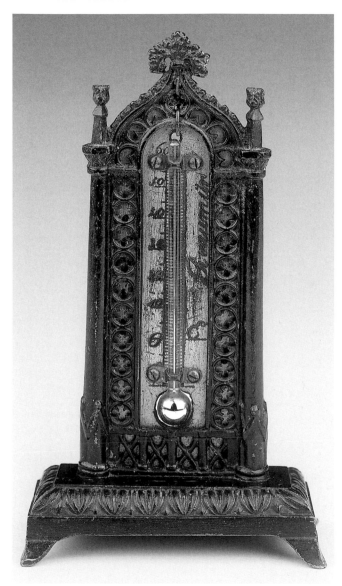

Cat. 791

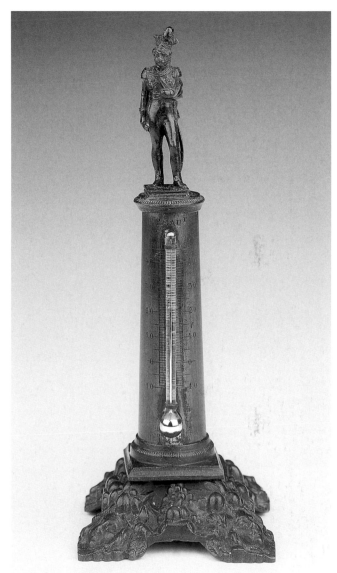

Cat. 792

ckow under the supervision of August Soller and August Stüler as a monument to the soldiers who were killed during the uprising of 1848 in Berlin. The monument was removed in 1948. / Auf einer Marmorplatte erhebt sich auf hohem Sockel, der von einem Gitter eingezäunt ist, ein aus vier Trommeln bestehender Rundpfeiler mit einem Adler auf dem Kapitell; wohl in Anlehnung an die Invalidensäule in Berlin (zerstört) modelliert; das Thermometer fehlt. Die Invalidensäule, die einmal im Berliner Invalidenpark stand, wurde 1850-54 nach einem Entwurf von Berthold Brunckow un-

ter der Leitung von August Soller und August Stüler errichtet, zur Erinnerung an die Soldaten, die bei dem Aufstand von 1848 in Berlin getötet worden waren. Das Denkmal wurde 1948 entfernt.

Candlesticks and Candelabra / Leuchter (Cat. 794-820)

794 Candlestick / Tafelleuchter
1810-20. – F./G. KPEG. – 31.5 x 10.5 x 10.5 cm (12 3/8 x 4 1/8 x 4 1/8 in.).
Lamprecht 17, Photo 8. – Inv. 1986.266.
Lit.: Andrews, 424, fig./Abb. 8. – Arenhö-vel 1982, 167, no. 354. – Cat. Köln 1979, no. 264. – Eberle, 74. – Gleiwitzer Kunst-guß 1935, 25. – Hintze 1928a, 71, pl./Taf. I, no. 5 (*„Hercules"*; Gleiwitz P.-C. 1847). – Ostergard 1994, 229, no. 87. – Schmidt 1981, 176, fig./Abb. 163.
The stem is in the form of Dionysus (Bac-chus) with a beard, goat's skin, and holding grapes in his hands, with gilt acanthus leaves on the base and candle socket. The same figure was also used for a candelabra with two or three arms (Spiegel 1981, 145, fig. 38). / Der Leuchterschaft in Form einer Herme des Gottes Dionysos (Bacchus) mit bärtigem Kopf, Widderfell und Weintrau-ben in den Händen, mit vergoldeten Akan-thusblättern am Fuß und oben an der Tülle. Der Leuchtertypus wurde ferner für Kan-delaber mit Aufsätzen für zwei oder drei Kerzen benutzt (Spiegel 1981, 145, Abb. 38).

795 Candlestick / Tafelleuchter
1810-20. – F./G. KPEG. – H. 32.5 cm (12 13/16 in.); D. of base / des Sockels 11.7 cm (4 5/8 in.). – 4 pcs./T.
Lamprecht 18, Photo 8. – Inv. 1986.267.
Lit.: Andrews, 424, fig./Abb. 8. – Arenhövel 1982, 166 f., no. 352. – Hintze 1928a, 71, pl./Taf. I, no. 16 (Gleiwitz P.-C. 1847). – Ostergard 1994, 227, no. 83. – Schmidt 1981, 175, fig./Abb. 161.
The stem in the form of Demeter (Ceres) holding a cornucopia. / Der Leuchterschaft in Form einer Herme der Göttin Demeter (Ceres) mit Füllhorn. Cp./Vgl. Cat. 801.

796 Pair of Candlesticks / Paar Tafel-leuchter
(Fig. p./Abb. S. 290)
1820-30. – 31 x 8 x 8 cm (12 3/16 x 3 1/8 x 3 1/8 in.). – 5 pcs./T. – Marked on the base / bez. auf der Unterseite *„F".*
Lamprecht 19-20, Photo 12. – Inv. 1986.268 a-b.
The stem in the form of a woman in classi-cal dress with both hands raised to her shoulders. / Der Leuchterschaft in Form ei-ner Frauengestalt in antikisierender Klei-dung, beide Hände zur Schulter angehoben.

Cat. 794

◄ Cat. 793

**797 Pair of Candlesticks / Paar Tafel-
leuchter**

(Fig. p./Abb. S. 291)

1820-30. – F./G. KPEG. – H. 23.3 cm
(9 3/16 in.); D. of base 12.8 cm (5 1/16 in.). –
6 pcs./T.

Lamprecht 21-22. – Inv. 1986.269 a-b.

On a hexagonal base, the lower stem is of
acanthus fronds and the upper stem is a
simple column. / Auf sechseckigem Sockel;
der untere Leuchterschaft aus Akanthuswe-
deln, der obere säulenartig, leicht ausschwin-
gend.

**798 Pair of Candlesticks / Paar Tafel-
leuchter**

(Fig. p./Abb. S. 290)

1810-20. – F./G. Seebass. – H. 22.8 cm
(9 in.); D. of base 10.9 cm (4 5/16 in.). –
4 pcs./T. – Marked on underside of (b) /
Bez. auf der Unterseite (b) „A. R. Seebass à
Berlin".

Lamprecht 23-24, Photo 10. – Inv. 1986.270
a-b.

Lit.: Ferner and Genée, 94, fig./Abb. 130.

On round base, the stem is fluted and ta-
pered and the candle socket is in the form
of a leafy urn. / Auf rundem Sockel der sich
erweiternde, gerippte Schaft mit einer kelch-
artigen Tülle.

**799 Pair of Candlesticks / Paar Tafel-
leuchter**

(Fig. p./Abb. S. 290)

1810-20. – F./G. KPEG. – 22.5 x 8.8 x
10.7 cm (8 7/8 x 3 7/16 x 4 3/16 in.). –
5 pcs./T.

Lamprecht 46-47, Photo 15. – Inv. 1986.271
a-b.

Lit.: Arenhövel 1982, 166, no. 350. – Bar-
tel 2004, 113, no. 263 f. – Hintze 1928a,
71, pl./Taf. I, no. 9 (Gleiwitz P.-C. 1847),
122, pl./Taf. II, no. 17 (Sayn Musterb.
1846). – Ostergard 1994, 227, no. 84.

In the form of a kneeling female water car-
rier in classical dress with the candle socket
on her head. Cast also at Blansko (Blansko
1919, fig. 113). / Der Leuchterschaft in der
Form einer knienden Wasserträgerin mit
Kerzenhalter auf dem Kopf. Gegossen auch
in Blansko (Blansko 1919, Abb. 113).

**800 Pair of Candlesticks / Paar Tafel-
leuchter**

(Fig. p./Abb. S. 290)

1820-30. – F./G. KPEG. – H. 21 cm (8 1/4
in.); D. of base / des Sockels 8 cm (3 1/8 in.).
– 10 pcs./T.

Lamprecht 34-35, Photo 6. – Inv. 1986.272
a-b.

Lit.: Arenhövel 1982, 165 f., no. 348. – Aus
einem Guß, 211, no. 924 f. – Cat. Köln
1979, no. 269. – Cat. Leipzig 1915, 119,
no. 58 f. – Grzimek 1982, 179, no. 106. –
Hintze 1928a, 71, pl./Taf. I, no. 19 (Glei-
witz P.-C. 1847).

The stem in the form of a cupid with a
raised bow kneeling on a columnar pedestal
with applied relief decoration, on his head
the candle socket; one is missing the lower
part of the bow. / Der Leuchterschaft in Form
eines knienden Amors mit gehobenem Bo-
gen auf säulenartigem Sockel mit Relief-

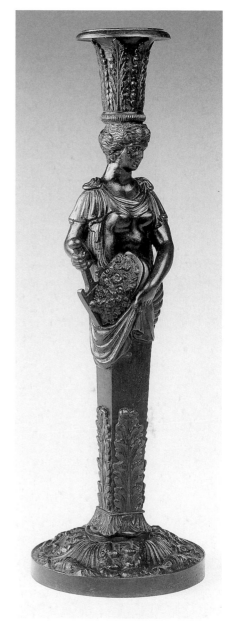

Cat. 795

dekor, auf dem Kopf die Tülle; bei einem
fehlt der untere Teil des Bogens.

801 Candelabrum / Kandelaber

(Fig. p./Abb. S. 9)

1810-20. – F./G. KPEG. – 43 x 28.5 cm
(16 15/16 x 11 1/4 in.); D. of base / des
Sockels 11 cm (4 5/16 in.).

Lamprecht 83, Photo 7. – Inv. 1986.273 a.

Lit.: H. v. Sp., 300. – Cat. Leipzig 1915,
114, no. 6. – Hintze 1928a, 60, no. 273 (here
called "Flora" / hier „Flora" genannt). –
Ostergard 1994, 230, no. 89.

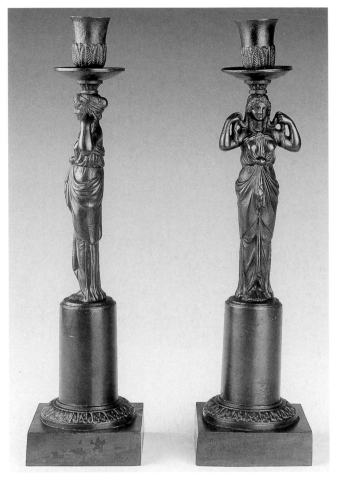

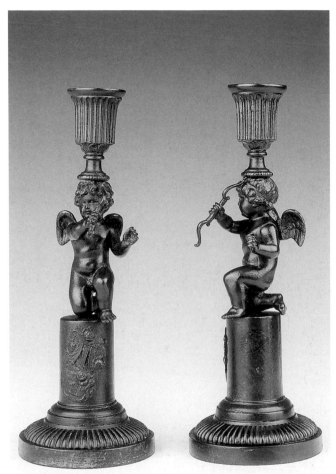

Cat. 796

Cat. 800

Cat. 798

Cat. 799

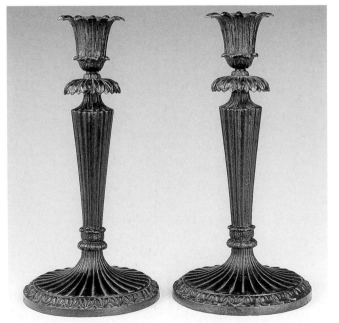

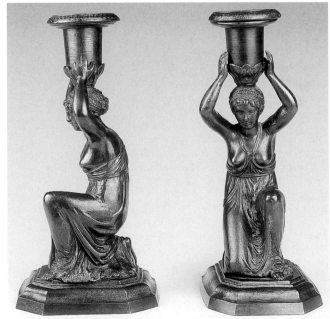

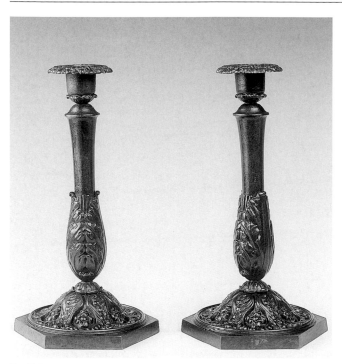

Cat. 797

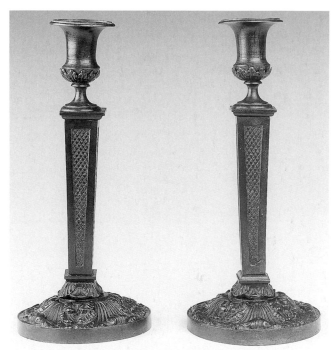

Cat. 802

Cat. 803

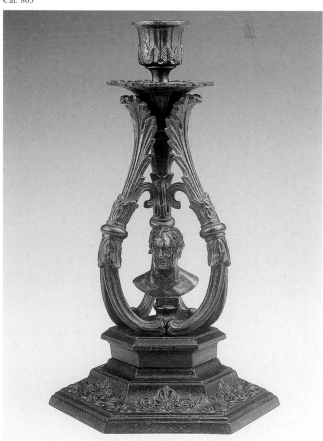

The stem in the form of Demeter (Ceres; s. Cat. 793), supporting two scrolled arms with three urn-shaped candleholders. / Der Leuchterschaft in Form einer Herme der Göttin Demeter (Ceres; s. Cat. 793), mit zwei volutenartigen Armen und drei kelch-artigen Tüllen. Cp./vgl. Cat. 795.

802 Pair of Candlesticks / Paar Tafel-leuchter
1820-30. – F./G. KPEG. – H. 24.4 cm (9 5/8 in.); D. of base / des Sockels 10.5 cm (4 1/8 in.). – 7 pcs./T.
Lamprecht 84-85, Photo 7. – Inv. 1986.273 b-c.
Lit.: Grzimek 1982, 180, no. 107. – H. v. Sp., 300.
On a decorative round base, the tapered columnar stem with latticework and the candle socket in the form of a footed urn. / Auf verziertem, rundem Sockel der sich er-weiternde, pfeilerförmige Schaft mit Gitter-motiv, die Tülle in Form einer antiken Vase.

803 Candlestick / Tafelleuchter
Second half of the 19th century / 2. Hälfte des 19. Jh. – F./G. Mägdesprung (?). – H. 27 cm (10 5/8 in.); D. of base / des Sockels 17 cm (6 11/16 in.). – 9 pcs./T.
Lamprecht 96, Photo 5. – Inv. 1986.274.
On a hexagonal base, a central gilt-bronze

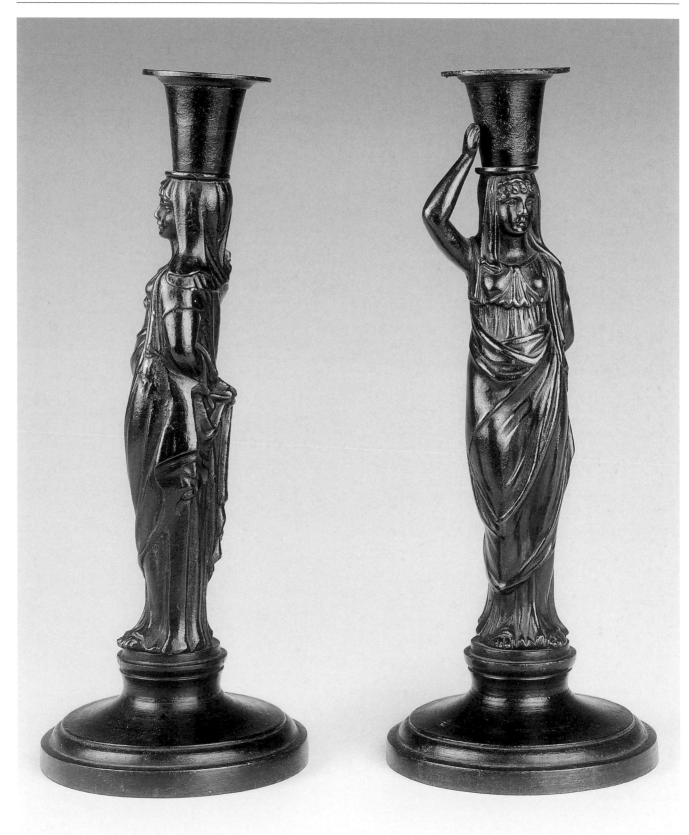

bust of Johann Wolfgang von Goethe with the name *"GOETHE"* on the front, surrounded by three scrolling and banded acanthus leaves that curve upward to support the urn-shaped candle socket. A distantly related candleholder with the bust of Schiller is illustrated in the Mägdesprung Musterbuch (Reichmann, 257, no. 5009 b; also available with the busts of *"Göthe, Kaiser, Kronprinz, Bismark, Moltke"*). / Auf sechseckigem Sockel in der Mitte die vergoldete Bronzebüste Johann Wolfgang von Goethes mit dem Namen *„GOETHE"*, umgeben von drei gerollten und gebundenen Akanthusblättern, die sich aufwärts biegen und die Tülle tragen. Ein entfernt verwandter Leuchter mit der Büste Schillers ist im Mägdesprunger Musterbuch abgebildet (Reichmann, 257, no. 5009 b; lieferbar auch mit den Büsten *„Göthe, Kaiser, Kronprinz, Bismark, Moltke"*).

804 Pair of Candlesticks / Paar Tafelleuchter

1815-20. – Mod. after a design by / nach einem Entwurf von Karl Friedrich Schinkel. – F./G. Johann Conrad Geiss (?). – H. 22.7 cm (8 15/16 in.); D. of base / des Sockels 9 cm (3 9/16 in.). – 3 pcs./T. – Marked on the base / bez. auf der Unterseite a) „G"; b) „M".
Lamprecht 147-148, Photo 9. – Inv. 1986.275 a-b.
Lit.: Arenhövel 1982, 166, no. 351. – Cat. Gliwice 1988, no. 49, fig./Abb. 25. – Grzimek 1982, 180, no. 108. – Hintze 1928a, 71, pl./Taf. I, no. 10 (Gleiwitz P.-C. 1847), 122, pl./Taf. II, no. 16 (Sayn Musterb. 1846). – S. also/auch Schmidt 1981, 175, fig./Abb. 162 for an illustration of Schinkel's design / für eine Abbildung von Schinkels Entwurf.
The stem is in the form of a classical basket carrier. / Der Leuchterschaft in der Form einer antikisierenden Korbträgerin.

805 Pair of Candlesticks / Paar Tafelleuchter
(Fig. p./Abb. S. 294)
1810-20. – F./G. KPEG. – 28.2 x 8.5 x 8.5 cm (11 1/8 x 3 3/8 x 3 3/8 in.). – 3 pcs./T.
Lamprecht 149-150, Photo 12. – Inv. 1986.276 a-b.
Lit.: Arenhövel 1982, 167, no. 353. – Hintze 1928a, 71, pl./Taf. I, no. 17 (Gleiwitz P.-C. 1847), 122, pl./Taf. II, no. 18 (Sayn Musterb. 1846).
On a square base, the stem is in the form of a caryatid. / Auf quadratischem Sockel der Schaft in Form einer Karyatide.

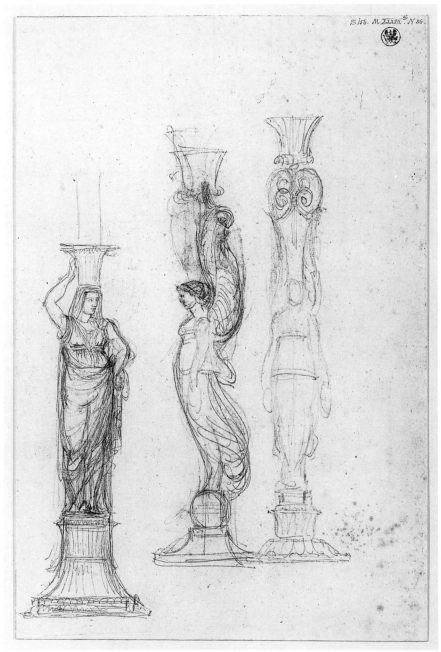

Fig./Abb. 48 Karl Friedrich Schinkel, designs for candlesticks / Entwürfe für Kerzenleuchter; pencil drawing/Bleistiftzeichnung; Berlin, Kupferstichkabinett, SMB, Inv. SM 37 b. 86 (cp./vgl. Cat. 804).

◄ Cat. 804

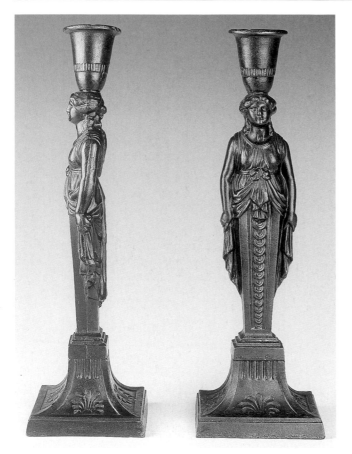

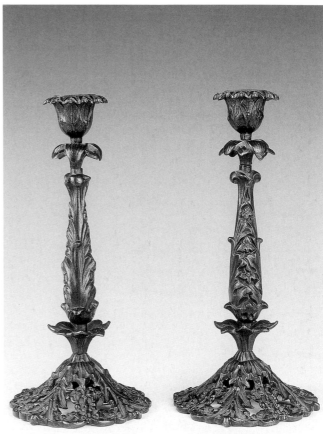

Cat. 805 Cat. 806 Cat. 807 ▶

806 Pair of Candlesticks / Paar Tafel-leuchter
1830-40. – F./G. KPEG (?). – H. 23.8 cm (9 3/8 in.); D. of base / des Sockels 11.5 cm (4 1/2 in.). – 5 pcs./T.
Lamprecht 161-162. – Inv. 1986.277 a-b.
On a pierced, decorative base, the stem is in the form of acanthus fronds and the candle socket is in the form of a tulip. / Auf durch-brochenem, verziertem Sockel der Schaft in Form von Akanthusblättern, die Tülle in Form einer Tulpe.

807 Pair of Candlesticks / Paar Tafel-leuchter
1810-20. – F./G. KPEG. – H. 31 cm (12 3/16 in.); D. of base / des Sockels 12.6 cm (4 15/16 in.). – 14 pcs./T.
Lamprecht 77-78, Photo 21. – Inv. 1986.277 c-d.
Lit.: Arenhövel 1982, 164, no. 342. – Cat. Leipzig 1915, 115, no. 16 f. – Hintze 1928a, 71, pl./Taf. I, no. 14 (Gleiwitz P.-C. 1847),

122, pl./Taf. II, no. 9 (Sayn Musterb. 1846). – Schmuttermeier, 34, no. 32.
On a round base, the tapered, columnar stem is supported by three lion paw feet topped by a gilt band; at the top is a row of three gilt stars and the candle socket is in the form of a footed urn with gilt acanthus leaves supported by three owls with out-stretched wings; a) two owls are missing; b) one star is missing. A pair of French pati-nated and gilt-bronze candlesticks of an iden-tical model sold at Sotheby's Olympia Lon-don, January 13, 2004, lot. 78. / Auf runder Platte der säulenartige, sich nach oben er-weiternde Schaft von drei Löwentatzen un-ter einem vergoldeten Band getragen, oben eine Reihe von drei vergoldeten Sternen, die Tülle mit vergoldeten Akanthusblättern von drei Eulen mit ausgespannten Flügeln getragen; a) zwei Eulen fehlen; b) ein Stern fehlt. Zwei französische patinierte und ver-goldete Bronzeleuchter nach identischem Modell wurden bei Sotheby's Olympia Lon-don, 13. Januar 2004, Losnr. 78 verkauft.

808 Pair of Candlesticks / Paar Tafel-leuchter
1840-50. – Mod. possibly after a design by / vielleicht nach einem Entwurf von Alfred Richard Seebass. – F./G. Zimmermann or/ oder Carlshütte (?). – H. 30.7 cm (12 1/16 in.); D. 13.5 cm (5 5/16 in.). – 9 pcs./T.
Lamprecht 167-168. – Inv. 1986.278 a-b.
Lit.: Arenhövel 1982, 165, no. 347. – Fer-ner and Genée, 47, fig./Abb. 48. – Hanauer Eisen, 36, 65, no. 6.1. – Ostergard 1994, 228, no. 85.
The foot is made of three breast plates; the stem is supported on a pair of shields and is made of war implements such as a flag, chain mail, a sword, an ax, a spear, and fas-ces; the candle socket is in the form of a helmet over flame bobeche. An identical pair, marked "E. G. Zimmermann/Hanau" was sold by Leo Spik, Berlin, auction 604, March 29, 2003, lot. 1815. / Der Fuß aus drei Brustpanzern, der Leuchterschaft auf zwei Schilden und aus Waffentrophäen wie Fahne, Kettenhemd, Schwert, Hellebarde,

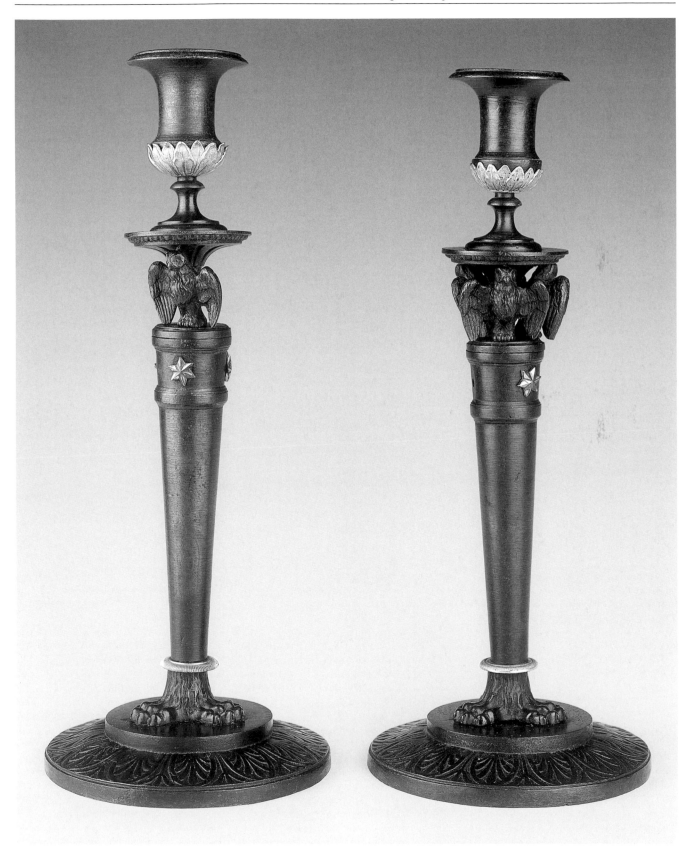

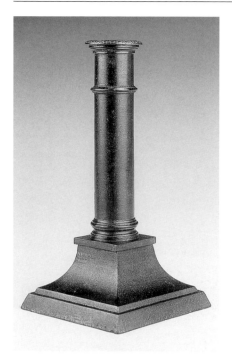

Cat. 809

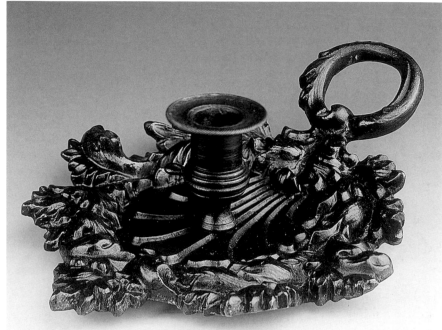

Cat. 810

Cat. 808

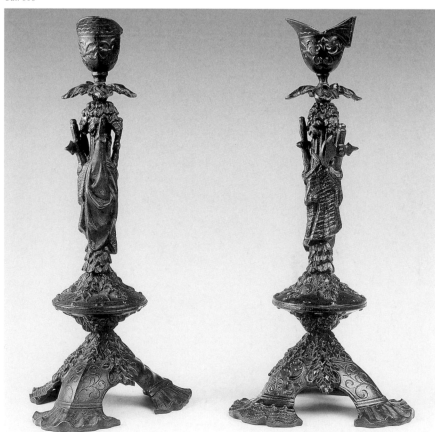

Speer und Fascienbündel, die Tülle in der
Form eines Helms mit Flammenteller; ein
identisches Paar, bez. „E. G. Zimmermann/
Hanau" wurde bei Leo Spik Berlin, Auk-
tion 604, 29. März 2003, Losnr. 1815, ver-
kauft.

809 Candlestick / Tafelleuchter
1820-30. – 21.5 x 10.9 x 10.9 cm (8 7/16 x
4 5/16 x 4 5/16 in.). – 3 pcs./T.
Lamprecht 191. – Inv. 1986.280 a-b.
Lit.: Ostergard 1994, 228, no. 86.
The square base curves upward to create a
pedestal support for the plain, columnar stem
with a simple, detachable bobeche. / Der
quadratische, kräftig aufsteigende, sich ein-
schwingend verjüngende Sockel trägt einen
schlichten, sparsam gegliederten säulenar-
tigen Schaft, der in der Tülle endet.

**810 Chamber Candlestick / Kammer-
leuchter**
1820-30. – F./G. KPEG (?). – 3.6 x 12.9 x
10.3 cm (1 7/16 x 5 1/16 x 4 1/16 in.). – 2
pcs./T.
Lamprecht 194. – Inv. 1986.281.
On a shell-shaped plate with leafy decor,
the candle socket is in the form of a footed
vase, with a ring handle. / Ein Untersatz in
Form einer Muschel mit Blätterbesatz trägt

in der Mitte eine vasenartige Tülle; der Griff ringförmig.

811　Candlestick / Tafelleuchter

1830-40. – F./G. probably/wahrscheinlich Seebass.
18.3 x 9.8 x 9.8 cm (7 3/16 x 3 7/8 x 3 7/8 in.). – 4 pcs./T.
Lamprecht 200. – Inv. 1986.282.
Lit.: Cp./vgl. Hanauer Eisen, 40, 66, no. 7.2.
The stem is in the form of a young male figure feeding a pair of birds; on his head rests the candle socket. / Der Leuchterschaft in Form eines Jungen, der Vögel füttert, auf dem Kopf die Kerzentülle.

812　Pair of Candlesticks / Paar Tafelleuchter

Ca. 1820. – F./G. KPEG (?). – H. 24.3 cm (9 9/16 in.); D. of base / des Sockels 12 cm (4 3/4 in.). – 5 pcs./T.
Lamprecht 244-245, Photo 10. – Inv. 1986.283 a-c.

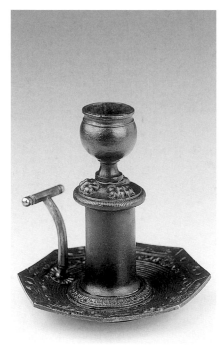

Cat. 813

On a decorative, round base, the lower stem is in the form of a bulbous, footed vase, the columnar upper stem is fluted and the candle socket is in the form of acanthus fronds; the brass bobeches are not original. / Auf verziertem runden Sockel der untere Leuchterschaft in Form einer bauchigen Vase, der obere Schaft gerippt und säulenartig, die Kerzentülle aus Akanthusblättern; ihre Einsätze aus Messing nicht original.

813　Chamber Candlestick / Kammerleuchter

1825-35. – F./G. KPEG (?). – H. 11.6 cm (4 9/16 in.); D. of base / des Sockels 10.9 cm (4 5/16 in.). – 5 pcs./T.
Lamprecht 247, Photo 10. – Inv. 1986.284.
On an octagonal base with a border design of sea creatures and stylized leaves, the round, columnar stem with a candle socket in the form of a bulbous, footed vase with three paw feet; the (not original) handle is brass. / Auf achteckigem Teller mit Bordürenmuster aus Meereswesen und stilisierten

Cat. 811

Cat. 812

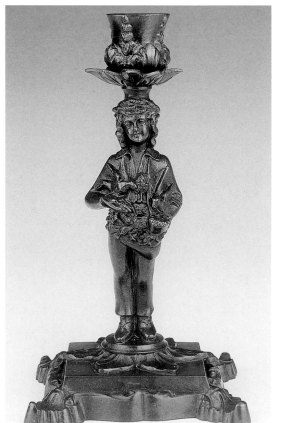

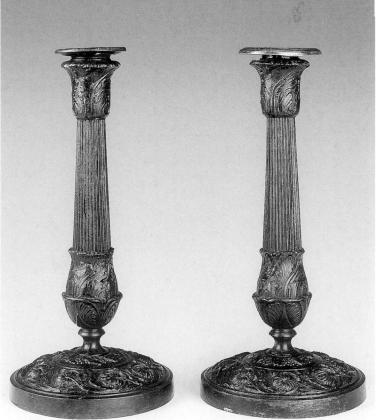

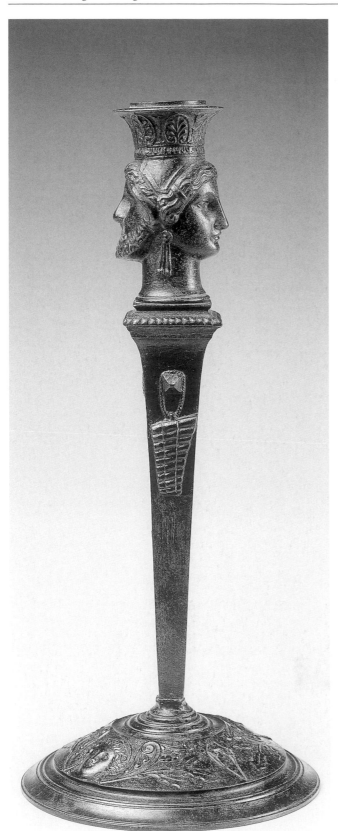

◄ Cat. 814

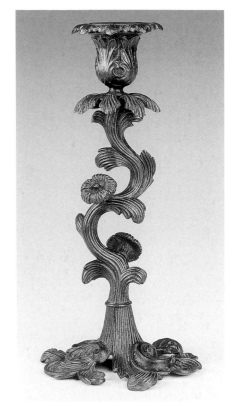

Cat. 816

Cat. 815

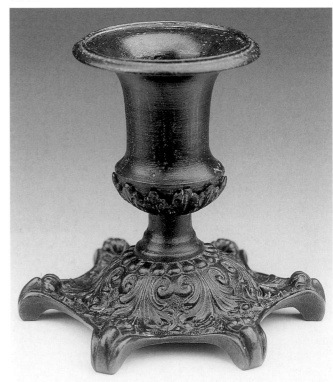

Blättern der runde Schaft mit Kerzentülle in Form einer bauchigen Vase, der (nicht zugehörige) Griff aus Messing.

814 Candlestick / Tafelleuchter
1820-30. – F./G. KPEG (?). H. 27.3 cm (10 3/4 in.); D. of base / des Sockels 11.9 cm (4 11/16 in.).
Lamprecht 253. – Inv. 1986.285.1.
On a round, domed base, the tapered and square, columnar stem with panpipe, horn, amulet, and foliate motif on each side; the candle socket is in the form of a Janus head. / Auf rundem, gewölbtem Sockel der sich erweiternde quadratische Leuchterschaft mit Panflöte, Horn, Amulett und Blattmotiven auf jeder Seite, die Kerzentülle in Form eines janusartigen Kopfes.

815 Candlestick / Tafelleuchter
1820-30. – F./G. KPEG (?). – H. 8.3 cm (3 1/4 in.); D. of base / des Sockels 8.8 cm (3 7/16 in.). – 3 pcs./T.
Lamprecht 266. – Inv. 1986.285.2.
The base with six scrolled feet; the candle socket is in the form of a footed vase. / Der Sockel mit sechs gerollten Füßen, die Kerzentülle in Form einer Vase.

816 Candlestick / Tafelleuchter
1840-50. – F./G. Blansko (?). – H. 25.2 cm (9 15/16 in.); D. of base 12.2 cm (4 13/16 in.). – 5 pcs./T. – Marked on the base / bez. auf der Unterseite „521".
Lamprecht 925. – Inv. 1986.286.
Lit.: Cp./vgl. Blansko 1919, fig./Abb. 114. – Ostergard 1994, 230, no. 88.
On an irregular base of scrolling leaves, the stem is in the form of a stylized flower stalk with two buds; the candle socket is in the form of blooming flower. / Auf unregelmäßigem Sockel aus gerollten Blättern der Leuchterschaft in Form eines aufrankenden stilisierten Blattstiels mit zwei Blütenknospen, die Kerzentülle in Form eines Blütenkelchs.

817 Candlestick / Tafelleuchter
1880-90. – F./G. Mägdesprung. – H. 29.6 cm (11 5/8 in.); D. of base / des Sockels 18 cm (7 1/16 in.).
Lamprecht 208, Photo 5. – Inv. 1986.288.1.
Lit.: Cp./vgl. Reichmann, 257.
On a round base with feet in the form of cannons, the stem is comprised of a pyramid of cannon balls with a drum and two-headed eagle wearing a shield with the image of St. George and the Dragon, the candle socket is in the form of a crown, the

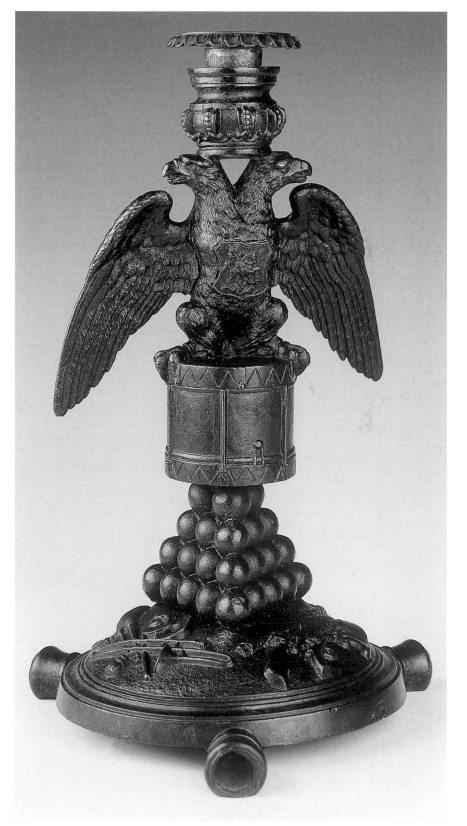

Cat. 817

Cat. 818 Cat. 819 ▶

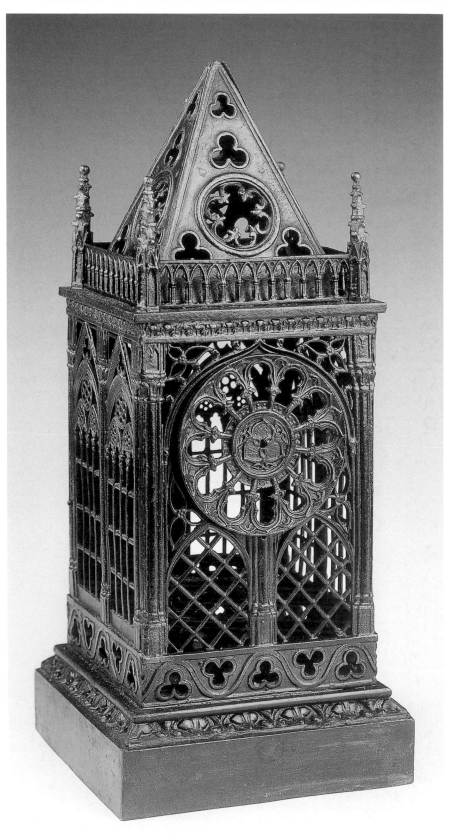

bobeche is a later addition. Reichmann in-
cludes an illustration from the Mägdesprung
Musterbuch of a series of candleholders
described as *"Lampenfüße"*, or lamp bases,
among them an image of this model. / Auf
rundem Sockel mit Füßen in Form von Ka-
nonen der Leuchterschaft aus einer Pyra-
mide von Kanonenkugeln, einer Trommel
und einem zweiköpfigen Adler mit Schild,
darauf das Bild von Sankt Georg und dem
Drachen, die Kerzentülle in der Form einer
Krone; der Tülleneinsatz wurde später bei-
gegeben. Reichmann zeigt aus dem Mäg-
desprunger Musterbuch eine Reihe von
Leuchtern, hier jedoch als *„Lampenfüße"*
bezeichnet, unter denen sich auch dieser
Tafelleuchter befindet.

818 Chamber Votive / Kammerleuchter
1820-30. – F./G. KPEG (?). – 8.8 x 13.5 cm
(3 7/16 x 5 5/16 in.); D. of base / des Sok-
kels 12.2 cm (4 13/16 in.). – 5 pcs./T.
Lamprecht 43, Photo 3. – Inv. 1986.499 a-b.
On a round plate a pair of dolphins supports
the holder for a cut glass insert, with a loop
handle; the glass is not original. / Auf run-
dem Teller tragen zwei Delphine das Gestell
für den Glaseinsatz, mit ringförmigem Griff;
das Glas nicht original.

819 Lantern / „Lampenhäuschen"
1825-40. – F./G. KPEG. – 31 x 13 x 13 cm
(12 3/16 x 5 1/8 x 5 1/8 in.). – many pcs. /
viele T.
Inv. 1962.133 a-b. – Gift of / Schenkung
von Dr. and Mrs. Maurice Garbáty.
Lit.: Hintze 1928a, 85, pl./Taf. XV, no. 4

(Gleiwitz P.-C. 1847). – Ostergard 1994, 234, no. 94.

A richly and delicately decorated, pierced Gothic architectural structure with pointed roof and square base serves as a lantern. One side opens to allow for placement of a candle. The finial on the roof's spike is missing; traces of bronze patina. / Ein reich und zierlich durchbrochenes gotisierendes Gebäude mit spitz zulaufendem Dach steht auf quadratischem Sockel und dient als „Lampenhäuschen". Eine Seite aufschiebbar zum Hineinstellen einer Kerze. Der Hahn auf der Dachspitze weggebrochen; Spuren ehemaliger Bronzierung.

Cat. 820

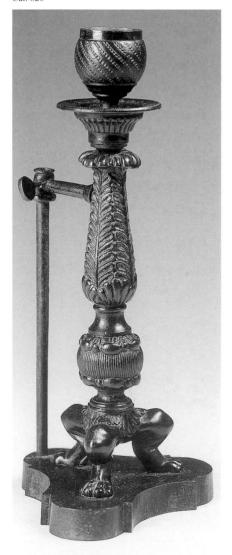

820 Candlestick / Tafelleuchter

1820-30. – F./G. KPEG. – H. 20.6 cm (8 1/8 in.); D. 8.7 cm (3 7/16 in.).
Lamprecht 181, Photo 9. – Inv. 1986.279.
Lit.: Arenhövel 1982, 164, no. 344. – Cat. Köln 1979, no. 267. – Hintze 1928a, 84, pl./Taf. XIV, no. 1-2 (Gleiwitz P.-C. 1847), 122, pl./Taf. II, no. 11 (Sayn Musterb. 1846). – Ostergard 1994, 266, no. 135 (here used as a stand for a lithophane / hier als Ständer für eine Lithophanie benutzt).

The trefoil base supports a tripod stand of three lion paw feet; the stem is comprised of stylized foliage; the candle socket is in the form of a bulbous vase, with an attachment for a lithophane, a reflector, or shade. In Sayn Musterbuch (pl. II, no. 11), a variation of the candlestick without the attachment. / Der Fuß aus drei Löwentatzen auf entsprechend dreifach einschwingender Plinthe trägt den gegliederten und vegetabil verzierten Schaft mit der Tülle, der im oberen Drittel eine Halterung zeigt, durch die ein Rundstab von der Plinthe her verläuft und die zur Aufnahme einer Lithophanie oder eines Reflektors dienen kann. Im Sayner Musterbuch (Taf. II, no. 11) der Tafelleuchter in etwas abgewandelter Form ohne Halterung.

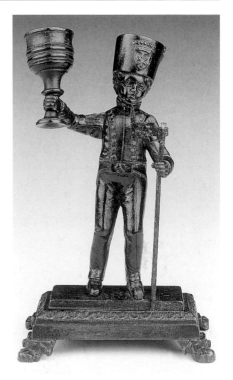

Cat. 821

Cat. 821 (detail)

Toothpick and Match Holders / Zahnstocher- und Zündholzhalter (Cat. 821-29)

821 Toothpick Holder / Zahnstocherhalter

Second quarter of the 19th century / 2. Viertel des 19. Jh. – 14.2 x 9.1 x 5.7 cm (5 9/16 x 3 9/16 x 2 1/4 in.). – 6 pcs./T.
Lamprecht 261. – Inv. 1986.241.

On a rectangular base a young man wearing a miner's uniform with a tall hat, upon which is a baron's crown above a coat of arms, on the belt buckle is a crossed hammer and gad; the man holds in his left hand a *Bergparte* (a miner's ceremonial ax or hatchet) and in his raised right hand he holds a large goblet for toothpicks. / Auf rechteckigem Sockel ein junger Mann in Bergmannsuniform mit hohem Hut, darauf eine Freiherrenkrone oberhalb eines Wappenschilds, auf der Schnalle des Fahrleders Schlägel und Eisen; in der Linken eine Bergparte (Prachtbeil der Bergleute), der rechte Arm erhoben, in der Hand einen großen Kelch für Zahnstocher haltend.

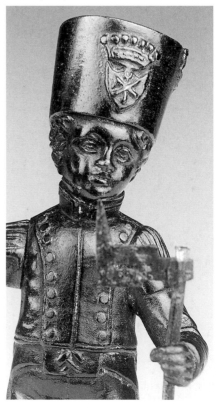

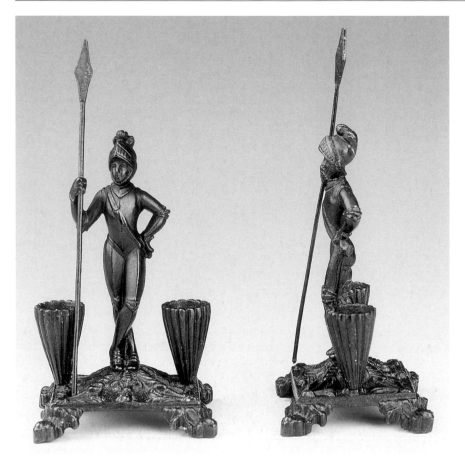

Cat. 822

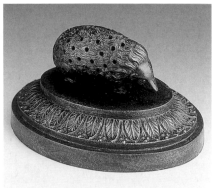

Cat. 823

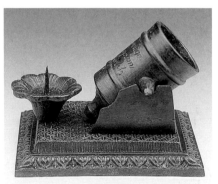

Cat. 824

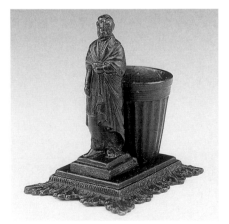

Cat. 826

822 Pair of Toothpick Holders / Paar Zahnstocherhalter

1830-40. – F./G. KPEG. – 13.5 x 6.1 x 5.1 cm (5 5/16 x 2 3/8 x 2 in.).
Lamprecht 164-165. – Inv. 1986.305 a-b.
Lit.: Cp./vgl. Hintze 1928a, 81, pl./Taf. XI, no. 6, 90, pl./Taf. XX, no. 7 (figure/Figur; Gleiwitz P.-C. 1847).
On a rectangular base, the central figure of a warrior with a staff is flanked by a pair of fluted vases. An identical figure was used by the Gleiwitz foundry as part of a clock and an inkwell. / Auf rechteckigem Sockel ein Krieger mit Stab zwischen einem Paar gerippter Vasen; eine identische Figur wurde von der Gleiwitzer Gießerei als Teil einer Uhr und eines Schreibzeugs benutzt.

823 Toothpick Holder / Zahnstocherhalter

1830-40. – F./G. KPEG. – 5 x 9.5 x 7.6 cm (1 15/16 x 3 3/4 x 3 in.).
Lamprecht 91. – Inv. 1986.309.

Lit.: Bartel 2004, 107, no. 191. – Hintze 1928a, 70, no. 707 (Gleiwitz P.-C. 1847; *„Zahnstochergestell […] Stachelschwein"*). – Schmidt 1976, fig./Abb. 16. – Schmidt 1981, 185, fig./Abb. 185.
On an oval base rests a hedgehog with holes in its body designed to hold toothpicks. / Auf ovalem Sockel ein Stachelschwein mit Löchern im Körper für Zahnstocher.

824 Match and Candle Holder / Zündholz- mit Kerzenhalter

1815-20. – F./G. KPEG (?). – 7.3 x 9.6 x 7.7 cm (2 7/8 x 3 3/4 x 3 1/16 in.).
Lamprecht 193. – Inv. 1986.343.1.
On a rectangular base, the match holder is in the form of a cannon with the inscription *"Marengo/Wagram/Austerlitz"*; the candle holder is in the form of a flower. / Auf rechteckigem Sockel der Zündholzhalter in Form einer Kanone mit der Inschrift *„Marengo/Wagram/Austerlitz"*, der Kerzenhalter in der Form eines Blütenkelchs.

825 Toothpick Holder / Zahnstocherhalter

Second quarter of the 19th century / 2. Viertel des 19. Jh. – 7.6 x 9.5 x 5 cm (3 x 3 3/4 x 1 15/16 in.).
Lamprecht 197. – Inv. 1986.343.2.

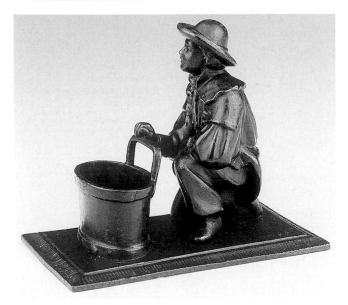

Cat. 825

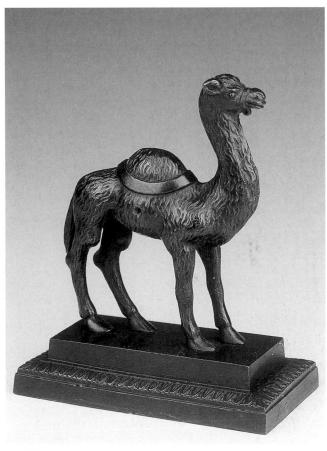

Cat. 829

Cat. 827 Cat. 828

On a rectangular base, a male peasant kneels behind a bucket. / Auf rechteckiger Platte kniet ein Bauer hinter einem Eimer.

826 Toothpick Holder / Zahnstocherhalter
1820-30. – F./G. KPEG (?). – 7.6 x 5.2 x 6.2 cm (3 x 2 1/16 x 2 7/16 in.).
Lamprecht 198, Photo 32. – Inv. 1986.343.3.
On a rectangular base, the figure of Alexander von Humboldt (1769-1859), Prussian naturalist and explorer, standing in front of a large ribbed container for toothpicks. / Auf rechteckigem Sockel die Figur Alexander von Humboldts, Naturforscher und Geograph, vor einem großen gerippten Gefäß für Zahnstocher.

827 Toothpick Holder / Zahnstocherhalter
1840-50. – 13 x 7 x 6.3 cm (5 1/8 x 2 3/4 x 2 1/2 in.). – 4 pcs./T.
Lamprecht 202. – Inv. 1986.343.4.
On a square base, the figure of a female

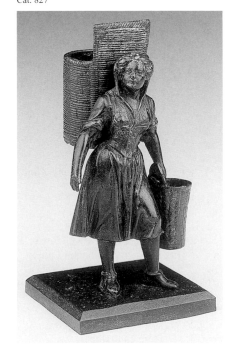

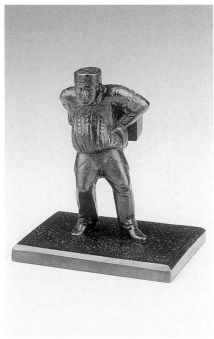

vintner in Rhenish costume with vat and basket. / Auf quadratischer Platte steht eine Winzerin in rheinischer Tracht mit Kiepe und Korb.

828 Toothpick Holder / Zahnstocherhalter (Fig. p./Abb. S. 303)
Mid 19th century / Mitte des 19. Jh. – F./G. Kasli (?). – 10.5 x 9.2 x 6.3 cm (4 1/8 x 3 5/8 x 2 1/2 in.).
Lamprecht 939. – Inv. 1986.343.8.
On a rectangular base the figure of a miner leaning slightly forward from the weight of a basket on his back designed to hold toothpicks (now missing), his left hand on his hip. / Auf rechteckiger Platte steht, sich leicht nach vorn beugend, ein Bergmann mit dem linken Arm auf der Hüfte; ursprünglich mit einem Korb oder Sack für Zahnstocher auf dem Rücken (fehlt).

829 Match Holder / Zündholzhalter
1820-30. – F./G. KPEG. – 13 x 10.7 x 6 cm (5 1/8 x 4 3/16 x 2 3/8 in.).
Inv. 1962.120. – Gift of / Schenkung von Dr. and Mrs. Maurice Garbáty.
Lit.: Arenhövel 1982, 177, no. 372. – Hintze 1928a, 80, pl./Taf. X, no. 1 (Gleiwitz P.-C. 1847).
On a rectangular base the figure of a camel, originally with a basket for matches (now missing) hanging on each side. / Auf abgestuftem, rechteckigem Sockel ein Dromedar; ursprünglich mit zwei angehängten Körben (heute fehlend) für Zündhölzer.

Plates and Dishes / Teller und Schalen (Cat. 830-53)

830 Snuffer Tray / Lichtscherenteller
Ca. 1810. – Mod. by/von Christoph Mendel (?). – F./G. KPEG. – 23.2 x 9 cm (9 1/8 x 3 9/16 in.).
Lamprecht 140, Photo 29. – Inv. 1986.221.21.
Lit.: Arenhövel 1982, 176, no. 370. – Ferner and Genée, 57, fig./Abb. 54. – Hintze 1928a, 90, pl./Taf. XX, no. 2 (Gleiwitz P.-C. 1847), 122, pl./Taf. II, no. 22 (Sayn Musterb. 1846). – Ostergard 1994, 226, no. 81. – Stummann-Bowert 1984, 105, no. 121.
The pointed oval tray with a pierced border, in the middle a radiant lyre. Christoph Mendel was a modeler at the Gleiwitz foundry after 1802. This model was also used at Horowitz and Mariazell. / Spitzovale Scha-

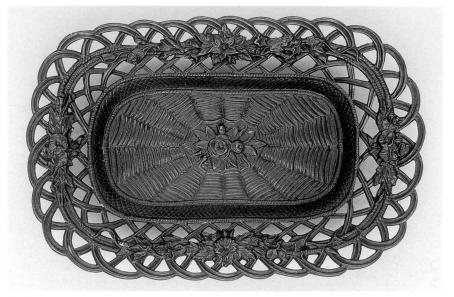

Cat. 837

le mit durchbrochenem Rand, in der Mitte eine Lyra im Strahlenoval. Christoph Mendel war Modelleur an der Gleiwitzer Gießerei nach 1802. Dieses Modell wurde auch in Horowitz und Mariazell benutzt.

831 Plate / Zierteller
1820-25. – Mod. by/von Louis Beyerhaus based on a design attributed to / nach einem Entwurf Karl Friedrich Schinkels (zugeschrieben). – F./G. KPEG. – D. 28.8 cm (11 5/16 in.).
Lamprecht 141, Photo 30. – Inv. 1986.259.1 a.
Lit.: Arenhövel 1982, 191 f., no. 405. – Aus einem Guß, 121, no. 231. – Bartel 2004, 84, no. 10. – Cat. Leipzig 1915, 116, no. 30. – Gleiwitzer Kunstguß 1935, 46. – Gloag, 214, fig./Abb. 264. – Historismus 1989, 12, no. 202. – Howard, 7. – Renaissance der Renaissance, 234, no. 257. – Schmidt 1981, 173, fig./Abb. 156. – Simpson, 145, fig./Abb. 130. – Spiegel, 141, fig./Abb. 33. – Stummann-Bowert 1984, 105, no. 122.
Round and pierced, with scrolling foliage and a central medallion surrounded by four pointed oval reserves, within which are figures of sea gods and sea creatures; the outer border is of scrolling foliage; with traces of bronze patina. / Rund und durchbrochen, verziert mit einrollenden Pflanzen, in der Mitte ein Medaillon von vier spitzovalen Segmenten mit Tritonen und Seepferden, der Außenrand mit Voluten; Reste von Bronzierung.
Cp./vgl. Cat. 832.

Cat. 830

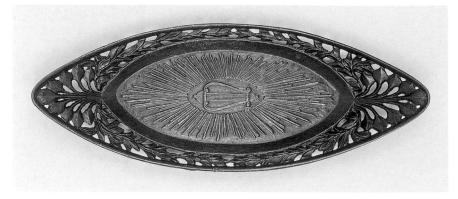

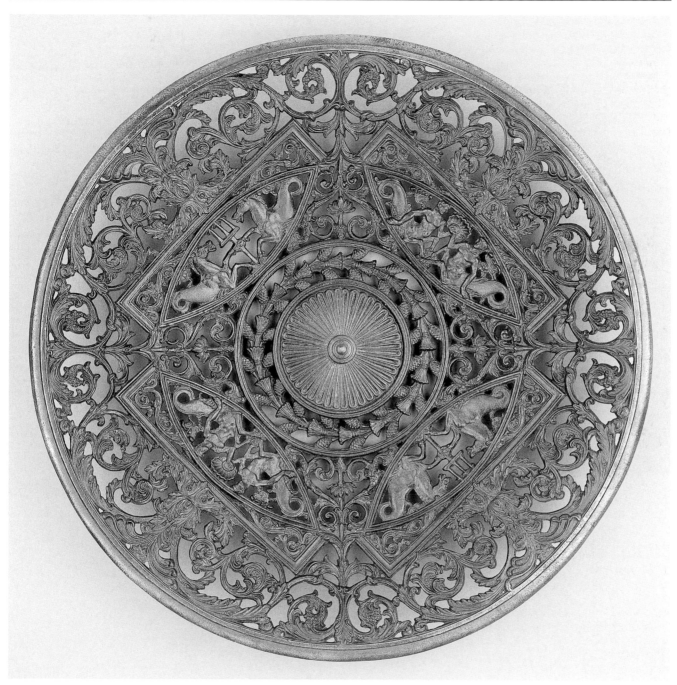

Cat. 831

832 Plate / Zierteller (no. Fig./o. Abb.)
1820-25. – Mod. by/von Louis Beyerhaus.
– F./G. KPEG. – D. 29.4 cm (11 9/16 in.)
Lamprecht 142, Photo 30. – Inv.
1986.259.1 b.
Lit.: S. Cat. 831, and/und ACIPCO 1941a,
fig./Abb. 5.
This plate is based on the same model as
that in Cat. 831. Traces of bronze patina. /
Dieser Teller beruht auf demselben Modell
wie Cat. 831. Reste von Bronzierung.

833 Plate / Zierteller
1820-30. – Mod. after a design by / nach
einem Entwurf von Karl Friedrich Schin-
kel. – F./G. KPEG. – D. 22 cm (8 11/16 in.).
Lamprecht 143, Photo 29. – Inv. 1986.259.2.
Lit.: Arenhövel 1982, 192, no. 406. – Cat.
Gliwice 1988, no. 80, fig./Abb. 38. – Cat.
Leipzig 1915, 118. no. 50. – Gleiwitzer
Kunstguß 1935, 46. – Grzimek 1982, 174,
no. 85. – Ostergard 1994, 221, no. 74. –
Schmidt 1981, 172, fig./Abb. 155.
The so-called "River Gods" plate; in the
middle is a stylized flower and scrolling
vines with four pointed oval reserves, within
which are the figures of Neptune with a tri-
dent, sea nymphs with sea creatures, and a
sea god riding a dolphin; the outer edge with
swans and scrolling vines. / Der sogenannte
„Flußgötterteller" zeigt innerhalb eines
Kreisrings aus Ranken und Schwänen vier
spitzovale Segmente, die durch Neptun mit
Urne und Dreizack, eine Nereide auf einem
Hippokampen, einem Eroten auf einem
Delphin und eine Nereide mit Steuerruder
auf einem Delphin gefüllt sind. In der Mitte
ein kleines Medaillon umgeben von Ran-
kenwerk.

834 Footed Plate / Fußteller
(no. Fig./o. Abb.)
1820-30. – Mod. after a design by / nach
einem Entwurf von Karl Friedrich Schin-
kel. – H. 4.3 cm (1 11/16 in.); D. 22 cm
(8 11/16 in.). – Marked on foot / bez. auf
dem Fuß „3167".
Lamprecht 257. – Inv. 1986.298.3.
Lit.: S. Cat. 833.
This "River Gods" plate is based on the same
model as that in Cat. 833 and 835 f.; traces
of green paint. / Diesem „Flußgötterteller"
liegt das gleiche Modell wie Cat. 833
und 835 f. zugrunde; Reste grüner Farbe.

835 Footed Plate / Fußteller
(s. also Fig. p./Abb. S. 346)
1820-30. – Mod. after a design by / nach
einem Entwurf von Karl Friedrich Schin-

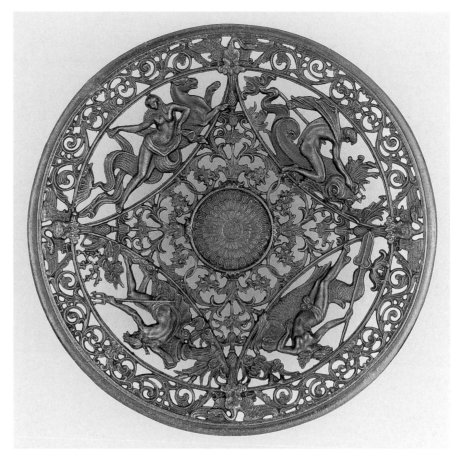

Cat. 833

Cat. 835

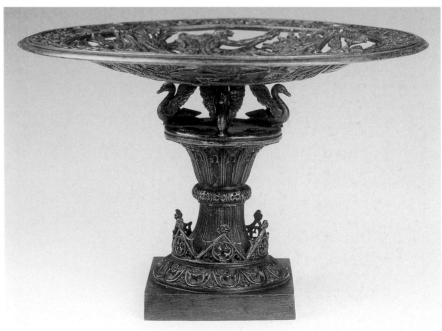

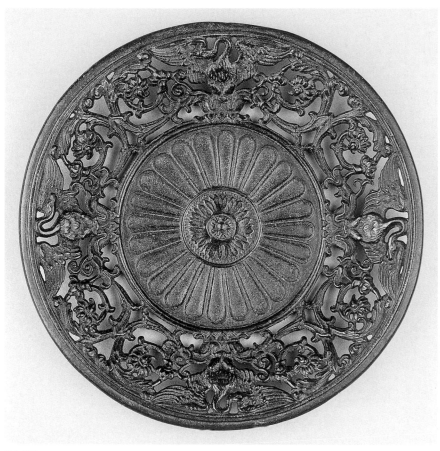

Cat. 838

Cat. 839

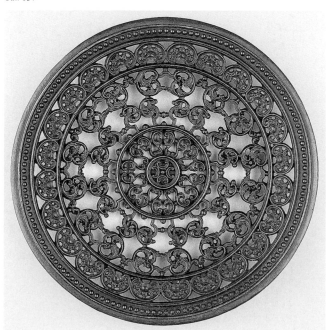

kel. – F./G. KPEG. – H. 15.5 cm (6 1/8 in.); D. 23.3 cm (9 3/16 in.).
Inv. 1962.135. – Gift of / Schenkung von Dr. and Mrs. Maurice Garbáty.
Lit.: S. Cat. 833.
This plate is based on the same model as that in Cat. 833 f. and Cat. 836, however it is here mounted on a foot decorated with Gothic arches and four swans. Traces of bronze patina and gilding. / Diesem Teller liegt das gleiche Modell wie Cat. 833 f. und 836 zugrunde, er ist hier jedoch auf einen Fuß mit gotisierenden Bögen und vier Schwänen montiert. Reste von Bronzierung und Vergoldung.

836　Plate / Zierteller (no. Fig./o. Abb.)
Mid 20th century / Mitte des 20. Jh. – Mod. after a design by / nach einem Entwurf von Karl Friedrich Schinkel. – Replica by an unknown American foundry. / Nachguß durch eine unbekannte Gießerei in den USA. – D. 21 cm (8 1/4 in.). – Marked on the rev. / bez. auf der Rs. „*1236 C EMIG 2 1197*".
Inv. 00.276. – Anonymous gift. It was probably acquired by the museum from ACIPCO. / Unbekannte Stiftung, wahrscheinlich von ACIPCO erworben. / (s. also/auch Cat. 913).
Lit.: S. Cat. 833.
This "River Gods" plate is based on the same model as that in Cat. 833-35. / Dieser „Flußgötterteller" beruht auf dem gleichen Modell wie Cat. 833-35.

837　Pair of Baskets / Paar Körbe
(Fig. p./Abb. S. 304)
1820-30. – F./G. probably/wahrscheinlich KPEG. – 3.2 x 23.1 x 15.5 cm (1 1/4 x 9 1/8 x 6 1/8 in.).
Lamprecht 74-75. – Inv. 1986.297 a-b.
Lit.: Gleiwitzer Kunstguß 1935, 41. – Ostergard 1994, 222, no. 75. – Rasl 1980, no. 84, fig./Abb. 46.
In the form of a shallow basket with pierced sides in a basket weave pattern with intertwined flowers; the interior with a central floral motif. This model was also cast in Horowitz. / In Form eines flachen Korbs mit durchbrochenem Flechtwerk und Blumen, das Innere mit zentralem Blütenmotiv. Das Modell wurde auch in Horowitz gegossen.

838　Plate / Zierteller
1820-30. – F./G. KPEG. – D. 15.2 cm (6 in.).
Lamprecht 145, Photo 31. – Inv. 1986.259.4.
Lit.: Schmidt 1981, 173, fig./Abb. 157.
With a wide pierced outer border of scroll-

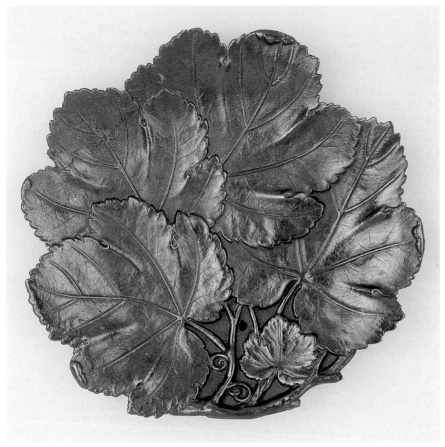

Cat. 841

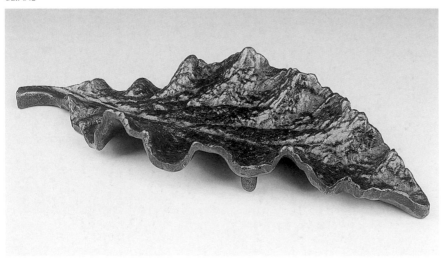

Cat. 842

ing foliage and swans; the central motif is a stylized flower. / Mit einem breitem Rand von Ranken und Schwänen, in der Mitte eine stilisierte Blume.

839 Plate / Zierteller
(Fig. p./Abb. S. 307)
1820-30. – H. 2 cm (13/16 in.); D. 17.3 cm (6 13/16 in.). – Marked on the rev. / bez. auf der Rs. „233".
Lamprecht 263, Photo 29. – Inv. 1986.298.4.
Round and pierced, with a beaded rim and rows of scrolling foliage, C-scrolls, and vines. / Rund und durchbrochen, mit Perlstab am Rand und Reihen von Voluten sowie sich einrollenden Ranken. / (s. Cat. 840).

840 Plate / Zierteller
(no. Fig./o. Abb.)
1820-30. – F./G. KPEG (?). – H. 2.1 cm (13/16 in.); D. 17.3 cm (6 13/16 in.).
Inv. 1962.134. – Gift of / Schenkung von Dr. and Mrs. Maurice Garbáty.
This plate is the same model as that in Cat. 839. / Dieser Teller beruht auf dem gleichen Modell wie Cat. 839.

841 Fruit Plate / Obstteller
1840-50. – F./G. Berggießhübel (?). – 23.5 x 24.7 cm (9 1/4 x 9 3/4 in.).
Lamprecht 275. – Inv. 1986.298.6.
Lit.: Andrews, 423, fig./Abb. 7. – Aus einem Guß, 240, no. 2107. – Blansko 1919, fig./Fig. 44. – Gleiwitzer Kunstguß 1935, 47. – Hintze 1928a, 90, pl./Taf. XX, no. 8 (Gleiwitz P.-C. 1847). – Historismus 1989, 229, no. 499. – Ostergard 1994, 225, no. 80.
In the form of four large and one small overlapping grape leaves. Perhaps originally mounted on a foot. / In Form von überlappenden Weinblättern. Möglicherweise ursprünglich auf einem Fuß montiert.

842 Dish / Schale
1845-55. – F./G. Mägdesprung. – 2.6 x 19.9 x 8.8 cm (1 x 7 13/16 x 3 7/16 in.). – Marked on the base in oval "M" and foundry mark. / bez. auf der Unterseite im Oval „M" mit Gießereimarke.
Lamprecht 296. – Inv. 1986.298.7.
In the form of a leaf with two short legs for support on one side. Traces of bronze patina. / In Form eines Blattes mit zwei kurzen Stützen auf einer Seite. Reste von Bronzierung.

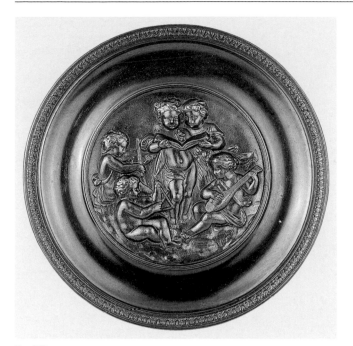

Cat. 843

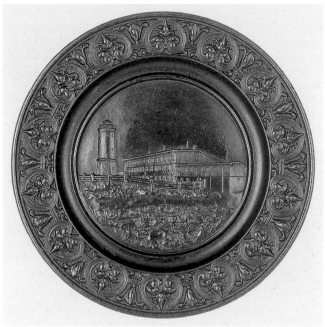

Cat. 845

843 Footed Dish / Fußschale

Third quarter of the 19th century / 3. Viertel des 19. Jh. – F./G. Blansko (?). – H. 13.9 cm (5 1/2 in.); D. 24.6 cm (9 11/16 in.).
Lamprecht 923. – Inv. 1986.298.8.
Lit.: Aus einem Guß, 222, no. 1645. – Ferner and Genée, 152, fig./Abb. 323.
On round foot, the round plate with central high relief of five putti playing musical instruments and singing, possibly emblematic of Hearing. The relief with a bronze patina. Compare examples of similar scenes in Blansko 1919, figs. 262 and 264. / Auf rundem Fuß der Teller mit zentralem Relief von fünf musizierenden Putten. Das Relief bronziert. Vergleiche ähnliche Puttenszenen bei Blansko 1919, Fig. 262 und 264.

844 Plate / Zierteller

(Fig. p./Abb. S. 311)
Second quarter of the 19th century / 2. Viertel des 19. Jh. – H. 3.1 cm (1 1/4 in.); D. 23.3 cm (9 3/16 in.).
Lamprecht 942. – Inv. 1986.298.9.
Pierced, with a border of scrolling foliage, the central medallion with the portrait bust of Ludwig I of Bavaria in profile left. / Breiter durchbrochener Rand mit Rankenwerk, in der Mitte ein Porträtmedaillon mit dem Bildnis Ludwigs I. von Bayern im Profil nach links.

845 Plate / Zierteller

1850-60. – F./G. Ilsenburg. – D. 22 cm (8 11/16 in.).
Lamprecht 941. - Inv. 1986.299.
Lit.: Ilsenburg c, pl./Taf. 86, no. 1768.
Round, with a rim composed of stylized flowers in heart-shaped cartouches, the center with an image of the "Brockenhaus" with look-out tower in Wernigerode. Similar plates can be found in the Mägdesprung

Musterbuch from 1897 (Reichmann, 273, pl. 648). / Ein reliefierter, vegetabil verzierter Rahmen umschließt eine Darstellung des „Brockenhauses" mit Aussichtsturm in Wernigerode. Ähnliche Teller im Mägdesprunger Musterbuch von 1897 (Reichmann, 273, Taf. 648).

Cat. 846

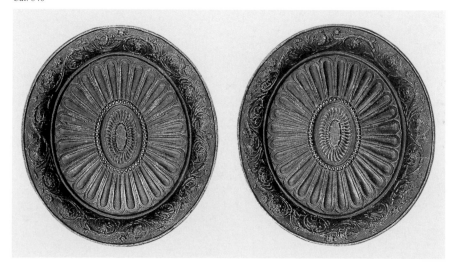

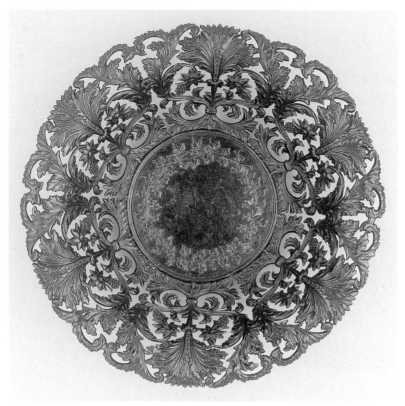

Cat. 851 (a)

Cat. 851 (b)

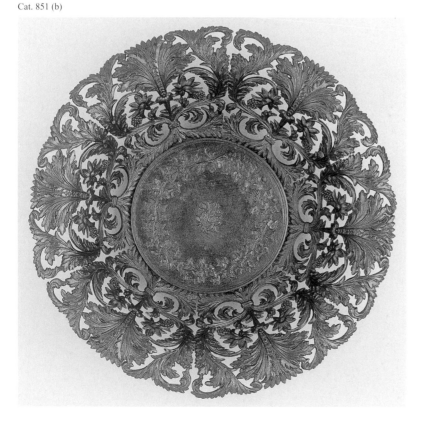

846 Pair of Plates / Paar Teller
(Fig. p./Abb. S. 309)
1820-30. – F./G. KPEG. – 10.3 x 11.6 cm
(4 1/16 x 4 9/16 in.).
Lamprecht 51-52, Photo 31. – Inv. 1986.315
a-b.
The rim is decorated with scrolling flowers
and vines; the center is a stylized sunflow-
er. Probably used as a receptacle for game
tokens. / Der Rand der leicht ovalen kleinen
Teller durch eine umziehende Wellenranke
aus Blättern und Blüten geschmückt, in der
Mitte eine stilisierte Sonnenblume. Wohl als
Ablagen für Spielmarken gedacht.

847 Plate / Teller
Ca. 1830. – F./G. KPEG (?). – 8.6 x 10.3 cm
(3 3/8 x 4 1/16 in.).
Lamprecht 53, Photo 31. – Inv. 1986.316.
Oval, with a fluted rim; the center with
three playing cards within an acanthus leaf
border. Probably designed as a receptacle
for game tokens. / Oval mit geripptem Rand,
in der Mitte drei Spielkarten innerhalb ei-
ner Bordüre aus Akanthusblättern. Wohl als
Ablage von Spielmarken gedacht.

848 Three Plates / Drei Teller
1825-30. – F./G. KPEG (?). – H. 1.1 cm
(7/16 in.); D. 9.1 cm (3 9/16 in.).
Inv. 1962.89 a-b, 1962.89 d. – Gift of /
Schenkung von Dr. and Mrs. Maurice Gar-
báty.
The rim with a basket-weave pattern; in the
center three playing cards against a stippled
ground within a stylized leaf border. Origi-
nally a set of four (used as receptacles for
game tokens). / Der Rand mit Korbflecht-
muster, in der Mitte drei Spielkarten auf ei-
nem punktierten Grund innerhalb einer Bor-
düre aus stilisierten Blättern. Ursprünglich
ein Satz von vier Tellern (für die Ablage
von Spielmarken).

849 Plate / Zierteller
1835-40. – F./G. Blansko (?). – D. 19.9 cm
(17 13/16 in.).
Lamprecht 274. – Inv. 1986.298.5.
Lit.: Blansko 1919, fig./Fig. 36. – Gleiwit-
zer Kunstguß 1935, 47. – Leisching, 216. –
Mundt 1973, no. 43. – Rasl 1980, no. 69,
fig./Abb. 40. – Schmuttermeier, 39, no. 41.
With pierced, Gothic arches and tracery,
the center with a stylized floral motif of
blind tracery interspersed with blind Gothic
trefoils. A hole in the center suggests that
this plate may originally have been mount-
ed on a foot. This model was also cast by
Joseph Glanz in Vienna and in Horowitz. /

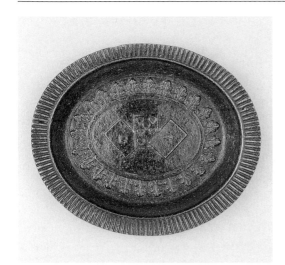

Cat. 847

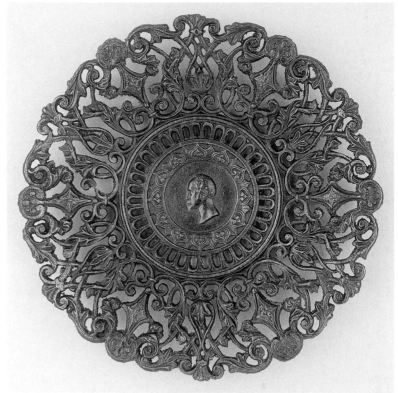

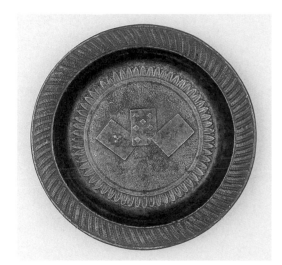

Cat. 848

Cat. 844

Cat. 849

Cat. 850

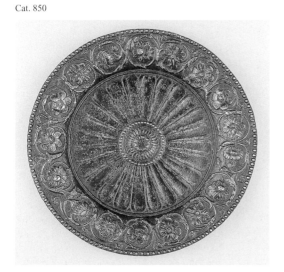

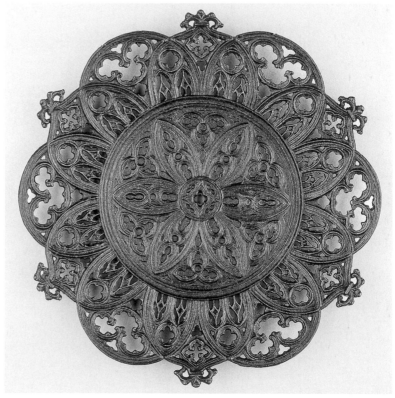

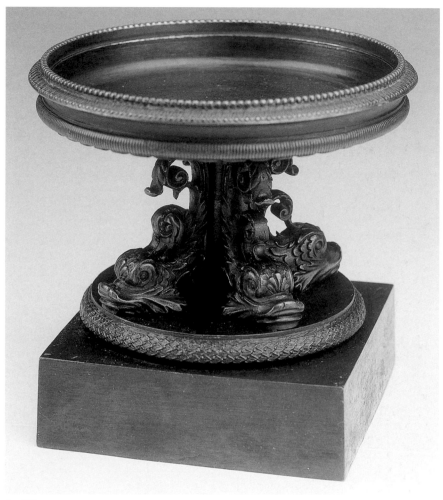

Cat. 853

Mit durchbrochener Fahne in Maßwerkbögen mit Kreuzblumen, im Fond Rosette mit Zwickeldreipässen in gotisierenden Formen. Das Loch in der Mitte könnte bedeuten, daß der Teller ursprünglich auf einem Fuß montiert war. Das Modell wurde auch von Joseph Glanz in Wien und in Horowitz gegossen.

850 Plate / Zierteller
(Fig. p./Abb. S. 311)
1820-30. – F./G. Horowitz (?). – D. 18.7 cm (7 3/8 in.). – Marked on the rev. / bez. auf der Rs. „634".
Lamprecht 146, Photo 31. – Inv. 1986.260.
Lit.: Ostergard 1994, 220, no. 72. – Schmuttermeier, 39, no. 40.
The rim with stylized, scrolling vines and flowers; the middle is designed as a stylized flower. / Der Rand mit Wellenranken und

Blüten, der Tellerspiegel als stilisierte Blume gestaltet.

851 Pair of Bowls / Paar Schalen
(Fig. p./Abb. S. 310)
1840-50. – H. 6.1 cm (2 3/8 in.); D. 27 cm (10 5/8 in.).
Lamprecht 72-73, Photo 30. – Inv. 1986.296 a-b.
Lit.: ACIPCO 1941a, fig./Abb. 5. – H. v. Sp., 298. – Howard, 7. – Ostergard 1994, 222, no. 76. – Simpson, 145, fig./Abb. 130.
The wide, pierced rim of scrolling leaves and bunches of grapes; the central well with an ivy wreath and a small rose bouquet; a) central rose motif missing. / Breite durchbrochene Ränder von sich einrollenden Ranken und Weintrauben, in der Mitte ein Efeukranz und ein kleiner Rosenstrauß; bei a) fehlt der Rosenstrauß.

852 Covered Tureen / Deckelterrine
(Fig. p./Abb. S. 55)
Ca. 1830. – F./G. KPEG. – 24.4 x 41.7 x 22.5 cm (9 5/8 x 16 7/16 x 8 7/8 in.).
Lamprecht 262. – Inv. 1986.325.1-2.
Lit.: Andrews, 423, fig./Abb. 6. – Bartel 2004, 84, no. 16. – Jailer-Chamberlain, A14.
On a round foot, the oval tureen with stylized leaves on the lower body and stylized flowers on the upper body, with two double scrolled handles with sea monster masks and leaf motifs, the domed cover with stylized leaves and a pinecone finial. / Auf rundem Fuß die ovale Terrine, ihr Korpus mit vegetabilen Motiven verziert; Grotesken aus Fischköpfen und Pflanzen bilden die Henkel; der gewölbte Deckel mit stilisierten Blättern und Pinienzapfen als Knauf.

853 Footed Dish / Fußschale
Ca. 1820. – F./G. KPEG. – H. 10.9 cm (4 5/16 in.); D. 11.6 cm (4 9/16 in.).
Lamprecht 65, Photo 4. – Inv. 1986.295.
Lit.: Cat. Leipzig 1915, 117, no. 38.
On a square base, the round foot with a scale pattern, with four dolphins, whose tails support the shallow dish with fluted underside. / Auf quadratischem Sockel der runde Fuß mit Fischschuppen-Motiv, darauf vier Delphine, deren Schwänze die runde flache Schale der gerillten Unterseite tragen.

Vases / Vasen (Cat. 854-58)

854 Pair of Vases / Paar Vasen
1820-30. – F./G. KPEG. – H. 14 cm (5 1/2 in.); D. 10.6 cm (4 3/16 in.).
Lamprecht 48-49, Photo 12. – Inv. 1986.320 a-b.
Lit.: Arenhövel 1982, 183, no. 389. – Hintze 1928a, 77, pl./Taf. VII, no. 2 (Gleiwitz P.-C. 1847). – Stummann-Bowert, 94, no. 17.
Urn-shaped, on a square plinth with a round foot, the lip with egg-and-dart motif. / In Form einer Urne auf quadratischer Plinthe mit rundem Fuß, der Rand mit Eierstabmotiv.

855 Warwick Vase / Warwick-Vase
1828-30. – Mod. (1826) by/von Wilhelm August Stilarsky. – F./G. KPEG. – H. 23.7 cm (9 5/16 in.); D. 31 cm (12 3/16 in.).
Lamprecht 103, Photo 16. – Inv. 1986.321.
Lit.: Arenhövel 1982, 186, no. 396. – Aus einem Guß, 120, no. 227. – Bartel 2004, 85 f., no. 23. – Bartel and Bossmann, 87-93. – Gleiwitzer Kunstguß 1935, 42. – H. v. Sp.,

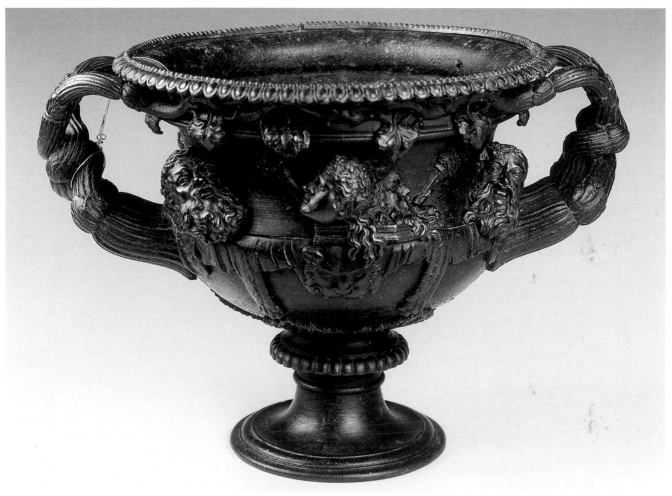

Cat. 855

Cat. 854

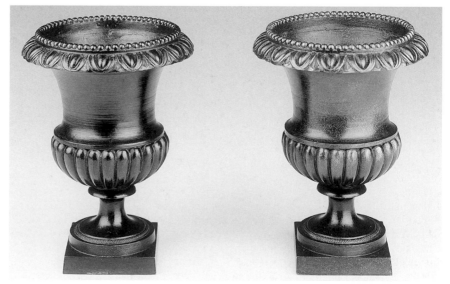

299. – Hintze 1928a, 77, pl./Taf. VII, no. 7 (Gleiwitz P.-C. 1847). – Schmidt 1981, 163 f., fig./Abb. 144.

Copy of a colossal carved marble vase discovered at Hadrian's Villa in Tivoli in 1771 by the Scottish antiquary Gavin Hamilton, who sold it to Sir William Hamilton. Hamilton had it restored and sold the vase to the Earl of Warwick, who did not license copies of the vase until the 1820s. In June of 1826 Karl Friedrich Schinkel saw copies of the vase at the Birmingham factory of Sir Edward Thompson. That same year one of these copies was sent to Berlin, where it was modeled in reduced size by August Wilhelm Stilarsky. An example was shown at the Berlin Academy exhibition in 1828. The original vase remained at Warwick Castle until 1985 when it was acquired by Glasgow Museums and Art Galleries. The

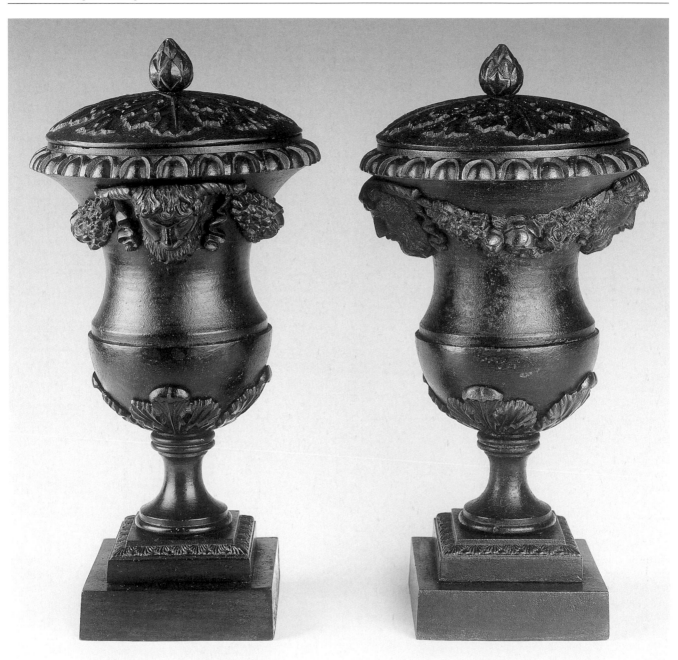

Cat. 856

Cat. 857 ▶

vase was also cast by other foundries (s. also Snodin, 188, no. 135). / Kopie einer großen Marmorvase, die in der Villa Hadrian in Tivoli 1771 vom schottischen Antiquar Gavin Hamilton gefunden wurde. Die Vase wurde an Sir William Hamilton verkauft, der sie restaurieren ließ und an den Earl of Warwick verkaufte. Letzterer ließ erst in den zwanziger Jahren des 19. Jahrhunderts Kopien anfertigen. Im Juni 1826 sah Karl Friedrich Schinkel Kopien der Vase in der Birminghamer Fabrik von Sir Edward Thompson. Im selben Jahr wurde ein Exemplar nach Berlin gebracht, wo in reduzierter Form Wilhelm August Stilarsky ein Modell anfertigte. Ein Exemplar wurde 1828 in der Akademie-Ausstellung in Berlin gezeigt. Die originale Vase blieb in Warwick-Castle bis 1985, als die Glasgow Museums and Art Galleries sie erwarben. Sie wurde auch von anderen Gießereien hergestellt (s. auch Snodin, 188, no. 135).

856 Pair of Covered Vases / Paar Deckelvasen
1810-20. – F./G.KPEG. – H. 30 cm (11 13/16 in.); D. 15.6 cm (6 1/8 in.).
Lamprecht 104-105, Photo 16. – Inv. 1986.322.1 a-b and 2 a-b.
On a small, round foot mounted on a square plinth, the lower body with leaf decoration, the upper body with satyr masks and garlands; the rim with egg-and-dart motif, and the cover with stylized leaves and an artichoke finial. / Auf kleinem, rundem Fuß über quadratischer Plinthe, der untere Gefäßkörper mit Blattdekor, der obere mit Masken und Blumengewinden, der Rand mit Eierstabmotiv geziert, der Deckel mit Akanthusblättern und einem Knauf in Form einer Artischocke.

857 Vase
1820-30. – F./G. KPEG Sayn (?). – H. 26.6 cm (10 1/2 in.); base/Sockel 11.4 x 11.4 cm (4 1/2 x 4 1/2 in.); D. 12.1 cm (4 3/4 in.).
Lamprecht 195, Photo 17. – Inv. 1986.323.
On a square base, a round foot with slender stem; the body with a relief scene of putti with an ox on one side, and on the other three putti eating grapes, all beneath grape vines and bunches of grapes; the two tightly scrolled handles suggest an origin at the Sayn foundry (cp. Friedhofen, 128, no. 2). / Auf quadratischer Plinthe erhebt sich der zierliche, ornamentierte Fuß und

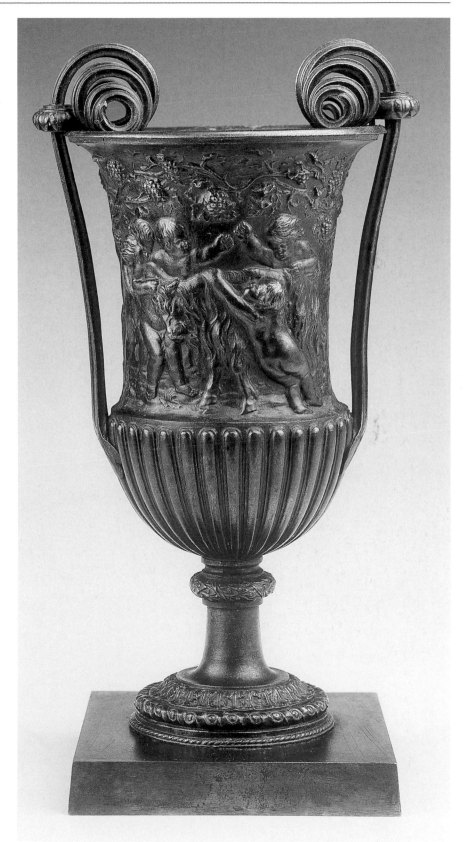

Cat. 858

Miscellaneous / Verschiedenes (Cat. 859-926)

859 Bookstand / Buchständer
1840-50. – F./G. Zimmermann. – 30.5 x 25.7 x 5.7 cm (12 x 10 1/8 x 2 1/4 in.). – Marked on the rev. / bez. auf der Rs. „*VERLAG BEI E. G. ZIMMERMANN IN HANAU*".
Lamprecht 213. – Inv. 1986.221.20.
Lit.: Andrews, 427, fig./Abb. 15. – Hanauer Eisen, 47, no. 12.35. – Ostergard 1994, 259, no. 126.
On a support of scrolling foliage, the bookstand with the figures of Johann Wolfgang von Goethe and Friedrich von Schiller standing within Gothic arches; in the middle a lyre on an altar decorated with laurel leaves and the masks of Comedy and Tragedy; above is a design of scrolling vines, leaves and flowers; the actual support for a book is wood. / Auf einem Untergestell aus Rankenwerk stehen links und rechts die Figuren Johann Wolfgang von Goethes und Friedrich von Schillers neben einem gotisierenden Bogen, der in der Mitte auf einem Altar eine Lyra mit Lorbeerblättern und die Masken der Komödie und der Tragödie zeigt. Ein Dekor aus Ranken, Blättern und Blumen schließt den Ständer oben ab; eine schmale Holzlatte dient als Stütze für ein Buch.

860 Bookstand / Buchständer
1840-50. – F./G. Zimmermann. – 25.5 x 20.8 cm (10 1/16 x 8 3/16 in.). – Marked on the rev. / bez. auf der Rs. „*11958 VERLAG BEI E. G. ZIMMERMANN IN HANAU*".
Inv. 1983.99. – Gift of / Schenkung von Mr. and Mrs. Leo M. Bashinsky.
On a stand of scrolling vines, the pierced bookstand in a design of Gothic arches and

trägt den Gefäßkörper, dessen Wandung auf der einen Seite Putten mit einem Ochsen zeigen und auf der anderen Putten beim Traubenessen. Über diesen Szenen eine umziehende Ranke aus Weinblättern und Trauben. Die beiden oben mehrfach eingerollten Henkel deuten auf eine Entstehung in Sayn (vgl. Friedhofen, 128, no. 2).

858 Vase
Ca. 1830. – F./G. KPEG. – H. 18.1 cm (7 1/8 in.); D. 13.7 cm (5 3/8 in.).
Lamprecht 196, Photo 18. – Inv. 1986.324.
Lit.: Cp./vgl. Arenhövel 1982, 183, no. 388. – Hintze 1928a, 77, pl./Taf. VII, no. 3 (Gleiwitz P.-C. 1847; with a different central band / mit anderer Verzierung in der Mitte).
The ribbed, two-handled vase with a central band with brass overlay in the form of a torch, bow, a quiver of arrows, and two birds between two star motifs; at the rim brass flowers, of which some are missing. / Eine zweihenkelige, oben und unten gerippte Vase, dazwischen eine Art umlaufende glatte Hohlkehle mit einzeln aufgesetzten, reliefierten Gelbgußmotiven aus einer Fackel, einem Bogen, einem Köcher mit Pfeilen und zwei Vögeln, steht auf einem ausschwingenden Fuß über einer quadratischen Plinthe. Den Rand ziert oben eine Reihe von Gelbgußblüten, von denen einige fehlen.

Cat. 859

quatrefoils; above a design of scrolling vines and leaves. / Aus gotisierenden Spitzbögen bestehender Ständer, oben und unten von einrollendem Rankenwerk begleitet. Auf der Rückseite die Stütze.

861 Jewelry Stand / Schmuckständer
1820-30. – F./G. KPEG. – 16.8 x 8.6 cm (6 5/8 x 3 3/8 in.); D. of base / des Sockels 5.7 cm (2 1/4 in.). – 5 pcs./T.
Lamprecht 87, Photo 3. – Inv. 1986.222.6.
Lit.: Aus einem Guß, 211, no. 918. – Hintze 1928a, 84, pl./Taf. XIV, no. 6 (Gleiwitz P.-C. 1847), 124, pl./Taf. IV, no. 1 (Sayn Musterb. 1846).
On a tripod base, a three-sided pedestal upon which rests a stylized flower with a protruding stem supporting a garland, torch, and quiver of arrows, attached to this are hooks for jewelry. One hook is missing and one side is broken; the finial is missing. / Auf dreiseitiger Plinthe ein hoher dreiseiti-

ger Sockel, auf dem ein Blütenkelch mit hohem Stengel steht, der mit Laubgewinde, Fackel und Köcher verziert ist und eine Reihe von Haken für Schmuck trägt. Ein Haken fehlt und eine Seite ist gebrochen; das obere Teil fehlt.

862 Jewelry Stand / Schmuckständer
1820-30. – F./G. KPEG. – 17 x 8.8 cm (6 11/16 x 3 7/16 in.); D. of base / des Sokkels 7 cm (2 3/4 in.). – 4 pcs./T.
Lamprecht 80. – Inv. 1986.222.15.
Lit.: Cp./vgl. Aus einem Guß, 106 f., no. 218. – Hintze 1928a, 84, pl./Taf. XIV, no. 7 (Gleiwitz P.-C. 1847).
On a round, bell-shaped base with a relief scene of playful putti is a lyre with a winged female mask with hooks for jewelry (cp. also Cat. 738). / Auf rundem, glockenförmigem Sockel mit Reliefszene von spielenden Putten erhebt sich eine Lyra aus einer

Cat. 861

Cat. 862

Cat. 860

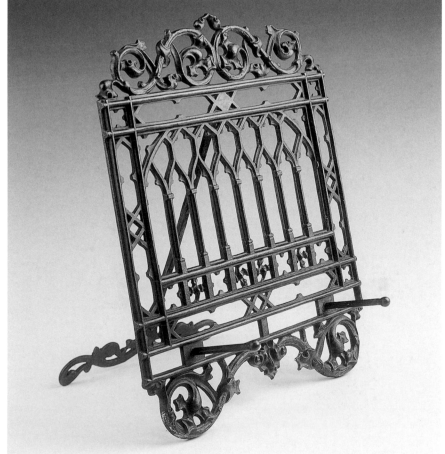

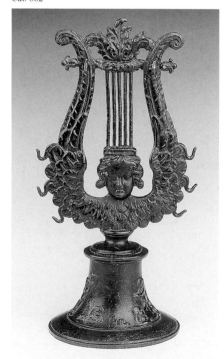

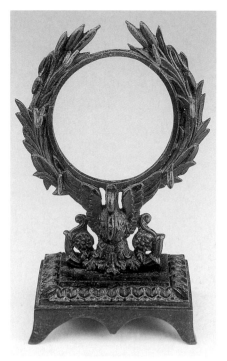

Cat. 863

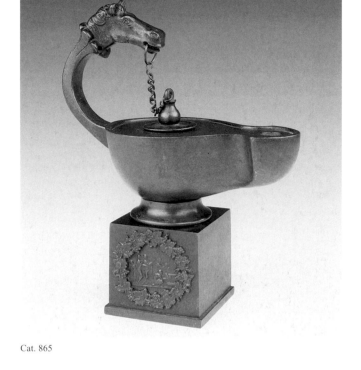

Cat. 865

Cat. 864

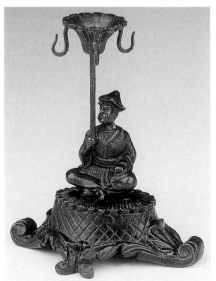

geflügelten Frauenmaske mit Haken für Schmuck (vgl. auch Cat. 738).

863 Jewelry Stand / Schmuckständer
1820-30. – F./G. KPEG. – 12.4 x 8.5 cm (4 7/8 x 3 3/8 in.); base/Sockel 4.8 x 4.8 cm (1 7/8 x 1 7/8 in.).
Lamprecht 153. – Inv. 1986.222.16.

864 Jewelry Stand with Candle Holder / Schmuckständer mit Kerzenhalter
1835-40. – F./G. Devaranne (?). – 8.5 x 7.3 x 5.7 cm (3 3/8 x 2 7/8 x 2 1/4 in.).
Lamprecht 154, Photo 4. – Inv. 1986.222.17.
Lit.: Cp./vgl. Arenhövel 1982, 218, no. 470. – cp./vgl. Schmidt 1981, 206, fig./Abb. 210 (here a watch holder signed by Devaranne with the same seated figure / hier ein Uhrständer, signiert von Devaranne, mit der gleichen sitzenden Figur).
On a round base designed to look like a cushion, a seated Asian figure holds a candle holder in the form of an umbrella with hooks for jewelry. / Auf rundem Sockel ein sitzender Asiat, der eine Stange mit einer Kerzentülle in der rechten Hand hält, an der sich Haken für Schmuck befinden.

Lit.: Hintze 1928a, 89, pl./Taf. XIX, no. 8 (Gleiwitz P.-C. 1847).
On a four-footed square base with a palmette border, the stand is in the form of a laurel wreath supported by a swan with outstretched wings; with three hooks on each side for jewelry. / Auf vierfüßigem, quadratischem Sockel mit Palmettenbordüre trägt ein Schwan mit gespreizten Flügeln einen Lorbeerkranz mit jeweils drei Haken für Schmuck an den Seiten.

865 Oil Lamp / Öllampe
Mid 19th century / Mitte des 19. Jh. – F./G. Ilsenburg (?). – 10 x 12 x 6.8 cm (3 15/16 x 4 3/4 x 2 11/16 in.).
Lamprecht 186, Photo 5. – Inv. 1986.287.
Lit.: Ilsenburg b, no. 986.
The footed lamp with a handle in the form of a horse's head from whose mouth hangs a chain that is attached to the cover; on a square pedestal; traces of bronze patina. / Lampe mit Fuß, der Griff in Form eines Pferdekopfes, von dessen Maul eine Kette hängt, die mit dem Deckel verbunden ist; auf kubischem Sockel. Reste von Bronzierung.

866 Lamp Base / Lampenfuß
Second half of the 19th century / 2. Hälfte des 19. Jh. – F./G. Meves. – H. 32.5 cm (12 13/16 in.); D. 17.4 cm (6 7/8 in.). – many pcs. / viele T. – Marked on the underside of the waves / Bez. auf der Unterseite der Wellen „Verlegt A. Meves, Berlin".
Lamprecht 209. – Inv. 1986.288.2.
On a round base a pair of sailors in a boat in water, one with the initials "KM" on his hat and smoking; the central pole leads to an umbrella-like element, which originally attached to a lamp. / Auf rundem Sockel zwei Matrosen auf einem Boot im Wasser, der eine rauchend und mit den Initialen

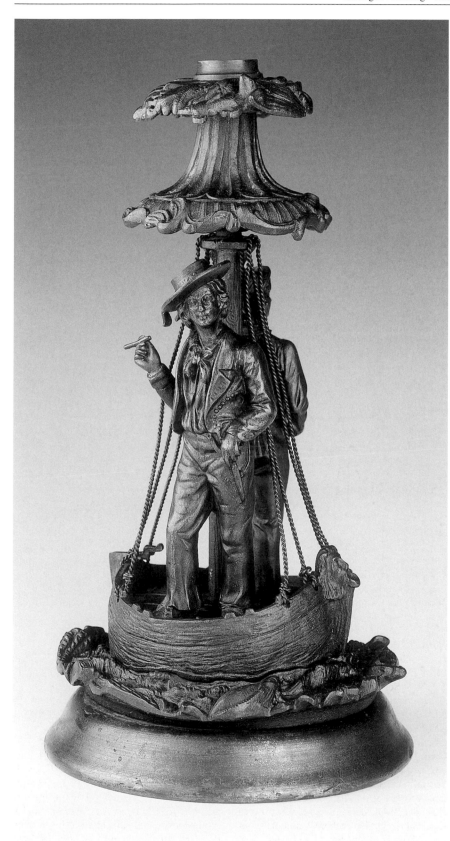

Cat. 867

Cat. 868

◄ Cat. 866

„*KM*" am Hut. Auf dem Mast zwei schirm-
artige Gebilde zur Aufnahme einer Lampe.

**867 Pair of Knife Rests / Paar Messer-
bänkchen**
1820-30. – F./G. KPEG. – 2.5 x 6.4 cm (1 x
2 1/2 in.). – 3 pcs./T.
Lamprecht 159-160. – Inv. 1986.300 a-b.
Lit.: Aus einem Guß, 218, no. 1568. –
Hintze 1928a, 89, pl./Taf. XIX, no. 18 e
(Gleiwitz P.-C. 1847).
Three-sided, the ends with foliage and a
central rosette. / Mit dreiseitigen Enden aus
Pflanzen und einer Rosette in der Mitte.

**868 Pair of Knife Rests / Paar Messer-
bänkchen**
First quarter of the 19th century / 1. Viertel
des 19. Jh. – F./G. KPEG. – 2.1 x 10.1 x
3.3 cm (13/16 x 4 x 1 5/16 in.).
Lamprecht 250-251, Photo 34. – Inv.
1986.301 a-b.
The ends of scrolling foliage, the center
with banded scrolling elements. / Die En-
den aus Voluten, in der Mitte gebundene
Voluten.

**869 Pair of Knife Rests / Paar Messer-
bänkchen**
Second quarter of the 19th century / 2. Vier-
tel des 19. Jh. – F./G. KPEG. – 2.7 x 7.7 x

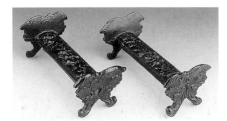

Cat. 869

Cat. 870

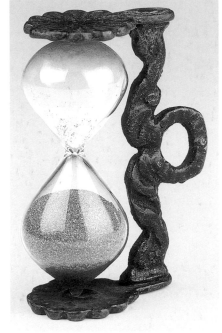

Cat. 871

3.5 cm (1 1/16 x 3 1/16 x 1 3/8 in.). –
3 pcs./T.
Lamprecht 280-281. – Inv. 1986.302 a-b.
Lit.: Aus einem Guß, 218, no. 1569. – Hintze 1928a, 89, pl./Taf. XVIIII, no. 18 f. (Gleiwitz P.-C. 1847). – Ostergard 1994, 255, no. 122.
On scrolled feet with stylized foliage, the central rest a design of foliage and berries. / Auf gerollten Füßen mit stilisiertem Laubwerk, die Auflage mit Blättern und Beeren verziert.

870 Napkin Ring (?) / Serviettenring (?)
First half of the 19th century / 1. Hälfte des 19. Jh. – D. 5.2 cm (2 1/16 in.); W./B. 5.3 cm (2 1/16 in.).
Lamprecht 163. – Inv. 1986.304.
In the form of a signet ring. / In Form eines Siegelrings.

871 Hourglass / Sanduhr
1830-40. – 5.6 x 4 x 2.1 cm (2 3/16 x 1 9/16 x 13/16 in.). – 3 pcs./T.
Lamprecht 71, Photo 32. – Inv. 1986.307.
Lit.: Schmidt 1976, fig./Abb. 16.
The top and the bottom in the shape of a flower; the handle in the form of a bird. / Oben und unten in Form einer Blume gebildet, der Griff in Form eines Vogels.

872 Hourglass Holder / Halter für eine Sanduhr
Brass/Messing. – 19th century / 19. Jh. – H. 7.5 cm (2 15/16 in.); D. 4.3 cm (1 11/16 in.). – 7 pcs./T.
Lamprecht 290. – Inv. 1986.308.
The top and the bottom of the holder are in the form of round medallions with ducks and the inscription *"Three Minutes Warranted"* connected with three spindles; the hourglass (now missing) was held in place by floral prongs. / Die beiden runden Medaillons oben und unten sind mit Enten verziert, tragen die Inschrift *„Three Minutes Warranted"* und sind durch drei Spindeln verbunden. Der Glaseinsatz war von Blütenkelchen gehalten und fehlt heute.

873 Bell / Glocke
1835-40. – F./G. Devaranne (?). – H. 10.5 cm (4 1/8 in.); D. 7.6 cm (3 in.).
Lamprecht 166. – Inv. 1986.306.
In the form of an Asian temple with a design of flowers, foliage, birds, snakes, and insects; the handle is in the form of a seated Asian figure with a bird on his shoulder. / In Form eines asiatischen Tempels mit Reliefdekor aus Blumen, Blättern, Vögeln, Schlangen und Insekten, der Griff in Form eines sitzenden Asiaten mit einem Vogel auf der Schulter.

874 Mortar and Pestle / Mörser und Pistill
17th century / 17. Jh. – Mortar/Mörser: 14.3 cm (5 5/8 in.), D. with handles / mit Griffen 14.5 cm (5 11/16 in.); pestle/Pistill 26.4 cm (10 3/8 in.); pestle handle / Pistillgriff 9.4 cm (3 11/16 in.). – 2 pcs./T.
Lamprecht 210, Photo 5 (mortar only / nur Mörser). – Inv. 1986.310 a-b.
The cylindrical mortar with two sea monster handles; the pestle with a T-grip. / Zylindrischer, dreifach gegliederter Mörser mit zwei Delphinen als Griffen, das Pistill mit T-Griff.

875 Mortar and Pestle / Mörser und Pistill
Early 19th century / Frühes 19. Jh. – Mortar/Mörser: 10.9 cm (4 5/16 in.), D. 9 cm (3 9/16 in.); pestle/Pistill: L. 18.1 cm (7 1/8 in.). – 2 pcs./T.
Lamprecht 211. – Inv. 1986.311 a-b.
The mortar is cylindrical, the pestle has a knob grip. / Zylindrischer Mörser, das Pistill mit rundem Griff.

876 Frame / Rahmen
Second half of the 19th century / 2. Hälfte des 19. Jh. – 19.1 x 15.2 cm (7 1/2 x 6 in.).
Lamprecht 238. – Inv. 1986.312.1.
Rectangular, with a border of acanthus leaves and scrolling foliage. / Rechteckig mit Rahmen aus Akanthusblättern und Laubwerk.

Cat. 872

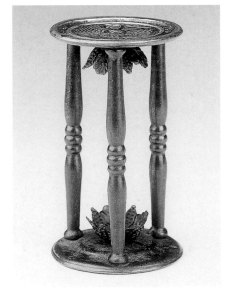

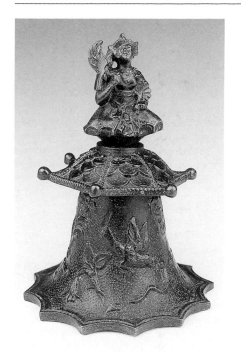

Cat. 873

Cat. 874

Cat. 875

Cat. 876

877 Frame / Rahmen
(Fig. p./Abb. S. 322)
First half of the 19th century / 1. Hälfte des
19. Jh. – 13 x 18 cm (5 1/8 x 7 1/16 in.).
Lamprecht 239. – Inv. 1986.312.2.
Rectangular, on either side are spiral col-
umns flanking two "wildmen" in niches be-
low eagles with outstretched wings; above
and below a design of scrolling foliage. /
Rechteckig, auf beiden Seiten jeweils ein
nackter Mann auf einem Sockel zwischen
gewedelten Rundpfeilern stehend, darüber
ansteigendes Laubwerk mit Adlern links
und rechts.

878 Frame / Rahmen
(Fig. p./Abb. S. 322)
19th century / 19. Jh. – 24.5 x 20.9 cm
(9 5/8 x 8 1/4 in.).
Lamprecht 287. – Inv. 1986.312.3.
Rectangular, with scrollwork and on both
sides winged figures; below is an empty
brass plate for an inscription. / Rechteckig,
mit Voluten und geflügelten Figuren auf
beiden Seiten, unten eine leere Messing-
platte für eine Inschrift.

Cat. 877

Cat. 878

879 Frame / Rahmen
First half of the 19th century / 1. Hälfte des
19. Jh. – 25.5 x 17.7 cm (10 1/16 x 6 15/16
in.).
Lamprecht 270. – Inv. 1986.314.1.
Decorated with farm implements and tools,
roses, birds, sheaves of wheat, and a cherub
below; at the top is a cornucopia. / Aus
landwirtschaftlichen Emblemen gebildet.
Oben gekreuzte Füllhörner mit Rosen und
einem Taubenpärchen.

880 Frame / Rahmen
20th century / 20. Jh. – F./G. Herron Stove
and Manufacturing Company, Chattanooga,
Tennessee. – 39.3 x 43.3 cm (15 1/2 x
17 1/16 in.).
Lamprecht 949. – Inv. 1986.523. – Given to /
Geschenk an ACIPCO 1940 by/von T. H.
Benners & Company, Birmingham, Alaba-
ma.
Reproduction of a 19th century Rumanian
picture frame. Oval, supported on two feet
with putti, flowers, and leaves, at the top is
a pair of birds. The rear support is missing. /
Reproduktion eines rumänischen Bilder-
rahmens aus dem 19. Jh. Der querovale
durchbrochene Rahmen auf zwei Füßen, mit
Blumen, Blättern, Putten und Vögeln ver-
ziert. Wohl als Photographierahmen gedacht.
Die Stütze hinten fehlt.

881 Letter Scale / Briefwaage
Second half of the 19th century / 2. Hälfte
des 19. Jh. – Brass fittings by / Messingbe-
schläge von M. Tauber, Leipzig. – 21.6 x
17.7 x 9.5 cm (8 1/2 x 6 15/16 x 3 3/4 in.).
– 8 pcs./T. – Fittings marked / Beschläge
bez. „M Tauber / LEIPZIG".
Lamprecht 177, Photo 5. – Inv. 1986.341.
Lit.: Ostergard 1994, 269, no. 139.
The firm of M. Tauber in Leipzig was
founded in 1800 as a business dealing in
optical and photographic supplies. From
1900 to 1908 the company had additional
offices in Dresden. It closed in March 1933. /
Die Firma M. Tauber in Leipzig wurde 1800
als Lieferant von optischen Geräten ge-
gründet (später kamen photographische Ma-
terialien hinzu). Von 1900 bis 1908 unter-
hielt die Firma ebenfalls Büros in Dresden.
Im März 1933 wurde die Firma geschlossen.

882 Ashtray / Aschenbecher
Second half of the 19th century / 2. Hälfte
des 19. Jh. – F./G. Mägdesprung (?). – 6.3 x
12.8 x 8.8 cm (2 1/2 x 5 1/16 x 3 7/16 in.).
Lamprecht 940. – Inv. 1986.343.9.
An oval dish with a Vitruvian scroll border;

Cat. 879

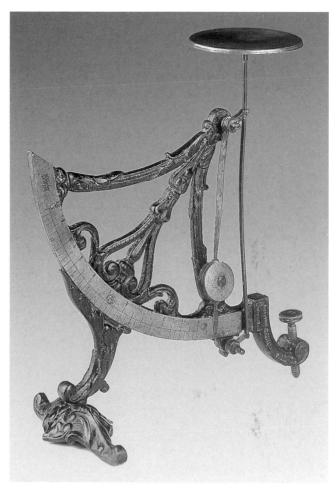

Cat. 881

Cat. 880

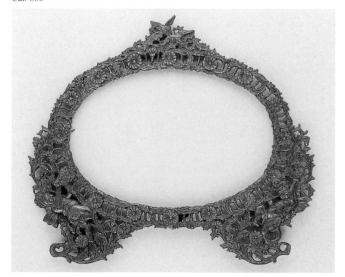

Cat. 882

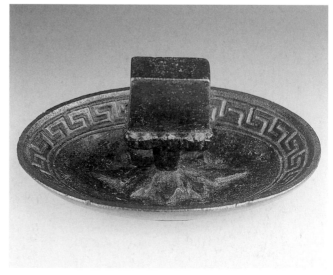

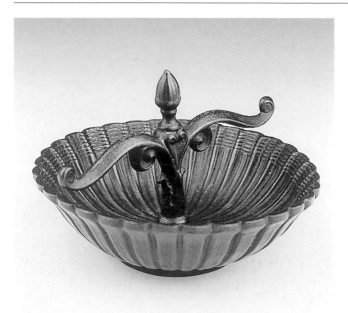

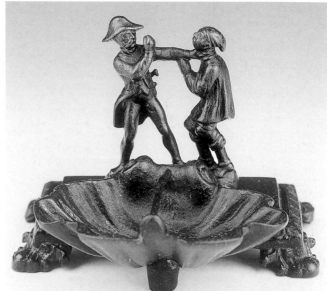

Cat. 883

Cat. 885

Cat. 884

Cat. 890

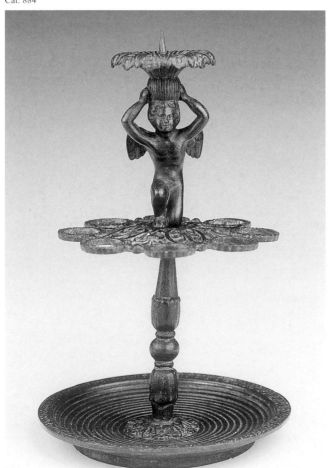

in the center is a square block mounted on a foot. A similar ashtray appears in the Musterbuch of the Mägdesprung foundry (Reichmann, 269, no. 219). / Ovale Schale, in der Mitte ein Quader auf einem Fuß montiert. Ein ähnlicher Aschenbecher ist im Musterbuch der Mägdesprunger Gießerei abgebildet (Reichmann, 269, no. 219).

883 Ashtray / Aschenbecher

First quarter of the 19th century / 1. Viertel des 19. Jh. – F./G. KPEG. – H. 6.3 cm (2 1/2 in.); D. 9.8 cm (3 7/8 in.).
Lamprecht 938. – Inv. 1986.344.2.
The round, fluted dish with a central handle in the form of a scroll with a pinecone finial. / Runde kannelierte Schale mit mittlerem Griff in der Form einer Volute mit Pinienzapfen als Knauf.

884 Ashtray and Cigar Stand with Candle Holder / Aschenbecher mit Zigarrenhalter und Kerzenhalter

Mid 19th century / Mitte des 19. Jh. – F./G. Seebass (?). – H. 15.5 cm (6 1/8 in.); D. of dish / der Schale 10 cm (3 15/16 in.). – 6 pcs./T.
Lamprecht 155, Photo 19. – Inv. 1986.344.7.
The shallow, round dish with concentric rings, the baluster-shaped stem supports a disk pierced with holes to hold cigars, above this kneels a winged putto with a candle holder in the form of a flower on his head. / Flache runde Schale mit konzentrischer Riefelung, der balusterähnliche Schaft trägt eine durchlochte Scheibe zur Aufnahme von Zigarren, darüber kniet ein geflügelter Putto mit einem Kerzenhalter in Form einer Blume auf dem Kopf.

885 Ashtray / Aschenbecher

Ca. 1875. – F./G. Mägdesprung. – 6.8 x 8.5 x 7.9 cm (2 11/16 x 3 3/8 x 3 1/8 in.). – Marked on the base with foundry mark and "8". / bez. auf der Unterseite mit Gießereimarke und „8".
Lamprecht 206. – Inv. 1986.344.3.
Lit.: Cp./vgl. Cat. Meves, pl./Taf. 13, no. 756.
The dish in the shape of a shell on a rectangular base with four leafy feet, upon this a uniformed man with raised right fist holding a peasant at the throat. These figures also appear as part of a support for a thermometer and a pocket watch holder and are listed in Cat. Meves as "Holzdiebgruppe". / Die Schale muschelförmig auf einem rechteckigen Sockel mit vier Blattfüßen, darauf ein Uniformierter mit erhobener rechter

Faust, der einen Bauern am Hals festhält. Diese beiden Figuren kommen auch als Aufsatz eines Thermometergestells vor und sind in Cat. Meves als „Holzdiebgruppe" aufgeführt.

886 Fire Steel / Feuerstahl

1830-40. – F./G. KPEG. – 4.5 x 6.8 cm (1 3/4 x 2 11/16 in.). – 2 pcs./T.
Lamprecht 225, Photo 34. – Inv. 1986.344.5.
Lit.: Aus einem Guß, 214, no. 984. – Preis-Courant [...] Lauchhammer, 4, pl./Taf. 41, no. 13 b. – Schmidt 1976, fig./Abb. 16.
In the shape of a ram on curved runner. / In Form eines Widders auf gerundetem Läufer.

887 Fire Steel / Feuerstahl

Second quarter of the 19th century / 2. Viertel des 19. Jh. – 8.5 x 2 cm (3 3/8 x 13/16 in.).
Lamprecht 226a, Photo 34. – Inv. 1986.344.6 b.
Oblong, with jagged edges. / Länglich mit gezackten Ecken.

888 Fire Steel / Feuerstahl

Second quarter of the 19th century / 2. Viertel des 19. Jh. – 7.5 x 3.1 cm (2 15/16 x 1 1/4 in.). – 2 pcs./T. – Impressed on the side / Eingestochen an der Seite „W. II".
Lamprecht 226, Photo 34. – Inv. 1986.344.6 a.
A scrolled handle on a curved runner. / Volutengriff auf gerundetem Läufer.

889 Fire Steel / Feuerstahl

First half of the 19th century / 1. Hälfte des 19. Jh. – F./G. KPEG (?). – 2.4 x 6.1 cm (15/16 x 2 3/8 in.). – 2 pcs./T.
Inv. 1962.136. – Gift of / Schenkung von Dr. and Mrs. Maurice Garbáty.
Lit.: D'Allemagne, 230, G.
In the shape of two fighting dogs on a steel runner. / In Form zweier kämpfender Hunde auf einem Läufer aus Stahl.

890 Calendar / Kalendarium

1840-50. – F./G. KPEG. – 13.3 x 9.7 cm (5 1/4 x 3 13/16 in.).
Lamprecht 180. – Inv. 1986.503.
A round face with the numbers 1 through 31 (for the days of the month) on the outer rim with letters for the days of the week above, as finial scrolling vines. The adjustable pointer is in the middle, surrounded by foliate decoration. The pointer, numbers, and letters are gilded. / Auf dem Außenrand einer kreisförmigen Scheibe die Zahlen 1 bis 31 (für die möglichen Monatstage), oben Buch-

Cat. 886

Cat. 887

Cat. 888

Cat. 889

staben für die Wochentage, darüber Rankenwerk. In der Mitte der einstellbare Zeiger, umgeben von vegetabilem Dekor. Zeiger, Zahlen und Buchstaben sind vergoldet.

891 Bellpull / Klingelzug

1820-30. – F./G. KPEG. – Lower piece / unteres Teil 16.3 x 12 cm (6 7/16 x 4 3/4 in.); upper piece / oberes Teil 6 x 11 cm (2 3/8 x 4 5/16 in.). – 4 pcs./T.
Lamprecht 237, Photo 20. – Inv. 1986.506.
The upper piece is rectangular with Gothic tracery, the lower piece has three lobes with

Gothic tracery and is attached to a circular element with a rosette; from this hangs a round pull of scrolling foliage. The upper and lower pieces were connected with woven bands (here shown in shortened form). / Der obere Teil rechteckig mit gotisierendem Maßwerk, der untere Teil dreipassig mit gotisierendem Maßwerk, das mit einem kreisringförmigen, verzierten Griff zum Ziehen verbunden ist. Zur Verbindung von oberem und unterem Teil wurden gewebte Bänder benutzt (hier nur verkürzt dargestellt).

892 Card Press / Kartenpresse
1830-40. – F./G. KPEG. – 4.7 x 15.8 x 9.5 cm (1 7/8 x 6 1/4 x 3 3/4 in.).
Lamprecht 285. – Inv. 1986.507.
Rectangular, comprised of two plates that are connected at each end with a thumbscrew in the form of a squirrel with nuts, the cards were placed between the plates, which were then tightened so that after the game the cards could be flattened again. The upper plate with the image of "Laurentia von Tangermünde" (after the statuette by Christian Daniel Rauch; cp. Cat. 614). / Rechteckig, aus zwei Platten bestehend, die an den beiden Enden durch jeweils eine Flügelschraube zusammengeschraubt werden konnten, damit die dazwischen befindlichen Karten nach dem Spiel ihre gerade Form wiedererlangten. Die obere Platte mit einer Darstellung der „Jungfrau Laurentia von Tangermünde" (nach der Statuette von Christian Daniel Rauch; vgl. Cat. 614), die zwei Flügelmuttern in Form von nüsseknabbernden Eichhörnchen.

893 Bottle Stopper / Flaschenstöpsel
1825-30. – F./G. KPEG (?). – H. without cork / ohne Korken 7.6 cm (3 in.); W./B. 4.7 cm (1 7/8 in.).
Lamprecht 289. – Inv. 1986.515 a.
An oval medallion with the portrait bust of a Roman warrior on both sides, with two stylized leaf handles and a plumed finial. The cork is broken. / Ein ovales Medaillon mit dem Porträt eines römischen Kriegers auf beiden Seiten, mit zwei stilisierten Blattgriffen und gefiedertem Knauf. Der Korken gebrochen.

894 Corkscrew / Korkenzieher
First quarter of the 19th century / 1. Viertel des 19. Jh. – L. 8.1 cm (3 3/16 in.); D. 1 cm (3/8 in.). – 2 pcs./T.
Lamprecht 944. – Inv. 1986.517.
In the form of a gun barrel, the corkscrew with a round eye. The screw is partially

Cat. 891

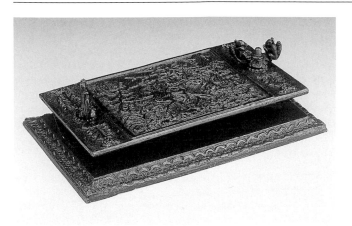

Cat. 892

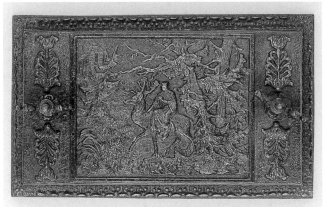

Cat. 892

broken off. / In Form eines Geschützrohrs, der Korkenzieher mit Öse, die Schraube zum Teil weggebrochen.

895 Chess Piece / Schachfigur
1845-55. – Mod. by/von Alfred Richard Seebass. – F./G. Zimmermann. – H. 6 cm (2 3/8 in.); D. 2 cm (13/16 in.).
Lamprecht 228. – Inv. 1986.338.2.
Lit.: Cat. Leipzig 1915, 116, no. 26 (erroneously identified as a seal / irrtümlich als

Siegel identifiziert). – Hanauer Eisen, 21 f., Spiel 6. – Historismus 1989, 71 f., no. 281. The bishop from the chess set "The Thirty Year's War". / Der Läufer vom Schachspiel „Der Dreißigjährige Krieg".

896 Chess Piece / Schachfigur
1820-30. – F./G. KPEG Berlin (?). – H. 4 cm (1 9/16 in.); D. of base 2.2 cm (7/8 in.). Lamprecht 229. – Inv. 1986.338.3.
Lit.: Cat. Leipzig 1915, 116, no. 27 (erro-

neously identified as a seal / irrtümlich als Siegel identifiziert). – Hanauer Eisen, 19 f., Spiel 2.
The figure of a French peasant leaning on a cane on a round base is the pawn from the chess set "Napoleon vs. Friedrich II" that was reproduced at a number of iron foundries. / Die Figur eines französischen Bauern mit Stock auf runder Platte ist der Bauer vom Schachspiel „Napoleon gegen Friedrich II.", das von vielen Eisengießereien gegossen wurde.

Cat. 893

Cat. 894

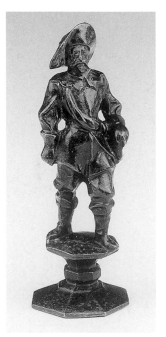

Cat. 895

Cat. 896

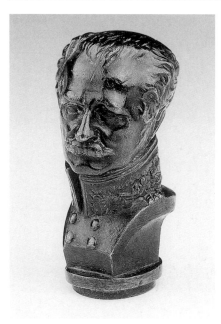

Cat. 897

The knob is a rosette, the grip a design of scrolling foliage. / Der Knopf eine Rosette, der Griff aus sich einrollenden Blättern.

899 Bootjack / Stiefelknecht „Naughty Nellie"

19th century / 19. Jh. – 7.2 x 25 x 12 cm (2 13/16 x 9 13/16 x 4 3/4 in.). Lamprecht 936. – Inv. 1986.516. Lit.: Ames, 123, fig./Abb. 347 (called/genannt „Naughty Nellie").

In the form of a reclining woman wearing underclothes and boots with her hands behind head. / In Form einer liegenden Frau, mit Unterwäsche und Stiefeln bekleidet, die Arme hinter dem Kopf verschränkt.

900 Pair of Garden Chairs / Paar Gartenstühle

Ca. 1830. – Mod. after a design by / nach einem Entwurf von Karl Friedrich Schinkel. – F./G. KPEG Berlin or/oder Gleiwitz. – 78 x 54 x 48 cm (30 11/16 x 21 1/4 x 18 7/8 in.). Inv. 2002.139.1-2. – Museum purchase with partial funds provided by Andrew Duxbury in memory of J. Steven Spivey. / Ankauf zum Teil mit Mitteln von Andrew Duxbury zum Andenken an J. Steven Spivey.

Lit.: Cp./vgl. Himmelheber, fig./Abb. 61-63. The pierced crest rail holds a central lyre motif flanked by two winged figures each pouring a liquid into a bowl, the figures terminate at the waist in a scrolling acanthus leaf; the seat and seat back a series of cast-iron rods and the curved armrests terminate in C-scrolls, the X-shaped legs decorated with a central anthemion motif on either side. / Die durchbrochene, obere Rückenlehne durch eine Lyra und zwei in Akanthusblättern endenden geflügelten Genien, die Öl in eine Schale gießen, geschmückt, der Sitz und die Rückenlehne aus

897 Cane Handle / Stockgriff

Bronze. – 1820-30. – F./G. KPEG (?). – 5.6 x 3 cm (2 3/16 x 1 3/16 in.). Lamprecht 300. – Inv. 1986.511.

In the form of the portrait bust of Gebhard Leberecht Blücher, Prince of Wahlstatt, Prussian field marshal. / In Form der Büste Gebhard Leberecht Blüchers, Fürst von Wahlstatt, preußischer Feldmarschall.

898 Door Handle / Türklinke

First half of the 19th century / 1. Hälfte des 19. Jh. – F./G. KPEG (?). – 15.3 x 8.5 x 5.4 cm (6 x 3 3/8 x 2 1/8 in.). Lamprecht 932. – Inv. 1986.514.

runden Stabeisen, die gebogenen Seitenlehnen enden in Voluten, die X-förmigen Beine mit Anthemionmotiven.

901 Pair of Andirons / Paar Kaminböcke

(Fig. p./Abb. S. 330) First half of the 19th century / 1. Hälfte des 19. Jh. – 21.5 x 43.5 x 11 cm (8 7/16 x 17 1/8 x 4 5/16 in.). Lamprecht 293-294. – Inv. 1986.508.1-2. In the form of the draped and laureate bust of Napoleon I Bonaparte on a pedestal. / In Form einer drapierten und mit einem Lorbeerkranz geschmückten Büste Napoleon I. Bonapartes auf einem Sockel.

902 Fireback / Kaminplatte

(Fig. p./Abb. S. 331) Ca. 1880. – Mod. Elihu Vedder. – 77.8 x 71.1 cm (30 5/8 x 28 in.). – Ins. „No. 9 COPYRIGHTED. 188[...]. [...] FURNACE."

Cat. 899

Cat. 898

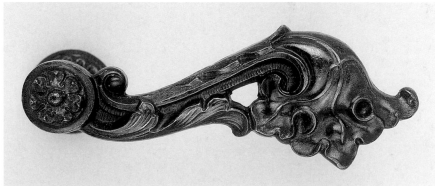

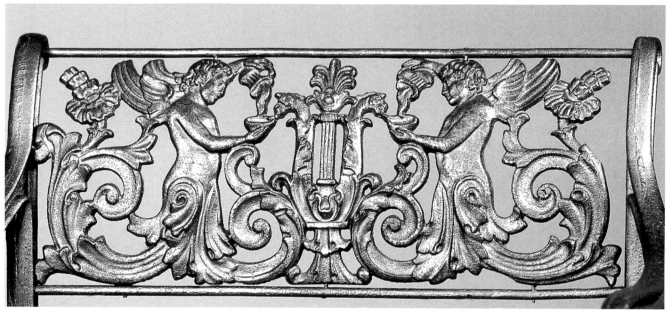

Cat. 900 (detail)

Cat. 900 (cp. fig./vgl. Abb. 49; p./S. 337)

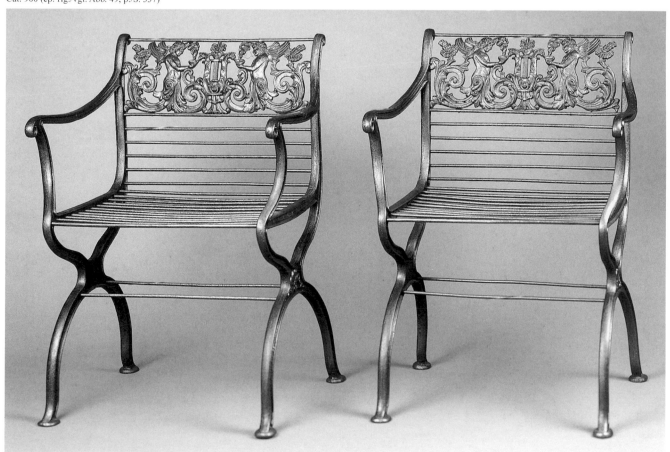

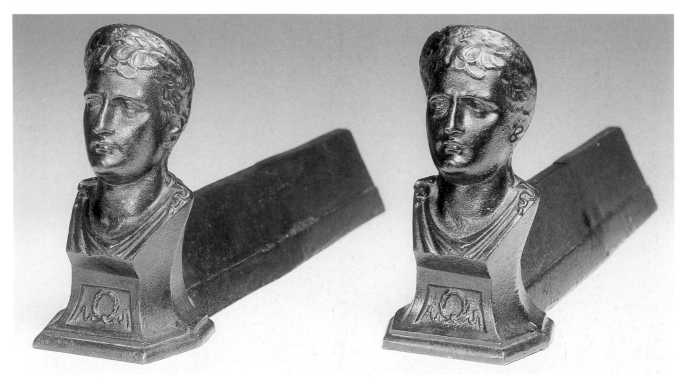

Cat. 901

Cat. 904 (a)

Cat. 904 (b)

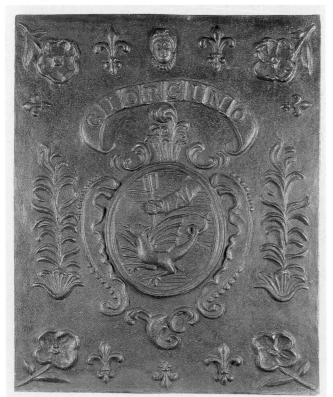

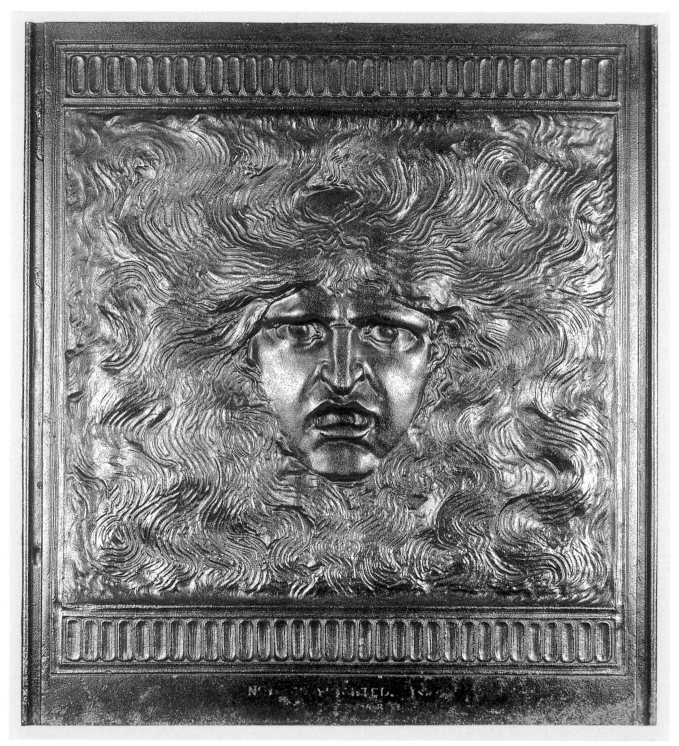

Cat. 902

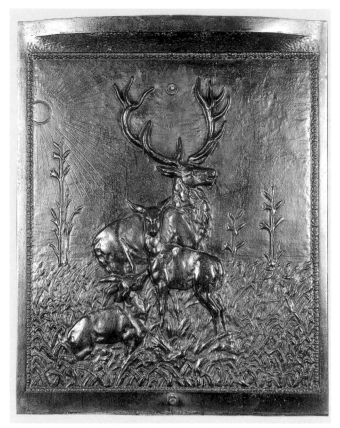

Cat. 903

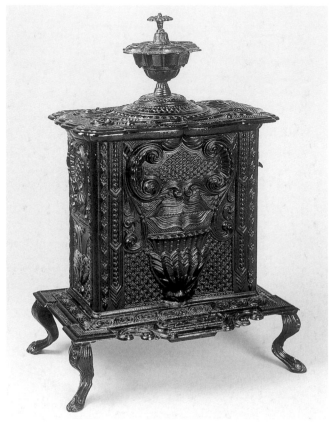

Cat. 905

Inv. 00.1. – Anonymous gift. / Unbekannte Stiftung.
In the middle an androgynous head with long, flowing hair. This piece is the central part of a three-part fireback. / In der Mitte ein androgyner Kopf mit langen, fließenden Haaren. Dieses Stück ist das mittlere Teil einer dreiteiligen Kaminplatte.

903 Stove Plate / Ofenplatte
19th century (?) / 19. Jh. (?). – 64 x 51 cm (25 3/16 x 20 1/16 in.).
Inv. 00.17. – Anonymous gift. / Unbekannte Stiftung.
In the middle deer at rest in a landscape. / In der Mitte ein Hirsch in einer Landschaft.

904 Two Stove Plates / Zwei Platten eines Ofens
(Fig. p./Abb. S. 330)
1940. – F./G. ACIPCO. – 72.4 x 58.4 cm (28 1/2 x 23 in.). – 2 pcs./T.
Inv. 1986.519.1-2.
Lit.: Kassel, fig./Abb. 32.
The first plate with a central mask surrounded by fleurs de lis and roses with the

name *"GIORGINO"*; the second plate with similar decoration. Copy of a cast-iron box stove that was made for the Giorgino family in Colmar by the Zinsweiler foundry in 1763. The model for this cast was made by Mrs. Joe E. Carter, a Birmingham artist, after a photo of the original. Birmingham Museum of Art, Lamprecht Collection Records; typed manuscript by Mary McFarland Brown, December 1940. / Die erste Platte mit zentraler Maske umgeben von fleur de lis und Rosen mit dem Namenszug *„GIORGINO"*, die zweite etwas einfacher ähnlich verziert. Kopie eines Eisenofens, der 1763 für die Giorgino-Familie in Colmar von der Zinsweiler-Gießerei gegossen wurde. Das Modell wurde von Mrs. Joe E. Carter, Künstlerin aus Birmingham, nach einem Foto des Originals geschaffen. Birmingham Museum of Art, Lamprecht Collection Records; Typoskript von Mary McFarland Brown, Dezember 1940.

905 Parlor Stove / Zimmerofen
1847-53. – F./G. W. & R. P. Resor, Cincinnati, Ohio. – 74.9 x 67.3 x 47 cm (29 1/2 x

26 1/2 x 18 1/2 in.). – many pcs. / viele T. – Marked / bez. „W. & R. P. RESOR / Cincinnati. O. / PAT'D 1847 / No. 3".
Inv. 1984.200 a-b. – Gift of the estate of Mrs. Grace Price Hines. / Geschenk aus dem Nachlaß von Grace Price Hines.
Small, square stove on a wide platform with four cabriole legs, decorated with scrolls, beading, repeating geometrical patterns, and stylized pineapples; the top with scalloped edges; the urn finial is removable; with a small hinged door on the side and an opening in back. / Kleiner quaderförmiger Ofen auf einer breiten Platte mit vier Beinen, dekoriert mit Voluten, Perlstab, sich wiederholenden geometrischen Mustern und stilisierten Ananasfrüchten; oben die Kanten ausgebogen; der Knauf in der Form einer Vase ist abnehmbar; mit kleiner aufklappbarer Tür an der Seite und einer Öffnung hinten.

906 Stove Grate / Ofengitter
Ca. 1825. – Mod. after a design by / nach einem Entwurf von Friedrich August Stü-

Cat. 906

ler. – F./G. KPEG Berlin. – 23.7 x 39.3 cm (9 5/16 x 15 1/2 in.).
Lamprecht 463, Photo 36. – Inv. 1986.460.
Lit.: Howard, 3. – Schuette, 286, fig./Abb. 19. – Simpson, 142, fig./Abb. 127.
Rectangular and pierced with two opposing hippocampi on a fountain surrounded by scrolling foliage. / Rechteckig und durchbrochen mit zwei gegenständigen Hippokampen auf einer Art Brunnenschale, aus der eine Fontäne aufsteigt. An den Seiten und unten zierliches Rankenwerk.

907 Bullet Shell / Geschoß
(Fig. p./Abb. S. 334)
19th century (?). – H. 16.5 cm (6 1/2 in.); D. 7.6 cm (3 in.).
Lamprecht 212. – Inv. 1986.505.

908 Ornament / Zierstück
First quarter of the 19th century / 1. Viertel des 19. Jh. – F./G. KPEG. – D. 6 cm (2 3/8 in.).
Lamprecht, Photo 33. – Inv. 1986.1169.

With scrolls and shell motifs; with a hole in the center. / Mit Voluten und Muschelmotiven, mit Loch in der Mitte.

909 Ornament / Zierstück
First half of the 19th century / 1. Hälfte des 19. Jh. – 7.5 x 9.5 cm (2 15/16 x 3 3/4 in.).
Lamprecht 464, Photo 33. – Inv. 1986.461.1.
In the shape of a ram's head. / In Form eines Widderkopfs.

Cat. 908

Cat. 909

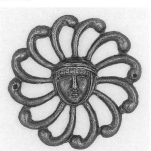

Cat. 910

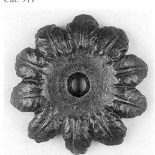

Cat. 911

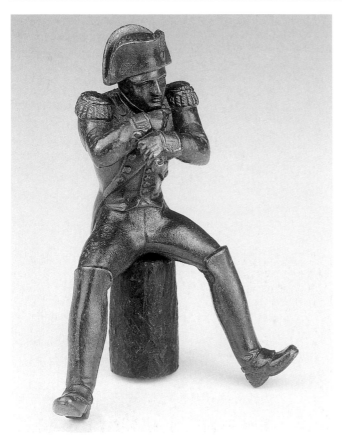

Cat. 912

Cat. 907

910 Ornament / Zierstück
(Fig. p./Abb. S. 333)
First half of the 19th century / 1. Hälfte des
19. Jh. – D. 4.5 cm (1 3/4 in.).
Lamprecht 465, Photo 33. – Inv. 1986.461.2.
In the shape of a stylized rosette with a fe-
male mask in the center. / In Form einer
stilisierten Rosette mit Frauenmaske in der
Mitte.

911 Ornament / Zierstück
(Fig. p./Abb. S. 333)
First half of the 19th century / 1. Hälfte des
19. Jh. – D. 3.8 cm (1 1/2 in.).
Lamprecht 466. – Inv. 1986.461.3.
In the shape of a rosette. / In Form einer
Rosette.

**912 Napoleon I Bonaparte / Napoleon I.
Bonaparte**
1815-30. – F./G. KPEG. – 10.5 x 8 x 5.6
cm (4 1/8 x 3 1/8 x 2 3/16 in.)
Lamprecht 918. – Inv. 1986.224.4.
Napoleon I Bonaparte seated on a stump,
probably originally part of a paperweight. /

Napoleon I. Bonaparte auf einem Baum-
stumpf sitzend; wohl zu einem Briefbe-
schwerer gehörend.

913 Stand / Ständer
20th century / 20. Jh. – 7 x 12 cm (2 3/4 x
4 3/4 in.). – Marked on the underside / bez.
auf der Unterseite: „1236 B EMIG 1“.
Inv. 00.277. – Anonymous gift. / Unbekann-
te Stiftung.
Not part of the original Lamprecht Collec-
tion, but probably acquired from ACIPCO.
Possibly a foot for plate Cat. 836. / Gehört
nicht ursprünglich zur Lamprecht-Samm-
lung, aber wahrscheinlich durch ACIPCO
erworben. Möglicherweise ein Fuß für den
Teller von Cat. 836.

914 Base (?) / Ständer (?)
20th century / 20. Jh. – F./G. Hamilton, Ohio.
– 4.4 x 18.4 x 11.4 cm (1 3/4 x 7 1/4 x 4 1/2
in.). – Marked on the underside / bez. auf der
Unterseite: foundry mark / Gießereimarke
„H“ in circle / im Kreis and/und „169-11 2“.
Inv. 00.274. – Anonymous gift. / Unbekann-
te Stiftung.

915 Base (?) / Sockel (?)
20th century / 20. Jh. – F./G. Hamilton,
Ohio. – 35.5 x 17.8 cm (14 x 7 in.). –
Marked on the underside / bez. auf der
Unterseite: foundry mark / Gießereimarke
„H“ in circle / im Kreis and/und „GB 416“.
Inv. 00.284. – Anonymous gift. / Unbekann-
te Stiftung.

**916 Base Fragment (?) / Ständerfrag-
ment (?)**
20th century / 20. Jh. – F./G. Hamilton, Ohio.
– H. 5.4 cm (2 1/8 in.); D. 21.2 cm (8 3/8 in.).
– Marked on the underside / bez. auf der
Unterseite: foundry mark / Gießereimarke
„H“ in circle / im Kreis and/und „71“.
Inv. 00.282. – Anonymous gift. / Unbekann-
te Stiftung.

**917 Base Fragment (?) / Ständerfrag-
ment (?)**
20th century / 20. Jh. – H. 8.2 cm (3 1/4 in.);
D. 23.5 cm (9 1/4 in.).
Inv. 00.281. – Anonymous gift. / Unbekann-
te Stiftung.

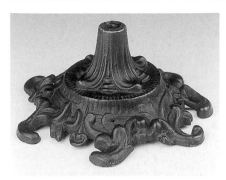

Cat. 913

Cat. 914

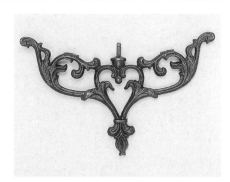

Cat. 921

918 Stand Fragment (?) / Ständerfragment (?)
20th century / 20. Jh. – D. 35.5 cm (14 in.).
Inv. 00.272. – Anonymous gift. / Unbekannte Stiftung.

919 Base (?) / Ständer (?)
20th century / 20. Jh. – F./G. Hamilton, Ohio.
– H. 8.3 cm (3 1/4 in.); D. 43.1 cm (16 15/16 in.). – Marked on the underside / bez. auf der Unterseite: foundry mark / Gießereimarke „H" in circle / im Kreis.
Inv. 00.271. – Anonymous gift. / Unbekannte Stiftung.

920 Ornament Fragment / Ornamentfragment
20th century / 20. Jh. – F./G. Hamilton, Ohio.
– 37.4 x 20.3 cm (14 3/4 x 8 in.). – Marked on the underside / bez. auf der Unterseite: foundry mark / Gießereimarke „H" in circle / im Kreis and/und „GB 211".
Inv. 00.285. – Anonymous gift. / Unbekannte Stiftung.

Cat. 915

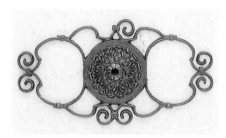

Cat. 920

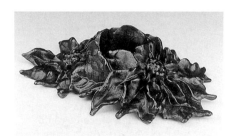

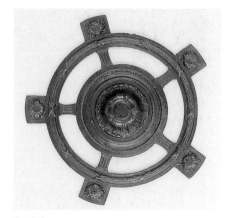

Cat. 918

Cat. 919

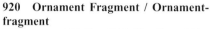

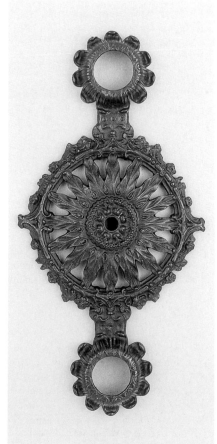

Cat. 916

Cat. 917

921 Frame Fragment (?) / Rahmenfragment (?)
(Fig. p./Abb. S. 335)
20th century / 20. Jh. – 12 x 18.4 cm (4 3/4 x 7 1/4 in.).
Inv. 00.273. – Anonymous gift. / Unbekannte Stiftung.
Probably a support for a frame. / Wohl Aufsatz eines Rahmens.

922 Dial as a Part of a Globe or Nautical Tool (?) / Skalenring als Teil eines Globus oder eines nautischen Geräts (?)
20th century / 20. Jh. – D. 45.7 cm (18 in.).
Inv. 00.270. – Anonymous gift. / Unbekannte Stiftung.
The simple, narrow annulus with a circular arrangement of a total of 360 degrees, but divided into four 90 degree segments, the numbers begin on each side with zero and run up and down to 90 degrees. / Schmaler schlichter Kreisring mit umlaufender Einteilung in insgesamt 360 Grad, hier jedoch in vier mal 90 Grad, die Zählung beginnt jeweils an den Seiten mit 0 und verläuft dann nach oben und nach unten bis 90 Grad. Not part of the original Lamprecht Collection, but probably acquired from ACIPCO. / Nicht ursprünglich ein Teil der Lamprecht-Sammlung, aber wahrscheinlich von ACIPCO erworben.

923 Stand (?) / Ständer (?)
20th century / 20. Jh. – F./G. Hamilton, Ohio. – H. 10.8 cm (4 1/4 in.); D. 33 cm (13 in.). – Marked on the underside / bez. auf der Unterseite: foundry mark / Gießereimarke „H" in circle / im Kreis and/und „8781". Inv. 00.269. – Anonymous gift. / Unbekannte Stiftung.

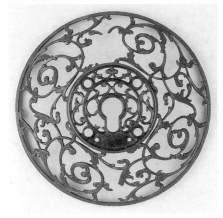
Cat. 923

Cat. 922

924 Machine Fragment (?) / Maschinenfragment (?)
20th century / 20. Jh. – 40.6 x 39.7 cm (16 x 15 5/8 in.).
Inv. 00.268. – Anonymous gift. / Unbekannte Stiftung.

925 Machine Part (?) / Maschinenteil (?)
20th century / 20. Jh. – 47.6 x 14.6 cm (18 3/4 x 5 3/4 in.). – Marked on the rev. / bez. auf der Rs. „BB2".

Cat. 924

Inv. 00.280. – Anonymous gift. / Unbekannte Stiftung.

926 Company Sign / Firmenschild
20th century / 20. Jh. – F./G. Surface Combustion Corporation, Maumee, Ohio. – 29.1 x 37.4 cm (11 7/16 x 14 3/4 in.). – Marked on the front / bez. auf der Vs. *„SURFACE COMBUSTION TOLEDO, OHIO, U.S.A."*. Inv. 00.283. – Anonymous gift. / Unbekannte Stiftung.

Cat. 925

Cat. 926

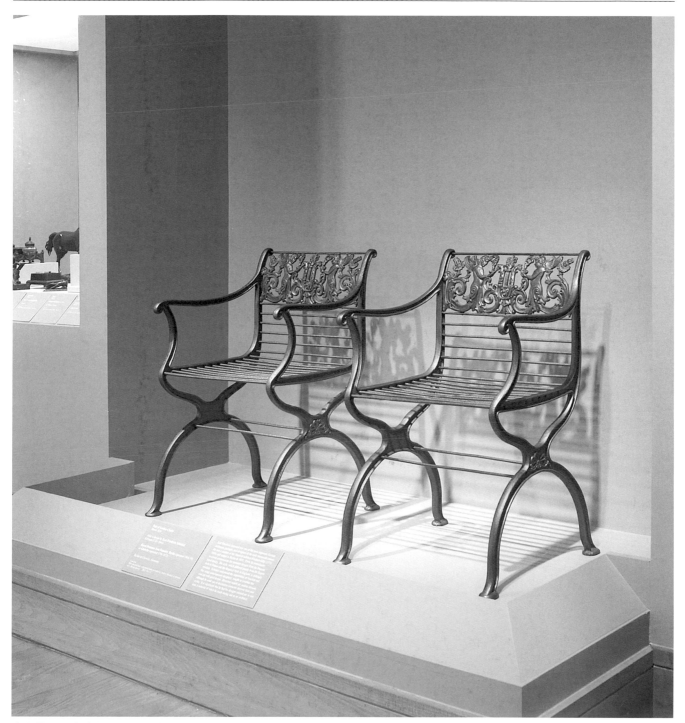

Fig./Abb. 49 Birmingham Museum of Art, view of the gallery / Blick in die Ausstellung; photo/Aufnahme 2008 (cp./vgl. Cat. 900).

Pieces Missing from the Lamprecht and Garbáty Collections Since the Inventory of 1986 / Verschollene Stücke seit der Inventur von 1986 (Cat. 927-88)

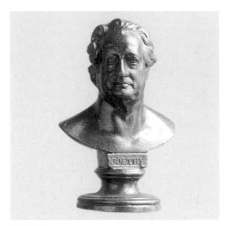

Cat. 928

927 Pocket Watch Holder / Taschenuhr-ständer
(no. Fig./o. Abb.)
30.2 x 15.7 cm (11 7/8 x 6 3/16 in.).
Lamprecht 99. – Inv. 1986.222.9.
With hounds and eagles, with acanthus ornament, on a rectangular base. Pair to Lamprecht 100. Cp. Cat. 756. / Mit Jagd-hunden und Adler, mit Akanthusornament auf rechteckigem Sockel. Gegenstück zur Lamprecht 100. Vgl. Cat. 756.

928 Johann Wolfgang von Goethe (1749-1832)
Bust/Büste.
Mod. Leonhard Posch after/nach Christian Daniel Rauch. – H. 7 cm (2 3/4 in.). / Ins. „GOETHE".
Lamprecht 121, Photo 4. – Inv. 1986.223.7.
Lit.: Forschler-Tarrasch, no. 890.

929 Peasant Girl Holding a Jug / Bauernmädchen, das einen Krug hält
(no. Fig./o. Abb.)
Statuette.
H. 12.1 cm (4 3/4 in.).
Lamprecht 216. – Inv. 1986.237.

930 Tray / Tablett
(no. Fig./o. Abb.)
D. 21.9 cm (8 5/8 in.).
Lamprecht 144. – Inv. 1986.259.3.
Round and pierced. / Rund und durchbrochen.

931 Lithophane Stand / Lichtschirm-gestell
Lamprecht 94, Photo 2. – Inv. 1986.289.3.
In the shape of an oak tree trunk. / In der Form eines Eichenstammes.

932 Lithophane Stand / Lichtschirm-ständer (no. Fig./o. Abb.)
34.3 x 11.4 cm (13 1/2 x 4 1/2 in.).
No/ohne Lamprecht no. – Inv. 1986.289.5 a-c.
On circular base with cluster column; lithophane and foot missing. / Auf kreisförmi-gem Sockel mit Büschelstand; Lithophanie und Fuß fehlen.
Although this object is listed in the accession book of the museum, no such object is listed in the *"Sammlung Lamprecht Hand-exemplar"* or the *"Kunstwerke aus Eisen-guss aus der Sammlung Professor G. Lamp-recht Leipzig"*. It can be assumed that this

Cat. 931

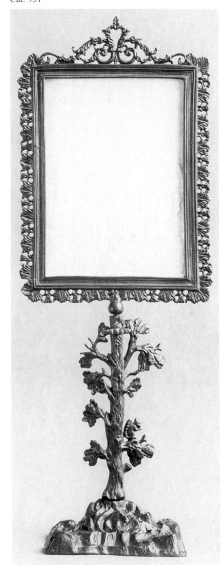

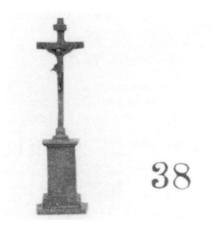

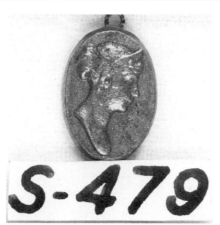

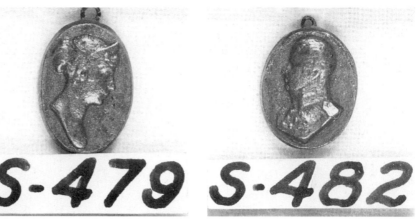

Cat. 939 Cat. 941 Cat. 942

book entry reflects a clerical error and that one piece was perhaps catalogued by the museum twice. / Obwohl dieses Objekt in dem Inventarbuch des Museums aufgelistet ist, ist es nicht im „Sammlung Lamprecht Handexemplar" oder im „Kunstwerke aus Eisenguss aus der Sammlung Professor G. Lamprecht Leipzig" eingetragen. Vermutlich handelt es sich hier um einen Schreibfehler oder um eine doppelte Eintragung seitens des Museums.

933 Game Token / Spielmarke
(no. Fig./o. Abb.)
Obv./Vs.: Seated figure with banner. / Sitzende Figur mit Fahne.
Rev./Rs.: „STETS MIT DEM GLÜCK IM BUND".
D. 2.9 cm (1 1/8 in.).
Lamprecht 54. – Inv. 1986.317.1.

934 Game Token / Spielmarke
(no. Fig./o. Abb.)
Obv./Vs.: Two figures running. / Zwei rennende Figuren.
Rev./Rs.: „RASCH! UND DAS SPIEL GEHT GUT".
D. 2.9 cm (1 1/8 in.).
Lamprecht 55. – Inv. 1986.317.2.

935 Game Token / Spielmarke
(no. Fig./o. Abb.)
Obv./Vs.: Seated Argus with cow. / Sitzender Argus mit Kuh.
Rev./Rs.: „ WIE ARGUS AUF DER HUT".
D. 2.9 cm (1 1/8 in.).
Lamprecht 57. – Inv. 1986.317.4.

936 Game Token / Spielmarke
(no. Fig./o. Abb.)
Obv./Vs.: Figure of a card player. / Figur eines Kartenspielers.
Rev./Rs.: Ins. illegible/unleserlich.
Lamprecht 58. – Inv. 1986.318 a.

937 Game Token / Spielmarke
(no. Fig./o. Abb.)
Obv./Vs.: Cat and mouse. / Katze und Maus.
Rev./Rs.: „SPOTTEND OFT WANDELT DAS SPIEL SICH IN LEID".
Lamprecht 59. – Inv. 1986.318 b.

938 Box for Game Tokens / Kästchen für Spielmarken
(no. Fig./o. Abb.)
Lamprecht 219. – Inv. 1986.319.
The cover with the figure of a man. / Der Deckel mit der Figur eines Mannes. / Cp. also/vgl. auch Cat. 296-99.

939 Crucifix / Kruzifix
9.2 x 1.9 cm (3 5/8 x 3/4 in.).
Lamprecht 38. – Inv. 1986.326.1.

940 Cross Pendant for a Relic / Kreuzanhänger für eine Reliquie
(no. Fig./o. Abb.)
25.1 x 12.1 cm (9 7/8 x 4 3/4 in.).
Lamprecht 289. – Inv. 1986.327.3.

941 Pendant with Portrait of Queen Luise of Prussia (1776-1810) / Anhänger mit Porträt der Königin Luise von Preußen
Bust in profile right. / Brustbild im Profil nach rechts.

1.6 x 1.3 cm (5/8 x 1/2 in.).
Lamprecht 479S. – Inv. 1986.328.1.

942 Pendant with Portrait of August Wilhelm Anton, Graf Neithardt von Gneisenau (?; 1760-1831) / Anhänger mit Porträt von August Wilhelm Anton, Graf Neithardt von Gneisenau
Bust in profile left. / Brustbild im Profil nach links.
1.6 x 1.3 cm (5/8 x 1/2 in.).
Lamprecht 482S. – Inv. 1986.328.3.

943 Pendant with a Cossack on Horseback / Anhänger mit reitendem Kosaken
(no. Fig./o. Abb.)
1.6 cm x 1.3 cm (5/8 x 1/2 in.).
Lamprecht 483S. – Inv. 1986.328.4.
Smaller copy of Cat. 273. / Verkleinerung von Cat. 273.

944 Pendant with Portrait of King Friedrich August I of Saxony (1750-1827; 1806 King) / Anhänger mit Porträt des Königs Friedrich August I. von Sachsen (1806 König)
(Fig. p./Abb. S. 340)
Bust in profile right. / Brustbild im Profil nach rechts.
1.6 x 1.3 cm (5/8 x 1/2 in.).
Lamprecht 484S. – Inv. 1986.328.5.

945 Shoe Buckle / Schuhschnalle
(Fig. p./Abb. S. 341)
5.4 x 5.7 cm (1 1/8 x 2 1/4 in.).
Lamprecht 559S. – Inv. 1986.329.7.
Oval, framed with pierced volutes. / Oval, mit durchbrochenen Voluten.

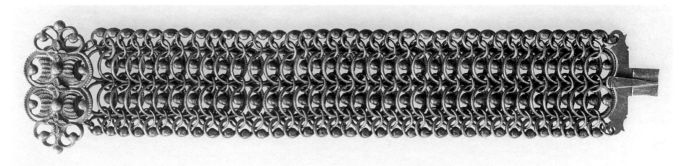

Cat. 946

Cat. 944

946 Bracelet / Armband
20 x 3.5 cm (7 7/8 x 1 3/8 in.).
Lamprecht 514S, Photo 55. – Inv.
1986.330.3.
The bracelet chain-like, the clasp with scrolling decoration. / Das Band ketten-hemdartig, der Verschluß mit Voluten.

947 Earring / Ohrgehänge
(no. Fig./o. Abb.)
L. 1.6 cm (5/8 in.).
Lamprecht 533S, Photo 54. – Inv.
1986.332.4 b.
Pair to Cat. 530. / Gegenstück zu Cat. 530.

948 Earring / Ohrgehänge
L. 1.9 cm (3/4 in. no Fig./o. Abb.).
Lamprecht 534S. – Inv. 1986.332.5.
Arch shaped, the top part gilded and ar-ranged to catch in a rosette. / Bogenförmig, das Oberteil vergoldet und so eingerichtet, dass es in einer Rosette befestigt werden kann.

949 Pair of Earrings / Paar Ohrgehänge
L. 3 cm (1 3/16 in.).
Lamprecht 540S, Photo 54. – Inv.
1986.332.6 a-b.
With tracery rosettes in six sections. / Mit sechsteiligen durchbrochenen Rosetten.
Lit.: H. v. Sp., 300.

950 Signet Ring / Siegelring
D. 3 cm (1 3/16 in. no Fig./o. Abb.).
Lamprecht 498S. – Inv. 1986.334.1.

The band wide, with empty plate. / Das Band breit, mit leerer Platte.

951 Signet Ring / Siegelring
(no. Fig./o. Abb.)
D. 2.5 cm (1 in.).
Lamprecht 501S. – Inv. 1986.334.4.
With a "W" engraved on an octagonal plate. / Mit auf der achteckigen Platte ein-graviertem „W".

952 Signet Ring / Siegelring
D. 2.5 cm (1 in.).
Lamprecht 502S, Photo 55. – Inv.
1986.334.5.
With an antique lamp engraved on an octag-onal plate. / Mit einer antiken Lampe auf der achteckigen Platte.

953 Signet Ring / Siegelring
D. 2.2 cm (7/8 in.).
Lamprecht 503S, Photo 55. – Inv.
1986.334.6.
With an anchor and eye engraved on an oc-tagonal plate. / Auf der achteckigen Platte Anker und Auge eingraviert.

Cat. 949

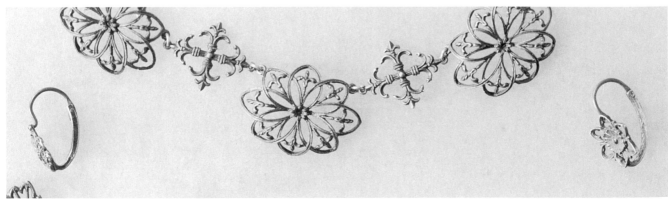

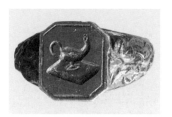

Cat. 952

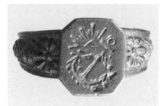

Cat. 953

Cat. 957

954 Signet Ring / Siegelring
(no. Fig./o. Abb.)
D. 2.2 cm (7/8 in.).
Lamprecht 504S. – Inv. 1986.334.7.
With a lyre and a sheet of music engraved
on an octagonal plate. / Auf der achtecki-
gen Platte eine Leier und ein Notenblatt
eingraviert.

955 Ring / Fingerring
(no. Fig./o. Abb.)
D. 1.7 cm (11/16 in.).
Lamprecht 487S. – Inv. 1986.334.11.
Finely ribbed with the symbols of faith,
love, and hope on small oval medallions. /
Fein gerippt mit den Symbolen für Glaube,
Liebe und Hoffnung auf kleinen hochova-
len Medaillons.

956 Signet Ring / Siegelring
(no. Fig./o. Abb.)
Lamprecht 556S. – Inv. 1986.334.12.
With fish scale motif and a sphinx en-
graved on the plate. / Mit Fischschuppen-
motiven und mit einer Sphinx auf der acht-
eckigen Platte eingraviert.

**957 Pair of Buttons or Cufflinks / Paar
Knöpfe oder Manschettenknöpfe**
D. 1.6 cm (5/8 in.).
Lamprecht 489S. – Inv. 1986.335.4 a-b.
In the shape of a rosette in eight parts. / In
Form einer achtteiligen Rosette.

**958 Fragment of a Piece of Jewelry /
Fragment eines Schmuckstücks**
1 x 1.3 cm (3/8 x 1/2 in.).
Lamprecht 542S. – Inv. 1986.336.1.
Octangonal, pierced. / Achteckig, durch-
brochen.

959 Ornament
Lamprecht 543S. – Inv. 1986.336.2.
Rosette, octagonal with pierced decoration. /
Rosette, achteckig mit durchbrochenem De-
kor.

960 Male Mask / Männliche Maske
1.2 x 1 cm (1/2 x 3/8 in.).
Lamprecht 544S. – Inv. 1986.336.3.

961 Signet / Siegel
(Fig. p./Abb. S. 342)
Lamprecht 546S. – Inv. 1986.338.12.

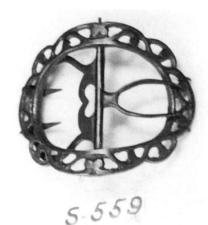

Cat. 945

962 Pipe Stopper / Pfeifenstopfer
(Fig. p./Abb. S. 342)
L. 12.1 cm (4 3/4 in.).
Lamprecht 937. – Inv. 1986.344.1.
With a bust of Napoleon. / Oben mit einer
Büste Napoleons.

Cat. 958

Cat. 959

Cat. 960

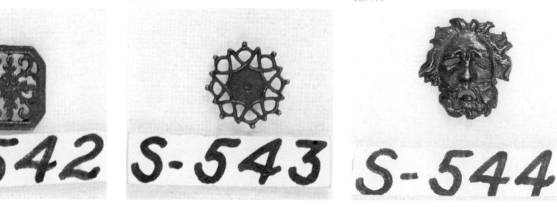

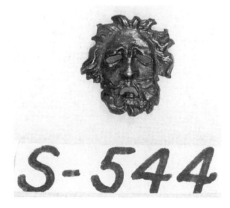

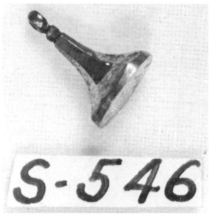

Cat. 961

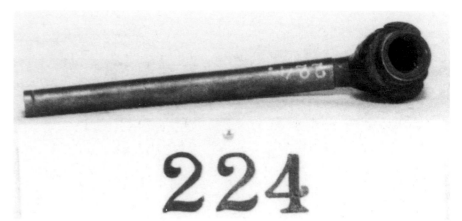

Cat. 963

Cat. 962

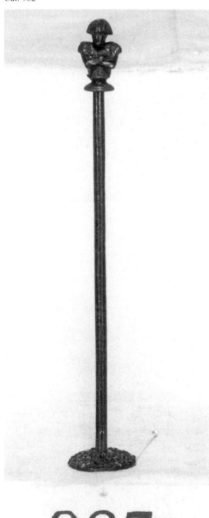

963 Tobacco Pipe / Tabakpfeife
L. 8.6 cm (3 3/8 in.).
Lamprecht 224. – Inv. 1986.344.4.
With the head of Pan, in silver mount. / Mit
einem Kopf Pans in Silberfassung.

**964 Portrait Medallion of Napoleon I
Bonaparte, Emperor of the French
(1769-1821; 1804 Emperor) / Porträtme-
daillon von Napoleon I. Bonaparte, Kai-
ser der Franzosen (1804 Kaiser)**
Bust in profile right in the uniform of the
highest officer of the Grenadier Guards
with sash. / Brustbild im Profil nach rechts
in der Uniform des Obersten der Grena-
diergarde mit Ordensband.
Mod. Leonhard Posch. – F./G. KPEG – D.
10.5 cm (4 1/8 in.).
Lamprecht 307. – Inv. 1986.346.6.
Lit.: Forschler-Tarrasch, no. 12. – Hintze
1928a, 34, pl./Taf. 58, no. VII, 8.

**965 Portrait Medallion of Maria Ludo-
vica, Empress of Austria (1787-1816) /
Porträtmedaillon der Maria Ludovica,
Kaiserin von Österreich**
Bust in profile left with diadem. / Brustbild
im Profil nach links mit Diadem. / Ins.
„MARIA LVDOVICA KAI. V. ÖSTER-
REICH".
Ca. 1814-15. – Mod. Leopold Heuberger. –
F./G. KPEG Gleiwitz. – D. 5.4 cm (2 1/8 in.).
– Sign. below truncation / unterhalb des
Brustabschnitts „HEUBERGER".
Lamprecht 328. – Inv. 1986.360.
Part of a series made by Heuberger on the
occasion of the Congress of Vienna. / Teil
einer Serie, die anläßlich des Wiener Kon-
gresses geschaffen wurde. / Cp. also/vgl.
auch Cat. 38.

**966 Portrait Medallion of King Fried-
rich I of Württemberg (1754-1816; 1808
King) / Porträtmedaillon des Königs
Friedrich I. von Württemberg (1808 Kö-
nig)**
Bust in profile right. / Brustbild im Profil
nach rechts. / Ins. „FRIEDRICH KÖNIG V.
WÜRTEMBERG".
Ca. 1814-15. – Mod. Leopold Heuberger. –
F./G. KPEG Gleiwitz. – D. 5.4 cm (2 1/8 in.).
– Sign. below truncation / unterhalb des
Brustabschnitts „HEUBERGER".
Lamprecht 331, Photo 60. – Inv. 1986.363.
Part of a series made by Heuberger on the
occasion of the Congress of Vienna. / Teil
einer Serie, die anläßlich des Wiener Kon-
gresses geschaffen wurde.

**967 Portrait Medallion of George,
Prince Regent of England (1762-1830; as
George IV King of Great Britain and
Ireland; King of Hanover) / Porträtme-
daillon von Georg, Prinzregent von Eng-
land; als Georg IV. König von Großbri-
tannien und Irland; zugleich König von
Hannover)**
Bust in profile right in uniform. / Brustbild
im Profil nach rechts in Uniform. / Ins.
„GEORG PRINZ REGENT V: ENG-
LAND".
Ca. 1814-15. – Mod. Leopold Heuberger. –
F./G. KPEG Gleiwitz. – D. 5.4 cm (2 1/8 in.).
– Sign. below truncation / unterhalb des
Brustabschnitts „HEUBERGER".
Lamprecht 333. – Inv. 1986.365.
Part of a series made by Heuberger on the
occasion of the Congress of Vienna. / Teil
einer Serie, die anläßlich des Wiener Kon-
gresses geschaffen wurde.

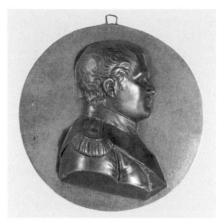

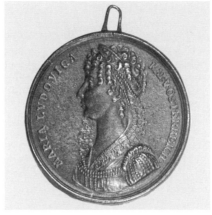

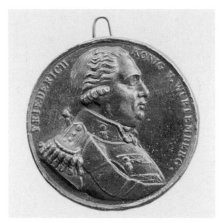

Cat. 964

Cat. 965

Cat. 966

968 Portrait Medallion of Queen Victoria of the United Kingdom of Great Britain and Ireland (1819-1901; 1838 Queen) and Prince Albert, The Prince Consort (1819-61) / Porträtmedaillon der Königin Victoria des Vereinigten Königreiches von Großbritannien und Irland (1838 Königin) und des Prinzgemahls Albert
Conjoined heads left with dolphins and a trident. / Köpfe nach links mit Delphinen und einem Dreizack. / Ins. „VICTORIA D.G. BRIT. REG. F. D. ALBERTUS PRINCEPS CONJUX." and/und „MDCCCLI".
1851. – Mod. William Wyon. – F./G. Royal Mint, London. – D. 7.9 cm (3 1/8 in.). – Sign. „Wyon. Royal Mints. 1851".
Lamprecht 354, Photo 61. – Inv. 1986.385.

969 Portrait Medallion of Friedrich Justin Bertuch (1747-1822) / Porträtmedaillon von Friedrich Justin Bertuch
(no. Fig./o. Abb.)
Bust in profile left. / Brustbild im Profil nach links.
D. 8.6 cm (3 3/8 in.).
Lamprecht 367. – Inv. 1986.394.

970 Plaque with Cupid Seated on a Rock with a Dog / Plakette mit Amor auf einem Stein sitzend mit einem Hund
(no. Fig./o. Abb.)
Mod. after/nach Berthel Thorvaldsen. – 10 x 7 cm (3 15/16 x 2 3/4 in.).
Lamprecht 442. – Inv. 1986.446.6.
Lit.: ACIPCO 1941b, fig./Abb. 3.

971 Gem / Gemme
(no. Fig./o. Abb.)
Lamprecht 273M. – Inv. 1986.481.74.

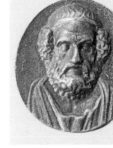

Cat. 972

Cat. 973

Cat. 977

972 Gem / Gemme
Bust of a youth in profile left with long hair. / Brustbild eines Jugendlichen im Profil nach links mit gelockten, langen Haaren.
Lamprecht 284M. – Inv. 1986.481.85.

973 Gem / Gemme
Bust of a bearded man front. / Brustbild eines bärtigen Mannes von vorn.
Lamprecht 285M. – Inv. 1986.481.86.

Cat. 967

Cat. 968

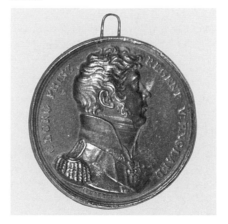

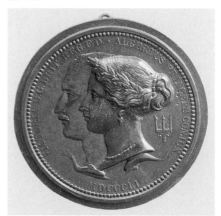

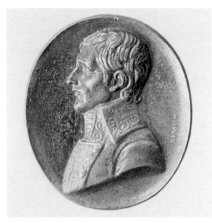

Cat. 978

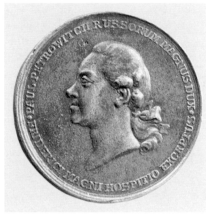

Cat. 980 (Obv./Vs.)

Cat. 983

974 Gem / Gemme
(no. Fig./o. Abb.)
Lamprecht 295M. – Inv. 1986.481.96.

975 Gem / Gemme
(no. Fig./o. Abb.)
Lamprecht 324M. – Inv. 1986.481.125.

976 Gem / Gemme
(no. Fig./o. Abb.)
Lamprecht 370M. – Inv. 1986.481.171.

977 Gem / Gemme (Fig. p./Abb. S. 343)
Hercules and/und Omphale (?).
Lamprecht 388M. – Inv. 1986.481.189.

978 Medal with Portrait of Napoleon I Bonaparte, Emperor of the French (1769-1821; 1804 Emperor) / Medaille mit Porträt von Napoleon I. Bonaparte, Kaiser der Franzosen (1804 Kaiser)
Obv./Vs.: Bust in profile left in uniform. / Brustbild im Profil nach links in Uniform.
F./G. KPEG Gleiwitz. – 4.1 x 3.5 cm (1 5/8 x 1 3/8 in.). – Sign. right/rechts „Simon".
Lamprecht 447M, Photo 59. – Inv. 1986.495.29.
Lit.: Schuette, 283, fig./Abb. 15.
Cp. also/vgl. auch Cat. 79.

979 Medal / Medaille
Obv./Vs.: Victoria, Goddess of Victory. / Viktoria, Göttin des Sieges. / Ins. around/Umschrift „GOTT SEGNETE DIE VEREINIGTEN HEERE".
Rev./Rs.: „BEI LEIPZIG IN DER VÖLKER SCHLACHT 16.-19. OKT. 1813".
D. 1.6 cm (5/8 in.).
Lamprecht 461M. – Inv. 1986.495.43.

980 Medal Commemorating the Visit of Grand Duke Paul I of Russia (1754-1801; 1796 Kaiser) to Berlin in 1776 / Medaille auf den Besuch des Großfürsten Paul I. von Rußland 1776 in Berlin
Obv./Vs.: Head in profile left. / Kopf im Profil nach links. / Ins. „PAUL PETRO-WITCH RUSSORUM MAGNUS DUX. FRI-DERICI MAGNI HOSPITIO EXCEPTUS".
Rev./Rs.: Minerva with the arms of Russia and Prussia. / Minerva mit den Wappen von Rußland und Preußen. / Ins. „[...] MINER-VA" and/und „ANNO MDCCLXXVI".
Probably cast after a struck medal of 1776. / Wohl nach einer geprägten Medaille von 1776 gegossen. – D. 4.1 cm (1 5/8 in.).
Lamprecht 468M, Photo 61. – Inv. 1986.495.48.

Cat. 979

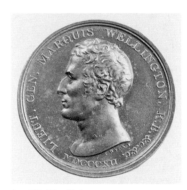

Cat. 981 (Obv./Vs.)

Cat. 981 (Rev./Rs.)

Cat. 982

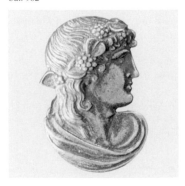

981 Medal Commemorating the Victories of Arthur Wellesley, Duke of Wellington (1769-1852) in Spain / Medaille auf die Siege von Arthur Wellesley, Herzog von Wellington, in Spanien
Obv./Vs.: Bust in profile left. / Brustbild im Profil nach links. / Ins. „LIEUT. GEN. MARQUIS WELLINGTON. K.B. &c. &c. MDCCCXII".
Rev./Rs.: Three garlanded shields with the arms of Britain, Portugal, and Spain on a plinth with captured military trophies. / Drei mit Blumen behängte Schilde mit den Wappen von Britannien, Portugal und Spanien auf einem Sockel mit Kriegsbeute. / Ins. on the plinth / auf der Plinthe „VIMEIRA TALAVERA BUSACO CIUDAD RODRIGO BADAJOZ SALAMANCA" and/und „ENTER'D MADRID AUGUST XII".
1812. – Mod. Thomas Wyon. – F./G. KPEG Gleiwitz. – D. 4.3 cm (1 11/16 in.). – Sign. on truncation / am Halsabschnitt „T. WYON F.".
Lamprecht 469M, Photo 60. – Inv. 1986.495.49.
Lit.: Bramsen 1160. – Eimer 16.

982 Portrait of an Unknown Young Man / Porträt eines unbekannten jungen Mannes
Obv./Vs. Bust in profile right with ivy wreath. / Brustbild im Profil nach rechts mit Efeukranz.
2.5 x 1.9 cm (1 x 3/4 in.).
Lamprecht 519S, Photo 52. – Inv. 1986.495.55 a.
Lit.: H. v. Sp. 1917, frontispiece/Frontispiz.

983 Incense Burner on Tripod Stand / Räuchergefäß auf einem Dreifuß
H. 13 cm (5 1/8 in.); D. 13 cm (5 1/8 in.).
Lamprecht 44. – Inv. 1986.500.

984 Picture Frame / Bilderrahmen
(no. Fig./o. Abb.)
1940. – F./G. Herron Stove and Manufacturing Company, Chattanooga, Tennessee.
Lamprecht 948. – Inv. 1986.522 (donated to ACIPCO by / Schenkung an ACIPCO von T. H. Benners & Company, 1940).
Reproduction of a Romanian frame. / Kopie eines rumänischen Rahmens.

985 Tray for Game Tokens / Tablett für Spielmarken
(no. Fig./o. Abb.)
D. 8.9 cm (3 1/2 in.).
Inv. 1962.89 c. – Gift of / Schenkung von Dr. and Mrs. Maurice Garbáty.
With playing card design in center. / In der Mitte ein Spielkartenmuster.

986 Portrait Medallion of Queen Luise of Prussia (1776-1810) / Porträtmedaillon der Königin Luise von Preußen
(no. Fig./o. Abb.)
H. 3.8 cm (1 1/2 in.).
Inv. 1962.92. – Gift of / Schenkung von Dr. and Mrs. Maurice Garbáty.
In gold mount. / In Goldfassung.

987 Ring with Portrait of a General / Ring mit Porträt eines Generals
(no. Fig./o. Abb.)
D. 3.8 cm (1 1/2 in.).
Inv. 1962.93. – Gift of / Schenkung von Dr. and Mrs. Maurice Garbáty.

988 Plaque with a Biblical Scene / Plakette mit einer biblischen Szene
(no. Fig./o. Abb.)
1827. – 8.9 x 14 cm (3 1/2 x 5 1/2 in.).
Inv. 1962.99. – Gift of / Schenkung von Dr. and Mrs. Maurice Garbáty.

Pieces Missing from the Lamprecht Collection Based on a List Created by ACIPCO on February 8, 1949 / Verschollene Stücke aus der Lamprecht-Sammlung nach einer Liste von ACIPCO vom 8. Februar 1949 (Cat. 989-94)

989 Statuette of the Gutenberg Monument at Mainz / Statuette des Gutenberg-Denkmals in Mainz
(no. Fig./o. Abb.)
Mod. after/nach Berthel Thorvaldsen. – H. with pedestal / mit Sockel 13.5 cm (5 5/16 in.); H. of figure / der Figur 7 cm (2 3/4 in.).
Lamprecht 125.

990 Paperweight / Briefbeschwerer
(no. Fig./o. Abb.)
Statuette of the Horse Tamer / Statuette des Rossebändigers.
Mod. after/nach Christian Friedrich Tieck. – 10 x 12.5 x 5 cm (3 15/16 x 4 15/16 x 1 15/16 in.). – Sign. crossed hammer and gad / Schlägel und Eisen.
Lamprecht 174.
Lit.: Bartel 2004, 105, no. 165. – Bartel and Bossmann, 99, fig./Abb. 121. – Schuette, 281.
Miniature reproduction of the group on the Old Museum in Berlin. / Verkleinerung der Gruppe auf dem Alten Museum in Berlin.

991 Fragment of a Meteor that Dropped near Halle / Fragment eines Meteors, der bei Halle gefunden wurde
(no. Fig./o. Abb.)
7 x 4 cm (2 3/4 x 1 9/16 in.).
Lamprecht 267.

992 Bowl Commemorating the Victories of the Franco-Prussian War of 1870/71 / Schale auf die Siege während des Deutsch-Französischen Kriegs von 1870/71
(no. Fig./o. Abb.)
H. 1 cm (3/8 in.).
Lamprecht 271.
In the center a medallion with the image of Germania with a wreath and an eagle with palm branch, on a high base. / In der Mitte ein Medaillon mit Darstellung der Germania mit Kranz und Adler mit Palmenzweig, auf hohem Sockel.

993 Holder for a Ball of Twine / Behälter für ein Garnknäuel
(no. Fig./o. Abb.)
H. 19 cm (7 1/2 in.); D. 11 cm (4 5/16 in.).
Lamprecht 933.
Of two hemispherical, pierced bowls on a round base. / Zwei halbkugelförmige, durchbrochene Gebilde auf rundem Sockel.

994 Bottle Cork Press / Flaschenkorkpresse
(no. Fig./o. Abb.)
29 x 11 cm (3 9/16 x 4 5/16 in.).
Lamprecht 934.
In the shape of a dragon, with a screw mechanism to attach to a table. / In Form eines Drachens, der an einem Tisch befestigt werden kann

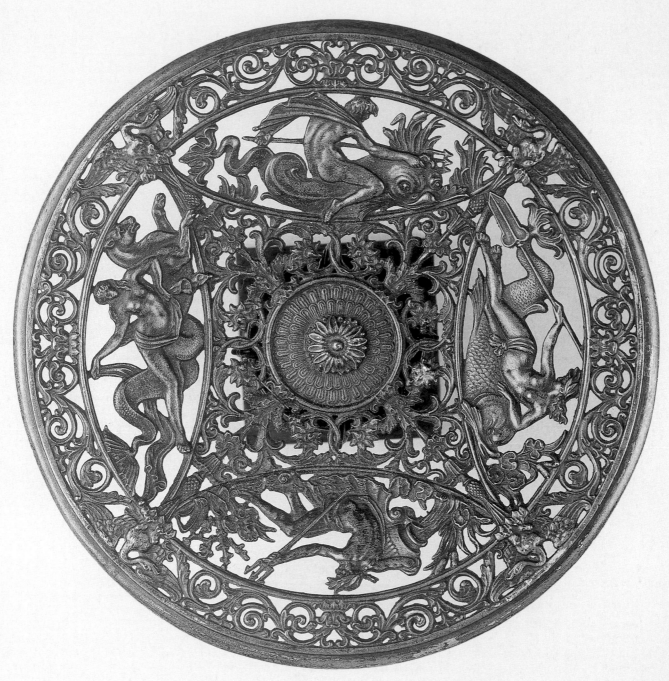

Cat. 835

APPENDIX / ANHANG

General Abbreviations / Allgemeine Abkürzungen

ACIPCO	American Cast Iron Pipe Company
A.D.	Anno Domini
B.C.	before Christ
Bd., Bde.	Band, Bände
betr.	betreffend / regarding
bez.	bezeichnet
Bh.	Bust height / Büstenhöhe
Bl.	Blatt
BMA	Birmingham Museum of Art, Birmingham, Alabama, USA
ca.	circa
Cat.	Catalogue, Catalogue number / Katalog, Katalognummer
cm	centimeter / Zentimeter
Co, Co.	company
cp.	compare
D.	diameter / Durchmesser
d. Ä.	der Ältere
dat.	dated, datiert
d. J.	der Jüngere
Dr.	Doktor
ed., eds.	edited, editor(s)
e. g.	exempli gratia (zum Beispiel)
et al.	et alii
e. V.	eingetragener Verein
F.	foundry
f.	following / und folgende
G.	Gießerei
g	gram / Gramm
geb.	geboren
gest.	gestorben / gestochen
gez.	gezeichnet
H.	height / Höhe
Hl.	Heilige(r)
in.	inch
Inc.	incorporated
Ins.	inscription / Inschrift
Inv.	Inventory, Inventory (accession) number / Inventar, Inventarnummer
Jg.	Jahrgang
Jh.	Jahrhundert
Jr.	junior / Junior
Kgl.	Königlich

KPEG	Königliche Preußische Eisen-Gießerei
KPM	Königliche Porzellan-Manufaktur Berlin
L.	Length / Länge
l.	left / links
Lit.	literature / Literatur
Ltd.	limited
Mod.	model, modeled by / Modell, modelliert von
n.d.	no date / ohne Datum
N. F.	Neue Folge
no.	number / Nummer
n. p.	no publisher, no publication place / kein Verlag, kein Publikationsort
n. pag.	no page number / ohne Seitennumerierung
Nr.	Nummer
o.	ohne
Obv.	obverse
o. g.	oben genannt
o. J.	ohne Jahresangabe
p.	page
P.-C.	Preis Courant
pcs.	pieces
Photo	photograph / Photographie
pl.	plate
PPM	Plaue Porzellan-Manufaktur
pt.	part / Teil
r.	right / rechts
Rs.	Rückseite
Rev.	reverse
S.	Seite
s.	see / siehe
SächsStAL	Sächsisches Staatsarchiv Leipzig
sign.	signed / signiert
SMB	Staatliche Museen zu Berlin
SSB	Stiftung Stadtmuseum Berlin
Sr.	senior / Senior
St.	Saint / Sankt
T.	Teile
Tab.	Tabula (pl. / Taf.)
Taf.	Tafel
v.	von
v. Chr.	vor Christus
VEB	Volkseigener Betrieb
verh.	verheiratet
vgl.	vergleiche
vol(s).	volume(s)
Vs.	Vorderseite

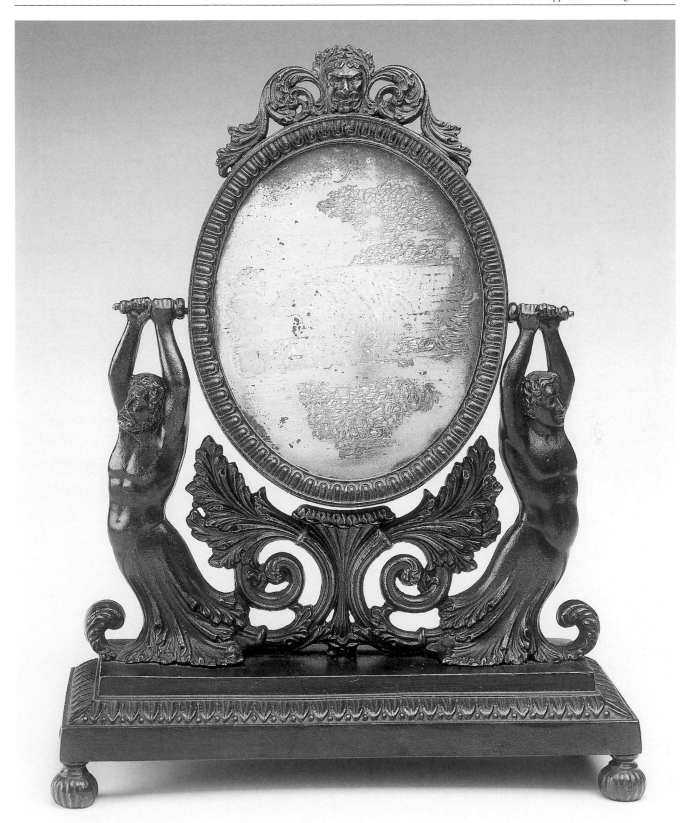

Mirror / Kippspiegel (Cat. 731)

Cast-Iron Foundries and their Abbreviations / Eisengießereien und ihre Abkürzungen

The year in parentheses after each foundry name indicates in general only the year in which the name was assumed, if known, not the foundry's year(s) of operation. For German foundries, the name of the current federal state is indicated after the city in which the foundry was located. / Eine Jahreszahl in Klammern nach einem Firmennamen bezeichnet im allgemeinen nur das Jahr, aus dem er übernommen werden konnte, nicht dessen Laufzeit. Nach den Orten der Bundesrepublik Deutschland sind die Namen der heutigen Bundesländer genannt.

ACIPCO
– *„American Cast Iron Pipe Company"* (1905), Birmingham, Alabama, USA.

Alexanderhütte
– Huta Aleksandra Białogenie, Poland/ Polen.

Berggießhübel
– Eisenwerk Berggießhübel bei Dresden, Berggießhübel, Land Sachsen.

Blansko
– Eisenwerk Blansko (Hugo Franz Altgraf zu Salm-Reifferscheidt; 1822), Blansko bei Brünn (Brno), Austria / Österreich (today Czech Republic / heute Tschechien).
– *„Fürstlich Salm'sche Blansker Eisenfabrik"* (um 1852).
– Fürstlich Salmsches Eisenwerk, Blansko.
– *„Eisenwerke Blansko"* (1919).

Bodenwöhr
– *„Königlich Bayerisches Eisenhüttenwerk Bodenwöhr"* (1910), Bodenwöhr bei Neunburg, Land Bayern.

Buchbergsthal
– Eisenwerk Buchbergsthal (Mid-19th century / Mitte 19. Jahrhundert), Buchbergsthal, Kreis Troppau (Opava), Austria / Österreich (today Czech Republic / heute Tschechien).

Buderus
– *„J. W. Buderus Söhne"* (1812), Hirzenhain, Land Hessen.
– *„Buderus'sche Eisenwerke"* (1817).
– *„Buderus Aktiengesellschaft, Buderus-Kunstguß"* (1950).

Carlshütte
– *„Carls-Hütte bei Rendsburg, Hartwig Holler"* (1827), Büdelsdorf bei Rendsburg, Land Schleswig-Holstein.
– *„Carls-Hütte bei Rendsburg, Hartwig Holler & Co"* (1839).
– *„Actiengesellschaft der Holler'schen Carlshütte bei Rendsburg"* (1869).
– *„Ahlmann-Carlshütte K. G."* (1941).

Clausthal
– Eisengießerei, Clausthal (Clausthal-Zellerfeld), Harz, Land Niedersachsen.

Devaranne
– Siméon Pierre Devaranne, Juwelier und Eisengießer (1828), Berlin.

Eisenberg
– Eisenhüttenwerk Eisenberg, Eisenberg, Land Rheinland-Pfalz.

Finspong
– Eisenwerk Finspong, Finspong, Sweden/Schweden.

Johann Conrad Geiss
– Johann Conrad Geiss (Geiß), *„Goldarbeiter, Juwelier und Eisengießer"* (1804), Berlin.

Gladenbeck
– Bronzegießerei Hermann Gladenbeck (1851), Berlin.
– *„Aktien-Gesellschaft vormals H. Gladenbeck & Sohn, Bildgiesserei"* (1904), Berlin.

Glanz
– Bronze- und Eisengießerei Josef Glanz (1831), Vienna/Wien, Austria/Österreich.

Halbergerhütte
– Halberger Hütte (Mid-19th century / Mitte 19. Jahrhundert), Brebach-Fechtingen bei Saarbrücken, Land Saarland.
– *„Rud. Böcking & Cie. Erben Stumm-Halbach & Rud. Böcking G.m.b.H., Halberger Hütte"* (1910).

Hamilton, Ohio
– *„Hamilton Foundry and Machine Company"* (1891), Hamilton, Ohio, USA.

Gustav Harkort, Leipzig
– Maschinenwerkstatt und Eisengießerei Gustav Harkort, Leipzig, Land Sachsen.

„Herron Stove and Manufacturing Company", Chattanooga, Tennessee, USA.

Horowitz
– Eisenwerk Horowitz (Rudolf Graf Wrbna), Horowitz (Horovice), Austria/ Österreich (today Czech Republic/ heute Tschechien), in addition/dazu die Gießerei Schichtamt Komorau (Komárov).

Ilsenburg
– *„Gräflich Stolberg-Wernigerödische Factorei zu Ilsenburg am Harz"* (um 1875), Ilsenburg, Land Sachsen-Anhalt.
– *„Fürstl. Stolberg'sches Hüttenamt, Abteilung Kunstgießerei, Ilsenburg am Harz"* (1909).

Fig./Abb. 50 Title page / Titelseite „PREIS-COURANT von gegossenen eisernen Küchengeschirren etc. etc. der Königl: Eisengiesserei bei Gleiwitz. Gültig pro 1859"; in Preis-Courant Gleiwitz 2005, 89 (detail).

Fig./Abb. 51 Sayner Hütte from the West / von Westen, lithograph by / Lithographie von Georg Osterwald after a drawing by / nach einer Zeichnung von Hans Osterwald, 1830/31; Bendorf, Rheinisches Eisenkunstguss-Museum, Inv. 4.535.

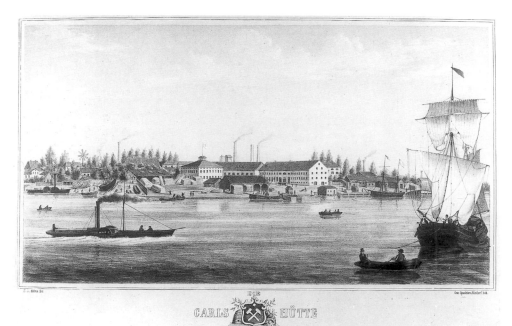

Fig./Abb. 52 View of the salesroom at the KPEG Berlin, bronze model (reversed image) for an iron plaque / Blick in das Verkaufsmagazin der KPEG Berlin, Bronzemodell (seitenverkehrt) der Eisenplakette, ca. 1820; Berlin, SSB, Inv. II 60/218 a; in Bartel 2004, 32, 123, Cat. 432.

Fig./Abb. 53 View of the / Ansicht der Carlshütte bei Rendsburg, 1858; lithograph/Lithographie, sign. „E. J. Helms fec." and/und „Otto Speckter u. Niedorf lith."; Büdelsdorf, Eisenkunstgussmuseum.

– „*Eisenmanufaktur Fürst Stolberg Hütte GmbH*" (2007).

Kasli
– Eisengießerei Kasli-Werk im Kyschtymer Kreis, Russia/Rußland (1896).

Königshütte (Harz)
– „*Königl. Hannoversches Eisenwerk Königshütte*", Bad Lauterberg am Harz, Land Niedersachsen.
– „*Königlich Preußische Eisenwerke zu Königshütte bei Lauterberg*" (um 1870).
– „*Königshütte GmbH*" (1919).
– „*Königshütte Wilh. Rudolf KG*" (1935).

KPEG
– Königlich Preußische Eisen-Gießereien (Gleiwitz, Berlin or Sayn, if no specific attribution is possible / Gleiwitz, Berlin oder Sayn, wenn keine genauere Zuweisung möglich ist).

KPEG Berlin
– „*Königliche Eisengiesserei zu Berlin*" (1815), Berlin.

KPEG Gleiwitz
– „*Königliche Eisengiesserei bei Gleiwitz*" (1847), Gleiwitz (Gliwice), Oberschlesien (today Poland / heute Polen).
– „*Königliches Hüttenamt Gleiwitz O/S.*" (1911).
– „*Preußische Bergwerks- und Hütten-Akt.-Ges., Betriebsstelle Kunstgießerei Gleiwitz*" (1938).

KPEG Sayn
– „*Königliche Eisengiesserey zu Saynerhütte*" (1823), Bendorf-Sayn, bei Koblenz, Land Rheinland-Pfalz.
– „*Königlich-Preussische Eisenhütte zu Sayn bei Ehrenbreitstein*" (um 1835).
– „*Fried. Krupp Akt.-Ges., Saynerhütte bei Sayn*" (1910).

Lauchhammer
– „*Gräflich Einsiedelsches Eisenwerk Lauchhammer*" (1825), Preußen, Provinz Sachsen, heute Land Brandenburg.
– „*Gewerkschaft der Gräflich von Einsiedelschen Eisenhütten*" (1840).
– Aktiengesellschaft „*Lauchhammer vorm. Gräflich Einsiedelsche Werke*" (1872).
– „*Linke-Hofmann-Lauchhammer A.G.*" (1925).
– „*Kunstgießerei Lauchhammer GmbH & Co. KG*" (2000).

Mägdesprung
– „*Herzogliche Eisenhütte Mägdesprung*" (1850), Mägdesprung, Orts-

teil von Harzgerode, Land Sachsen-Anhalt.
– „*Mägdesprunger Eisenhüttenwerk A. G. vorm. T. Wenzel*" (1898).
– „*Mägdesprunger Eisenhüttenwerk GmbH*" (1917).

Mariazell
– „*Kaiserliches königliches Eisengußwerk nächst Maria Zell, in Steyermark*" (1820), Austria/Österreich.

Meves
– „*Kunst-Eisen- und Zink-Giesserei von Albert Meves [Mewes] in Berlin*" (ca. 1850-60), Berlin.
- „*Dr. Otto Marckwald & Albert Hankel, (Albert Meves Nachfolger) Berlin, Chausseestr. 86*" (1867).

Neusalz a. O.
– „*Eisen- und Emailierwerk Wilh. von Krause Neusalz a. O.*" (1920), Neusalz an der Oder, Schlesien (today Poland / heute Polen).

Seebass
– „*Fabrik feiner Eisenguß- und Bronze-Waaren Alfred Richard Seebass [Seebas]*" (1829-40), Berlin.
– „*Gießerei von Alfred Richard Seebass & Co.*" (1840-46), Hanau, Land Hessen.
– „*Eisengießerei und Fabrik bronzierter Eisenguss-Waaren von Alfred Richard Seebass & Co. in Offenbach a/M.*" (1846-1904), Offenbach am Main, Land Hessen.

Surface Combustion Corporation (1915), Maumee, Ohio, USA.

Vombach
– Gießerei F. L. Vombach, Frankfurt am Main, Land Hessen.

Wasseralfingen
– „*Königl: Würtemberg: Eisengiesserey Wasseralfingen*" (1811-1921), Aalen-Wasseralfingen, Land Baden-Württemberg.
– „*Schwäbische Hüttenwerke Wasseralfingen G.m.b.H.*" (1921).

W. & R. P. Resor (1819), Cincinnati, Ohio, USA.

Zimmermann
– „*Fabrik für feinen Eisenguß und eiserne Kunstsachen E*[rnst]. *G*[eorg]. *Zimmermann*" (1840), Hanau, Land Hessen.
– „*E. G. Zimmermann in Hanau, Fabrik feiner Eisenguss- und Bronze-Waaren, Kunst- & Gebrauchs-Gegenstände, Marmorschleiferei, Galvanoplastische Anstalt*" (1874).

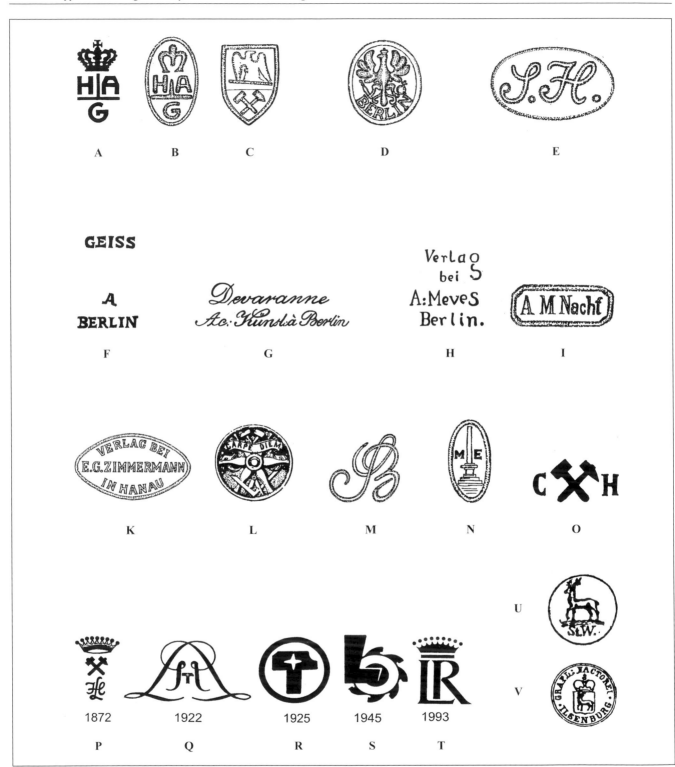

Fig./Abb. 54 Foundry Marks / Marken von Eisengießereien
A-C Hüttenamt Gleiwitz (20th century/20. Jh.)
D KPEG Berlin (?)
E KPEG Sayn
F Geiss, Berlin
G Devaranne, Berlin
H-I Meves, Berlin

K-L Zimmermann, Hanau (L in W. Neuwirth, *Markenlexikon für Kunstgewerbe I*, Vienna/Wien 1978, no. 418)
M J. W. Buderus Söhne
N Mägdesprung
O Carlshütte bei Rendsburg (used since 1834/seit 1834 in Gebrauch)
P-T Lauchhammer (in *275 Jahre Eisenguss in Lauchhammer*, Lauchhammer 2000).
U-V Ilsenburg (in Neuwirth, like no./wie L, no. 146, 420).

Literature / Literatur

Abbildung der Eisernen Waaren welche auf Malapane, Gleiwitz und Creutzburg in Schlesien gegossen werden. 2nd vol. Leipzig. Baumgärtnerische Buchhandlung, n. d. [Lamprecht Library B.26.].

Abbildung der Eisernen Waaren welche auf Malapane, Gleiwitz und Creutzburg in Schlesien gegossen werden. 3rd vol. Leipzig: Baumgärtnerische Buchhandlung, n. d. [Lamprecht Library B.27.].

Abbildung von Gusswaaren der Königl. Würtemb. Eisengiesserey Wasseralfingen. Wasseralfingen, 1850. [Lamprecht Library B.39.].

ACIPCO 1941a – *The Lamprecht Collection of Cast Iron Art*. Birmingham: American Cast Iron Pipe Company, 1941.

ACIPCO 1941b – *The Lamprecht Collection of Cast Iron Art* (expanded version). Birmingham: American Cast Iron Pipe Company, 1941.

"Acipco's Lamprecht Collection of Cast Iron Art Displayed at Museum," in *ACIPCO News*, vol. 68, no. 9 (October 1983), 10 f.

"Alter Kunst-Eisenguß," in *Das Illustrierte Blatt 8* (February 18, 1917), 10. [Lamprecht Library, no number / ohne Nr.].

Ames – Alex Ames. *Collecting Cast Iron*. Ashbourne: Moorland Publishing, 1980.

Andrews – Gail C. Andrews. "Prussian artistic cast iron," in *The Magazine Antiques* (February 1983), 422-27.

Arenhövel 1982 – Willmuth Arenhövel et al. *Eisen statt Gold. Preußischer Eisenkunstguß aus dem Schloß Charlottenburg, dem Berlin Museum und anderen Sammlungen*. Berlin: Verlag Willmuth Arenhövel, 1982.

Arenhövel, Willmuth. "Der Berliner Eisenguß," in Grzimek 1982, 150-94.

Arenhövel, Willmuth. "Eisenguss am Beispiel einer norddeutschen Hütte," in *Die nützlichen Künste. Gestaltende Technik und Bildende Kunst seit der Industriellen Revolution*, ed. by Tilmann Buddensieg and Henning Rogge. Berlin: Quadriga Verlag, 1981, 251-62.

Arenhövel, Willmuth. "Manufaktur und Kunsthandwerk im 19. Jahrhundert," in Berlin und die Antike, 209-50.

Arenhövel, Willmuth. "Preußischer Eisenkunstguß," in *Weltkunst 52* (November 15, 1982), 3292-95.

Art Castings from the VEB Schwermaschinenbau Lauchhammerwerk. Lauchhammer: VEB Schwermaschinenbau, n. d.

"Art in Cast Iron, Southwest Museum", in *Los Angeles Times* (January 24, 1926), C35.

Auktion Künker – Auktion Fritz Rudolf Künker Münzhandlung. *Medaillenkunst aus 6 Jahrhunderten*. Katalog zur 36. Auktion 12. März 1997 (Osnabrück).

Aus einem Guß – Jörg Schmalfuß et al. *Aus einem Guß. Eisenguß in Kunst und Technik (Berliner Beiträge zur Technikgeschichte und Industriekultur. Schriftenreihe des Museums für Verkehr und Technik Berlin 9)*. Berlin: Nicolaische Verlagsbuchhandlung, 1988.

Bahrfeldt – Emil Bahrfeldt. *Die Münzen- und Medaillen-Sammlung in der Marienburg*. 7 vols. Danzig and Königsberg (1901-29).

Bange 1922 – E. F. Bange. *Beschreibung der Bildwerke der christlichen Epochen*, vol. 2 *Die italienischen Bronzen der Renaissance und des Barock*, pt. 2: *Reliefs und Plaketten*. Berlin and Leipzig: Walter de Gruyter & Co., 1922.

Bartel 2004 – Elisabeth Bartel et al. *Die Königliche Eisen-Giesserei zu Berlin 1804-1874*. Berlin: Stiftung Stadtmuseum Berlin/Verlag Willmuth Arenhövel, 2004.

Bartel, Elisabeth. "Berliner Eisen – Ein einmaliges Sujet der Kunstgeschichte und ein Kapitel Berliner Kulturgeschichte," in *DG Verein Deutscher Giessereifachleute e. V. (ed.). Giessereihistorisches Kolloquium. VDG-Fachtagung 15. und 16. Juni 2005*. Düsseldorf: VDG, 2005, 109-19.

Bartel and Bossmann – Elisabeth Bartel and Annette Bossmann, eds. *Eiserne Zeiten. Ein Kapitel Berliner Industriegeschichte*. Berlin: Stiftung Stadtmuseum Berlin/Verlag Willmuth Arenhövel, 2007.

Bauhoff – Günther Bauhoff. "Die Ofenplattensammlung des Vereins deutscher Eisenhüttenleute," in Festschrift Kippenberger 1, 358-67.

Baumann, Carl-Friedrich et al. *Eisenhütten in Bendorf (Schriften des Stadtmuseums Bendorf 1)*. Bendorf: Stadtverwaltung Bendorf/Stadtmuseum, 1990.

Bayerischer Kunstgewerbeverein in München. *Sonderausstellung Eisen. Alte und neue Eisenarbeiten*. Munich: Bayerischer Kunstgewerbeverein, 1916. [Lamprecht Library B.43.].

Becker, Vivienne. "Bracelets for Bullets," in *House & Garden*. 155, no. 6 (June 1983), 48 f.

Beierlein – J. P. Beierlein. *Die Medaillen und Münzen des Gesamthauses Wittelsbach*. Munich, 1901.

Beitz – Egid Beitz. "Urkundliches zu den frühen Neujahrsplaketten und anderen Eisenkunstgüssen der Sayner Hütte," in *Wallraf-Richartz-Jahrbuch 2* (1925), 88-104.

Bekker 1998 – Gerd Bekker. *Europäische Plaketten und Medaillen vom 15. bis zum 18. Jahrhundert. Bestands- und Verlustkatalog der Sammlung des Grassimuseums Leipzig*. Leipzig: Grassimuseum/Museum für Kunsthandwerk, 1998.

Bekker 2001 – Gerd Bekker. *Europäische Plaketten und Medaillen des 19. und 20. Jahrhunderts. Bestandskatalog der Sammlung des Grassimuseums Leipzig*. Leipzig: Grassimuseum/Museum für Kunsthandwerk, 2001.

Bericht der Königlichen Akademie für graphische Künste und Buchgewerbe zu Leipzig. Ostern 1902-04. Leipzig: J. J. Weber, 1904.

Bericht der Königlichen Akademie für graphische Künste und Buchgewerbe zu Leipzig. Ostern 1904-06. Leipzig, 1906.

Bericht der Königlichen Akademie für graphische Künste und Buchgewerbe zu Leipzig. Schuljahre 1906-08. Leipzig: Poeschel & Trepte, 1908.

Bericht der Königlichen Akademie für graphische Künste und Buchgewerbe zu Leipzig. Schuljahre 1908-10. Leipzig, 1910.

Bericht der Königlichen Akademie für graphische Künste und Buchgewerbe zu Leipzig. Schuljahre 1912 bis 1914. Leipzig, 1914.

Berlin und die Antike – *Berlin und die Antike. Architektur, Kunstgewerbe, Malerei, Skulptur, Theater und Wissenschaft vom 16. Jahrhundert bis heute*, Cat., ed. by Willmuth Arenhövel. Berlin: Deutsches Archäologisches Institut/Staatliche Museen Preußischer Kulturbesitz, 1979.

Bernhart, Max. *Medaillen aus den Befreiungskriegen* (source unknown; loose leaf pages / Quelle unbekannt, lose Blätter) [Lamprecht Library no number / ohne Nr.], 626-28.

Besprechungen der Sammlung Lamprecht (miscellaneous newspaper reviews of 1915 and 1916 Leipzig exhibitions / verschiedene Zeitungsartikel über die Ausstellungen 1915 und 1916 in Leipzig) [Lamprecht Library B.45.].

Bethmann Hollweg and Westphal – Asta von Bethmann Hollweg and Volker Westphal. *Beispiele Berliner Plastik aus 200 Jahren. 35 Jahre Kunsthandel in Berlin 1966-2001*. Berlin: Galerie Westphal, 2000.

Bimler 1913a – Kurt Bimler. "Deutsche Eisenplastik vor hundert Jahren," in *Die Plastik* 10 (1913), 84-88. [Lamprecht Library B.9.].

Bimler 1913b – Kurt Bimler. "Berliner Eisenplastik," in *Eisen-Zeitung* 34 (1913), 1010-12. [Lamprecht Library B.12.].

Bimler 1914a – Kurt Bimler. "Sayner (rheinische) Eisenplastik vor hundert Jahren," in *Eisen-Zeitung* 35 (1914), 113-15. [Lamprecht Library B.13.].

Bimler 1914b – Kurt Bimler. "Deutscher Eisenkunstguß," in *Kunst und Handwerk* 4 (1914), 92-98, 111-16. [Lamprecht Library B.10.].

Bimler 1914c – Kurt Bimler. *Modelleure und Plastik der Königlichen Eisengießerei bei Gleiwitz* (Sonderabdruck aus der Monatsschrift *Oberschlesien*). Kattowitz: Verlag Gebrüder Böhm, 1914. [Lamprecht Library B.14.].

Bimler, Kurt. *August Kiß: ein Bildhauer aus Oberschlesien*. Kattowitz: Verlag Gebrüder Böhm, 1915.

Blansko 1919 – Eisenwerke Blansko (photocopied pages from company's illustrated sales catalogue / Seitenkopien aus einem illustrierten Verkaufskatalog), n. d. [ca. 1919].

Bloch 1990 – Peter Bloch. *Bildwerke 1780-1910 aus den Beständen der Skulpturengalerie und der Nationalgalerie (Die Bildwerke der Skulpturengalerie Berlin 3)*. Berlin: Staatliche Museen Preußischer Kulturbesitz/Gebr. Mann Verlag, 1990.

Bloch and Grzimek – Peter Bloch and Waldemar Grzimek. *Das klassische Berlin. Die Berliner Bildhauerschule im neunzehnten Jahrhundert*. Berlin: Propyläen Verlag, 1978.

Blum – Jürgen Blum, Wolf-Dieter Müller-Jahncke and Stefen Rhein. *Melanchthon auf Medaillen 1525-1997*. Ubstadt-Weiher: verlag regionalkultur, 1997.

Boeckmann, Henriette. "City Gets Rare Art Collection," in *Los Angeles Times* (May 11, 1924), A5.

Bolzenthal – Heinrich Bolzenthal. *Skizzen zur Kunstgeschichte der modernen Medaillen-Arbeit (1429-1840)*. Berlin, 1840.

Book of Wedgwood – *The Book of Wedgwood Bas-reliefs*. Barlaston: Josiah Wedgwood & Sons (n. d.).

Börsch-Supan – Helmut Börsch-Supan, ed. *Die Kataloge der Berliner Akademie Ausstellungen 1786-1850 (Quellen und Schriften zur bildenden Kunst*, ed. by Otto Lehmann-Brockhaus and Stephan Waetzoldt). 3 vols. Berlin: Bruno Hessling Verlag, 1971.

Bott and Spielmann – Gerhard Bott and Heinz Spielmann, eds. *Künstlerleben in Rom. Berthel Thorvaldsen (1770-1844). Der dänische Bildhauer und seine deutschen Freunde*. Nuremberg: Germanisches Nationalmuseum, 1992.

Brachert, Thomas. *Der schwäbische Eisenkunstguß. Öfen und Ofenplatten*. Marburg: N. G. Elwert Verlag, 1958.

Bramsen – L. Bramsen. *Médaillier Napoléon Le Grand 1799-1809*. Hamburg: Verlag der Münzhandlung Peter Siemer, 1977 (reprint; original Paris and Copenhagen 1904-13).

Bredt, F. W. "Eisenguß im Rheingebiet und in der Literatur," in *Mitteilungen des rheinischen Vereins für Denkmalpflege und Heimatschutz* 11 (1917), 86-94.

Brehm 2003 – Knut Brehm, Bernd Ernsting, Wolfgang Gottschalk und Jörg Kuhn. *Stiftung Stadtmuseum Berlin. Katalog der Bildwerke 1780-1920*. Mit einer Einführung von Jörg Kuhn (*LETTER Schriften* 14). Cologne: LETTER Stiftung, 2003.

Brockmann – Günther Brockmann. *Die Medaillen der Welfen*. Vol. 1 *Linie Wolfenbüttel*. Vol. 2 *Linie Lüneburg/Hannover*. Cologne: Verlag Dr. G. Brockmann, 1985-87.

Buderus Kunstguß 1997 – *Buderus-Kunstguß in Eisen, Bronze und Aluminium. Gesamtprogramm.* Hirzenhain: Buderus Guss GmbH Kunstgiesserei, 1997.

Călian – Livia Călian and Maria Magdalena Jude. *Catalogul Medaliilor Napoleoniene/Napoleonic Medals Catalogue.* Cluj-Napoca: Muzeul National de Istorie al Transilvaniei, 1995.

Carney 2008 – Margaret Carney. *Lithophanes.* Atglen, PA: Schiffer Publishing Ltd, 2008.

"Cast Iron Art Display Shown at Park Museum," in *Los Angeles Times* (July 2, 1926), A5.

Cat. Berlin 1916 – *Gußeisen. Sonderausstellung von Kunstgüssen deutscher Eisenhütten bis zur Gegenwart, insbesondere der Kgl. Eisengießerei in Berlin.* Berlin: Königliches Kunstgewerbemuseum, 1916. [Lamprecht Library B.42.].

Cat. Blansko – Illustrated catalogue from the / Illustrierter Verkaufskatalog der *„Fürstlich Salm'schen Blansker Eisenfabrik. Niederlage in Wien"*, n. d. (after / nach 1852).

Cat. Gliwice 1988 – Włodzimierz Błaszczyk, ed. *Der Eisenkunstguss aus Gliwice – Tradition und Gegenwart.* Gliwice and Dessau: Museum Gliwice/Staatliches Museum Schloß Mosigkau, 1988.

Cat. Köln 1979 – *Geschenke von Freunden. Fünf Rheinische Sammlungen.* Cologne: Museen der Stadt Köln, Kunstgewerbemuseum, 1979.

Cat. Leipzig 1915 – *Ausstellung Deutscher Kunst des XIX. Jahrhunderts aus Privatbesitz.* N.F. 2nd revised ed. Leipzig: Leipziger Kunstverein, November-December 1915. [Lamprecht Library B.41.].

Cat. Leipzig 1916 – *Kriegergrabmal. Kriegerdenkmal.* Ausstellung im Städtischen Kaufhaus zu Leipzig. Leipzig: Städtisches Kunstgewerbe-Museum, 1916. [Lamprecht Library B.46.].

Cat. Leningrad 1976 – *Berliner Eisenkunstguß der ersten Hälfte des 19. Jahrhunderts aus dem Kunstgewerbemuseum der Staatlichen Museen zu Berlin* (in russ.), Leningrad, 1976.

Cat. Meves – *Preiss-Liste der gezeichneten Gegenstände der Kunst-Eisen- und Zink-Giesserei von Albert Meves in Berlin, Chausseé-Strasse No. 86* (Berlin, ca. 1850-60).

Cat. Paris 1978 – *Catalogue Général Illustré des Éditions de la Monnaie de Paris,* vol. 2: *de la 1ère à la 3e République.* Paris, 1978.

Cat. Rheinromantik 2001 – Cat. *Preußische Facetten: Rheinromantik und Antike. Zeugnisse des Wirkens Friedrich Wilhelms IV. an Mittelrhein und Mosel,* Wolfgang Brönner et al., ed. Landesamt für Denkmalpflege Rheinland-Pfalz. Regensburg: Schnell + Steiner, 2001.

Cat. Thorvaldsen 1977 – Cat. *Bertel Thorvaldsen. Skulpturen. Modelle. Bozzetti. Handzeichnungen. Gemälde aus Thorvaldsens Sammlungen.* Cologne: Museen der Stadt Köln, 1977.

Chaplin, Lois Trigg. *ACIPCO. American Cast Iron Pipe Company. The Golden Rule at Work since 1905.* Birmingham: American Cast Iron Pipe Company, 2005.

Clifford – Anne Clifford. *Cut-Steel and Berlin Iron Jewellery.* New York: A. S. Barnes and Company, 1971.

Collignon 1984 – Jean-Pierre Collignon. *Medailles Politiques et Satiriques, Decorations et Insignes de la 2e Republique Française 1848-1852.* Paris, 1984.

Collignon 1989 – Jean-Pierre Collignon. *La Medaille Française au XIXe Siècle et l'Histoire.* Charleville-Mézières: Musées de Charleville-Mézières, 1989.

The Crystal Palace Exhibition – Illustrated Catalogue, London 1951 (Reprint of *The Art Journal,* London 1851). New York: Dover Publications, 1970.

Custodis, Paul-Georg. *Die Sayner Hütte in Bendorf* (*Rheinische Kunststätten* 241; ed. by Rheinischer Verein für Denkmalpflege und Landschaftsschutz). Neuss: Gesellschaft für Buchdruckerei, 1980.

Custodis, Paul-Georg. *Die Sayner Hütte in Bendorf.* Cologne: Rheinischer Verein für Denkmalpflege und Landschaftsschutz, 1986.

D'Allemagne, Henry René. *Decorative Antique Ironwork. A Pictorial Treasury* (Dover Reprint of *Musée Le Secq des Tournelles à Rouen: Ferronnerie ancienne* originally published by J. Schmit, Paris, in 1924). New York: Dover Publications, 1968.

"Das Eisen," in *Was man wissen muß* 22 (1921). [Lamprecht Library B.1.].

Dębowska 2000 – Elżbieta Dębowska. *Dziewietnastowieczna biżuteria zeliwna.* Gliwice (Gleiwitz): Muzeum w Gliwicach, 2000.

Dębowska 2006 – Elżbieta Dębowska, Elisabeth Bartel and Barbara Friedhofen. *Europäischer Eisenkunstguss. Die Königlich-Preußischen Eisengießereien Gliwice Berlin Sayn,* ed. by Rheinisches Eisenkunstguss-Museum, Sayn. Coblenz: Görres Verlag, 2006.

Degen 1970 – Kurt Degen. "Skulpturen aus Eisen – Betrachtungen zum Eisenkunstguß in Lauchhammer," in Festschrift Kippenberger 1, 245-88.

Deutsches Museum. Führer durch die Sammlungen. Leipzig: Verlag von B. G. Teubner, 1907 [Lamprecht Library B.3.].

Domanig 1896 – Karl Domanig. *Porträtmedaillen des Erzhauses Österreich von Kaiser Friedrich III bis Kaiser Franz II.* Wien: Verlag Gilhofer und Rauschburg, 1896.

Domanig 1907 – Karl Domanig. *Die deutsche Medaille in kunst- und kulturhistorischer Hinsicht.* Wien: Verlag Anton Schroll & Co., 1907.

Dressler, Willy Oskar. *Dresslers Kunstjahrbuch.* Rostock: Verlag von Dresslers Kunstjahrbuch, 1913.

Dudda, Johannes. *Friedrich Schiller auf Münzen und Medaillen.* Weimar: Nationale Forschungs- und Gedenkstätten der Klassischen Deutschen Literatur in Weimar, n. d. [2004].

Eberle – Martin Eberle. *Bestandskatalog der Sammlung unedler Metalle. Europäisches Kunsthandwerk aus Bronze, Messing, Kupfer und Eisen vom 12. bis zum 19. Jahrhundert.* Leipzig: Grassimuseum/Museum für Kunsthandwerk, 1996.

Eckardt – Götz Eckardt. *Johann Gottfried Schadow 1764-1850. Der Bildhauer.* Leipzig: E. A. Seemann Verlag, 1990.

Eggers – Friedrich and Karl Eggers. *Christian Daniel Rauch.* 5 vols. Berlin, 1873-91.

Eigler 2003 – F. W. Eigler. "Danneckers Schiller-Büste als zeitgenössischer Eisenguß aus Wasseralfingen," in *Weltkunst* 73, no. 5 (May 2003), 708-10.

Eigler 2004 – F. W. Eigler. *Eisenkunstguss in Wasseralfingen unter besonderer Berücksichtigung der klassizistischen Periode.* Oberhausen: Verlag Karl Maria Laufen, 2004.

Eigler 2006 – F. W. Eigler. *Eiserne Porträts. Büsten, Statuetten, Plaketten, Medaillen aus zwei Jahrhunderten 1800-2000.* Sonderdruck aus *konstruieren + giessen* 31, no. 1-4 (2006).

Eimer – Christopher Eimer. *Medallic Portraits of the Duke of Wellington.* London: Spink & Son, 1994.

"Eine unbekannte Goethe-Statuette von Rauch," in *Illustrirte Zeitung* (March 22, 1906), 451. [Lamprecht Library, no number/ohne Nr.].

Eisen-Recepte: Eisen-Rost-Schutzmittel usw. (miscellaneous loose leaf articles in folder / lose Blätter mit Artikeln in Mappe) [Lamprecht Library B.5.].

Eisen-Kunst-Guss. Sachsen und das alte Sachsen. Lauchhammer. (miscellaneous loose leaf articles in folder / lose Blätter mit Artikeln in Mappe) [Lamprecht Library B.17.].

Eisen-Kunst-Guss. Preussen. (miscellaneous loose leaf articles in folder / lose Blätter mit Artikeln in Mappe) [Lamprecht Library B.18.].

Eisen-Kunst-Guss. Harz. Thüringen. (miscellaneous loose leaf articles in folder / lose Blätter mit Artikeln in Mappe) [Lamprecht Library B.19.].

Eisen-Kunst-Guss. Württemberg (Wasseralfingen, Stuttgart). Bayern. (miscellaneous loose leaf articles in folder / lose Blätter mit Artikeln in Mappe) [Lamprecht Library B.20.].

Eisen-Kunst-Guss. Oesterreich (Steiermark, Tirol). Italien. (miscellaneous loose leaf articles in folder / lose Blätter mit Artikeln in Mappe) [Lamprecht Library B.21.].

Eisen-Kunst-Guss. Frankreich. England. Holland. (miscellaneous loose leaf articles in folder / lose Blätter mit Artikeln in Mappe) [Lamprecht Library B.22.].

Eisen-Kunst-Guss. Russland. Polen. (miscellaneous loose leaf articles in folder / lose Blätter mit Artikeln in Mappe) [Lamprecht Library B.23.].

Eisen-Kunst-Guss. Eiserne Ofen, Kamine & Kamin-Einsätze. Ofenplatten. Kamin-Platten. Heiz-Mäntel. Feuerhunde usw. (miscellaneous loose leaf articles in folder / lose Blätter mit Artikeln in Mappe) [Lamprecht Library B.24.].

Eiserne Brücken aus aller Welt (miscellaneous loose leaf articles in folder / lose Blätter mit Artikeln in Mappe) [Lamprecht Library B.25.].

Ernsting – Bernd Ernsting. *Ludwig Gies. Meister des Kleinreliefs.* (*LETTER Schriften* 3). Cologne: LETTER Stiftung, 1995.

Ferner and Genée – Helmut Ferner and Elfriede Genée. *Kleinkunst in Eisenguss.* Brünn: Petr Dvorák Verlag, 1992.

Ferrous Finery. An Exhibition Which Explores the Use of Iron and Steel for Body Adornment, Cat. Memphis, TN: The National Ornamental Metal Museum, 1983.

Festschrift Kippenberger – *Studien zum künstlerischen Eisenguß. Festschrift für Albrecht Kippenberger zum 19. Dezember 1970*, ed. by Gerhard Seib. 2 vols. Marburg: N. G. Elwert, 1970.

Flaxman – John Flaxman. *Mythologie und Industrie. Kunst um 1800.* Katalog der Ausstellung in der Hamburger Kunsthalle. Munich: Prestel Verlag, 1979.

Forrer – Leonhard Forrer. *Biographical Dictionary of Medallists, Coin-, Gem- and Seal-Engravers, Mint-Masters, etc., Ancient and Modern. With References to their Works, B.C. 500-A.D. 1900.* 8 vols. London: Spink & Son, 1902-30.

Forschler-Tarrasch – Anne Forschler-Tarrasch. *Leonhard Posch (1750-1831). Porträtmodelleur und Bildhauer mit einem Verzeichnis seiner Werke und deren Vervielfältigungen in Eisen- und Bronzeguß, Porzellan und Gips* (*Die Kunstmedaille in Deutschland* 15, ed. by Wolfgang Steguweit). Berlin: Deutsche Gesellschaft für Medaillenkunst e.V./Verlag Willmuth Arenhövel, 2002.

Forschler 1995 – Anne Forschler. "Glück Auf! Eiserne Neujahrskarten der preußischen Gießereien," in *Museumsjournal* 9, no. 1 (January 1995), 62 f.

Forschler-Tarrasch 2008 – Anne Forschler-Tarrasch, "A Preliminary Look at the Relationship between Wedgwood and the Royal Prussian Iron Foundries in Germany," in *Proceedings of the Fifty-First and Fifty-Second Wedgwood International Seminars*, ed. by Anne Forschler-Tarrasch. Birmingham: Wedgwood International Seminar, 2008, 65-74.

Forschler, Anne. *Cast-Iron New Year's Cards from Prussian Foundries.* University of California, Riverside (unpublished manuscript / unveröffentlichtes Manuskript), 1995.

Förschner 1982 – Giesela Förschner. *Goethe in der Medaillenkunst* (*Kleine Schriften des Historischen Museums Frankfurt/Main* 16). Frankfurt: Historisches Museum Frankfurt am Main, 1982.

Frede 1932 – Lothar Frede. "Die zeitgenössischen Goethe-Medaillen," in *Berliner Münzblätter* 52, no. 352 (March 1932), 445-53.

Frede 1958 – Lothar Frede. "Leonhard Posch. Ein Reliefbildner der Goethezeit," in *Zeitschrift für Kunstwissenschaft* 12, no. 3-4 (1958), 179 210.

Frede 1959 – Lothar Frede. *Das Klassische Weimar in Medaillen.* Weimar: Insel-Verlag, 1959.

Frede, Lothar. "Medaillen auf Schiller aus seiner Zeit," in *Blätter für Münzfreunde und Münzforschung* 79, no. 11/12 (November/December 1955), 365-71.

Friedhofen – Barbara Friedhofen et al. *Sayner Hütte. Architektur, Eisenguss, Arbeit und Leben*, ed. by Förderkreis Abtei Sayn. Koblenz: Görres Verlag, 2002.

Fuchs – Ulrike Fuchs. *Der Bildhauer Adolf Donndorf. Leben und Werk.* Stuttgart: Konrad Theiss Verlag, 1986.

Fuld – George Fuld. "The Washington before Boston Medal," in *Token and Medal Society Journal*, vol. 3 (1966), 111-27.

"Funeral Services for Max Koehler at Priester Home," in *The Davenport Democrat and Leader* (March 27, 1929), 21.

Furtwängler – Adolf Furtwängler. *Die antiken Gemmen. Geschichte der Steinschneidekunst im klassischen Altertum*, 3 vols. Berlin and Leipzig: Giesecke & Devrient, 1900.

Gayle, Margot, and Riva Peskoe. "Restoration of the Kreuzberg Monument: A Memorial to Prussian Soldiers," in *Association for Preservation Technology (APT) Bulletin* 27, no. 4 (1996), 43-45.

Genée 1992 – Elfriede Genée. "Der herbe Reiz – vom Eisenschmuck aus dem vorigen Jahrhundert," in *Parnass* 2 (May-June 1992), 86-92.

"General 'Ike' Likes Lamprecht Collection," in *ACIPCO News* (October 1952), 4.

Geschichte und Feyer des ersten Jahrhunderts des Eisenwerks Lauchhammer (reprint; original Dresden 1825). Lauchhammer: Kunstgußmuseum, 1996.

"Gipsabgüsse nach einem Modell der Igel-Säule," in *Beiblatt zur Zeitschrift für bildende Kunst* X, no. 13 (January 8, 1875), 203 f.

Glaeser, Edmund. "Von deutschem Eisenkunstguß aus alter und neuer Zeit," in *Die Gießerei* (1929), 443.

Gleiwitzer Kunstguss 1935 – *Gleiwitzer Kunstguss. Statuen, Kleinplastiken, Plaketten, kunstgewerbliche Gegenstände nach historischen und neuzeitlichen Modellen.* Preußische Bergwerks- und Hütten-Akt.-Ges., Abt. Betriebsstelle Kunstgiesserei Gleiwitz (including Nachtrag 1938). Gleiwitz: Preussag, 1935.

Gloag – John Gloag and Derek Bridgwater. *A History of Cast Iron in Architecture.* London: George Allen and Unwin, 1948.

Gottschalk – Jürgen Gottschalk et al. *Münzen und Medaillen aus den Sammlungen der Stiftung Stadtmuseum Berlin.* Berlin: Stiftung Stadtmuseum Berlin, 1997.

Grolich, Vratislav. *Blanenská Umělecká litina.* Katalog. Blansko: Okresní Muzeum Blansko, 1991.

Grund, Rainer. "Friedrich von Schiller auf Medaillen und Plaketten. Zu Neuerwerbungen des Münzkabinetts seit 1990," in *Dresdener Kunstblätter* 49 (May 2005), 289-97.

Grundmann, Günther. "Die Kunstgußabteilung der Paulinenhütte Neusalz/Oder," in Festschrift Kippenberger 1, 336.

Grzimek 1982 – *Berliner Kunst von 1770-1930. Studiensammlung Waldemar Grzimek.* Berlin: Berlin Museum, 1982.

Hanauer Eisen – Richard Schaffer-Hartmann and Peter Christian Reuel. *Hanauer Eisen. Eisenkunstguß von A. R. Seebaß und E. G. Zimmermann.* Hanau: Magistrat der Stadt Hanau, Kulturamt/Museenverwaltung, 1999.

Hartmann, Idis B. *Gold gab ich für Eisen. Der schlesische Eisenkunstguß im 19. Jahrhundert (Schriftenreihe der Stiftung Schlesien* 4). Hanover: Stiftung Schlesien, 1992.

Hellwag – Fritz Hellwag. "Wasseralfinger Eisengussreliefs," in *Kunstgewerbeblatt* N. F. 24 (1912), 1 f. [Lamprecht Library B.16.].

Heres, Gerald. "Zum Klassizismus der napoleonischen Medaillen," in *Wissenschaftliche Zeitschrift der Universität Rostock* 17 (1968), 661-66.

Hildebrand – Bror Emil Hildebrand. *Sveriges och Svenska Konungahusets Minnespenningar. Praktmyut och Belöningsmedaljer.* Stockholm, 1875.

Hillegeist – Hans-Heinrich Hillegeist. "Die staatliche Königshütte bei Lauterberg und ihr Kunstguß im 19. Jahrhundert," in Festschrift Kippenberger 1, 196-220.

Himmelheber – Georg Himmelheber. *Möbel aus Eisen. Geschichte, Formen, Techniken.* Munich: Verlag C. H. Beck, 1996.

Hintze 1928a – Erwin Hintze. *Gleiwitzer Eisenkunstguss* (Hg. mit Unterstützung der Generaldirektion der Preußischen Bergwerks- und Hütten-Aktiengesellschaft in Berlin). Breslau: Verlag des schlesischen Altertumsvereins, 1928.

Hintze 1928b – Erwin Hintze. "Berliner Privatunternehmer für Eisenkunstguss," in *Schlesiens Vorzeit in Bild und Schrift. Zeitschrift des schlesischen Altertumsvereins (Jahrbuch des Schlesischen Museums für Kunstgewerbe und Altertümer* 9). Breslau, 1928, 151-76.

Hintze 1931 – Erwin Hintze. "Zur Geschichte des Eisenkunstgusses im Bereiche der Tschechoslowakei," in *Festschrift zum 60. Ge-*

burtstage von E. W. Braun, ed. by K. Cernohorsky. Augsburg: Dr. Benno Filser Verlag, 1931, 202-39.

Historismus 1989 – *Historismus. Angewandte Kunst im 19. Jahrhundert.* Vol. 2 *Kunsthandwerk und Kunstgewerbe.* Beate Dry-v. Zezschwitz et al. Kassel: Staatliche Kunstsammlungen Kassel, 1989.

Hoffmann – Tassilo Hoffmann. *Jacob Abraham und Abraham Abramson. 55 Jahre Berliner Medaillenkunst 1755-1810.* Frankfurt am Main: F. Kauffmann Verlag, 1927.

Holst – Christian von Holst. *Johann Heinrich Dannecker. Der Bildhauer.* Stuttgart: Edition Cantz/Staatsgalerie Stuttgart, 1987.

Howard – Richard Howard. "The Lamprecht Collection Cast Iron Objects of Art," in *Bulletin of the Birmingham Art Association* 1, no. 2 (October 1951), 3-10.

H. v. Sp. 1917 – H. v. Sp. "Künstlerische Arbeiten in Eisen aus älterer Zeit," in *Velhagen & Klasings Monatshefte* 31 (May 1917), 298-301. [Lamprecht Library B.48.].

I. B., "Bildwerke in Eisen. Zur Gußeisenausstellung im Kgl. Kunstgewerbemuseum Berlin," in *Der Cicerone* 8 (1916), 478-83.

Ilsenburg a – *Preis-Verzeichnis der Kunstguss-Waaren der Gräflich Stolberg-Wernigerödischen Factorei zu Ilsenburg Am Harz.* Ilsenburg, n. d. [ca. 1875] (with two Supplements from ca. 1879 / mit zwei Nachträgen von ca. 1879).

Ilsenburg b – *Musterbuch der gräfl. Stolbergschen Factorei Ilsenburg.* (Volume with photographs affixed to 71 plates in the / Band mit aufgeklebten Photographien auf 71 Taf. in der Kunstbibliothek Berlin, Staatliche Museen zu Berlin PK) n. d. [ca. 1877].

Ilsenburg c – *Tafelwerk des Fürstlich Stolbergschen Hüttenamtes a. Harz.* n. d. (after 1914). 161 pl./Taf.

"Iron Art Purchase Sought," in *Los Angeles Times* (March 12, 1926), A6.

Jailer-Chamberlain – Mildred Jailer-Chamberlain. "American Iron. The Practical and the Decorative," in *Antique Review* 31, no. 5 (May 2005), A1 ff.

Janzig, Godehard. "'Das zarteste, reinste, keuscheste Metall schließt das kräftigste, männlichste, stärkste ein' – Karl Friedrich Schinkels Entwurf des Eisernen Kreuzes," in Schreiter and Pyritz, S. 151-69.

Jaschke and Maercker – Norbert Jaschke and Fritz P. Maercker. *Schlesische Münzen und Medaillen, Ergänzung und Weiterführung des Werkes von Ferdinand Friedensburg und Hans Seger: Schlesiens Münzen und Medaillen der neueren Zeit.* Ihringen: Verlag Fritz P. Maercker, 1985.

Johannsen, Otto. "Die Erfindung der Eisengußtechnik," in *Stahl und Eisen* 39 (November 27, 1919), 1457-66; 1625-29.

Kähler, Susanne ed. *„Kunstwerke aus Schmutz gefertigt." Karl Friedrich Schinkel und die Ästhetik des Eisens.* Lauchhammer: Kunstgussmuseum, 2006.

Kassel – Kassel, *Ofenplatten und Plattenofen im Elsaß.* Straßburg: Illustrierte Elsässische Rundschau, 1903.

Kieling, Uwe. "Siméon Pierre Devaranne. Biographische Notizen zum Berliner Eisenkunstgießer anläßlich seines 125. Todestages," in *Bildende Kunst,* no. 7 (1984), 326-28.

Kippenberg – *Katalog der Sammlung Kippenberg.* 3 vols. 2nd ed. Leipzig: Insel Verlag, 1928.

Kippenberger, Albrecht. *Der künstlerische Eisenguß.* Marburg: N. G. Elwert-Verlag, 1952.

Kirmis n. d. – M. Kirmis. "Die eisernen Neujahrskarten der Saynerhütte," in *Sammler-Daheim* 10 (date?), 26. [Lamprecht Library, no number/ohne Nr.].

Kirmis 1899 – M. Kirmis. "Die eisernen Neujahrskarten der Kgl. Eisengießerei zu Berlin," in *Sammler-Daheim* 47 (1899), 3 f. [Lamprecht Library, no number/ohne Nr.].

Kirmis 1912 – M. Kirmis. "Die Münzen und Medaillen Napoleon Bonapartes," in *Sammler-Daheim* 49 (1912), n. pag. [Lamprecht Library, no number/ohne Nr.].

Kirmis 1915/16 – M. Kirmis. "Eisernes Geld," in *Sammler-Daheim* 8 (1915/16), n. pag. [Lamprecht Library, no number/ohne Nr.].

Kirmis, M. "Eiserner Schmuck aus der Empirezeit," in *Sammler-Daheim* 15 (1910), n. pag. [Lamprecht Library, no number/ohne Nr.].

Klauß 1994 – Jochen Klauß. *Goethe als Medaillensammler.* Weimar: Böhlau Verlag, 1994.

Klauß 2000 – Jochen Klauß. *Die Medaillensammlung Goethes.* 2 vols. (*Die Kunstmedaille in Deutschland* 13, ed. by Wolfgang Steguweit and Gerhard Schuster). Berlin: Deutsche Gesellschaft für Medaillenkunst/Goethe-Nationalmuseum der Stiftung Weimarer Klassik, 2000.

Klein 2005 – Ulrich Klein. "Schillermedaillen und Schillermünzen von Dannecker bis Theumer," in *Numismatisches Nachrichtenblatt* 54 (May 2005), 181-93.

Kloevekorn, Fritz. *200 Jahre Halbergerhütte 1756-1956.* Saarbrücken: Saarländische Verlagsanstalt und Druckerei, 1956.

Köcke – Ulrike Köcke. *Katalog der Medaillen und Plaketten des 19. und 20. Jahrhunderts in der Kunsthalle Bremen.* Bremen: Kunsthalle Bremen, 1975.

Kunstwerke aus Eisenguss aus der Sammlung Professor G. Lamprecht Leipzig (unpublished manuscript / unveröffentlichtes Manuskript; Grassimuseum Leipzig).

Lakeos, Nick. "Made to Last," in *Sunday Montgomery Advertiser* (August 28, 1994), 7H f.

Lamprecht 1915 – "Ältere künstlerische Eisengüsse aus der Sammlung Gustav Lamprecht, Leipzig," in *Cat. Ausstellung Deutscher Kunst des XIX. Jahrhunderts aus Privatbesitz.* Leipzig: Leipziger Kunstverein im Museum der bildenden Künste, 1915, 112-32.

"Lamprecht Collection Feature of Radio Program," in *ACIPCO News* (April 1972), 13 f.

„Lamprecht Collection Presented to Museum as ACIPCO Gift," in *ACIPCO News* (February 1987), 1 f.

Langer 2003 – Heiderose Langer and Martina Pall. *Schmuck und andere Kostbarkeiten. Eisenkunstguss aus der Hanns Schell Collection Graz.* Velbert: Deutsches Schloss- und Beschlägemuseum, 2003.

Lauchhammer Bildguss 1927 – *Lauchhammer Bildguss* (Gs. 3). Lauchhammer: Mitteldeutsche Stahlwerke Aktiengesellschaft Lauchhammerwerk, 1927.

Lauchhammer Bildguss 1929 – *Lauchhammer Bildguss* (Gs. 5). Lauchhammer: Mitteldeutsche Stahlwerke Aktiengesellschaft Lauchhammerwerk, 1929.

Lauchhammer Bildguss 1932 – *Lauchhammer Bildguss* (Gs. 11). *Nachtrag 1 zu unserem Katalog Gs5.* Lauchhammer: Mitteldeutsche Stahlwerke Aktiengesellschaft Lauchhammerwerk, 1932.

Lauchhammer Bildguss 1933 – *Lauchhammer Bildguss* (Gs. 20). Lauchhammer: Mitteldeutsche Stahlwerke Aktiengesellschaft Lauchhammerwerk, 1933.

Lawton Lindsey, Estelle. "Campaign for Funds Will be Launched by Mrs. Davis, Museum Official," in *Los Angeles Examiner* (July 2, 1926).

Lehnert 1897 – Hildegard Lehnert. *Henri François Brandt, erster Medailleur an der Königlichen Münze und Professor der Gewerbe-Academie zu Berlin (1789-1845). Leben und Werke.* Berlin: Bruno Hessling, 1897.

Leichter – Hans Leichter. "Berliner Lithophanien. Eine fast vergessene grafische Technik des Biedermeier," in *Der Bär von Berlin. Jahrbuch des Vereins für die Geschichte Berlins,* ed. by Walter Hoffmann-Axthelm and Walther G. Oschilewski, no. 23 (1974), 50-69.

Leisching – Eduard Leisching. "Über Gußeisen, mit besonderer Berücksichtigung des österreichischen Kunsteisengusses," in *Kunst und Kunsthandwerk* 20 (1917), 185-218.

Limberg, Charles F. *Life with the Koehler Family on the Mississippi from Davenport to Memphis* (unpublished manuscript / unveröffentlichtes Manuskript), 1979. Courtesy the Missouri Historical Society.

Lindner, Helmut. "Nützliches aus Eisen," in *Weltkunst* 61 (October 1, 1991), 2828 f.

Fig./Abb. 55 Title page from / Titelseite der Festschrift anläßlich des hundertjährigen Bestehens der Giesserei Lauchhammer, 1825.

Lindsey, Estelle Lawton. "Famous Lamprecht Collection of Wrought Iron May Remain in L.A. if $75,000 can be Raised," in *Los Angeles Times* (April 1926).

Lippold – Georg Lippold. *Gemmen und Kameen des Altertums und der Neuzeit.* Stuttgart: J. Hoffmann, 1922.

Loos 1842 – Gottfried Loos. *Verzeichnis sämmtlicher Denk- und Gelegenheitsmünzen, welche aus der Berliner Medaillen-Münze von G. Loos seit der Gründung dieser Anstalt durch den Hof-Medailleur Daniel Friedrich Loos hervorgegangen sind.* Berlin, 1842.

Luedders, Arthur R. *Hercules in Wedgwood's World.* N. pag. The Wedgwood International Seminar, 1985.

Lüer, Hermann, and Max Creutz. *Geschichte der Metallkunst. 1. Kunstgeschichte der unedlen Metalle: Schmiedeisen, Gusseisen, Bronze, Zinn, Blei und Zink.* Stuttgart: Verlag Ferdinand Enke, 1904.

Maaz – Bernhard Maaz, ed. *Johann Gottfried Schadow und die Kunst seiner Zeit.* Cologne: Dumont Buchverlag, 1994.

Macht – Carol Macht. *Classical Wedgwood Designs. The Sources and Their Use and the Relationship of Wedgwood Jasper Ware to the Classical Revival of the Eighteenth Century.* New York: M. Barrows and Company, 1957.

Mackay 1973 – James A. Mackay. *The Animaliers: a collector's guide to the animal sculptors of the 19th and 20th centuries.* New York: Dutton, 1973 [with the reproduction of part of the Mène Cat. / mit dem Abdruck eines Teils des Mène-Katalogs].

Magazin von Abbildungen der Gusswaaren aus der Königlichen Eisengiesserei zu Berlin. 8 vols. Berlin: G. Reimer, 1815-ca. 1830. [1819 Lamprecht Library B.31.; 1823 Lamprecht Library B.32.].

Malajewa, S. G. *Eisenkunstguss aus dem Ural, KASLI. Meisterwerke der Volkskunst von Russland.* Moscow: Russisches Museum für dekorativ-angewandte und Volkskunst/Interbook Business, 2005.

Malkowsky, Georg. "Zur Geschichte und Ästhetik des Kunsteisengusses," in *Die Gießerei* 2, no. 12 (1915), 133-40.

Mann – J. Mann. *Anhaltische Münzen und Medaillen vom Ende des XV. Jahrhunderts bis 1906.* 2 vols. Hanover: Verlag H. S. Rosenberg, 1907.

Märker 1975 – Peter Märker, *Eisenkunstguß aus der ersten Hälfte des 19. Jahrhunderts. Kleingerät und Schmuck.* (*Kleine Hefte* 2). Frankfurt am Main: Museum für Kunsthandwerk Frankfurt am Main, 1975.

Marquardt 1983 – Brigitte Marquardt. *Schmuck. Klassizismus und Biedermeier 1780-1850. Deutschland, Österreich, Schweiz.* Munich: Verlag Kunst und Antiquitäten, 1983.

Marquardt 1984 – Brigitte Marquardt. Cat. *Eisen, Gold und Bunte Steine. Bürgerlicher Schmuck zur Zeit des Klassizismus und des Biedermeier. Deutschland, Österreich, Schweiz.* Berlin: Verlag Willmuth Arenhövel, 1984.

Marquardt, Brigitte. "Eisenschmuck. Patriotischer Schmuck im 19. Jahrhundert," in *Weltkunst* 60, no. 23 (December 1, 1990), 4070-72.

Marquis, Neeta. "City gets Unique Display. Southwest Museum Exhibit One of Few Collections of Kind Now in Existence," in *Los Angeles Times* (December 20, 1925), B2.

Martin, Werner. *Manufakturbauten im Berliner Raum seit dem ausgehenden 17. Jahrhundert.* Berlin: Gebr. Mann Verlag, 1989.

Matzdorf, Alice. *Eisenkunstguß.* (loose leaf pages, source unknown / lose Blätter, Quelle unbekannt; 1916) [Lamprecht Library, no number/ohne Nr.], 1659-61.

Mayerhofer, Ursula. "Bemerkungen zum Eisengußschmuck," in *Alte und Moderne Kunst* 27 (1982), 48 f.

"Max Koehler Dies (Obituary)," in *The Daily Herald* (Pass Christian, Mississippi) (March 23, 1929), 6.

"Max Koehler Dies Suddenly; Heart Disease," in *The Davenport Democrat and Leader* (March 25, 1929), 15.

"Max Koehler, Once St. Louis Attorney," *Dies in Mississippi,* in *St. Louis Post-Dispatch* (March 24, 1929).

Meier 1927 – Ortwin Meier. *Heinrich Friedrich Brehmer, der Meister der deutschen Porträtmedaille des 19. Jahrhunderts.* Hildesheim and Leipzig: August Lax Verlagshandlung, 1927.

Menadier 1901 – Julius Menadier. *Die Schaumünzen des Hauses Hohenzollern.* Berlin: Königliche Museen, 1901.

Mende 2004 – Jan Mende. "Formsand und Kupolofen. Technik des Eisengusses," in Bartel 2004, 39-41.

Mènes catalogue (Djinn, Cheval a la Barriere) [s. Mackay 1973].

Mildenberger, Hermann et al. *Eisenkunstguß-Museum Büdelsdorf* (*Führer zu schleswig-holsteinischen Museen* 8). Neumünster: Karl Wachholtz Verlag, 1990.

Mitteilungen des Städtischen Kunstgewerbe Museums zu Leipzig. Bericht für die Jahre 1915 und 1916, no. 8 (March 1917).

Mitteilungen des Städtischen Kunstgewerbe Museums zu Leipzig. Bericht für das Jahr 1917, no. 9 (February 1918).

Modell-Verzeichniß der Königlichen Eisengießerei zu Gleiwitz (loose pages from various sales catalogues / lose Blätter von verschiedenen Verkaufskatalogen; n. d.) [Lamprecht Library B.28.].

Mölbert – Klaus Mölbert. *Taschenuhrständer. Von der Schnitzkunst zur industriellen Herstellung. Eine 200jährige Geschichte.* Pfungstadt and Bensheim: Edition Ergon, 1997.

Montfaucon – Bernard de Montfaucon. *L'antiquité expliquée et représentée en figures.* 15 vols. Paris, 1719-24.

Müller, Bernd. "Neujahrsplaketten, -medaillen und -karten. Reliefs aus der Blütezeit preußischer Eisenkunstgußindustrie," in *Weltkunst* 58, no. 17 (September 1987), 2258-62.

Müller-Jahncke – Wolf-Dieter Müller-Jahncke. *Apothekerbildnisse auf Medaillen und Plaketten. 1. Deutschsprachiger Raum* (*Veröffentlichungen der Internationalen Gesellschaft für Geschichte der Pharmazie e. V.* 48). Stuttgart: Wissenschaftliche Verlagsgesellschaft, 1980.

Mundt 1973 – Barbara Mundt. *Historismus. Kunsthandwerk und Industrie im Zeitalter der Weltausstellung* (*Kataloge des Kunstgewerbemuseums Berlin* VII). Berlin: Kunstgewerbemuseum SMPK, 1973 (2nd ed. 1983).

Mundt, Barbara. "Alfred Wolters, Bonn (1856-1943). Ein Stahlwarenfabrikant sammelt Berliner Eisen," in *Glück, Leidenschaft und Verantwortung. Das Kunstgewerbemuseum und seine Sammler.* Berlin: Staatliche Museen zu Berlin – Kunstgewerbemuseum, 1990.

Mundt, Barbara. *Historismus. Kunstgewerbe zwischen Biedermeier und Jugendstil.* Munich: Keysersche Verlagsbuchhandlung, 1981.

Müseler – Karl Müseler. *Bergbaugepräge. Dargestellt auf Grund der Sammlung der Preussag Aktiengesellschaft.* 3 vols. Hanover: Preussag Aktiengesellschaft, 1983.

Nazin, Sergey S. *Cast Iron can be compared with gold. Russian and foreign art of medal-making in the early XIX-XXI centuries.* Exhibition catalogue. Moscow: State Historical Museum, 2008. (Russian and English).

Nazin, Sergey S. "Ein unbekanntes Eisengußmedaillon," in *MünzenRevue* 40, no. 2 (February 2008), 149-56.

Nazin, Sergey S. "Identification of European casting plants and private foundries from monograms and stamps," in *Antikvariat* 43, no. 12 (December 2006 [Part I]), 30-39; 44, no. 1-2 (2007 [Part II]), 52-61; 46, no. 4 (April 2007 [Part III]), 24-35 (Russian).

Nelson, James R. "Elegant Curiosities, Delightful Discoveries," in *The Birmingham News* (January 31, 1982), 7E.

Neubecker – Ottfried Neubecker. "Eisernes Kreuz," in *Reallexikon zur Deutschen Kunstgeschichte.* vol. 4, ed. by Ernst Gall and L. H. Heydenreich. Stuttgart: Alfred Druckenmüller Verlag, 1958, 1064-67.

"Neujahrskarten aus Gußeisen aus dem Besitz des Majors Schweitzer," in *Bilder aus aller Welt 51* (1916), 1817 f. [Lamprecht Library, no number/ohne Nr.]

Nieper, Ludwig. *Die Königliche Kunstakademie und Kunstgewerbeschule zu Leipzig. Bericht über die Zeitdauer von Ostern 1896 bis Ostern 1898.* Leipzig, 1898.

Nieper, Ludwig. *Die Königliche Kunstakademie und Kunstgewerbeschule zu Leipzig. Bericht über die Zeitdauer von Ostern 1898 bis Ostern 1900.* Leipzig, 1900.

Nieper, Ludwig. *Die Königliche Kunstakademie und Kunstgewerbeschule zu Leipzig. Festschrift und amtlicher Bericht.* Leipzig, 1890.

Niggl 1965 – Paul Niggl. *Musiker Medaillen.* Hofheim am Taunus: Verlag Friedrich Hofmeister, 1965.

Nitsche, Julius. *Eisenguss.* Berlin: Gustav Weise Verlag, 1942.

Nungesser – Michael Nungesser. *Das Denkmal auf dem Kreuzberg von Karl Friedrich Schinkel.* Berlin: Bezirksamt Kreuzberg von Berlin/Verlag Willmuth Arenhövel, 1987.

Offizieller Führer durch die Empire-Ausstellung. Grosse Kunstausstellung Dresden 1904. Blasewitz: Alwin Arnold & Gröschel, 1904. [Lamprecht Library B.40.].

Olding – Manfred Olding. *Die Medaillen auf Friedrich den Großen von Preußen 1712 bis 1786.* Regenstauf: H. Gietl Verlag & Publikationsservice, 2003.

Olson, Thelma. "Iron Casting as an Art," in *Museum Graphic. The Museum Patrons Association of the Los Angeles Museum* 1, no. 5 (May 1927), 184-89.

Oppermann, Th. "Der Bildhauer Hermann Ernst Freund, der Schöpfer des Gleiwitzer Lekythos (1786-1840)" (Sonderabdruck aus der

Monatsschrift *Oberschlesien* 16, no. 1). Kattowitz: Verlag von Gebrüder Böhm, 1917. [Lamprecht Library B.15.]

Osborn, Max. *Handbuch des Kunstmarktes. Kunstadressbuch für das Deutsche Reich, Danzig und Deutsch-Österreich.* Berlin: Antiqua Verlagsgesellschaft Hermann Kalkoff, 1926.

Osborn, Max, Adolph Donath and Franz M. Feldhaus. *Berlins Aufstieg zur Weltstadt. Ein Gedenkbuch herausgegeben vom Verein Berliner Kaufleute und Industrieller aus Anlaß seines 50jährigen Bestehens.* Berlin: Verlag von Reimar Hobbing, 1929 (Reprint; Berlin: Gebr. Mann Verlag, 1994).

Ostergard 1994 – Derek E. Ostergard, ed. *Cast Iron from Central Europe, 1800-1850.* New York: The Bard Graduate Center for Studies in the Decorative Arts, 1994.

Osterwald – Carl Osterwald. *Das Römische Denkmal in Igel und seine Bildwerke, mit Rücksicht auf das von H. Zumpft nach dem Originale ausgeführte 19 Zoll hohe Modell, beschrieben und durch Zeichnungen erläutert von Carl Osterwald. Mit einem Vorworte von Goethe.* Coblenz: Karl Baedeker, 1829.

Ostwald, Hans. "Eiserne Glückwunschkarten," in *Berliner Lokal-Anzeiger* (December 31, 1924), loose leaf pages / lose Blätter [Lamprecht Library, no number/ohne Nr.].

Papendorf, Lothar. "Zur Geschichte des Berliner Eisenkunstgusses," in *Metall im Kunsthandwerk.* Berlin: Staatliche Museen zu Berlin, Kunstgewerbemuseum (DDR), 1967, 321-36.

Peshkova – I. M. Peshkova. *The Art of Kasli Masters.* 2 vols. Chelyabinsk: Southern-Ural Publishers, 1983.

Pichler – Matthias Pichler. *Der Mariazeller Eisenkunstguß (Leobener Grüne Hefte 65).* Vienna: Montan-Verlag, 1963.

Planiscig – Leo Planiscig. *Die Bronzeplastiken. Statuetten, Reliefs, Geräte und Plaketten.* Vienna: Kunsthistorisches Museum, 1924.

Planiscig, Leo. *Die Estensische Kunstsammlung, Bd. 1. Skulpturen und Plastiken des Mittelalters und der Renaissance.* Vienna: Verlag Anton Schroll & Co., 1919.

Platen, Max. "Die Gold- und Silbersammlung des 'Vaterlandsdank' ausgestellt im Kgl. Kunstgewerbemuseum in Berlin," in *Kunstgewerbeblatt* 27 (1915/16), 201-03. [Lamprecht Library, no number/ohne Nr.].

Pniower – Otto Pniower. "Berliner Eisen," in *Mitteilungen des Vereins für die Geschichte Berlins* 41 (1924), 21-23.

Preis-Courant der Kunstguss-Waaren auf dem Gräflich Einsiedelschen Eisenwerk zu Lauchhammer. (Lauchhammer, ca. 1830-45).

Preis-Courant Gleiwitz 2005 – Leszek Jodlinski, Barbara Malik and Joanna Jenczewska. *Gliwicki Preis-Courant. Wzorniki wyrobów Królewskiej Odlewni Zeliwa w Gliwicach w zbiorach Muzeum*

Geschichte
des Eisens
mit Anwendung
für
Künstler und Handwerker
von
Sven Rinman,
Königl. Schweb. Bergrath und Ritter des Wasa-Ordens.

Aus dem Schwedischen übersetzt
und
mit Anmerkungen und Zusätzen
versehen
von
Dr. C. J. B. Karsten,
Königl. Preuß. Ober-Hüttenrath und Ober-Hüttenverwalter
für die Provinz Schlesien.

Erster Band
mit einem Kupfer und dem Bildnisse des Verfassers.

Liegnitz
In Kommission bei Triepel und Kuhlmey.
1814.

Fig./Abb. 56 Title page and frontispiece from / Titelseite und Frontispiz von Rinman, 1814.

w Gliwicach / Der Gleiwitzer Preis-Courant. Die Musterbücher der Erzeugnisse der Königlichen Eisengiesserei in Gleiwitz. Aus den Sammlungen des Museums in Gleiwitz (polish and german). Gliwice: Muzeum w Gliwicach, 2005.

Preis-Courant über Kunst-Guss-Sachen der Carlshütte bei Rendsburg [...] Mit Bezug auf unsere Lithographien. Rendsburg: Carlshütte Hartwig Holler & Co, 1868.

Pulch, Maria. "Der Eisenkunstguß der Sayner Hütte," in Rheinische Blätter (January 1, 1939), 26-28.

Pyritz 1994 – Albrecht Pyritz. "A History of Cast-Iron Technology and the Prussian Iron Industry," in Ostergard 1994, 129-53.

Raabe, Nancy. "Splendid Casts," in The Birmingham News (March 23, 1997), 1Ff.

Rasl 1980 – Zdeněk Rasl. Decorative Cast Ironwork. Catalogue of Artistic and Decorative Iron Castings from the 16th to 20th Centuries Preserved at the National Technical Museum of Prague. Prague: National Technical Museum, 1980.

Rasl, Zdeněk, and Vlasta Olicová. Böhmischer Eisenkunstguss. Sonderausstellung des Technischen Nationalmuseums Prag und des Burgenländischen Landesmuseums. Eisenstadt: Amt der Burgenländischen Landesregierung – Landesmuseum, 1983.

Ratner, Megan. "Rediscovering Cast Iron from Central Europe," in German Life (November 1994), 14 f.

Redlich 1953a – Fritz Redlich. "A German Eighteenth-Century Iron Works during its First Hundred Years: Notes Contributing to the Unwritten History of European Aristocratic Business Leadership," in Bulletin of the Business Historical Society 27, no. 2 (June 1953), 69-96.

Redlich 1953b – Fritz Redlich. "A German Eighteenth-Century Iron Works during its First Hundred Years: Notes Contributing to the Unwritten History of European Aristocratic Business Leader-

ship-II," in *Bulletin of the Business Historical Society* 27, no. 3 (September 1953), 141-57.

Redslob – Edwin Redslob. "Der Eisenkunstguß in seiner klassischen Epoche," in *Eisen und Stahl*, ed. by Werner Doede. Düsseldorf: Kuratorium Kunstausstellung Eisen und Stahl, 1952, 60-64.

Reichmann – Matthias Reichmann. *Die Harzer Eisenhütte unterm Mägdesprung. Ein Beitrag zum Kunstguss im Nordharz* (unpublished dissertation, Martin-Luther-Universität Halle-Wittenberg, 2001).

Reif, Rita. "When a Prussian King Played Decorator," in *The New York Times* (June 19, 1994), H35.

Reilly 1989 – Robin Reilly. *Wedgwood*, 2 vols. London: Macmillan Publishers Ltd., 1989.

Reilly and Savage – Robin Reilly and George Savage. *Wedgwood. The Portrait Medallions*. London: Barrie and Jenkins, 1973.

Reinach – Salomon Reinach. *Rèpertoire de reliefs grecs et romains*, 2 vols. Vol. I: Les ensembles. Paris: Ernest Leroux, 1909-12.

Renaissance der Renaissance 1992 – *Renaissance der Renaissance. Ein bürgerlicher Kunststil im 19. Jahrhundert. (Schriften des Weserrenaissance-Museums Schloß Brake 5)*. Munich and Berlin: Deutscher Kunstverlag, 1992.

Reuel 2004 – Peter Christian Reuel. "Johann Friedrich Malchow – Modelleur, Ziseleur und Bildhauer des Eisenkunstgusses," in *Neues Magazin für Hanauische Geschichte, Mitteilungen des Hanauer Geschichtsvereins 1844 e. V.* (2004), 77-86.

Rinman 1814 – Sven Rinman. *Geschichte des Eisens mit Anwendung für Künstler und Handwerker. Aus dem Schwedischen übersetzt und mit Anmerkungen und Zusätzen versehen von Dr. C. J. B. Karsten.* 2 vols. Liegnitz: In Kommission bei Triepel und Kuhlmey, 1814.

Röber, Wolf-Dieter. *Lauchhammer Eisenkunstguß-Plastiken in Wolkenburg*. Wolkenburg: Gemeindeverwaltung Wolkenburg, 1991.

Rosenberg – Marc Rosenberg. "Eisenschmuck," in *Kunstgewerbeblatt für das Gold-Silber und Feinmetall-Gewerbe* 3 (1896), 41-45. [Lamprecht Library B.11.].

Rulau and Fuld – Russell Rulau and George Fuld. *Medallic Portraits of Washington*, 2nd ed. Iola: Krause Publications, 1999.

Rürup, Reinhard, ed. *Jüdische Geschichte in Berlin*. Berlin: Edition Hentrich, 1995.

Ruthenberg – Vera Ruthenberg. "Das klassizistische Bildnis im Werk von Christian Daniel Rauch," in *Wissenschaftliche Zeitschrift der Universität Rostock* 17 (1968), 759-63.

Saarinen, Aline B. "Birmingham's Third Annual is Diverse Program of Cultural Activities," in *The New York Times* (February 28, 1954), X10.

Salaschek – Sunhild Salaschek. *Katalog der Medaillen und Plaketten des 19. und 20. Jahrhunderts im französischen und deutschen Sprachraum in der Hamburger Kunsthalle*. 2 vols. Hamburg: Hamburger Kunsthalle, 1980.

"Sayner Eisenkunstguß," in *Kruppsche Monatshefte* 8 (January 1927), 16-20.

Scheidig – Walther Scheidig. "Adolf Straube – ein Weimarer Bildhauer (1810-1839)," in *Jahrbuch der Staatlichen Kunstsammlung Dresden* 18 (1986), 75-104.

Schiller, Artur. *Katalog des Oberschlesischen Museums zu Gleiwitz; Part 1 Oberschlesische Gegenstände*. Gleiwitz: Oberschlesisches Museum, 1915. [Lamprecht Library B.44.].

Schlüter – Margildis Schlüter. *Münzen und Medaillen zur Reformation, 16. bis 20. Jahrhundert*. Hanover: Kestner-Museum, 1983.

Schmidt 1976 – Eva Schmidt. *Der Eisenkunstguß*. Dresden: VEB Verlag der Kunst, 1976.

Schmidt 1981 – Eva Schmidt. *Der Preußische Eisenkunstguß. Technik, Geschichte, Werke, Künstler*. Berlin: Gebr. Mann Verlag, 1981.

Schmidt, Eva. *Schlesischer Eisenkunstguss*. Breslau: Schlesien Verlag, 1940.

Schmidt, Eva. "Zur Entwicklung von Kleinplastik, Medaillen und Schmuck im Eisenkunstguss. Ein Beitrag zur Geschichte des Gleiwitzer Eisenkunstgusses," in Festschrift Kippenberger 1, 221-44.

Schmidt, Eva. "Zur Geschichte des Gleiwitzer Eisenkunstgusses," in *Anschauung und Deutung. Willy Kurth zum 80. Geburtstag. Studien zur Architektur und Kunstwissenschaft*, ed. by G. Strauss. Berlin: Akademie-Verlag, 1964, S. 203-16.

Schmidt, Hans, and Herbert Dickmann. *Bronze- und Eisenguß. Bilder aus dem Werden der Gießtechnik*. Düsseldorf: Giesserei-Verlag, 1958.

Schmitz 1916 – Hermann Schmitz. *Gußeisen. Sonderausstellung von Kunstgüssen deutscher Eisenhütten bis zur Gegenwart insbesondere der Kgl. Eisengießerei in Berlin*. Berlin: Königliches Kunstgewerbemuseum in Berlin, 1916.

Schmitz 1917 – Hermann Schmitz. *Berliner Eisenkunstguß. Festschrift zum fünfzigjährigen Bestehen des Königlichen Kunstgewerbemuseums 1867 bis 1917*. Hg. im Auftrag des Kgl. Kunstgewerbemuseums mit Unterstützung der Orlopstiftung. Munich: Verlag F. Bruckmann, 1917.

Schmitz, Hermann. "Kunstgewerbemuseum. Berliner Eisengüsse," in *Amtliche Berichte aus den Königlichen Kunstsammlungen* 36 (1914/15), 241-60.

Schmuttermeier – Elisabeth Schmuttermeier. *Eisenkunstguß der ersten Hälfte des 19. Jahrhunderts aus den Sammlungen des Österreichischen Museums für angewandte Kunst (MAK)*. Vienna: Österreichisches Museums für angewandte Kunst, 1992.

Schnell – Hugo Schnell. *Martin Luther und die Reformation auf Münzen und Medaillen.* Munich: Klinkhardt & Biermann, 1983.

Schreiter and Pyritz – Charlotte Schreiter and Albrecht Pyritz, eds. *Berliner Eisen. Die Königliche Eisengießerei Berlin. Zur Geschichte eines preußischen Unternehmens. Berliner Klassik. Eine Großstadtkultur um 1800. (Studien und Dokumente*, ed. Berlin-Brandenburgische Akademie der Wissenschaften, betreut von Conrad Wiedemann, vol. 9). Hanover-Laatzen: Wehrhahn Verlag, 2007.

Schubert, H. R. "Extracton and Production of Metals: Iron and Steel," in *A History of Technology*, ed. by Charles Singer, E. J. Holmyard, A. R. Hall, and Trevor I. Williams, vol. IV *The Industrial Revolution c 1750 to c 1850.* Oxford: Clarendon Press, 1967, 99-117.

Schuette 1916 – Marie Schuette. "Kunstwerke aus Eisenguss," in *Zeitschrift für bildende Kunst* N. F. 27 (1915/16), 281-89.

Schultze 1992 – Jürgen Schultze et al., ed. *Metropole London. Macht und Glanz einer Weltstadt 1800-1840.* Essen and Recklinghausen: Kulturstiftung Ruhr Essen/Verlag Aurel Bongers Recklinghausen, 1992.

Seidel, Paul. "Eine Erinnerung an den ersten Frauen-Verein 1813," in *Hohenzollern-Jahrbuch. Forschungen und Abbildungen zur Geschichte der Hohenzollern in Brandenburg-Preussen* 18, ed. by Paul Seidel. Berlin: Verlag Giesecke & Devrient, 1914, 237-40.

Sheehan, James J. *German History 1770-1866.* Oxford: Clarendon Press, 1989.

Simpson – Bruce L. Simpson. *Development of the Metal Castings Industry.* Chicago: American Foundrymen's Association, 1948.

Simson 1996 – Jutta von Simson. *Christian Daniel Rauch. Oeuvre-Katalog.* Berlin: Gebr. Mann Verlag, 1996.

Slayden, Bob. "Rare Collection of Cast Iron Objects Being Arrange for Exhibit in Service Building," in *ACIPCO News* (February 1940), 1.

Smith, L. Richard. *Josiah Wedgwood's Slave Medallion* (2nd revised ed.). Sydney: The Wedgwood Society of New South Wales, 1999.

Snodin, Michael, ed. *Karl Friedrich Schinkel: A Universal Man.* New Haven and London: Yale University Press/The Victoria and Albert Museum, 1991.

Sommer 1981 – Klaus Sommer. *Die Medaillen des königlich-preußischen Hof-Medailleurs Daniel Friedrich Loos und seines Ateliers.* Osnabrück: Biblio Verlag, 1981.

Sommer 1986 – Klaus Sommer. *Die Medaillen der königlich-preußischen Hof-Medailleure Christoph Carl Pfeuffer und Friedrich Wilhelm Kullrich.* Osnabrück: Biblio Verlag, 1986.

Spence, Joseph. *Mr. Polymetis; or, An Enquiry Concerning the Agreement between the Works of the Roman Poets and the Remains of the Ancient Artists.* London: Prints for R. and J. Dodsley, 1755, pl./Taf. 5.

Spiegel 1981 – Hans Spiegel. "Eisenkunstguß: Plastik, Schmuck und Gerät," in *Kunst des 19. Jahrhunderts im Rheinland* 5, ed. by Eduard Trier and Willy Weyres. Düsseldorf: Verlag Schwann, 1981, 117-54.

Spiegel 1983 – Hans Spiegel. *Der Eisenkunstguß der Sayner Hütte. Althans-Gedächtnis-Ausstellung 1981.* Bendorf: Stadtverwaltung Bendorf/Rhein, 1983.

Stamm – Brigitte Stamm. *Blicke auf Berliner Eisen (Aus Berliner Schlössern, Kleine Schriften* VI). Berlin: Verwaltung der Staatlichen Schlösser und Gärten, 1979.

Steffen, Erich. "Die Königliche Eisengiesserei in Berlin," in *Mitteilungen des Vereins für die Geschichte Berlins* 28 (1911), 25-28.

Steguweit 1997 – Wolfgang Steguweit, ed. *Medaillenkunst in Deutschland von der Renaissance bis zur Gegenwart. Themen, Projekte, Forschungsergebnisse. Vorträge zum Kolloquium im Schloßmuseum Gotha am 4. Mai 1996 (Die Kunstmedaille in Deutschland* 6). Dresden: Deutsche Gesellschaft für Medaillenkunst, 1997.

Steinsartz, Friedrich. "Künstlerischer Eisenguß," in *Das Eisen in der Kunst*, ed. by Hannes Dietl. Vienna: Gebr. Böhler & Co., 1940.

Stephan – Bärbel Stephan. *Skulpturensammlung Dresden. Klassizistische Bildwerke.* Munich: Deutscher Kunstverlag, 1993.

Stolz – Gerd Stolz. *Das Seegefecht vor Eckernförde vom 5. April 1849.* (Eckernförde 1986).

Straube 1918 – Herbert Straube. "Eisengusz in der angewandten Kunst," in *Dekorative Kunst* 26 (1918), 62-72.

Straube, Herbert. "Die Eisenkunstgußausstellung im Königl. Kunstgewerbemuseum zu Berlin," in *Das Metall* 4 (February 25, 1917), 50-52, 65-70.

Strothotte – Werner Strothotte. *Die Zeit in der Numismatik.* Gütersloh: Münzhandel + Verlag Beate Strothotte, 2004.

Stummann-Bowert – Ruth Stummann-Bowert. *Eisenkunstguß. Büsten, Statuetten, Medaillen, Medaillons, Gemmen, Plaketten, Wohngerät, Schmuck, Holzmodel (Die Sammlung der Buderus Aktiengesellschaft, Kunstguß-Museum in Hirzenhain).* Wetzlar: Buderus Aktiengesellschaft, 1984.

Tafelwerk Carlshütte bei Rendsburg. Konvolut von ca. 190 lithographierten Tafeln mit gußeisernen Produkten der Carlshütte, darunter zusammengebundene Tafeln (1-18) mit Objekten des Kunstgusses. Carlshütte bei Rendsburg (ca 1840-70). [Büdelsdorf, Eisenkunstgussmuseum].

Tattersall – Bruce Tattersall. *Wedgwood Portraits and the American Revolution.* Washington, D. C.: National Portrait Gallery, Smithsonian Institution, 1976.

Tewes – Bettina Tewes. *Gold gab ich für Eisen. Eisenschmuck und Kleingerät des Klassizismus und Biedermeier.* Dortmund: Museum für Kunst und Kulturgeschichte der Stadt Dortmund, 1995.

Fig./Abb. 57 Title page from / Titelseite von Tiemann, 1803.

Thiele 1920 – Alfred Thiele. "Der Kunstguss auf Saynerhütte," in *Kruppsche Monatshefte* 1 (November 1920), 185-91.

Thieme and Becker – Ulrich Thieme and Felix Becker, eds. *Allgemeines Lexikon der bildenden Künstler von der Antike bis zur Gegenwart.* 37 vols. Leipzig: E. A. Seemann Verlag, 1907-50.

Wilhelm Albrecht Tiemann. *Abhandlung über die Förmerei und Gießerei auf Eisenhütten. Ein Beitrag zur Eisenhüttenkunde.* Nürnberg: Raspesche Buchhandlung, 1803.

Warmbier, Jürgen et al. *Berliner Kunsthandwerk und Kunstgewerbe vom 17. bis zum 20. Jahrhundert.* Berlin: Märkisches Museum, 1987.

Wedgwood 1992 – Elizabeth Bryding Adams. *The Dwight and Lucille Beeson Wedgwood Collection at the Birmingham Museum of Art.* Birmingham, Alabama: Birmingham Museum of Art, 1992.

Wedgwood Basreliefs. Cameos, Plaques, Portraits and Medallions. Barlaston: The Wedgwood Museum [n.d.].

Weeks, Ted. "Museum has Major Exhibit of Cast Iron," in *The Birmingham News* (March 16, 1975).

Werlich, Robert. *Orders and Decorations of All Nations, Ancient and Modern, Civil and Military* (2nd ed.). Washingon, D. C.: Quaker Press, 1974.

Weyl – Adolph Weyl. *Die Paul Henckel'sche Sammlung Brandenburg-preußischer Münzen und Medaillen* (reprint; original published 1876/77). Berlin: VEB Verlag für Verkehrswesen, 1987.

Whiting – *Robert Whiting. Martin Luther und die Reformation auf Münzen und Medaillen.* Auktion Spink & Son, Zurich, April 19-20, 1983.

Widerra, Rosemarie. *Berliner Eisenkunstguß.* Berlin: Märkisches Museum, 1975.

Więcek – Adam Więcek. *Dzieje sztuki medalierskiej w Polsce.* Cracow: Wydawnictwo Literackie, 1972.

"Wie ein Denkmal gegossen wird," in *Die Wochenschau* 18 (n. d.), 566-68. [Lamprecht Library, no number/ohne Nr.].

Willard, John. "The Colorful Quad-City Beer Barons," in *Quad-City Times* (Davenport, IA) (October 9, 1977), D2.

Wirth, Irmgard. "August Kiss. Ein Berliner Bildhauer aus Oberschlesien," in *Schlesien* 7 (1962), 218-25.

Wirth, Irmgard. "Theodor Kalide. Ein Berliner Bildhauer aus Oberschlesien," in *Schlesien* 8 (1963), 141-50.

Wruck – Münzenhandlung Dr. Waldemar Wruck. *Universalsammlung [...] und die Eisenkunstguss-Sammlung Robert Recke. Versteigerungs-Katalog Nr. 24,* Berlin, Oktober 18-19, 1976.

Wurzbach-Tannenberg – Wolfgang R. von Wurzbach-Tannenberg. *Katalog meiner Sammlung von Medaillen, Plaketten und Jetons.* Hamburg: Münzhandlung Peter Siemer, 1978.

Zeitler, Julius. *Der Lehrkörper der Königl. Akademie für Graphische Künste und Buchgewerbe zu Leipzig im Jubiläumsjahr 1914.* Leipzig, 1914.

Zenker, Joseph. *Pantheon. Adressbuch der Kunst- und Antiquitäten-Sammler und -Händler, Bibliotheken, Archive, Museen, Kunst-, Altertums- und Geschichtsvereine, Bücherliebhaber, Numismatiker. Ein Handbuch für das Sammelwesen der ganzen Welt.* Esslingen: Paul Neff Verlag, 1914.

Zick, „Armor, schiffend" – Gisela Zick. "Briefbeschwerer Nr. 2: Amor, schiffend," in *ARTIG, Zeitschrift der Fachschaft Kunstgeschichte* (Universität Köln) 1 (2007), 14-23.

275 Jahre Eisenguss in Lauchhammer, Festschrift der Kunstgießerei Lauchhammer GmbH und Co. KG anlässlich des 275. Jahrestages des Lauchhammers am 24. August 2000 herausgegeben, Lauchhammer 2000.

Concordance of the Accession Numbers with the Catalogue Numbers / Konkordanz der Inventarnummern mit den Katalognummern

1952.22	Cat. 134
1953.151	Cat. 135
1954.70	Cat. 136
1955.55	Cat. 137
1956.180	Cat. 138
1957.265	Cat. 54
1962.86	Cat. 64
1962.87	Cat. 269
1962.88	Cat. 226
1962.89 a-b, d	Cat. 848
1962.89 c	Cat. 985
1962.90	Cat. 457
1962.91	Cat. 380
1962.92	Cat. 986
1962.93	Cat. 987
1962.94	Cat. 519
1962.95	Cat. 274
1962.96	Cat. 192
1962.97	Cat. 128
1962.98	Cat. 124
1962.99	Cat. 988
1962.100	Cat. 746
1962.101	Cat. 762
1962.102	Cat. 760
1962.103	Cat. 749
1962.104	Cat. 744
1962.105	Cat. 754
1962.106	Cat. 758
1962.107	Cat. 741
1962.108 a-b	Cat. 739
1962.109	Cat. 730
1962.110	Cat. 731
1962.111	Cat. 733
1962.112	Cat. 728
1962.113	Cat. 726
1962.114	Cat. 729
1962.115	Cat. 734
1962.116	Cat. 617
1962.117	Cat. 590
1962.118	Cat. 591
1962.119	Cat. 600
1962.120	Cat. 829
1962.121	Cat. 793
1962.122 a-b	Cat. 674
1962.123	Cat. 784
1962.124	Cat. 785
1962.125	Cat. 786
1962.126	Cat. 675
1962.127 a-b	Cat. 676
1962.128 a-c	Cat. 709
1962.129	Cat. 710
1962.130	Cat. 679
1962.131	Cat. 660
1962.132	Cat. 723
1962.133 a-b	Cat. 819
1962.134	Cat. 840
1962.135	Cat. 835
1962.136	Cat. 889
1983.99	Cat. 860
1984.200 a-b	Cat. 905
1986.221.1	Cat. 689
1986.221.2 a-e	Cat. 690
1986.221.3 a-e	Cat. 691
1986.221.4	Cat. 692
1986.221.5 a-d	Cat. 693
1986.221.6 a-d	Cat. 694
1986.221.7 a-b	Cat. 695
1986.221.8 a-d	Cat. 696
1986.221.9	Cat. 697
1986.221.10 a-d	Cat. 698
1986.221.11 a-f	Cat. 699
1986.221.12 a-b	Cat. 700
1986.221.13 a-c	Cat. 701
1986.221.14 a, c, e	Cat. 702
1986.221.15	Cat. 703
1986.221.16 a-c	Cat. 704
1986.221.17 a-d	Cat. 705
1986.221.18	Cat. 706
1986.221.19 a-b	Cat. 707
1986.221.20	Cat. 859
1986.221.21	Cat. 830
1986.222.1	Cat. 742
1986.222.2	Cat. 743
1986.222.3	Cat. 745
1986.222.4	Cat. 752
1986.222.5	Cat. 748
1986.222.6	Cat. 861
1986.222.7	Cat. 747
1986.222.8 a-b	Cat. 753
1986.222.9	Cat. 927
1986.222.10	Cat. 750
1986.222.11	Cat. 759
1986.222.12	Cat. 755
1986.222.13	Cat. 761
1986.222.14	Cat. 751
1986.222.15	Cat. 862
1986.222.16	Cat. 863
1986.222.17	Cat. 864
1986.222.18	Cat. 756
1986.223.1	Cat. 593
1986.223.2	Cat. 598
1986.223.3	Cat. 585
1986.223.4	Cat. 599
1986.223.5	Cat. 602
1986.223.6	Cat. 610
1986.223.7	Cat. 928
1986.223.8	Cat. 606
1986.223.9	Cat. 607
1986.223.10	Cat. 604
1986.223.11	Cat. 586
1986.223.12	Cat. 603
1986.223.13	Cat. 611
1986.223.14	Cat. 605
1986.224.1	Cat. 588
1986.224.2	Cat. 589
1986.224.3	Cat. 574
1986.224.4	Cat. 912
1986.225.1 a	Cat. 612
1986.225.1 b	Cat. 613
1986.225.2	Cat. 763
1986.226.1	Cat. 594
1986.226.2	Cat. 595
1986.226.3	Cat. 596
1986.226.4	Cat. 597
1986.227	Cat. 614
1986.228	Cat. 601
1986.229.1	Cat. 608
1986.229.2	Cat. 609
1986.230.1	Cat. 615
1986.230.2	Cat. 616
1986.231	Cat. 618
1986.232	Cat. 619
1986.233 a-c	Cat. 708
1986.234	Cat. 587
1986.235 a	Cat. 620
1986.235 b	Cat. 621
1986.235 c	Cat. 622
1986.236 a	Cat. 623
1986.236 b	Cat. 624
1986.237	Cat. 929
1986.238	Cat. 625
1986.239	Cat. 626
1986.240	Cat. 592
1986.241	Cat. 821
1986.242	Cat. 627
1986.243	Cat. 628
1986.244	Cat. 629
1986.245	Cat. 630
1986.246	Cat. 631
1986.247.1 a-b	Cat. 632
1986.247.2	Cat. 764
1986.248.1	Cat. 765
1986.248.2	Cat. 766
1986.249.1	Cat. 767
1986.249.2	Cat. 768
1986.250.1	Cat. 769
1986.250.2	Cat. 770
1986.250.3	Cat. 771
1986.250.4	Cat. 772

1986.251	Cat. 635	1986.289.5 a-c	Cat. 932	1986.317.4	Cat. 935
1986.252.1	Cat. 636	1986.289.6	Cat. 657	1986.318 a	Cat. 936
1986.252.2	Cat. 637	1986.289.7 a-c	Cat. 655	1986.318 b	Cat. 937
1986.252.3	Cat. 638	1986.290.1	Cat. 665	1986.319	Cat. 938
1986.253	Cat. 639	1986.290.2 a-d	Cat. 666	1986.319.1	Cat. 299
1986.254	Cat. 773	1986.291.1	Cat. 667	1986.319.2	Cat. 298
1986.255	Cat. 677	1986.291.2	Cat. 668	1986.319.3	Cat. 296
1986.256.2 a	Cat. 678	1986.291.3 a-b	Cat. 669	1986.319.4	Cat. 297
1986.256.2 b	Cat. 680	1986.292.1 a-b	Cat. 670	1986.320 a-b	Cat. 854
1986.256.3	Cat. 683	1986.292.2 a-b	Cat. 671	1986.321	Cat. 855
1986.256.4	Cat. 682	1986.293.1	Cat. 740	1986.322.1 a-b and 2 a-b	Cat. 856
1986.256.5	Cat. 681	1986.293.2	Cat. 735	1986.323	Cat. 857
1986.257.1	Cat. 684	1986.293.3 a-b	Cat. 736	1986.324	Cat. 858
1986.257.2	Cat. 685	1986.293.4	Cat. 757	1986.325.1-2	Cat. 852
1986.258.1	Cat. 686	1986.293.5	Cat. 737	1986.326.1	Cat. 939
1986.258.2	Cat. 687	1986.293.6	Cat. 738	1986.326.2	Cat. 640
1986.259.1 a	Cat. 831	1986.294.1	Cat. 788	1986.326.3	Cat. 641
1986.259.1 b	Cat. 832	1986.294.2	Cat. 789	1986.326.4	Cat. 642
1986.259.2	Cat. 833	1986.294.3	Cat. 790	1986.326.5	Cat. 643
1986.259.3	Cat. 930	1986.294.4	Cat. 791	1986.326.6	Cat. 644
1986.259.4	Cat. 838	1986.294.5	Cat. 792	1986.326.7	Cat. 645
1986.260	Cat. 850	1986.295	Cat. 853	1986.327.1	Cat. 514
1986.261	Cat. 658	1986.296 a-b	Cat. 851	1986.327.2	Cat. 515
1986.262	Cat. 659	1986.297 a-b	Cat. 837	1986.327.3	Cat. 940
1986.263 a-b	Cat. 664	1986.298.1	Cat. 672	1986.327.4	Cat. 516
1986.264	Cat. 661	1986.298.2	Cat. 673	1986.327.5	Cat. 517
1986.265	Cat. 662	1986.298.3	Cat. 834	1986.327.6	Cat. 288
1986.266	Cat. 794	1986.298.4	Cat. 839	1986.327.7	Cat. 518
1986.267	Cat. 795	1986.298.5	Cat. 849	1986.327.8	Cat. 520
1986.268 a-b	Cat. 796	1986.298.6	Cat. 841	1986.327.9	Cat. 521
1986.269 a-b	Cat. 797	1986.298.7	Cat. 842	1986.327.10	Cat. 522
1986.270 a-b	Cat. 798	1986.298.8	Cat. 843	1986.328.1	Cat. 941
1986.271 a-d	Cat. 799	1986.298.9	Cat. 844	1986.328.2	Cat. 523
1986.272 a-b	Cat. 800	1986.299	Cat. 845	1986.328.3	Cat. 942
1986.273 a	Cat. 801	1986.300 a-b	Cat. 867	1986.328.4	Cat. 943
1986.273 b-c	Cat. 802	1986.301 a-b	Cat. 868	1986.328.5	Cat. 944
1986.274	Cat. 803	1986.302 a-b	Cat. 869	1986.328.6	Cat. 524
1986.275 a-b	Cat. 804	1986.303 a-b	Cat. 536	1986.329.1	Cat. 546
1986.276 a-b	Cat. 805	1986.304	Cat. 870	1986.329.2	Cat. 557
1986.277 a-b	Cat. 806	1986.305 a-b	Cat. 822	1986.329.3	Cat. 558
1986.277 c-d	Cat. 807	1986.306	Cat. 873	1986.329.4	Cat. 559
1986.278 a-b	Cat. 808	1986.307	Cat. 871	1986.329.5	Cat. 547
1986.279	Cat. 820	1986.308	Cat. 872	1986.329.6	Cat. 548
1986.280 a-b	Cat. 809	1986.309	Cat. 823	1986.329.7	Cat. 945
1986.281	Cat. 810	1986.310 a-b	Cat. 874	1986.329.8 a-b	Cat. 549
1986.282	Cat. 811	1986.311 a-b	Cat. 875	1986.329.9	Cat. 560
1986.283 a-c	Cat. 812	1986.312.1	Cat. 876	1986.330.1	Cat. 532
1986.284	Cat. 813	1986.312.2	Cat. 877	1986.330.2	Cat. 533
1986.285.1	Cat. 814	1986.312.3	Cat. 878	1986.330.3	Cat. 946
1986.285.2	Cat. 815	1986.313.3	Cat. 732	1986.330.4	Cat. 534
1986.286	Cat. 816	1986.314.1	Cat. 879	1986.330.5	Cat. 561
1986.287	Cat. 865	1986.313.1	Cat. 724	1986.330.6	Cat. 562
1986.288.1	Cat. 817	1986.313.2	Cat. 725	1986.330.7	Cat. 535
1986.288.2	Cat. 866	1986.314.2	Cat. 727	1986.331.1	Cat. 509
1986.289.1 a-c	Cat. 652	1986.315 a-b	Cat. 846	1986.331.2	Cat. 510
1986.289.2 a-c	Cat. 653	1986.316	Cat. 847	1986.331.3	Cat. 511
1986.289.3	Cat. 931	1986.317.1	Cat. 933	1986.331.4	Cat. 512
1986.289.3 b-c	Cat. 654	1986.317.2	Cat. 934	1986.331.5	Cat. 563
1986.289.4	Cat. 656	1986.317.3	Cat. 295	1986.332.1 a-b	Cat. 527

1986.332.2 a-b	Cat. 528	1986.339.5	Cat. 778	1986.362	Cat. 16
1986.332.3 a-b	Cat. 529	1986.339.6	Cat. 779	1986.363	Cat. 966
1986.332.4 a	Cat. 530	1986.339.7	Cat. 780	1986.364	Cat. 36
1986.332.7 a-b	Cat. 531	1986.339.8	Cat. 139	1986.365	Cat. 967
1986.333.1	Cat. 543	1986.339.9	Cat. 140	1986.366	Cat. 30
1986.333.2	Cat. 544	1986.340.1	Cat. 711	1986.367	Cat. 60
1986.332.4 b	Cat. 947	1986.340.2	Cat. 712	1986.368 a	Cat. 11
1986.332.5	Cat. 948	1986.340.3	Cat. 713	1986.368 b	Cat. 12
1986.332.6 a-b	Cat. 949	1986.340.4	Cat. 714	1986.369	Cat. 83
1986.334.1	Cat. 950	1986.340.5	Cat. 715	1986.370	Cat. 113
1986.334.2	Cat. 537	1986.341	Cat. 881	1986.371	Cat. 95
1986.334.3	Cat. 538	1986.342.1	Cat. 781	1986.372	Cat. 76
1986.334.4	Cat. 951	1986.342.2	Cat. 782	1986.373	Cat. 107
1986.334.5	Cat. 952	1986.342.3	Cat. 783	1986.374	Cat. 228
1986.334.6	Cat. 953	1986.343.1	Cat. 824	1986.375	Cat. 45
1986.334.7	Cat. 954	1986.343.2	Cat. 825	1986.376	Cat. 104
1986.334.8	Cat. 539	1986.343.3	Cat. 826	1986.377	Cat. 96
1986.334.9	Cat. 540	1986.343.4	Cat. 827	1986.378.1	Cat. 6
1986.334.10	Cat. 541	1986.343.5	Cat. 717	1986.378.2	Cat. 7
1986.334.11	Cat. 955	1986.343.6 a-b	Cat. 718	1986.379	Cat. 35
1986.334.12	Cat. 956	1986.343.7	Cat. 719	1986.380	Cat. 55
1986.335.1	Cat. 564	1986.343.8	Cat. 828	1986.381	Cat. 44
1986.335.2	Cat. 565	1986.343.9	Cat. 882	1986.382	Cat. 110
1986.335.3	Cat. 566	1986.344.1	Cat. 962	1986.383	Cat. 112
1986.335.4 a-b	Cat. 957	1986.344.2	Cat. 883	1986.384	Cat. 48
1986.336.1	Cat. 958	1986.344.3	Cat. 885	1986.385	Cat. 968
1986.336.2	Cat. 959	1986.344.4	Cat. 963	1986.386	Cat. 142
1986.336.3	Cat. 960	1986.344.5	Cat. 886	1986.387	Cat. 27
1986.336.4	Cat. 571	1986.344.6 a	Cat. 887	1986.388	Cat. 28
1986.336.5	Cat. 513	1986.344.6 b	Cat. 888	1986.389	Cat. 9
1986.336.6	Cat. 567	1986.344.7	Cat. 884	1986.390.1	Cat. 87
1986.336.7	Cat. 575	1986.345	Cat. 61	1986.390.2	Cat. 92
1986.336.8	Cat. 545	1986.346.1	Cat. 79	1986.390.3	Cat. 91
1986.336.9	Cat. 568	1986.346.2	Cat. 78	1986.391.1	Cat. 51
1986.336.10	Cat. 542	1986.346.3	Cat. 227	1986.391.2	Cat. 49
1986.336.11	Cat. 569	1986.346.4	Cat. 80	1986.391.3	Cat. 50
1986.337.1	Cat. 550	1986.346.5	Cat. 81	1986.392	Cat. 109
1986.337.2	Cat. 551	1986.346.6	Cat. 964	1986.393	Cat. 58
1986.337.3	Cat. 552	1986.346.7	Cat. 141	1986.394	Cat. 969
1986.337.4	Cat. 553	1986.347.1	Cat. 32	1986.395	Cat. 94
1986.337.5	Cat. 554	1986.347.2	Cat. 33	1986.396	Cat. 85
1986.337.6	Cat. 555	1986.347.3	Cat. 34	1986.397	Cat. 84
1986.337.7	Cat. 556	1986.348	Cat. 93	1986.398	Cat. 59
1986.338.1	Cat. 576	1986.349	Cat. 102	1986.399	Cat. 8
1986.338.2	Cat. 895	1986.350.1	Cat. 21	1986.400	Cat. 229
1986.338.3	Cat. 896	1986.350.2	Cat. 22	1986.401	Cat. 57
1986.338.4	Cat. 577	1986.351.1	Cat. 40	1986.402	Cat. 52
1986.338.5	Cat. 578	1986.351.2	Cat. 43	1986.403	Cat. 108
1986.338.6	Cat. 579	1986.351.3	Cat. 38	1986.404	Cat. 105
1986.338.7	Cat. 580	1986.352	Cat. 24	1986.405.1	Cat. 71
1986.338.8	Cat. 581	1986.353	Cat. 42	1986.405.2	Cat. 68
1986.338.9	Cat. 582	1986.354	Cat. 13	1986.405.3	Cat. 69
1986.338.10	Cat. 583	1986.355	Cat. 106	1986.405.4	Cat. 67
1986.338.11	Cat. 584	1986.356	Cat. 19	1986.406.1	Cat. 74
1986.338.12	Cat. 961	1986.357	Cat. 73	1986.406.2	Cat. 75
1986.339.1	Cat. 774	1986.358.1	Cat. 62	1986.407	Cat. 232
1986.339.2	Cat. 775	1986.358.2	Cat. 18	1986.408	Cat. 143
1986.339.3	Cat. 776	1986.360	Cat. 365	1986.409	Cat. 144
1986.339.4	Cat. 777	1986.361	Cat. 3	1986.410	Cat. 145

1986.411	Cat. 146	1986.446.11	Cat. 171	1986.481.7	Cat. 332
1986.412	Cat. 230	1986.447	Cat. 103	1986.481.8	Cat. 330
1986.413.1	Cat. 193	1986.448	Cat. 172	1986.481.9	Cat. 318
1986.413.2	Cat. 195	1986.449	Cat. 173	1986.481.10	Cat. 313
1986.413.3	Cat. 198	1986.450.1	Cat. 70	1986.481.11	Cat. 304
1986.414	Cat. 200	1986.450.2	Cat. 235	1986.481.12	Cat. 320
1986.415	Cat. 199	1986.451.1	Cat. 234	1986.481.13	Cat. 336
1986.416	Cat. 204	1986.451.2	Cat. 236	1986.481.14	Cat. 325
1986.417	Cat. 206	1986.452	Cat. 41	1986.481.15	Cat. 314
1986.418	Cat. 208	1986.453	Cat. 5	1986.481.16	Cat. 305
1986.419 a	Cat. 207	1986.454	Cat. 65	1986.481.17	Cat. 331
1986.419 b	Cat. 209	1986.455	Cat. 37	1986.481.18	Cat. 323
1986.420	Cat. 217	1986.456	Cat. 205	1986.481.19	Cat. 321
1986.421.1	Cat. 220	1986.457	Cat. 174	1986.481.20	Cat. 339
1986.421.2	Cat. 221	1986.458	Cat. 175	1986.481.21	Cat. 333
1986.422.1	Cat. 210	1986.459	Cat. 176	1986.481.22	Cat. 328
1986.422.2	Cat. 215	1986.460	Cat. 906	1986.481.23	Cat. 341
1986.422.3	Cat. 211	1986.461.1	Cat. 909	1986.481.24	Cat. 310
1986.422.4	Cat. 212	1986.461.2	Cat. 910	1986.481.25	Cat. 345
1986.423	Cat. 218	1986.461.3	Cat. 911	1986.481.26	Cat. 300
1986.424	Cat. 223	1986.462	Cat. 17	1986.481.27	Cat. 346
1986.425.1	Cat. 202	1986.463	Cat. 115	1986.481.28	Cat. 315
1986.425.2	Cat. 203	1986.464	Cat. 4	1986.481.29	Cat. 308
1986.426	Cat. 219	1986.465	Cat. 196	1986.481.30	Cat. 322
1986.427	Cat. 224	1986.466	Cat. 10	1986.481.31	Cat. 302
1986.428	Cat. 225	1986.467	Cat. 2	1986.481.32	Cat. 317
1986.429.1	Cat. 213	1986.468	Cat. 177	1986.481.33	Cat. 340
1986.429.2	Cat. 214	1986.469	Cat. 111	1986.481.34	Cat. 343
1986.430	Cat. 147	1986.470	Cat. 287	1986.481.35	Cat. 337
1986.431.1	Cat. 116	1986.471	Cat. 82	1986.481.36	Cat. 306
1986.431.2	Cat. 118	1986.472	Cat. 178	1986.481.37	Cat. 311
1986.431.3	Cat. 119	1986.473	Cat. 197	1986.481.38	Cat. 351
1986.431.4	Cat. 120	1986.474	Cat. 1	1986.481.39	Cat. 324
1986.431.5	Cat. 121	1986.475 a	Cat. 29	1986.481.40	Cat. 349
1986.432.1	Cat. 148	1986.475 b	Cat. 66	1986.481.41	Cat. 347
1986.432.2	Cat. 149	1986.476	Cat. 53	1986.481.42	Cat. 307
1986.433	Cat. 150	1986.477.1	Cat. 89	1986.481.43	Cat. 326
1986.434	Cat. 151	1986.477.2	Cat. 90	1986.481.44	Cat. 312
1986.435	Cat. 152	1986.477.3	Cat. 88	1986.481.45	Cat. 329
1986.436	Cat. 153	1986.478.1	Cat. 114	1986.481.46	Cat. 348
1986.437	Cat. 154	1986.478.2	Cat. 117	1986.481.47	Cat. 350
1986.438	Cat. 155	1986.478.3	Cat. 122	1986.481.48	Cat. 338
1986.439	Cat. 156	1986.478.4	Cat. 123	1986.481.49	Cat. 327
1986.440	Cat. 157	1986.478.5	Cat. 129	1986.481.50	Cat. 342
1986.441	Cat. 158	1986.478.6	Cat. 126	1986.481.51	Cat. 498
1986.442	Cat. 159	1986.478.7	Cat. 125	1986.481.52	Cat. 468
1986.443	Cat. 160	1986.478.8	Cat. 127	1986.481.53	Cat. 436
1986.444	Cat. 231	1986.478.9	Cat. 130	1986.481.54	Cat. 375
1986.445	Cat. 161	1986.478.10	Cat. 131	1986.481.55	Cat. 494
1986.446.1	Cat. 162	1986.478.11	Cat. 132	1986.481.56	Cat. 433
1986.446.2	Cat. 163	1986.478.12	Cat. 133	1986.481.57	Cat. 495
1986.446.3	Cat. 164	1986.479	Cat. 179	1986.481.58	Cat. 496
1986.446.4	Cat. 165	1986.480	Cat. 180	1986.481.59	Cat. 354
1986.446.5	Cat. 166	1986.481.1	Cat. 301	1986.481.60	Cat. 469
1986.446.6	Cat. 970	1986.481.2	Cat. 316	1986.481.61	Cat. 470
1986.446.7	Cat. 167	1986.481.3	Cat. 334	1986.481.62	Cat. 443
1986.446.8	Cat. 168	1986.481.4	Cat. 344	1986.481.63	Cat. 471
1986.446.9	Cat. 169	1986.481.5	Cat. 309	1986.481.64	Cat. 472
1986.446.10	Cat. 170	1986.481.6	Cat. 335	1986.481.65	Cat. 303

1986.481.66	Cat. 473	1986.481.126	Cat. 508	1986.481.185	Cat. 412
1986.481.67	Cat. 492	1986.481.127	Cat. 428	1986.481.186	Cat. 369
1986.481.68	Cat. 474	1986.481.128	Cat. 430	1986.481.187	Cat. 463
1986.481.69	Cat. 475	1986.481.129	Cat. 416	1986.481.188	Cat. 435
1986.481.70	Cat. 476	1986.481.130	Cat. 381	1986.481.189	Cat. 977
1986.481.71	Cat. 362	1986.481.131	Cat. 390	1986.481.190	Cat. 448
1986.481.72	Cat. 477	1986.481.132	Cat. 458	1986.481.191	Cat. 413
1986.481.73	Cat. 370	1986.481.133	Cat. 405	1986.481.192	Cat. 368
1986.481.74	Cat. 971	1986.481.134	Cat. 415	1986.481.193	Cat. 98
1986.481.75	Cat. 478	1986.481.135	Cat. 389	1986.481.194	Cat. 99
1986.481.76	Cat. 434	1986.481.136	Cat. 438	1986.481.195	Cat. 491
1986.481.77	Cat. 479	1986.481.137	Cat. 459	1986.481.196	Cat. 367
1986.481.78	Cat. 480	1986.481.138	Cat. 450	1986.481.197	Cat. 393
1986.481.79	Cat. 372	1986.481.139	Cat. 391	1986.481.198	Cat. 26
1986.481.80	Cat. 364	1986.481.140	Cat. 454	1986.481.199	Cat. 419
1986.481.81	Cat. 481	1986.481.141	Cat. 373	1986.481.200	Cat. 464
1986.481.82	Cat. 482	1986.481.142	Cat. 451	1986.481.201	Cat. 409
1986.481.83	Cat. 497	1986.481.143	Cat. 506	1986.481.202	Cat. 445
1986.481.84	Cat. 493	1986.481.144	Cat. 460	1986.481.203	Cat. 432
1986.481.86	Cat. 973	1986.481.145	Cat. 371	1986.481.204	Cat. 410
1986.481.87	Cat. 359	1986.481.146	Cat. 406	1986.481.205	Cat. 465
1986.481.88	Cat. 499	1986.481.147	Cat. 461	1986.481.206	Cat. 414
1986.481.89	Cat. 483	1986.481.148	Cat. 374	1986.481.207	Cat. 466
1986.481.90	Cat. 484	1986.481.149	Cat. 431	1986.481.208	Cat. 408
1986.481.91	Cat. 485	1986.481.150	Cat. 447	1986.481.209	Cat. 442
1986.481.92	Cat. 355	1986.481.151	Cat. 358	1986.481.210	Cat. 427
1986.481.93	Cat. 486	1986.481.152	Cat. 407	1986.481.211	Cat. 422
1986.481.94	Cat. 487	1986.481.153	Cat. 382	1986.481.212	Cat. 397
1986.481.95	Cat. 360	1986.481.154	Cat. 452	1986.481.213	Cat. 421
1986.481.96	Cat. 974	1986.481.155	Cat. 398	1986.481.214	Cat. 449
1986.481.97	Cat. 488	1986.481.156	Cat. 446	1986.481.215	Cat. 404
1986.481.98	Cat. 467	1986.481.157	Cat. 399	1986.481.216	Cat. 395
1986.481.99	Cat. 489	1986.481.158	Cat. 396	1986.481.217	Cat. 507
1986.481.100	Cat. 500	1986.481.159	Cat. 441	1986.481.218	Cat. 379
1986.481.101	Cat. 377	1986.481.160	Cat. 503	1986.481.219	Cat. 420
1986.481.102	Cat. 378	1986.481.161	Cat. 376	1986.482	Cat. 72
1986.481.103	Cat. 490	1986.481.162	Cat. 439	1986.483	Cat. 181
1986.481.104	Cat. 501	1986.481.163	Cat. 249	1986.484	Cat. 77
1986.481.105	Cat. 319	1986.481.164	Cat. 429	1986.485	Cat. 201
1986.481.106	Cat. 411	1986.481.165	Cat. 425	1986.486	Cat. 182
1986.481.107	Cat. 440	1986.481.166	Cat. 387	1986.487	Cat. 183
1986.481.108	Cat. 426	1986.481.167	Cat. 453	1986.488	Cat. 184
1986.481.109	Cat. 361	1986.481.168	Cat. 505	1986.489	Cat. 185
1986.481.110	Cat. 385	1986.481.169	Cat. 504	1986.490	Cat. 186
1986.481.111	Cat. 388	1986.481.170	Cat. 363	1986.491	Cat. 187
1986.481.112	Cat. 423	1986.481.171	Cat. 976	1986.492	Cat. 188
1986.481.113	Cat. 386	1986.481.172	Cat. 101	1986.493	Cat. 46
1986.481.114	Cat. 365	1986.481.173	Cat. 15	1986.494	Cat. 237
1986.481.115	Cat. 403	1986.481.174	Cat. 97	1986.495.1	Cat. 239
1986.481.116	Cat. 366	1986.481.175	Cat. 456	1986.495.2	Cat. 238
1986.481.117	Cat. 444	1986.481.176	Cat. 100	1986.495.3	Cat. 240
1986.481.118	Cat. 384	1986.481.177	Cat. 400	1986.495.4	Cat. 241
1986.481.119	Cat. 383	1986.481.178	Cat. 455	1986.495.5	Cat. 242
1986.481.120	Cat. 417	1986.481.179	Cat. 418	1986.495.6	Cat. 243
1986.481.121	Cat. 402	1986.481.180	Cat. 462	1986.495.7	Cat. 244
1986.481.122	Cat. 424	1986.481.181	Cat. 437	1986.495.8	Cat. 245
1986.481.123	Cat. 502	1986.481.182	Cat. 392	1986.495.9	Cat. 246
1986.481.124	Cat. 394	1986.481.183	Cat. 86	1986.495.10	Cat. 247
1986.481.125	Cat. 975	1986.481.184	Cat. 25	1986.495.11	Cat. 248

1986.495.12	Cat. 233	1986.497.9	Cat. 285	2006.19	Cat. 787
1986.495.13	Cat. 250	1986.497.10	Cat. 401		
1986.495.14	Cat. 251	1986.498.1-2	Cat. 720	2007.16 a-b	Cat. 716
1986.495.15	Cat. 252	1986.499 a-b	Cat. 818	2007.17	Cat. 216
1986.495.16	Cat. 253	1986.500	Cat. 983		
1986.495.17	Cat. 254	1986.501.1-2	Cat. 721	no/o. Inv.	Cat. 989
1986.495.18	Cat. 255	1986.502	Cat. 722	no/o. Inv.	Cat. 990
1986.495.19	Cat. 256	1986.503	Cat. 890	no/o. Inv.	Cat. 991
1986.495.20	Cat. 257	1986.504	Cat. 688	no/o. Inv.	Cat. 992
1986.495.21	Cat. 258	1986.505	Cat. 907	no/o. Inv.	Cat. 993
1986.495.22	Cat. 259	1986.506	Cat. 891	no/o. Inv.	Cat. 994
1986.495.23	Cat. 260	1986.507	Cat. 892		
1986.495.24	Cat. 261	1986.508.1-2	Cat. 901		
1986.495.26	Cat. 262	1986.509	Cat. 646		
1986.495.27	Cat. 14	1986.510	Cat. 663		
1986.495.28	Cat. 63	1986.511	Cat. 897		
1986.495.29	Cat. 978	1986.512	Cat. 189		
1986.495.30	Cat. 47	1986.513	Cat. 190		
1986.495.31	Cat. 263	1986.514	Cat. 898		
1986.495.32	Cat. 264	1986.515	Cat. 647		
1986.495.33	Cat. 265	1986.515 a	Cat. 893		
1986.495.34	Cat. 31	1986.516	Cat. 899		
1986.495.35	Cat. 39	1986.517	Cat. 894		
1986.495.36	Cat. 266	1986.519.1-2	Cat. 904		
1986.495.37	Cat. 267	1986.520	Cat. 648		
1986.495.38	Cat. 268	1986.521	Cat. 649		
1986.495.39	Cat. 270	1986.522	Cat. 984		
1986.495.40	Cat. 271	1986.523	Cat. 880		
1986.495.41	Cat. 272	1986.524	Cat. 191		
1986.495.42	Cat. 273	1986.525	Cat. 222		
1986.495.43	Cat. 979	1986.1168	Cat. 570		
1986.495.44	Cat. 20	1986.1169	Cat. 908		
1986.495.45	Cat. 275				
1986.495.46	Cat. 276	00.1	Cat. 902		
1986.495.47 a	Cat. 277	00.17	Cat. 903		
1986.495.47 b	Cat. 278	00.268	Cat. 924		
1986.495.47 c	Cat. 279	00.269	Cat. 923		
1986.495.48	Cat. 980	00.270	Cat. 922		
1986.495.49	Cat. 981	00.271	Cat. 919		
1986.495.50	Cat. 289	00.272	Cat. 918		
1986.495.51	Cat. 280	00.273	Cat. 921		
1986.495.52	Cat. 525	00.274	Cat. 914		
1986.495.53	Cat. 526	00.275	Cat. 650		
1986.495.54	Cat. 572	00.276	Cat. 836		
1986.495.55 a	Cat. 982	00.277	Cat. 913		
1986.495.55 b	Cat. 573	00.278	Cat. 633		
1986.495.56	Cat. 290	00.279	Cat. 634		
1986.496.1	Cat. 291	00.280	Cat. 925		
1986.496.2	Cat. 293	00.281	Cat. 917		
1986.496.3	Cat. 294	00.282	Cat. 916		
1986.496.4	Cat. 292	00.283	Cat. 926		
1986.497.1	Cat. 281	00.284	Cat. 915		
1986.497.2	Cat. 282	00.285	Cat. 920		
1986.497.3	Cat. 283	00.292	Cat. 651		
1986.497.4	Cat. 284	00.293	Cat. 194		
1986.497.5	Cat. 352	00.294	Cat. 286		
1986.497.6	Cat. 353				
1986.497.7	Cat. 356	2002.139.1-2	Cat. 900		
1986.497.8	Cat. 357	2002.3	Cat. 56		

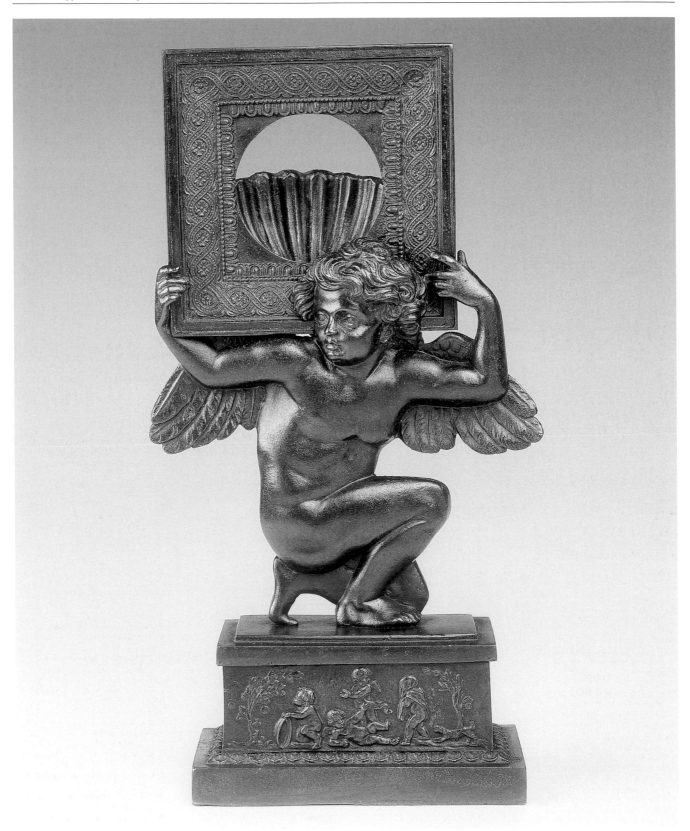

Pocket Watch Holder / Taschenuhrhalter (Cat. 742)

Index / Register

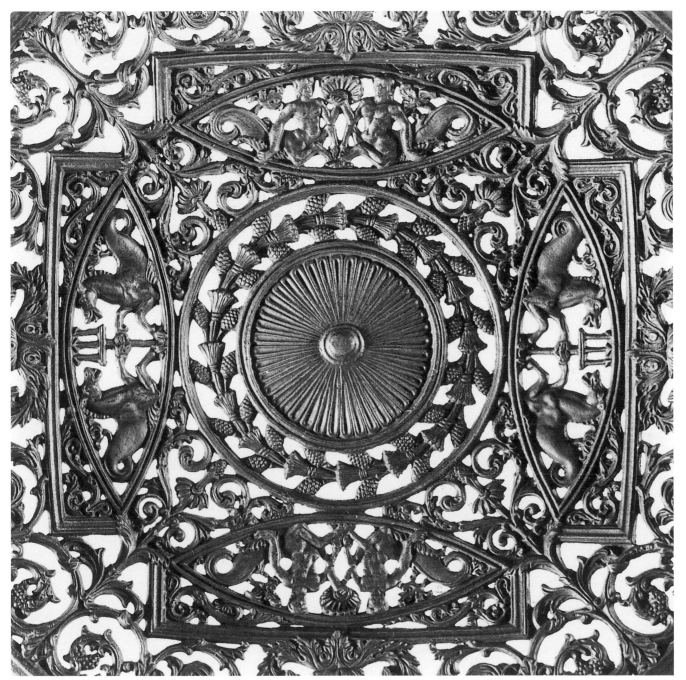

Fig./Abb. 58 Detail of a plate after the model in Cat. 831 / Ausschnitt eines Tellers nach dem Model von Cat. 831.

Acknowledgments

This catalogue could not have been produced without the help of numerous people and institutions. Above all, I would like to thank Gail C. Andrews, the R. Hugh Daniel Director of the Birmingham Museum of Art, who has supported this project from the start and who has helped see it through to completion. I would like to thank Esta Kamplain, volunteer extraordinaire and good friend, whose help cataloguing the collection was instrumental during the early phases of the project, and who has served as a welcome source of support and assistance ever since. Sean Pathasema photographed the entire collection, mostly while serving as an unpaid intern at the Museum. We are fortunate to have his beautiful images of the objects within the pages of this catalogue. My colleagues in the Registrar's Department, Melissa Falkner Mercurio, Mary Villadsen, Suzanne Stephens, and Lisa Stewart offered support at every turn, and for that I am grateful. A special thanks to Jeannine O'Grody for her continued friendship and encouragement during the various stages of the catalogue. Thanks also to Kristi Taft, a member of the Museum's development staff, who enthusiastically raised funds to support this publication.

My sincere thanks go to Dr. Willmuth Arenhövel and his colleagues Hannah Arenhövel and Norbert Schulz for editing and designing this beautiful catalogue.

I greatly appreciate the following for their assistance and for providing me with information needed to prepare this catalogue:

Dr. Katrin Achilles-Syndram, Berlin; Professor Kenneth Barkin, Riverside, California, University of California; Elisabeth Bartel, Berlin, Stiftung Stadtmuseum Berlin; Julia Blume, Leipzig, Hochschule für Grafik und Buchkunst; Dr. Margaret Carney, Toldeo, Ohio, The Blair Museum of Lithophanes; Professor Dr. F. W. Eigler, Essen; Dr. Matthias Frotscher, Lauchhammer, Kunstgussmuseum; Dr. Thomas Garbáty, Ann Arbor, Michigan; Hans-Heinrich Hillegeist, Göttingen; Manuela Krüger, Berlin, Staatliche Museen zu Berlin Preussischer Kulturbesitz, Kunstgewerbemuseum; Cynthia H. Lovoy, Birmingham, Alabama, American Cast Iron Pipe Company; Dr. Ursula Marcum; Vicki McCargar, Los Angeles, The Los Angeles Times; Karl-Heinz Mehnert, Leipzig, Museum der bildenden Künste; Stig Miss, Copenhagen, Thorvaldsens Museum; Eberhard Patzig, Leipzig, Museum für Kunsthandwerk; Jennifer Spurrier, Lubbock, Texas, Texas Tech University; Sarah Wesson, Davenport, Iowa, Davenport Public Library.

Additionally I would like to thank the employees of the following institutions:

Sächsisches Staatsarchiv Leipzig; Stadtarchiv Leipzig; Geheimes Staatsarchiv Preussischer Kulturbesitz, Berlin; St. Louis Historical Society; Natural History Museum of Los Angeles County; Southwest Museum; Stadtarchiv und Stadthistorische Bibliothek Bonn; Kirchliches Archiv Leipzig; Stadt Leipzig, Grünflächenamt, Abteilung Friedhöfe; Amtsgericht Leipzig, Nachlassgericht; Stadtgeschichtliches Museum Leipzig; St. Louis Post-Dispatch; St. Louis County Library; Biloxi Public Library; Los Angeles Public Library.

Heartfelt thanks are also due my dear friends Angelika Stanke-Peatman and Dr. William Peatman, who read my text in both English and German and offered suggestions and corrections that have helped to greatly enhance it. Finally, I thank my husband, Jürgen Tarrasch, for his continued support and cheerfulness throughout the long process of preparing a catalogue of this size.

Danksagung

Ohne die Hilfe zahlreicher Personen und Institutionen hätte dieser Katalog nicht geschrieben werden können. An erster Stelle gilt mein herzlicher Dank Gail C. Andrews, Direktorin des Birmingham Museum of Art, die die Katalogisierung und Bearbeitung der Eisenkunstguß-Sammlung dauerhaft unterstützte. Weiterhin danke ich Esta Kamplain, freiwillige Mitarbeiterin des Museums und gute Freundin, die mir bereits seit dem frühen Stadium der Katalogisierung der Sammlung hilfreich zur Seite stand. Sean Pathasema hat die ganze Sammlung photographiert, meistens während er als unbezahlter Praktikant im Museum arbeitete. Seine qualitätvollen Aufnahmen ermöglichten erst die gute Bebilderung dieser Veröffentlichung. Meine Kolleginnen in der Registrier-Abteilung, Melissa Falkner Mercurio, Mary Villadsen, Suzanne Stephens und Lisa Stewart, haben mich auf Schritt und Tritt unterstützt, und dafür bin ich ihnen sehr dankbar. Ein besonderer Dank gilt Jeannine O'Grody für ihre ununterbrochene Freundschaft und Unterstützung während der verschiedenen Phasen des Katalogs. Gedankt sei auch Kristi Taft, Mitglied der Fundraising-Abteilung des Museums, die die nötigen finanziellen Mittel für die Publikation eingeworben hat, und Dr. Willmuth Arenhövel und seinen MitarbeiterInnen Hannah Arenhövel und Norbert Schulz, die mit viel Engagement diesen Katalog erstellt haben.

Für Hilfe und Beratung danke ich außerdem:

Dr. Katrin Achilles-Syndram, Berlin; Professor Kenneth Barkin, Riverside, California; Elisabeth Bartel, Berlin, Stiftung Stadtmuseum Berlin; Julia Blume, Leipzig, Hochschule für Grafik und Buchkunst; Dr. Margaret Carney, Toldeo, Ohio, The Blair Museum of Lithophanes; Professor Dr. F. W. Eigler, Essen; Matthias Frotscher, Lauchhammer, Kunstgussmuseum; Dr. Thomas Garbáty, Ann Arbor, Michigan; Hans-Heinrich Hillegeist, Göttingen; Manuela Krüger, Berlin, Kunstgewerbemuseum, Staatliche Museen zu Berlin Preußischer Kulturbesitz; Cynthia H. Lovoy, Birmingham, Alabama, American Cast Iron Pipe Company; Dr. Ursula Marcum; Vicki McCargar, Los Angeles, The Los Angeles Times; Karl-Heinz Mehnert, Leipzig, Museum der bildenden Künste; Stig Miss, Kopenhagen, Thorvaldsens Museum; Eberhard Patzig, Leipzig, Museum für Kunsthandwerk; Jennifer Spurrier, Lubbock, Texas, Texas Tech University; Sarah Wesson, Davenport, Iowa, Davenport Public Library.

Weiterhin danke ich den Mitarbeitern der folgenden Institutionen: Sächsisches Staatsarchiv Leipzig; Stadtarchiv Leipzig; Geheimes Staatsarchiv Preußischer Kulturbesitz, Berlin; St. Louis Historical Society; Natural History Museum of Los Angeles County; Southwest Museum; Stadtarchiv und Stadthistorische Bibliothek Bonn; Kirchliches Archiv Leipzig; Stadt Leipzig, Grünflächenamt, Abteilung Friedhöfe; Amtsgericht Leipzig, Nachlaßgericht; Stadtgeschichtliches Museum Leipzig; St. Louis Post-Dispatch; St. Louis County Library; Biloxi Public Library; Los Angeles Public Library.

Tief empfundener Dank gilt ferner meinen guten Freunden Angelika Stanke-Peatman und Dr. William Peatman, die meinen Text auf englisch und deutsch gelesen und mit Vorschlägen und Korrekturen bereichert haben. Letztendlich danke ich meinem Mann, Jürgen Tarrasch, für seine intensive Unterstützung während der langen Zeit, die nötig ist, um einen Katalog dieser Art zu erarbeiten.

Financial assistance for this catalogue was generously provided by:
- The Peter Krueger-Christie's Foundation. This foundation underwrote research travel with a grant as part of its ongoing program to support scholarship within the field of the decorative arts.
- The National Endowment for the Arts
- The Members Board of the Birmingham Museum of Art
- The Adele Pharo Azar Charitable Trust.

These subsidies have allowed us to bring the Museum's important collection of European cast iron to a wider audience and have given the collection a life beyond the Birmingham Museum of Art.

Die Drucklegung der Publikation wurde dankenswerterweise finanziell gefördert durch:
- The Peter Krueger-Christie's Foundation als Teil ihres laufenden Programms zur Unterstützung von wissenschaftlichen Arbeiten im Bereich Kunstgewerbe;
- The National Endowment for the Arts;
- The Members Board of the Birmingham Museum of Art; und
- The Adele Pharo Azar Charitable Trust.

Diese Fördermittel haben uns es ermöglicht, diese wichtige Sammlung von europäischem Eisenkunstguß einem breiten Publikum außerhalb des Birmingham Museums of Art bekannt zu machen.

Anne Forschler-Tarrasch, Ph.D.
The Marguerite Jones Harbert and John M. Harbert III
Curator of Decorative Arts

Dr. Anne Forschler-Tarrasch
The Marguerite Jones Harbert and John M. Harbert III
Curator of Decorative Arts

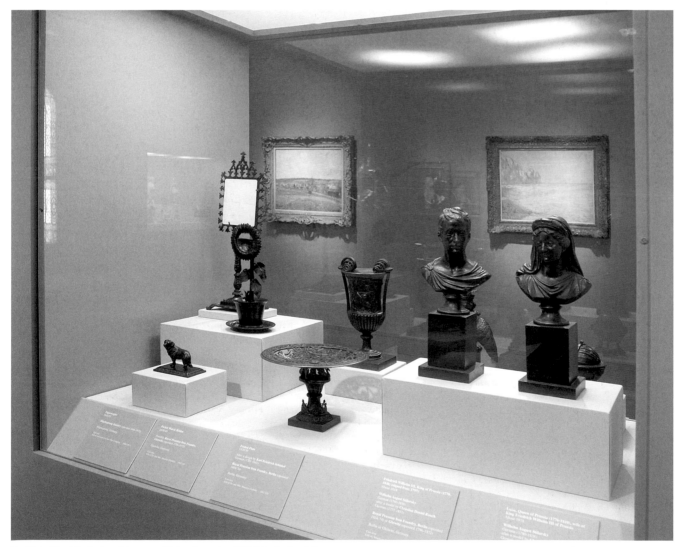

Fig./Abb. 59 Birmingham Museum of Art, gallery view / Blick in die Ausstellung; photo/Aufnahme 2008.

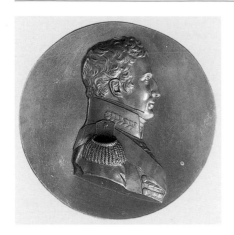
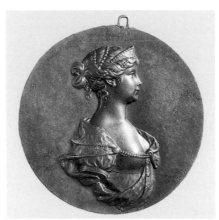
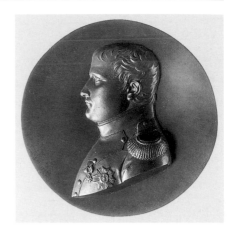

Anne Forschler-Tarrasch

LEONHARD POSCH, Porträtmodelleur und Bildhauer, 1750-1831

Mit einem Verzeichnis seiner Werke und deren Vervielfältigungen in Eisen- und Bronzeguß, Porzellan und Gips
(Deutsche Gesellschaft für Medaillenkunst e. V., Die Kunstmedaille in Deutschland, vol. 15, edited by Wolfgang Steguweit)
Format 21 x 26 cm (8 1/4 x 10 1/4 in.), 284 pages with more than 1,000 illustrations, bibliography and index; hardcover
ISBN 978-3-922912-55-2
$ 90.00 / Euro (D) 89,–

Austrian-born modeler Leonhard Posch was an artist, whose creativity unfolded in three of the major capitals of Europe: Vienna, Berlin, and Paris. He specialized in miniature relief portraits, which he formed in wax directly from a live model. The result was subtly conceived, yet very realistic "masterpieces" in small format. Posch created portraits of many of the rulers of his time as well as members of their royal families. He also modeled the likenesses of military officers – heroes of the Wars of Liberation – and personalities from popular culture. In all, Posch created a group of more than 800 portrait medallions, many of which were cast in iron at the royal Prussian iron foundries.
The book includes 1,038 catalogue entries, including missing and erroneously attributed works, and is an invaluable reference for museums, collectors, and art dealers.

Anne Forschler-Tarrasch

LEONHARD POSCH, Porträtmodelleur und Bildhauer, 1750-1831

Mit einem Verzeichnis seiner Werke und deren Vervielfältigungen in Eisen- und Bronzeguß, Porzellan und Gips
(Deutsche Gesellschaft für Medaillenkunst e. V., Die Kunstmedaille in Deutschland, Band 15, herausgegeben von Wolfgang Steguweit)
Format 21 x 26 cm, 284 Seiten mit über 1.000 Abbildungen, Literatur und Register; Fadenheftung, Hardcover.
ISBN 978-3-922912-55-2
Euro (D) 89,– / sFr 155,–

Der aus Österreich stammende Modelleur Leonhard Posch war ein Künstler, der seine Kreativität in drei Hauptstädten Europas entfaltete: Wien, Berlin und Paris. Seine miniaturhaften Reliefporträts sind wahre Meisterwerke im Kleinformat, die er unmittelbar „nach dem Leben" schuf: Mitglieder der königlichen Familien, Generäle oder Persönlichkeiten des kulturellen Lebens. Zahlreiche dieser mehr als 800 Bildnisse wurden unter anderem auch als Eisengüsse durch die Königlichen Preußischen Eisengießereien vervielfältigt.

Das Werkverzeichnis von 1.038 Nummern enthält auch die verschollenen und die irrtümlicherweise zugeschriebenen Arbeiten. Das Buch ist ein unentbehrliches Nachschlagewerk für Museen, Händler und Sammler.

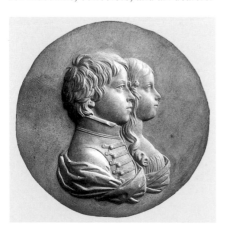

VERLAG WILLMUTH ARENHÖVEL
Treuchtlinger Straße 4
D-10779 Berlin-Schöneberg
Telefon: (030) 2 13 28 03
Fax. (030) 2 18 19 95

Zu beziehen durch Ihre Buchhandlung:
Available through your local bookstore:

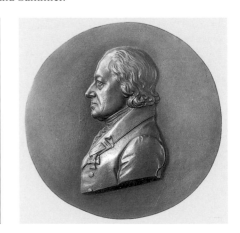